Eighth Edition

Retail Buying

JAY DIAMOND, Professor Emeritus

Department of Marketing, Retailing, Fashion
Nassau Community College

GERALD PINTEL, Professor Emeritus

Department of Accounting and Business Administration
Nassau Community College

PEARSON
Prentice
Hall

Upper Saddle River, New Jersey 07458

Library of Congress Cataloging-in-Publication Data

Diamond, Jay.

 Retail buying/Jay Diamond, Gerald Pintel.—8th ed.

 p. cm.

 Includes index.

 ISBN 0-13-159236-X

 1. Purchasing. I. Pintel, Gerald. II. Title.

 HF5437. D46 2008

 658.7'2—dc22 2006100483

Editor-in-Chief: Vernon R. Anthony
Acquisitions Editor: Jill Jones-Renger
Managing Editor: Mary Carnis
Production Liaison: Janice Stangel
Manufacturing Manager: Ilene Sanford
Manufacturing Buyer: Cathleen Petersen
Production Editor: Heather Willison
Senior Marketing Manager: Leigh Ann Sims
Marketing Assistant: Les Roberts
Senior Marketing Coordinator: Alicia Dysert
Printer/Binder: RR Donnelly/Harrisonburg
Cover Designer: Wanda España/Wee Design Group
Senior Design Coordinator: Miguel Ortiz
Image Credit: Aaron Cobbett, Getty Images/Stone

Director, Image Resource Center: Melinda Patelli
Manager, Rights and Permissions: Zina Arabia
Manager, Visual Research: Beth Brenzel
Manager, Cover Visual Research & Permissions:
 Karen Sanatar
Image Permission Coordinator: Ang'john Ferreri

Pearson Prentice Hall™ is a trademark of Pearson Education, Inc.
Pearson® is a registered trademark of Pearson plc
Prentice Hall® is a registered trademark of Pearson Education, Inc.

Pearson Education LTD.
Pearson Education Singapore, Pte. Ltd
Pearson Education, Canada, Ltd
Pearson Education–Japan
Pearson Education Australia PTY, Limited

Pearson Education North Asia Ltd
Pearson Educación de Mexico, S.A. de C.V.
Pearson Education Malaysia, Pte. Ltd
Pearson Education, Upper Saddle River, NJ

10 9 8 7 6 5 4 3 2 1
ISBN-10: 0-13-159236-X
ISBN-13: 978-013-159236-0

Brief Contents

Contents

Preface

While many of the principles and practices utilized in purchasing for retail operations remain constant, there are some new approaches as well. One in particular is the focus on the diverse ethnicities that retailers are beginning to address in their merchandising plans. A new chapter titled "Multiculturalism: Assessing the Product Needs of America's Major Ethnicities" focuses on the ever-increasing numbers of minority consumers that continue to become more important to retail operations. Attention is paid to the demographic structure of African Americans, Hispanics, and Asian Americans, in particular, the growth potential for major products purchased by these ethnicities, multicultural merchandising and operational approaches, and the buyer's role in attracting the major ethnic consumer markets.

With more and more purchasing accomplished globally, professional buyers are faced with the nuances of purchasing abroad. Another new chapter, "The Importance of Business Etiquette When Purchasing in Global Markets," examines behavior during the buying process. Specifically, the chapter addresses such areas as social and cultural awareness, political neutrality, the mastering of cross-cultural skills, and the practice of appropriate business etiquette in offshore markets.

The chapters that have been carried over from the previous edition have been updated to reflect what the buyer faces every day in his or her pursuit of excellence. In addition, new artwork, including a new color insert, some new Retail Buying Focuses, and additional case problems have been incorporated to make this the most up-to-date text of its kind in the field. The end-of-chapter sections remain including *Language of the Trade, Summary of Key Points, Review Questions,* and *Case Problems.*

Acknowledgments

In bringing this edition of *Retail Buying* up-to-date, the authors called upon industry professionals to provide their expertise and new visuals. Those who contributed the new materials, as well as those who provided the basic information that was carried over from the previous edition, include the following:

Chiqui Cartagena, managing director of multicultural communications at Meredith Integrated Marketing; Ellen Diamond, Diamond Educational Productions; Allan Ellinger, Marketing Management Group principal; Leslie J. Ghize, The Doneger Group; Todd Kahn, executive vice president and chief operating officer, Sean John; Sheri Litt, associate dean of business, Florida Community College at Jacksonville; Donna Lombardo, fashion buyer, Belk Department Stores; Bernt Ullman, president, Phat Fashions; David Wolfe, creative director of D3 Design Direction; and Brett Wright, CEO and founder, NuAmerica Agency and chief creative officer and cofounder, *Uptown* magazine.

In addition, special thanks go to the reviewers of the manuscript from the world of academia, for their suggestions regarding the contents of this edition.

Introduction

So You Want to Be a Buyer . . .

The dream of many aspiring buyers is to lead a professional life that is filled with glamour and continuous excitement. For the fashion buyer, the dream might include trips to Paris to see the couture collections, power lunches at Le Cirque 2000 in New York City or Spago in Los Angeles, and the ability to direct consumer appetites that will translate into sales. While some of these aspirations are achievable, they are, for the most part, dreams, not reality. For the novice buyer, the bubble quickly bursts and the real world of buying takes over. Often the glamourous lunches are replaced with quick visits to nondescript venues or, perhaps, dining al fresco at the street vendor's cart, and the real trials and tribulations of the buyer's day takes center stage.

More typical of the buyer's life is haggling with vendors for better prices, trying to get greater promotional allowances, pacing the floor waiting for the arrival of a shipment that was advertised in that day's newspaper, agonizing over a late shipment from an overseas resource, and confronting a manufacturer who promised you exclusivity on items you found in a competitor's window. Although these occurrences are not everyday events, they nonetheless are part of the realities that buyers must deal with.

No matter what classification of merchandise you are given the responsibility to purchase, the rules of the game are the same. Whether it is apparel, accessories, electronics, appliances, food, or anything else, the bottom line is what counts. Those who do not bring the anticipated profits to the company will more than likely be asked to leave.

To make money for the company and to achieve the expected monetary rewards, the challenges awaiting the buyer are numerous. Some, such as foreign travel, provide excitement, while others, such as meeting last year's sales figures or convincing a vendor to confine a line to your trading area, might be trying. It is also realistic to expect unforeseen problems that are not the fault of the buyer. It might be a severely rainy spring that limits customers' purchasing swimsuits or a dry spell that restricts the need for raincoats. Whatever the problem, the buyer is held accountable for moving the merchandise.

The buyer who is motivated to begin each day on a positive note will be able to handle most of the obstacles with which he or she is confronted. With a great deal of enthusiasm, a love for the job, and the constitution to handle the unforeseen, a successful career will be in the making. The monetary rewards will follow and the luxuries of life will be reachable.

When you have finished this book, you will have read about every aspect of buying and the roles played by those in the field. Now read on and begin to dream of the rewards that await you.

SECTION ONE
Introduction to Retail Buying

Today's professional buyer faces more challenges than ever before. While yesteryear's professional buyers were required to address numerous problems and make decisions that would maximize profits for the companies they represented, the breadth and depth of those problems pale in comparison with what the buyers of today must confront each and every day.

Although it is true that traditional retailers have been in existence for more than one hundred years, off-price merchants have joined the scene to offer another type of shopping, and catalogs have become a major force in retailing; the competition of the past was nothing like it is in today's retail arena. In addition to the continuous growth in all of these retailing endeavors, *e-tailing,* or electronic retailing, has added yet another challenge for buyers to address. Many of the major operations are no longer involved in just one aspect of retailing, but operate divisions that include both on-site and off-site ventures that enable them to reach consumers who prefer different shopping experiences.

Today's buyer—whether a traditional buyer, an off-pricer, a discounter, or a store is the brand company that features only its own private-label merchandise—must continue to satisfy the needs of those who enter brick-and-mortar operation. Many buyers will have to take on additional roles to merchandise the inventories of both the on-site and off-site divisions. Some will have to address the specific needs of those who buy on the home shopping networks, another type of venture that continues to attract more and more shoppers every day.

In trying to find the best possible merchandise for each of these retail ventures, buyers will continue to make use of the many outside specialists available to them. These market specialists include resident buying offices, fashion forecasters, and retail reporting services. Each offers a different type of assistance that can make the buyer's challenges more manageable.

In this section of the book, attention will focus on the roles played by the buyer in addition to purchasing, the different types of brick-and-mortar operations they buy for, the off-site ventures that are having an impact on traditional selling, and the specialists who are there to provide knowledgeable assistance for the buyers' planning and eventual purchasing.

CHAPTER 1

The Buyer's Role

On completion of this chapter, the student should be able to:

- Explain the buyer's role in traditional retailing operations such as department stores, chains, and single-unit independent stores.
- Describe some of the factors that help determine the scope of the buyer's role in the retail organization.
- Discuss why today the department store buyer rarely has responsibility for the sales staff, as he or she once had in the past.
- Illustrate the lines of authority in a major store's merchandising division and where the buyer has his or her place.
- Explain the personal qualifications needed by store buyers to perform their duties and responsibilities.
- List and discuss the duties and responsibilities that store buyers perform in their daily routines.
- Identify the career opportunities for buyers in retailing and related industries.

Anyone who has pursued a career oriented toward merchandising fully understands that the challenges demanded of him or her are significant. These individuals are on the firing line each and every day. The decision making required of the merchandisers must be accurate so that the company represented can turn an acceptable profit.

Within the ranks of the merchandising division of the major stores are the general merchandise manager, several divisional merchandise managers, and a host of buyers. It is the buyer who has the ultimate responsibility for selecting merchandise from the vast number of resources available for purchasing. In situations where the orders are significant in terms of dollar commitment, a merchandise manager is sometimes called upon to help with the buying decision. When a consumer examines a variety of shoe styles for his or her own use, the ultimate decision may be difficult to make. Of course, the choice is a personal one, with no considerations other than self-satisfaction. When the professional buyer makes the final selections, personal satisfaction is not of paramount importance. Customer satisfaction and company profitability are the only barometers by which the purchases are judged. Thus it is apparent that a great deal of the fate of the company is in the hands of the buyer.

Of course, the buyer is only one player on a team of many. Just as the lead actor in a theatrical production is not solely responsible for the success of the production or the star athlete the only one who makes the team victorious, it is generally a

team effort that makes or breaks the ultimate goal. In retailing, the proper management of other activities in the store such as customer service, advertising and promotion, and special events also contributes to the organization's success. Buyers alone cannot make the retailer's dream come true.

Today competition is greater than it has ever been. Not only are brick-and-mortar operations of all kinds expanding in numbers that were never thought possible, as are their off-site divisions, but off-site outlets that do business only through catalogs, home shopping networks, and Internet Web sites are also reaching consumers with a multitude of wares in ever-increasing numbers. For retail operations housed in stores, along with these other outlets, the buyer's role becomes even more important. It is the merchandise that is most important for all of these businesses, and only the buyer can satisfy the needs of the consumer by making the correct choices.

Since the focus of this book is on the buyer, every aspect of his or her daily responsibility will be addressed in this and other chapters.

THE BUYER'S ROLE

Many who wish to embark on a career in retailing do so with the intention of becoming a buyer. The role seems to provide a wealth of excitement and, often, glamour. The buyer of electronics and appliances may not have these expectations, but the would-be purchasers of fashion-oriented merchandise often believe this comes with the territory. While some fashion buyers are fortunate enough to experience some of these glamorous trappings—attending designer runway shows and making trips to exotic destinations—this is by no means the norm for the buying profession. On the contrary, the role of the buyer is multifaceted; many of the tasks performed are rigorous and challenging.

Merchandise selection is just one of many activities that are regular parts of the buyer's day. This and other tasks will be explored in the following sections.

The Scope of the Buyer's Role

Before you can define the scope of the buyer's role, factors such as the type of organization in which he or she is employed, organizational structure of the company, the dollar volume, the merchandise classifications, the number of staff personnel, and the location of the retail outlets must be assessed.

COMPANY ORGANIZATIONAL STRUCTURE

Those who are familiar with retailing, either as practitioners or as students learning about the industry, understand that each organization requires a specific structure to carry out its goals. There are many different types of retail operations—those that are more traditionally oriented such as department stores, chains, and single-unit independents; operations that exclusively feature their own merchandise under

private labels and are commonly referred to as **store is the brand** companies; franchises and licensed stores; and the off-site variety, from which continued growth is expected. The latter classification is atypical in retailing in that the operations do not have store locations. It is these retailers—specifically catalog operations, home shopping networks, and Internet Web sites—that are experiencing great gains in sales.

Each of these retail classifications will be discussed in this chapter. The major ones will be explored further in later chapters.

Chain Organizations. In the early days of retailing, the general store was often the place in which consumers could make their purchases. General stores offered a variety of unrelated products. When merchandise became more plentiful, merchants began to specialize in just one type of goods in new ventures called *limited line stores*. These ventures, ultimately to become known as specialty stores, were greeted with

Buyer examining merchandise in the showroom.
(Courtesy of Ellen Diamond.)

success, and their owners began opening other units. Thus the **chain organization,** a name given to two or more units (often as many as a couple thousand units) under common ownership, enjoyed extreme financial rewards.

Today, the majority of the chains are centrally organized. They are managed from corporate headquarters, where all of the decision making is made. The buyer, who is the central character in this book, operates from this centralized facility and has very little in-store contact with the various units. The major responsibility is purchasing, with communication coming by way of the telephone, faxes, and e-mail.

Typical of these chains are Target and Wal-Mart, each of which operates as discount value-oriented merchants; Petite Sophisticate, a traditional operation that specializes in apparel for the smaller-female figure; The Limited, a company that deals exclusively with its private-label brands; Stein Mart, an off-price operation, and The Gap, a store is the brand company that deals exclusively with its own brand.

Department Stores. Department stores are either of the **full-line** designation, in that they carry a wide assortment of hard goods and soft goods, and occasionally prepared and gourmet foods, or the **specialized** entries that restrict their offerings to one or two merchandise types, such as apparel and accessories. The former group includes companies like Macy's, Dillard's, and Belk, and the latter, Neiman Marcus and Nordstrom.

In the vast majority of these companies, the buyer operates from the store's main retail facility, known as the **flagship store,** and is responsible for purchases for that unit as well as the **branches.** Others, however, operate from centralized locations, similar to those utilized by chains. At one time, the sales staff was the buyer's responsibility, but as organizations expanded, this management function was generally removed as a day-to-day activity. Today, with catalogs and Internet Web sites becoming important to these retailers, some buyers are called on to make purchases for these outlets as well as for the stores.

Single-Unit Independents. Although the trend has been and continues to be big business in retailing, there are still entrepreneurs who wish to operate their own stores. Many of them are extremely successful since they are able to offer their clientele both specialized merchandise and personalized services. Most important in this classification are specialty stores that feature just one item such as shoes, jewelry, or apparel, and boutiques that generally sell limited quantities of higher-priced ladies apparel and accessories, and sometimes custom-made items. The owner usually has the buying responsibility, although in these independent ventures, as they grow in size, other professional buyers such as those who are employed by resident buying offices, a type of business that will be discussed later in the book, may be used.

Franchised Operations and Licensed Stores. Before you can actually understand the role of the buyer in a franchised operation, it is necessary to become familiar with the **franchising** concept. As defined by the Small Business Administration, "A franchise contract is a legal agreement to conduct a given business in accordance with prescribed operating methods, financing systems, territorial domains, and commission fees."

There are two major parties in a franchising arrangement, the **franchiser** and the **franchisee**. The former is the party who has come up with the concept. He or she has

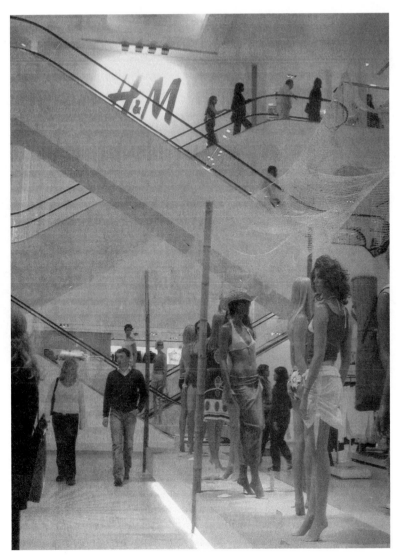

H & M is an international fashion megachain that produces its own lines.
(Courtesy of Ellen Diamond.)

developed a product, idea, or formula that is generally retail oriented. After a few units have become successful retail operations, expansion could take place, as in the case of traditional chain organizations in which all of the stores are centrally owned and managed. In franchising, the franchiser chooses to go the expansion route by allowing individuals to open stores in specific locations. For a startup fee, and other monetary requirements, the franchisees, or owners of theses individual units, are given the right to operate their own businesses. Of course, as the earlier definition indicates, the franchisees must follow specific rules and regulations that have been set forth by the franchisers. The vast majority of franchises are food oriented and bear such famous names

Belk is one of America's largest department stores.
(Courtesy of Ellen Diamond.)

as McDonald's, Wendy's, and Burger King. There are, however, many others that retail wearing apparel, accessories, and home furnishings.

Similar to franchising is **licensing.** The significant difference is that in franchising there is a startup fee for the privilege of becoming a member of a franchise family. In licensing, there typically isn't a startup fee. One of the most well-known licensed arrangements is Benetton—the largest retail licenser in the world, with more than five hundred units in the United States alone. Another is Ralph Lauren. As with the franchise arrangement, licensees are required to follow the merchandising philosophies established by the licensers.

The buyer's role in both franchising and licensing is quite different from that in any of the other retailing formats. The merchandise sold in the stores is either produced by the franchiser or licenser or purchased by buyers for distribution to the individual units. Generally, the individual stores have no buying responsibility. In some situations, however, the individual merchants have some say about the merchandise assortments they will carry in their stores. In the Benetton organization, for example, where the company produces several thousand styles, the individual licensees have the right to choose or "buy" the items from the company that they believe best satisfy the needs of their customers. Thus while they do not have the right to make purchases from outside vendors, as most buyers do, they do have these limited purchasing privileges.

Catalogs. The catalog phenomenon continues to grow. What was once a method to bring some extra sales revenue to retailers is now a retailing mainstay. The major

Benetton is the world's largest licensed fashion retailer.
(Courtesy of Ellen Diamond.)

department stores such as Macy's, Bloomingdale's, Belk, and Dillard's, as well as the chains like Victoria's Secret, Crate & Barrel, and Pottery Barn, use catalogs throughout the year to reach their markets. Some of the stores feature catalogs in which the merchandise is available only through this means, and some like Macy's, for example, have separate buying staffs to buy the merchandise that is featured in the catalogs.

Other retail organizations use the catalog as their only means to reach the target markets. They have neither stores in which customers may shop nor any other means to sell their goods. Spiegel, for example, is primarily a catalog operation, with just a few retail closeout centers used to dispose of slow-selling items.

Home Shopping Outlets. With more and more people having less time to shop in stores, cable television has given them the opportunity to make purchases right from their easy chairs. The two major entries are QVC and HSN. They sell a variety of merchandise with the specialties of both being jewelry and women's apparel. With reported sales by these major outlets at more than 25,000 transactions per hour, the buyers are constantly scouring the globe for merchandise.

The Internet. In terms of overall retail sales, the Internet is beginning to generate significant revenues for the majority of companies using it. Each year they continue to beat the previous year's sales. This channel is being used by retailers all over the

Macy's has a separate catalog division in addition to its brick-and-mortar operations.
(Courtesy of Ellen Diamond.)

world with established stores and catalog operations. Some businesses are based exclusively on the Net, with this their only means of selling to consumers. One enormously successful Web site is Amazon.com, which sells books and CDs at discounted prices. With this success story, more and more organizations are either entering into this concept or expanding their existing Web site operations.

As with the other retail concepts such as the in-store ventures and off-site outlets, the buyer plays a significant role.

DOLLAR VOLUME

When you think of the department store buyer of both the flagship and branch stores, the dollar volume and responsibility for purchasing is generally enormous. By contrast, the buyer for a small independent operation with just one unit has very little dollar volume to consider. The scopes of their activities will thus be quite different from each other.

Because of the enormous volume generated, the buyer for the major department store, chain organization, and catalog operation or other off-site ventures is unlikely to have responsibilities other than purchasing. Travel to various parts of the globe to make purchases and product development are just about all they are expected to handle. Other management chores are left to different employees. On the other hand, small company purchasers generally have other obligations. They might be called on to manage their sales associates, change merchandise displays, and handle advertising.

MERCHANDISE CLASSIFICATION

Although all buyers have a number of responsibilities in common, the nature of the merchandise they purchase often dictates different functions. Fashion buyers, for example, by the very nature of the perishability of the goods and the quick changes in fashions, must always be in contact with specialists and in-store personnel to educate them in terms of what shoppers are likely to be looking for. They might be called on to assist with fashion shows, trunk shows, and other fashion-oriented promotions as part of their regular routines.

Buyers of food items, on the other hand, do not have to perform such activities.

STAFF PERSONNEL

Large retail operations such as chain organizations and department stores are structured as **line and staff** operations. This arrangement allows for two specific groups of employees. The line people are those who have the decision-making powers and perform tasks that provide revenue for the company. The staff people are the ones who assist or advise the line personnel with information that will hopefully make the operation run smoothly.

Many of those with staff positions are part of the merchandising division. In the major retail operations with fashion orientations, they might include a fashion director and a comparison shopper. The former is a specialist whose role is to cover the primary markets, such as the textile mills, where they learn about new fabrications, color trends, and so on. They then scout the secondary markets to assess the products that the designers and manufacturers are planning to offer for sale. They also meet with fashion forecasters to determine which styles should be stressed in their company's merchandise assortment. With this information in hand, the fashion director then meets with the retailer's buyers and merchandisers to help them plan their fashion purchases.

The latter, the comparison shoppers, although not as frequently used by retailers as are fashion directors, provide information about the prices of the company's competitors. They regularly visit the stores that offer the most competition to determine what products they are emphasizing, where the merchandise is being featured on the selling floor, and what prices are being charged. In an era when price-cutting is dominant, it is essential to know at what price the competition is retailing comparable items.

In-store comparisons are not the only means used to "shop" the competition. Daily examinations of newspapers also reveal what the opposition is featuring and what

prices are being charged. Catalogs are also carefully scrutinized to determine how competitive the merchandise offerings of the other stores are by comparison. Off-site outlets such as the Internet and home shopping cable programs are also closely examined.

In most of the larger organizations, the staff in the merchandising division is supervised by the general merchandise manager, but these individuals provide service for everyone in the division.

LOCATION OF RETAIL OUTLETS

In single-unit organizations, as has been stressed earlier, the buyer is often a jack-of-all-trades, playing a number of roles. In department store organizations where there are numerous branches and in chains where the units may number more than one thousand, the buyer's role is generally restricted to purchasing. The stores are geographically distant from each other, making regular visits difficult. Therefore, in-store management is left to others. Decision making is based on computerized reports, and telephone, faxing, and e-mail communications.

In some organizations, the buyer might oversee advertising for his or her department and make general recommendations concerning promotions, but the main responsibility is for purchasing. In the earlier years of retailing, when buyers were responsible for fewer stores, their roles were broader.

Duties and Responsibilities of Buyers

Whether the buyer is someone who works for a small independent operation, a department store with branches, a chain organization with numerous units, a catalog operation, an Internet-based company, or a home shopping outlet, several duties and responsibilities need to be performed. Of course, the nature and size of each organization dictates exactly what will be required as part of the buyer's routine. Collectively, the following provides an overview of the major activities that the buyer performs.

MERCHANDISE SELECTION

Of primary importance to any retail operation, no matter how large or small, is the selection of the merchandise to be resold to consumers. The merchandise must be suited to the needs of customers in terms of price, quality, and individual tastes. Not only must the buyer be able to select the merchandise that has the most potential for resale and profit, but he or she must carefully plan the purchases. This planning includes determining what will be bought, deciding on the quantities of each item, selecting resources, and determining the appropriate time for the merchandise to be available to the shoppers. The importance and complexity of each of these planning "items" will be examined in later chapters.

Charged with enormous responsibility, the buyer spends the most time planning and executing the acquisition of the merchandise.

MERCHANDISE PRICING

Once the merchandise has been purchased, the selling price must be determined. Although pricing policies are usually established by top management and administered

The store buyer's major responsibility is to purchase merchandise.
(Courtesy of Ellen Diamond.)

by the merchandise managers who supervise the buyers, the store buyer is often left to price merchandise in a manner that will maximize profits for the company. Although following guidelines is a general practice, such factors as price competition on a particular item, poor sales results, and so forth can contribute to the buyer's right to make his or her own pricing decisions.

The various concepts that apply to pricing are further examined in Chapter 17.

PRODUCT DEVELOPMENT

With the enormous amount of competition at every level of retailing, merchants are faced with the problem of distinguishing themselves from each other. Whether it is the traditional retail outlet, the off-pricers or discounters, or the off-site operations, the same products seem to appear over and over again in merchandise offerings. There is a similarity among items, but the prices charged by each retailer may vary.

In fashion retailing, where competition is extremely keen, designers such as Ralph Lauren, Donna Karan, Tommy Hilfiger, and Calvin Klein dominate the merchandise assortments. Shoppers often get bored with the same inventories in each store they enter, but without these "labels" the stores, or catalogs for that matter, would not be able to sell to the shoppers who crave these fashion signatures.

To eliminate some of the sameness of the product mix, many merchants offer items that are exclusive to their inventories. This is known as **private-label** merchandise and bears a label that has been developed by the store. For example, labels like Alfani and Charter Club are available only on Macy's selling floors, in its catalogs, and on its Web site. Other retailers have gone even further with these exclusive offerings and

stock their shelves and racks only with merchandise that they have had made for them. These stores, such as The Gap, Banana Republic, and The Limited, have built businesses on this merchandising concept and are retail strategists who promote "the store is the brand" philosophy. In these cases, the name of the store and the brand they carry are one and the same.

Since the concept has such wide acceptance, some buyers are called on to add product development to their role. They are not designers, but individuals who determine what their customers want and suggest to management styles that might be created to be included in the inventories. With the knowledge of what is in the marketplace, such as new fabrications and silhouettes and color directions, they are able to come up with products that would be exclusive to their companies.

In most situations, however, the retailers have outside contractors who create the products. In the very large organizations, there might even be a company-owned plant that does its own manufacturing of the private-label items. Retailers who promote significant inventory levels of private-label merchandise exclusively use product developers rather than their buyers to create these lines.

EXTENSIVE TRAVEL

For many years, regional markets were the mainstay for buyers of every type of merchandise. Whether it was the fashion buyer who headed for New York City's Garment Center, the largest market in the United States for ready-to-wear, or Chicago's Apparel Mart for the same type of merchandise, or the food buyer who purchased from vendors all across America, purchasing was generally accomplished on domestic soil.

Typically, buyers chose the venues closest to their homes since the manufacturers generally had representation in all of these markets. In addition to purchasing at America's vendor showrooms, many buyers frequented the trade expositions to view the lines and write their orders. These visits are more important than ever because the buyer's time is often limited and many lines can be screened quickly, under one roof. Expos such as MAGIC in Las Vegas (the largest for the menswear industry) and NAMSB in New York City (the second largest menswear show) attract tens of thousands of buyers each time they are in session. Trade periodicals such as *Women's Wear Daily (WWD)* and *Daily News Record (DNR)* regularly list the different types of trade shows, their locations, and when they will be in operation.

With such a vast assortment of vendor collections, one might wonder why today's buyers are circling the globe several times a year to make their purchases. Whether it is clothing, accessories, home furnishings, or foods, buyers are always looking for merchandise from new places.

A number of factors contribute to this worldwide exploration, including lower wholesale prices, goods that are unavailable in domestic markets, prestigious fashion collections that are on the forefront of design, and so forth. Thus buying might require trips to the Asian markets, the European fashion capitals, and even some third-world nations where merchandise may be acquired for very little money.

Overseas travel is generally restricted to major retailers who have both the financial resources to sponsor such trips and the buying potential to warrant such expenditures. The nature of extensive travel is further explored in Chapter 13, as is the special attention in terms of proper etiquette that the buyer must demonstrate as is discussed in Chapter 14.

A buyer examines fabrics for use in her company's private-label collection.
(Courtesy of Ellen Diamond.)

ADVERTISING, PROMOTION, VISUAL MERCHANDISING, AND PUBLICITY

The major retailers have in-house advertising and promotion staffs who produce all of the advertising for newspapers, television, magazines, and catalogs; special events; and visual presentations aimed to capture the shopper's attention.

These staffs have the responsibility to develop and produce all of the ads and commercials for the company, either by themselves or sometimes with the assistance of an advertising agency, to create special events, and to develop and install visual

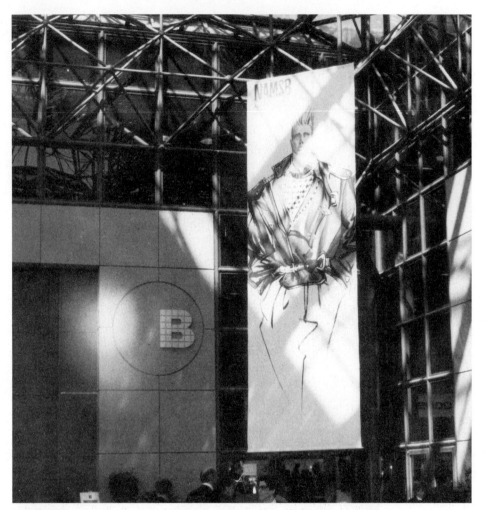

The NAMSB show is one of America's largest men's trade expositions.
(Courtesy of Ellen Diamond.)

presentations in windows and interiors. In many of these operations, however, the buyer also plays an important role. While the promotional team has the expertise to create the projects, they have little knowledge of merchandising. Who is better qualified than the buyer to select the specific items to be advertised or featured in displays? He or she knows what is hot, the selling points that should be stressed, and anything else that would bring positive results to the company. In Chapter 20, the involvement of many buyers in this area is further explored.

COMMUNICATION WITH THE MERCHANDISE DEPARTMENTS

Independent retailers with just one store communicate with their staffs on a daily basis and quickly acquire information that could be helpful to future buying plans. Buyers who have merchandising responsibilities for numerous stores in a vast geographical

The merchandise to advertise is generally selected by the buyer.
(Courtesy of Ellen Diamond.)

region, however, cannot visit them regularly. Since feedback from the various people who interact with the customers on a regular basis is imperative, it is necessary to have a plan that provides for communication with them. By establishing such a plan, the buyers are able to feel the pulse of their departments throughout the organization. In this way, they can better serve the needs of their clientele.

The focus of these buyers' attention is with both in-store department managers and sales associates. These are the individuals who learn firsthand such important pieces of information as what types of goods the shoppers are looking for that are not on the selling floor. The store's records quickly tell the buyers which merchandise is selling quickly and which items are slow sellers, but not the merchandise that is being sought by the shoppers that is not in stock. Only some sort of direct communication will provide such information. Some of the ways in which this exchange of information is generated are discussed below.

Store Visits. In some of the larger organizations, the buyers determine which branches or units are the best barometers to gather firsthand merchandising information

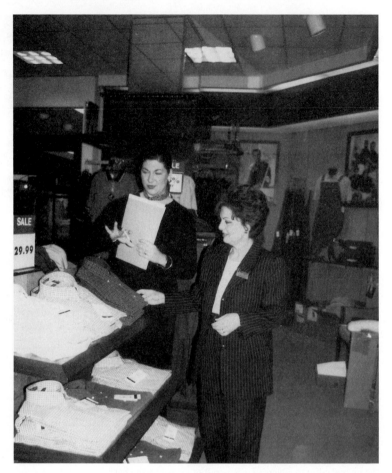

A menswear buyer makes regular store visits to communicate with sales associates and managers. *(Courtesy of Ellen Diamond.)*

that will improve purchasing. By selecting one or two stores that are typical of the others in the group, the buyer can make routine visits and use the information gathered to plan for all of the stores that are his or her responsibility. At Belk, for example, buyers based in one of the regional offices make regular visits to their major units in the malls to meet with department managers and sales associates. They also carefully check interior displays of merchandise and make suggestions as to how and where they would like certain styles featured. By merely moving an item from one floor location to another, sales of that product could improve. No amount of telephoning or other communication method could possibly afford such information.

Telephone Communication. Of course, daily telephone calls between the buyer and the selling-floor personnel are still used even though e-mail is the route used by more retailers. These are generated either by the buyer or the department manager. A buyer might want to know what kind of sales activity is taking place during a special promotion or how shoppers are reacting to new merchandise. The department manager

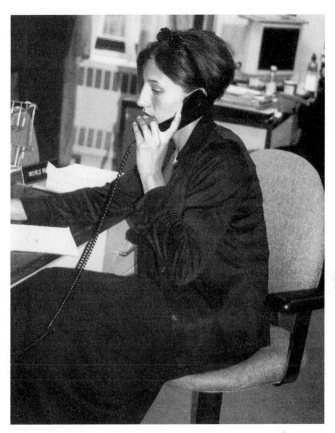

Telephoning is a quick way for the buyer to communicate with retail outlets.
(Courtesy of Ellen Diamond.)

might want to inquire about the availability of certain merchandise that is out of stock or offer advice on possible reorders. The telephone provides quick interaction.

Fax. The fax has offered an opportunity for buyers and sellers to communicate in yet another timely fashion. It doesn't take the department managers away from their selling-floor responsibilities as does the telephone. It also may be used to forward a visual document to or from the buyer. For example, if the buyer wishes to have merchandise placed on a display fixture in a certain manner, a picture of this would eliminate any confusion. The use of the telephone in such a situation might not clearly deliver the message.

E-mail. The emergence of e-mail has added yet another dimension to the communication effort. Instant messages or questions that require immediate responses can be delivered to the stores by the buyer. With most retailers having a wealth of computer terminals throughout the store, quick decision making can take place. More and more buyers are using this communication technique.

In-House Video. One of the more important parts of a buyer's job is to make certain that when new merchandise arrives at the store, the department managers and

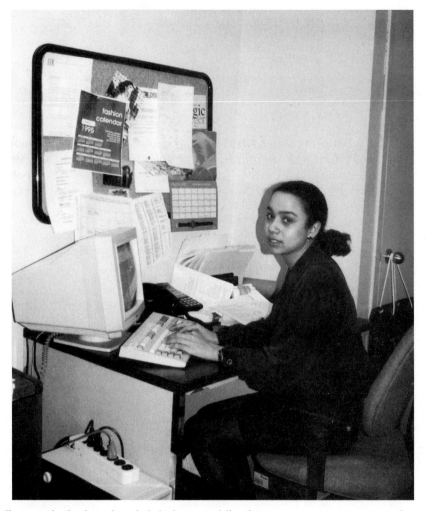

E-mail communication is used regularly by buyers to deliver instant messages to store personnel.
(Courtesy of Ellen Diamond.)

sales associates are aware of the item's selling points. Such factors as fabrication advantages and price competitiveness often help make the sale. While this type of communication is helpful at any time during a season, it is at the beginning of a new season that it is extremely important. In stores, the buyers present the highlights of the new merchandise that is headed for the selling floor on closed-circuit TV. The buyer shows each item and discusses its selling features. It might be the new colors for the season, a fabric that will launder easily without the necessity of ironing, or a silhouette that has the potential to become a winner.

Some stores are taking this method of communication even further by offering an interactive approach. Not only may the buyer make his or her presentation, but questions and responses may be exchanged between the buyer and the department managers.

Some major retailers have used special information days during which the buyers, store managers, department managers, and sales associates meet to provide an orientation about new merchandise. Such presentations may take place at in-house facilities or outside venues. While this has been successful, it does take a great deal of planning and often a good deal of expense, especially if the presentation arena is away from the store's premises. In its place, the in-house video has proven effective as well as cost-efficient.

DEPARTMENT MANAGEMENT

In the early 1900s, major retailers subscribed to an organizational structure known as the **Mazur Plan.** It was a four-division approach to managing a retail operation that had merchandising as one of its divisions. In this plan, the buyer was responsible not only for purchasing, but also for the management of the selling floor and the sales associates. While this worked satisfactorily when there was perhaps a main or flagship store and one or two branches, it didn't work as well when the stores started to expand. Buyers were just too busy with other chores to take care of the daily requirements of department management. In the vast majority of retail organizations, department management is no longer the responsibility of the buyer. In small operations, however, where the buyer is housed within the store, this type of arrangement still exists.

Reassigning some of these duties and responsibilities to other individuals frees the buyer to spend more time on merchandising matters.

SCHEDULE SETTING

When you examine the many different tasks performed every day by the buyer, it is obvious that only careful planning will enable him or her to perform in a productive manner. With responsibilities such as merchandise acquisition, pricing considerations, extensive travel to wholesale markets, meetings with market specialists, and so forth, a working schedule must be established to do the job.

Even the best-planned schedule doesn't address some unforeseen situations. Thus the schedule, although carefully executed, must allow for these unusual occurrences.

The plan should address all of the different duties and responsibilities of the buyer, which may include:

- How many hours are typical of the workweek.
- The number of people for whom there is direct supervision, such as assistant buyers, and how much time is spent with them in meetings.
- What responsibility, if any, there is on the selling floor. In some major retail organizations, the buyers are expected to sell during peak periods such as the day after Thanksgiving until Christmas Eve.
- The size of the department in terms of dollar and unit volumes.
- The distance of the wholesale markets from the store's headquarters and whether it is domestic or foreign buying or a combination of both.
- How much responsibility there is for involvement with advertising, special events, and visual merchandising.
- The need to interact with staff personnel such as a fashion director or comparison shopper.

Once these factors have been considered, the buyer must arrange a schedule on a priority basis, leaving some "breathing time" for the unexpected.

Personal Qualifications, Qualities, and Abilities for a Buying Career

At one time in retailing, stories were told of individuals who started out on the lowest rung of the ladder, such as a stock clerk, and eventually rose to become a buyer, or sometimes even to the level of top management. While these stories are wonderful to relate, this is no longer typical of the industry. Today's buying hopefuls must possess leadership, management, and decision-making skills to meet the challenges of the career.

A substantial number of interviews with buyers, merchandise managers, and directors of human resources in many different retail classifications, in many parts of the country, revealed that a wealth of personal qualifications, qualities, and abilities are necessary for a successful buying career. Those questioned included both large and small store merchants. Their responses generally included the following qualifications, qualities, and abilities.

EDUCATION

A college education is considered a must for a buying career. Whereas some individuals may possess many of the other necessary qualifications, few buying hopefuls will be considered for such a career without the formal education.

Retailers desire the best college-educated personnel they can find. Generally, those sought after have majored in retail business management, marketing, business administration, or fashion merchandising. Courses such as merchandising, mathematics, computer use, accounting, selling, psychology, and those that include units on product information are considered essential by those who make the ultimate hiring decisions. Although the business-oriented student is generally preferred, retailers do consider liberal arts graduates who show an interest in retailing and a desire to pursue a buying career.

To understand the many different reports and financial statements that come across the buyer's desk on a regular basis, such as inventory analysis summaries, open-to-buy positions, active seller positions, unit sales summaries, and others, a mastery of quantitative analysis is a must. Except for the rarest cases, this ability can be acquired only through formal education.

The question of how much formal education is needed to achieve the level of buyer is often debated. Is a two-year associate's degree sufficient? Is a bachelor's degree a must? Or is a master's degree even better? In the major department stores that have executive training programs, a minimum of a bachelor's degree is generally required. Some even seek those who have graduate business degrees. Many chain organizations will accept associate-degreed graduates for their training programs and eventually promote them to assistant buyers and eventually buyers.

There are a great number of major retailers who will hire the two-year graduates and offer them tuition reimbursement for part-time study so that they can acquire their bachelor's degrees.

There is no absolute educational formula. Those with the ambition and a limited educational background might enter a retail organization and demonstrate in lesser jobs that they have the practical knowledge and desire for upward mobility. Sometimes this track will eventually lead to a buying career.

ENTHUSIASM

When two candidates for employment offer similar credentials in terms of education and experience, the enthusiastic candidate is more likely to be hired. It is generally agreed that candidates who aspire to become buyers and will interact with assistant buyers, department managers, and sales associates should have an enthusiastic attitude to motivate them in their jobs. This enthusiasm could then transfer to the shoppers who are looking to make purchases. It might not be considered a qualification, but perhaps an important quality.

ANALYTICAL EXCELLENCE

With decision making always present in the buyer's daily routine, analytical ability is a must. Should I buy the safe basic colors of the season, or should I buy the fashion colors? Should a new price point be added to the inventory, or should I stay with the price points that have proven to generate the most sales in the past? Should the items that have sold well be advertised, or should newer, more exciting styles be promoted in the newspaper? Should some of the promotional dollars be spent on television commercials, or should the newspaper get all of the budgeted advertising allocation? These are just some of the questions that require buyer analysis. Only analytical excellence will help measure and evaluate situations and trends necessary for sound decision making.

ABILITY TO ARTICULATE

Buyers, by the very nature of the job, are continuously interacting with people. When visiting vendors to evaluate new lines and make their merchandise selections, they must be able to articulate the terms in their negotiations. When speaking with their superiors, such as divisional merchandise managers, in the hope of acquiring a larger purchasing budget, communications skills are essential. They must be able to communicate with their assistants in a meaningful and knowledgeable manner so that the assistants will be able to carry out delegated responsibilities. The ability to articulate with department managers and sales associates will help give them a better understanding of new merchandise and how to handle questions from the shoppers to whom they hope to sell.

A buyer's communication skills should be not only of a verbal but also of a written nature. With the buyer often based in corporate headquarters away from the selling floors, or visiting foreign arenas where a wealth of purchases are now made, written communication is extremely important. Information regarding a particular style or inventory level can quickly be obtained through faxing or by e-mail. When clearly and concisely spelled out, the response will surely contain the desired information.

PRODUCT KNOWLEDGE

How could a buyer make merchandise purchasing decisions without the necessary product information? New technology has significantly expanded vendor offerings, and only the educated can satisfactorily evaluate them.

A good starting point for gaining product knowledge is by taking classes offered in many colleges. Many offer apparel and accessories courses that detail the language of the trade and detail construction techniques, silhouette explanations, and technical information on textiles and nontextile fabrications. Other courses feature information needed by home furnishings buyers, such as materials used in the products, furniture

periods, color comprehension, and so forth. Still other courses are geared for those who purchase hard goods and feature information about appliances and furniture.

In addition to formal college instruction, a wealth of information can be acquired through discussions with merchandise managers, trips to factories, meetings with market representatives, interaction with vendors, and reading trade journals.

With all of the merchandise changes being offered in most product classifications, it is essential that the buyer update his or her knowledge on a regular basis. Only then will he or she be able to help maximize profits.

OBJECTIVITY

When you purchase for your own needs, the ultimate selection is based purely on what makes you happy. For professional purchasers to follow this approach would be disastrous for the company. A female buyer, with the responsibility to buy dresses, for example, cannot gauge each style by her personal preferences. While the dress in question might satisfy her own needs, the selection could be inappropriate for her customers. Similarly, a male buyer for men's apparel cannot purchase items that seem appropriate for his personal needs unless they fit into the **model stock** that has been preplanned. Objectivity must prevail. Choices must be made keeping in mind the wishes of the customers that have been reflected by past sales records, consultations with market representatives, trade paper forecasts, and other objective resources. If this rule is not followed, the store's shelves are apt to be left with merchandise the customers have rejected.

KNOWLEDGE OF THE MARKET

To make certain that the best possible merchandise will be chosen for the store's clientele, buyers must know about all of the possible resources from which purchases may be made. Not only must they know where the best deals may be made, but they must be able to assess which vendors will deliver the goods on time (many are notorious for late shipments), which will deliver goods exactly like the samples, and which have the best production capabilities.

Although selection of the right products is extremely important, without the quality and time considerations the goods might not prove to be successful sellers.

FORECASTING

One of the more difficult tasks that buyers face is predicting what direction the merchandise is taking. For purchasers of staple items such as appliances, food, athletic socks, and the like, there is little risk involved. However, for fashion buyers, where change is a constant, accurate forecasting is a must. Should longer-length skirts be stocked, or should the shorter ones that have sold successfully during the past season be continued? Which colors are best to focus on—the safe neutrals or the fashion tones suggested by the fashion editors?

While past sales help in forecasting, as do the experts in the field such as the fashion forecasters, the buyer must have the ability to make his or her own judgments. Through continuous communication with in-store personnel such as store and department managers, fashion directors, and sales associates, the pulse of the customer can be felt. It is the customer who has particular likes and dislikes, and with this information, accurate forecasts are more likely to be made.

DEDICATION

Working long, irregular hours is typical for buyers. Unlike those who work nine-to-five days, buyers cannot predict how long it will take to complete their obligations. During peak purchasing periods such as **market week**—a period when fashion buyers make purchases for the next season—and when in attendance at trade shows and expositions to see the new collections, the days are extremely long. When high-volume selling periods such as Christmastime might require working on the selling floor, there is no telling how many hours will be worked each day. The opening of a new branch could necessitate many hours making certain that the inventories are presented in the best possible arrangements on the selling floor and that displays are carefully set.

Only those dedicated to the job and able to endure these long days will go on to be successful in their careers as buyers.

APPEARANCE

Although presented at the end of this long list, a professional appearance is one quality without which a buyer may not be successful. Whether on the selling floor or for trips to vendor resources, the properly attired individual will make the best impression.

Proper grooming and dress give the buyer the edge in both of these situations. On the selling floor, the buyer will serve as a role model for assistant buyers, department managers, and sales associates. When interacting with the store's customers, the better-groomed individual will impart a positive image, and more than likely will help gain the customers' confidence.

Most of the major stores have a policy on proper dress so that a uniform image will be projected by the buyers both in the store and in the wholesale markets.

The Buyer's Relationship with Management Personnel

As you will learn throughout this book, the buyer interacts with different levels of management. Some are individuals in their own divisions, both above and below them in the table of organization, or others who are employed in other segments of the store's structure. In addition to the merchandising division, particularly in large retail organizations, the buyer may interact with those specializing in advertising, visual merchandising, special events, store and department management, and human resources.

MERCHANDISING

In large chains and department stores, the buyer's superior is the divisional merchandise manager. This executive is responsible for such tasks as disseminating the merchandise budget, setting goals for the division, and establishing a fashion image if the store has a fashion orientation. The buyer seeks guidance and counsel from the divisional merchandise manager because most likely he or she has served in a purchasing capacity and has the experience that could assist the buyer in decision making.

Below the buyer are the assistants who help in many ways. Good communication with these people will tell them exactly what is required of them and how they can better serve the buyer's needs.

In fashion organizations, fashion directors help apparel and accessories buyers with their future purchasing plans. A good relationship with them will help with the difficult task of forecasting which styles are likely to make the grade.

ADVERTISING

Whether in a small single-unit operation or a large organization, the buyer usually has an advertising responsibility. He or she doesn't have anything to do with the artistic areas of the broadcast or print media designs, but is generally the one who makes the merchandise selections. Who better than the buyer to know which items should be promoted?

Through regular communication and a good working relationship with the advertising manager, the buyer is likely to have ads placed that will assure his or her department of the proper consumer exposure. Advertising is the best means by which a merchant "prospects" for customers.

VISUAL MERCHANDISING

In most major department stores, chains, and independent single-unit operations, one of the motivational devices used to attract shoppers to specific merchandise is visual merchandising. Displaying specific products in windows and store interiors in a style that will capture the shopper's attention will result in purchases.

As in advertising, the merchandise selected for display is usually the buyer's decision. Choosing items to be featured in displays that are either trendsetting or are getting attention in the editorial pages of leading consumer magazines (as in the case of fashion merchandise) or those that are price competitive (as might be the case for any type of products) will help promote sales.

With the right merchandise selection and the appropriate display setting, good sellers may become winners.

SPECIAL EVENTS

Whether it is a fashion show, anniversary sale, or any special store promotion with a merchandise orientation, the buyer is the one who selects the items to be used for the special event. As with other promotional endeavors such as advertising and display, the insertion of the right merchandise can contribute to more sales.

STORE AND DEPARTMENT MANAGEMENT

Although the buyer is often based in corporate headquarters, far from the store's branches and individual units, a good, steady relationship with the store or department managers is a must. These are the people who learn firsthand about customer merchandise requests and complaints and forward this information to the buyer to make adjustments to their inventories. These are also the managers who might position the goods on the selling floor in a manner that will enhance sales.

Through proper communication techniques, as discussed earlier in the chapter, the buyer ensures cooperation that will make his or her bottom line more profitable.

HUMAN RESOURCES

Selecting the people who are best suited to aid the buyer in his or her everyday role is not the responsibility of just one person. Although the buyer makes the ultimate decision concerning the choice of assistant buyers, the human resources department plays a significant role in the selection process. Through the proper recruitment techniques and screening devices, the buyer will receive a list of candidates that has been narrowed to those with the most potential. In this way, the buyer is needed for only a brief period to make the final decision, and is saved from spending valuable time that could be used for other responsibilities.

By working closely with the people in human resources, the type of individuals sought by the buyer can be more easily discovered. Although initially the recruitment procedure is based on company job descriptions, a word from the buyer will most often help give specific suggestions for the search.

When the working relationships between the buyer and the other members of the store's management team have been solidified, and a regular dialogue has been established, the overall success of the company is better served.

EVALUATION OF BUYERS

Buying is the lifeblood of the retail operation. Without the proper merchandise, retailers wouldn't turn the profits needed to make the business prosper and ultimately expand. Because of this, most buyers are paid excellent salaries, with some earning more than executives in other fields.

To make certain that the buyers are performing as expected, they are regularly evaluated by their superiors, the divisional and general merchandise managers.

Specifically, evaluation is based on one or more of three criteria: sales figures, inventory levels, and margin results.

Sales

Sales volume is expected to increase according to reasonable goals that have been established by the merchandise managers. They are figured not only in terms of dollars, but also in units sold. Most major retailers evaluate effectiveness by **sales per square foot.** That is, each department must generate a specific preestablished annual dollar amount according to the square footage allocated.

Inventory Levels

A careful inspection of inventory figures will reveal indicators of buyer effectiveness such as stock turnover (the number of times in a period the average amount of inventory on hand is sold), how much merchandise has been left in the inventory past the expected selling period, and how much has been carried from one season to the next.

Margin Results

Such factors as initial markup (the difference between original cost and what the merchandise has been marked to sell for), the maintained markup (the actual selling prices after discounts have been taken to move slow sellers), and the department's profit are just some of the margin considerations on which buyers are judged.

Those who successfully achieve the goals that have been established for them usually have the opportunity for promotion to the level of divisional manager, and in some cases, the highest position on the merchandising team—general merchandise manager.

CAREER OPPORTUNITIES

The need for buyers continues to escalate in retail operations all across America. Population explosions, coupled with a retailer's need for expansion to serve the masses of people, make a buying career one that is reachable in most geographical locations. Not only are merchants expanding their store facilities, but many are now developing separate merchandising teams for their catalog operations and Web sites. Some merchants operate exclusively on the Internet and need buyers to purchase the significant amounts of goods generated by these sales. Still other retail venues, such as the home shopping networks, require large merchandise purchases.

With the sales projections for these organizations for future years ever increasing, those with special skills and talents can be sure of careers as buyers that will be both exciting and financially rewarding.

While the future is bright for a retail buying career, few, if any, achieve the level of buyer fresh out of college. Ladder climbing is typical: Potential buyers must first be evaluated at the executive trainee level, then as assistant buyers, and sometimes as department managers. Whatever route a retailer establishes, each step must be completed before the title of *buyer* can be bestowed.

In addition to retail opportunities, there are parallel buying positions that might be as attractive. Resident buying offices, or market specialist groups as they are often referred to, need the services of buyers. As we will learn in Chapter 6, resident buyers have more traditional workweeks than their store counterparts. Their positions are more advisory oriented than decision making. Of course, their salaries are not commensurate with those of the store's buyers.

Although surveys indicate that many industries have discriminated against women in terms of promotions and salaries, retailing has long offered equal opportunity for both sexes. Not only do women earn salaries that are commensurate with those of men, but there are generally more women than men employed as buyers.

An advantage of a buying career is its availability in every part of the country, as well as overseas. While some industries are confined to specific geographic areas, buyers are able to work in most regions. With numerous companies enjoying global expansion, buyers are often needed in foreign countries to serve the needs of the stores located there. Even the major resident buying offices have branches in other parts of the world, and buyers are needed in those places to scout the wholesale markets.

As you will learn throughout this book, there are many facets to the job of buyer in both small and large organizations. Few other careers offer the challenges and rewards generated by performing the buying tasks.

Language of the Trade

branches
chain organization
flagship store
franchisee
franchiser
franchising
full-line department store
home shopping outlets
licensing
line and staff tables of organization
market week
Mazur Plan
model stock
private-label
sales per square foot
specialized department store
store is the brand

Summary of Key Points

1. Chain organizations, with units numbering anywhere from two to several thousand, operate in a variety of formats. Some are traditionalists dealing in regularly priced merchandise, with others classified as discounters and off-pricers.
2. Department stores are either full-line operations or specialized organizations.
3. Both franchises and licenses are companies that enable individual merchants to operate units within a parent organization as long as they follow prescribed regulations established by this parent company.
4. Catalogs are becoming more and more popular in retailing. Some are offered by merchants who operate stores, while others are available from companies that sell to customers only through catalogs.
5. Interactive retailing via the home shopping networks and the Internet Web sites continues to increase in sales year after year.
6. Buyers' roles differ from company to company. Their activities are based on merchandise classifications, dollar volume, and the location of the retail outlets in their organizations.
7. With the trend toward private-label merchandise, many store buyers have taken on the role of product development.
8. In stores where the entire inventory is private-label merchandise, the concept is known as the store is the brand.
9. Buyers are often called on to interact with the managers of departments such as advertising and visual merchandising to make certain that their products are well promoted.
10. Communication with the merchandise departments is extremely important, and when in-person visits are rare, other means such as telephoning, faxing, and e-mail are used by the buyers.

11. A new concept used by some major retailers to educate store personnel regarding new items is in-house video.
12. Buyers must set schedules for themselves so that they are able to fulfill all of their duties and responsibilities in a timely manner.
13. Among the more important personal qualifications, qualities, and abilities necessary for a successful buying career are formal education, analytical excellence, the ability to articulate, product knowledge, and objectivity.
14. Buyer evaluations are most often based on sales, inventory levels, and margin results.
15. A buying career affords you both excitement and monetary rewards, as well as an opportunity to work in just about any area of the country.

Review Questions

1. Why is the company's organizational structure important in determining the scope of the buyer's role?
2. How does buying for individual franchised units differ from that which is done for non-franchised stores?
3. What purpose do staff personnel serve in the merchandising division of a store?
4. What is meant by *line and staff organizational structure?*
5. Why has the buyer's role increased in stores that carry private-label merchandise?
6. Explain the term *the store is the brand.*
7. For what reasons has merchandise acquisition gone to areas other than the domestic markets?
8. Does the buyer have any responsibility for advertising?
9. Other than through store visits, how does the buyer communicate with department management?
10. How does an in-house video communication system help the buyer?
11. Why has the Mazur Plan given way to new organization structures in retailing?
12. Is it important for the buyer to establish a personal schedule?
13. How necessary is formal education to becoming a buyer?
14. Where can a buyer learn more about product knowledge?
15. What criteria are used for buyer evaluation?
16. Other than buying for a store, is there any other type of buying career that parallels retailing?
17. Why does the availability of buying jobs continue to expand?
18. Why is buying an excellent choice for women?

CASE PROBLEM I

About to graduate from college, Toby Phillips has been investigating the possibility of a buying career with several companies. During her last semester, she participated in a number of recruitment sessions on campus. Human resources managers from the major retail organizations have interviewed her, and the time for a decision is drawing near. After considerable investigation and deliberation she has narrowed her choice to three companies, one a department store with fifteen branches, one an off-price chain operation with seventy-five units, and one a catalog company without any stores.

A summary of these opportunities follows.

1. Crane's Department Store is based in Kansas City, Missouri. Its flagship is in the downtown area, with the branches in the suburban part of the city and in St. Louis. It is a specialized operation catering to women's and men's clothing and accessories. Its executive training program is limited to twenty-five trainees each year. The trainees participate in a rotational program that rotates them through different jobs and takes them to a number of branches in both Kansas City and St. Louis. Regular evaluations are performed every three months. The successful trainees generally achieve the level of buyer or some other executive position within five years. The starting salary is $30,000, with regular increases every six months, until a regular managerial position has been achieved. In that case, salaries are commensurate with the demands of the job and individual progress.
2. Centrally operated from New York City, Sebastion's, an off-price specialty chain dealing exclusively in women's apparel, has seventy-five units throughout the eastern seaboard. It has been in business for twenty years and expects to open ten new units every year. Its merchandise offerings include closeouts from all of the top designers and manufacturers as well as private-label products made exclusively for the company. The private-label goods are generally developed by the buyers. The buyer is responsible for covering the New York City Garment Center as well as overseas markets. The starting salary is $32,000, with periodic increases based on performance.
3. Potpourri is a retail catalog company that doesn't have any stores. Its business is all catalog generated. Based in Chicago, it has been in business for fifteen years, dealing exclusively with ornaments and accessories for indoor and outdoor gardens. Each year since its beginning, Potpourri has had significant sales increases. It employs eight buyers, with each having a different merchandise responsibility. The available position is for a buyer of glass and metal products used to grow indoor plants. The company has no formal training program, but on-the-job assistance is used to train new employees. The starting salary is $32,000.

 Ms. Phillips, who lives in New York City, majored in retailing at a four-year college and has a 3.2 grade point average.

Questions

1. Develop a list of criteria for Ms. Phillips to use in the evaluation of the three opportunities.
2. Which job would you recommend she choose? Why?

CASE PROBLEM 2

Mary Wright has been working as a buyer of children's wear for five years. During her tenure at the store, the company has expanded from six units to twenty-seven. One of the more important parts of her job is to keep in touch with the individual store managers as well as the sales associates. This communication always afforded Ms. Wright the opportunity to meet with the store employees to discuss the highlights of the next season's offerings. With such information, the merchandise is easier to sell. While the company was a small operation, this was easily achieved with regular store visits. Since the significant growth, in-person contact has been difficult.

Management at the company believes that the use of the telephone, e-mail, and faxes could serve the same purpose. Ms. Wright would like to see some other system in place to make the dissemination of product information more meaningful.

Question

1. Describe a system that the store might use to satisfy Ms. Wright and the other buyers' needs.

CHAPTER 2

Buying for Traditional Retail Organizations

On completion of this chapter, the student should be able to:

- Identify the different types of retail organizations that comprise the traditional classification.

- Distinguish between department stores that are considered to be full line and those that are specialized.

- Describe organization charts and explain why retailers develop them.

- Discuss the major divisions found in most department store organizational structures.

- Explain the roles of the general merchandise manager and the divisional merchandise managers.

- List the various duties and responsibilities of assistant buyers.

- Discuss the relationship between the department stores' flagships and their branches.

- Describe why the merchandise assortments found in branches often differ from those found in the flagship store.

- Define the term *chain organization,* and list the various types found in this retail classification.

- Explain why most major chains include divisions of real estate and construction in their tables of organization.

A walk through any of the major malls in the United States such as Roosevelt Field in Garden City, New York; the Mall of America in Bloomington, Minnesota; the Gardens in Palm Beach Gardens, Florida; Old Orchard in Chicago, Illinois; or the downtown central districts in many of America's major cities immediately brings to our attention a wealth of retail establishments. Whether they are full-line department stores like Macy's or specialized entries such as Saks Fifth Avenue, units of specialty chains such as Casual Corner and Foot Locker, or single-unit independent stores, they are all considered to be traditionalists in terms of their approaches to buying and merchandising. That is, they buy the largest percentage of their merchandise from vendors at the beginning of the season at the regular wholesale prices, and sell them to their customers at the full retail prices.

The regional mall is a major venue where traditional retailers locate their branch stores.
(Courtesy of Ellen Diamond.)

Unlike the types of chains already noted, in which the majority of merchandise is purchased from independent vendors and sold by the retailers to their customers, store is the brand is a group that specializes exclusively in private-label merchandise. As noted in the previous chapter, this method of doing business is based on a retailing strategy known as the store is the brand. Companies like The Gap, Banana Republic, and the numerous divisions of The Limited such as Express and Victoria's Secret exemplify this retail category. While these stores either produce their own merchandise or have the goods made exclusively for their use, they do not require buyers, in the traditional sense, to procure merchandise. In Chapter 18, the buyer's role in this type of merchandising will be explored.

Retailing today also features other types of formats from which shoppers may make their purchases. Included are the discounters such as Target and Wal-Mart and the off-price retail operations such as Burlington Coat Factory, Stein Mart, Loehmann's, Marshalls, and Men's Wearhouse, and the **off-site** outlets such as catalogs, home shopping networks, and Internet Web sites. Since their operations are distinctly different from the traditionalists, they will be explored separately in other chapters.

To properly merchandise any of these retail operations, buyers must have specific qualifications to carry out their duties and responsibilities. With these special talents, they are likely to help their companies maximize profits.

Banana Republic is a chain that engages in the store is the brand concept.
(Courtesy of Ellen Diamond.)

In this chapter, we will focus on the characteristics of each of the traditional organizational groups as well as the necessary qualifications of their buying personnel. The other classifications will be discussed in the next three chapters. As already noted, this category of retailers is confined to department stores, chain organizations, and single-unit independents. Although they all possess similar characteristics, each has other characteristics exclusive to its individual classification.

DEPARTMENT STORES

Within this group there are two subclassifications, each based on the merchandise it offers. One is the **full-line department store**; the other is the **specialized department store** organization. The former offers a wide assortment of hard goods and soft goods such as apparel and accessories for the entire family, cosmetics, furniture, tableware, electronics, and bedding and also features nonmerchandise departments such as travel centers and beauty salons. Typical of these full-line organizations are Bloomingdale's, Belk, and Dillard's. Stores such as Macy's and Carson Pirie Scott also feature departments that offer a variety of prepared foods.

The specialized department store restricts its offerings to a large assortment of one or two merchandise classifications. In this group are stores like Nordstrom, Neiman Marcus, Saks Fifth Avenue, and Bergdorf Goodman. They are generally

Macy's is the world's largest full-line department store with more than 850 units.

upscale operations that specialize in fashion apparel and accessories for women, men, and children.

Although the merchandise emphasis in each of these groups is different, their organizational structures are generally the same.

Divisions of the Organization

In the department stores and chains, there are several *divisions* or *functions* that make up the organizational structure. In the **table of organization,** a division features a number of different departments as well as the personnel who carry out the responsibilities that have been assigned to them. They also depict the lines of authority for management purposes. In this way, there is no duplication of effort on the part of those employed by the company. While each is a somewhat independent entity, there is a great deal of interaction among the various divisions and departments to ensure that the operation functions as a cohesive unit.

The tables of organization vary from one department store to another, with each establishing that which is best suited to their needs. They do, however, feature most of the same divisions. Whereas these divisional designations or names might be slightly different in many of the cases, there is a significant similarity among all of them.

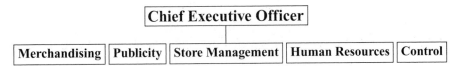

A five-function organizational structure.

Department stores, as do all other major retailers, prepare organization charts, which are graphic presentations of their tables of organization. Each chart features the divisions of the company and the departments found within each one. Sometimes the company is so large that it is necessary to offer individual charts of the various divisions to completely spell out their operations.

The chart above features a typical organization chart for a department store that utilizes five divisions or functions. It should be noted that the number of divisions varies from company to company and generally ranges from four to seven.

An overview of the various divisions of the five-function plan spells out their specific roles in the operation.

Merchandising. The division that is considered to be the lifeblood of the retail organization is merchandising. In it, the *general merchandise manager* (GMM), the *divisional merchandise managers* (DMMs), and the *buyers* and their *assistant buyers* are responsible for making certain that the appropriate merchandise is purchased for the store and that it will satisfy the needs of the customers.

General Merchandise Manager. At the helm of the merchandising division is the **general merchandise manager.** He or she serves as a policy maker and operating officer along with the others in the company who head their divisions. This is an extremely important role in a retail company, regarded by many to be the most important after the company's chief executive officer. The duties and responsibilities of the GMM are discussed below.

Developing an overall merchandise budget: After the analysis of past sales for the entire operation, and considering any economic factors that might increase or decrease future sales, a merchandise budget is established.

Establishing the store's merchandise direction with top management: Retailers generally proceed from year to year with a merchandise direction and philosophy that they used in the past, in terms of product lines, quality, and price points. Of course, this direction is not engraved in stone and must be examined each year to see if changes are warranted. If the venture continues to be profitable, and the established goals are achieved, major changes are not necessary. However, if business and economic indicators tell of different consumer needs that might be successfully addressed by the organization, then merchandise changes might be in order. It might be the expansion of a bedding department to include designer labels that were once reserved for apparel or the inclusion of more value-oriented lines of merchandise to attract the shoppers who are seeking more for their money. Whatever the case, it is the GMM who must be aware of any potential merchandise changes and must alert the others in top management positions about them.

Determining the budgetary allocations for divisional merchandise managers: The overall merchandise budget must be divided among the DMMs. This is based on

past sales for each division, potential for curtailment or expansion of each division, and any outside indicators that might require merchandise adjustments.

Carrying out top management's merchandising policies: Although the GMM is the chief of the merchandising division, policies that apply to this segment of the organization are not his or hers alone. Merchandising policies come from a meeting of the minds of those in top management, of which the GMM is a member, and sometimes from the company's board of directors. Whatever the case, when the ultimate merchandising decisions are made, it is the GMM who must carry them out.

Meeting with the merchandising team: Regular meetings must be on the agenda with the divisional merchandise managers, buyers, fashion directors (if this is a fashion retailer), and anyone else who can help make the division a more productive one. Of course, impromptu meetings must always take place as occasions arise.

Visiting the wholesale markets: While the buyer is charged with the responsibility for merchandise procurement, the GMM makes regular market visits during peak purchasing periods. Meetings with market specialists, attendance at trade expositions, and showroom visits with the appropriate DMM and buyer will help make certain that the merchandise needs of the store will be met for the coming season. When sizable orders are being considered, this is an extremely important market visit for the GMM.

Divisional Merchandise Manager. Next in command in the merchandising division are the **divisional merchandise managers.** Their numbers vary according to the size of the operation and the breadth of its offerings. They act as the liaison between the GMM and the numerous buyers within their division. Specifically, they participate in a variety of duties and responsibilities that include many of the following.

Assisting and advising the general merchandise manager: Although the GMM has the full responsibility for overseeing the store's merchandising division and formulating the necessary plans to maximize profits for the company, the DMMs play a role in this planning. They provide the GMM with trends that might affect sales for their respective divisions; offer advice on how certain departments might be expanded; and examine the potential for new private labels that might bolster sales in a particular area, competition from area retailers that could hamper sales, and sales projections that would have an impact on the distribution of the budget.

Distributing the division's budget to the buyers: Given the merchandise budget for the coming season from the GMM, the DMM has the responsibility of distributing it to the various buyers in his or her departments. This is not a uniform distribution, but one that is based on past sales of each department and estimates of future sales. The divisional manager must carefully assess economic conditions, potential changes in styles (especially if a department is one that is highly volatile because of fashion influences), and any other factors that could improve or impede future sales for a department. With all of these conditions carefully considered, the budgeted figures are then expended to the different buyers.

Coordinating the efforts of the buyers: Each retail organization has a merchandising philosophy that it wishes to project to the general public so that it might motivate the consumer to shop there. By disseminating this concept to the buyers, it will be likely that an overall merchandising image will be guaranteed in each of the DMM's departments.

Advising buyers on merchandise acquisition: Since divisional merchandise managers came up from the ranks of buyers, they have firsthand knowledge of the buying scene. With this invaluable information, they are able to assist the buyers in terms of planning for future purchases, product assessment, resource selection, purchasing negotiations with vendors, and forecasting and planning future sales.

Buyers. Immediately below the divisional merchandise managers are the buyers. Their duties and responsibilities have been outlined in the first chapter. Since they are the focus of this book, their roles will be examined throughout.

Assistant Buyers. As discussed in Chapter 1, the duties and responsibilities of the buyer are exhaustive. To relieve the buyer of some of these tasks, and to have some input from others who are familiar with a department's merchandising needs, assistant buyers are employed. They perform a host of activities in addition to advising the buyers, as discussed in the following text.

Selecting the merchandise and reordering: When the buyer visits the market, especially in preparation for the next major purchasing period, the assistant usually goes along. In this way, the buyer can get another opinion about potential selections and familiarize the assistant with the various products. Major purchases are the responsibility of the buyer, but some purchases, particularly from lines that have been bought over and over again, might be delegated to the assistant.

Reorders of fast-selling items are also generally placed by the assistant buyer. The buyer makes the decision, but the assistant places the orders.

Following up orders: After the orders have been placed, often delivery isn't forthcoming as rapidly as promised. In these situations, the assistant buyer either calls on the vendors at the places of purchase, telephones, faxes, or e-mails to determine if there are any delivery problems. In cases of special orders, where customers are waiting for merchandise they have ordered from the store, the follow-up is extremely important.

Working with sales associates: Whether the assistant buyer is in the flagship store, as is often the case with department stores, or in a company's buying facility that might be separate and apart from the store, there must be communication with the sales associates. Through either in-person communication or some means of telecommunication, there must be regular contact. In this way, the needs of the shoppers, as ascertained by the sellers, may be assessed. This is extremely important to determine what merchandise is being requested but not being stocked and any other information that can help future purchasing plans. Although the computer gives a great deal of vital merchandise information to the buyer and the assistants, it isn't able to communicate the customers' requests that aren't being addressed. This responsibility is often shared by the buyers with their assistants.

Interacting with shoppers: By being on the selling floor during certain selling periods, the assistant buyer can learn firsthand the wishes of the shoppers who are in the store. Although this information is sometimes forthcoming from the sales associates, firsthand interaction with customers is best. With all of the tasks needed to be performed by the assistants and the time spent performing other chores, this may be a limited role. Whenever possible, visits to branches are also beneficial so that department managers and sales associates can express their opinions about the merchandise assortments.

The assistant buyer performs a host of activities for the buyer.
(Courtesy of Ellen Diamond.)

Performing other duties: Other daily tasks may include helping the buyer determine which items might be considered for advertising, promotions, and visual merchandising presentations; preparing merchandise returns to vendors; reviewing computer printouts for assessment of all the items in the inventory; placing merchandise in key positions to guarantee customer attention; and prescreening lines of merchandise to determine if the buyer needs to see them. Assistant buyers who diligently perform these duties are on their way to becoming buyers.

Other Merchandising-Related Positions. In many of the very large department stores, the merchandising division maintains one or more departments that are technically known as **staff functions.** Unlike the merchandising team that has the direct responsibility for making the merchandising decisions, the people in the staff positions are there to advise and support the merchandisers. Their roles are quite significant in many retail operations, particularly those with a fashion orientation. Of major importance is the **fashion director.** He or she covers the wholesale markets long before the buyer gets there. By providing this service well in advance of the buyer's need to prepare a **model stock** (the assortment of merchandise that satisfies the needs of the customer), all of the information concerning fashion trends in terms of silhouette, color, fabrications, and so

forth is assessed and brought back to the buyer for use in his or her buying plans. Another staff position in some stores is the **comparison shopper.** This individual scouts the competitors' advertisements and inventories to determine if there are any price conflicts between the companies. In many stores this job has been eliminated, with this responsibility given to the assistant buyer. Another function that might fall within the merchandising division includes **testing bureaus,** where merchandise might be put to certain tests to determine reliability. The latter is used only by the giants in the industry.

PUBLICITY

With the fierce competition being faced by retailers every day, it is necessary to get the attention of the consumer as often as possible. It is the publicity division, called the sales promotion division by some retailers, that has this responsibility.

This division is often divided into four departments, each with a specific role in gaining customer attention: advertising, visual merchandising, special events, and publicity. In many store organizations, the buyer often participates in the publicity division's endeavors by selecting merchandise that suits the needs of the particular event or campaign that is being developed.

The publicity division employs specialists who perform a variety of functions ranging from the preparation of advertisements to the installation of visual presentations in windows and on the selling floor. Included in this division's roster are artists, copywriters, layout experts, display installers, lighting experts, press writers, and others.

In Chapter 20, this division will be explored, including the manner in which the buyer assists those in the division with their promotional tasks.

STORE MANAGEMENT

In the store management division, those involved range from the upper levels of the management team down through the sales associates who interact with the shoppers. In the early years of retailing, as described earlier, many of the major stores employed a table of organization known as the Mazur Plan, in which the sales personnel were part of the merchandising division and were the responsibility of the buyers. Today, however, with the buyer's role so full of other duties and responsibilities that warrant a great deal of time away from the store, as well as expansion through the opening of many branch stores, in most major companies this role has been given to the store management division.

Although the buyer does not have direct supervisory responsibility over the department managers and sales associates, he or she interacts with them regularly nonetheless. Communication with those in the selling departments is extremely vital to the buyer, whether it is through in-person visits, closed-circuit TV, or by telephone, faxes, or e-mail. By maintaining these direct lines of communication, the buyer is able to disseminate merchandise information to them and ascertain any ideas that they might have from their interaction with shoppers. A full discussion of this communication is presented in Chapter 19.

HUMAN RESOURCES

The recruitment and training of store employees is the role of the human resources division. The buyer's role is limited in terms of working with this division, except in cases where new assistant buyers are needed in the store. In that situation, the buyer

alerts human resources to his or her need for an assistant and helps with job descriptions to use in recruitment procedures.

Once human resources has recommended candidates for the open positions, it is the buyer who makes the final decision of who is hired.

CONTROL

The division that makes the accounting and credit decisions is called the *control division*. The buyer's involvement is often with accounts payable to make certain that the purchased items are properly charged, along with answering questions concerning discounts, delivery charges, and so forth. Unless there are discrepancies with vendors, these chores are generally routine.

Branch-Store Organization

The running of the department store is overseen by those in the upper strata of the store's management team. Headed by a CEO and the managers of the various divisions and input from the board of directors, decision making generally takes place at the company's flagship store, with the home office as an alternative choice. Although the flagship is key to the success of the company, a vast amount of business is realized at the numerous branches. Since the 1950s, the expansion of branches has been a steady factor in retailing. As the suburban markets grew, retailers opened these units to accommodate the needs of the consumers in those areas. Although the branches are managed by a team headed by a store manager and other managerial staff members and the rules of operation are established by the company's management team, there must be continuous interaction between these two management groups. The most significant involvement comes from the merchandising division, with the buyers playing the major roles. Of paramount importance are the buyers' visits to the branches to evaluate their merchandise needs. Since there might be variations in the branches in terms of specific merchandise needs such as assortments, price points, and other factors, these visits are necessary to maximize the success of these units. Although a wealth of computerized reports are generated for buyer evaluation and guidance, in-person visits to the branches can address issues that these reports cannot provide.

Some of the variations found in the branches that differ from the flagship include different populations, different merchandise needs, and different price emphasis.

POPULATION DIFFERENCES

When a retailer establishes its merchandising policies, it looks at its potential trading market and determines its merchandising needs. One of the factors deals with its potential customers' careers and lifestyles. For example, if the flagship is based in a downtown, central shopping district, as is Macy's East in New York City, the population served is more often a sophisticated clientele that is unmarried, married without children, or perhaps married with a small family. When expansion takes place into suburban outlets, the population is likely to be different. There might be single households or marrieds without children, but the more dominant family is the one with children. With this information in mind, the focus of the store's merchandise requirements might differ from those of the downtown flagship.

Branch stores, such as this Saks brick and mortar, are major forces in retail sales.
(Courtesy of Ellen Diamond.)

MERCHANDISE DIFFERENCES

Department stores generally like to have the branch stores carry a representation of the merchandise carried by their flagships. However, this might be an impractical approach to maximize the branch's profits. While there might be some of the same merchandise as found in the main store, the assortment might be different. A smaller inventory for career dress and more merchandise oriented toward leisure might be the wiser choice. Similarly, the flagship might not focus on products for outdoor living such as garden furniture, whereas this might be a natural product classification given the nature of the suburban locations. These and other factors must be considered to make the merchandise assortment appropriate for these shoppers' needs.

PRICE POINT VARIATION

Generally, the flagship operation carries a wide assortment of merchandise at many **price points,** the major focus of prices that are merchandised by a company. Since their clientele base is usually made up of different family income ranges, they must carry an assortment that caters to all of their needs. In the suburban branches, however, there is

Talbot's is a typical specialty chain.
(Courtesy of Ellen Diamond.)

often a more homogeneously grouped population in terms of income. Because of this, the price points must be appropriate for the needs of that specific clientele. Thus, the merchandise assortment might place emphasis on higher price points if the population served is more affluent. Merely carrying the same price points in the same quantities as the flagship store might be inappropriate.

If the buyer regularly visits the branches, firsthand analysis of the variations from one branch to another can take place. Discussions with the store manager, department heads, and sales associates may reveal some merchandise price point directions that computerized reports will not reveal. By making this a practice, it is more likely the merchandising decisions will be wisely made.

CHAIN ORGANIZATIONS

Within this major retail classification, as mentioned briefly in the chapter opening, are different groups of stores. They include the specialty stores, discount operations, super-markets, drugstores, variety stores, and those that specialize exclusively in their own product lines—the private-label merchants. What they all have in common is best understood through the broad definition of a *chain:* a group of stores of essentially the same type,

Chain store table of organization.

centrally owned, and with some degree of centralization. Chains include retailers that have as few as two units and those that number as many as two thousand or more.

Divisions of the Organization

The organizational structure of most chain organizations parallels that of the department store. They usually have many of the same divisions such as merchandising, publicity, store management, human resources, and control, each of which is responsible for the same duties and responsibilities in both types of organizations. Therefore, there is no need to reexamine these divisions. In the chains, however, there are often divisions other than those that have been discussed in the department store organization. Those divisions make these types of companies function better.

The nature of the chain organization is centralization. That is, unlike the department store, which generally operates from the flagship store, the chain operates from a central location or corporate headquarters where decision making for all of the units takes place. Known as company headquarters, it houses those who are responsible for all of the policies that govern the business. Included are the different levels of executives responsible for merchandising, advertising, accounting, warehousing, traffic and transportation, human resources, equipment and supplies, research, and sales.

The chart above displays a typical table of organization for a chain that features eight divisions. Those that have not been discussed in the section on department stores will be explored at this time.

REAL ESTATE AND CONSTRUCTION

Many of today's chains are in a constant state of expansion. Some have as many as two thousand units and are constantly looking to open more to meet the needs of consumers all across the nation and, in some cases, abroad. Wal-Mart, for example, is constantly opening new units in other countries. Before new locations may become a reality, a considerable amount of research must go into the planning. The real estate and construction division must research population trends, income, family size, competition, and other factors that would help evaluate the new site under consideration.

In addition to new locations, there is always the need to update the existing units. Renovations are often the order of the day to make certain that the stores have a fresh look that will appeal to customers. At this time, The Limited Group is updating many existing units in its organization so that they will have the right appearance for success

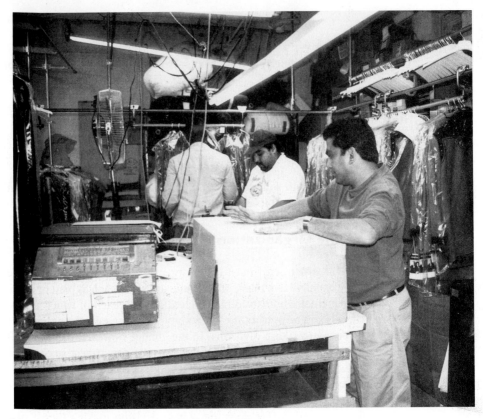

Merchandise being sent from central warehouse to stores.
(Courtesy of Ellen Diamond.)

in the new millennium. This construction may be one that entirely alters the unit or merely makes the changes necessary to give it a fresh face.

WAREHOUSING

Merchandise purchases are most often sent directly to a central location for redistribution to the individual stores. In the larger chains, there may be regional warehouses so that the merchandise may reach the stores within that geographical location in a more timely manner. The receiving and movement of the goods is a major concern for the company. It involves checking incoming goods, marking them according to the buyer's instructions, entering the merchandise descriptions and quantities into the computer, and anything else that guarantees accurate record keeping.

SUPPLIES AND EQUIPMENT

The various supplies and equipment that are needed to keep the units in good working order such as light bulbs, wrapping materials, cleaning compounds, office supplies, and so forth are controlled by this division. When you think of the size of an organization as large as The Gap, the numbers of merchandise hangers that must be purchased and distributed indicates the complexity of this division.

The boutique is typical of a single-unit independent retailer.
(Courtesy of Ellen Diamond.)

SINGLE-UNIT INDEPENDENTS

The dream of many people interested in retailing is to be in business for themselves. Some have gained their experience by working in large operations, while others might have had some formal retail educational training and wish to test their entrepreneurial skills in a small store of their own. Generally, single-unit independent stores are specialty stores that feature just one merchandise classification, such as children's wear or shoes, boutiques that sell limited quantities of higher-priced fashion merchandise, gourmet food emporiums that feature quality prepared foods, and the like.

Unlike the formal structures found in the department stores and chains that employ vast numbers of employees, these ventures are generally run by a handful of people. Of course, some of these stores grow and eventually employ many people.

The proprietor is most often a multitalented individual who performs numerous tasks. He or she purchases the merchandise, determines the selling prices, hires employees, sells to customers, manages the sales staff, performs clerical tasks, and does anything else that is necessary to operate his or her business.

The actual organizational structure might include, in addition to the owner, a store manager who is in charge during the owner's absence, an assistant manager if one is warranted, and salespeople. Others might include an alterations person in a boutique or a chef in a gourmet food store that specializes in takeout meals.

The numbers and types of people employed are determined by the size of the business, the role played by the owner, and the products offered for sale.

Organization of a small independent store.

A typical small independent retailer that specializes in fashion apparel and has only one unit is often organized as shown in the chart above.

Language of the Trade

comparison shopper
divisional merchandise manager
fashion director
full-line department store
general merchandise manager
model stock
off-site
price points
specialized department store
staff functions
table of organization
testing bureau

Summary of Key Points

1. Traditional retail operations are found all across the United States and abroad. Most typically they are located in malls, downtown central districts, and small shopping centers.
2. The traditionalists are categorized as department stores, chain organizations, and single-unit independents.
3. Department stores are classified as either full line or specialized. Stores like Bloomingdale's and Macy's are examples of the full-line classification, with Neiman Marcus and Nordstrom the specialized type.
4. Department stores are organized into a number of divisions or functions, each of which plays specific roles in the store.
5. The merchandising division is often known as the lifeblood of the store since its success is based on the merchandise that is carried.
6. At the helm of merchandising is the general merchandising manager, who is involved in directing the store's merchandise image and determining the store's overall merchandise budget. Next in line are the divisional merchandise managers, who oversee the buyers in

their divisions and distribute to them the money that is used for purchases. Finally, it is the buyers in each division's departments who purchase the merchandise.

7. The other divisions that are typical of department store structures are publicity, which is responsible for advertising, special events, and visual merchandising; store management, which oversees the selling staff; human resources, which hires, evaluates, and trains employees; and control, which concerns itself with accounting and credit matters.

8. Branch stores follow the same rules of operation of the flagship. However, it is the branch store manager who carries out the established procedures of the organization.

9. Chains are most often classified as specialty chains, discounters, off-pricers, supermarkets, drugstores, and variety stores. Their tables of organization parallel that of department stores, but in most cases they feature additional divisions.

10. Many small stores, known as single-unit independents, are in operation all across the country. They usually specialize in one type of merchandise. Their tables of organization are quite limited, since they generally employ just a few people. At their helm is the owner, who is often involved in all of the store's activities.

Review Questions

1. Describe the traditional classification of retail stores, and give examples.
2. How does the traditional chain organization differ from those that belong to the category that employs the store is the brand retail strategy?
3. Differentiate between full-line department stores and those that are specialized.
4. What is meant by the term *table of organization?*
5. In a department store that utilizes the five-division structure, which divisions are generally included?
6. Who is the chief executive of the merchandising division, and what responsibilities does he or she have?
7. How important are the roles of divisional merchandise managers?
8. What responsibility does the divisional merchandise manager have in terms of merchandise budgeting?
9. Is the assistant buyer an important player in the merchandising division? Explain.
10. What is meant by the term *following up orders,* and whose responsibility is it to do this?
11. Define the term *staff functions.*
12. If a major retailer employs a comparison shopper, what is the position and what responsibilities does it carry?
13. Does the buyer interact with the human resources division? How?
14. If the buyer is provided with a wealth of computerized reports for merchandise assessment, why are visits to branch stores necessary?
15. Why might a department store's branch stock a merchandise assortment that is different from that of the flagship?
16. List the various types of chains that fall into the traditional chain classification.
17. Why do many of the major chain organizations include a real estate and construction division in their table of organization?
18. Explain the operation of the warehousing division of a chain organization.
19. What role does the owner of a single-unit independent store generally play?

CASE PROBLEM I

In 1980, the Curtis family opened a retail operation that specialized in apparel for the family, fashion accessories, and some merchandise for the home. The first two categories accounted for approximately 80 percent of the merchandise assortment; the last, which featured bedding, dinnerware, flatware, glassware, and some gift items, accounted for the rest.

As the years passed, the Curtises expanded their operation not only in terms of space that they acquired when adjoining stores abandoned their operations, but also in merchandise offerings. While apparel had always been the mainstay of the business, the shoe, jewelry, and handbag departments became more important, as did the products for the home.

What began as a small company with the Curtis family at the head, with Jim and Marge Curtis sharing most of the responsibilities, steadily grew into a major retail player in its Midwest, downtown location. As business grew, the Curtises could not handle all of the buying and merchandising chores, and they had to employ others to perform some of the purchasing.

At first one buyer was responsible for home furnishings, while another handled the accessories areas. As these departments grew, the buying duties were again expanded to include additional buyers, one each for menswear, women's apparel, children's wear, shoes, jewelry, handbags, dinnerware, glassware, and bedding. The Curtises were now involved strictly as the general merchandisers, involving themselves with budgeting, sales forecasting, policy making, and other managerial tasks. The buyers were the store's purchasers.

Although this expansion proved to be profitable right into the new millennium, the chores handled by the buyers became too broad for them to handle. Specifically, their responsibility for managing the sales staffs in their respective departments, as the Curtises did in the early days, was no longer a viable approach. Merchandise procurement, now an international task, with markets in many countries far away from the store, took the buyers away from their retail bases for long periods. With this situation, it became less and less possible for them to spend adequate time on the selling floor with the sales associates.

At this point, the company is looking to amend its organizational structure in some way to relieve the buyers of the sales management responsibility without risking the success the business has realized in all of its years in operation.

Two proposals have been made by a group of buyers representing their team. One would be to expand the duties of the buyers' assistants to include management of the sales associates in their departments. The other would be to hire department managers who would oversee the sellers.

At this time, the Curtises are still not sure if any new approach would have merit but are willing to listen to the details of the proposals.

Questions

1. Is it appropriate to continue the original plan of buyers managing the sellers?
2. Can the assistant buyers properly function as the sales associates' managers?
3. Would the addition of department managers best serve the needs of the company? Present the advantages and disadvantages of each proposal.

CASE PROBLEM 2

Typically, many of today's major chains began with a single unit that was opened to serve the needs of the consumers in a small trading area. The merchandise assortment was restricted to one classification, such as shoes, and the store was operated solely by what is often referred to as a mom-and-pop team. As their initial store, The Men's Loft, showed a positive profit picture, Barbara and John Stevens considered expansion, with similar units in neighboring communities.

Ten years after the venture began, Barbara and John were the owners of a successful small menswear chain that numbered five units. They were geographically situated within a 50-mile radius of their first store. They now had a store manager for each operation, an assistant manager, and as many salespeople as sales warranted. The buying and merchandising responsibilities were handled by Barbara and John from an office above the original store, along with others such as advertising, employee hiring and evaluation, supply purchasing, and many other chores. The merchandise ordered for the stores was received directly by each unit. The only other assistance they required was an outside accounting firm to handle the financial aspects of the business and a visual merchandiser who went from store to store to install window and interior displays.

As time went by, additional units were added to the chain. When the number reached fifteen, the Stevenses began to consider new organizational concepts to better serve the company. They thought the time was ripe for a centralized management approach, but they weren't sure which one to take. They were certain that they wanted to continue the business as a menswear operation. Many people suggested expanding into other merchandise classifications such as women's apparel, but with their knowledge only of menswear, they didn't consider this option.

As they continued to consider their options, the chain grew into a twenty-unit company. With increased sales, year after year, and the stores now located within a 250-mile radius, different problems began to surface. They included shipments made to the individual stores, the inefficient handling of sales staffs in each unit, and others.

Without a centralized plan it was possible that the organization could no longer function profitably.

Questions

1. Discuss the advantages and disadvantages of The Men's Loft's becoming a centralized operation.
2. Suggest a centralized organizational structure that would have merit for their present number of stores and also for future expansion.

CHAPTER 3

Buying for Discount Operations

On completion of this chapter, the student should be able to:

- Name the leading merchandising generalists in the field and discuss their product assortments.

- Describe the operations and merchandise mixes of the specialists in discount retailing.

- Discuss the primary merchandising philosophy of the retail discount operations.

- Identify the merchandise resources that are used to acquire products that are sold in discount operations.

- Describe the specifics of the Robinson Patman Act and why it was enacted into legislation.

- Differentiate between resident buying offices and merchandise brokers, both of whom are product resources for retailers.

- Discuss the typical timing of purchases for both traditional and discount retailers, and why one group is able to sell at lower prices.

- Explain the product classifications in which independent discount retailers stock their inventories.

Not too long ago, the traditional department stores and chain organizations were the favorite places for shoppers to make a large percentage of their wearable and household purchases. At these stores, replete with a wealth of brand names and private labels, the consumers availed themselves of marquee labels and nationally advertised brands as well as lesser-known offerings to satisfy their needs. It would not be long before Americans were given a chance to show their buying savvy and satisfy themselves with quality merchandise, albeit at value prices. The discount organizations came to life, with such names as Target and Wal-Mart, leading the way, with a vast assortment of apparel, accessories, home furnishings, and small appliance product lines. Along with these merchandising generalists were the specialty discounters who limited their inventories to one product classification. The former group might be compared to the full-line department stores that carry products for the entire family, while the latter somewhat resembles the specialized department store that restricts its offerings to one broad line of merchandise.

Wal-Mart is the world's leading discount operation.
(Courtesy of Ellen Diamond.)

Today, many of the product classifications that grace department store selling floors are but a fraction of what they once were. Furniture, major appliances, and electronics are generally gone from these traditional merchandise mixes. Retail emporiums have replaced them with more soft goods that bring a greater profit to these stores. These products have become central to the discounters in the United States. Their success has made them one of the faster-growing segments of retailing. The importance of the discount operation in American retailing may be best realized by scanning the list of the top one hundred retailers in the United States that is published each year by *Stores Magazine*. The most recent list, published in 2006, shows that Wal-Mart and Home Depot, both discounters, enjoy the first and second spots of all retailing establishments.

Discounting is not only for major retail operations, but for small independent merchants as well. Throughout the United States many upscale boutiques are successfully capturing the attention of shoppers who want the best in fashion, but at a modest savings.

The explosion in discount retailing has challenged many buyers and merchandisers in terms of their purchasing expertise. Not only must they be able to offer quality merchandise at discounted prices, they also must be able to convince vendors who otherwise want to sell only to the traditional companies who maintain price.

CLASSIFICATION OF MAJOR DISCOUNT ORGANIZATIONS

There are numerous types of operations within this retail classification. Although their model stocks differ from one another in terms of products and price points, their overall philosophies are the same.

Merchandise Generalists

When one goes value shopping for a variety of family needs, he or she often heads to stores like Target, Wal-Mart, and Kmart, now a part of Sear Holdings since they merged with Sears. In those premises one is able to purchase anything to satisfy both personal and household needs. Whether it is clothing, shoes, jewelry, small appliances, housewares, electronics, or even garden products, the assortments are there for the purchasing. Just as in the traditional chains and department stores, there are separate departments that enable shoppers to find what they are ready to purchase more easily. The different sections are clearly marked, making shopping a pleasurable adventure.

The Retail Buying Focus explores Target stores.

Target, a leading discounter, had its roots in traditional department store retailing.
(Courtesy of Ellen Diamond.)

A Retail Buying Focus

TARGET

Unlike most other mass merchandisers whose emphasis is on discounted merchandise, Target has department store roots. Back in 1961, Dayton's department store identified a demand for a store that sold less-expensive goods in a quick, convenient format.

In 1962, the first Target store opened in Roseville, Minnesota. It was the first retailer to offer well-known national brands at discounted prices. Soon after that, the company began to open an enormous number of units all across the country. Before long it had stores in forty-seven states. At this time, they number 1,300 stores.

The typical store averages 126,000 square feet, with the Super Targets more than 175,000 square feet.

Their merchandise offerings include a wealth of different product classifications that include apparel for the whole family, shoes, jewelry, home furnishings, garden products, health products, and food, all of which are discounted to sell below the manufacturer's suggested retail price.

In addition to its bargain prices, the company offers a wide range of services that are not usually associated with discount retailing. These include gift registries, gift cards, annual shopping events for seniors and people with disabilities, and delivery.

Also unlike many discount operations, Target has an Internet Web site from which a wide variety of merchandise is available. Recognizing that a large percentage of the population is either too busy to make in-store visits, or merely prefers off-site shopping, it continuously changes its web offerings to coincide with the newest goods that are found in the stores.

The company's management skills and attention to consumer demands have made it one of the most successful discounters in retailing history.

Specialty Discounters

With specialization the key to success for many traditional chain organizations, the discounters have followed suit by opening retail chains that parallel the traditionalists, but offer discounts on all of their merchandise. The different types of specialty stores include electronics discounters such as Best Buy, furniture giants such as Rooms To Go, housewares and home furnishing companies such as Linens 'n Things and Bed Bath & Beyond, toy merchants such as Toys Я Us, and home improvement centers headed by Home Depot and Lowe's.

Specialty stores also offer well-known products at prices that are typically lower than the traditional retail organizations.

The Retail Buying Focus explores Home Depot.

Specialty discounters generally locate their stores in "power centers."
(Courtesy of Ellen Diamond.)

Linens 'n Things is a major specialty discounter that specializes in home furnishings.
(Courtesy of Ellen Diamond.)

Warehouse Operations

Somewhere between the merchandise generalists and the specialty discounters are the warehouse operations. The former group sells a variety of hard goods and soft goods and the latter restricts its offerings to one major classification of merchandise.

A Retail Buying Focus

HOME DEPOT

When Bernie Marcus and Arthur Blank opened their first store in Atlanta on June 22, 1979, little did they or anyone else know that the home improvement industry was changed forever. Initially, the first few stores were adjuncts to Treasure Island Stores, purveyors of fine grocery products, where around 25,000 products were stocked. Today, an average Home Depot store is approximately 130,000 square feet, and offers about 40,000 products.

The founder's vision was to open warehouse-type structures that would be filled with a wide assortment of well-known products at the lowest prices in the industry. In addition to the price advantage that would be offered to its customers, there would be a wealth of well-trained associates who would provide the best customer service in the industry. With this vision in mind, the company grew, as of this writing, to more than 1,500 stores in forty-nine states, Canada, Puerto Rico, and Mexico.

With customer service a key to its success, along with the values the company offers, the service offerings rival those of the traditional retailers in the chain where full pricing is the policy. Included are free design and decorating consultations, truck and tool rental, home delivery, and free in-store clinics that help homeowners develop their do-it-yourself skills.

Having captured the attention of those devoted to its typical line of products, Home Depot expanded to another type of discount operation. Known as the EXPO Design Center, this group of stores features upscale products for the home, including linens, dinnerware, tableware, glassware, decorator accents, lamps, and other specialty products. Like the original home centers, this group—now numbering more than fifty units—also subscribes to the discount theory.

The success of the company can best be expressed in its rise in retail rankings for all types of operations. At the beginning of 2006, Home Depot was second to the leading retailer in the United States, Wal-Mart.

Home Depot is the number one home improvement discounter.
(Courtesy of Ellen Diamond.)

The warehouse operation's product mix falls somewhere in the middle. The most successful of these warehouse companies merchandises primarily a wide assortment of food products that include everything from packaged staples to fresh produce. Along with these "bread and butter items" is a comparatively small selection of high-volume clothing articles, linens, electronics, cameras, office supplies, and pharmaceuticals.

Unlike their discount counterparts, these organizations do not allow free access to their premises. Consumers must pay an annual fee in order to avail themselves of the bargains that await them. While such an arrangement might seem unusual, the success of companies like Costco, Sam's, and BJ's indicates its wide acceptance by the public.

The Retail Buying Focus explores Costco.

Table 3.1 represents the top ten discount operations in the United States according to sales volume.

Costco is the number one discount warehouse operation that offers a product mix of food, apparel, electronics, and household items.
(Courtesy of Ellen Diamond.)

TABLE 3.1 Top Ten Discount Operations

Company	Major Merchandise Classification(s)
Wal-Mart	Apparel, accessories, home furnishings, food products
Home Depot	Home products, nursery supplies
Costco	Food, beverages, wines, apparel
Target	Apparel, accessories, home furnishings, small appliances, electronics, garden supplies, food
Lowe's	Home products, nursery supplies
Best Buy	Electronics, appliances
TJX	Apparel, home fashions
Staples	Office supplies and furniture, printing
Kohl's	Family apparel
Toys Я Us	Toys, juvenile furniture, baby clothing

A Retail Buying Focus

COSTCO

One of the most amazing success stories in retailing history is that of Costco. New to the retail scene in 1976, the company has gone on to become the fifth largest company in terms of sales volume.

The company's concept was born in a converted airplane hangar in San Diego, California, under the name Price Club. Its commitment, right from the beginning, was to provide shoppers with the best quality brand-name merchandise at the lowest possible prices. Initially, it served only small businesses, but quickly changed its policy to include nonbusiness members. This change was not only to expand its business potential but also to gain a better buying presence in the wholesale markets where larger orders would result in better costs with the savings passed on to the membership. With the opening of additional warehouses, Costco became the first company to grow from zero sales to $3 billion in less than six years.

In 1993, Costco and Price Club merged, and began to operate under the Price-Costco banner. At that point they had 206 locations and annual sales in excess of $16 billion. In 1997, the company dropped *Price Club* from its name, and Costco now has grown to 473 locations with sales of over $51.9 billion. In addition to the United States, it operates units in Canada, Mexico, the United Kingdom, South Korea, Japan, and Taiwan.

The operating philosophy has always followed the same principle—to keep costs down and pass the savings on to the membership. The large member base, which pays $45 per year, brings in an enormous amount of money and helps provide the rock-bottom price strategy.

Memberships come in a variety of formats. In addition to the basic consumer plans, Costco offers executive, business, and gold star memberships, each serving a different need of corporate accounts.

Costco is behind only Wal-Mart, Home Depot, Kroger, and Sears Holdings which includes Kmart, in terms of sales volume, and continues to grow every year.

CHARACTERISTICS OF THE DISCOUNT OPERATION

In many ways, the discount operation is similar to the classification of retail organizations discussed in Chapter 2. Their tables of organization are often comparable to the chains, and the titles and people involved in purchasing are also similar. The characteristics that are different most often are concerned with merchandising philosophy and product acquisition.

Merchandising Philosophies

Whereas the traditional retailer bases its merchandising philosophies on the *full markup* when it prices its goods, the discounter operates on the concept of selling merchandise at a price lower than the full markup. The specifics of **markup,** which will

be fully examined in Chapter 17, involve the amount that is added to the wholesale cost of the merchandise to arrive at the selling price or retail. Typically, traditional department stores and chain organizations mark up their merchandise anywhere from 50 to 60 percent, and sometimes even more. The discounter, on the other hand, works at a lower markup, often 20 to 25 percent less than traditional counterparts. By working at these lower prices, the sales volume is generally greater than if the full retail prices were charged.

The inventories are replete with brand names that are immediately recognized by the shoppers who frequent these operations.

Since the profit margins are often affected by the lower markups philosophy, more and more of the discount operations are infusing their inventories with private brands that are exclusive to their companies. By doing so, they are able to obtain better markups than those achieved on the merchandise they purchase from vendors. The approach to this type of merchandising is often through the development of celebrity labels and brands. One of the earliest marriages of this type was undertaken in 1985 between Kmart and actress Jaclyn Smith, who designed an apparel line exclusively for Kmart. With its success, Kmart soon entered into another celebrity agreement with Martha Stewart, the guru of home design.

Other retailers whose operations are primarily discount oriented also subscribe to the private brand concept. Costco, for example, has a wealth of products bearing its Kirkland brand name. With the markups so low for its nationally branded goods, Costco makes up the difference with these items that are available only at its warehouse outlets. The concept of private labeling and branding is fully explored in Chapter 18.

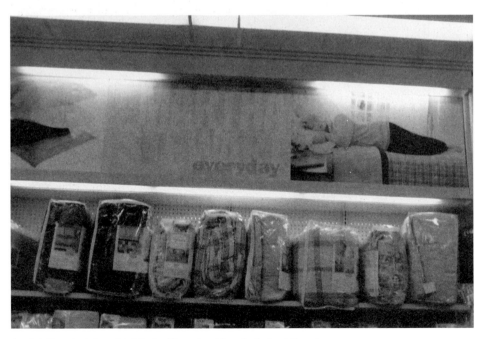

A celebrity private brand is Martha Stewart, sold exclusively at Kmart.
(Courtesy of Ellen Diamond.)

Product Acquisition

The buyers and merchandisers who purchase for this retail classification are often the industry's major purchasers. Since they represent many of the country's major retail operations in terms of volume, their purchasing requirements are considerable. They, like their traditional buyer counterparts, travel far and wide to procure the best available merchandise for their retail outlets. Their purchases are made from nationally known manufacturers, lesser-known producers, market specialists such as resident buying offices and merchandise brokers, and developers of private brands.

NATIONALLY KNOWN MANUFACTURERS

A walk through any discount operation immediately brings to your attention well-known brands and labels that are often found in more traditionally oriented retail outlets. The only difference is the price. Whether it is apparel, accessories, home furnishings, or food products, the labels are immediately familiar ones. With the enormous sums these buyers are ready to commit, the manufacturers are eager to make the sale. While the prices they pay for the goods are the same as those paid by the traditionalists who generally purchase in smaller quantities, often they are given special consideration because of the extent of the orders. There might be promotional allowances, delivery priority, or the waiver of shipping charges in lieu of lower prices. Although the nature of these purchases might cause you to reason that they should be rewarded with lower wholesale prices, the **Robinson Patman Act,** a key piece of federal legislation,

The private Kirkland brand is part of the merchandise mix at Costco.
(Courtesy of Ellen Diamond.)

disallows price discrimination no matter what the size of the order. This act was established to protect smaller purchasers and to make the playing field a level one in which all merchants can do business. The law does have one provision that often enables the discounter to gain a price advantage: if the manufacturer can prove that the size of a large order saves money in the production of goods, the savings may be passed on to the purchaser.

You might wonder why manufacturers who sell to traditional merchants would sell to the discounters as well, and perhaps jeopardize their relationships with traditional companies. Aside from the fact that discounters generally purchase more than their conventional retailing counterparts, the manufacturers are bound by law to sell to any qualified retailers; in addition, they cannot force them to maintain predetermined prices. At one point, producers were able to dictate the prices retailers had to charge their customers through the use of fair-trade agreements. These agreements forced all retailers to charge the same prices for the same goods. The concept was declared unconstitutional and prevented such price restrictions.

In terms of who is able to purchase from a particular vendor, the law is also quite clear that any company may buy from any producer as long as it is able to pay for the goods in a timely manner as stated on the purchase order. Many years ago, vendors were able to pick and choose their retail customers and provide exclusivity for those they chose. As unfair trading became illegal, so did the exclusive arrangements that were once prevalent in the industry.

The advantage of being able to offer those brands and labels that are nationally advertised and immediately recognized by the consumer has given the discounter an edge that makes his or her operation a place where consumers may find an abundance of quality items at value prices.

LESSER-KNOWN PRODUCERS

Although the inclusion of well-known brands in a discounter's inventory provides the company with instant product recognition and contributes to the retailer's company loyalty, the markups achieved on these items are generally low. To make up for these lower prices, most discounters elect to augment their better-known brands with merchandise from lesser-known producers. By doing so, the latter group of products may be marked at a higher percentage, so that their inclusion in the inventory will help the company bolster its average markup. This is not to say that poor-quality goods should be merchandised along with the nationally advertised brands.

While the better-recognized product lines are easy to select, their unheralded counterparts are often difficult to find. The challenge is for the company's merchandising team to locate vendors whose goods haven't gained national attention, but at the same time make a perfect fit in its merchandise mix. A great deal of scouting, both here and abroad, must be undertaken to locate these potentially successful products. It is not unusual for the company's buyers to venture off to third-world nations that often produce goods of this nature.

Another advantage that is often realized in the procurement of such goods is the willingness of the manufacturers to provide incentives to the retailer. It might be in the form of promotional dollars that could be used to call attention to the items, free shipping, and better terms that include extended payment periods.

It is the negotiation ability of buyers of these lesser-known products that often provides an edge to the retailers they represent. The scope of such endeavors is fully explored in Chapter 16.

MARKET SPECIALISTS

In every wholesale industry there are specialists whose task it is to locate merchandise from vendors that will satisfy the needs of potential clients. These companies are divided into two groups: the *resident buying office* and the *merchandise broker*. Their general roles are somewhat similar in that each is in business to bring together buyers and sellers.

Resident Buying Offices. Market specialists called **resident buying offices (RBOs)** often serve the fashion apparel and accessories markets. They are generally separate organizations that have as their members retailers that operate fashion-oriented companies. Their major function is to locate vendors with desirable merchandise that will satisfy the product needs of those they represent. Their ability to bring together sellers and buyers makes them important to both parties. The vendor is able to locate potential customers who might otherwise be difficult to find. The buyer has the advantage of locating quality merchandise without having to scour the globe, a costly and time-consuming venture. When both parties are satisfied, the result is a perfect "merchandising" marriage.

Resident buying offices charge their retail clients a fee for their services, which is discussed in Chapter 6.

Merchandise Brokers. Another type of business that brings together vendors and retailers for the purposes of merchandise procurement is the **merchandise broker**. Their role is similar to the RBO except that the merchandise offerings are not restricted to fashion apparel and accessories, and the fee for the service is paid by the vendor. Often, products of this nature are for closeouts that the vendor wishes to dispose of in a timely manner.

DEVELOPERS OF PRIVATE BRANDS

The previously mentioned private brands and labels are sometimes included in the discount retailers' model stock. Their inclusion is expressly to take the competition out of the equation, and thus enable them to gain higher markups than those charged for nationally branded items that are carried by competing discounters. In these times where Internet competition is of paramount concern to the brick-and-mortar value retailers, the need for merchandise that is exclusive to their inventories is significant. In the case of the giant discounters in the field, much of the private branding is accomplished through subsidiary divisions of their organizations. For smaller value-oriented operations, the task is often left to outside businesses that develop such products. In these cases, it is often the buyer who interfaces with the manufacturer to come up with designs that would satisfy the needs of their clientele. With this cooperation between vendor and retailer, a more salable product is likely to be the end result.

Timing of the Purchase

As is the case with purchasing planning for every retail classification, be it the traditional retailer, the off-site operation, or a value-oriented operation, the timing of the purchase is vital to the success of the company. When to bring the products into the brick-and-mortar outlets or catalogs is a very important factor to consider. If it is earlier than the shopper is willing to buy, then monies will be required to pay the invoices long before sales are made. If the goods arrive too late, potential sales will be lost.

Unlike the traditional buyer who has timing requirements generally early in the season as dictated by the industry in which it operates, the discounter must deal with different purchasing timetables according to the types of goods that will be incorporated in the inventory. For its regular product purchases, it buys the same as its traditional counterparts, whenever the season opens. For the discounter's own brands, the planning and purchasing must also coincide with the preestablished dates set by the leading vendors in the wholesale markets. For **manufacturer's closeouts,** which are often included in the merchandise mix, the timing is of an opportunistic nature, or whenever the "bargains" become available.

The discount buyers wear "different hats" in terms of purchase timing, and are almost always in the wholesale marketplaces to make certain the goods are available and deliverable when they need them.

INDEPENDENT DISCOUNT RETAILERS

Although the greatest amount of customer awareness in terms of discount retailing is most notably with the giants in the industry, there are a significant number of independent entrepreneurs that also sell their goods at prices below the traditional retail. With their larger counterparts able to offer a wealth of services to attract shoppers to their premises and off-site ventures, the smaller merchant oftentimes must use the only tool he or she has to operate a successful retail venture, *price*. With operating costs relatively low, sometimes calling only for the owner and perhaps an employee or two to run the operation, reduced rentals in off-the-beaten-path locations, and word of mouth as the only means of attracting customers, the ability to sell at a lower than traditional price is a reality. The enormous costs of employee benefits packages, lower insurance premiums, and do-it-yourself visual merchandising also contribute to a reduction in expenses.

Retailers of this size are generally specialists who deal exclusively with apparel and accessories primarily for women, with some selling men's and children's wear. With markups generally at least 20 percent lower than the conventional retail operations, stores of this nature often attract the attention of the shopper interested in quality merchandise, but at lower prices. You might wonder why they are able to remain as viable businesses with the likes of the giants in the field who also offer value shopping. The answer is simple: Some shoppers prefer the comforts of a small store with personalized attention to the impersonal environments generally found in the major

discount chains. Although the merchandise is often the same, the pleasantries and comfortable surroundings found in these small stores are an attraction to a percentage of the consuming public.

The buyer for such operations is generally the owner or perhaps a manager. He or she shops in the same manner as those who purchase for the giants in the industry. They go directly to nationally known manufacturers, seek out lesser-known producers, visit trade fairs to get an overview of their markets, and belong to resident buying offices to make sure they are in touch with their respective industries.

THE BUYER'S ROLE IN PURCHASING FOR DISCOUNTERS

While the role of the buyers of the aforementioned types of operations is somewhat similar in many ways to that of the buyers for traditional operations, there are some differences. Their concentration centers on the acquisition of merchandise that could be offered at discount prices, but, at the same time, bring a profit to the company they represent.

Among their priorities are establishing relationships with vendors that will bring them the best possible prices, and convincing those vendors who are reluctant to sell to them because of the potential problems with their traditional accounts, to do so.

Vendor Relationships

Every buyer for traditional operations must establish vendor relationships to ensure that they will be treated fairly in terms of prompt delivery, return privileges, and so forth. The discount purchasers, however, must take the lead to give them the edge when special pricing becomes available and "deals" are going to be offered. In this way, they will be ready to capitalize on purchases that will give them a better markup, and ultimately a greater profit for their company. With merchants of this nature doing business on less than the typical markup (a topic that will be discussed later in Chapter 17) gaining that competitive pricing edge is a must.

Acquisition of "Off-Limit" Merchandise

Buyers who represent the traditional retail operations are "committed," by the very nature of their business practices, to sell the products at the standard, accepted prices. For example, if a shopper goes from Saks to Neiman Marcus, he or she will find the same line, if both stores carry it, identically priced. Often, the price is suggested by the manufacturer, or is understood by the industry, as the price it should be marketed. On the other hand, the discounter is reluctant to sell at the established price since this is in direct opposition to what discounting is all about. Manufacturers of highly desirable merchandise are reluctant to sell to the discounters because their pricing practices might discourage traditional retailers to purchase from them. To overcome this objection, the discount buyer must be able to convince the seller that he or she would be willing to

abide by some stipulations that wouldn't affect the sales to the traditionalists. It might include a commitment not to advertise the brand, or to remove the labels and identifying tags. Sometimes, special products, under different labels, might be the answer to distinguish the lines. In any case, the discount purchaser must be a seasoned negotiator to excel in this position.

Language of the Trade

> manufacturer's closeout
> markup
> merchandise broker
> merchandise generalists
> resident buying office (RBO)
> Robinson Patman Act

Summary of Key Points

1. The leading discount merchandising generalists in the United States are Wal-Mart and Target.
2. Of the top one hundred retailers in the United States, the 2006 list shows that Wal-Mart and Home Depot, both discount operations, are ranked first and second in the country.
3. Merchandise generalists carry a wealth of products that range from apparel to electronics.
4. Specialty discounters restrict their offerings to one major merchandising classification.
5. The different types of specializations offered by the specialty discounters include furniture, toys, home products, and housewares.
6. The primary merchandising philosophy is to sell products at a price that is lower than the traditional markups conventional retailers charge their customers.
7. Product acquisitions for discounters come from nationally known manufacturers, lesser-known producers, developers of private brands, and market specialists.
8. The Robinson Patman Act was introduced as federal legislation to disallow price discrimination among retailers.
9. A resident buying office assists the buyer in learning about vendor offerings.
10. Merchandise brokers are in business to bring together buyers and sellers.
11. Buyers for discount operations often buy their goods at the same time as their traditional retail counterparts. When it comes to closeouts, however, they buy opportunistically.
12. There is a significant number of independent discounters in the United States that operate successful retail ventures because of their discount pricing policies. They are able to compete with their large discount chain counterparts because, in addition to the lower prices they charge, they also provide personalized service.

Review Questions

1. Which retailer enjoys the status as the number one discounter in the United States?
2. What product mix does the merchandise generalist offer its clientele?
3. Why have the traditional department stores reduced or eliminated hard goods and electronics from their inventories?
4. How do Home Depot's current retail locations differ from those that were first used?

5. In what way does the typical Home Depot operation differ from another of its concepts, the EXPO Design Center?
6. Which is the number one warehouse operation that is based in the United States, and how is it able to sell its products at such low prices?
7. What is the primary merchandising philosophy of all discount operations?
8. In what way have many discounters adjusted their inventories to improve their average markups?
9. From whom do discounters purchase the majority of their merchandise?
10. Explain the major provision of the Robinson Patman Act.
11. Why do many discount operations buy from lesser-known manufacturers if the nationally known producers provide immediate customer recognition of their products?
12. What are the two major types of market specialists that assist buyers and sellers in the wholesale marketplace, and how do their roles differ?
13. Does the timing of purchases differ for the discounter from that of the traditional retailer?
14. How is the independent discount retailer able to compete with the giants in the industry?

CASE PROBLEM I

Julie Stevenson has had the American dream of opening her own business ever since she graduated from college. As a fashion buying and merchandising student she studied every facet of the women's wear industry and exemplified the qualities of one who would successfully enter the field. With an excellent academic record she had many entry level positions available to her. Still dreaming of entrepreneurship, she chose the one that she believed would eventually help her achieve her dream.

Ms. Stevenson began as an assistant buyer of fashion apparel for Damon's, an upscale department store, and after just three years she was promoted to buyer. She covered all of the domestic markets, as well as some overseas venues to make her purchases. Her record with Damon's was outstanding in that her planned profit margins were always achieved. Life was wonderful at the company, but in the back of her mind her lifelong dream still wasn't reached.

Three months ago she decided to make the leap and open a store of her own. With enough money saved, she believed a small operation was within her reach. She considered opening a small boutique that would carry high fashion merchandise, but unlike the company she worked for, this was to be a discount operation. She would cover the domestic markets with which she was familiar, and purchase products that would fall into the same price point category offered by Damon's. The only difference would be the prices she would charge.

Ms. Stevenson decided that a 20 percent discount would entice shoppers into the store, and that at this markup she would enjoy success. With the best of intentions, she decided to discuss the venture with someone who was a professional in the fashion industry. Her dream was almost shattered when Jim Martin, her confidant, said that her markup wouldn't be sufficient to turn a profit, and that her goal wouldn't be reached. He also asked why shoppers would prefer to patronize her store instead of the discount giants in the field.

Questions

1. How could Ms. Stevenson work on such a small markup and still operate a profitable business?
2. How might she better serve her clientele than the major discounters in the field?

CASE PROBLEM 2

When John Matthews and Alex Michaels first joined forces in 1985 to begin a new discount operation, their initial plan was to offer value prices for nationally branded merchandise. They chose the route of generalist merchandising, carrying a cross section of products that would include apparel for the family, home furnishings, electronics, tools, and toys. Their emphasis would be on nationally recognized merchandise that would be sold at about 20 percent below the standard conventional retail prices that were charged by their traditional retail counterparts. The store's name that was chosen was National Brands to emphasize the nature of their product mix. With a great deal of advertising that featured the value orientation of the company, it quickly became a success.

Within a fifteen-year period, the company expanded and opened twelve additional units, all within a trading area of two hundred miles. Like its first venture, each of the units was greeted with significant success. It continued to concentrate on brand names, and sparingly introduced lesser-known producer lines into the mix. As National Brands entered the new millennium, however, it began to notice a little slip in overall sales. It wasn't a particular merchandise classification, but an across-the-board decline. Always believers in marketing research either to develop new concepts for their company or to investigate trouble spots, Matthews and Michaels retained the services of a recognized research organization that specialized in retailing.

After six months of investigation and an exhaustive study that included questionnaires, observations, and focus groups, Greentree Research Associates was ready to render its findings. The data revealed that there was too much competition from other retailers who were located in National Brands's trading areas. These competitors included some warehouse operations as well as several specialty discounters. Many carried lines that were either identical to those merchandised by National Brands or sufficiently similar to cause problems for them.

At this point, Greentree recommended several approaches that National Brands could pursue to meet the challenges that now faced the company. Among them were the following suggestions:

1. It could work on an even lower markup than it was accustomed to, so that the company could provide the lowest prices to the consumers in the region.
2. It could deemphasize the national brands that it carried and offer lesser-known products.
3. It could concentrate on closeout merchandise that it could purchase opportunistically.
4. It could begin a program of private branding and add those products to the existing merchandise mix.

At this point, the partners, together with their senior management team, are evaluating the different approaches suggested by the research team. Although several meetings have

taken place to find a solution, none has been forthcoming that would help return the company to its financially successful position.

Month after month, National Brands is experiencing drops in sales and the ultimate result of poor earnings.

Questions

1. Do you believe the company should continue on its present path? Why?
2. Do any of the suggestions from the research merit consideration? If so, which ones and why?
3. What plan do you believe would bring the company back to its initial level of success and why?

CHAPTER 4

Buying for Off-Price Retail Operations

On completion of this chapter, the student should be able to:

- Discuss the concept of off-price buying and where it has its roots.

- Give evidence supported by research that off-pricers sell for considerably less than their department store counterparts.

- Explain the various reasons why the off-price buyer is able to purchase at prices well below the original wholesale price.

- Explain why manufacturers often remove their labels from the garments that are sold to the off-price buyer.

- List three concessions that are given to vendors by buyers who purchase off-price.

- Describe how the Internet is used by the buyer in off-price purchasing.

- Make a list of famous designers and manufacturers whose merchandise is often sold at discount to off-pricers.

The off-price concept in retailing, which is extremely popular today, is really not new. The trade journals and writings about the early days of Loehmann's describes an operation that made its fortune by buying bits and pieces of merchandise at reduced prices and reselling them to customers at lower than the traditional prices. Its success was due to the efforts of Frieda Loehmann, who made daily trips to the wholesale markets in New York City's Garment Center to scoop up merchandise that vendors had to move from their inventories. The merchandise that she purchased was always of the best quality. The reasons that the vendors needed to dispose of these items were that the season's end was drawing near, some colors didn't sell as well as expected, there were "broken" size ranges, and some styles sold at less than anticipated levels. Whatever the reason, Loehmann was ready to make a deal for cash that was stored in her familiar black tote bag so that she could drive a better bargain. The designers and manufacturers were only too happy to make these deals since the traditional retailers bought only on terms that allowed for later payment. News of her visits to the wholesale marketplace quickly spread from vendor to vendor, waiting for her to appear at their companies. Frieda Loehmann was in town to purchase off-price.

Loehmann's original selling venue was in her home in Brooklyn, New York. Shoppers would come there to examine and purchase the few items that were available for sale. Her space needs began to increase as her sales began to soar, which necessitated

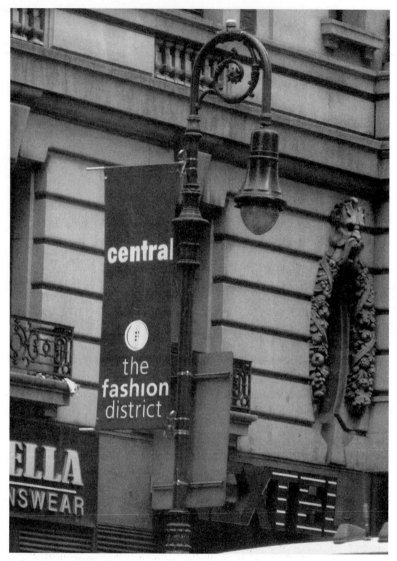

The fashion district in New York City's Garment Center where Frieda Loehmann made her off-price purchases.
(Courtesy of Ellen Diamond.)

her move to a small shop in Brooklyn. Eventually, the visits to the market became more frequent. She and a driver in a small black van made the rounds looking for merchandise that they could immediately bring back to the store. The placing of orders, as is the typical rule in traditional retailing, was out of the question since such goods were sold only at the regular prices.

The Loehmann's organization now stretches to states all over the country. It still conducts the same type of retailing as did its founder, Frieda Loehmann, to whom many in the field give credit as the originator of off-price purchasing and retailing. The stores carry vast assortments of women's clothing and accessories; some even

Loehmann's "Back Room."
(Courtesy of Ellen Diamond.)

stock menswear. Areas in these stores called Loehmann's "Back Room" feature the highest-price merchandise in the inventory, including couture products from many global markets.

The term **off-price** is often confused with discounting. Although both formats feature merchandise with a value orientation, they are not the same concepts. The off-pricers purchase goods far below the regular wholesale price and pass the savings on to the consumer. The discounter pays the usual wholesale price and resells the merchandise at prices that have a lower markup. The former's markup is generally the same as the traditionalists, their price feature coming from the savings they enjoy from off-price purchasing. The latter works on a lower markup and makes up for it by selling in large volumes.

Some of the better-known off-price merchants include Marshalls, Syms, T.J. Maxx, and the aforementioned Loehmann's. The most popular of the discounters are Wal-Mart, Home Depot, and Target, the focus of which was featured in Chapter 3.

The number of off-price operations continues to grow in the United States, making it an excellent arena for buyers to work. They are found coast-to-coast, featuring a wide assortment of goods in addition to apparel and accessories, and such items as home furnishings, toys, outdoor furniture, and food products. Their locations include freestanding venues; off-price merchandising centers such as the ones in Freeport, Maine; Reading, Pennsylvania; and Orlando, Florida; and **power centers,** shopping areas that cluster high-volume, value-oriented retailers.

One of the largest malls in the United States is Sawgrass Mills in Fort Lauderdale, Florida, a place where bargains are the order of the day. The Retail Buying Focus explores one of retailing's major entries into this aspect of business.

Marshalls is one of America's leading off-price retailers.
(Courtesy of Ellen Diamond.)

A Retail Buying Focus

SAWGRASS MILLS

With the success of two malls dedicated to "bargain" shopping, the developers of Potomac Mills in northern Virginia and Franklin Mills outside Philadelphia went to the drawing board and created what was to become the largest of such retail environments in the United States. Occupying a tremendous tract of land in Fort Lauderdale, Florida, far away from the traditional major shopping centers but conveniently located for consumers, Sawgrass Mills, shown on page 75, was born. Under one roof, scores of merchants offer vast assortments of goods at below traditional prices in more than two miles of store frontage. Sawgrass Mills opened just prior to the Christmas selling season in 1990, and the throngs who attended the inauguration, as well as those who returned time and time again to grab the bargains, seemed to indicate that the concept was destined to become an enormous success. The predictions were right! Sawgrass continues to add considerably more space to its facility, with new "wings" and a wealth of additional merchants to fill the spaces.

The outlets housed there include closeout centers for such major retailers as Saks Fifth Avenue, which features an "Off 5th" store, and Neiman Marcus, with its bargain facility known as "Last Call." Other shops include manufacturers and designers such as Donna Karan, Ralph Lauren, Dexter, Unisa, and Emanuel Ungaro, who feature "overruns" from their own collections, and retail chains such as Barney's, Ann Taylor, The Gap, and others that use these stores to sell slow-moving merchandise from their regular units.

Sawgrass Mills is not just a "plain pipe rack" operation; it provides comfortable rest areas, food courts, a number of exciting restaurant environments, including Rainforest Café, special events, and visual presentations that make the shopping experience a total pleasure. You need only look at the vast parking fields filled with cars to know that the shoppers are willing and eager to take home the specially priced merchandise that the store buyers have made available.

The success of Sawgrass Mills has spread to the Chicago area with Gurnee Mills, and other locations across the United States.

Sawgrass Mills is one of the country's largest bargain-shopping venues.
(Courtesy of Ellen Diamond.)

OFF-PRICE: FACT OR FICTION?

While the off-price phenomenon gains momentum, many traditional retailers try to dispel the price differential between themselves and the off-pricers by stating that the items offered for sale at these "bargain" retail outlets are second-quality manufacturer rejects, end-of-season closeouts that have lost their luster, poor-quality copies of original designs, unwanted colors, or ill-fitting. Is the merchandise offered by the off-pricer the

same as that found in the typical department store or specialty chain? Or is it some poor-quality bargain items mixed together with the "real thing"? Is off-price fact or fiction?

The research of Kirby and Dardes, "A Pricing Study of Women's Apparel in Off-price and Department Stores," in the *Journal of Retailing* indicates that there were, in fact, major price differences between the off-pricers and department stores: "Average prices for all twenty items during thirteen weeks were 40% greater in department stores than in off-price stores." The twenty items in the study included shirts, blouses, vests, sweaters, jeans, slacks, skirts, dresses, suits, and jackets.

Although this research does scientifically prove the reality of the price advantage in off-price stores, it is not the only indicator that off-price is fact not fiction. Today's consumer is an educated one. He or she is generally knowledgeable about quality, timeliness of styling, prices, and other factors needed to make appropriate purchases. With enormous numbers of consumers visiting and buying from the off-price merchants, it is obvious that they have spoken and have determined that off-pricers provide the goods they want at prices lower than charged by the traditional retail operations.

MAKING THE PURCHASE

If the merchandise is the same except for price, how can the off-pricers sell for less? Is it magic? Or is it because of their different approach to the acquisition of the goods? Of course, the latter response is the correct answer.

When you study the manner in which the traditional merchant plans and makes purchases in Chapters 9, 10, and 11, you will learn that a great deal of the time is spent on qualitative and quantitative planning. Most want to be first in bringing the goods to their customers, and therefore pay the most for the merchandise. It is similar to the purchase of an automobile. At the beginning of the new model year, prices for the cars are usually at their highest. When sales start to soften, prices often begin to fall and incentives are offered to dispose of inventory. Those willing to wait generally are afforded the bargain prices. The concept is the same for the off-price operation: Wait as long as you can to buy and the prices are apt to fall. In this way, the off-pricer is able to sell for less.

The factors that play an important part in the buyer's role as an off-price purchaser include timing of the purchase, assortment, special handling, label removal, transportation, and terms of payment. Some of these considerations are the same as when goods are bought for the traditional operations that charge their customers full price, as we will discuss later in Section Two, "Planning the Purchase," with others falling exclusively in the off-price category.

Timing

Being willing to wait a little longer gives the edge to the retailer who deals in "bargain" prices. The traditional store generally purchases early so that the customers will be able to shop prior to the season for which the merchandise has been made. Stores, for example, that stock inventories geared to the college-bound shopper must have fall merchandise in their inventories as early as June to give these customers time to assemble

the wardrobes that they will take with them to school. Fashion-forward merchants such as Bloomingdale's, Macy's, Saks Fifth Avenue, Neiman Marcus, and Nordstrom base their reputations on being the first in their trading areas to introduce the new collections. While this approach gives the shopper the privilege of buying early, it results in the highest prices for merchandise.

The off-price retailer's philosophy is quite different. His or her approach to purchasing is always **opportunistic.** That is, when the opportunity arises for a purchase of desirable merchandise at rock-bottom prices, the deal is consummated. It would please the off-price retailers to be able to purchase early, but price is what they offer their clientele. To do so, they play a wait-and-see game. They don't plan for market week, a time when the traditional buyers visit the wholesale market to see the new collections. The off-pricers wait until the new lines have been shipped to the stores before they set out to make their deals. By playing the game by this set of rules, they can visit the same vendors as the department store and traditional specialty chain buyers, only it's to see what these vendors have on hand and must unload to make room for next season's goods. In fashion merchandising, where seasons are short and often unpredictable, manufacturers and designers are often hungry for business.

The traditional retailer has had the chance to test the merchandise and reorder **hot items**—goods that are fast sellers. Profitable seasons are made on hot items, which make up for the markdowns attributed to poor sellers. In today's fashion world, however, reorders are becoming less and less popular, except in very few cases, with merchants looking for new merchandise all the time. Except for these few winners, there is always an abundance of well-known, designer merchandise available at closeout prices. Even at the season's end, some of these previous hot sellers are included as part of the bargain packages. By waiting patiently, and knowing where to find the best bargains, the off-price buyer is able to make a purchase well below the original wholesale price. It is not rare to see labels such as DKNY, Ralph Lauren, Calvin Klein, and Tommy Hilfiger at comparatively low prices. Understand, though, that the merchandise acquired at discount is generally in-season. In some cases, when the buy is at such low prices, but the selling season in the store is at an end, the purchase is made and then packed away, to be brought out for the next appropriate selling period. This practice is somewhat dangerous since fashion merchandise might lose its desirability. When these deals are made, it is the buyer who must ascertain if the goods have sufficient staying power to be carried over to another selling time.

Table 4.1 shows the timing of the purchases, delivery periods, and wholesale price differentials. Analysis of these data shows that the only conditions of the purchase that were different were date of purchase, delivery, and wholesale price. Why was the price different? The department store buyer, in the quest for early introduction of the item, had to make an earlier commitment to the vendor, and by doing so paid the higher price. This ensured receipt of goods on April 15 for selling through

TABLE 4.1 Comparison of Retailer Cost and Delivery on Same Style

	Style	Date of Purchase	Delivery	Description	Wholesale Price
Department store	842	March 1	April 15	Red dresses	$52
Off-price retailer	842	June 1	June 1	Red dresses	$36

the summer season, which concludes toward the end of June. The off-price buyer didn't plan to purchase style 842 specifically but did so at the end of the season, when the price became more attractive. Since the merchandise was in the vendor's inventory, it was available for immediate delivery, at a reduced price, with sufficient time left to sell it to the store's clientele. Even though the off-pricer's selling period is shorter, the price attraction should make it sell quickly. Waiting for this later date doesn't guarantee that all merchandise will be available at lower prices, but considering the enormity of production, especially in fashion merchandise, the off-price buyer is willing to take that risk.

Assortment

In Section Two you will discover that traditional store buyers prepare a buying plan that centers on a **model stock,** an inventory that is designed to feature an appropriate assortment of styles, sizes, and colors that will appeal to the company's clientele. By looking at past sales and other buyer sources of information such as the trade papers, reports from market specialists, and fashion forecasters, the buyer develops a merchandise assortment in terms of number of styles, and how much inventory is needed for each one. This assortment or model stock ensures a good cross section of merchandise.

The off-price buyer's plan is different from that of the department store buyer. Purchasing decisions are not as closely based on specific colors, exact size allocations, or styles, but on price. Because price is the dominant factor in the off-price buyer's decision making, he or she will forgo the specificity so common to department store purchasing and will purchase only discounted goods that fit into the store's general concept. When visiting a resource and negotiating the off-price purchase, the buyer often buys "incomplete size ranges" or assorted colors. The department store buyer must stay with the assortment specified in the model stock that has been planned prior to purchasing.

Table 4.2 shows the comparison of a same-style purchase from two buyers. It is obvious that the off-price buyer is willing to purchase a large quantity, perhaps the remainder of the vendor's inventory for that style, in colors and sizes that are in stock. Because of this, the wholesale price is considerably less than that paid by the department store counterpart.

Special Handling

Buyers who purchase for their stores at full price often make special demands on the vendors. Some retailers require that their store labels be sewn into each garment and that the merchandise be shipped on special hangers or in individual plastic casings. The resource

TABLE 4.2 Comparison of Same-Style Purchase for Department Stores and Off-Pricers

	Style	Color	Sizes	3	5	7	9	11	13	15	Total Pieces	Price
Department store	615	Pink		1	2	2	3	2	1	1	12	$50
		Blue		1	2	2	3	2	1	1	12	$50
Off-price retailer	615	Assorted	Assorted								85	$32

is generally amenable to such demands because the merchandise is being purchased for the top price. Those who consider price first are willing to forgo these special handling accommodations. It is equivalent to the shopper who buys a gift at Bloomingdale's or Neiman Marcus and expects expert gift wrapping at no extra cost versus the customer who buys off-price and is willing to wrap the purchase at home. The off-price retailer buys on a **"no-frills"** basis.

Label Removal

Often, manufacturers of nationally advertised brands and designer merchandise remove their labels from merchandise priced below the original wholesale price as a condition of the sale, although labels are becoming more commonplace at many off-price stores. By removing labels, the vendors can somewhat protect their department store and traditional chain retail accounts who have paid the full price and resell at higher prices. While off-pricers would always prefer to have the recognizable labels intact so that they will attract a larger segment of the buying public motivated by famous labels, the concession is reluctantly granted to gain an even better price advantage.

Removal of the label might eliminate the most prominent identifiable mark of a particular manufacturer, but off-price merchants point to the other features that allow for easy identification. The lining of a garment, for example, might feature a designer logo, and the buttons might have a similar design. The shopper at off-price stores is often an expert in the art of discovering the name of the manufacturer. Many shop the department stores to learn about what is in fashion and then move on to the off-pricers to see if they can find the same items at lower prices. Syms, an off-price chain that specializes in men's and women's clothing, often with the labels removed, boasts "An Educated Consumer Is Our Best Customer." Syms is saying that, with or without the label, their customers can easily discern quality goods. Label removal is thus a small price to pay for top-quality fashion merchandise at considerably reduced prices.

Transportation

In the negotiation process, traditional store buyers often demand that the seller pay for delivery of the goods. With large retail organizations, FOB (literally, free on board) destination which requires that the seller pay for the shipping, is generally a forgone conclusion.

The situation is quite different in off-price purchasing. Because the seller has agreed to a reduction in the purchase price, the "extras" often wanted by the buyer are taken away. One of these extras, the cost of shipping, is absorbed by the retailer. Many off-price merchants make their own arrangements, either by private transport or their own trucks, to transport the goods at their own cost. Of course, this expense is generally figured into the markup on the new merchandise.

Terms of Payment

One major problem endured by vendors concerns payments for merchandise. Retail buyers demand as much time as they possibly can before they pay their bills. In

some merchandise classifications, swimsuits for example, the manufacturer permits as many as four months for the invoice to be settled. This demand by the typical traditional retailer often causes a cash-flow problem for the seller. By giving in to the buyer's demands for extended time in which to pay the bills, the manufacturer's ability to run a business might be hampered. To compound the problem, many retailers take even longer to pay their invoices than allowed by the terms of the purchase.

When selling to the off-pricer, the situation is different. Since the wholesale price has been considerably reduced, the vendor requires earlier payment. In some cases, where the prices are rock bottom, immediate payment may be required. In this way, both the buyer and seller are satisfied. Sellers get the money they need to pay expenses, and the buyers get merchandise at a price that will make it more appealing to the customer.

Chapter 16 will focus on the various terms that buyers and sellers must agree to before the order may be finalized.

PRICING "OFF-PRICE"

Although, as we have discussed, off-price merchants pay less for the merchandise they bring to their inventories, many people are under the impression that they take a lower markup when they price their goods. Some do work on a lower markup because they "turn" their merchandise faster than their traditional retail counterparts and generally restrict their customer services; however, the vast majority mark up their goods to levels that rival the department stores. The merchandise is purchased at discount, but it is marked up more than the off-pricers would have you think.

Table 4.3 shows how the off-pricers can take the usual markup and still offer customers bargain prices. The mathematics used to determine markup will be fully explored in Chapter 17.

In the example shown in Table 4.3, the markup taken by both merchants is known as **keystone plus markup.** This indicates that the cost has been doubled and a few extra dollars added to arrive at the retail price. When **keystone markup** is used, the cost is merely doubled to get to the retail price. Most department stores work on keystone plus, as do many off-pricers.

Note from Table 4.3 that the markups are almost identical. Although the off-price merchant makes an excellent profit after all of the expenses have been paid, the off-price customer is saving a significant amount of money. The only differences that the off-price customer must be willing to accept include the inability to buy early in the season, environments that may not be comfortable in which to shop, and limited services. The bottom line, however, is savings.

TABLE 4.3 Markup Similarities for Department Stores and Off-Pricers

	Cost	Retail	Markup (on Retail)
Department store	$52	$110	53%
Off-price retailer	$36	$75	52%

INDIRECT PURCHASING

In most off-price operations, buyers are employed to make the company's purchases just as they are in traditional department store and specialty chains. As in the case of the traditional retailers, off-price stores use outside market specialists or resident buyers to cover the markets in their absence. A daily examination of the wholesale marketplace is vital to the success of the off-pricer. Distance from the various vendors and tasks required of the buyer in the store prevent daily market visits. To get a better handle on market conditions, outside agencies and specialists are used.

Some companies that specialize in off-price purchasing are either in business solely to cater to this retail segment or have separate divisions that deal exclusively with discounted goods. Not only is there representation in all of the major domestic regional markets, but also in many overseas wholesale venues. Price Breakers, based in New York City, deals exclusively in this type of merchandise, while The Doneger Group has a separate division called Price Point Buying to handle these purchases. In the following Retail Buying Focus, the Price Point Buying service is explored.

A Retail Buying Focus

PRICE POINT BUYING

The Doneger Group has been a mainstay in the fashion industry for many, many years. Starting out as a small resident buying office, headed by its founder Henry Doneger, it now enjoys the enviable position of being the largest company of its kind in the United States. The growth has taken place with the acquisition of numerous rival companies, both large and small, and the introduction of new divisions to serve specialized needs. One of these specialized divisions is called Price Point Buying.

Price Point Buying is an off-price buying service that specializes in popular-priced to moderate-priced women's sportswear in all size ranges. It is dedicated to servicing volume-oriented retailers who have a constant need for off-price merchandise. With the use of a great number of market specialists who are well-versed in this type of product, the retailer is provided with a competitive edge. Coupled with the advantage of professional representation is enormous buying power as well as a presence right in the wholesale market.

One of the major advantages of Price Point Buying is that vendors are always seeking out the service with discounted merchandise. Buyers at this Doneger division are regularly contacted by manufacturers and designers to present off-price goods. In addition to these contacts from the vendors, the buying specialists make daily rounds to make certain that they haven't missed any buys for their clients.

To better serve the needs of the retailers they represent, the staff members have extensive retailing backgrounds, and they understand what is necessary to ensure their store's profitability.

Interaction with the client base is accomplished by several means of communication. Fliers, telephoning, faxing, and now the Internet are means of letting the merchants

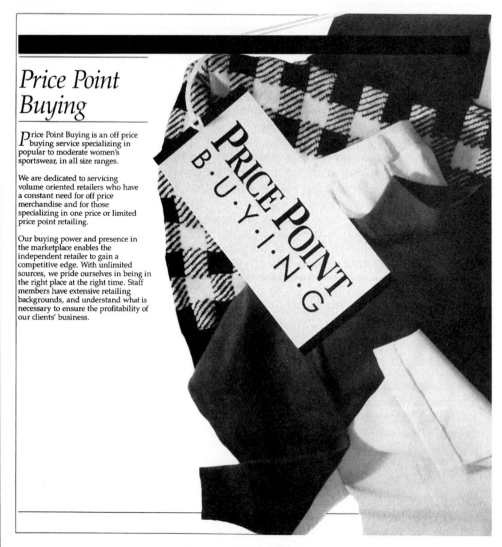

Price Point Buying

*P*rice Point Buying is an off price buying service specializing in popular to moderate women's sportswear, in all size ranges.

We are dedicated to servicing volume oriented retailers who have a constant need for off price merchandise and for those specializing in one price or limited price point retailing.

Our buying power and presence in the marketplace enables the independent retailer to gain a competitive edge. With unlimited sources, we pride ourselves in being in the right place at the right time. Staff members have extensive retailing backgrounds, and understand what is necessary to ensure the profitability of our clients' business.

Price Point Buying is an off-price service provided by The Doneger Group.
(Courtesy of The Doneger Group.)

know what is available. The Internet has proven to be a device that helps make purchases faster.

By subscribing to the Price Point Buying Web site, retailers are able to get photographs and facts on their computers about merchandise that is available at reduced prices. In a matter of seconds, the items available for sale are photographed, downloaded, and sent to the potential purchasers.

With its continued dedication to this type of buying, Doneger's Price Point Buying has made discount purchasing available to retailers who have neither the resources nor the time to conduct this type of buying on their own, and to others who need regular market information.

In times when vendors are overstocked and must make room for the next season's offerings, the indirect purchasers are a means to quick merchandise disposal. Not only does the retailer benefit from this association, as you have learned, but so does the producer, who needs to sell to many stores without the complications of individually contacting each one.

CONCESSIONS TO VENDORS

To gain access to merchandise produced by leading designers and manufacturers, off-price merchants must be willing to make certain concessions as a condition of the purchase. These include the locations of the retail outlets, the manner in which the merchandise will be promoted, and the unconditional purchase of the goods.

Location of the Retail Outlets

To make certain that their regular customers are not harmed by those who sell off-price, the vendors generally sell their "distressed" inventories to companies whose locations are far away from the traditional malls and downtown central districts. By staying with this practice, both types of merchants are satisfied. The traditional stores that purchase early in the season are able to maintain their regular markups and not be fearful of a nearby competitor who sells for less.

The off-price merchants usually locate themselves in power centers where other "bargain" merchants locate, in neighborhood clusters, or in freestanding stores. As a result, the traditional retailer's clientele will not be in the same vicinity as the off-price outlets when looking to make purchases. Many of those off-price merchants who have a great deal of clout have small shopping centers that bear their names. Loehmann's outlets, for example, generally locate themselves in Loehmann's Plazas all across the country.

Promotional Considerations

The lifeblood of most retailers is advertising, special events, and visual merchandising. These endeavors bring shoppers to the stores and hopefully turn them into purchasers. Without advertising, for example, the crowds would more than likely diminish. The names of key manufacturers and designers are highlighted in the retailers' promotions so that their "marquee labels" will attract attention. Many shoppers seek well-known merchandise, since these "signatures" generally guarantee something special.

Many vendors are willing, in fact, to participate in these traditional retailer's promotions. By offering cooperative incentives in which they share equally in the cost of advertising with the retailer, they are often rewarded with more business.

Off-price merchants, on the other hand, forgo any promotional dollars from vendors. They are chiefly concerned with price. In fact, they are often bound by the vendors' demand not to advertise the "famous labels." The vast majority of off-price

The power center is an arena where many off-pricers, such as Filene's Basement, are located. *(Courtesy of Ellen Diamond.)*

merchants wishing to announce that they have such goods at greatly reduced prices usually restrict their ads to such generalities as "20% to 50% Lower than Department Store Prices" or "Famous Designer Labels for Less." It is this guarantee to the vendors that enables the off-price buyer to purchase the same merchandise as the department stores.

Unconditional Purchasing

Many vendors are willing to make certain concessions to their regular accounts who purchase at full price. They often accommodate them by allowing **chargebacks** or discounts on merchandise that didn't sell as well as expected. By doing this, retailers are able to reduce the merchandise on the selling floor and not take discounts that will cause them monetary losses. In some cases they might even allow the stores to return the unwanted goods for a full credit to their accounts.

Off-price buyers, however, do not enjoy the same conditions. They buy the goods at the negotiated prices and take their chances as to their salability. Since the goods are often purchased in **job lots**—a term used to describe an assortment of goods without any consideration for specific colors or sizes—there might be some pieces in the **closeout** that are not "perfect." The condition of the sale is generally on an "as-is" basis. Once purchased, the goods cannot be returned to the vendor. This is the nature of buying off-price, and the purchaser is well aware of the risks involved.

TRADITIONALISTS AS OFF-PRICE PURCHASERS

Although the discussion thus far has concentrated on off-price merchants who deal exclusively in merchandise that is bought at rock-bottom prices, it should be noted that traditional retailers also avail themselves of such merchandise.

If you carefully scan the newspaper advertisements of department stores, for example, the term *special purchase* will often be seen. **Special purchases** is just another term used to describe purchases at off-price.

The reason for the traditionalists to participate in such merchandising is to bolster the markups they finally achieve for the goods they sell. For example, when some items do not sell as quickly as expected, the prices are reduced. By cutting these prices, the buyer is actually realizing a lower markup than initially expected. To gain an "overall" higher markup for the department, merchandise that can be "mixed" into the inventory is sought at better prices. By doing this, the merchant is improving his or her average markup. Specifically, if an item was originally bought at the wholesale price of $30 to be retailed for $60, the desired markup would be achieved if the item sold for that price. If it had to be marked down 25 percent to $45, the markup would not be maintained as originally planned. However, if the buyer was able to buy the same item off-price for $20 and sell it for the new selling price of $45, the loss on the earlier purchase price would be made up. Chapter 17 carefully examines such considerations.

In actual practice, many vendors would like to dispose of all their "distress" merchandise to their regular department store and specialty store accounts rather than to the off-price merchants. In this way, they do not jeopardize their names and they present a means of greater profitability to their regular-price customers. Of course, this is not always the case. The regular accounts might not have the need for more of the same merchandise because they could be making room for new arrivals, or the closeout inventories may be so significant that the only way to dispose of the goods is by way of the off-price merchants.

It should be noted that not only are the larger department stores and chains given the opportunity to buy the closeouts. Small retailers often buy these items, in lesser quantities of course, from the vendors they use regularly. They too mix these items in with their regular inventories. Some of the small retailers avail themselves of the heavily discounted merchandise through the services of resident buying offices or market specialists that make them aware of such situations.

Large or small, retailers are always searching for means to improve their maintained markup positions, and off-price purchasing is one method they employ.

THE INTERNET AND OFF-PRICE

As in-store off-price retail operations continue to expand, the Internet is making inroads into this type of merchandising. The Internet has joined the bandwagon of merchants offering goods at less than what is being charged by department stores and specialty chains. With the enormous success of online discounters such as Amazon.com, others featuring bargain prices have started to appear in this off-site venue. Another is eBay.com, where bargains may be available as fixed prices, or from bidding opportunities where consumers compete with each other for the best price.

Fashion is now making news on Internet Web sites. One of the early entries that has proven that there is a market for such items is DesignerOutlet.com. The company sells overruns of current-season fashion merchandise that is purchased off-price and sold well below the originally expected retail price. It began in 1996 with just 60 products for

sale, and today is running a business that features 65 lines with more than 1,200 products. Now, such mainstays as Amazon and eBay, who once sold a wealth of products that were not fashion oriented, have joined the fray and feature numerous designer labels.

Day after day, other Web sites are being launched to take advantage of the consumer market looking for such goods but without the time to shop in stores. Chapter 15 will offer a complete picture of this buying methodology.

THE SUPPLIERS OF OFF-PRICE GOODS

As much as they don't want to offend their regular traditional store buyers and jeopardize future business with them, almost all manufacturers and designers at every conceivable price point have some merchandise they must rid themselves of. These are not just the run-of-the-mill brands, but marquee-type labels that are quick to attract consumer attention.

Off-price stores regularly display merchandise from Ralph Lauren, Calvin Klein, DKNY, Tommy Hilfiger, Liz Claiborne, Evan Picone, and others. No line is sacred if there are goods left at the end of the season and room is needed for the next season's offerings.

Language of the Trade

chargebacks
closeouts
hot items
job lots
keystone markup
keystone plus markup
model stock
no-frills purchasing
off-price
opportunistic purchasing
power centers
special purchases

Summary of Key Points

1. Off-price retailing has its roots in the 1920s, when Frieda Loehmann started a business in her home featuring merchandise obtained from fashion designers at lower than the regular wholesale prices.
2. The number of off-price outlets in the United States continues to grow, with such names as T.J. Maxx, Marshalls, Loehmann's, and Burlington Coat Factory leading the way.
3. Off-price retailers tend to congregate in power centers and in off-price merchandising centers, the largest of which are the Mills outlets.
4. While some traditional retailers spread the word that off-price is just a myth, its reality has been clarified by numerous marketing research investigative reports.
5. The off-pricer's philosophy is to buy opportunistically.
6. Although off-price retailers sell for less, their achieved markups are basically the same as their traditional retail counterparts.

7. To protect their reputations, some vendors require label removal when the merchandise is sold off-price.
8. With the tremendous increase in the availability of off-price merchandise, some market specialists such as Price Point Buying are making their offerings known and available via the Internet.
9. To avail themselves of the closeouts, most off-price merchants locate their stores far away from the traditional retailers so that they won't antagonize them and hinder their chances for such goods.
10. Generally, promotion of off-price merchandise is done without the mention of the labels being offered.
11. Many traditional retailers are mixing off-price purchases with their regular inventories to bolster their profit margins.
12. New outlets for off-price merchandise are popping up on the Internet to appeal to individuals who have little time to shop in stores.

Review Questions

1. What well-known off-price retailer is credited by many to have started this type of operation?
2. Are the terms *off-price* and *discounting* interchangeable? Explain.
3. Explain the term *power center.*
4. Are off-price retailers really charging less for the same merchandise found in department stores?
5. Compare the timing of purchases for traditional stores and off-price operations.
6. In what way does the assortment requested by the department store buyer differ from that of off-price merchants?
7. Why do some vendors insist on their labels being removed from goods sold to the off-pricers?
8. How different are the initial markups made by off-price stores and department stores?
9. What is meant by the term *keystone plus markup?*
10. In what way does the indirect purchaser assist the off-price purchaser with his or her merchandise acquisitions?
11. How does Price Point Buying get information and photographs of products that are available at reduced prices in a matter of a few minutes?
12. Why is it advisable for off-price merchants to locate their stores away from the traditional malls and downtown central districts?
13. In what way does the vendor sometimes give consideration to the retailers who paid full price for the merchandise?
14. Does the traditional department store ever purchase off-price goods? Why?
15. How can the small merchant participate in buying off-price items?

CASE PROBLEM 1

Langtree's is a small department store located in Pennsylvania. In operation for eighteen years, it has made its success on offering quality merchandise and service. Langtree's upper-middle-class customers purchase merchandise that features labels such as Liz Claiborne, Calvin Klein, DKNY, Ralph Lauren, and a host of other reputable names.

About three years ago, Langtree's received its first taste of off-price competition. Clayton's, an off-price operation, opened a store eight miles from Langtree's downtown flagship location. The new venture, unlike Langtree's was "off-the-beaten-path" and free-standing. Although the two companies were not direct competitors, they carried some identical lines. Because the new store was just a short car ride away, some of Langtree's customers visited Clayton's and purchased the same goods off-price for less. Some of the customers complained to Langtree's that although the service at Clayton's was poor, the price differential was significant.

Throughout the last few years, ever since Clayton's arrival, business has slightly declined at Langtree's, and management assessed the problem as price competition from the new merchant in town. Management held several meetings to determine a solution to combat shrinking sales. Three suggestions for coping with the situation were made.

Mr. Birmingham, the general merchandise manager, suggested a plan to upgrade service to an even higher level and to ignore the price competition. He believes that the customer who shops at Clayton's is only a "fringe" shopper at Langtree's, whose business is not important. He feels that new, upgraded services such as personal shopping, VIP charge cards for preferred customers, and a new gourmet dining room would keep the better customers.

Mr. Austin, the store's fashion director, believes that a new promotional strategy to extol the "fashion first" approach at Langtree's would help retain its share of the market. By promoting fashion clinics, trunk shows with designer appearances, special storewide fashion themes, and other events, Langtree's would separate its operation from Clayton's.

The third plan, the work of Mr. Laughton, is a radical approach to the problem: "If you can't fight them, join them." He suggests a total change in philosophy, one that would transform Langtree's into an off-price company. He says that their location would be perfect to attract scores of bargain-hunting shoppers.

At present, the situation hasn't been resolved and pressure to make a change has mounted.

Questions

1. Which, if any, of the three proposals seems to be the right solution? Defend your answer with knowledgeable reasoning.
2. Could you suggest another plan that might help Langtree's retain its profitable position?

CASE PROBLEM 2

Patricia Reynolds recently fulfilled her dream of opening a warehouse-type off-price retail operation. Fully aware that a traditional mall or downtown location would make it difficult to purchase off-price, Ms. Reynolds chose a warehouse that formerly housed a toy manufacturing company. The parking area was large and could accommodate more cars than she needed for a profitable business.

She had no trouble buying because her location was out of the mainstream of retailing. She consented to buying later than the vendors' regular customers, having the labels removed, and paying on a COD (cash on delivery) basis. Ms. Reynolds also promised not to take the traditional advertising route, which prohibited her from mentioning her resources in newspapers.

She opened the doors three months ago, and business was much below her expectations. Although she was surrounded by factories and other companies in the general vicinity, the shoppers didn't come in the numbers necessary for success. She put up flags and banners around the building in the hope that they would attract attention, but still no luck. Her merchandise, the best that could be found and at low prices, sat on the shelves and racks. Her instinct told her to forget about her commitment barring "informative" advertising, but she knew such a breach would prevent her from getting more goods.

Question

1. How could Ms. Reynolds promote her operation without breaking her word to the vendors?

CHAPTER *5*

Buying for Off-Site Retail Operations

On completion of this chapter, the student should be able to:

- Discuss the different approaches that store retailers take to purchasing merchandise for their off-site outlets.
- Define the term *brick-and-mortar retailing.*
- Describe the different types of catalogs for which buyers purchase.
- Explain the differences between buying for stores and for direct retailing catalogs.
- Discuss the different considerations a buyer must address before purchasing merchandise that will be sold via e-tailing.
- Describe the types of merchandise that are most often featured on the home shopping programs and the reasons for such a narrow offering.

There is a great deal of evidence that the traditional approach to retailing—namely, stores, or **brick-and-mortar retailing** establishments as they are referred to by industry professionals, where customers make their purchases—is being challenged. At the beginning of the twenty-first century, retailers of every size and format were either significantly involved in selling by other means, such as catalogs or through **e-tailing** on Internet **Web sites,** or formulating plans to become involved. Today, these operations continue to attract more and more consumers.

Shoppers who regularly visited their favorite stores to make their purchases are now using these methods for satisfying their needs. Although shopping had been a routine that many consumers enjoyed, changes in buying habits were necessitated by lifestyle changes and less time to make store visits. With more people working two jobs to meet the spiraling cost of living and record numbers of women who once worked exclusively in the home now moving into every possible type of career outside the home, for some there is little time to buy in the traditional manner.

To address this new "playing field" and not be caught short of the numbers of shoppers needed to make their companies profitable, changes had to be made to the methods for generating business. Not too many years ago, several major retailers didn't see the need for change and ultimately closed their doors. Rather than join the ranks of household names such as Gimbel's, A&S, Garfinkel's, and B. Altman & Company,

who went out of business, today's educated merchants are carefully planning for future success.

Although the catalog business is not new, it has never had the impact on retail sales that it does today. In the past, most stores sent catalogs to their customers during peak selling periods such as Christmas or Mother's Day, and perhaps to announce a sale. Today, the picture has changed radically. Consumer mailboxes are being inundated with as many as four or five catalogs a day from the very same stores the consumers would normally visit and from companies who sell merchandise by this means without any stores.

At the same time, other competition for in-store shopping is coming via the "**e-commerce**" route on the Internet. Each day, more and more Web sites are appearing on computer screens all over the world featuring every type of merchandise from clothing to food. Many of the merchants are those who operate stores, while others retail their products only electronically. You can sit down at the computer, any time of the day or night in most parts of the world, and purchase antiques, books, travel, CDs, designer apparel, jewelry, and just about anything else. From every indication, the sales generated by this outlet grow every day.

Yet another off-site operation, the shopping channels on television, is cutting into sales that were formerly made in stores. This format enables the in-home shopper to see the actual merchandise and be able to interact with the broadcast's sellers if there are questions to be answered. With sales recorded at more than twenty thousand per hour during some of the time slots, this is an outlet that requires a constant flow of merchandise.

With each of these fast-growing **off-site retail** segments, buyers are becoming more important than ever before. Not only must they purchase merchandise for a defined consumer base, but they must also consider a much broader trading area than that of the traditional store buyers.

The nature of the off-site retail outlets will be explored in this chapter as well as the challenges faced by buyers to serve them.

CATALOG RETAILING

Before the buyer's role in purchasing for catalogs can be explored, it is necessary to examine the different types of companies that use catalogs to reach their markets. Some traditional retailers integrate their in-store and off-site ventures, whereas others have separate divisions for each type of outlet. Others are "catalog-only" merchants, who use only the direct-mail approach to selling their goods.

Department Stores

The backbone of retailing for the past hundred years has been the department store. Whether it was a visit to the company's flagship or to a branch location, the consumer was able to find a wealth of merchandise to satisfy his or her needs. Augmenting the in-store purchasing arena was and is an assortment of catalogs that are either directed to the store's regular customers or to others in the hope that they will become

Carson Pirie Scott is a full-line department store based in Chicago, Illinois.

customers. The department stores are structured either as full-line operations or specialized stores.

FULL-LINE DEPARTMENT STORES

Stores such as Macy's, Bloomingdale's, and Carson Pirie Scott are full-line stores. They feature complete merchandise assortments that include apparel for the family, accessories, home furnishings, electronics, and in some cases, specialty foods. The merchandise featured in the stores is often also sold in the catalogs. The buyers merely select some of the merchandise that has been earmarked for their stores for insertion in the catalogs. While this is standard practice, a new route is being taken by some of the major retailers. In companies like Macy's, for example, a great deal of attention is being paid to the catalog operation. To make a full-scale effort in this direct retailing venture, Macy's has now opened a separate catalog division in which a full merchandising team has been put in place to make all of its purchases. In this way, the company is able to address the merchandise needs of people well outside its regular trading areas.

SPECIALIZED DEPARTMENT STORES

When the department store organization first appeared on the scene, it was a format that featured a wide assortment of hard goods and soft goods. Soon after its introduction, some merchants felt that by restricting its product line to a narrower classification it could provide more depth in specific merchandise. Thus the specialized department

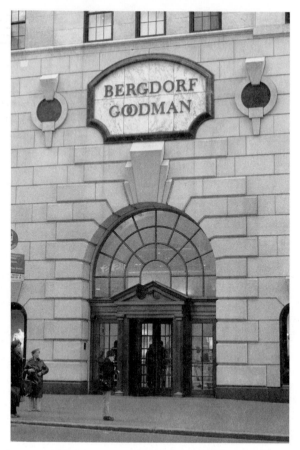

Bergdorf Goodman is an example of a specialized department store.

store was born. Typical of those companies doing business today are Saks Fifth Avenue, Nordstrom, Neiman Marcus, Fortunoff, and Bergdorf Goodman. As is the case in their stores, the catalogs they produce specialize in one or a few merchandise classes. Fortunoff, for example, specializes in jewelry and home furnishings; Bergdorf Goodman restricts its goods to apparel and accessories for women and men; and Nordstrom sells upscale fashions for the family.

Some of the aforementioned companies feature more than one type of catalog, with each marketed for a different purpose. One organization that subscribes to this philosophy is Neiman Marcus, the Dallas-based retailer. In the Retail Buying Focus, some of its distinctly different catalogs are discussed.

One of the more recent adjustments to these and other department store catalog offerings is merchandise that is available only through catalogs and not in the stores. The items featured might not generate a sufficient amount of interest inside the store, but with the vast audiences reached by catalogs, different merchandise might be warranted. In looking through the catalogs, notations such as "available by mail only" indicate that the store is looking for sales outside the normal trading area.

A Retail Buying Focus

NEIMAN MARCUS CATALOGS

When Neiman Marcus first entered the retailing scene, its mission was to target the upper-income class in Dallas, Texas. With a host of expensive, quality items, many of which were unique to Neiman Marcus, the company quickly attracted a large number of followers. Throughout its history, it regularly scouted the world for the unusual. In-store retailing was not its only vehicle for selling merchandise. For many years, it produced, and continues to produce, its now famous *Christmas Book,* a catalog that is legend among retailers and consumers. Not just another catalog to examine, this one features, along with traditional, upscale fashions, a collection of "His and Her" items that are unlike anything else in the marketplace.

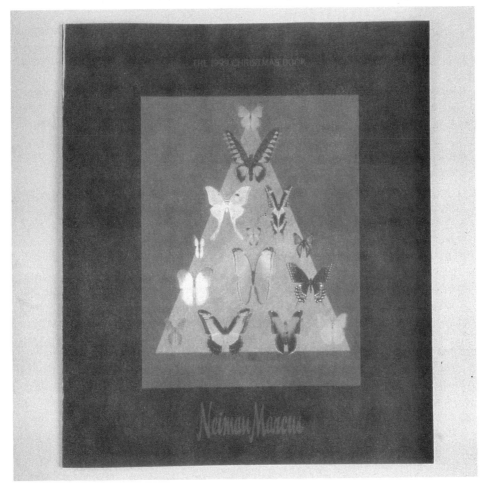

Neiman Marcus's *Christmas Book* is a unique catalog.
(Courtesy of Neiman Marcus Direct.)

Buyers are called on to sharpen their imaginations and purchasing skills to come up with gift suggestions that are truly original and are available in "pairs" for sale to couples. Among the more unusual merchandise offered in the past were his and her mummy cases that were facsimiles of the purchasers; his and her diamonds, each costing more than $1 million; and his and her LTV Hummers, motor vehicles used in Operation Desert Storm, at $50,000 each.

Recognizing that the order of the day wasn't merely for exotic Christmas shopping, Neiman Marcus continues to expand the *Christmas Book* to feature traditional wear alongside the exotic.

With the success of the catalog earmarked for the Christmas shopping season, the company began to offer other catalogs. It began with one called *NM Edits,* which featured fashion-forward items for the coming season. Today, Neiman Marcus has replaced this offering with one simply called *The Catalog.* In it, customers are able to purchase the retailer's very-high-end merchandise that is available in the stores and some items that are for only catalog sales.

Other direct-mail merchandise books introduced by the company include the *Linen Catalog* and the *Home Catalog.* As the titles indicate, these publications feature wide assortments of these items. The idea to approach these markets came about as the result of the significant amount of business now being generated in bedding, table linens, and home furnishings. With the limited space in the stores available for such merchandise, the catalog was deemed the best approach to expand these offerings.

Given the broader use of its catalogs, Neiman Marcus employs many more buyers than ever before. Some have the responsibility to purchase for in-store departments and to select some items for inclusion in the catalogs. Others are employed exclusively to buy items sold only for direct mail.

Specialty-Chain Organizations

Specialty chains and specialized department stores, although using similar merchandising approaches that restrict merchandise offerings, are technically different types of businesses. The former is a company with anywhere from two to more than a thousand "small" units, with the latter usually having "large" stores that feature a flagship and, perhaps, no more than one hundred branches.

As is the case with department stores, the chains have also embraced the catalog as a means of generating increased sales. Some of the leading chains include The Limited, which has several different divisions such as Express and Bath & Body Works in its organization, with each specializing in a different type of merchandise; Ann Taylor, a company that promotes private-label fashion merchandise for women; and Williams-Sonoma, a housewares merchant.

The chains also rely on the catalog to provide additional revenue for their companies. Some merely send a catalog that features the same assortment found in the stores, whereas others focus on additional merchandise for their direct-mail customers. Victoria's Secret, for example, sells women's sportswear in the catalog in addition to

lingerie. This expansion of the merchandise offering for the catalog necessitates a different buying team to make these purchases.

Note, however, that catalogs for specialty chains are generally not as frequently used as are those of department stores, but nonetheless they do bring in a great deal of business. There are some exceptions such as Pottery Barn and Crate & Barrel.

Catalog Operations

Retailing by mail and phone is by no means restricted to companies with brick-and-mortar operations. There are more and more organizations being formed each day for the purpose of getting a share of the market that prefers to purchase at home or does so because of time limitations. Every conceivable product line and price point is available from catalog companies. Some feature the same full line of merchandise as is found in the department stores, while others restrict their offerings to a narrower product base such as is found in the specialty chains.

The largest of the direct retailing general merchandise businesses is Spiegel. Featuring a wide assortment ranging from apparel and accessories for the family to products for the home, Spiegel sends its buyers all over the globe to seek out merchandise that will fit most families' needs. Lands' End, a part of Sears Holdings on the other hand, limits its assortment to clothing and some wearable accessories for men and women, while Herrington, in its *Enthusiasts' Catalog,* sells only products with a golf, motoring, travel, fitness, photography, and audio orientation.

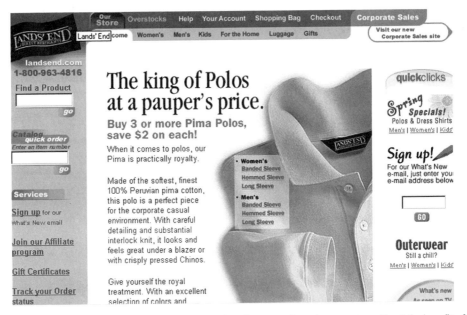

Lands' End, a catalog division of Sears Holdings, is a direct merchant that operates without the benefit of stores.
(Courtesy of Ellen Diamond.)

Phone center for order taking at Spiegel.
(Courtesy of Spiegel Catalog.)

Although the catalog business continues to boom, some of these merchants are feeling that a "store" presence will help them gain an even broader customer base. Some are opening stores, on a limited basis, throughout the country to bring their merchandise to the traditional shoppers. Their belief is that once customers have been satisfied in the store, they will then make additional purchases through the catalogs.

Companies such as Smith & Hawken, which features merchandise for gardeners; The American Girl, specialists in dolls; and Patagonia, direct marketers that sell specialty items for sports enthusiasts and outdoors people, have entered into the traditional retail environments. Patagonia's stores are owned and operated by Great Pacific Iron Works. Thus without the challenge of running a retail operation, the company has the advantage of having its merchandise featured in a limited number of stores and hopefully gaining an additional customer base that will also use the catalog for future purchasing.

In the Retail Buying Focus, the Spiegel empire, a company whose operation parallels that of the traditional department store, is examined.

Unlike the Spiegel operation, Patagonia's catalog is highly specialized, and it serves a very different type of customer. Unlike Spiegel, it also markets its catalog merchandise in stores that are affiliated with the company. The next Retail Buying Focus shows how the organization makes its appeal to a much narrower segment of the market than does Spiegel.

A Retail Buying Focus

THE SPIEGEL CATALOG

Spiegel, Inc., the nation's largest direct marketer and specialty retailer, was founded in 1865. It sells apparel, household furnishings, and other merchandise through semiannual catalogs and various specialty catalogs. Spiegel reaches more than thirty million households in the United States. While the business is primarily a catalog operation, it does have a few outlet shops that dispose of overstocked or end-of-season merchandise.

Buyers and merchandisers alike are provided substantial information about customer purchases from computer-generated reports. Such data include customer demographics, behavioral information, merchandise preferences, and price points within the various markets. Through constant analysis, the buyers are better able to serve their customer's needs. In addition, primary research is a regular company undertaking. Studies are conducted that produce firsthand information about consumer preferences.

Typical of the consumer research done was a questionnaire that was inserted in a company catalog. Many of the responses confirmed the organization's own merchandising thoughts, whereas some turned up requests that hadn't been considered before the survey. About 72 percent responded affirmatively to the company's customer advisory panel.

The success of the catalog is certainly due to the company's efforts to consider the consumer in the decision-making process; its mix of merchandise that includes both nationally advertised brands, many of whose items are specifically manufactured for Spiegel, and private-label items; and buyers' careful attention to merchandise acquisition and development. If problems arise, customer service representatives quickly address them.

Spiegel recognizes that while it doesn't have some of the advantages of companies that operate from stores, such as interaction with department managers and shoppers to determine merchandise needs firsthand, its regular involvement with research provides it with the information needed to run a successful business.

The customer service department at Spiegel Catalog.
(Courtesy of Spiegel Catalog.)

SIZE AND MEASURING INFORMATION

For a Perfect Fit:

FASHIONS. Order the size you usually wear. If you have any questions, our Ordertakers will be happy to assist you. You'll find Misses sizes for average figures, Petite sizes for women under 5'4" and Women's sizes 14 and up, as well as several styles in Tall Sizes (5'7½" to 6') and Women's Petite Sizes (under 5'4"). For men, we offer items in Big and Tall sizes.

Sizes 14W/14WP-26W/26WP. To assure the best fit, use the size chart below.

Women's Sizes	14W/14WP	16W/16WP	18W/18WP	20W/20WP	22W/22WP	24W/24WP	26W/26WP
	—		1X		2X		3X
Women's Tops*	—	36	38	40	42	44	46
Women's Bottoms*	30	32	34	36	38	40	—
Bust (inches)	39-40½	41-42½	43-44½	45-46½	47-48½	49-50½	51-52½
Waist (inches)	30-31½	32-33½	34-35½	36-37½	38-40½	41-43½	44-46½
Hips (inches)	41-42½	43-44½	45-46½	47-48½	49-50½	51-52½	53-54½

*Women's top and bottom sizes (36-46 and 30-40) are simply identifying a size number and do not represent a specific garment or body measurement.

SKIRT LENGTHS. Skirt lengths are measured from **natural** waist to hem. The sketch below converts inches to real skirt lengths for a 5'6" woman.

19"
21"
23"

Unisex sizes: men's sportswear sizes with women's equivalents.

Unisex sizes	XS	S	M	L	XL
Women's sizes	4	6-8	10-12	14-16	18

RINGS. Order your normal size, or if you're not sure of your size, wrap a narrow piece of paper snugly over your knuckle and mark where it overlaps. Place the mark at "A" on the chart below. The left edge of the paper will fall at your proper size.

13 12 11 10 9 8 7 6 5 4 A ▶

SHEETS/BED RUFFLES.
Most of our sheets are sized to fit standard mattresses.

Twin	39 x 76"	Full	54 x 76"
Queen	60 x 81"	King	78 x 81"

Some of our fitted sheets are available with corner pockets that will accommodate the new, deeper mattresses. These extra long pockets may also fit over feather beds or orthopedic cushions used on top of your mattress. To determine which sheets you need, measure the depth of your mattress at the corner.

Standard sheets fit mattress or topped depth of 7-9".
Deep Pocket sheets fit mattress or topped depth of 8-12".
Universal sheets fit mattress or topped depth of up to 14".

Bed ruffle lengths are measured from top of box spring to floor.

RUGS. To determine which size is right for your needs, use these guidelines:
- For dining areas, add 6 feet to the length and width of the table.
- Allow 3 feet on all open sides of a bed.
- Leave 8 inches of floor exposed around baseboards when covering an entire room.
- For entries and halls, consider the thickness of the rug and how the doors open.
- For added protection and cushioning, or to prevent rugs from slipping, we suggest using rug pads, grips or rug-to-rug pads.

TABLECLOTH SIZES.
To select the proper size tablecloth, determine the depth (in inches) of cloth overhang you'd prefer (usually 6-12 inches) and multiply it by 2. Add to the length of the table (in inches) as you intend to use it (with or without leaves). Repeat for width. Order the cloth size that corresponds to final dimensions.

WALLCOVERINGS. (a) Measure length of each wall to be covered (in feet). Do not subtract for door or windows. (b) Measure height from floor to ceiling. (c) Multiply height of each doorway and window by its width. (d) Multiply (a) x (b), then subtract half of (c) from this amount for the total square footage to be covered. (e) To determine the number of rolls you'll need, divide the total square footage by the applied coverage of each roll. (The applied coverage figure is found in the catalog description.) Add 10% for repeat patterns.

Size and measuring information help reduce merchandise returns and promote customer satisfaction.
(Courtesy of Spiegel Catalog.)

A Retail Buying Focus

PATAGONIA

The best word to describe the merchandise found in the Patagonia catalog, as well as the manner in which it appeals to its potential customers, is *unique*. Primarily a catalog company, it also sells some of its merchandise through stores that are affiliated with the company, and some to other independent outlets. However, the greatest portion of its sales are through direct mail.

When you examine the catalog, it is obvious that there is more to it than just the goods it sells. One page after another, as well as special inserts, speaks to causes such as protection of the environment and the role Patagonia plays as an environmental activist. Most product classifications are presented with pertinent information on ecology, environmental concerns, or fiber information about how the fabrics have been constructed from what would otherwise be considered waste materials. For example, within the product classification Watersports, a progress report is featured about waterways, dams, and reservoirs, and how various agencies are helping make them safer for salmon reproduction. Another extols the virtues of the company through their manufacturing processes that "make clothes out of soda bottles," and they use scraps of Synchilla, a synthetic fiber, before they hit the cutting room floor to make new fabrics.

It also makes a statement about the company's overall purpose: "Patagonia exists as a business to inspire and implement solutions to the environmental crisis." It goes on to say, "Patagonia has given more than $14 million to 900 grassroots environmental groups," and that the company converted its entire sportswear line to 100 percent organically grown cotton, a move that provoked a fundamental change about attitudes toward agriculture.

While publicizing these messages might seem an excellent way to show that industry does care about more than just selling goods and making a profit, it also tends to decrease the size of the potential consumer base. Some might be offended by their efforts and others might just see this approach as a public relations ploy to gain even more business. To show that they are on the level with their philosophy, they print some of the negative mail they receive about their programs in the catalog. One such piece of mail stated:

> Patagonia—Greetings from Grants Pass, Oregon. Saw your ad in the Daily Courier. I have a suggestion. Why don't you bastards keep your nose out of our business. And our lives!! Come around here and we will take care of pikes like you! YOU LIE AND YOU WILL BE STOPPED. STAY OUT AND STAY HOME. MIND YOUR OWN BUSINESS.

While most companies would keep this message away from their catalog customers, Patagonia takes the stand that not everyone can be satisfied and that there are dissenters to their philosophy.

With increased sales and more frequent mailings, the company has proven that there is room in the catalog industry for those who do not subscribe to the "me-too" way of doing business and have a sufficient number of customers who provide them with a profit.

HOME SHOPPING NETWORKS

It was during the early 1980s that television viewers were first introduced to a new type of programming. Rather than entertainment, informational programs, and news broadcasts, the audience was shown a variety of goods available for their purchase. On several cable stations, merchandise that featured a "bargain" orientation was displayed. Promoted at what were said to be lower than regular retail prices, with both the regular and "special" price displayed, viewers were invited to make their selections and call in their requests.

Today, as we are at the beginning of the new millennium, more and more business is being accomplished in this manner. On such programming as the Home Shopping Network and QVC, the two major entries using this format, hundreds of thousands of transactions are recorded every day.

The format used by these "programs" involves someone showing the specific item or featuring it on a live model. In addition to merchandise that has been purchased by the company's buyers, well-known personalities come on to sell their own product lines. Celebrities such as Ivana Trump, Connie Stevens, and Joan Rivers make regular appearances on the home buying screens.

Interaction with the customers has become a regular feature on these programs. Those wanting additional information may call the station and speak with representatives about specific items. Sometimes the discussion is with the "stars," giving it even more meaning to many shoppers.

Another motivational device used to encourage purchasing involves on-screen merchandise inventories for each item and how quickly it is selling. The number of

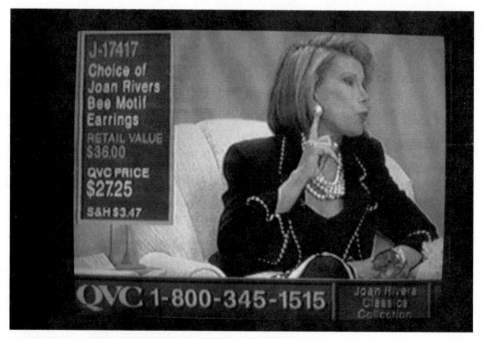

Joan Rivers sells her jewelry collection on QVC.

pieces still available for sale keeps changing as the sales are made, encouraging the doubters to buy more quickly or possibly be faced with a sold-out sign.

With most of the programming spanning a full day, the companies usually feature a schedule that shows when each of the merchandise categories will be featured on the air. "Fashion Coordinates" might be on at one o'clock, "Ideas to Beautify the Home" at two, and so forth. In this way, shoppers can set time aside when the items in which they are interested will be featured.

For people who do not have the time to shop the stores and find that the pictures in catalogs do not provide enough information for them to buy, shopping on television has been the answer for many.

E-TAILING

Every day, more people are turning to their computers as a means of purchasing goods and services. With computers in nearly every work environment and more being bought for personal use in the home, they are a natural outlet for merchants to sell their wares.

Although the overall sales generated thus far pale by comparison to in-store and off-site shopping such as catalogs, the outlook seems extremely positive for merchants engaged in e-commerce. Each year, sales continue to increase, making this channel an excellent purchasing outlet. Sales for 2005 reached $200 billion, and were expected to reach even greater numbers by the end of the decade. Another bright note is that men are responsible for 49 percent of online purchases, far more than they spend in brick-and-mortar operations.

With the Internet being a relatively new tool for purchasing, a brief discussion of how it may be accessed by potential shoppers is presented.

For as little as $23 per month, services like America Online and Comcast provide people with unlimited access to the Internet and all of the Web sites that feature goods and services for sale. By either entering an exact Web site name, which takes you to a specific merchant's location, or using a "**search engine**" such as Yahoo to find a category or directory that lists different types of merchandise, the user is able to locate the desired merchandise. Bluefly.com, for example, is a Web site that features designer merchandise at greatly reduced prices. It features a vast assortment of the latest fashions at rock-bottom prices. Amazon.com, an enormous retailer of books and CDs, features just about everything in those product lines at lower than traditional store prices, and as mentioned earlier in the chapter is realizing significant sales of fashion merchandise. Expedia.com is a Web site that enables the shopper to purchase seats on planes typically at a cost less than they would pay using a travel agent.

While many of these sites are used as the only means for companies to sell their products, traditional retailers of every size and classification have joined the Internet method of reaching potential customers. The Gap, for example, sells its basic products, such as khaki pants, on its Web site. Shoppers can easily make the purchase and have the merchandise sent directly to their homes. The site is an interactive one in which customer questions may be addressed and immediate responses given. Most department stores, chain organizations, and catalog operations that have successfully entered the

DesignerOutlet.com is a Web site for designer merchandise at bargain prices.
(Courtesy of Ellen Diamond.)

Internet to reach broader markets include J. Crew, Eddie Bauer, Levi's Store, L.L. Bean, JCPenney, Big and Tall, Brooks Brothers, Disney Store, Jos. A. Bank, Spiegel, and Macy's.

As with catalogs and home buying networks, the potential consumer market is extremely large, and competition is significant. People all over the world with Internet access can be presented with merchandise that they will often be unable to find in stores in their trading areas. Even if the merchandise is available locally, the prices on the Internet are often better. A case in point follows.

A report in *USA Today* tells about a shopper wanting to purchase Portmeirion dinnerware. It was available in many stores throughout the United States, but the selling price was $150 per place setting, a price that was too high for the shopper. By searching the Web, beginning with the word *discount,* a number of different sites came onto the screen. Ultimately portmeirion.net appeared, where the dishes were offered at a 50 percent discount! The order was placed with a guaranteed date of delivery and an assurance that any damaged pieces would be replaced. Both the retailer and the customer were happy.

As is the case in traditional in-store retailing, merchants are always looking for ways in which to distinguish their operations from the competition. It might be through advertising, special events, personalized service, private-label merchandise, or a host of other initiatives. Retailers who use the Web are also using gimmicks or other means to bring themselves to the attention of potential customers.

To differentiate themselves from other Web sites, Lands' End has developed a "personal model" feature on its Web site that lets women "try on" tailored clothes without ever leaving the computer. A 3-D silhouette is created after the customer answers a few questions about hair color, height, and body proportions. Then, in a sort of electronic dressing room, the customer can outfit the model to see how certain fashions would look.

The Gap Web site sells its basic products through e-tailing.
(Courtesy of Ellen Diamond.)

These two examples show how both the shopper and the Internet retailer can make the most of buying and selling on the Web.

Given the unlimited customer base that reaches the far corners of the globe, more and more buyers will be needed to purchase the merchandise to be sold through e-tailing. With relatively small markets being served by traditional buyer purchases for stores' inventories, the assortment of goods is generally restricted. On the other hand, with the limitless trading areas served by Internet users, buyers are able to purchase much broader assortments in terms of products and price points. This gives the professional buyer a greater latitude in purchasing and a more expansive wholesale market in which to seek goods. The following section deals with some of the different aspects of purchasing involved in the acquisition of merchandise sold by means of off-site outlets. It also explores the question being faced by retailers who maintain both stores and Web sites concerning integration or separation of the two operations.

OFF-SITE BUYER DUTIES AND RESPONSIBILITIES

In the preceding chapters, the duties and responsibilities of traditional and off-price retail buyers were addressed. Their roles included, in addition to purchasing, interaction with other members of the store organization such as advertising managers, department managers, visual merchandisers, and human resources people. This interaction is necessary to make certain that the goods within their merchandise classifications bring profits to the store. They often select the merchandise to be advertised and displayed, meet with department managers and sales associates to get feedback from shoppers, and communicate with human resources personnel to participate in the recruitment process.

While the qualifications for buying for these off-site retailers are much the same as those required for their store purchasing counterparts, the scope of the duties they perform are somewhat different: Their major function is purchasing; they don't interact with a sales staff on the selling floor or recommend merchandise to be advertised. Whereas they aren't concerned with visual presentation, they are concerned primarily with merchandise acquisition.

Traditional retailers draw their customer base from a well-defined trading area. The small independent store, for example, usually serves customers who are within a thirty-mile area. Major stores, such as department stores, have larger trading areas that encompass their flagship and branches. Each of the units generally draws from a thirty-mile radius. In giant chain organizations, often a national venture, the buying is also restricted to a narrow segment of the market, since chains usually locate themselves in areas that, although widely separated geographically, are similar to each other.

Catalogs, home buying outlets, and Internet Web sites, on the other hand, serve a much broader geographic market. In some cases, the market is a global one.

Catalogs

Catalogs are readily distributed anyplace on the globe that has inhabitants who might have a need to buy the company's goods. As a consequence, the buyers who purchase for these publications must address much broader merchandise requirements than their store buyer counterparts. The merchandise, if so widely distributed, must have a "universal" appeal so that the customer in Austin, Texas, will have the same interest as the one in Baltimore, Maryland. In addition to item selection, the price factor is an important consideration. Often, catalog shoppers seek merchandise that features a price advantage or is at least competitive with the stores they may visit in person. Numerous catalogs use the phrase *special prices* to get shoppers' attention. To bring the most favorable prices to the consumer, the buyer must be a talented negotiator and must obtain the lowest prices possible from the vendors. Finally, continuity must be maintained in many catalogs. Spiegel, for example, publishes its major catalog twice a year. With such a long selling period, the buyer must make certain that the vendors represented in the catalog will provide the goods in a timely fashion for the six-month period the catalog will be used. If this is not the case, sales will be lost, and customers might start to look elsewhere for their needs. This is a very important consideration that a buyer must address before any order is placed.

Home Buying Networks

As in the case of catalog operations, home buying outlets also serve enormous markets. In addition to the factors discussed in the previous section, the buyers employed by these companies must also evaluate the "visual" appeal of the items selected. Will the merchandise have an attractive on-screen appearance that will motivate shoppers to become customers? Will it be necessary to feature the merchandise on live models to

make it more appealing? Will it be necessary to underscore specific selling points to convince the viewer to buy?

A careful visual inspection of the items considered for purchase must be made to make certain that the sales potential for each can be achieved.

E-tailing

The fundamental considerations regarding merchandise acquisition for both catalogs and home purchasing networks are the same for those who buy goods to be sold on the Internet.

Buyers who purchase for brick-and-mortar operations as well as Internet Web sites must have both divisions in mind when they go to the wholesale markets. The items for the stores will have a narrower target market, while those destined for sale on the Internet will have widespread appeal. In cases where the store and the Web site are totally separated, purchasing by the Web site buyer is a different responsibility. Attention to in-store shoppers' needs is not a requirement. Buyers whose companies are strictly Internet based need to choose merchandise only for that outlet. These goods must be evaluated in terms of their appeal to a global audience and the prices for which they would retail. With price competition an extremely important factor on the Internet, the buyers must be excellent negotiators so that they can purchase at the lowest possible wholesale prices.

The time factor is another consideration. The buyer must determine the potential "life" of each product and be ready to make adjustments to the Web site with new styles if sales for current goods decline. Depending on the product classification, the selling periods vary. Books, for example, have comparatively long life cycles, whereas fashion items tend to have relatively shorter ones.

Inventory replenishment is another concern. For staple goods, this is not generally a problem. Items of this nature are always available from the vendors on short notice. Fashion items such as apparel and accessories are another matter. Manufacturers who produce this merchandise are often cautious and play a "wait and see" game before going into full-scale production. If a hot item surfaces, and it is not available for quick delivery, sales will be lost. During the negotiation for such goods, the buyer must get the producers' assurances that reorders will be filled in a timely manner. Even if this is risky business for the vendors, they must understand that without a guaranteed steady flow of goods, the buyers will seek other merchandise resources.

Another consideration is the graphics used in the item's presentation. Would an actual photograph of the product better serve the company's needs or would a sketch be more favorable? The buyer often advises those who prepare the Web sites as to which format would better present the merchandise.

Since purchasing merchandise for resale on the Web is a relatively new situation, professional buyers must always be ready to redefine their buying methods. Once a satisfactory formula has been achieved that brings profitable results to the company, the buyer's task will become more routine.

Chapter 15 provides a complete look at how merchants purchase on the Internet.

Language of the Trade

brick-and-mortar retailing
e-commerce
e-tailing
home buying networks
Internet shopping
off-site retailing
search engine
Web sites

Summary of Key Points

1. Off-site operations such as catalogs, home purchasing networks, and e-tailing are becoming more competitive with brick-and-mortar retailers than ever before.
2. Department stores, who once published only a few catalogs a year at peak selling times, are now producing an abundance of them throughout the year.
3. Some major retailers such as Macy's have opened separate divisions to handle the enormous volume of sales generated by their catalogs.
4. Catalogs are often unique and sell much more than just the typical merchandise found in stores. Neiman Marcus, for example, features unique, high-priced merchandise that appeals only to the country's most affluent consumers.
5. Many traditional retailers sell merchandise in their catalogs that is not available in their stores. Victoria's Secret, for example, sells a line of sportswear in its catalog, a product classification unavailable in its stores.
6. Some retailers are catalog-only operations. They use only the direct-marketing approach to reach the consumer.
7. Some companies use their catalogs for a dual purpose. In addition to selling merchandise, they also "sell" their customers on issues that concern the nation. Patagonia uses its catalog as a means of expounding on its position on environmental protection.
8. The home purchasing networks have increased their sales revenues by employing celebrities to sell goods.
9. With its global market, e-tailing has the capacity to reach a larger number of consumers than any of the other retail operations.
10. While the duties and responsibilities are the same for all professional purchasers, those involved in off-site buying face additional challenges.
11. The most important considerations that must be addressed by buyers who purchase merchandise for their company's Web sites include prompt delivery of goods from vendors, availability of items for reorder, and rock-bottom prices.

Review Questions

1. In what way have many merchants broadened their playing fields to attract more shoppers to their companies?
2. How have some major department stores expanded their catalog offerings that were once limited to holiday shopping seasons and other peak selling periods?
3. Why do retailers sell some merchandise in their catalogs that they don't sell in their stores?
4. How does the Patagonia catalog differ from most other retail catalogs?

5. Differentiate between brick-and-mortar catalog operations and those that are catalog-only businesses.
6. What marketing tool have the home shopping networks used to attract more attention to their merchandise?
7. Why are cable "shows" such as HSN and QVC using celebrities to sell their products?
8. What was the sales volume for e-tailing for the year 2005?
9. Discuss the purpose of interactive retail Web sites on the Internet.
10. Why are shoppers attracted to the Internet for their shopping needs?
11. Describe the "personal model" feature that Lands' End uses on its Web site to distinguish it from its competitors.
12. Discuss the manner in which retailers with stores operate Web sites.
13. In addition to the typical duties and responsibilities performed by traditional store buyers, what others do off-site ventures require of them?
14. What duties and responsibilities of many store buyers are not needed to be performed by those purchasing merchandise for catalogs, home buying networks, and the Internet?
15. How important a factor is time for buyers who purchase for the Internet?
16. Why must many catalog buyers make certain that there is product continuity when they finalize their merchandise acquisition plans?

CASE PROBLEM I

Gallop & Litt has been a successful specialty store merchant in Ohio, Missouri, and Kansas for more than thirty-five years. Today, it operates forty-eight stores in the three states. The merchandise assortment focuses on understated sportswear for the middle-income woman.

As is the case with other chain organizations, G & L, as the firm is usually referred to by its customers, operates a catalog division. The merchandise is acquired by the same buying staff for both in-store and catalog use and is basically the same for both divisions. That is, the most promising merchandise headed for the stores is earmarked for the catalog.

While the business has been generally profitable for all the company's years as a specialty retailer, management has decided it might be appropriate to expand the catalog division to make it even more profitable. After extensive brainstorming, the company's management team has narrowed down the expansion ideas to a few. They are as follows:

1. Instead of merely sending the store's catalogs to its regular customers in the trading area, as it has in the past, the operation should be expanded to serve markets from coast to coast.
2. The merchandise assortment should include classifications other than those featured in the stores and could include men's and children's clothing.
3. A separate buying team should be put in place for catalog purchases, with the present buying team relegated to in-store purchases.

Questions

1. Could such changes prove to be a danger to the store's profit picture?
2. How should the team evaluate each of the suggested new approaches for catalog sales?
3. Which changes, if any, would you suggest be made?

CASE PROBLEM 2

The Emporium is a department store organization that is based in Tennessee. It opened its doors in 1965 and now has a flagship store in downtown Memphis and twelve branches throughout the state. It is an extremely profitable business in both its brick-and-mortar outlets and its catalog division. Its merchandise assortment is similar to those that are considered full-line operations, featuring a wide variety of hard goods and soft goods.

With the Internet steadily gaining in popularity, management regularly discusses its potential entry into that arena. However, the management team is equally divided over the validity of such a venture. The old-line executives who have been with the company since its inception are satisfied with a status quo approach. They believe that their business has been very profitable and that they have all reaped the personal rewards that come from a successful business. The newer team members, those who joined the company in the past ten years, believe that the time is ripe to expand their horizons and begin an e-tailing operation. If this isn't attempted, they will be left behind and upstaged by other companies that are willing to take this step.

Some of the objections raised by the "old-timers" include the following:

1. The company is making a profit, and a new venture of this nature might turn the profits into losses.
2. No one on the staff has any experience for operating an e-tailing division.
3. The company's trading area is sufficiently close to the stores, and those customers wouldn't necessarily buy online.

Those in favor of the expansion counter with:

1. Companies that do not make inroads into this new off-site industry will ultimately lose business to those who have Web sites.
2. E-tailing will bring in a customer base that is global in nature.
3. A few new key players, with Internet selling experience, can be added to the company's management team to oversee the new operation.
4. The new division could begin with a limited merchandise offering and eventually expand it if business warrants it.

Questions

1. Have the old-line managers made a plausible point with their arguments?
2. Are the new managers taking a reasonable approach to forming this new division?
3. What are the advantages and disadvantages of the proposed expansion?
4. What safeguards can be put in place to guard against failure?

CHAPTER **6**

The Market Specialists and How They Service Retailers

On completion of this chapter, the student should be able to:

- Define the term *resident buying office* and discuss the advantages it affords to retailers.
- Explain the necessity of resident buying office representation for many retailers.
- Discuss the operation of an independent office and explain some of the services it provides for its clients.
- Explain why some major retailers prefer to have their own buying offices.
- Describe the private-label programs offered by some resident buying offices to their member stores.
- Explain how market specialists other than resident buying offices assist the retailer with purchasing plans.
- Discuss how a fashion forecaster helps buyers who are responsible for fashion purchases.

Efficient planning is key to the success of any store buyer. In this very competitive environment in which most of today's professional purchasers operate, having firsthand knowledge of the wholesale marketplace is a must. By having this information, the buyer is better prepared to acquire merchandise that will satisfy the prospective customer's needs in terms of prices, quality, function, and appropriateness. Among the many sources he or she uses in this planning phase are a variety of market specialists who provide invaluable merchandising information. Buyers who operate in a vacuum, without paying attention to these outside sources as well as a host of in-house indicators, faces the risk of performing ineffectively.

Without question, the **resident buying office** or **market consulting organization,** as many companies refer to themselves, is one of the most valuable external sources of buying and merchandising information. Of course, these are not the only market specialists who service the retail industry. Others include fashion reporting services, retail reporting agencies, fashion forecasters, nonfashion services, industrial publications, consumer magazines, and trade associations.

Through the proper use of these "advisory" services, the buyer is able to feel the pulse of the market without being physically present in it. Whether the buyer is working for a

company based in Omaha, Nebraska, or Memphis, Tennessee, and cannot be physically present in the marketplace except for a few times a year, affiliation and use of these agencies and services will more than likely make him or her a better-informed merchandiser.

In this chapter, attention will focus on all of the advisory sources outside the retailer's operation that make the buyer better prepared to face the challenges of proper merchandise acquisition.

NECESSITY FOR MARKET SPECIALIST REPRESENTATION

Buyers who are keenly aware of the current state of the markets in which they make their purchases are more likely to perform better than those who do not have up-to-the-minute market information. While most knowledgeable retailers agree that in-store

Fashion Avenue, the center of New York City's Garment Center wholesale market. *(Courtesy of Ellen Diamond.)*

records such as past sales are extremely important to future purchasing plans, they also acknowledge that outside informational sources are necessary adjuncts to any successful merchandise plans.

Affiliation with and representation by one or more of these external sources is necessitated by distance from the wholesale markets, which may be too great for regular visits; the need for regular communication about changes in the marketplace; and the fact that market specialists can alert buyers to news about best-seller items and assess newsworthy economic conditions that could affect merchandise planning.

Proximity to the Wholesale Markets

Today's wholesale markets are more than conveniently located domestic venues to which the buyer may easily travel. Many buyers who used to rely on the regional market that was closest to their company's headquarters find that this isn't enough to satisfy their purchasing needs. While fashion buyers in the Midwest were once able to make all of their purchases at the Chicago Apparel Center, the wealth of merchandise now available to them is not always found at this location. Goods from all of the world's resources, which might be better priced and better styled, might not have representation at these domestic wholesale arenas. Although travel to distant shores will give the buyer an opportunity to discover new resources and products, the cost of getting there may be prohibitive, and the time it takes for such pursuits may not be practical. Affiliation with resident buying offices often makes off-shore merchandise readily available to clients, since those offices generally have representatives scouring the globe to make arrangements for the procurement and distribution of such goods.

Communications regarding Changes in the Marketplace

Tucked away in some far-off location, the buyer doesn't always learn about changes that might affect his or her operation. For example, a new vendor might have opened its doors and be featuring a line that would fit perfectly into the buyer's merchandise mix. Initially, these new market resources generally pursue major retailers to try to obtain large orders, and resident buying offices who might recommend their new company to their clients. The smaller, less important user might not learn about the new vendor until much later. As a member of a resident buying office, the independent retailer is privy to such new merchandise resources and products. Other news that comes via the communication route with a resident buying office could concern delays in shipping from specific vendors, a matter that is often not passed on to the store buyer, and trends that might be coming to the forefront.

Notification about Best-Seller Items

During any selling season, retailers are always trying to learn about hot items in the market. A few of these best sellers often turn a lackluster season into one that is profitable. Although some of these items are already in a buyer's inventory, and have

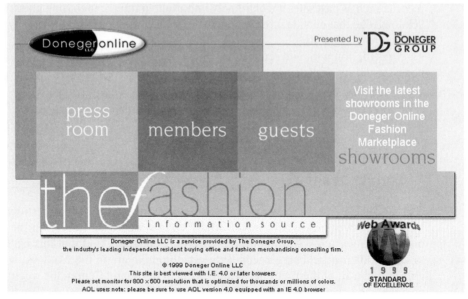

The Trend Alert tells the buyers about items that are taking the market by storm.
(Courtesy of The Doneger Group.)

been reordered, many are not. In addition to a resident buying office sending out fliers about these successful sellers, other industry specialists also report news about this merchandise. Fashion reporting services and retail reporting agencies carefully follow newspaper advertisements and examine the inventories of leading retailers to determine which items are selling significantly. Once the hot item has been discovered, they send bulletins to their members notifying them of the recommended item, the vendor's name, the wholesale price, and the names of the stores that have had success with it. When a buyer receives such information, he or she assesses his or her store's potential for the item and decides whether or not it would be suited to the inventory.

Assessment of Economic Conditions

Any professional buyer understands the importance of the economy to the success of his or her company. Buyers do keep abreast of the current economic news, but the information generally comes to them in very general terms. Since most companies are too small to maintain a staff to check on the economic factors that affect them, many look to outside organizations for this information. Resident buying offices, reporting agencies, trade associations, and the like often have specialists on their teams to provide such news. In this way, the store buyer may make successful merchandising decisions based on the economic news. In times when the indicators show an increase in consumer confidence, inventories may be expanded. Under more adverse conditions, a tightening of inventories could be the answer. Without this information, profits may be affected.

RESIDENT BUYING OFFICES

As we have been exploring the various types of market specialists, it is obvious that the resident buying office is the most important organization for providing market information, especially for retailers with a fashion emphasis. Typically, the resident buying office is a business that provides **advisory** and purchasing **services** for retailers. Unlike the retailers who are located in downtown shopping districts, malls, and a host of other environments, the resident buying offices are located within the major **wholesale markets** so that they can quickly assess the pulse of the market and make the necessary purchases as directed by their member stores. The largest number of these offices is located in America's *Garment Center* in New York City, with others located in regional markets like Dallas, Chicago, and Los Angeles. They represent merchants who buy men's, women's, and children's wear, haberdashery and accessories, and a host of home furnishings.

Just as there are different classifications of retailers, there are also different types of resident buying offices. They include private, cooperative, and independent offices, with the latter being the industry's most important.

The Private Office

Retailers of enormous size with specific needs find it beneficial as well as economical to maintain a buying office specifically for their own needs. Although this type of operation is not commonplace in retailing, some deem it necessary to the success of their outlets. Neiman Marcus, based in Dallas, Texas, with units throughout many of the major cities in the United States, maintains such an office. The nature of the Neiman Marcus operation perhaps necessitates such an exclusive arrangement. The company caters to the affluent through a merchandising mix incorporating high price and unusual offerings. Where a company's specialization is so unique and the market extremely limited in terms of independents who deal in such merchandise, affiliation with outsiders would be unsound.

Note that the term *corporate office* is sometimes used in place of *private office*. Macy's, for example, uses *corporate* to denote its buying office.

This type of organization is not limited to those dealing in the unusual, but is also maintained by high-volume users such as Sears Holdings.

Cooperative Ownership

Also few in numbers are the **cooperative** or associated **offices.** This type of enterprise is owned, operated, and controlled by a group of stores. The retail operations involved have some common interest, such as merchandise assortment and price points. The stores in these groups are either very large department stores or chains. They demand attention that in general cannot be supplied by the independents.

Policies, such as the scope of services to be offered, are established by a board of directors who are usually executives of the stores represented. The Associated Merchandising Corporation, known in the industry as AMC, is an example of a cooperatively owned office that represents major department stores. In addition to the typical services offered by the independent office, AMC has sufficient coverage in global

markets to enable member stores to avail themselves of merchandise from abroad. Another example of the cooperative office is Specialty Stores Association, whose affiliated stores are specialty women's stores rather than department stores.

Although this type of resident office arrangement provides the member stores with a certain degree of exclusivity and more attention than membership in the less-personal independent office would provide, it might have a disadvantage. That is, retailers find invaluable the exchange of information available from their counterparts in other parts of the country who belong to the same independent resident office. At periodic meetings at the independent offices, such as during **market week,** retailers can gain a great deal of insight into problems that confront others in the same situation. For example, a store in New York City could learn of a noncompeting store's experience in Los Angeles with a certain line of merchandise. Although the cooperative office does have a number of different retail organizations in its group, the number of stores represented is certainly fewer than in the independent resident buying office, and the exchange of information is correspondingly limited. The Doneger Group, the largest of the independents, represents more than eight hundred stores, giving the members invaluable opportunities for information exchanges.

The Independent Office

Most retailers in the United States are too small to satisfy their needs by maintaining private, corporate, or cooperative offices. The **independent office,** by far the largest type of resident buying office, offers operators of single stores, small department stores, and chain organizations much needed market representation. Without the enormous investment of private or semiprivate ownership, the smaller retailer can employ the services of a professional market specialist at a cost commensurate with its needs.

Dear Retailer:

Confirming our understanding, we shall for the period beginning _____ through _____ place at your disposal the complete facilities of our organization, and shall, on your behalf, perform all services usually performed by resident buyers including the placing of your orders for merchandise and the furnishing of market conditions.

For our services, we shall receive from you the annual fee of $_____ payable in advance in equal monthly installments of $_____ each, plus postage.

Unless either you or we shall give the other written notice to the contrary at least 60 days before the annual expiration date, we shall continue our service on your behalf.

Very truly yours,

Company Representative

AGREED TO:

Retail Organization Representative

Resident buying office contract.

For a fee, the retailer is entitled to all of the services rendered by the resident office. The fees charged are determined by the scope of activities offered and the particular requirements of the member retail stores. The actual charge is generally based on a predetermined rate for such items as postage, telephone and fax communications, and desk space for visiting store buyers. Purchases made by the office at the request of the individual retailer carry an additional expense in the form of a commission.

A simplified contract for membership in an independent office is shown on page 116. This is merely a simplified version of what is generally a more detailed contract between the retailer and the resident buying office.

With retailing becoming more competitive every day, it is vital for retailers to have a complete understanding of marketing and merchandising changes that could affect their operations. Although it would be beneficial for them to cover the wholesale markets on a regular basis, many have neither the time nor the funds necessary for complete exploration. Resident buying affiliation is therefore important to these companies so that they can make knowledgeable marketing and merchandising decisions without taking time from their in-house duties.

Some of the advantages of resident buying office membership include:

1. Merchandise effectiveness can be increased substantially so that smaller retailers can more knowledgeably compete with the giant department stores and chain organizations. These large retailers, through their private or cooperative offices, have a constant insight into market conditions. Through membership in an independent office, the smaller retailer can gain the same timely market information. Without representation, the buyer for the smaller operation, relegated to infrequent market visits, can easily miss market "happenings." Particularly in fashion merchandise, where a new fashion might revolutionize the current season, the buyer who is absent from the market might get the information too late for it to be meaningful. News of a "hot" color or silhouette that came into prominence after the buyer's visit to the market could be missed, and profits could be lost.

2. The exchange of information by noncompeting stores provides the retailer with the point of view of a retailing counterpart. Under the resident buying office system, retailers from different parts of the country meet and discuss their experiences. Thus a buyer from a northern region can meet with a southern retailer and pick the latter's brains about the current season's swimwear collection. Because the southern buyer merchandises swimwear all year long, the northerner can be led to the most appropriate merchandise before his or her season begins.

3. By belonging to a resident buying office, the smaller retailer immediately becomes more important to the vendors. Manufacturers and wholesalers recognize the important positions enjoyed by the offices merely because of their number of members. If a small merchant acts in unison with others in the group, the attention paid to him or her by the vendors increases significantly. Under similar conditions and circumstances, the retailer with representation in a resident buying office usually does better than a counterpart who goes it alone. For example, if a retailer decides to return merchandise to a manufacturer because of poor fit or some other reason, the manufacturer must decide whether to accept the return. If the returner of the goods belongs to an office, the return is easier than for an unaffiliated merchant. The reason for this prejudice is simple: Unhappy members of resident buying offices may complain to their representatives,

which could result in a boycott of the uncooperative vendor. Unhappiness from the lone retailer might result in no future purchasing, but future business from other retailers is not likely to be affected. By joining forces in the resident buying office, the individual business can bolster its position to compare with that enjoyed by the larger retail organizations.

4. Careful use of the services rendered by the resident buying office can substantially reduce the risks faced by independent retailers—and these risks are many! Of primary concern to the store buyer is the selection of the appropriate merchandise. While individual stores might rely on the expertise of their buyers, the resident office, through experienced, skillful trading, and a keen awareness of the marketplace, can advise store buyers on purchasing and its pitfalls. By narrowing down the available lines of merchandise and the available items to those that seem best suited to their members, the office helps the store buyer avoid purchasing errors. In addition to merchandise selection, buyers are concerned with delivery deadlines. Because the resident offices provide vendors with a great amount of business, the stores they represent enjoy preferential delivery over unaffiliated independent retailers. Having the right merchandise at the right time can substantially increase the efficiency of the retail operation.

5. One of the buying advantages enjoyed by large department stores and chain organizations is the purchasing of merchandise made to specification and labeled

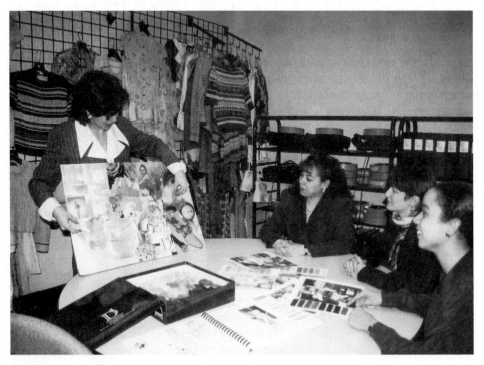

Resident buyers and assistants prescreen the market in anticipation of retail buyers' visits. *(Courtesy of Ellen Diamond.)*

exclusively under the store's name. Because private-label merchandising requires large purchases, smaller retailers are generally unable to participate in such endeavors. However, resident buying offices can and do provide their members with private-label merchandise that has been acquired for their exclusive distribution. Because the office generally represents hundreds of stores, its buying potential is commensurate with that of the giant retailers. The member retailer enjoys this exclusive merchandise because it is available only to the resident buying office's clients, and eliminates price cutting by competitors.

6. Initial orders need not be as large for resident buying office members as those placed by individual, small stores. Independent retailers, particularly those who are far removed from the wholesale markets, must place orders to cover their merchandise needs until the time of the next market visit or the road call from the vendor's salesperson. Stores with market representation are constantly being notified of new merchandise through brochures, telephone calls, faxes, and e-mails. These retailers enjoy the luxury of placing smaller orders, keeping their inventories at a minimum, and being apprised of any hot items in the market. Authorization to their market representatives can bring the merchandise to the store as efficiently as if the store buyer purchased the merchandise directly.

7. The resident office, through its multitude of services, provides much more than the purchase and recommendation of merchandise available. The vast number of services offered by the full-service offices, many of which will be discussed later in the chapter, can contribute dramatically to the efficiency of the retailer's entire operation. Such services could involve considerable expense if purchased elsewhere. Because resident buying offices offer packages of services to member stores, the costs involved are considerably reduced.

8. Recent years have seen an increase in the importance of merchandise produced abroad in the merchandising plans of American retailers. Few stores in our country have the resources necessary for direct negotiation with foreign producers. The large resident buying offices have permanently based foreign branches or send representatives periodically to distant lands to survey the goods available for purchase. Through office association, small retailers can be alerted to foreign merchandise and can purchase goods without having to incur the expense of trips abroad. This enables the small retailer to compete on still another level with department store and chain organizations.

SELECTION OF A RESIDENT BUYING OFFICE

The major retailers, of course, do not have to choose from the available resident buying offices for representation. They are serviced by their own **private offices** or by cooperative ventures. For the merchant who doesn't have this advantage, membership in an independent office is the route to take.

With a number of different buying offices in operation in the major wholesale markets, there are choices for the retailer. A number of factors should be addressed before any contractual arrangements for representation are made.

THE
DONEGER
GROUP

463 Seventh Avenue, New York, NY 10018
212-564-1266 Fax 212-629-5508

Opportunities In Working With The Doneger Group

The Doneger Group provides information, direction and services that make an important contribution to our clients' business. Specifically, we provide services in the following ways:

- Knowledge gained through our well-respected retailers provides important information and direction to all clients.

- Our comprehensive reporting service provides in-depth information relating to market developments, merchandising directions, and ideas to assist clients in anticipating retail trends.

- Usage of our Fashion Department for color, style and silhouette direction is invaluable.

- The Doneger Group as a diverse merchandising group, provides extensive time saving opportunities to our client's buying and merchandising staff in previewing the market, screening vendors, and in understanding the pulse and direction of the industry.

- Our talented merchandising team with extensive retail experience offers quality advice and guidance to all clients.

- During one on one consultations all aspects of the marketplace and our client's business are discussed and reviewed.

- Sourcing specifically for product development programs is accomplished through our extensive market research.

- Our merchandising team will challenge and make suggestions as to resource structure, key classifications and items as well as provide advice on retail marketing strategies.

- Management executives within The Doneger Group are available to serve as a sounding board for retail executives within our client base.

- Our modern, comfortable office facilities and conference rooms in the heart of the apparel industry are used for store meetings, styleouts, to meet with vendors, and as a home base for store personnel while in the New York marketplace.

- Any and all of our services can be customized to meet the needs and requirements of our individual client. We are a company that will do anything we can to build a solid foundation for a strong working relationship.

Resident buying offices, such as The Doneger Group, offer a host of services to their clients.
(Courtesy of The Doneger Group.)

Client Rosters

A very important consideration for the merchant concerns the stores that are already represented by the resident buying office under consideration. There are a number of reasons for this investigation.

When a resident office suggests merchandise for its member stores, there is the likelihood that each store will purchase the same goods. If two stores are located in close proximity to each other, this not only could result in identical inventories for both merchants but also could contribute to price competition. Retailers never want to stock the same merchandise as their closest competitors. Each retailer wants to have its own identity and project its own image. Thus the stores in the resident buying office's roster must be noncompeting to avoid problems.

Services Offered

Like their retail counterparts, resident buying offices' services vary from company to company. Some serve merely as buying agents and do little more than scout new merchandise and make recommendations to their clients. Others provide different degrees of service. Those that are full-line operations offer a host of services that include advertising and promotional suggestions, counseling on merchandise control matters, sales training by way of videos, and, of course, merchandise advisement and purchasing. Some of the offices limit their services to just a few.

The merchant must first assess his or her particular service needs and then select the company that most closely fulfills those needs. Paying for a company's representation when not all of its service offerings are necessary for the running of the retail operation is not cost-effective.

Cost of Membership

The expense involved in membership in a resident buying office varies from company to company. Retailers should investigate the costs of membership in each of the offices being considered. As addressed earlier, different offices provide different services, with the costs increasing as the level of services increases. The selection should be made so that the store may be properly serviced at an affordable price.

ORGANIZATIONAL STRUCTURES

Resident buying offices may be as diversified in their offerings as department stores or may restrict their merchandise to that offered by the specialty store. The better-known offices maintain departments in most of the lines found in the large department store, with emphasis on women's wear. The titles of the personnel employed by the larger offices generally follow the pattern of the stores they represent. The only difference is that those in the resident office's employ are primarily advisory in nature, while the store buyers and merchandisers are decision makers.

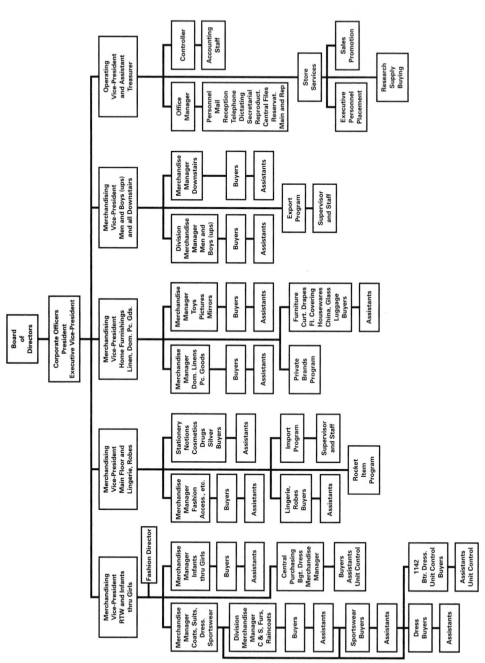

Organization chart of a full-line resident buying office.

Organization chart of a **specialized resident buying office.**

A typical organizational structure of a major, **full-line resident buying office** is shown on page 122. It features four merchandise divisions and a fifth that deals with operations.

A more specialized type of office caters exclusively to women's and children's clothing and accessories, as shown above. The structure shows three divisions, with very little attention paid to operating services. Some restrict their merchandise lines even more and pay attention to only one type of goods, such as women's wear.

SERVICES OF RESIDENT BUYING OFFICES

As briefly described earlier, the services provided by resident buying offices vary from company to company. The smallest office, with limited staff and facilities, may simply provide information concerning the purchase of merchandise and might buy according to the directions of the store. The larger and more diversified of these market specialist organizations offer their members a host of different services, ranging from merchandise procurement to promotional planning. The following services are those that are generally available from the larger offices.

Resident buyer and assistant evaluate merchandise in order to make recommendations to retail buyers. *(Courtesy of Ellen Diamond.)*

Buying Merchandise

As a general rule, store buyers are responsible for their own purchases. Their resident buyer counterpart, however, is available to make purchases as directed by the store buyer. The purchases that they do make are usually for *reorders* and *special orders*. *Initial orders* are usually the responsibility of the store buyer. There are, however, situations where the resident buyer will place initial orders.

REORDERS

A **reorder** is a replenishment of an item that has sold out. Buyers who are lucky enough to have a good number of reorderable items in stock are very likely to have successful seasons. When merchandise is popular in one store, it is more than likely popular in others, sometimes making it difficult to secure reorders as needed. The timing of the reorder in terms of prompt delivery is essential to the continued success of the item in the store. Late arrival of reordered goods can seriously affect sales and lead to reduced profit. Stores often call their buying office representatives to place the reorders. Because the office is located in the wholesale market and its representatives enjoy the powerful position of representing many stores, it can more easily motivate

the vendor to give these orders priority status. The supplier is more likely to respond to the pressures applied by the resident office than the individual retailer in Duluth, Minnesota.

SPECIAL ORDERS

As the name implies, **special orders** are for merchandise not usually carried by the store. The "special" might consist of a size not usually stocked, a different color of an item than that in the inventory, or an item that is currently unavailable. For example, a regular customer might want a dress for her daughter's wedding. The buyer might want to accommodate the request. Because a trip to the market might be impractical, an order bearing approximate specifications can be placed with the resident buying office. Because the office may have experience and expertise in merchandise that the member store doesn't stock, the special order can more easily be accomplished by allowing the resident buyer to make the purchase.

INITIAL ORDERS

Merchandise that is purchased for the first time is an **initial order.** Most stores place their own initial orders, but they sometimes call on their offices to perform this function. A store buyer might want to whet the clientele's appetites with new merchandise but may be unable to come to the market or have a road sales representative come to the store with new items. Given an idea of price, style, color, fabric, and so forth, the resident buyer will purchase the goods for the retailer. In instances in which the resident buyers have continuously purchased "the right numbers," stores come to rely on their judgment and increase the amounts of new purchases made by the resident offices.

In very limited numbers, some small stores make exclusive use of resident buyers to place all of their initial orders instead of employing their own buyers.

Cancelling Orders

When a buyer writes an order for future delivery, he or she is bound by the delivery dates noted on the order form. It is very much like a contract that requires both parties to live up to the terms of the deal. Sometimes, however, it becomes necessary for a store to cancel an order. The reason might be an overabundance of merchandise on hand due to a downswing in the economy or a reevaluation of the merchandise on order.

Vendors are not required to offer such changes to the stores. In cases where the retailer is a major department store or chain organization, its size gives the retailer clout and the cancellations are generally accepted. For the smaller merchant, this accommodation is often not the case. However, vendors are likely to accept a cancellation from a small store that has resident buying office affiliation. If the office's clients are not satisfied with the resource's cancellation, the resident buyer often steps in and gets satisfaction. As is the case with the larger retail operations, the resident offices have a good deal of clout because of their purchasing potential.

Resident buyer checks line of new resource.
(Courtesy of Ellen Diamond.)

Finding New Resources

The key to successful merchandising is making desirable merchandise available to customers. The bringing together of vendors and retailers whose merchandise needs and offerings blend is a function of the resident buyer. Progressive retailers are always seeking fresh goods to satisfy the needs of their customers. It is true that merchants spend the bulk of their budgets on lines that are established and proven. To provide the excitement and versatility of creative merchandise, however, retailers need to purchase new lines. Although it is possible to scout the market to seek out new merchandise resources, none can do it as successfully and capably as the market representatives in a resident buying office.

Resident buyers find new lines not only because of their close proximity to vendors, but also because the resources seek out the resident buyers. The manufacturer who can demonstrate to the resident office that it has innovative, timely, and desirable merchandise immediately has a whole world of prospective customers. If the vendor spent the time to locate new customers, one at a time, the task would be monumental

and prohibitive in terms of cost. Thus the resident office provides the supplier with potential users and also gives the retailer new resources. The marriage of the two can make the retailer's business more successful.

Recommending Hot Items

A **hot item** may be described as the one the buyer can't keep in stock because of great demand for it by customers. All buyers initially plan the purchase of merchandise with the hope that it will successfully sell and reorder. In reality, even the most seasoned buyers soon discover their share of less desirable items; they must often mark down some merchandise to dispose of it quickly. To ensure a successful season, the buyer actively searches for an item or items that will counterbalance the reduced profits from the slower-selling goods. A few hot items will do the trick. Resident buyers, through reports from member stores as well as from the vendors, are made aware of fast checkouts. This information is passed along to member stores in the form of newsletters, fliers, faxes, and e-mails. Sometimes, the resident office representative sends along order forms for quick delivery of this merchandise.

Following Up Orders

The placement of an order does not guarantee delivery of merchandise. Even the most careful and complete delivery instructions do not ensure that the buyer will receive goods on the agreed-on delivery date. Receiving merchandise at the appropriate time is of paramount importance to the operation of the buyer's department or store. How vital timing is may best be illustrated in a situation in which advertising is involved. A buyer might place an exceptionally large order for the express purpose of running an advertisement. Imagine how devastating it would be if the ad broke and the merchandise hadn't arrived. Sales could be lost and the store's reputation damaged. Customers might misunderstand the incident as being intentionally planned just to produce in-store traffic.

Resident buyer assistants perform the task of **following up orders** to make certain that shipments will be delivered at the specified time. The importance of the resident buying office to the manufacturer enables sufficient pressure to be applied to guarantee delivery. For a small, independent retailer to accomplish the same thing would be difficult. The distance between the retailer and the vendor, as well as the lesser importance of the individual store, makes it less likely that satisfaction can be attained as easily. Merchandise on order cuts into the efficiency of the store's operation, and the follow-up by the resident buying office helps get action.

Group Buying

Occasionally, resident buying offices can save the individual retailer money. By pooling orders, the office might be able to purchase a particular item at a lower price. Small retailers, because of their size, do not get the quantity discounts allowed on large purchases. Through combining orders, the resident buyer might enable the smaller merchant to qualify for the quantity discount.

Donegeronline LLC

RECOMMENDATIONS
REORDERING

Georgette Dresses in Updated Bodies

The AM/PM classification, including the LBD, is very strong at retail. The below 1-piece styles are reordering.

Type of retailer placing reorders: Department stores

Style number:	RID383-50R
Description:	1-piece printed pebble georgette halter with tie-back
Delivery:	2/28
Colors:	black/pink
Sizes:	4-14 or 6-16
Line Price:	$35.00
Terms:	8/10
Posted:	02-24-04

Style number:	RID291-015
Description:	1-piece double georgette with hardware and asymmetric hem
Delivery:	4/30
Colors:	black
Sizes:	4-14 or 6-16
Line Price:	$35.00
Terms:	8/10
Posted:	02-24-04

Back to Top

Back to Reordering Home Page | Back to Recommendations
Back to The Directory | Back to DonegerInfo.net

The Doneger Group alerts retailers to hot items that have been ordered.
(Courtesy of Ellen Diamond.)

Another situation that might prevent an individual buyer from making a purchase involves minimum order requirements. Some vendors establish minimum purchases that prevent the smaller user from buying some items. When this is the case, these smaller orders may be combined to generate a larger order that fits within the vendor's requirements.

Handling Complaints and Adjustments

Buyers spend considerable time and effort supplying merchandise for their stores. Diligent purchasers carefully scrutinize the merchandise offered and make their selections. However, store buyers often find that some suppliers are notorious for **substitute shipping.** That is, different colors from those originally ordered might be substituted, the wrong sizes might be sent, or materials that are inferior to the sample might replace the originals.

Knowledgeable buyers pay careful attention to incoming orders either by themselves in small operations or with the assistance of receiving room clerks in large companies. Deliveries are scanned to determine quality, proper assortment, and so forth. In some cases, errors are found. Buyers who insist on "merchandise as ordered" usually return the unwanted goods. Although the vendor hasn't followed instructions, it is often remiss in handling the customer's complaint and refuses an adjustment. Once again, the resident buyer can usually make the adjustment in accordance with the store buyer's wishes. Going it alone can result in frustration and dissatisfaction. Complaints can also include such problems as improper fit, late delivery, excessively high delivery costs, competitor price cutting, and poor merchandise wear.

Assisting during Market Week

Various types of new merchandise are made available to buyers periodically throughout the year. During market weeks, in particular, when the new lines are being previewed, the pace is hectic for buyers. To help the store's buyers, the market reps provide a great deal of assistance so that time in the market can be spent in a more productive manner.

The resident buying offices set up appointments with vendors, hold meetings with store buyers to discuss the merchandise trends for the new season, provide names of new resources for possible visits, and so forth.

Since the trips to the market during these times are generally relegated to one week and other trips might involve only a few days, careful planning is a must. Using the resident buying office in these visits will make the time spent in the market more productive.

Planning Promotional Activities

The smaller retailer often tries to emulate its large-store counterpart through a variety of promotional endeavors. Unlike the giants in the industry, the smaller merchants have neither the specialized talent necessary to handle promotional activities nor the capital needed for a great deal of outside assistance.

Large resident buying offices offer a number of promotional services that range from visual merchandising suggestions to fashion show production. The office might

During market week, resident buyers offer suggestions to clients.
(Courtesy of The Doneger Group.)

supply its member stores with suggestions for window displays or interior displays. Very often, newspaper advertising campaigns are recommended to help promote a particular line or open a new season. Even "canned" fashion show formats complete with commentary might be made available to stores.

Providing Global Market Information

With the enormous interest in foreign-made merchandise, the major offices are providing information to their clients on overseas markets and the products they feature. The larger, full-service resident offices provide continuous coverage of all the European and Asian markets that are in the forefront of manufacturing by maintaining offshore branches. In the fashion industry, they cover the fashion openings of the couture collections as well as those that feature *prêt-à-porter,* or ready-to-wear. In other industries, such as home furnishings, they make regular visits to assess these markets for their customers.

With this service, the smaller retailers are able to avail themselves of merchandise that was once available exclusively to the larger companies.

Developing Private-Label Products

To improve their markups and profitability, and to provide exclusive merchandise to their customers, most large retailers arrange to have merchandise for their own use.

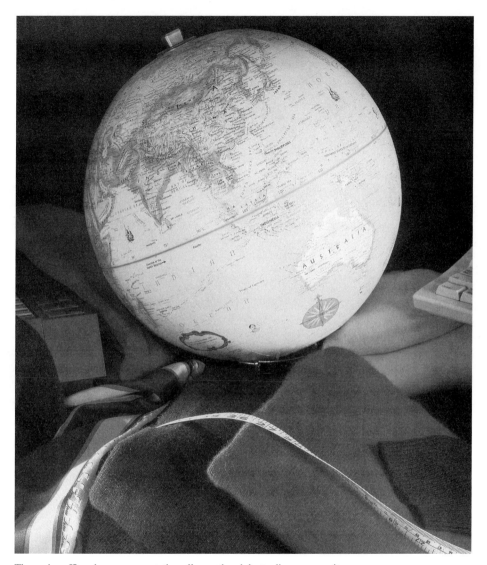

The major offices have representation all over the globe to discover new items.
(Courtesy of The Doneger Group.)

By eliminating competition in this manner, they can charge prices without worrying about other stores selling the merchandise for less. Because private-label merchandise requires enormous quantity commitments, this type of merchandising had been relegated to the giants of the retail industry.

Resident buying offices have come to the rescue of the retailer who would like to be afforded this type of goods, but individually, most have neither the resources nor the quantity potential necessary for their own programs. Most of the major offices are now involved in having goods produced under their own labels and are making them available to their member stores. Because the stores they represent are noncompeting, there is no concern about price cutting.

Major resident offices such as The Doneger Group provide a wealth of this merchandise for their clients. The buyers and other members of their team are actively involved in developing products that are earmarked for private labeling.

Researching

As market specialists, the resident offices are aware of the need to do research that will make their services more meaningful and timely. With the information acquired through the typical methods of research such as questionnaires, personal interviews,

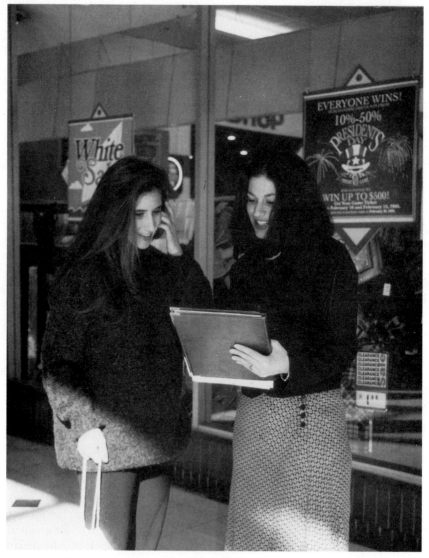

Through personal interviews, consumer preferences can be assessed.
(Courtesy of Ellen Diamond.)

focus groups, and the like, they are able to determine the long-range outlook for their clients.

With this service, the smaller retailers can study areas of concern. This service was once available only to their large retailer counterparts who had their own in-house research teams.

OTHER ADVISORY SERVICES

Buyers for retail organizations use a host of advisory services other than resident buying offices. Each of these contributes a great deal of information to buyers for all types of merchandise and helps them make better selections to satisfy their customers' needs. Some of the services used require membership, whereas others are merely sources available to the buyers without any significant expense.

Among the more important of these services are fashion reporting services, consulting services, retailing reporting agencies, fashion forecasters, nonfashion services, trade publications, consumer magazines, trade associations, and nonprofit public relations organizations.

Fashion Reporting Services

All buyers must be in constant touch with the trends that affect their products. Naturally, the more frequent and more drastic the product change, the more important the information is to the buyer. In the field of fashion, where change is always on the horizon, the buyer must devote a considerable amount of effort on a daily basis to keep current. To satisfy these needs, purchasers of women's, men's, and children's apparel and accessories often use the **fashion reporting services.** They provide day-to-day information on the latest trends in such vital areas as color, silhouette, and fabrications. Two of the major services are Faces Fashion Report and TFS—The Fashion Service.

Fashion Consulting Services

Similar to the reporting services, as discussed above, these companies provide an even greater in-depth service to fashion retailers of every size and format. Among the more important of these services is Tobe, an organization that is examined in the following Retail Buying Focus.

Retail Reporting Agencies

Many retailers rely on **reporting agencies** to provide them with vital information about their industry. Most of the news reported concentrates on fashion-oriented merchandise and is therefore directed toward stores with fashion orientations.

Donegeronline

DonegerInfo.Net

MARKETREPORTING
Week of 2/29/2004

Weekly Quotes

MANAGEMENT
OVERVIEW
BRIDGE/BETTER
SPORTSWEAR

· Monthly Reports
· Seasonal Planning
Guides

MODERATE
SPORTSWEAR
JUNIOR SPORTSWEAR
DRESSES
OUTERWEAR & SUITS
PLUS SIZES
ACCESSORIES
INTIMATE APPAREL
HOME ACCENTS
CHILDREN'S
MENSWEAR

Bridge/Better Sportswear

The arrival of new Spring receipts added excitement to selling floors this month. The customer is definitely responding favorably to newness. Top on her purchase list of must-have wardrobe updates have included something pink (followed by good retail reads on oranges and greens), something in a print (Pucci, conversationals, geometrics, florals and polka dots all strong), a new jacket (especially bouclé), a flirty skirt, a cashmere sweater in a Spring color, cabled sweaters, a fine gauge sweater with novelty trim and the continued importance of knit athleisurewear. In Contemporary, sportswear strengths have included miniskirts, flirty skirts, tissue knits, polos, tube tops and core denim bottoms.

Key Links:
-Meeting Schedule: Fall '04 Sportswear - Specialty Stores
-Fall '04 Sportswear Overview
-Fall '04 Sportswear Category Checklist
-Window Treatment: February Windows
-Trade Show Dates: Designer/Bridge/Better/Contemporary Markets

Bridge Sportswear

For spring, the key words are color, novelty and items. The customer is reacting positively to all the pinks, greens, oranges, yellows and blues on the selling floor. White, either as stand alone or mixed with color has been strong at retail.

Prints, such as Pucci, conversational, geometrics, polka dots and florals are adding to the assortment mix.

Key items are novelty jackets (especially boucle and double faced wools), flirty skirts (solids or printed with or without sash trims) are checking. Sweaters especially in cables are key both in cashmeres and cottons, with the new spring colors being key.

Key Links:
-Special Offerings: Early Bird Cashmere Incentive, Early Bird Incentive on Cashmere Classics

Better/Contemporary Knitwear

New Spring receipts continue to receive strong consumer reaction. Color and novelty details are driving business. As reported previously, hardware, feminine details, novelty prints and Marilyn necks have been key.

Contemporary Sportswear

Newness in contemporary includes a lot of color on the floors. Colors checking in sportswear are pink, orange, turquoise, white and black. Skirts are key, especially the flirty and mini silhouette. Novelty pants and skirts with ribbon/sash belt details have been strong.

Better Sportswear

Novelty jackets are key in Sportswear. Boucle, toppers and embellishments have been the strongest. Flirty skirts have been the newest silhouette checking in bottoms. Suit separates in bi-stretch have been selling well at retail. Activewear in french terry remains key as well.

Key Links:
- Multiple Special Offerings (Bridge/Better section)

Many resident buying offices deliver timely research information to their members.
(Courtesy of Ellen Diamond.)

A fashion forecaster assists buyers who are learning about new trends.
(Courtesy of Ellen Diamond.)

A Retail Buying Focus

TOBE

One of the best fashion resources in the industry is Tobe. It is an international fashion and retail consulting service. The clients include many of the most important department and specialty stores, mass merchants, chain organizations, the fashion press, as well as educational institutions that specialize in fashion merchandising, design, and retailing. The company essentially offers in-depth analysis of fashion and retailing, forecasting of trends, product and brand development, merchandising strategies, business planning, and news about the various fashion markets. For more than seventy-five years, Tobe has employed a host of retail specialists who cover the global fashion markets with an "unbiased" eye.

Of significant importance is the *Tobe Report*, considered by fashion industry professionals to be the most important and respected publication for the retailing community. Every facet of the industry—including women's, men's, and children's apparel; wearable accessories; home fashions; textiles; and color—is covered to provide up-to-the-minute information to e-tailers and multichannel merchants. Using the information gathered, they focus on in-depth projects for the top retail groups and other industry leaders. The end result of this service provides strategic solutions for problems that confront a wide range of fashion businesses. Most often, their suggested strategies improve company performance and ultimately, profitability.

Tobe enjoys the status of maintaining the highest standards and ethics that has made it into one of the most respected fashion consulting services in the industry.

(a) Fashion forecasters make their predictions well in advance of the season.
(Courtesy of The Doneger Group.)

variegated cotton twill polka dot

DETAILS:

- '50s Americana
- everything Elvis
- tux jackets, pants, shirts
- capri leggings, drainpipe jeans
- pencil or poodle skirts
- kitschy and iconographic art

bias printed star silk crepe de chine

98 *tfs spring & summer 2004 forecast*

(b) Forecaster predictions.
(Courtesy of The Doneger Group.)

The major player in this segment of the advisory service industry is the Retail Reporting Bureau. It is an unbiased, confidential organization. It normally makes monthly charges to its clients, the amount dependent on the retailer's volume and number of branches. In return for this fee, it provides its users with thirty to thirty-five merchandise news flashes per month that contain information on the goods that are selling best and the places where these sales are being made. It does this by simply shopping a broad range of retailer operations daily and regularly researching the various wholesale markets. It also studies newspaper advertisements on a daily basis and gets feedback from hundreds of buyers who cover the whole market.

Fashion Forecasters

Throughout the world there are numerous **fashion forecasters** who go one step further than the typical resident buying offices and reporting services. Companies such as Promostyl, with branches throughout the world; Alta MODA Fashion Consultants; Committee on Color & Trends; and Faces Fashion Report are just a few who provide this service. They help the buyers by predicting, well in advance of the purchasing season, what fashion trends could be expected. This helps the buyer with long-range planning.

One of the fashion world's better-known forecasters is David Wolfe, creative director of D3 Doneger Design Direction.

The Retail Buying Focus discusses Wolfe and his role in the industry.

A Retail Buying Focus

DAVID WOLFE

As creative director of D3 Doneger Design Direction, the fashion trend and color forecasting service for women's, men's, and children's wear, David Wolfe enjoys the enviable position of "America's Foremost Fashion Forecaster." His astute ability to predict fashion well in advance of the seasons enables designers to create the right silhouettes, in the appropriate colors and fabrications that are likely to have buyer appeal, and enables buyers to formulate their purchasing plans. He explains his lifelong interest in fashion as a "fascinating mix of style, economics, history, politics, weather, science, sex and a sense of humor."

A native of Ohio, Wolfe began his fashion career in a small-town department store, where he worked in a position that combined the responsibilities of fashion coordinator, buyer, copywriter, illustrator, and advertising manager. After gaining considerable experience in these aspects of fashion retailing, he spread his wings and tried his hand at an area for which he had great fondness, fashion art. He made his way overseas to London in the 1960s and established himself as a leading fashion artist. Soon after his arrival, he was besieged with offers from Galeries Lafayette, Liberty of London, Harvey Nichols, and Selfridges, companies that he eventually worked for. In 1969, he became one of the first to enter the fashion service industry and eventually became creative director of I.M. International, which catapulted him into becoming one of the world's

leading fashion forecasters and authorities. At that company, he was among the first to discover such talents as Armani, Lagerfeld, Montana, and Versace. When he returned to America, he helped form TFS—The Fashion Service—where he served as its president and ultimately became the creative director of D3 Doneger Design Direction.

He serves as a fashion consultant to Video-Fashion, whose weekly programs are broadcast via satellite to thirty million viewers worldwide, contributes articles to fashion publications through his affiliation with the Overseas Fashion Press Association, and is international fashion editor of *Men* and *Mode Couture* magazines.

Wolfe regularly delivers informative and amusing fashion-oriented lectures and appears in numerous fashion videos and on television, all of which make him a personality on the fashion scene.

Nonfashion Services

Nonfashion services provide generalized information not aimed at a specific product are also available to buyers. The services of Diversified Communications, Inc. are currently used by more than 150 department stores and specialty chains throughout the country. The program called Help Your Sell-f, a retail sales training program using standard CDs, is organized to fit into a semimonthly sales meeting. Each month, the store receives one tape for store management and two tapes for sales associates. The CDs have been carefully prepared by a professional production firm, a group of retail training directors, and a consulting behavioral psychologist. These CDs are especially helpful to buyers. By having the sales associates adequately prepared to sell their goods, the merchandise purchased by the buyers is apt to sell better.

Trade Publications

One of the surest and least costly ways to stay abreast of a buyer's particular merchandise responsibility is by reading the trade papers and magazines. These periodicals employ editorial staffs whose responsibility is to cover various markets and make assessments of them. The news in the fashion magazines and papers might include new styles, fabric favorites, and color trends. Buyers who must be up-to-date on their markets find these to be invaluable sources of information. In addition to those that report on fashion, there are other trade papers that concentrate on more generalized aspects of retailing. They provide buyers with information about technological advances regarding merchandise, marketing schemes, the effect of economic conditions that would affect consumer purchasing, and other areas of interest.

Those with fashion orientations include *Women's Wear Daily, Daily News Record, California Apparel News, Dallas Apparel News, Children's Business, Earnshaw's,* and *Footwear News.* A more generalized trade publication group includes *Chain Store Age Executive, Discount Merchandiser, VM & SD, Marketing News,* and *Stores Magazine.*

Consumer Magazines

One of the surest ways to discover what consumers are being told about new merchandise and trends is by reading the consumer magazines. Scanning magazines enables the buyer to concentrate on those items that seem to be getting the most attention from the press. For fashion buyers, magazines like *Elle, Elle Décor, Harper's Bazaar, Seventeen, Glamour,* and *Mademoiselle* are important reading.

Trade Associations

Retailers belong to one or more **trade associations** that offer them pertinent information on a variety of topics, including industry trends, economic indicators that affect merchants, merchandising directions, and so forth. By joining these groups, whose role is to assist their members in making the right decisions for their businesses, retailers are able to get yet another insight into how best to deal with their clienteles.

The largest of the retail associations is the National Retail Federation, or NRF, as it is generally referred to by its membership. Through lectures, panel discussions, expositions, films, and periodicals, it addresses most of the problems faced by retailers in general. It doesn't focus on any specific part of the retail industry, and it appeals to both large and small retailers.

Other trade associations that buyers, in particular, look to for information include the Fashion Group International, Leather Industries of America, Shoe Retailers League, National Mass Retail Association, and the Decorative Fabrics Association. Each provides a different insight into planning.

Language of the Trade

advisory services
cooperative office
corporate office
fashion forecaster
fashion reporting services
following up orders
full-line resident buying office
garment center
group buying
hot items
independent office
initial orders
market consulting organization
market week
nonfashion services
private-label product development
private office

reorders
resident buying office
retail reporting agency
special orders
specialized resident buying office
substitute shipping
trade association
wholesale market

Summary of Key Points

1. One or more types of market specialist representation assistance is necessary for retailers to keep a finger on the pulse of the marketplace.
2. Unlike retailers, market specialists are located within the wholesale markets and can keep abreast of what is happening there that is newsworthy.
3. The resident buying office is the most important of the market specialists.
4. Resident buying offices are organized as private, cooperative, corporate, or independent operations, with the latter being the most common.
5. Only retail operations that are extremely large or whose merchandise needs are unusual can operate private offices.
6. The largest of the independent resident buying offices is The Doneger Group. It is a full-service operation that represents more than eight hundred retail organizations.
7. When affiliation with an independent office is warranted, the retailer enters into a contract that spells out the terms and conditions of membership.
8. Some of the advantages of resident buying membership include regular coverage of the wholesale markets, attention to special merchandise requests, handling of complaints, purchasing merchandise, and so forth.
9. The choice of the right resident buying office depends on the roster of retailers represented by the group, the services it offers, and the costs involved.
10. Private-label merchandise is available from many resident buying offices, giving an edge to small retailers who wouldn't otherwise have access to such goods.
11. Fashion reporting services provide a great deal of fashion news to fashion-oriented retailers.
12. Trade publications are inexpensive means of helping buyers keep abreast of market conditions.

Review Questions

1. Which external informational source used by stores buyers is considered to be the most important?
2. Why is the term *advisory service* used when describing a resident buying office?
3. Where are the resident buying offices located?
4. How does a private resident buying office differ from a cooperative office?
5. What is the largest classification of resident buying offices?
6. If stores go into the market to make their purchases, why do most consider resident buying office affiliation necessary?
7. What advantage does exchange of information at resident buying offices give to member stores?

8. How can small retailers who are unable to produce their own private-label merchandise participate in this type of merchandising?

9. In addition to the mailing of brochures, telephone calling, and faxing, how do the resident buyers quickly communicate with the stores they represent?

10. What are the three major considerations used by merchants in selecting a resident buying office to represent them?

11. What is the difference between full-line and specialized resident buying offices?

12. In what way do reorders differ from special orders?

13. Define the term *hot item.*

14. What advantage does group buying, as offered by resident buying offices, afford small retailers?

15. Why are resident buyers often able to handle retailer complaints better than the stores themselves?

16. How does the resident buyer help make the store buyer's trip to the market more effective?

17. What is a fashion reporting service?

18. How do fashion forecasters assist store buyers?

19. Why is it important for buyers to regularly scan the pages of consumer magazines?

20. In what way does the NRF serve its retail membership?

CASE PROBLEM 1

Spotlight Shops is a small specialty chain located in New England. The organization has five units and specializes in women's and children's wear. Since its inception twelve years ago, the company's sales have continued to increase. In fact, Spotlight has also continued to increase its merchandise assortments of women's and children's wear significantly. One factor that has enabled it to increase its volume is a recent addition to its merchandising philosophy. In addition to its regular offerings, Spotlight has successfully increased its sales picture through periodic promotional events. Every season, the buyers prepare special promotional merchandise for disposal during three-day sales. The enormous success is becoming increasingly difficult to repeat because of the buyer's inability to obtain sufficient quantities of merchandise for these special events. Merchandise is available, but their distance from the wholesale markets and their many chores at the store make it virtually impossible for the buyers to find the time to seek out the necessary merchandise.

The company is currently deciding whether to hire outside representation to help with the problem or to add an additional buyer to make these promotional purchases.

Questions

1. Which route should Spotlight take?

2. If a resident buying office is the decision, which type should it join?

CASE PROBLEM 2

For the past forty-five years, Caldwell's Department Store has successfully operated its flagship store and eighteen branches in the Midwest. Its position as a midwestern department

store has steadily improved throughout the years. Competitors and noncompetitors alike consider the company to be one of the most progressive in retailing.

In the beginning, Caldwell's was a member of an independent resident buying office. With continued growth and expansion, the company decided that more personal attention was necessary for continued success. Ten years ago management moved in that direction by joining forces with fifteen other noncompeting department stores to organize a cooperative buying office. The arrangement proved to be very successful; Caldwell's continued to grow.

At present, the company is planning another expansion program. Management anticipates the opening of twelve high-fashion women's boutiques within the next ten years. Unlike the present organization, which features a full assortment of hard and soft goods at popular and moderate prices, the boutiques will feature high-fashion, expensive goods aimed at the affluent market.

Bearing in mind the expansion plan, some members of the top management team have suggested that the company organize its own private buying office. They believe the company's needs would be better served, particularly in light of the new expansion program. The remaining managers believe it would be wiser to remain affiliated with the cooperative office.

Question

1. With whom do you agree? Defend your position.

SECTION TWO
Planning the Purchase

Before the buyer visits the market to purchase merchandise, a significant amount of planning must be undertaken. If purchasing takes place without preliminary plans, the demise of the operation could result.

To bring the appropriate merchandise to the company in the required qualities and quantities, and to choose the best available vendors from whom to purchase, a variety of strategic plans must be developed. If the company is a new venture, those responsible for merchandise purchases must obtain a detailed composite of their target market. They must understand the demographics of their trading area and the specifics about potential customers—as discussed in Chapter 7—before they begin their purchasing plans. Even businesses that are already operating at the retail level should restudy their customer bases to learn of any changes.

One phenomenon that is significantly affecting purchase planning is the ever-increasing percentage of the population that is made up of different ethnicities. Multicultural differences affect the manner in which people buy, and the products that they prefer. From food to clothing, the "one-size-fits-all" philosophy is no longer appropriate for buyers to use in determining their merchandise mixes. Chapter 8 focuses on the demographic implications of the major diverse cultures, their buying power, how retailers are addressing these needs, and the state of the media used to attract these minority populations to the retailers. With basic customer analysis and the addressing of the multicultural phenomenon completed, the buyer can begin the purchase planning.

The research generally begins with the *six-month plan,* a roadmap developed by the buyer to bring the correct assortment of merchandise to the company for the next six months. The six-month plan involves investigation of past sales, what markdowns were necessary to dispose of slow sellers, which merchandise directions were most successful, and so forth. Another planning stage that must be developed is the *model stock,* which requires strict attention to styles, price points, sizes, and colors. Also important in the buying plan is the concept of *open-to-buy,* which tells the buyer how much money is available at any point in time to bring new inventory into the operation. This is an extremely important consideration because too much inventory can lead to markdowns and too little can result in lost

sales. Once the buyer has developed all of these plans, he or she is better able to determine what to buy in terms of quality and style, as well as what quantities to purchase—to select those resources for consideration in the purchasing at hand and to make decisions about the timing of the purchases. Skillful buyers, no matter how large or small the organization they represent, never make their purchases without this preliminary planning.

CHAPTER 7

Consumer Analysis

On completion of this chapter, the student should be able to:

- Discuss the various approaches used by retailers in the formation of focus groups.

- Describe the different methodologies used for information gathering in questionnaires.

- Differentiate between the questionnaire and observations techniques of marketing research.

- Define the term *demographics* and the role they play in providing information to the researcher.

- Describe the VALS concept and the role it plays in helping merchants distinguish one group from another.

- Differentiate among the various social classes and the distinguishing characteristics of each group.

- Identify the different family life cycle classifications and how each approaches purchasing needs.

- List the three types of buying motives and why they help buyers and merchandisers make their selections.

- Discuss Maslow's hierarchy of needs.

Unlike the consumers of yesteryear who had fewer avenues from which to make their purchases, today's shoppers are provided a wealth of opportunities and formats in which their merchandise needs may be satisfied. It is no longer necessary to visit a brick-and-mortar operation to make their selections; consumers can do so through catalogs, Internet shopping, or seated in front of their television sets to peruse the numerous cable shopping networks. Some even have their apparel needs satisfied through specialist visits to their workplaces.

Whatever the manner in which they make their personal selections, the task of the professional retail purchaser is to provide products that are both pleasing to their clientele and readily available for their consumption.

Whether the company is new to the retail scene or has been in operation for many years, it is essential to obtain up-to-the-minute information about the prospective or regular customers. By researching such areas as income, geographic concentration, family makeup and size, age classifications, occupations, and others that compose pertinent *demographics,* the approach to merchandise procurement will have

a scientific beginning and not one that results merely from the whims of those responsible for purchasing.

In this highly competitive retail environment, real planning is the key to success. The buyers and merchandisers who faithfully explore their consumer base, whether it is the potential purchasers or those who have shown themselves to be loyal customers, will more than likely be suitably armed to develop buying plans that will maximize profits for the companies in which they are employed.

The information they cull from the research studies that are undertaken either within their companies or by outside marketing research organizations is obtained through various means. These include the use of focus groups, interviews, questionnaires, and observations, each of which provides the information necessary for sound, professional buying decisions. Of course, the buyer is generally not responsible for such research even if it is undertaken inhouse, but is the recipient of the studies' data, from which purchasing ideas can be formulated.

With the information in hand, attention can now be focused on the qualitative and quantitative elements of the purchase plan.

CONSUMER ASSESSMENT

As has already been mentioned, the consuming public is no longer a relatively small segment of the population on which the retailer and its buying representative must concentrate. Given the almost unlimited domestic and global access of the Internet, the merchant's trading area has become enormous. With this in mind, consumer assessment is now a significant task to explore and examine. Of course, the size of the potential marketplace will vary from retailer to retailer. Those with brick-and-mortar operations that are global in nature, and with catalog and Internet capability extremely vast, will have to undergo intensive research analysis to carefully analyze their audiences. By contrast, the small entrepreneurs need only to examine their relatively small trading areas before they get a grasp of their marketplaces. Whatever the case, the research task that is carefully undertaken will provide the ammunition to bring positive results to the investigative retail organizations.

The Research Tools

The depth and breadth of the research project will dictate how much money will be expended for the study and what means of study will be incorporated, from which buyers may draw conclusions in terms of their purchasing plans. If the goal is to investigate merchandise on a companywide scale, then numerous tools might be employed. If, on the other hand, it is simply a specific product classification that warrants investigation, there might be the need to use only one type of research tool. Marketing research specialists determine the methodology that will be employed, with the project carried out by either in-house or outside sources.

The Retail Buying Focus discusses the role that Executive Solutions Inc. plays in marketing research, and the methodology it uses to gather information.

A Retail Buying Focus

EXECUTIVE SOLUTIONS INC.

One of the leaders in marketing research, with a client base that includes most of the Fortune 500 companies, Executive Solutions Inc. has been recognized as a major consulting firm in the United States. It represents such merchants as JCPenney, Koppenheiner, and Bath & Body Works and retail suppliers such as Guess Jeans, Sara Lee Hosiery, Anne Klein, and Hallmark Cards.

The firm's methodology incorporates focus groups, individual interviews, mall intercepts, telephone research, database analysis, in-home observation, and strategic consulting. It specializes in eliminating bias in group environments, in questioning techniques that allow for the discovery of more deeply held drivers of purchase motivation. Brand equity and positioning and new product development are among the numerous areas of research Executive Solutions partakes in.

One of the major methods of communication is *Focus TV*. Instead of having clients travel to places all over the globe, the company is able to tune in clients from the convenience of their own offices using state-of-the-art technology from Focus Vision and the moderating supervision of Executive Solutions staff. Using this technique, everyone, including the moderator, can participate in the discussions, just as if they were there in person. This methodology not only provides the answers to many of a company's questions in a timely manner, but it also eliminates the costs associated with travel. More information is available from the company's Web site at *http://www.executive solutions.com*.

FOCUS GROUPS

Many buyers consider the use of *focus groups* to be the best way to assess the likes and dislikes of their clientele and potential shoppers. **Focus groups** are composed of panels of people who are selected from the company's consumer base or from a cross section of individuals who fit the profile of the retailer's intended consumer market. They provide immediate response to a host of topics that are posed to them. Recognizing that we are in an era where the people and not the merchant dictate what will be bought, this firsthand information is invaluable to buyer merchandise planning and purchasing.

The focus group plan can take many different routes. One might be of the occasional variety where panels are organized as a specific need arises. In the case of a preteen department, for example, where sales haven't met expectations, a group may be assembled one time to evaluate the information culled from its participants. The buyer might then get a better understanding of the rights and wrongs of past purchase plans. Another approach would be the assembly of a panel that meets regularly to evaluate the entire company's merchandise offerings in terms of such factors as fashion direction, assortment, price points, and size allocations. This would give the organization's buyers and merchandisers a continuous flow of information that can be regularly used to make adjustments to the inventories.

Although the **college board** is not as dominant a focus group that it once was in department store planning, some retailers still use them. These panels are composed of

college students from various institutions of higher learning that are served by the retailer. By inviting these individuals to participate in the program, the buyers gain greater insight into the merchandise that would appeal to their college-age market. They would take the guesswork out of their purchase planning and concentrate on the items that the board believes would have the most appeal to their peers. Information such as prices, colors, fashion emphasis, price points, and fabrics, as offered by these students, would give the buyer an excellent starting point for purchases. Some stores have adapted this type of research to **teen boards** that comprise high-school-age students in their trading areas.

What is of paramount importance in the organization of these groups is that they are truly representative of the retailer's clientele and that the use of the information given by them be assessed in an unbiased manner. With objectivity the goal, the end results will be invaluable to buyer planning.

Note that participants in such programs, whether they make a one-time commitment or have an ongoing involvement, are usually paid for their services. In this way company management can generally be assured that those invited will make time for their participation.

QUESTIONNAIRES

One of the oldest methods of information gathering is the **questionnaire.** It is an impersonal method used to collect data that assists any type of business to solve its problems. In terms of buyer usage, a questionnaire can provide a wealth of information that can be used to direct the future of the company's merchandising plan or to solve any problems that have caused less than satisfactory sales results.

This methodology can be utilized in different formats. The use of mail questionnaires has long been a mainstay of research projects and still remains a vital approach to the procurement of information. The telephone has also been a traditional approach for information gathering, and remains an important method. Personal interviews may also be conducted to get answers to questions that are important to a study. With the enormous use of e-mail, questionnaires have now taken yet another route to gather the data necessary to make merchandising decisions. Many merchants regularly request a customer's e-mail address when they take the necessary information to establish charge accounts. With a significant number of people computer savvy and in the habit of reading their e-mails several times a day, the transmitting of a questionnaire to them could bring better results than any of the other traditional forms.

When selecting the one or perhaps two that are most appropriate for the buyer's specific needs, it is essential to evaluate the advantages and disadvantages of each type of questionnaire before the actual decision is made. Mail questionnaires, for example, might find their way into the wastebasket; telephone questioning might be too time-consuming for many people; and the direct face-to-face interview might be too personal for some individuals. There is no absolute guarantee that the use of a particular approach might bring the number of responses needed to provide the buyer with pertinent merchandise planning information. Getting professional advice from marketing research organizations as to the best approach for a particular study could help determine the manner in which the questionnaire will bring the greatest number of responses.

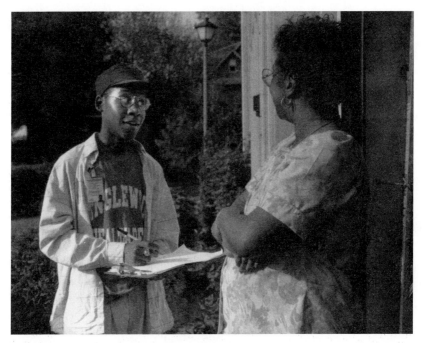

Personal interviews are often conducted at consumers' homes.
(Courtesy of Pearson Education, photo by Rhoda Sydney.)

The selection of the group that is to be targeted for questioning is another consideration. They may be individuals who have made purchases at the company or potential customers who have the appropriate personal characteristics to be considered as future purchasers.

To motivate people to respond to the questions and return their responses in a timely manner, they are frequently offered a monetary incentive or some other form of payment. Regular customers, for example, might be offered a merchandise discount on their next purchase.

The questionnaire on page 151 is typical of what some major retailers use to enhance the information from past sales and other sources that they use in planning their merchandise assortments.

OBSERVATIONS

Although the **observation technique** is not a significant research tool in today's studies, some buyers find it does provide a level of information that could be useful for purchase planning. Unlike the other formats used to collect data that require direct participation by individuals, this method relies solely on observing people in preselected environments and recording the observations.

Proponents of this technique are generally those involved in making fashion assessments. Their belief is that people are more likely to purchase new clothing, for example, similar to what they are wearing. Thus, if someone is seen sporting a high-fashion ensemble, chances are he or she will probably choose that type of merchandise again and again.

TABLE 7.1	Fashion Count, Men's Suits			
Jacket Style	*Pants Style*	*Leg Style*	*Pattern*	*Predominant Color*
Two button	Pleated	Straight, plain	Solid	Black
Three button	Fitted (no pleats)	Straight, cuff	Check	Navy
				Charcoal
Double breasted			Stripe	Brown
			Plaid	Tan
			Tweed	White
				Camel
				Green
				Burgundy
				Light gray

Note: Place an *X* next to the item that is observed and recorded.

The observation plan involves stationing "recorders" at predetermined places so that they can observe their targeted audience and complete the forms with which they have been provided (see Table 7.1). Once they have finished their chore, the data are compiled and analyzed.

Demographic Analysis

The study of the various population characteristics is known as **demographics.** They include population size, age, occupation, geographic concentration, education, and income. By examining these categories, the retailer can make a determination regarding his or her trading area and can more carefully tailor product needs to those within these market boundaries. The buyer—armed with this knowledge—will be able to translate the findings and determine what merchandise assortment will likely meet customer requirements.

One concept that more and more retailers are subscribing to is the segmentation system that involves clustering descriptions. The proponents of these systems—such as **PRIZM** (Potential Rating Index Zip Code Market) developed by Claritas, Inc., based in San Diego, California, and **ACORN** (A Classification Of Residential Neighborhoods) by ESRI Business Information Solutions—believe that variations among neighborhoods can be explained by social rank, household composition, mobility, ethnicity, population density, and housing information, each of which is important to appropriate merchandise acquisition.

More information about each system may be obtained on the Web at *http://www.claritas.com* and *http://www.infods.com*.

POPULATION CONSIDERATIONS

One of the more important demographic factors is an analysis of the trading area's population concentration. It is especially important if the company is brick-and-mortar based. In this case, the buyer should be aware of information such as whether the potential consumers live in an urban or suburban area since, oftentimes, their needs are

E-mail Questionnaire

Dear Charge Customer:

We are always looking to improve our merchandise selection and better satisfy your shopping needs. At this time, we are considering the expansion of our children's department to include a line of girls' preteen clothing and would like your input about the type of merchandise you would like to see in the new collection. As a regular customer in our stores, we value your opinion and expect it to play an important role in future merchandise plans.

For your participation, we are offering a 20% discount on your next purchase in any department in the store.

1. Are there any preteens in your immediate or extended family?

 Yes_____ No_____

2. If yes, approximately how much do you spend each year for this group?

 Up to $100 _____
 From $101 to $300 _____
 From $301 to $500 _____
 More than $500 _____

3. What types of merchandise would you like to see in the preteen collection?

 Please check the appropriate categories:
 Apparel _____
 Accessories _____
 Shoes _____

4. What price range would best suit your needs?

 Inexpensive _____
 Moderate _____
 Better _____

5. Do you prefer:

 Designer labels _____
 Nationally advertised brands _____
 Private-label merchandise _____
 An assortment that includes all of the above _____

6. What are the ages of the preteens that you would be shopping for? _____

7. Would you be more likely to purchase this merchandise through

 (Please check one or more categories)

 Store visits _____
 Catalogs _____
 Our website _____
 All of the above _____

8. Do you ever purchase preteen products as gifts?

 Yes _____
 No _____

We would appreciate it if you could e-mail your responses to us by November 15th so that we could plan for our department expansion.

 Thank you for your cooperation.

Sample e-mail questionnaire.

quite different. Typically, suburbanites tend to buy a greater amount of casual merchandise than do their city counterparts, thus requiring different model stock inventories.

Of course, in cases where the company has units in both urban and suburban areas, the buyer must make certain that each store carries only that merchandise that fits its particular needs. By committing to a uniform distribution policy, it is likely that, at the end of the season, many of the units will find themselves with unwanted merchandise, making markdowns a necessity.

In the case of off-site ventures, such as e-tailing, where there aren't any boundaries, the need for limiting inventories according to population concentration is unwarranted.

AGE CONSIDERATIONS

To tailor an inventory to the appropriate clothing and accessories products, it is essential that studies that concentrate on age classifications be undertaken. In this way, the buyer can plan to purchase the styles that have the most appeal to the clienteles. It is obvious that teenagers and young married people will not generally have the same clothing requirements. Although teenage girls and their mothers both wear trousers, the younger set is apt to purchase a trendier type, while the adults' taste will generally be more conservative.

The manner in which these age groups are classified vary from study to study. Some concentrate on designations such as *baby boomers* (those born between 1946 and 1964), *generation X* (generally, those in their twenties), and *generation Y* (those in their teens). Although these categories offer meaningful information, the general approach is to use the classifications used by the U.S. Department of Commerce (see Table 7.2).

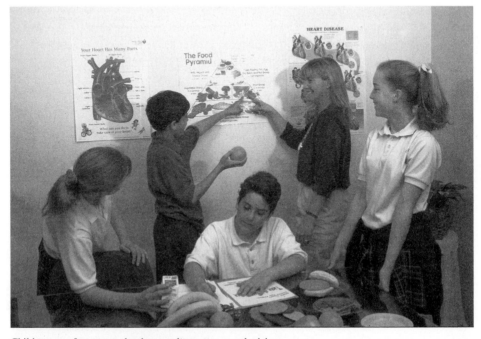

Children are often tempted to buy products seen on television.
(Courtesy of PhotoEdit, photo by Myrleen Ferguson Cate.)

TABLE 7.2 U.S. Department of Commerce Classifications

Classification	Ages	Preferences
Children	Birth to 12	Products seen on television
Teenagers	13 to 19	Trendy products at relatively lower price points; compact discs
Young adults	20 to 34	Fashion merchandise at prices higher than teenagers' products
Young middle-aged	35 to 49	Luxury products including high-fashion apparel, precious jewelry, original art, travel, upscale automobiles
Older middle-aged	50 to 55	Foreign travel, designer apparel and accessories (for the affluent), value merchandise for the remainder
Elderly (retirees)	56 and older	Health products, some fashion merchandise

Note: The age groupings are according to the Department of Commerce. The preferences, however, vary according to the incomes of those in the group, which may vary considerably.

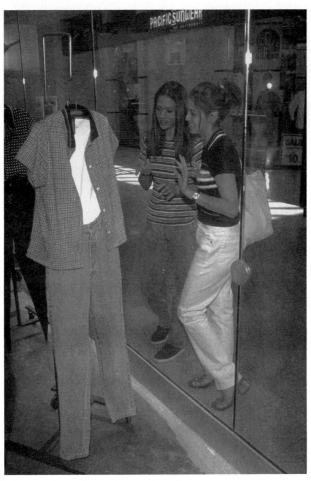

Teenagers generally buy trendy products at lower price points.
(Courtesy of PhotoEdit, photo by David Young-Wolff.)

CLIMATE

The general climate conditions of a region are important to consider when making purchases. If the company is a small chain in a warm climate such as Florida, swimsuits will be a merchandise classification that requires an assortment all year long. In the Northeast, however, the buyer must make certain that such products be merchandised only for the months preceding warm weather and during that season. In the case of major chain organizations, such as Banana Republic, with stores all across the country, the buyer often has to ensure that specific items be earmarked for certain stores, according to the season. In the warmer climate stores, heavy woolens would probably not be carried unless the area was one in which a wealth of tourists visit, and bring back purchases to their colder regions. In this company, however, some items—such as khakis—will have a place in every store.

OCCUPATION

The type of careers people have plays a significant role in the planning of their purchases. This is especially true when the product classification is clothing. While two people such as an attorney and a plant manager might have similar incomes, their apparel needs will certainly differ. The former will require suits, dress shirts, ties, and dress shoes for work. The latter will need only basic wear such as jeans and sports shirts to be appropriately dressed on the job.

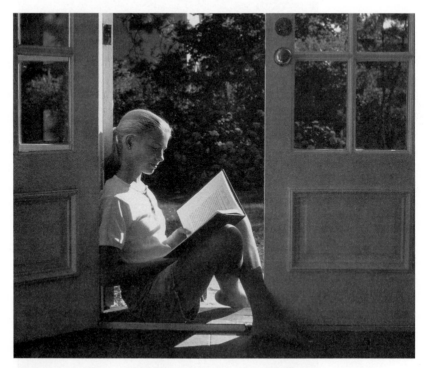

Young adults are more likely to buy fashion merchandise at price points that are higher than those of teenagers.
(Courtesy of Corbis/Stock Market.)

Careers play a significant role in the purchase of wearing apparel.
(Courtesy of Prentice Hall School Division, photo by Bill Burlingham.)

The trend toward working at home has also required buyers to rethink some of their purchases. With the number of people working at computers in home offices now in the millions, the standard dress is jeans and tee shirts.

Continuous reevaluation of occupations and the places of employment will give the buyer a head start on purchase planning.

INCOME

Ultimately it is income that dictates how much a person will spend. If the merchandising team that traditionally catered to a moderate-income family now believes a higher-priced merchandise assortment should be added to the company's mix, they must make certain that a portion of their clientele can afford it. Similarly, if a food chain wants to add gourmet selections that are pricier than the rest of their offerings, it is essential that there be sufficient consumer income to support the merchandising change.

The fact that people would like to have higher-priced merchandise doesn't guarantee that they will have sufficient disposable income to satisfy these desires. Income plays a very big role in the determination of how much will actually be spent for consumer purchases.

If attention is not paid to their potential shoppers' income, it is likely that the wrong assortment, in terms of price, will be bought by the buyers, and unwanted merchandise will be headed for the clearance racks.

EDUCATION

Even though two individuals might have the same income, their educational backgrounds often play a role in their purchasing. Those people possessing advanced

degrees often pursue careers that might warrant a particular mode of dress, whereas those with less education often will not have the same stringent dress codes. Bankers, for example, are inclined to need suits rather than casual clothing.

It is therefore essential to investigate the educational profile of the retailer's intended market, and select merchandise that will fit those consumers' needs.

LIFESTYLE

People's attitudes and lifestyles often contribute to their personal needs. Those with more laid-back approaches to life are less likely to purchase flamboyant dress than those who regularly seek social events as their means of entertainment. Someone who is an overachiever, for example, might prefer premium products such as the latest in electronic innovation.

A great deal has been written on the lifestyle factor, with none making more of an impact than the **VALS study.** The brainchild of SRI Consulting Business, the research focuses on a psychographic segmentation system that divides consumers into eight profiles: **Actualizers, Fulfilleds, Achievers, Experiencers, Believers, Strivers, Makers,** and **Strugglers.** These specific categories represent the interests, motivations, and habits of those in the group. Strugglers, for example, who are short on cash, are likely to use coupons for their grocery purchases and shop for discounts.

Table 7.3 briefly describes the characteristics of each profile.

By understanding these profiles, the buyer is better able to purchase the products that will satisfy them.

The VALS study may be viewed on the Web at *http://www.sric-bi.com/VALS.*

TABLE 7.3 VALS Consumer Classifications

Profile	Characteristics
Actualizers	Successful, sophisticated, active, "take-charge" people with high self-esteem and abundant resources.
Fulfilleds	Mature, satisfied, comfortable, reflective people who value order, knowledge, and responsibility.
Achievers	Successful career- and work-oriented people who like to feel in control of their lives.
Experiencers	Young, vital, enthusiastic, impulsive, and rebellious people who seek variety and excitement, savoring the new, the offbeat, and the risky.
Believers	Conservative, conventional people with concrete beliefs based on traditional, established codes: family, church, community, and the nation.
Strivers	Seekers of motivation, self-definition, and approval from the world around them. Striving to find a secure place in life.
Makers	Practical people who have constructive skills and value self-sufficiency. They live within a traditional context of life.
Strugglers	Chronically poor, ill-educated, low-skilled people without social bonds, the elderly, people concerned about health, and passive people.

Social Classes

When we read the newspapers or magazine articles, watch television, or listen to the radio, invariably the term **social class** is mentioned. Although the term is used globally, it tends to have different meanings in different countries. In the United States, social class specifically encompasses income, education, personal goals, attitudes, and sometimes even birthright. Two people with the same amount of wealth might belong to two different classes. Those with ancestral wealth and high social standing that has been passed onto them automatically belong to the upper-upper class. The others with an equal amount of money who are considered *nouveau riche* belong to the lower-upper class. Their purchases are often quite different. The former is more likely to buy understated but quality merchandise. The latter's purchases are more apt to be extravagant.

By studying the three major classes that are labeled upper, middle, and lower and their subclassifications that are divided into upper and lower classes, the buyer will have a better understanding of the motivations and needs of those in his or her trading area. In this way, purchases will be made to provide a better product mix from which the potential customers may choose.

UPPER CLASS

This group accounts for the wealthiest people in the United States, comprising about 3 percent of the population. More billionaires than ever before are in our society, making this group larger than at any time in the past.

Upper-Upper Class. Old family names such as Rockefeller and Vanderbilt immediately bring to mind the socially elite of our nation. This tiny fraction of the population resides in the most prestigious locales such as Palm Beach Florida, and Park Avenue in New York City. Haute couture is *de rigueur,* as is attending the world's elite schools and dining in gourmet restaurants. Money is never an object for this privileged class.

Those who cater to these people must provide the finest quality, but not necessarily the most extravagant products. Unlike their lower-upper-class counterparts who have a need to purchase conspicuously, their needs do not warrant such outward opulence. They have always lived in their upper-class style and have no need to "show" their success.

Lower-Upper Class. Through hard work, those in this class are sometimes even wealthier than those in the upper segment of this general classification. They are the movie stars and business tycoons who often get their satisfaction from sporting their riches for the entire world to see. Conspicuous spending is often their mantra. Their purchases revolve around luxury automobiles, private planes, couture clothing, and fabulous jewelry. Like those in the upper-upper class, they live in the wealthiest enclaves and frequent the best shops in the world. But, unlike those who were born into wealth, they might not be invited into the snobbiest country clubs.

MIDDLE CLASS

Approximately 42 percent of the population makes up the middle class. The two subclassifications, although in the same category, are completely different in their purchasing requirements.

Upper-Middle Class. Many retailers consider this group to be the best customers. Although they do not have the monetary resources of those in the upper class, they spend a great deal on a wealth of luxury items. They are purchasers of everything from designer clothing and precious jewelry to foreign cars and exotic travel. Labels like Ralph Lauren, Escada, and Donna Karan, and stores like Bloomingdale's and Saks Fifth Avenue satisfy their shopping needs.

Buyers who cater to such people need not worry about value merchandise but concentrate on products that give them the status and prestige that so many in this class are seeking.

Lower-Middle Class. With more modest incomes, those in this social class are generally more cautious about spending. They are also the purchasers of recognizable designer labels, as are their upper-middle-class counterparts, but they often buy from off-price merchants such as Marshalls, Stein Mart, and T.J. Maxx. They also frequent companies such as Target and Wal-Mart, where quality discounted merchandise is available to them.

Members of the lower-middle class are often sports enthusiasts, making them an excellent market for sporting goods apparel and accessories.

LOWER CLASS

This social class represents about 55 percent of the American population. With more than one-half of the people in this group, they are the main targets of retailers in the United States.

Upper-Lower Class. Price is the prime consideration for this group of people. With little left after their household expenses are paid, they are extremely cautious about how they spend their discretionary dollars. They are the bargain shoppers of our society, generally choosing off-pricers, discounters, warehouse outlets, and wholesale clubs such as Costco and Sam's for their personal needs. They are also the users of cable television's home shopping channels for clothing and inexpensive jewelry.

Lower-Lower Class. *Survival* is the word that best describes this group. Their only purchases are for food products and clothing that is an absolute necessity. They buy in thrift shops and secondhand stores.

Family Life Cycle

In addition to the research that merchants use in gathering information is the **family life cycle.** This concept groups traditional and nontraditional families according to the age and status of the heads of the households. It assumes that the purchasing patterns of those within these units are somewhat similar for all types of products including apparel, personal accessories, home furnishings, food, automobiles, housing, sports equipment, restaurant dining, recreation, and travel.

While most of the family designations have remained constant ever since researchers have investigated them, today's segmentation features a number of groups that are relatively new such as multiple-member shared households.

CHILDLESS SINGLES UNDER AGE FORTY-FIVE

With the need to support only themselves, this group often has a significant amount of discretionary income to purchase a wealth of products ranging from apparel, accessories, and self-improvement products to recreation, restaurant dining, and travel. The group members, of course—as is the case within any group—differ in terms of income. Those at the upper end of the earnings spectrum are the retailer's dream. They can afford anything they want and often buy designer labels such as Ralph Lauren and Calvin Klein; frequent upscale, fashionable restaurants; belong to upscale fitness centers; and fancy the most costly automobiles. Retail buyers who cater to this group of individuals need only to concentrate on products that are considered to be the finest in their merchandise classification.

However, not every childless single under the age of forty-five enjoys unlimited financial resources. Although their shopping requires a bit more caution, they too are able to spend as freely as they like once their rents and utilities have been paid. Typically for clothing they head for retailers like Banana Republic and Ann Taylor, travel a great deal—but to less-exotic places—and dine away from home extensively, albeit in less-expensive restaurants.

CHILDLESS SINGLES FORTY-FIVE AND OVER

As is the case of the forty-five and under group, they too tend to spend freely since their purchasing needs are expressly for themselves. They purchase anything they believe is important to their status in life and their well-being. With their wealth often continuing to grow and generally few obligations other than those they choose, they buy upscale fashion clothing, jewelry, home furnishings, and vacation homes and enjoy all of the other luxuries of life. They too, like their younger counterparts, are a retail buyer's dream.

SINGLE PARENTS

Many of today's households have single parents at their heads. With the divorce rate at an all-time high, the number seems to be growing constantly. These household heads often support themselves and their children, who may or may not live with them. Often their daily goal is to meet the expenses of existence. Typically it is the women in this group who have the responsibility of rearing their children while, at the same time, holding a position in the workplace. With women's salaries generally lower than men's, they often have little discretionary income left after their rents and utilities have been paid.

By necessity, the vast majority of those in the group head for the value-oriented retailers for their shopping needs. They frequent off-price operations such as Marshalls, Stein Mart, and T. J. Maxx; discounters like Target and Wal-Mart; and warehouse clubs such as Sam's and Costco. Dining out is an occasional event, as is travel.

MULTIPLE-MEMBER SHARED HOUSEHOLDS

By necessity, the sharing of households by those without family connections is growing in the United States. With the cost of living seeming to be ever-spiraling out of control, for many this is the only means of survival. These groups include singles who live together, members of same-sex relationships, members of the opposite sex in platonic relationships, and two sets of families with children.

As diverse as these "couplings" are, there are differences in how each spends its discretionary income. Singles who live together without the intention of marriage usually have a great deal of disposable income because they significantly reduce their living expenses through the sharing arrangement; same-sex relationships provide significant incomes for each partner, and without the potential for family rearing, often leave substantial sums for all kinds of purchases; two families living together, however, are generally "cash poor," making them impractical targets for anything but essentials.

SINGLE-EARNER COUPLES WITH CHILDREN

Although many households fall into this category, it is one that is declining in numbers. The cost of living has almost demanded that both parents return to work in a relatively short time after the birth of a child. Those who remain in this single-earner group are in the minority and tend to have problems meeting expenses except in unusual situations. The vast majority are value-oriented shoppers and stay that way at least until the youngest is in school. Then, both parents generally work, and move into better financial situations giving them greater buying potential.

DUAL-EARNER COUPLES WITH CHILDREN

The buying power of these couples depends, in part, on the ages of the children, and whether they live at home with their families. Those with small children in nursery school programs, for example, have less money to spend than their counterparts whose children are in public schools. Of course, by comparison to the preceding classification, this group is financially better equipped to spend on more than just the essentials of life. The upper-level earners are specialty store shopper regulars at retailers like Banana Republic, while their lower-earning counterparts are more apt to buy at The Gap or Old Navy.

As the children of these marriages reach college-level age, with tuition costs at record levels, they become cash poor and tend to return to a level of cautious spending.

CHILDLESS MARRIED COUPLES

Most of these couples have the benefit of two incomes. They need only to take care of their own wants and needs. Those at the lower level of the age spectrum often spend without concern, purchasing products that give them both prestige and comfort. The older members of this category generally spend a great deal on travel in addition to the other pleasures in life.

EMPTY NESTERS

Those who have raised families most often find themselves living without the responsibility of caring for their children once they have moved out. Where one time their purchasing requirements included needs for their children, they now have the luxury of spending on themselves. Often both partners continue to work, making them dual earners with the power to purchase necessities as well as luxuries.

As they age, they spend more and more on medication and services to make their later years more comfortable. When one member of this household either retires or is left alone after the death of a partner, the income significantly decreases, leaving only a fraction to spend.

Empty nesters are often the purchasers of products they once were unable to afford.
(Courtesy of Pearson Education, photo by Frank Labua.)

People do not often remain within a specific group for an entire lifetime. The childless single might marry; the dual earners with children might divorce; and those in shared households, who were divorced, now might remarry. Those who study the family life cycle must be aware of these potential changes so that they can plan their company's merchandising purchases in a way that will maximize profits (see Table 7.4).

CONSUMER BEHAVIOR

Aside from the assessment of the different types of consumers and the manner in which they are categorized by researchers, it is essential to study consumer behavior to get a complete picture of the individuals who make up the retailer's potential markets. When the motives of the American population are examined, the buyer is better equipped to make sound purchasing decisions.

Buying Motives

If you had a product to sell, and you wanted to appeal to consumers to motivate them to buy it, what stimulants would you offer to transform them from shoppers to customers? Would you emphasize price, safety, prestige, quality, or any other factors? Each of these motives, by themselves or in combinations, traditionally motivates

TABLE 7.4 Family Life Cycle Patronization	
Segments	*Typical Purchasing*
Childless singles under age forty-five	Designer labels, upscale cosmetics, foreign cars. Retailers frequented: prestige department and specialty stores.
Childless singles forty-five and over	Designer labels, expensive cars, costly vacations. Retailers frequented: high-fashion boutiques, upscale department stores like Bloomingdale's and Saks Fifth Avenue, upscale restaurants.
Single parents	Value-oriented off-pricers, discounters, and factory outlets. Retailers frequented: Marshalls, T.J. Maxx, Wal-Mart, Target, Sam's, and Costco.
Multiple-member shared households*	Varies from necessities for those single parents with children to luxuries for singles who live together. Retailers frequented: ranges from value retailers to high-end luxury merchants.
Single-earner couples with children	Value merchandise. Retailers frequented: Marshalls, Wal-Mart, Target, Costco, Sam's, and Burlington Coat Factory.
Dual-earner married couples with children	Moderate to upscale merchandise. Retailers frequented: Banana Republic, The Gap, Macy's, Dillard's, and Lord & Taylor.
Childless married couples	High-end products. Retailers frequented: Saks Fifth Avenue, Bloomingdale's, Ralph Lauren, and Neiman Marcus.
Empty nesters	Products and services once considered too expensive. Retailers frequented: Macy's, Lord & Taylor, and Talbot's.

*In this group, the patronage range is considerable because of the numerous subgroups within it.

people to buy. A Ralph Lauren shirt, for example, might warrant extolling the quality of the product, or perhaps the fashion sense that it delivers. Some people purchase automobiles such as the Mercedes-Benz for the reliability it delivers, whereas others make the purchase purely to achieve a higher status level. Whatever the reasons for a consumer's buying motives, the retailer must be able to examine all of the reasons why people are motivated to buy, and choose the ones that are most appropriate to appeal to its potential market.

Buying motives are segmented into three different classifications: *rational motives, status motives*, and *patronage motives*.

RATIONAL MOTIVES

When a consumer is considering a purchase, and price, quality, product care, functionality, practicality, and durability are the factors that govern this intended purchase, only **rational motives** are being considered. Shoppers who frequent the wealth of value-oriented retail establishments are primarily assessing the merchandise on those factors that constitute this classification of motives.

Retail giants such as Sam's and Costco, who operate giant warehouses filled with bargains; Target and Wal-Mart, who underscore price in their promotional endeavors; and Burlington Coat Factory, Marshalls, and T.J. Maxx, who emphasize price in their advertisements are all concentrating on the rational appeal to gain their share of the value-shopper market.

In times when the economy is faltering, and many consumers have to carefully spend their disposable and discretionary income, rational motives are regularly highlighted in the

retail marketplace. With less income available than in prosperous times, consumers are often more likely to purchase based on price and quality factors.

EMOTIONAL MOTIVES

At the other end of the motives spectrum is buying based purely on **emotional motives.** Does the Tommy Hilfiger design actually provide the wearer a better-quality garment, or does the famous logo so significantly placed for all to see offer a degree of prestige or status? Does the Prada handbag provide the individual with unique function and quality, or does the designer name offer the devotee a level of envy? When Calvin Klein's jeans were initially emblazoned with his logo on the back pockets, did that identifiable mark improve the quality of the design, or was it there merely to provide a means of gaining status for the wearer?

A significant number of households in the United States are more likely to buy products that offer them some form of prestige and status—and are willing to pay premium prices for such purchases. Whether it is apparel, accessories, home furnishings, automobiles, and the like, it is often the label that ultimately influences the consumer to buy.

The retailer's merchandising team must fully understand the nature of the motives that influence buying. If the research shows that price is more important than status, private labels might be the route to take. If, on the other hand, it is prestige that is the driving force, the way to go is with merchandise collections that are filled with designer names.

PATRONAGE MOTIVES

Today's consumers have more outlets to satisfy their needs than ever before. Deciding from whom and how they make their purchases is based upon a number of factors that include services provided, convenience, company return policies, merchandise assortment, and price. These **patronage motives** are relevant not only to brick-and-mortar operations but also to catalog ventures, Internet Web sites, and cable television shopping networks.

When the retail organization regularly provides the merchandise assortment that satisfies the customer's needs, and at the same time offers a level of expected service and shopping satisfaction, the end result is often company loyalty. These shoppers will return again and again to purchase, giving the retailer a customer base that will provide longtime patronage.

Maslow's Hierarchy of Needs

Yet another theory that provides additional analysis of the consumer marketplace is known as **Maslow's hierarchy of needs** (Table 7.5). The concept categorizes individual needs into five classifications beginning with those that are called *physiological needs,* the most basic, and concluding with *self-actualization needs.* Each level addresses different needs that require fulfillment before you can move onto the next. Table 7.5 represents each of the five levels of the theory. The broadest level is the one that speaks to physiological needs, with each of the other levels becoming narrower and more difficult to attain. The least number of individuals reach the level of self-actualization.

TABLE 7.5 Maslow's Hierarchy of Needs

Needs Classifications	Requirements and Product Needs
Physiological	Food, water, shelter, and clothing
Safety	Health and life insurance, safety features on automobiles such as airbags and quality tires
Social	Cosmetics, jewelry, image automobiles
Esteem	Couture clothing, designer labels, performance automobiles, prestigious country clubs
Self-actualization	Symphony subscriptions, museum memberships, graduate education

When buyers and merchandisers have a better understanding of the Maslow theory, as well as all of the others that address consumer behavior, a more salable inventory will be mounted that will satisfy the targeted consumer population. The net result will be fewer markdowns and greater profitability.

Language of the Trade

achievers
ACORN system
actualizers
believers
college board
demographics
emotional motives
experiencers
family life cycle
focus group
fulfilleds
makers
Maslow's hierarchy of needs
observation technique
patronage motives
PRIZM system
questionnaire
rational motives
social classes
strivers
strugglers
teen board
VALS study

Summary of Key Points

1. Now that retailers have an ever-growing trading area due to off-site outlets such as catalogs and the Internet, the task of assessing consumer preferences is greater than in the past.

2. Focus groups have become more important to merchants in their approach to better understanding their customers.

3. Questionnaires typically use the telephone, mail, and personal interview, and the latest methodology, the Internet, to gather information about consumers.

4. The observation technique, while not as important a research tool as the questionnaire and focus group, nonetheless serves the purposes of some retail operations.

5. Demographic analysis addresses such areas as population, age, climate, occupation, income, education, and lifestyle.

6. The VALS concept concentrates on lifestyle and focuses on eight specific psychographic segments.

7. Social classes are divided into three classifications, upper, middle, and lower class. Each is then further divided into the upper and lower portions of the specific categories.

8. The smallest of the social classes is the upper class with just 3 percent of the total population; the largest is the lower class with 55 percent.

9. The family life cycle segments groups into age categories and how each group fits according to its stage in the cycle of life.

10. One of the newest classifications in the family life cycle that is continuously growing is the one known as multiple-member shared households. This group includes singles living together, members of same-sex relationships, members of the opposite sex in platonic relationships, and two sets of families with children.

11. Consumer behavior analysis focuses on rational, emotional, and patronage motives.

12. Maslow's hierarchy of needs categorizes individual needs into five distinct classifications: physiological, safety, social, esteem, and self-actualization.

Review Questions

1. Describe the concept of Focus TV as offered by Executive Solutions Inc.

2. Define the term *focus group* and discuss how this research methodology helps the retailer with his or her decision making.

3. Define the term *college board.*

4. Why is the questionnaire such an important part of market research?

5. In what way does the e-mail questionnaire better serve the retail establishment?

6. How does the observation method of information gathering differ from the observation technique?

7. Briefly describe the nature of the PRIZM concept as utilized by Claritas, Inc.

8. What is the scope of demographic analysis and how does it help buyers and merchandisers make better product selections for their customers?

9. List the different Department of Commerce demographic classifications pertaining to age.

10. On what does the VALS study featured by SRI Consulting Business focus?

11. According to the VALS consumer classifications, what are the differences between Actualizers and Experiencers?

12. If the upper class is the wealthiest group in the United States, why do researchers break the category into two components?

13. Which is the largest social class in the United States and what portion of the population does it represent?

14. What assumptions does the family life cycle assume regarding purchasing?

15. Why is the multiple-member shared household becoming more and more important to market researchers?

16. In what way do rational motives differ from emotional motives?
17. What factors do consumers who are regular patrons of retail enterprises consider?
18. Describe Maslow's hierarchy of needs.

CASE PROBLEM I

Pot Pourri, Ltd., opened its doors as a women's specialty store ten years ago. Throughout its first eight years of operation, Pot Pourri catered to the more affluent female, each year beating the previous year's sales figures. Sales volume last year was $2.5 million.

Fifteen months ago the company decided to expand its operation by acquiring additional space in an adjoining building and by adding two new merchandise lines. The store developed a program to include menswear and children's wear departments. The rationale behind the move was the ever-growing demand for these two merchandise classifications by the retailer's clientele. After considerable investigation, Pot Pourri went ahead with its plans and opened the expanded operation six months ago.

Purchasing for the new departments was assigned to Amanda Matthews, former women's wear assistant with the company, and Marc Litt, formerly the buyer in a large menswear department of a medium-priced department store.

At this point, Pot Pourri is disappointed with the new departments' business. Sales are well below what was anticipated. The problem seems to be one of improper merchandise selection rather than customer traffic, because the number of shoppers on the selling floor has been considerable.

In an effort to correct the situation, management is planning to organize a research study. It is hoped that the findings will alleviate the present situation. The only management concern at the moment is cost. Although their thinking is progressive, both the size of the company and the budgetary restrictions limit the type of research they can undertake.

Questions

1. Do you think management's move toward expansion was correct?
2. Discuss the type of research that would probably benefit the store most, bearing in mind its organizational and financial situation.

CASE PROBLEM 2

The Male Ego, a menswear brick-and-mortar chain, has just recruited Joy Green to serve as their merchandise manager for sportswear. Until recently, she enjoyed many years as the buyer of men's apparel for an off-price menswear operation. Her tenure with the company helped it become one of the leaders in this retailing segment.

With her considerable experience in the field, albeit not in exactly the same arena as is The Male Ego, the company thought her track record good enough to hire her for this position. She has always had an excellent reputation in the industry with the vendors from whom she purchased.

Not one to jump right into a new position without carefully studying the consumer market she would serve, Ms. Green embarked on a plan that would help her learn more about the wants and needs of her new clientele. She began first by walking through the selling floors of the chain's more important units, and "eyeballing" the shoppers. She could see what they were wearing and try to establish criteria for her first merchandise collection. She also delved deeply into the company's past sales records to try to determine the types of products that had the most appeal. With all of this information carefully digested, she still wasn't completely satisfied. She wanted to have a greater insight into the lifestyles of The Male Ego's current customer base as well as those who would be potential patrons.

Ms. Green is still searching for the right information without having to use a marketing research firm to do the job.

Questions

1. Which recognized study do you believe Ms. Green should examine to give her an indication of lifestyle classifications?
2. Once she has determined which profile best describes her company's customer, how might she go about getting direct input from that group?

Multiculturalism: Assessing the Product Needs of America's Major Ethnicities

On completion of this chapter, the student should be able to:

■ Discuss the demographic implications of the major ethnicities in terms of their shopping needs.

■ Address the buying power of African Americans, Hispanics, and Asian Americans.

■ Explain the growth potential for apparel, cosmetics and fragrances, and foods for the three main ethnicities in the United States.

■ Describe how Sears is making changes to attract more attention from diverse cultures.

■ Discuss the state of the media used to attract the minority population in America.

As you learned in the preceding chapter, consumer analysis is extremely important in making certain that every area is addressed before the retail buyers can properly assess needs. While such factors as income, occupation, education, age, and lifestyle are among the paramount considerations necessary for retail buyer assessment before any purchasing decisions are finalized, it is also essential to consider the potential for more specific needs and wants of the numerous ethnicities that comprise our population. The notion that "one size fits all" is no longer relevant in today's society. Whether it is food, cosmetics, clothing, or many other product categories, each ethnic group might have preferences that are different from the others, and by addressing them, the result could be increased sales.

Retailers of all types are paying greater attention to multiculturalism, and its effect on purchasing, than ever before. Retail giants such as Sears, JCPenney, Wal-Mart, Target, and Kohl's have made significant attempts to capture the ever-growing spending power of the ethic groups by abandoning a uniform merchandise assortment in each of their stores, and fashioning their inventories to include specific products that have greater appeal in certain geographical locations. Sears has refashioned about one hundred stores to appeal to multicultural customers in a manner that was once considered unnecessary in the retail arena.

One of the indicators that accounts for the sudden interest in the needs of the major ethnicities is the fast-growing number of businesses that are owned by minorities.

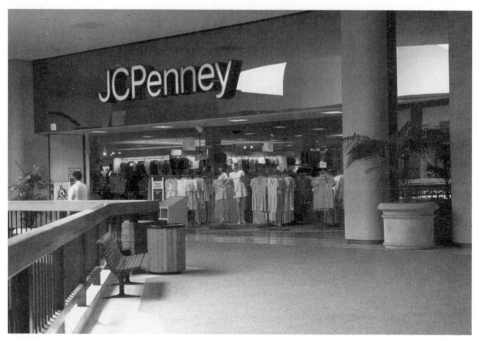

JCPenney is a leader in capturing ethnic minority shoppers.

The number of firms owned by both African Americans and Hispanics is growing at a significant rate. As reported by the Bureau of the Census, black-owned firms have exploded at the rate of 45 percent from 1997 to 2002, more than four times the national average. Hispanic-owned businesses, for the same period, grew at a rate of 31 percent. In addition, blacks make up about 12 percent of the population in the United States, and by the year 2050, it is estimated that the Hispanic population in the United States will number one in four!

Business ownership by these two minorities indicates that their wealth and potential buying power will continue to increase. This, coupled with the anticipated growth in their overall population numbers, indicates that they are quickly becoming major purchasing forces in America, and are being studied by retailers to help them better address their specific product needs.

In addition to the African American and Hispanic population segments, Asian American growth is also increasing. They, too, represent a market that in the past received little attention. Along with the others, they amount to significant numbers that require study to reveal their special wants and needs.

Specifically, multicultural merchandising is the order of the day. In addressing this relatively new phenomenon in retailing, a number of different assessments must be made in order to maximize profits within these diverse populations. Included is the ever-important study of the multicultural demographics, the growth potential for selected products in the major ethnicities, the approaches used by retailers to capture the attention of these markets, the buyer's role in making purchases that fit the needs of the different ethnicities, and the role that advertising plays in attracting the attention of the minority consumer.

Business group comprised of multicultural ethnicities.

DEMOGRAPHICS

The study of the population traits and characteristics of these minorities, or the **demographics,** is vital to the buyer's assessments of their product needs. A good starting place is to begin by studying the data collected by the **Census Bureau.** The general census population is studied every ten years, with the most recent being the year 2000. Of paramount importance in this data is the overall population of the United States and how it was broken down in terms of white Caucasians, African Americans, Hispanics, and Asians, the most important groups in terms of sheer numbers, the buying power of these groups, and the mean household incomes for each. Through careful study of each minority, the retailers and their merchandising teams can assess the potential impact they will have on decisions concerning merchandise needs.

Although the general population breakdown is important to examine, it is even more important to analyze the specific demographics of the major **ethnicities.** Since these are the ones that will need careful assessment by the merchandisers and buyers in determining the breadth and depth of the offerings that are expected to attract them, careful study is vital to the retailer's overall success.

Specifically, the following figures give the merchandising teams real data that will affect their purchases.

Population

At the time of the census survey in 2000 there were an estimated 293 million people in the United States. The breakdowns, according to ethnicities, were:

White Caucasians	216.9 million
African Americans	36.4 million
Hispanics	35.3 million
Asians	11.9 million

Buying Power

For the year 2001, the ethnic communities' buying power was estimated to be:

White Caucasians	$6,219.8 billion
African Americans	572.1 billion
Hispanics	452.4 billion
Asian Americans	296.4 billion

Household Mean Income

According to the census, the mean annual income was:

All races combined	$57,045
White Caucasians	61,237
African Americans	40,068
Hispanics	42,410
Asians	70,221

Although there are many ethnicities in the United States, three are major components that affect the nature of retail inventories. While the American Muslim population is rapidly expanding, at this point it doesn't represent sufficient numbers to warrant specific merchandising direction for retail operations.

These figures are not current, but from many indicators, the percentage of the minorities in terms of overall population continues to increase. A case in point, as stated earlier in the chapter, is that by the year 2050, one in four workers will be Hispanic.

There are some trends and implications that buyers and merchandisers should consider when making their purchasing plans. Included are:

- For the first time, the Hispanic or Latino/Latina population as it is often referred to, has surpassed the African American numbers.

Multiethnic group of graduates.

- It is estimated that by 2010, minorities are expected to comprise one-third of the American population, and since many of their needs are different from the general population, their merchandise wants must be carefully analyzed and considered.

- Although blacks as a group still trail whites in education, they have made substantial gains. In 2000, 72 percent of blacks had a minimum of a high school diploma as compared to 84 percent of whites. This increase in educational achievement generally translates into higher wages, thus the potential for more purchasing power.

- The Hispanic consumers, with their buying power estimated at $452 billion in 2001, now reaches $700 billion, with an expectancy of $1 trillion by the end of the decade.

- Today there are designers in a variety of product classifications that are either African American, Hispanic, or Asian, and are gaining in their appeal to ethnic minorities (many of whom will be discussed later in the chapter). Carefully considering their impact on consumer spending is a must for retail buyers.

- Between now and 2020, the three major ethnic populations are expected to grow at six times the rate as the nonethnic population. In terms of percentages, the ethnic population will grow by 36 percent and the nonethnic by only 6 percent.

- While the growth numbers indicate ethnic population explosion, the areas of the major growth will be concentrated in the following cities, indicating that retailers in these areas will need to address ethnic needs:

Miami	81%
Los Angeles	68%
New York	61%
Houston	54%
San Francisco	47%
Dallas	43%
Washington	43%
Chicago	42%
Atlanta	40%
Philadelphia	30%

• In terms of overall population, if the major ethnicities in the United States were considered as a separate nation, they would become the world's fourth largest economy.

GROWTH POTENTIAL FOR MAJOR PRODUCTS PURCHASED BY ETHNIC MINORITIES

Examination of population growth of the major ethnic groups reveals that they are becoming very important purchasers of consumer goods. These diverse groups do not necessarily fill their needs with the standard fare that retailers have long offered to them. More and more are opting to buy products that fit their specific lifestyles. Retailers are finally facing the realization that such focused merchandising will attract more diverse groups to their stores, catalogs, and Web sites, and increase their overall sales volume.

In the following discussion the three most important minorities, in terms of purchasing power, will be explored in their use of clothing and accessories; cosmetics, fragrances, and beauty aids; and foods products.

African Americans

Although their pure population numbers are almost the same as the Hispanics, their buying power is considerably greater. With clothing and accessories their most important expenditure, closely followed by cosmetics and fragrances, and then food products, they are a market that retailers of all types must consider in their merchandising plans.

CLOTHING AND ACCESSORIES

As a group, African American women make clothing and accessory purchases their single most important expenditure after they have satisfied the basic requirements such as food and shelter. The statistics provided by Cotton Incorporated's *Lifestyle Monitor*, its research aim, indicate that 38 percent of the women in this minority stated they love to shop, a higher percentage than either their Caucasian or Hispanic counterparts. Further evidence of the importance of black women to the retailing community was that 28 percent spent more than $200 in the month that just preceded the survey, compared with 14 percent of the Hispanics and 12 percent of the Caucasians.

According to the fashion director of *Essence* Magazine, a leader in African American publications, this market is just beginning to be tapped, with a significant potential for sales. Based upon e-mails and letters, the magazine's director concluded that

African American women executives are excellent fashion consumers.

price was not an issue for this market. Agreeing with this view, Cotton Incorporated's *Monitor* revealed that 64 percent of African American women would pay more for an item of better quality, compared with 57 percent of Caucasian women and 54 percent of Hispanic women.

The female segment is not alone in this trend. The black man is also becoming a major force in clothing purchases. In ever-increasing numbers, he is spending more on clothing than ever before, and at price points that continue to upwardly spiral. Designer labels are especially receiving attention by the African American male population. Collections such as Sean John, designed by P. Diddy, and Phat Fashions, the creation of Russell Simmons have, in particular, caught the attention of the African American man. Leather products have also become especially attractive to this market.

Teenagers too are impacting the apparel market. With the notable success of the rappers and hip-hop performers, the young are spending considerable sums emulating their heroes. Jeans, in particular, are the major purchases for this group. This youth market purchases more jeans than either Hispanics or Caucasians.

Rounding out the African American apparel purchasing power is the significant amounts spent on children's wardrobes. In every category, style has become one of the most important purchasing considerations.

COSMETICS, FRAGRANCES, AND BEAUTY AIDS

In addition to clothing and accessories, cosmetics, fragrances, and beauty aids follow in importance to African Americans. The merchandise offerings include a wealth of different products ranging from the popular-priced offerings found in pharmacies such

African American teens are major fashion consumers.

as Walgreens and CVS to the higher-priced products merchandised in department stores and specialty organizations. Together, these merchandise classifications are reaching unparalleled sales figures. Industry professionals estimate that the share of today's total sales of $6 billion for these beauty products is spent by ethnic minorities to the tune of $1.5 billion, with African Americans accounting for the greatest numbers.

The brands that are directed toward the African Americans are either those that are exclusively produced by companies that specialize in ethnic products, or major mainstream companies such as Adrien Arpel and Bobbi Brown. These household brands are in direct competition with companies such as Flori Roberts, Iman, Interface, and Patti LaBelle that strictly cater to the African American woman. Recognizing that people of color require specific cosmetic colorations and care products to enhance their complexions, these and other companies continue to develop more and more products, and are realizing unprecedented sales.

FOOD PRODUCTS

Rounding out the major consumer product classifications is food. Although the Asian American and Hispanic communities focus on a great deal of specialized offerings, the African Americans do so to a lesser extent. Produce such as collard greens, a staple in many diets, is generally available in most major food outlets, with these and other products more plentiful in areas that are significantly inhabited by the black population.

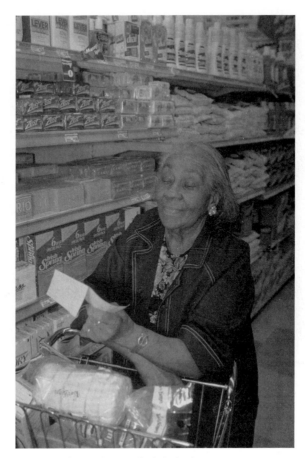

African American seniors are major purchasers of ethnic foods.

Hispanics

Whereas Hispanic and African American population figures are approximately the same, their disposable income is spent somewhat differently. Although clothing, accessories, and beauty products result in significant purchases, on average they spend more of their income on food.

CLOTHING AND ACCESSORIES

This product classification is by no means a minor purchase, even though in total it is less than that spent on food products. More and more celebrity names are being used as marketing tools to attract Hispanics to clothing and accessory lines. Marquee celebrities are being successfully used in an effort to increase sales in these product classifications. Names such as Daisy Fuentes, fashion model and the subject of a Retail Buying Focus in this chapter; fashion model, designer, and author Lucy Pereda; guitarist and singer Carlos Santana; and one of the hottest actresses in film and on television, Jennifer Lopez, are designing lines that are finding significant appeal with

Fashion is an ever-growing product classification for Hispanics.

the Hispanic market segment. In addition to their being involved in the design aspect of fashion, many are just being used to attract the attention of the consumer. Singer Christina Aguilera, for example, is considered the most important marketing "tool" to influence the purchases of teenagers according to *Women's Wear Daily*. In a list that includes Cindy Crawford, Teri Hatcher, Hilary Duff, and Jennifer Lopez, she is number one.

COSMETICS, FRAGRANCES, AND BEAUTY AIDS

Lagging behind the African American market in this product classification are the Hispanics. The reason is that their complexions are almost always similar to Caucasians, therefore most Hispanics opt for products that are marketed to the general population. There is, however, a trend toward establishing cosmetic lines that are specifically for the Latino/Latina market. Zalia, the industry leader at this time, produces a complete line of cosmetics and accessories targeted exclusively at Hispanic women. The line was developed by Monica Ramirez, a first-generation American of Peruvian descent, whose fame came as a beauty pageant winner and makeup artist. Dissatisfied with the products that were primarily directed toward Caucasian women, and its neglect of colorations that would flatter Hispanics, she initiated the trend toward specific makeup for her "Latina sisters" or *chicas*.

It is still a fledgling market, but sales continue to increase every year, with new companies such as Sacha Cosmetics joining the fray.

A Retail Buying Focus

DAISY FUENTES

Born in Havana, Cuba, and eventually making the United States her home, she began her professional career as a weather forecaster on WXTV, an affiliate of Univision. Her audience appeal soon helped her move up the ladder to news anchor at Telemundo's New York affiliate. Her newfound popularity on the Hispanic network eventually helped her move from news reporting to a new career as host of MTV Latino. With all of the accolades and a significant Hispanic following, she became a superstar model. She accepted an offer from

Kohl's, a Wisconsin-based retailer that operates more than five hundred stores in thirty-six states, to develop lines of clothing and accessories.

Beginning with women's apparel, she soon added other products to make her an important part of the Kohl's merchandising mix. Jewelry and handbags soon followed, and with their success, swimwear was next. It was her idea to offer the collection in a "mix and match" concept in which women could customize the look that was best suited for their body type.

Not only have her fashion collections brought significant sales to Kohl's but they have also helped increase the organization's Hispanic customer base.

Daisy Fuentes.

FOOD PRODUCTS

It is in this product classification that Hispanics spend more than their non-Hispanic counterparts. They tend to have larger households, and on average spend 17.5 percent of their incomes on foods such as flour, rice, sugar, fats, and oils.

They often purchase at local *bodegas* where they are able to satisfy the majority of their food purchases. These are small, independent operations that are owned by Hispanics. The packaged foods are often labeled in Spanish, even if it is the same

Hispanics lead in food purchasing of all minorities.

product that is found in traditional supermarkets and grocery stores. National manufacturers recognize that in order to successfully communicate with much of the Latino/Latina population, the "customized" labeling is essential. Many of the buyers for the big food chains are addressing the Hispanic needs by purchasing an assortment of the products that have such appeal.

Asian Americans

Ranking third in numbers behind the African American and Hispanic ethnicities, Asian Americans are especially favored by many retailers because they account for the highest mean household income. In terms of population increase, they and Hispanics are growing at a faster rate than the rest of the population. Their purchasing power is excellent, as reported by Media Audit, a research group. In its most recent survey of eighty six U.S. markets, Media Audit discovered that 56 percent of Asian Americans have household incomes of more than $50,000. They are what merchants dream about because in addition to their high incomes, they love to shop. *Retail Traffic* magazine reports that Asian Americans are the most concerned of all the ethnic groups about keeping up appearances.

CLOTHING AND ACCESSORIES

Asian Americans were among the first ethnicities to produce world-famous designers. Hanae Mori, a couture designer, once alone in this industry, has been joined by marquee

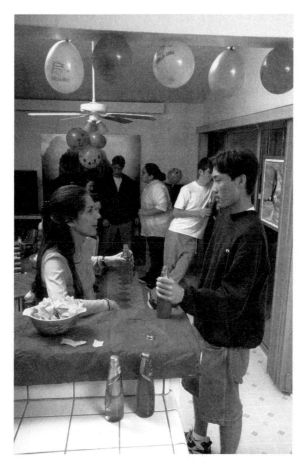

Asian American teens are important fashion consumers.

names such as Anna Sui, Vivienne Tam, and Vera Wang. Each has achieved design recognition through numerous prestigious fashion awards. Newer names to achieve distinction are Maki Doherty-Ryoke, Eugenia Kim, Siri Kuptamethee, Mary Ping, and Jean Yu.

Although their following has many Asian American consumers, they enjoy greater success from the Caucasian population. For example, Vera Wang bridal gowns are anything but "ethnic oriented," and appeal to the upper classes who can afford them. Their collections are the dreams that buyers always envision since they are able to satisfy both consumer markets.

In terms of multicultural retailing, it is the Asian American population to whom retailers are paying the least attention. Some astute buyers, however, are exploring ways in which to attract greater numbers of this ethnicity. One has been to skew their size distribution to small, petite sizes, since this population is typically smaller.

With the involvement of Asian American advertising agencies such as Kang & Lee, major retailers such as Sears are hoping to increase their share of this multicultural segment's purchases.

COSMETICS, FRAGRANCES, AND BEAUTY AIDS

Except for a few product lines, Asian American women are shortchanged in their quest to purchase special cosmetics and beauty aids that will enhance their complexions. One exception has been the Zhen cosmetics that are available at both retail brick-and-mortar operations and online. The company was founded by Susan Yee, an Asian American, and has captured the majority of this market. Another company that specializes in cosmetics for this ethnicity is Skinlight Cosmetics Ltd., a mail-order house based in Surrey in the United Kingdom.

FOOD PRODUCTS

It is in the food classification that Asian American needs are best satisfied. A wealth of products are available in specialty stores and supermarkets throughout the United States where there are heavy concentrations of Asian Americans. In areas like Flushing, New York, where there is a significant concentration of Chinese families, large supermarkets have opened that feature extensive lines of Asian foods, along with the traditional fare. In addition, major supermarkets that are located throughout the United States

Cosmetic producers are beginning to reach out to Asian Americans.

not only stock these specialized foods but also have specially labeled packages, in many Asian languages, on their shelves.

With the continuous influx of people from the Peoples Republic of China, South Korea, Vietnam, and other Asian regions, the need for their "traditional" foods increases. It is an expanding market that seems to be getting more attention from specialty food suppliers as well as the major companies that are adding more ethnic food lines to their offerings.

It is important for the retail buyers to assess these markets and make available the products that will capture the attention of this ethnic population.

MULTICULTURAL MERCHANDISING AND OPERATIONAL APPROACHES

To capture the attention of the ever-expanding ethnicities in the United States, more and more retailers are developing strategies that will encourage them to satisfy their merchandise needs in their brick-and-mortar operations, through catalog usage, and with online purchasing.

Companies such as JCPenney, Wal-Mart, and Sears are paying greater attention to the **multicultural** markets. In particular, Sears buyers and merchandisers have made inroads in attracting the attention of the major ethnicities. Some of the recent multicultural merchandise initiatives at the company is discussed in the following Retail Buying Focus.

Sears is a leader in reaching multicultural consumers.

A Retail Buying Focus

SEARS

Having been one of the perennial mainstays of American retailing, Sears is making an effort to carry out some new approaches that will hopefully bring attention to an even broader segment of the population, the major ethnicities.

With revenues of more than $40 billion, it has traditionally offered a wide product range to families all over the country. In addition to its full-line store operations, its also offers a variety of merchandise through its Web site, and a variety of specialty catalogs.

Sears' success has generally been due to its willingness to make changes in merchandising and operational direction when considered necessary by business indicators. One of the areas in which Sears is paying particular attention is in addressing the needs of an ever-growing multicultural population. Specifically, it is wooing different ethnicities with the expansion of its offerings in style and fashion, and is paying attention to the different ways in which these groups can be tempted to shop at Sears.

Some of the approaches Sears is pursuing include:

- Partnering with Lucy Pereda, fashion model, designer, and author, and well known to the Hispanic community, to design collections that are exclusive to Sears. The merchandise has specific Latino/Latina appeal because of its ethnic label. With Hispanics comprising about 20 percent of the customers living within Sears' primary trading areas, it has proven to be an appropriate merchandising measure.

- Developing a clothing line called Latina Life that is being partnered with *Latina* magazine. This has increased the availability of fashion products to the Hispanic market.

- Developing relationships with multicultural marketing agencies. The Bravo Group and Latinsphere are Hispanic agencies; Burrell Advertising and Circulation Expertise are African American; and Kang & Lee is an Asian American firm.

- Using "faces" in ads that represent the minorities of the communities to which they are directed. For example, if the majority of the customer base in a particular area is African American, the ads will feature blacks.

- Pioneering in the use of bilingual advertising. This has been attempted through the use of Hispanic "spots" on the Si TV channel that features both Spanish and English.

- Introducing its own Spanish language magazine, *Nuestra Gente*, which means "Our People," with a circulation of more than 865,000.

- Partnering with the National Council of La Reza, the most influential Latino/Latina organization in the country, with a program called "From House to Home." The program researches the needs of Hispanic families.

- Developing "The Good Life" calendar that features acclaimed African American talent. In this way it acknowledges this customer base.

- Employing sales associates who can converse in the languages spoken by different ethnic groups such as Hispanics and Asians Americans.

- Using multicultural mannequins in visual presentations in areas that are densely populated by specific ethnic groups.

Early indications reveal that their new strategies are meeting with success.

In addition to the aggressiveness of Sears, Wal-Mart is also attempting to focus on the ethnic minorities. It is putting the most emphasis on the Hispanic population, the fastest growing of the minority groups. The world's largest retailer now prints its monthly circulars in Spanish as well as in English, has launched its own Hispanic magazine, *Viviendo* ("Living"), has a workforce in which 54 percent speak Spanish, features a merchandise mix in which 52 percent of the products have Hispanic relevancy, and stock 43 percent of its items with labels in Spanish.

Other approaches include Macy's introduction of lines such as Cubavera, by Perry Ellis International, that feature women's apparel targeted to Hispanics; Kmart's expansion of its private-label program to include lines such as the Thalia Sodi Collection, designed by Mexican actress-singer Thalia Sodi; and Kohl's addition of a line of clothing by Daisy Fuentes, model and former host of MTV's *House of Fashion*.

REACHING ETHNIC GROUPS THROUGH ADVERTISING

As you will discover in Chapter 20, the retailer's purchasing agent has responsibilities that cut across many promotional outlets. Of significant importance is his or her involvement in advertising.

In terms of capturing the attention of the major ethnic groups, it is extremely important for the buyer to have a complete knowledge of the media that addresses these diverse markets. While the retailer's message can be easily delivered to the American consumer through the use of traditional television programming, radio, newspapers, magazines, direct marketing, catalogs, and the Internet, the delivery is most often in English. However, the increase in the multicultural population and its significant purchasing power has motivated savvy merchants to address specific needs of this market, deliver their messages in other languages, and create ad campaigns that utilize ethnic models in their layouts.

Although many advertisers have recognized the benefit in using African American, Hispanic, and Asian American models in their ads, they often merely use them as substitutes in ads that originally featured white models. Without adjusting the "**advertising copy**" the ad might not be relevant to these ethnic markets. To maximize the potential profits from these different cultures, many retailers are contracting with specialized advertising agencies to help them with their ad campaigns. Some of the better-known ethnic agencies include Accentmarketing, Coral Gables, Florida; the Bravo Group, New York City; NuAmerica, New York City which is featured in a Retail Buying Focus in this chapter; Dieste & Partners, Dallas, Texas; Kang & Lee Advertising, New York City; and Mendoza, Dillon & Associates, Newport Beach, California.

A Retail Buying Focus

NUAMERICA AGENCY

This innovative agency was founded to capture the real essence of urban multiculturalism and provide a context for different types of companies that wish to communicate and interface with the hottest demographic ever—the hip-hop generation.

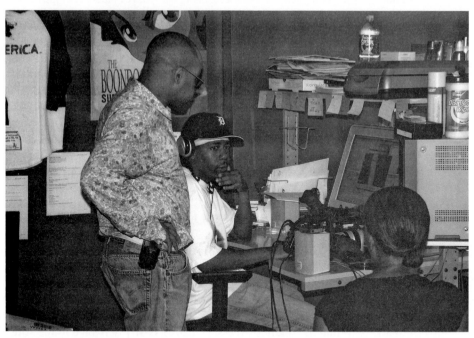

Brett Wright, NUAMERICA Agency CEO, discusses an ad project.

Brett Wright, the company's CEO and a leader in the advertising and marketing field, along with Andre Harrell, record company and film company executive on the West Coast, cofounded the agency. With a wealth of knowledge and hands-on experience in music, the Internet, publishing, advertising, film, and the fashion industry, they have the proven talents to bring innovation in the deliverance of brands to urban culture. NUAMERICA not only generates advertising campaigns for many well-known companies, but also is involved in marketing strategy and consulting. It specializes in developing a business's overall goals and comprehensive brand plans, events and promotions, cutting-edge Web development, and focus group research that enables the use of culturally relevant "language" in campaigns. In addressing and focusing on the changing faces of urban culture, NUAMERICA has attracted such companies as Pepsi, Luster Products, Courvoisier, Rocawear, Apollo Theater, And 1, *Uptown* Magazine, Bulldog Bikes, Showtime Networks, Oster Products, and Tommy Hilfiger.

NUAMERICA was the first agency specializing in ethnic minority advertising to choose Harlem as a base of operations. As the beginning of what Wright called a *New Renaissance*, Harlem also attracted Bill Clinton to set up his offices.

NUAMERICA's success has been due to its ability to figure out solutions for everyday problems of clients, including creating the appropriate marketing message, directing their strategies, designing the appropriate aesthetics for their ads, and determining if they are communicating efficiently and connecting with their consumers.

One of its proudest moments came when it took on the challenge of servicing the Apollo Theater account. The goal was not to make money, but to be aligned with an institution that was looking to reshape its vision and strategy.

Buyer knowledge of all the available ethnic media, which has expanded a great deal in recent years, is necessary to ensure that the right outlets are selected. The following is an overview of the state of the ethnic media:

- Spanish-language newspapers have a combined circulation of over 1.7 million, and more than thirty-five newspapers.
- There are two Spanish-language television networks in the United States, Telemundo and Univision. The former owns fifteen stations and has thirty-five affiliates, whereas the latter owns fifty stations and has forty-three affiliates.
- There are two hundred African American periodicals in the United States with combined readerships of fifteen million. The leading newspapers are the *Amsterdam News*, New York City; the *Philadelphia New Observer;* and the *Michigan Citizen.*
- Asian publications continue to grow but the different languages account for the comparatively small readership of each. The leaders are the *World Journal*, a Chinese entry from New York City with a circulation of 250,000, and the *Korea Times* of Los Angeles, with a circulation of 43,000.
- More than forty million people in the traditional minority communities are being served by the ethnic media.

More and more magazines are being published that serve these consumer groups. Hispanic consumer periodicals, for example, are realizing greater than anticipated subscription growth. African Americans are now able to read a wealth of different magazines to suit their lifestyles. One of the newer entries is *Uptown*, a magazine that focuses on urban African American lifestyles. While the number of magazines directed toward the Asian American market is limited by comparison to the two other ethnicities, they too are increasing in number. The following chart lists a representation of those magazines published for the major ethnic markets in the United States.

African American*	Hispanic*	Asian American**
Jet	People en Espanol	Jade
Essence	Latina	Hyphen
Ebony	Selecciones	Audrey
Black Men	TV y Novelas	Asiance
Black Enterprise	Vanidades	aMagazine

* Top sellers, ranked accordingly
** Unranked.

THE BUYER'S ROLE IN ATTRACTING MAJOR ETHNIC CONSUMER MARKETS

In addition to the involvement in advertising previously discussed, the buyer must also make certain that he or she is well versed in the specific needs of the major ethnic consumers, and how they can be addressed to maximize sales. Following are some of the ways in which these markets can be adequately addressed.

Uptown is a new magazine directed toward African Americans.

- Making certain that the products of minority celebrities are utilized. Serena Williams, known to the world as a major tennis champion, and an African American, and Jennifer Lopez, a Hispanic, are each designing collections that will more than likely appeal to their constituents.

- Reading the wealth of newspapers and magazines that are earmarked for these market segments. There are articles that speak to fashion, and more specifically, the styles that are being touted by the editorial press. The reader, in turn, often uses these writings as a guide to their future purchases.

- Paying strict attention to size allocations. In areas where Asian Americans are in abundance, the female figures are generally more petite than that of the whites. By stocking a better selection of smaller sizes, this is likely to result in greater sales.

- Using visual presentations that feature models of ethnic cultures. Today, every mannequin manufacturer produces models that feature African American, Hispanic, and Asian American coloration, hair texture, and facial features. In this way, the shoppers can better relate to the displays.

- Producing fashion shows that utilize a representation of ethnic models. Consequently, the minority audience can more closely relate to the featured merchandise.

Language of the Trade

advertising copy
Census Bureau
demographics
ethnicity
multicultural

Summary of Key Points

1. The notion that one-size-fits-all is no longer relevant in today's society.
2. An ever-increasing number of businesses are owned by minorities, resulting in greater spending power for them.
3. By the year 2050 the Hispanic population will be one in four, making them an extremely important market segment for merchants.
4. There are many designers entering the fashion world with significant gains in their appeal to their ethnic heritages.
5. African American women make clothing and accessory purchases their single most important expenditure after they have satisfied their basic needs.
6. Hispanics spend more of their income on food products than on any other purchases.
7. Asian Americans have the highest average mean incomes of the ethnic minorities.
8. Merely inserting ethnic minority faces in ads that were initially aimed at Caucasian markets are ineffective as marketing tools.
9. Many retailers are retaining specialized advertising agencies to capitalize on the minority population.
10. There are more than two hundred African American periodicals in the United States, the importance of this market segment.

Review Questions

1. Why is the one-size-fits-all merchandising approach no longer practical for today's retailers to follow?
2. How will the fact that there is an ever-increasing number of businesses owned by ethnic minorities help retail sales?
3. Why is it important to study ethnic demographic numbers and not just general demographics?

4. In terms of population percentage, what number is being estimated as the portion of minorities in the overall population figure by 2010?

5. Why is the fact that minorities are becoming better educated than ever before important to retailers?

6. What is the major product classification that is most important to African American women after they have satisfied their basic needs?

7. What has made the teenage black population a bigger force in retail sales?

8. Which of the three major ethnicities accounts for the greatest sales in specialized cosmetics?

9. How has Kohl's attracted greater attention from the Hispanic community?

10. Why is it more difficult to label foods destined for the Asian American population than for the other minorities?

11. Which major retailer has introduced the Spanish magazine *Nuestra Gente* to attract more of that minority consumer to the company?

12. Is it effective to merely change the faces in ethnic ads and keep the remainder of the ad components in tact?

13. What are the two major Hispanic television stations in the United States?

14. Which of the ethnic minorities has more media outlets directed to it?

15. How do size concentrations differ for Asian Americans than for the other ethnicities?

CASE PROBLEM I

When the Sophisticated Junior opened its first store in Michigan, it was a time when a segment of the female market was underserved. Up until the early 1950s, there was little, if any, apparel that was tailored to fit the shorter-waisted figure. Most items were produced in misses sizes and often required alterations to fit many of the consumers.

It was then that the Sophisticated Junior opened its doors with a specialty that catered to this narrower, shorter female. The specialization that it subscribed to made it different from the rest of the merchants in its general trading area. It wasn't long before the company began to realize sales and profits far beyond what it had imagined. With the first store a success, the business was on the road to becoming a chain operation, and eventually reached other cities within Michigan. The merchandise assortment, first exclusively featuring dresses, ultimately included sportswear and a wealth of accessories.

Throughout its years, the Sophisticated Junior entered into many different retail formats to respond to the needs of its customers and prospective clientele. First it was direct marketing with a catalog that quickly became a success; then, five years ago, the Internet was employed with its Web site bringing newfound sales. The company, at that time, operated thirty-two stores, published five seasonal catalogs, and featured a Web site.

To make certain that its success would continue, the company's management team focused on market research to ensure that they were aware of any changes in their customer base, and would address them when indicators warranted them to do so. Up to this time the research had directed them in terms of merchandising directional changes, new promotional approaches, store design, and so forth. The most recent research indicated a major occurrence that would probably affect the company's future. While management team members were aware of the increase in the different ethnicities that now made up their consumer base in many of their stores, they were not aware of the increasing numbers that would affect them

down the road. Specifically, the increase in African American, Hispanic, and Asian American populations were becoming significant.

Attention now focused on whether or not it would be necessary to rethink their merchandising strategies and redirect their model stocks to reflect those ethnicities' wants and needs. Would the one-size-fits-all philosophy continue to serve the company well, or would changes be necessary if it were to continue on the successful path it has enjoyed ever since it opened its doors? Would store designs have to be adjusted? Would visual merchandising require changes? Would advertising require new approaches? Would the Web site need redesigning to capture this growing segment of the market? These are just some of the questions that required answers.

Management, with the help of a marketing research firm, began to tackle the problem. Many suggestions were made such as:

1. Adjust the merchandise mix to feature at least 50 percent of the products that had a specific appeal to ethnic groups.
2. Plan a store-by-store evaluation and adjust only those inventories that indicated an ethnic population was in the trading area.
3. Change all of the advertising to focus on different ethnic themes.
4. Utilize visual presentations that employed ethnic mannequins.
5. Ignore any changes until a time when sales severely faltered.

At this point, management team members are still planning their next move.

Questions

1. With which, if any, of the management suggestions are you in agreement? Defend your answers with sound reasoning.
2. Pretend that you were a member of the management team. What suggestions would you make in terms of possible changes at the Sophisticated Junior? Make certain that logical reason is the basis for your suggestions.

CASE PROBLEM 2

Barbara Jean Anderson and Betty Meyers have worked together for the past five years at the Perfect Fit Specialty stores. The company has been in business since 1985, and has been very successful as merchandisers of fashion apparel and accessories. Ms. Anderson is the buyer of junior sportswear, and Ms. Meyers is the buyer of a wide range of accessories that include belts, fashion jewelry, and novelty items. They are both in the same merchandise division and regularly interface with each other to make certain that their purchases are focused on the same merchandising concepts such as colors, price points, and so forth.

As is the case with many retail buyers, each has the desire of entrepreneurship. Owning their own businesses, or being partners in such a venture, is their dream. Their ability to work together has been demonstrated time and again, and has made them believe that they would be perfectly suited to become partners in a retail venture.

Before they jumped into this venture they met with financial advisors who made certain they had sufficient capital for such an undertaking. Based on their recommendations, they began a search for the right location. After many months they came upon a property that

would be suited to their plans, and for a rent that would be appropriate. With all of the basic requirements of establishing a business taken care of, such as establishing credit, determining the number of employees they would need to begin the operation, and so forth, they were now ready to choose a merchandising approach that would have the most potential for success. The Fabulous Female was ready to begin its operation.

After examining the demographics of the trading area in which they would begin their venture, the women learned that it was a multicultural setting, with 50 percent of the consumers comprised of the three major ethnicities—African American, Hispanic, and Asian American—and the remainder Caucasian. Their problem was to decide if they would be better served to offer a product mix that had appeal to all cultures, offer a mix that would have half of the products earmarked for the typical Caucasian market and half for the major ethnicities, or just specialize in an assortment that would be directed only toward the minority shoppers in the community.

At this point they are still determining the best strategy for success.

Questions

1. Should the women merely offer a general merchandise mix that would suit most needs?
2. Should the product mix reflect 50 percent of the items that would be attractive to Caucasians and the rest to the minority groups?
3. Should they restrict their offerings only to the three major ethnicities?

CHAPTER 9

What to Buy

On completion of this chapter, the student should be able to:

- Discuss the effect of the store's merchandising policies on the buyer's selection of goods.

- Explain the importance to the buyer of past sales information that addresses price, color, size, and style.

- Discuss how computers have enabled the buyer to make meaningful decisions about purchases.

- Describe the various research techniques that bring information to the buyer that helps with future buying decisions.

- Explain how sales associates and managers help the buyers assess customer needs.

Most professionals in the retail industry readily agree that the lifeblood of any store, catalog, or e-commerce operation is the products that are made available to the consumer. It is the merchandising team, specifically the buyer, that is given the challenge to purchase goods that will meet the needs of the prospective customers. Knowing what the customer will be attracted to, and what price he or she is willing to pay for the goods, will greatly enhance the company's chance for success. When a customer has been satisfied with a purchase, the likelihood is that he or she will buy again and again, steadily enlarging the merchant's potential for future business.

Today's merchandise assortment is greater than ever before. Vendors all over the globe are producing vast assortments of goods in every product classification. Whether it is fashion-oriented wearable products, home furnishings, foods, or anything else, the availability seems endless. From this wealth of merchandise, the buyer must be able to select those items that have the most potential for customer acceptance. He or she must be a professional who is able to discover what is in the marketplace and to assess which items should become a part of the company's inventory. When this has been successfully accomplished, in all likelihood sales will soar and profits will be made.

Buyers use a variety of sources to achieve the goals that have been established for them by management. These sources are divided among those that are in-house and those that are external to the company. Of paramount importance is the information that is generated from inside the company. Specifically, past sales records, merchandise manager input, communication with sales associates and department managers, customer surveys, and merchandise request systems play the most important roles in

determining what merchandise should be purchased, and these are the focus in this chapter. The external sources such as the resident buying offices, reporting services, fashion forecasters, and trade associations, already explored in Chapter 6, showed us how the buyer dovetails outside information with what comes from inside the retail organization.

While the buyer is given a great deal of latitude in the purchase of merchandise, he or she is not given free reign to accomplish the task. Each company develops specific merchandise policies that govern merchandise acquisition. It is within this framework that the buyer must operate and initiate purchasing plans.

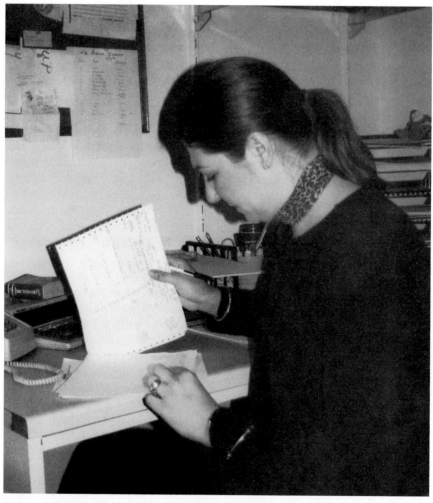

The buyer examines past sales records to develop future buying plans.
(Courtesy of Ellen Diamond.)

MERCHANDISING POLICIES

Whether the company is a small, independent entrepreneurship, or a major retail giant, its merchandising success depends on the buyer's understanding of its policies and the proper carrying out of them.

Policies are formulated to make certain that the potential customer has a clear understanding of what he or she can expect in terms of price points, merchandise quality, product exclusivity, variety, timing of the introduction of goods, assortment, and price policy.

Once these policies have been established, the buyer must adhere to them and acquire the most appropriate goods that fit with them.

Price Points

To attract a specific market segment to their company, retailers often begin with a price point policy. A **price point** is the focus of the selling prices that the retailer has established. It may be, for example, a moderate range of prices that will have middle-class appeal, or higher-priced merchandise that will attract the affluent shopper. The determination is based on the trading area in which the merchant operates and the incomes and lifestyles of those within these defined areas.

The price point is not a very narrow range, but one that includes a number of different prices. In shoes, for example, a moderate price point structure might include footwear that ranges from $50 to $120 a pair. By using this approach, merchants in **brick-and-mortar establishments** are not inundated with shoppers who are either unable to purchase merchandise at these prices or are not interested in moderate-priced goods. They can be more assured that those entering their stores are willing and able to purchase items priced at these levels.

When the buyer purchases goods within these price categories, he or she is on the road to maximizing profits for the company.

Merchandise Quality

Most styles, whether in clothing, wearable accessories, home furnishings, or other products, are generally available in a variety of qualities. Two sofas, for example, similar in design could be priced hundreds of dollars apart because they differ considerably in such areas as fabrication, construction, and finishing. Similarly, two dresses might have almost identical appearances, but the materials used in manufacturing them could differ significantly to result in different prices.

The retail operation must concentrate on a particular quality level that best suits its customers' needs.

Product Exclusivity

Some merchants pride themselves on the exclusive merchandise deals they are able to secure from vendors. Companies like Neiman Marcus and Saks, for example, have

merchandising philosophies that concentrate on this exclusivity to attract shoppers who have needs for such items. By establishing such a philosophy, often these merchants are able to obtain higher markups than most other retailers would achieve for the same merchandise.

Another philosophy concerning exclusiveness of goods deals with **private label** merchandise. The company must direct its buyers about what the proportion of those items should be in relation to the overall merchandise in the store. Private-label merchandise affords the retailer the luxury of achieving higher markups because it is free from price competition.

While some retailers concentrate on exclusivity, others opt for other merchandise philosophies such as relying on a wealth of nationally advertised brands for the bulk of their inventories.

Whatever the philosophy regarding exclusivity of products, the buyer must stay within the guidelines established by management.

Variety

Whether to restrict its offerings to a very narrow variety or to offer a wider choice is another management decision. Should the furniture department concentrate on contemporary styles, or should the assortment feature all periods? As with other areas of concern, the decision rests with the retailer. Once the variety factor has been established, shoppers can quickly assess whether this retailer will satisfy their needs.

Timing of Introduction of Goods

Some merchants take pride in being the first to feature merchandise in their trading area. This is particularly true of those who sell fashion merchandise. They are the fashion leaders, and they motivate their clientele to purchase goods that are "hot off the press" so that they can be the first to wear them. Other retailers play it safe by waiting until the vendor has edited the line, keeping only the numbers that seem to be destined for wider appeal. In this way, the latter group avoids the pitfall of early introduction of merchandise but also forgoes the aura of being "**fashion first merchants.**"

Finally, the off-price retailer waits to buy when vendor prices are sharply reduced and gives up an opportunity for early introduction. Since price is the ultimate factor in such merchandising, the introduction time is irrelevant.

Assortment

How wide an assortment should be made available is yet another merchandising philosophy that needs to be defined. Should the inventory be limited in terms of colors and sizes, or should it be restricted to a narrower choice? Should innovative styles be included in the model stock, or should the emphasis be on basics? These are but two of the questions that need policy direction so that the buyer will know exactly what the merchandise emphasis should be. Whatever the policy, it should be strictly adhered to by the buyer.

Price Policy

The pricing considerations available to the retailer may be many. A company may choose to sell only at the traditional price—that is, take a markup that is standard in the industry. Another might subscribe to a discounting philosophy that provides the shopper with lower prices. Still another price policy could concentrate on off-price merchandise that carries a regular markup but is able to sell for less than the usual retail because of its initial lower wholesale cost.

Some companies stick to just one philosophy, whereas others might opt for all of these pricing structures. For stores that use all of them, there might be a need to be competitive in one of the store's departments to meet the competition through discounting, to feature special purchases at certain times that require off-price buys, and to rely on traditional pricing for most departments at most times.

Whatever the decision, the buyers must follow the guidelines and purchase accordingly.

INTERNAL SOURCES OF BUYER INFORMATION

To properly plan each purchase, the buyer must carefully assess a host of internal sources of information. While it is conceded that past sales records are the backbone of any buying plan, other indicators should be carefully examined before any buying decisions are made. In addition to the past sales data, other notable sources include input from the merchandise manager, suggestions from the department managers and sales associates, and consumer research. Each offers a different means of providing pertinent information to the buyer.

Past Sales

Today's buyer has more information available concerning past sales performance than at any other time in the history of retailing. The records that were kept not too long ago pale by comparison to what is now commonplace in retailing. Typical of yesteryear were numerous hand-recorded entries that needed continuous, painstaking updates in order to provide the proper information for the buyer's decision making.

With the advent of the computer and all of the pertinent data it provides, it is hard to believe that not long ago, retailers had to rely on hand-generated systems for their information. Inventory sheets of the simplest kinds were used to indicate such information, according to vendor, as in-stock styles, wholesale and selling prices, colors, and sizes. Each piece of merchandise was tagged and the tag removed from the item once it was sold. A clerk would then place an X through the sold merchandise, telling the merchant what was still remaining in the inventory. Buyers would carefully examine each vendor's record and make judgments as to which were bringing a profit to the company, which styles were worthy of reorders, and what types of merchandise, in general, appealed to the customers. Today, even the smallest merchant uses a computer that generates a wealth of reports that enable buying to be accomplished more scientifically. With the use of a variety of computer programs, just about any type of record keeping can be accomplished.

	SHERI ASSOCIATES 3780 Broadway New York, New York 539-7420												
Style	Price	Colors	Sizes										
7534 Cotton 	$22.50 $45.00 Received April 20	Red White Yellow	8 X̶ 8	10 10 10	12 10 (X̶2)	14 12 14	16 12 16	 14 	 14 	 16 			
6423 Linen	$24.75 $50.00 Received May 10	Black Green	10 8	12 10	12 12	14 X̶4	14 16	16 	(X̶8) 				
1239 Cotton	$24.75 $50.00 Received May 15	White	8	10	X̶2	12	12	X̶4	14	16	16	18	

Key: 4 — vendor code number
 X — merchandise sold
 Ⓧ — sold but returned

Hand-recorded inventory records were forerunners to today's computerized forms.

In larger retail organizations, teams of computer programmers are employed to create programs or sets of instructions needed by buyers and merchandisers to perform their merchandising tasks. Each is tailored to the specific requirements of the company. A variety of documents that formally required considerable time to assemble are now at the user's fingertips any time of the day, week, or month. With the speed and accuracy afforded by computers, a buyer can immediately access the reports necessary for precise decision making. So vital are these informational reports to buyers that in addition to using them in their home offices, many can be seen toting them to the wholesale markets when they are there to make purchases.

The reports that are typically generated include those that address size and color sales analysis, classification and pricing, active sales, six-month planning, open-to-buy positions, basic stock replenishment, price adjustments, unit sales summaries, and a host of others. Those pertinent to the qualitative decisions regarding buying will be discussed in this chapter, with others addressed in the appropriate places in other parts of the book.

While the reports provide what seems to be endless merchandise information, it is the buyer's analysis that makes it meaningful.

ANALYSIS OF PAST SALES INFORMATION

Just as other managers and executives must analyze data available to them for making decisions, so must buyers. Even when identical information is examined by two

businesspeople, different conclusions may be drawn. The interpretations of the data may vary considerably. In retailing, those with considerable experience and formalized training tend to make the best decisions.

The importance of **sales analysis** cannot be overstressed. It tells the buyer how well his or her past purchases were accepted by the customers, as well as how profitable they were for the company.

Specifically, buyer analysis takes place in the categories discussed below.

Classification. Merchandise is grouped according to the **product classification** in which it falls. Men's tailored clothing is a classification. Within each classification there may be many subclasses. In the men's tailored class, a subclass would be "dress pants."

In staple or basic goods, classification changes are infrequent. For example, men's white handkerchiefs, children's tricycles, 60-watt bulbs, and snow tires are usually in stock for many years without change. These items are the standards that merchants count on for a steady flow of sales and profit. So predictable are the sales of these types of items that **automatic reordering** is often used. The computer is programmed to print out a reorder once each of these predetermined items fall to a prescribed inventory level. Extremely useful in this type of reordering, and for other practices, the advent of radio frequency identification (RFDI) has proven extremely important. This system is a technology of identification via radio frequencies. It can reveal, at any time, exactly how much merchandise is on hand, make reordering a simple task, and track the location of the shipping containers that will bring the merchandise to the retailer. This makes stock management and real-time accountability a reality.

It is the merchandising of fashion items that requires that careful attention be paid to the classifications. Since fashions may be introduced for a period and withdrawn at a later time because of disinterest, such analysis is compulsory. In men's clothing, for example, a major change took place in the early 1990s with the introduction of Friday wear. It was a revolutionary approach to men's proper dressing at the office. The new look featured an array of casual clothing, once taboo in the work world, for use one day a week—Friday. Very close attention was paid to this classification because it was an entirely new approach that the buyer had to assess for future purchasing considerations. Buying more than the customers chose to purchase would have a severe impact on profits; buying too little could result in an equally damaging situation. Although past sales records had no previous history with this new merchandise, the buyer had to draw conclusions from other merchandise introductions in the past and how the customers accepted them.

Classifications, even in fashion merchandise, are rarely changed. When it does seem appropriate, the decision is usually made by the entire merchandising team, not only the buyer.

Price. One of the most important aspects of merchandising is offering the appropriate price points to the prospective customer. Stores are often known to shoppers by their pricing images. The reputation might be "high-priced," "bargain-priced," or somewhere in between. Whatever the case, merchandise purchased must fall within the established range.

Although the price points are carefully spelled out by the merchandise managers, there is some degree of interpretation exercised by the buyer. By analyzing past sales records, a buyer can determine which price, from all that is stocked, is selling best.

Sometimes, there is an indication that a department should "trade down" (emphasize a lower price point) or "trade up" (feature higher-priced goods).

Many years ago, Macy's faced the dilemma of price points. At the time, the company was a moderately priced department store. From careful analysis by management it was felt that the market to which it was catering would someday decline. It was believed that trading up or trading down was the solution. When all of the pricing data from past sales were considered, along with information from numerous outside indicators, the decision was made to make Macy's a higher-priced retailer. With its present position as a renowned, successful merchant of quality merchandise that features upscale price points, the decision was right.

Most pricing adjustments need not take the drastic steps of Macy's. In most cases, it is merely a shifting of price emphasis. A sweater buyer, for example, after examining sales records for the past three years might observe a trend that shows that the higher-priced sweaters sell more quickly, leaving lower-priced goods for markdowns. If the typical selling prices ranged from $35 to $85, and most sales were generated in the $65 to $85 category, it might seem obvious that the new range should be repositioned to eliminate the $35 items and begin at $50 and range to $100. Of course, all of this is a judgment call; only time will tell if the analysis was correct.

The classification of price report shown on page 201 is typical of some that feature pricing information used by buyers. They are often provided on a daily, weekly, or monthly basis, and are used to make necessary adjustments.

Style. The terms **style** and **fashion** are not interchangeable. Style denotes the silhouette or shape of something, whereas fashion describes the style that is currently being accepted by consumers. Style is used not only to describe apparel and wearable accessories, but also for furniture, appliances, tableware, bed linens, and so forth. For example, a sofa may be a contemporary style, a piece of luggage may be a carpack, and a refrigerator may be a side-by-side style. Thus, not only are fashion buyers concerned with style, but so are their hard-goods counterparts.

Buyers periodically scan their sales records to evaluate the "movement" of their offerings in terms of which styles are selling successfully, trends of particular styles, inactivity of some styles, and so forth. Whether the buyer is merely deciding whether or not to reorder an item, or is making preparations for the next season's purchases, style information is of paramount importance. Careful attention to the records will tell the buyer not only about hot items, but will also provide long-range information.

You might wonder about how the buyer judges the purchase of something vastly different from merchandise already in the inventory. Past sales will give historical data about the "old," but certainly not the "new" that has yet to be tested. One way in which buyers make these judgments is by examining the company's track record with regard to untried goods. If, for example, previous sales indicate a willingness on the part of its customers to try something new, chances are other new items will meet with approval. A fashion buyer who successfully introduced miniskirts as soon as they came onto the fashion scene one season, and then also had success with ankle-length styles the next season, is likely to be successful with almost anything that is making a new fashion statement. On the other hand, if records indicate a tendency for customers to stick with basic styles, the introduction of something unique might be unprofitable.

CL PRICE	TOTAL	-O-	-J-	-H-	-N-	-U-	-L-	-R-	-C-	-W-
A1 HALF APRONS&BIBS										
1.00 S	32	12	6	4	1	2		3		4
1.79 S	22	11		3	1	4		2		1
2.25 S	23	5	1	6	1		2	6		2
2.50 S	23	6	4	6		6	1			
2.75 S	17	4	2	5		2	1	1		2
2.99 S	1	1								
5.50 S	18	4		4	2	7		1		
TOT UN S	136	43	13	28	5	21	4	13		9
TOT $ S	.3	.1		.1		.1				
A2 COBBLERS										
2.50 S	50	19	3	5		4	6	8		5
2.59 S	107	28	11	23	2	18	9	4		7
3.00 S	9	1		4		2	2			
3.50 S	10	1		1	3	3	2			
4.25 S	2	1						1		
7.00 S	1	1								
TOT UN S	179	51	14	33	5	27	19	18		12
TOT $ S	.5	.1		.1		.1	.1			
A3 BIBS & COVERALLS										
12.99 S	-1				-1					
TOT UN S	-1				-1					
TOT $ S					.					
A0 ALL APRONS										
1.00 S	32	12	6	4	1	2		3		4
1.79 S	22	11		3	1	4		2		1
2.25 S	23	5	1	6	1		2	6		2
2.50 S	73	25	7	11		10	7	8		5
2.59 S	107	28	11	23	2	18	9	4		7
2.75 S	17	4	2	5		2	1	1		2
2.99 S	1	1								
3.00 S	9	1		4		2	2			
3.50 S	10	1		1	3	3	2			
4.25 S	2	1						1		
5.50 S	18	4		4	2	7		1		
7.00 S	1	1								
12.99 S	-1				-1					
TOT UN S	314	94	27	61	9	46	23	31		21
TOT $ S	.8	.2	.1	.2		.1	.1	.1		

Classification of price report.

ACTIVE STYLE REPORT

Active style report.

Thus the seasoned buyer understands that past sales records that concentrate on style information might not address what is currently being offered in the wholesale marketplace. Only careful analysis of these records will help the buyer make the right choice.

An example of the information available to the buyer who is making "style" decisions is shown on page 202.

Color. Another factor in the all-encompassing buying decision involves color. Whether it is clothing, furnishings for the home, paint, or luggage, the variety of available colors is at an all-time high. Buyers, because of space and budgetary limitations,

Color samples, provided by forecasters, help buyers become familiar with the new season's offerings. *(Courtesy of The Doneger Group.)*

are unable to stock every conceivable color that the vendors offer. They must choose from the assortment the few that will tend to be the ultimate choices of their customers. Will the shoes sell better in basic black, or will hot pink attract more attention? Should the glassware be stocked in "clear," or should the new tinted glass colors be purchased? Will patterned dinnerware be the choice, or will customers want solids? These are just some of the questions concerning color about which the buyer must make decisions.

As with the other factors, color records are meticulously kept and religiously studied by the buyer. The decision to buy a particular style might prove disastrous, not because of its shape or silhouette, but because the color might not appeal to customers. It is true that certain colors are considered to be hot for the season, but they might not please the customers. Even within the same company, different branches or units might require different color selections.

Study of past sales records will not only point up the colors that sold best during the previous selling period, but will also, if properly analyzed, indicate overall color information. For example, if during the past season customers bought the "latest" color, pink, more than any other color, and in the season before bought the "latest" color, yellow, and so forth, the buyer could assume that these customers are generally receptive to the "latest" color. It would then be comparatively safe for the buyer to purchase whatever color is being promoted as the "latest" in the future. However, if surveying past records indicates steady acceptance of "basic colors" and reluctance to purchase "new colors," adherence to basics seems to be in order.

Sizes. Before the 1950s, when American consumers went to purchase clothing, they found relatively few size ranges. They would buy what they found appealing and alter the merchandise for proper fit. Buyers didn't worry as they do today over decisions about the quantities of each size needed. Today's retailer affords the customer as much size differentiation as there are colors. Menswear buyers are offered regulars, longs, shorts, portlies, cadets, extra sizes, extra longs, and so forth, in tailored clothing. It gets even more complicated when dress shirts are being purchased. With neck sizes ranging from $14^{1}/_{2}$ to 17, and sleeve lengths measuring from 32 to 37, the offerings are significant. Women's wear buyers also face size decisions, with the availability of such classifications as misses, juniors, women's, half-sizes, petites, diminutives, and talls. Space is often a major problem, especially in the units of chain organizations and small stores, making careful size selection a necessity.

A major problem could arise if size evaluation from past sales is not carefully addressed. The buyer who merely purchases "full size ranges" without paying attention to the sizes that sold well in the past could be left with inventory that doesn't sell. The styles might be appealing, but often some sizes are left in stock. By examining the size "printouts," the buyer is able to determine which sizes sell best and which sizes might need fewer pieces. In some instances, past sales records will show that for certain styles, the elimination of a size or two might be the better approach to take.

While this might seem to be tedious research, the end result would probably be fewer items left for markdowns.

Materials. Now buyers are being shown more changes in fibers and materials than ever before. Hundreds of different "miracle fibers" as well as the old standby natural fibers and countless blends are available in a variety of constructions. It should be

noted that "materials" selection is not restricted solely to fabrics, but also to others that embody glass, plastics, wood, metals, stone, faux stone, and the like. Buyers of furniture, luggage, dinnerware, glassware, carpeting, and so forth are faced with the same decisions about material selection as are their apparel-buying counterparts.

The proper analysis of past sales records that include material descriptions gives the buyer information on customer acceptance. Materials, like styles and colors, change in terms of customer demand. The records indicate which are in demand at a certain time. Other records that retailers keep also reveal information on merchandise returns. Careful examination might indicate returns for "poor fabric wear." If these are obvious, such materials should not be considered for future purchases.

Finally, the buyer must enter the market understanding that there isn't one single fiber or material that could please every customer. Decisions must be made to include only those that have shown past acceptance, and some newer ones that are being touted by the industry.

Frequency of Purchase. Many records that are kept by buyers and merchandisers provide information concerning the frequency of purchase. Buyers simply cannot justify stocking merchandise that sells infrequently, except in certain circumstances, such as needing an item that might complete an outfit. In swimwear merchandising, for example, sometimes buyers include a piece or two of an eye-catching accessory that enhances a swimsuit but isn't necessarily for sale. These are often referred to as "window pieces." By and large, this is a rare exception. Faced with a turnover problem, which will be examined in Chapter 17, buyers must eliminate the merchandise that sits in inventory and ties up shelf space as well as capital. Weeding out the slow sellers is very difficult. There isn't a buyer in the world who can buy perfectly. There is, however, sufficient information in past sales records to indicate definite slow sellers. These items contribute to lower profits and must be eliminated.

Customer Returns. Occasionally buyers are puzzled by the poor showing of merchandise that seems to have all the earmarks of a winner but is still in stock at inventory-taking time. The problem may be due to faults other than price, color, style, and the like. Examination of past sales records might indicate that customers liked the merchandise and purchased it, only to return it to the store. The fit might be improper or the fabric faulty. Some sales records provide information concerning customer returns that have been determined through questioning at the time of the return. Consistently returned merchandise could serve as an indicator to the buyer that further investigation is needed; this could lead to a correction of whatever was wrong or discontinuation of the item or vendor in question. Only through constant use of this information on returns can the buyer correct the problem.

Input from the Merchandise Manager

In the larger retail organizations, as we learned in Section One, the buyer is supervised by two levels of merchandisers: the general merchandise managers and the divisional merchandise managers. These upper-level managers have all served as buyers before they reached these positions and have acquired a wealth of knowledge that they could pass on to the buyers whom they supervise.

GENERAL MERCHANDISE MANAGER

At the helm of the retailer's merchandising division, the **general merchandise manager (GMM)** generally has had vast experience, first as a buyer and second as a divisional merchandise manager. He or she initially was assigned to a particular merchandise classification and made the purchases. Those who performed their purchasing activities in a most successful manner, and brought profits to the company, were often rewarded with a promotion to the next level, that of a divisional merchandise manager. In this position they had the opportunity to broaden their skills and help buyers under their supervision achieve merchandising success.

The most successful of the divisional merchandise managers (DMMs) ultimately reach the level of GMM, a place in the merchandising division that enables them to direct the acquisition of products for the company.

Although the GMMs don't usually have a great deal of direct contact with the buyers, they do set the tone for the company's merchandising philosophy and pass this information on to the buyers through the DMMs. Of course, seasoned GMMs understand the need for their buyers to have access to them to gain certain merchandising insights, and generally subscribe to open-door policies.

DIVISIONAL MERCHANDISE MANAGERS

The persons who provide the most direct merchandising assistance to the buyers are the **Divisional Merchandise Managers (DMMs)**. They not only serve as information sources for those in their divisions, but they also accompany the buyers to the wholesale markets during market weeks when major purchases are made.

DMMs are knowledgeable in every aspect of merchandising since they have also served as buyers. Their knowledge of the various wholesale markets, vendors, product information, and so forth, makes them excellent teachers for new buyers.

Buyers with especially large merchandise budgets come to rely on the DMMs for assistance in preparing model stocks and other plans necessary to achieve profits for the company.

Input from the Sales Associates and Department Managers

In the brick-and-mortar operations, those who are on front lines, regularly interacting with the customers, are the department managers and sales associates. Some buyers are housed in the retailer's flagships and enjoy constant, in-person contact with these people, while others positioned outside the store use the telephone, faxes, and e-mails for their communications.

Much of the information that these contacts provide cannot be obtained through computer use. By the very nature of their jobs, sales associates and department managers learn about some of the reasons the customers *didn't* purchase. Among them are the following:

1. The merchandise desired wasn't carried by the store.
2. The item in question wasn't in stock at the time.
3. The fit was poor. (How often do customers try on merchandise, only to find that the fit is improper?)

Visits to trade expositions *(above)* enable buyers to see numerous collections under one roof. Off-shore markets are regularly visited by buyers to give their merchandise mixes an international flavor *(left)*.

Men's and women's collections are traditionally introduced on runways.

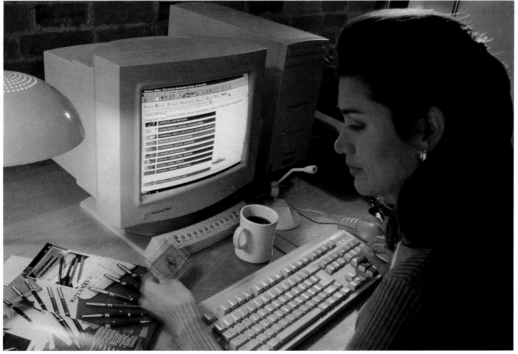

Shopping on the Internet is gaining in popularity with both males and females.

Catalog shopping is growing at an unparalleled rate.

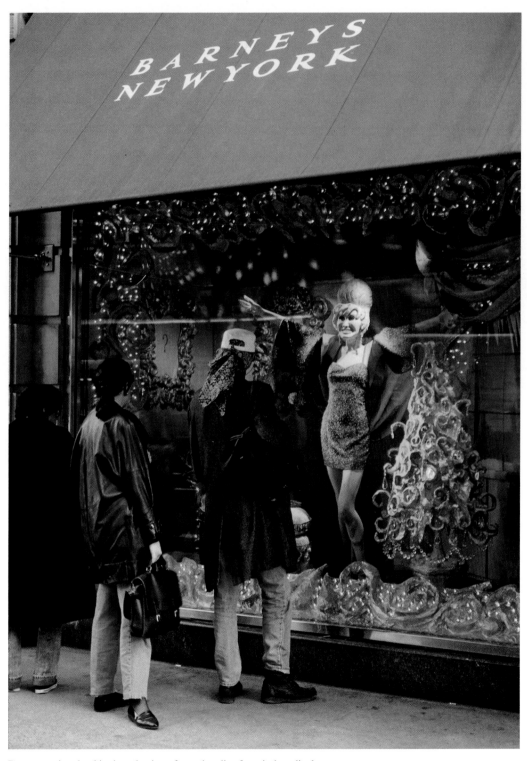

Buyers are involved in the selection of merchandise for window displays.

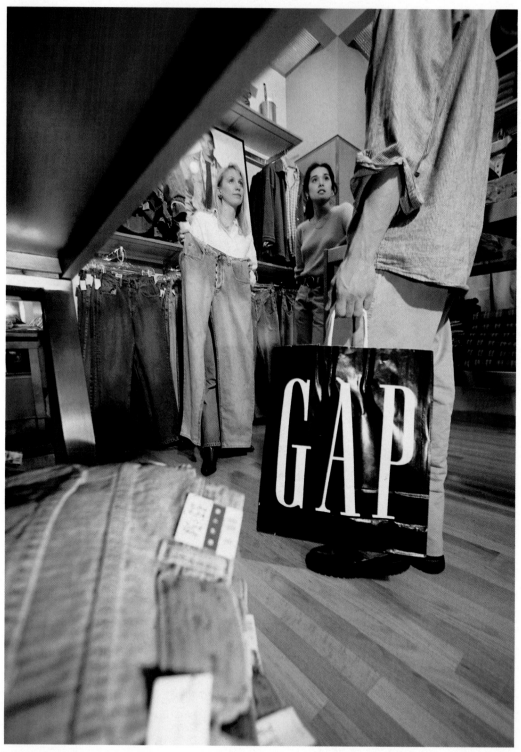

The Gap was the first retail chain to subscribe to "store is the brand" merchandising.

DIVERSITY IS NOT JUST A HEADLINE. IT'S THE FULL STORY.

Nielsen Media Research, the TV Ratings Company, proudly supports the Apollo Theater Spring Benefit.

Nielsen
Media Research
Every view counts.

For more information, visit www.everyonecounts.tv

a vnu business ©2006. Nielsen Media Research. All Rights Reserved.

This ad indicates the importance of multicultural-ism in today's business environment.

Most major retailers are engaged in significant efforts to capture the attention of different ethnicities.

Sales associates help buyers learn about shoppers' needs.
(Courtesy of Ellen Diamond.)

4. The size needed was unavailable, and larger or smaller sizes were requested.

5. The color assortment was incomplete.

Either through regular meetings with these store employees, or through the communication networks previously discussed, the information can be brought to the buyer's attention. Without this, planning of future purchases would not be complete.

In some retail operations, management has instituted a **want slip** system. Sales associates are provided with forms that are filled out when specific customers' requests could not be satisfied. These are then turned over to the buyers, who examine them and determine how their inventories could be adjusted to meet these wants.

Even when the system is not as formal, regular communication between the buyers and those on the selling floor is invaluable.

Language of the Trade

automatic reordering
brick-and-mortar establishments
divisional merchandise manager (DMM)
fashion
fashion-first merchants
general merchandise manager (GMM)
price point
private label
product classification
sales analysis
style
want slips

Summary of Key Points

1. Once upper management has established the company's merchandising goals, the buyers use a variety of sources to achieve them.
2. The most important sources used by buyers to help in the planning of purchases are those found in-house.
3. Merchandising policies must address specific factors such as price points, merchandise quality, exclusivity of product, timing of the introduction of the goods, assortment, and price policy.
4. To attract a specific market segment, a price point, or focus of the selling prices, must be established.
5. Many buyers are involved in the development of private-label merchandise that provides a degree of exclusivity for their model stocks.
6. Past sales records provide buyers with information such as size and color sales analysis, active sales, open-to-buy positions, and a host of others.
7. In the merchandising of staple goods, some retailers use automatic reordering systems instead of calling on buyers to perform this responsibility.
8. Careful attention to past sales records helps buyers evaluate the movement of their offerings.
9. Buyers generally cannot justify the stocking of slow-selling items except in the case when a particular item is needed to enhance a fast seller.
10. General merchandise managers and divisional merchandise managers, once buyers themselves, are invaluable resources for buyers with regard to merchandising decisions.
11. Sales associates and department managers, who are on the front lines, are able to pass on requests from the consumers concerning merchandise needs.

Review Questions

1. Where does the most important information come from that is used by the buyer when purchase plans are being formulated?
2. Who formulates the merchandising policies in retail operations?
3. What are price points, and why must they be established?
4. How are buyers guaranteeing a certain degree of exclusivity in their inventories?
5. Who establishes the proportion of private-label merchandise in a store's overall inventory?
6. Do buyers always opt to buy fashion merchandise as early in the season as possible?
7. Why is today's buyer able to plan purchases more efficiently than yesteryear's counterpart?
8. Define the term *classification*.
9. Describe how automatic reordering systems operate.
10. How can price reports help the buyer make adjustments to his or her price points?
11. Distinguish between the terms *style* and *fashion*.
12. If fashion colors change from season to season, how can past sales records help buyers make fashion-color decisions for future purchases?
13. Why, on rare occasions, do buyers purchase merchandise that is destined to be a slow seller?
14. Can the examination of customer return records help the buyer with future purchases?
15. Why are the retailer's merchandise managers important resources for buyers when making their purchasing plans?
16. How can a department manager or sales associate assist the buyer?
17. Through what means are buyers able to communicate with sales associates or department managers when often they are a distance from the stores?
18. What information can sales associates provide buyers that computers cannot?
19. What is a want slip system?

CASE PROBLEM I

Fashion World is a small chain operation that specializes in women's apparel and accessories. Ever since it opened its first unit in 1995, its success had been better than anticipated. With each additional unit in the organization, which now numbers five, the sales figures kept improving. At this point, however, the company noticed a slight dip in sales volume in three of the stores.

Since the company is a relatively small operation, it was not equipped with an in-house research team to try to determine where the problem lies. The partners, Jack Slaughter and Sam Jacobson, decided to employ the services of a marketing research team to uncover the problem. On Target, a company that specializes in retail research, was their choice. After three months of investigation it was determined that the newly opened off-price venture, Fashion For Less, was probably the cause of the problem. Three of its units were in the same trading areas as the "value" merchant's outlets. Close inspection and analysis of inventories revealed that some of the same lines were being sold, but at lower prices. Marquee labels such as Liz Claiborne, Ralph Lauren, and Calvin Klein were in full supply.

Fashion World had the choice to drop the designer collections that caused unfair competition, but decided that its presence was still needed to round out their merchandise assortments. Without them, many shoppers would probably look to other merchants for these lines.

After a great deal of discussion, Mr. Slaughter came to the conclusion that private branding was the answer to the problem. By adding some items that were exclusive to the company, some of the sales volume that was being lost could now be made up with the new merchandise. Shoppers would not be able to find these items at any other locations in the company's trading area, because private branding affords them the luxury of exclusivity. Mr. Jacobson, however, fully aware of the private-brand concept as he once was the fashion coordinator of a major department store organization, felt that the concept was appropriate only to major merchants.

At this point, the two haven't resolved their problem.

Questions

1. Does private branding seem to be the answer for the company? Why or why not?
2. In what ways could Fashion World possibly merchandise private labels without getting into its own production?

CASE PROBLEM 2

Janet Eastland has been hired as the children's wear buyer at Crompton's Department Store. The company grossed $28 million last year, with the children's department share amounting to $2.2 million. Crompton's is based in the Deep South and consists of a flagship store and eight branches. The branch stores are all located within a 150-mile radius of the flagship, in which Ms. Eastland has her office.

Crompton's, a progressive department store, has all the latest information systems in operation at the flagship. The buyers receive numerous periodic reports, such as style and color analysis, price analysis, and size status.

Ms. Eastland, formerly a buyer with a smaller company, uses all the buyer information she receives. She is, however, disappointed that all the functions she performs, coupled with the distance to the branches, make it difficult for her to get branch department management and sales associate input for merchandise decision making. Being a firm believer in these store members as important information sources, she is concerned about the lack of it at Crompton's.

At present, management is trying to develop a method that would satisfy Ms. Eastland's wishes.

Question

1. What kind of system could be developed that would enable the company to accommodate the buyer?

CHAPTER 10

How Much to Buy

On completion of this chapter, the student should be able to:

- Explain the importance of a six-month merchandise plan and discuss its construction.
- Define the term *model stock* and explain its importance in retailing.
- Define the terms *classification* and *subclassification* and explain how they are used in inventory planning.
- Use the open-to-buy formula to determine how much money is available for purchasing at any given time.
- Discuss the importance of automatic stock replenishment.

Along with the decisions concerning what merchandise should be purchased for the next buying period, as examined in the previous chapter, are matters of a quantitative nature. That is, how much should the buyer be prepared to purchase for each of the items selected from vendor offerings? This is an extremely important aspect of purchase planning, and extreme caution must be taken to ensure that the right decisions about quantity will be made. It is obvious that buying too much will likely cause markdowns that will affect the retailer's bottom line. Of course, buying too little will result in lost sales, another circumstance that will likely affect the company's profit picture.

It is generally conceded by professional merchandisers that even the most careful planning is not foolproof. Nonetheless, a carefully executed preliminary plan that involves buyer communication with divisional merchandise managers most often results in the most efficient plan possible.

As in planning what to buy, the buyer relies on a wealth of informational reports that address past sales as well as information from external resources. Through careful study of these reports, consultation with market specialists, and examination of trade journals and other business periodicals, the road to completing the purchase plan gets under way.

Many of the same computerized reports examined in Chapter 6 are also used for quantitative decision making and need not be discussed here. In this chapter, only factors that relate directly to inventory amounts will be featured, including six-month merchandise planning, model stock development, and open-to-buy planning.

THE SIX-MONTH MERCHANDISE PLAN

One of the first tasks that a buyer must complete in planning dollar purchases is the merchandise plan or **dollar merchandise plan.** In most major retail operations, the period

for which plans are formulated is six months, although this time frame is not essential for every operation. Hence, the term **six-month plan** is the one that most buyers are required to focus on.

The dollars that the buyer must work with have been determined initially by the general merchandise manager, who has overall budgetary responsibility for merchandise, and the divisional merchandise manager, who determines how much money each buyer in his or her division will be allowed to spend. Given this allocation, the buyer must complete the necessary forms, inserting the figures that he or she will be targeting for the next six-month selling period. Most buyers use two different forms. One addresses particular items that are in the inventory and that will be continued for the next time period and the quantity increase or decrease that will be targeted. The other simply uses overall dollar amounts, without any attention given to specific products. While past sales are always the key indicator by which these future purchasing decisions are made, the outside sources already noted also contribute to dollar purchase planning. Such indicators, as published by the Federal Reserve Bank on economic conditions, are also used in these determinations. If, for example, the economic condition's predictions are such that prosperity is expected to spiral upward, this would give buyers of luxury items such as precious jewelry and furs the impetus to increase their purchases of these products. On the other hand, if the outlook seems gloomy, curtailing the dollar amounts earmarked for these products would seem appropriate.

Merchandise planning is extremely important, and if every indicator is carefully assessed, there is potential for increased profitability.

If we examine the first six-month merchandise plan featured on page 213, we see a number of different categories and symbols in the report that might not be understood. They are:

- *Stores:* In organizations with more than one unit, each is indicated by a code number. The discrepancy in the allocated dollar amounts for each store represents the buyer's decision that some will require more merchandise than others.
- *MKD $:* Markdown dollars represent the percentage of sales that the buyer predicts will be necessary to mark down for each time period.
- *BOM Inv $:* This figure represents the buyer's opinion about how much inventory will be needed at the beginning of the month.
- *AVG INVTY:* This is the average inventory for the six-month period.
- *TURN:* This figure represents stock turnover, the number of times the average inventory sells in a store during a time period. It will be further explored in Chapter 17.

A six-month plan for private-label merchandise that addresses particular styles along with the quantities that will be purchased for each is shown on page 215. In this situation, by carefully examining the figures, there will be sharp increases in the number of units that will be purchased for some items, equally sharp decreases for others, and the elimination of still others for the next period. Some of the symbols that are used in the report are explained for better comprehension. They are:

- *NY:* Next year.
- *TY:* This year.
- *CLASS:* The classification of the type of merchandise that the styles fit into.
- *OTD $:* Open-to-date dollars.

SPRING 2006 PLANS

Dept: 355 **Markup %:** 58.0

	JANUARY	FEB	MARCH	APRIL	MAY	JUNE	JULY	AUGUST	TOTAL SEASON	
Sales%		12.0%	17.0%	19.0%	14.0%	27.0%	11.0%			
Markdown%		35.0%	35.0%	35.0%	35.0%	35.0%	35.0%			
Stores: 100										Turn:
Sales $:		36.0	51.0	57.0	42.0	81.0	33.0	25.0	300.0	1.19
MKD $:	8.2	12.6	17.9	20.0	14.7	28.4	11.6		105.0	
Purchases$:		59.2	69.6	59.9	101.0	47.7	53.4		390.7	
BOM Inv $:		250.0	260.6	261.4	244.3	288.5	226.9	235.7	252.5	
Stores: 101										Turn:
Sales $:		14.4	20.4	22.8	16.8	32.4	13.2	15.8	120.0	1.17
MKD $:	3.9	5.0	7.1	8.0	5.9	11.3	4.6		42.0	
Purchases$:		24.3	27.8	23.9	40.4	19.1	27.1		162.7	
BOM Inv $:		100.0	104.9	105.2	98.3	116.0	91.4	100.7	102.3	
Stores: 102										Turn:
Sales $:		12.0	17.0	19.0	14.0	27.0	11.0	11.3	100.0	1.16
MKD $:	3.1	4.2	6.0	6.7	4.9	9.5	3.9		35.0	
Purchases$:		20.1	23.2	20.0	33.7	15.9	20.8		133.6	
BOM Inv $:		85.0	88.9	89.2	83.5	98.2	77.7	83.6	86.6	
Stores: 103										Turn:
Sales $:		8.4	11.9	13.3	9.8	18.9	7.7	5.6	70.0	1.16
MKD $:	1.4	2.9	4.2	4.7	3.4	6.6	2.7		24.5	
Purchases$:		13.3	16.2	14.0	23.6	11.1	12.2		90.4	
BOM Inv $:		60.0	62.0	62.1	58.1	68.5	54.1	55.9	60.1	
TOTALS										
Sales $:		70.8	100.3	112.1	82.6	159.3	64.9	57.7	590.0	
MKD $:		24.8	35.1	39.2	28.9	55.8	22.7		206.5	
Purchases$:		116.9	136.9	117.7	198.5	93.8	113.5		777.3	
BOM Inv $:		495.0	516.3	517.8	484.2	571.2	449.9	475.8	501.5	

SALES	590.0
MARKDOWNS	206.5
PURCHASES	777.3
AVG INVTY	501.5
TURN	1.18

Six-month plan for spring 2006.

Once the six-month plan has been finalized, the next step is for the buyer to develop his or her department's model stock.

MODEL STOCK DEVELOPMENT

Proper assortment planning is necessary if the buyer expects to bring a profit to the company. The inventory must contain a satisfactory assortment of items so that the customer's needs will be satisfied. Thus the buyer must develop a **model stock,** a merchandise offering that carefully outlines the classifications of merchandise to be purchased, the different subclassifications, price points, size distributions, and color choices.

Model stock development is quite different for staple goods than for fashion merchandise. The former is a simple matter since there is generally continuity of these products in the inventory. Men's handkerchiefs and dress socks change very little from season to season and are therefore always necessary in the department's merchandise mix. Buyers of these items merely note the quantities that will be needed for future selling. Fashion merchandise, on the other hand, is a significantly more challenging task to coordinate into a model stock. With styles going in and out of favor much of the time, careful attention to this type of planning is essential. Because there are extreme differences between the two merchandise categories, each will be discussed independently of the other.

Staple Merchandise

Much of the profit achieved by retailers comes from the **staple merchandise** they stock in their inventories—merchandise that is always in fashion. Rarely do these products require markdowns for disposal at the end of a season because there isn't really an end to the season; they carry through from season to season and from year to year. Examples of staple goods include greeting cards, groceries, basic bras, men's boxer shorts, fine china, and so forth. Because of the long life expectancy of these types of goods, complicated merchandising is not necessary.

Of course, the staple offerings are part of a buyer's six-month plan. Once the dollar amount has been budgeted, the buyer merely makes sales projections for the period and determines the inventory levels needed for those projections. Within each product classification, colors, fabrics, and the like must be figured into the plan. Since the colors and fabrics are usually very basic, the problem is not a difficult one.

To clarify the concept better of model stock development for staple goods, Table 10.1 shows a simple plan for a candy department in a department store. It features a six-month plan that runs from January through June. The projection is based on past sales records as well as current trends regarding consumer weight consciousness.

Analysis indicates that candy consumption peaks during February for Valentine's Day, traditionally the greatest sales period for candy. Other months that are important to the department are April, for Easter, and May, for Mother's Day. January is the slowest selling time for candy, as indicated by the minimum amount of expected business.

PRIVATE LABEL RECAP - FALL 2006

DEPARTMENT 355

NY—NEXT YEAR PLAN PURCHASE UNITS FALL 2006
TY—THIS YEAR UNITS PURCHASED FALL 2002

KNITS WILL BE SHOWN IN JANUARY.- THIS IS A ROUGH ESTIMATE
BOLDED ITEMS ARE FALL 1999 PROGRAMS

CLASS	VENDOR	DESCRIPTION	COST	RETAIL	OTD $	JUNE NY	JUNE TY	JULY NY	JULY TY	AUG NY	AUG TY	SEPT NY	SEPT TY	OCT NY	OCT TY	NOV NY	NOV TY	DEC NY	DEC TY	TOTAL NY	TOTAL TY
3530	SADDLEBRED	SOLID PEACH TWILL	$10.75	$36.00	$24.99	0	0	0	0	2646	300	1578	144	2442	384	2790	876	0	0	9456	1704
	SADDLEBRED	PRINTED TWILL	$10.75	$36.00	$24.99	0	0	0	0	972	0	0	0	0	0	0	0	0	0	972	0
	SADDLEBRED	SOLID DENIM	$10.75	$36.00	$24.99	0	0	0	0	0	0	684	144	0	0	372	456	0	0	1056	600
	SADDLEBRED	CORDUROY	$10.75	$36.00	$24.99	0	0	0	0	0	0	0	0	1104	480	0	624	0	0	1104	1104
	SADDLEBRED	YARN DYED FANCIES	$10.75	$36.00	$24.99	0	0	0	0	780	0	0	0	0	0	984	0	0	0	1764	0
	ANDHURST	CVC	$8.00	$26.00	$17.99	0	0	4056	1488	0	2358	1728	2070	2718	4452	3552	1668	0	0	12054	12036
	ANDHURST	FLANNEL	$0.00	$0.00	$0.00	0	0	0	0	0	0	0	1746	0	744	0	1182	0	0	0	3672
	SADDLEBRED	SUEDED POPLIN	$0.00	$0.00	$0.00	0	0	0	0	0	288	0	0	0	288	0	384	0	0	0	960
TOTALS		CLASS 3530—L/S WOVENS				0	0	4056	1488	4398	2946	3990	4104	6264	6348	7698	5190	0	0	26406	20076
3540	SADDLEBRED	S/S PIGMENT DYE PIQUE		$28.00	$17.99	1200	0	672	0	0	90	0	0	0	0	0	0	0	0	1872	90
	SADDLEBRED	S/S PIGMENT DYE TEE		$16.00	$11.99	1200	0	672	0	0	0	0	0	0	0	0	0	0	0	1872	0
TOTALS		CLASS 3540 S/S KNITS				2400	0	1344	0	0	90	0	0	0	0	0	0	0	0	3744	90
3550	SADDLEBRED	MOCK TURTLENECK		$28.00	$19.99	0	0	0	0	0	600	0	0	0	0	1000	966	0	0	1000	966
	SADDLEBRED	TEXTURED HENLEY		$28.00	$19.99	0	0	0	0	0	600	1400	0	0	792	0	0	0	0	1400	1392
	ANDHURST	L/S BLENDED KNIT	$0.00	$0.00	$0.00	0	0	0	0	0	0	0	600	0	630	0	720	0	0	0	1950
	ANDHURST	TURTLENECK	$0.00	$0.00	$0.00	0	0	0	0	0	0	0	0	0	0	0	360	0	0	0	360
TOTALS		CLASS 3550 L/S KNITS				0	0	0	0	0	600	1400	600	0	1422	1000	2046	0	0	2400	4668
GRAND TOTAL		PRIVATE LABEL ALL CLASSES				2400	0	5400	1488	4398	3636	5390	4704	6264	7770	8698	7236	0	0	32550	24834

Six-month plan for private label, fall 2006.

215

TABLE 10.1 Model Stock Development for a Candy Department			
Month	Stock (First of Month)	Sales (Dollars)	Markdowns (Quantities)
January	12,000	$4,000	100
February	50,000	30,000	300
March	26,000	12,000	500
April	33,000	16,000	400
May	35,000	17,000	400
June	23,000	12,000	300

Note that there is some decision making during these periods. During Easter, candy eggs and bunnies are stocked, and for Valentine's Day, heart-shaped boxes. From previous experience, the buyer is almost always able to predict quantities of each. Also obvious from the model stock is the fact that very little is attributed to markdowns, a factor that is quite different in fashion merchandise.

For candy that is not season or holiday oriented, many stores simply use automatic reordering systems for stock replenishment, a topic that will be discussed later in the chapter.

Once the buyer has managed this buying chore for a given period, the development of such a model stock and its purchasing becomes second nature.

Fashion Merchandise

Each season, buyers of fashion-oriented merchandise have a monumental task in determining the quantities that will be needed for their inventories. Deciding which item will be bought in large quantities and which will be purchased in smaller amounts is no simple task. While records of past sales give some insights into quantity considerations, they are by no means sufficient to finalize the model stock offering.

New styles emerge each season in the vendors' collections. Some might be adaptations of current successful sellers, some might be the same items but in different fabrications and colors, and others might be designs that are completely different from what is currently available. Because of the newness of such items, buyers call on market specialists, examine trade papers and consumer periodicals, and attend industrial seminars to help determine how much they should buy of each style. It is not that they won't buy the latest designs if their companies are fashion oriented, but the problem concerns how much of each they should buy. When the current trend in skirt lengths focuses on minis, and the new collections feature a wealth of midcalf lengths, the buyer is often uncertain as to how much to buy in each category.

As shown in the chart on page 217, the planning is not as complex as if the product were more of a fashion risk. The items are those that are regularly carried, but the colors must be adjusted according to the upcoming season. Also, each unit in the organization, noted by a store number, is earmarked to receive different quantities. This decision is based on past sales.

In cases where the coming season is replete with a significant number of new fashion trends and products, the model stock development is not as simple. Buyers must

STYLE #	DESCRIPTION	COLOR	RETAIL	PK	STORES 90	91	92	93	94	95	96	97	98	99	100	101	102	103	104	105	106	107	108	109	110	111	112	TOTAL UNITS	TOTAL $
1115BIG	SOLID PIQUE BIGS	GREY	$30.00	1	4	8	8	8	8	8	3	3	3	4	4	3	6	8	8	6	8	3	8	6	6	3	3	129	$3,870
	SOLID PIQUE BIGS	WHITE	$30.00		6	10	10	10	10	10	3	3	3	6	6	3	8	10	10	8	10	5	10	8	8	5	5	167	$5,010
	SOLID PIQUE BIGS	IVORY	$30.00	1	5	7	8	8	8	7	3	3	3	5	5	3	5	7	7	5	7	5	7	5	5	5	5	128	$3,840
	SOLID PIQUE BIGS	GREEN	$30.00	1	5	7	8	8	8	7	3	3	3	5	5	3	6	7	7	6	7	5	7	6	6	5	5	132	$3,960
	SOLID PIQUE BIGS	NAVY	$30.00	1	6	10	10	10	10	10	3	3	3	6	6	3	6	10	10	6	10	5	10	6	6	5	5	159	$4,770
	SOLID PIQUE BIGS	RED	$30.00	1	3	6	8	8	8	6	3	3	3	3	3	3	4	6	6	4	6	3	6	4	4	3	3	106	$3,180
					29	48	52	52	52	48	18	18	18	29	29	18	35	48	48	35	48	26	48	35	35	26	26	821	$24,630
1115TALL	SOLID PIQUE TALLS	GREY	$30.00	1	4	8	8	8	8	8	3	3	3	4	4	3	5	8	8	5	8	3	8	5	5	3	3	125	$3,750
	SOLID PIQUE TALLS	WHITE	$30.00	1	6	7	10	10	10	7	3	3	3	6	6	3	7	7	6	7	7	5	7	7	7	5	5	145	$4,350
	SOLID PIQUE TALLS	IVORY	$30.00	1	5	6	8	8	8	6	3	3	3	5	5	3	5	6	6	5	6	5	6	5	5	5	5	122	$3,660
	SOLID PIQUE TALLS	GREEN	$30.00	1	5	6	8	8	8	6	3	3	3	5	5	3	6	6	6	6	6	5	6	6	6	5	5	126	$3,780
	SOLID PIQUE TALLS	NAVY	$30.00	1	6	7	10	10	10	7	3	3	3	6	6	3	6	7	7	6	7	5	7	6	6	5	5	141	$4,230
	SOLID PIQUE TALLS	RED	$30.00	1	3	6	8	8	8	6	3	3	3	3	3	3	4	6	6	4	6	3	6	4	4	3	3	106	$3,180
					29	40	52	52	52	40	18	18	18	29	29	18	33	40	40	33	40	26	40	33	33	26	26	765	$22,950
	TOTALS BIG & TALLS		UNITS		58	88	104	104	104	88	36	36	36	58	58	36	68	88	88	68	88	52	88	68	68	52	52	1586	$47,580
			RETAIL		$1,856	$2,816	$3,328	$3,328	$3,328	$2,816	$1,152	$1,152	$1,152	$1,856	$1,856	$1,152	$2,176	$2,816	$2,816	$2,176	$2,816	$1,664	$2,816	$2,176	$2,176	$1,664	$1,664		

Basic stock replenishment—model assortment of private-label Saddlebred.

segment their model stocks to address **product classifications, subclassifications,** styles, price points, sizes, and colors. Each will be explored individually and then presented in a distribution summary.

CLASSIFICATION

The term **classification** refers to the particular kinds of items that are found in a department. For example, a furniture department would carry many classifications, such as case goods (bedroom sets, dining room tables, etc.), upholstered pieces, lamps, rugs, and so forth. A men's department would offer tailored clothing (suits, sports coats, dress trousers, etc.), casual wear, shirts, and so forth. In Tables 10.2 to 10.6, the junior sportswear buyer plans each of the product classifications in his or her department in terms of subclassification (styles), price points, sizes, and colors, as well as a concluding distribution summary. The actual data have been significantly minimized for better comprehension. In reality, the numbers are much higher.

Under the classification heading, the various types of products that are merchandised by this buyer are listed. The columns dated 2006 indicate present sales, stock in dollars, and quantities. The "planned" columns feature the buyer's intentions for the next season. Careful examination shows that some classifications will receive more attention than at the current time, and others will receive less. Specifically, the buyer is increasing the goals in sweaters, shirts, pants, and skirts; decreasing purchases of outer jackets and two-piece sets; and remaining constant in blazers. These decisions are based on such factors as predictions by fashion forecasters, market specialists, and trade publications, a focus of which is presented in this chapter, and of course, past sales.

STYLE

Once the classification summary shown in Table 10.2 has been completed, the buyer prepares a detailed breakdown of each classification according to style or subclassification. It is not sufficient, for example, to merely plan to purchase 525 skirts; you must also make certain that all types have been included. Thus further planning is necessary. Using the *skirt* classification as an example, the model stock for that product is further developed (Table 10.3).

TABLE 10.2 Junior Sportswear Department Classification Summary

	Sales (Dollars)		Stock (Dollars)		Stock (Quantities)	
Style	*2006*	*Planned*	*2006*	*Planned*	*2006*	*Planned*
Sweaters	$17,000	$21,200	$42,800	$44,000	1,512	1,540
Shirts	7,000	8,400	15,200	16,000	760	800
Pants	22,000	24,000	54,000	58,000	1,350	1,400
Skirts	7,800	9,000	20,600	22,000	502	525
Outer Jackets	15,600	1,460	34,000	30,000	156	140
Two-piece sets	12,800	9,200	40,000	18,000	128	90
Blazers	3,600	3,600	12,000	12,000	150	150
Totals	$85,000	$90,000	$218,600	$200,000		

TABLE 10.3 Junior Sportswear Department, Style (Subclassification) Summary of Skirts

	Sales (Dollars)		Stock (Dollars)		Stock (Quantities)	
Style	2006	Planned	2006	Planned	2006	Planned
Short textures	$1,800	$3,000	$4,800	$8,000	147	230
Short flannels	1,800	2,400	4,800	5,400	140	170
Knee-length textures	1,200	1,400	2,800	3,000	40	50
Knee-length flannels	1,400	1,400	3,200	3,200	42	50
Long-length, assorted	1,600	800	5,000	2,400	133	25
Totals	$7,800	$9,000	$20,600	$22,000	502	525

A Retail Buying Focus

FAIRCHILD PUBLICATIONS

John Fairchild began a trade publication many years ago that concentrated on the fashion industry. It has since grown into the most powerful of its kind. Designers, manufacturers, textile mills, resident buyers, fashion coordinators, merchandisers, buyers, sales representatives, fashion editors, and the like each subscribe to one or more of the Fairchild publications and faithfully follow the news they print.

The organization, now a division of Advance Publications, a subsidiary of Conde Nast, publishes a host of different papers, each concentrating on a specific segment of the fashion industry. *Women's Wear Daily (WWD)* is its most recognizable production. Others include the *Daily News Record,* or *DNR* as it is referred to in the trade, a paper that covers the men's wear industry, *Children's Business, Salon News, SportStyle, Footwear News, Decorative Home,* and *HFN,* previously called *Home Furnishing Daily.*

This trade publication empire covers not only the domestic markets for all of its classifications, but also regularly explores the global market to supply its readership with the latest in fashion innovation and trends from around the world. Reporters and camera crews can be seen at all of the major fashion-collection openings and report on what they believe will be hot and what will not. Many a designer's wrath has been piqued when his or her collection has not been favorably presented to the subscribers. Geoffrey Beene, for example, banned Fairchild from ever reviewing another collection when the editors of *WWD* gave the designer a less-than-complimentary review.

In addition to their reviews of the manufacturers' and designers' lines, the papers also report on what's happening in the marketplace. These include articles on new store openings, changes in retailer's merchandising philosophies, retailer and manufacturer expansions, economic conditions, restructuring of fashion organizations, and any other news that would keep readers abreast of market conditions.

Known by many as the bibles of the fashion industry, the pages of the various publications are carefully scrutinized to learn the latest in newsworthy fashion and retailing.

Breaking down the figures according to style, the buyer has further developed the model stock plan. At this point, he or she is equipped to purchase skirts in the necessary quantities by subclassification. The buyer is no longer operating in the dark with meaningless amounts. In this particular case, analysis shows confidence in the desirability of short skirts. The fact that he or she has substantially increased planned purchases in that style shows that the buyer believes that demand will be greater. Eliminating longer skirts could be disastrous in terms of sales, since some customers change their buying habits more slowly and might still want the longer length. It is obvious that the most significant increase is expected in the short-length category, in which the buyer has significantly increased planned purchases.

PRICE POINTS

The next step in planning involves further segmentation according to price. How simple it would be if the department carried merchandise at only one price. We all know, however, that there are always several **price points** from which to choose—the focus of the selling prices that the retailer has established.

The buyer, continuing to refine the plan, prepares a price breakdown. At this time, a potential inflationary economy coupled with a rise in the price of raw materials have caused the buyer to add an additional price point to the department's model stock. Whereas the past plan featured only two prices, the new plan calls for three. Again, this is a simplification of what most stores merchandise. Note that the totals in Table 10.4 must agree with the numbers represented across the board listed after "short textures." Since the buyer hadn't purchased the $70 price point in the past, the dollars and quantities earmarked for purchases are merely educated guesses.

SIZES

Having completed the price analysis, the buyer must tackle the problem of converting these numbers into specific sizes to be purchased. It is not only a matter of buying eighty pieces at $60, as planned in Table 10.4, but a problem of which sizes and quantities of each of the eighty pieces should be ordered.

Size allocation is based almost consistently on past records. Because customers remain constant from one period to another, it is safe to assume that the sizes needed will generally be the same as in the past. A departure from the buyer's typical size breakdown is necessary when the particular style lends itself better to a particular size. For example, large sizes might be eliminated if the style is one that overly accentuates

TABLE 10.4 Junior Sportswear Department, Price Point Breakdown—Short Textured Skirts

Price Point	Sales (Dollars)		Stock (Dollars)		Stock (Quantities)	
	2006	Planned	2006	Planned	2006	Planned
$50	$600	$780	$1,800	$2,150	36	43
60	1,200	1,800	3,000	4,800	50	80
70	—	420	—	1,050	—	15
Totals	$1,800	$3,000	$4,800	$8,000	86	138

the individual's figure. In Table 10.5, the planned size breakdown is similar in proportion to that for the previous year, since the style was basically the same. Only the amounts were increased to conform to the planned quantity increase.

COLOR

Finally, the buyer must translate all of the figures into the colors that appear to be important for the coming season. Because fashion colors usually change from one year to the next, the buyer cannot simply purchase the colors that have sold well in the past and eliminate the slow sellers. Instead, the buyer must make an overall decision based on customers' acceptance of fashion colors, in general. For example, if past records indicate customers to be fashion oriented, the buyer will be safe in purchasing the new fashion colors of the coming season. Color sense and final decision making come as a result of consultation with market specialists, fashion forecasters, study of the fashion periodicals, reporting service materials, meetings with the store's merchandise managers and fashion directors, and the buyer's own knowledge. Color plays an important role not only in the department's merchandise but also in the development of the entire store's color "look" for the season. If color is properly selected and is compatible in all fashion departments, the customer can properly accessorize clothing purchases. If attention is paid to proper color coordination, sales are likely to increase in all the fashion areas of the store. Table 10.6 shows how the buyer might plan colors for the junior sportswear department's $60 short-length textured skirts as planned in the previous breakdown.

TABLE 10.5 Junior Sportswear Department, Size Analysis—$60 Short Textured Skirts

	Sales (Dollars)		Stock (Dollars)		Stock (Quantities)	
Sizes	2006	Planned	2006	Planned	2006	Planned
5			$360	$540	6	9
7			480	720	8	12
9			540	960	9	16
11			720	1,200	12	20
13			540	840	9	14
15			360	540	6	9
Totals	$1,200	$1,800	$3,000	$4,800	50	80

TABLE 10.6 Junior Sportswear Department, Color Breakdown—$60 Short Textured Skirts

	Sizes					
Colors	5	7	9	11	13	15
Black	3	4	5	6	4	3
Brown	3	4	5	6	4	3
Purple	2	3	4	6	4	2
Green	1	1	2	2	2	1
Totals	9	12	16	20	14	9

TABLE 10.7 Junior Sportswear Department, Distribution Summary, Skirts (Excerpted)

				Sizes					
Style	Price	Quantity	Colors	5	7	9	11	13	15
Short textured	$60	80	Black	3	4	5	6	4	3
			Brown	3	4	5	6	4	3
			Purple	2	3	4	6	4	2
			Green	1	1	2	2	2	1

Note that the total adds up to eighty pieces, a number derived from Table 10.5. In Table 10.6, the buyer is purchasing greater quantities of black and brown, with the greatest number of pieces in the middle sizes, typically the department's best-selling sizes. Purple is being touted as a new fashion color, thus the buyer purchases this in slightly smaller amounts than the "safer" black and brown. Green is a "long shot" and is cautiously being planned. Since these are only educated guesses, only time will tell if they were correct. Of course, because this is only an initial model stock, inventory adjustments, according to color, can be made as the season progresses.

DISTRIBUTION SUMMARY

To more easily understand the figures shown in Tables 10.2 to 10.6, they are summarized in Table 10.7 in a more compact presentation. It is an excerpted summary that features the eighty short textured skirts, at the $60 price point, in the sizes and colors planned.

Once these merchandising plans have been established, the resources from which they will be purchased and when they will be arranged for delivery are next on the buyer's agenda. Chapter 11 explores how these determinations are made.

THE BUYING PLAN

Having developed the six-month merchandising plan and the model stock, it is necessary for the buyer to formulate a **buying plan,** a task that involves adjusting purchases according to the merchandise that is already on hand, as well as merchandise commitments that have been made.

In purchasing, it is important for the buyer to stay reasonably within the limits of the buying plan. This does not mean, however, that he or she should be inflexible. If something new is available and hadn't been planned for the department, the buyer should adjust the plan and revise the model stock. But caution must be exercised when making changes. The buyer should not be easily pressured by vendors, but should carefully consider the merits. The buyer who has planned judiciously will not have to make major changes.

Experienced buyers recognize the need for early purchasing in the market and early placement of orders to guarantee prompt arrival of the merchandise. Without attention to this, competitors might gain an advantage, and less selling time will be available for the season.

In carrying out their plans, buyers must carefully consider the fluctuations of their own stock levels. Because store policy generally dictates that budgets must be strictly adhered to, buyers must be constantly aware of inventory fluctuation which involves analysis of open-to-buy positions.

Open-to-Buy

Knowing how much money the buyer has to spend at any given time is extremely important. If a buyer discovers a new item and wishes to purchase it, there must be money in the budget to do so. Thus experienced buyers try never to reach the peak of their budgetary allocations so that new merchandise might be bought to "freshen" their inventories. A hot item might be just what the buyer needs to improve profits, and this might come from a style that wasn't accounted for in the initial stages of buying. Most vendors add a few items to their lines after their initial collections have been introduced, if the need arises. The buyer should always have the funds needed for these purchases.

The key is to have an **open-to-buy (OTB).** Technically, the OTB is the difference between how much the buyer needs for a period to reach his or her sales goals less the merchandise that is already available to him or her.

Although computer programs quickly produce these calculations for buyers and merchandise managers, an understanding of the concept is important for decision making.

The following illustration shows the basic fundamentals of open-to-buy, addressing the variables that are used in its calculation.

ILLUSTRATION

The inventory at retail for budget footwear for Gallop's Department Store was figured at $30,000 on August 1, with an inventory planned at $40,000 on August 31. Planned sales were $14,000, with markdowns of $1,000 for the month. The buyer has already made merchandise commitments to vendors for August of $12,000 at retail. What was the open-to-buy?

FORMULA

Merchandise needed for period × merchandise available = OTB

SOLUTION

Merchandise needed (August 1–31)

End-of-month planned inventory	$40,000
Planned sales	14,000
Planned markdowns	1,000
Total merchandise needed	$55,000

Merchandise available (August 1)

Opening inventory	$30,000
Commitments	12,000
Total merchandise available	42,000
Open-to-buy	$13,000

This is the typical open-to-buy calculation for the beginning of a month.

Through an adjustment in the procedure, a buyer can figure the open-to-buy for any day of the month. This might be needed to determine if there are sufficient funds available to immediately add an item to the inventory.

ILLUSTRATION

Alex Litt, sweater buyer for Michael's Specialty Shop, is contemplating a sizable off-price purchase for immediate delivery for the January sale. To make certain he has the available funds, he must determine his open-to-buy for this date, December 19. The following figures were made available to him:

Present inventory at retail (December 19)	$8,000
Inventory commitments (December 19)	1,200
Planned end-of-month inventory (December 31)	18,000
Planned sales	6,500
Actual sales	5,200
Planned markdown	175
Actual markdown	150

SOLUTION

Merchandise needed (December 19–31)

End-of-month planned inventory		$18,000
Planned sales	$6,500	
Less actual sales	5,200	
Balance of planned sales		1,300
Planned markdowns	175	
Less actual markdowns	150	
Balance of planned markdowns		25
Total merchandise needed		$19,325

Merchandise available (December 19)

Present inventory	$ 8,000	
Commitments	1,200	
Total merchandise available		9,200
Open-to-buy (December 19)		$10,125

Again, this is merely to show how the mathematics work. There are numerous computer programs available to calculate open-to-buy figures.

AUTOMATIC STOCK REPLENISHMENT

In many retail operations, much of the inventory may be found with considerable regularity. Their presence is not based on changes in fashion, but on a regular need by the company's consumers. These items include greeting cards, packaged food products, men's dress hosiery, and other staple items. They are often the products

OPEN TO BUY

33.0%

MONTH JUNE
DEPT. 355

Vendor / Order Detail

BARS	PO#	VENDOR	EVENT	SHIP	CANCEL	UNITS	COST	RETAIL	MU	DESCRIPTION	TOTAL UNITS	TOTAL RETAIL	UNITS RECEIVED	RETAIL RECEIVED
										BASIC STOCK REPL$ / ESTIMATED UNITS	3374	$224.9	74.2	13.9
	111222333	GRAND SLAM	FATHERS DAY	5-27	6-5	408	11.25	34.00	66.9	RETRO TIPPED PIQUE / UNITS	408	13.9	664	$22.6
	2223334444	DUCK HEAD	FATHERS DAY	5-25	6-5	924	16.50	40.00	58.8	TOUR GRP S/S KNITS / UNITS	924	37.0	1,321	$52.8
	333444555	GUY HARVEY	00	5-22	6-5	510	8.50	18.00	52.8	ASSORTED TEES / UNITS	510	9.9	450	$8.5
	555666777	JANTZEN	FATHERS DAY	5-27	6-5	804	10.50	36.00	70.8	COTTON GOLF KNITS / UNITS	804	28.9	664	$23.9
	666777888	SAUCE	FATHERS DAY	5-27	6-5	1104	7.25	28.00	74.1	S/S KNITS / UNITS	1104	30.9	1,104	$30.9
	777888999	NATURALIFE	00	5-27	6-5	720	10.75	36.00	70.1	ASST KNITS / UNITS	720	25.9	719	$25.9
	550484606	BUGLE BOY	FATHERS DAY	5-25	6-15	1860	8.50	28.00	69.6	S/S PRINT PIQUES / UNITS	1860	52.1	1,854	$51.9
	792415608	PALMLAND	00	5-25	6-5	600	12.00	26.00	53.8	S/S JACQUARDS / UNITS	600	15.6	600	$15.6
	885615608	ARROW	FATHERS DAY	5-22	6-5	600	7.00	28-34.00	78.1	S/S TMENT KNITS / UNITS	600	19.2	586	$18.7
	521685608	MUNSINGWEAR	00	6-5	6-11	1236	12.00	40-42.00	70.2	OFF PRICE KNITS / UNITS	1236	49.8	1,185	$47.8
	862685606	NATURAL ISSUE	FATHERS DAY	5-27	6-4	960	11.00	34.00	67.6	S/S JACQS / UNITS	960	32.6	984	$33.5
						9726				TOTAL	13,100	$390.0	10,131	$332.1

Plan Purchases (size grid — summary rows)

	14.2	13.9	13.8	9.0	9.0	8.1	5.4	8.1	8.1	8.1	6.3	6.3	4.2	12.6	13.0	13.0	11.7	13.0	8.1	7.3	6.5	6.5	6.5	4.9	Total
units	109	497	505	535	399	563	511	583	207	287	395	473	460	490	510	514	350	484	520	573	179	266	269	241	
BASIC STOCK REPL$	4.7	4.6	4.6	3.0	3.0	2.7	1.8	2.7	2.7	2.7	2.1	2.1	1.4	4.2	4.3	4.3	3.9	4.3	2.7	2.4	2.1	2.1	1.6	74	74.2
ESTIMATED UNITS	213	269	207	135	165	122	61	122	122	122	96	96		195	195	176	195	122	110	110			66	74	3374
TOTAL UNITS	24.2	21.8	19.1	15.1	12.6	11.6	9.2	17.1	16.3	15.3	11.3	11.2	8.8	21.2	23.5	21.4	18.2	22.2	17.9	13.2	14.0	13.5	12.9	8.5	$390.0
TOTAL ORDERS	813	737	651	507	435	398	309	560	512	500	377	389	291	693	801	699	608	759	566	464	458	476	458	272	13,100
OPEN TO BUY	-10.0	-7.9	-5.3	-6.1	-3.6	-3.5	-3.8	-9.0	-7.2	-6.8	-5.0	-4.9	-8.6	-10.5	-8.4	-3.4	-4.5	-9.2	-9.8	-5.9	-6.7	-7.0	-6.4	-3.6	($165.1)

ACT

Open-to-buy printout.

that are most profitable to their stores. To maximize their profitability, merchants must make certain that they are in stock at all times to satisfy their customer's needs. If they aren't readily available, shoppers could go elsewhere for the product and, perhaps, make other purchases along with the particular product he or she is seeking.

One way in which the retailer makes certain that inventories of staple goods are always stocked at a predetermined level is with the use of computerized automatic reordering. The system analyzes every staple item in terms of sales patterns and determines its ideal inventory level so that profits can be maximized. The ideal inventory is then compared to the actual inventory that is kept up-to-date in the computer's memory. The amount of goods on order is considered, and when the inventory level is below the ideal level, the computer automatically generates a printed reorder that is ready to be checked by the buyer or assistant buyer and is then transmitted to the vendor. This transmittal may take place through traditional mail, faxing, e-mail, or even a tie-in to the vendor's computer.

Automatic reordering, when used properly, not only saves times for the buyer to perform other duties, but also maximizes efficiency. To make certain that the proper inventory levels are being maintained, periodic examination of sales must be examined. In this way, the reorders may be increased or decreased as sales demand.

Today, supermarkets are the largest users of automatic reordering, since much of their inventory is staple oriented. Canned goods, beauty items, cereals, and similar inventory items are merchandised in this manner. Of course, other retailers use this type of system.

FASHION MERCHANDISE REPLENISHMENT

Staple items are only a part of the inventories that retailers merchandise. Fashion merchandise is by far more difficult for buyers to assess in terms of quantitative needs. The perishability factor, generally associated with fashion, makes the task a difficult and challenging one. If a hot item, for example, indicates a need to order more, the arrival might come too late to be profitable, and markdowns might have to be taken to sell off the remainder of the inventory. Conversely, if reorders are not considered, there might be a profit shortfall due to the consumer's desire for the unavailable items. Many buyers try to set limits on reorders, paying attention to only those styles that seem to have the most potential for continuous sales. Too often, a hot fashion really turns out to be a fad, with its popularity short-lived.

A printout of an automatic replenishment report used by some buyers is shown on page 227. It gives a week-by-week analysis of specific items and shows whether reorders are still in the department's best interest.

As a final note, without strict attention to quantitative matters, whether he or she is purchasing merchandise of a staple nature or items with a fashion orientation, the buyer might not be able to deliver the profits to the store as outlined by management.

INVENTORY BELOW MINIMUM

DEPT: 033 APPLIANCES VENDOR: 3000000 GENERAL ELECTRIC CO ------X

SELECTION BY DEPT: 33 CLASS: 113 VENDOR: ALL

CLASS 113

STYLE CS-6 DESCRIPTION MIST CURLING IRON - COMPACT SKU# 0330012-6

UNIT COST	UNIT RETAIL	LAST RECEIPT	LEAD TIME	MIN BUY	MIN STOCK	MAX STOCK	ON HAND	ON ORDER	DUE DATE	AVG WKY SALES	WEEKS SUPPLY	STORE NO.	SUGG REORDER
7.49	12.99	09/28	21	6	12	24	8	6	11/15	2.3	3	01	6
7.49	12.99	10/05	15	6	18	30	6	6	11/15	2.8	2	02	6
7.49	12.99	10/01	17	6	12	24	7	12	11/15	1.5	4	03	18
7.49	12.99	09/17	18	6	24	30	7		11/15	4.3	2	04	12
7.49	12.99	09/26	16	6	12	24	5	12	11/15	3.8	1	05	12
7.49	12.99	10/08	15	6	18	30	7	6	11/15	3.2	2	06	18

STYLE TOTAL..... COST: 494.34 66 *

CLASS

STYLE PRO-12 DESCRIPTION 1200 W. FOLD-A-WAY DRYER SKU# 0330018-7

UNIT COST	UNIT RETAIL	LAST RECEIPT	LEAD TIME	MIN BUY	MIN STOCK	MAX STOCK	ON HAND	ON ORDER	DUE DATE	AVG WKY SALES	WEEKS SUPPLY	STORE NO.	SUGG REORDER	
13.99	21.99	10/05	15	3	21	30	6	6	11/05	3.4	2	01	18	
13.99	21.99	10/06	18	3	18	30	5	6	11/05	4.5	1	02	6	
13.99	21.99	10/05	21	3	15	24	6	9	11/06	5.0		03		
13.99	21.99	10/04	24	3	21	30	9	3	11/06	4.3	2	04	18	
13.99	21.99	10/04	20	3	24	30	32			4.0	3	05	0	
13.99	21.99	10/03	18	3	18	27	6	6	11/18	3.8	2	06	15	*** OVER MAX ***

STYLE TOTAL..... COST: 797.43 57 *

DEPT TOTAL..... COST: 1,291.77 123 **

VENDOR TOTAL.... COST: 5,468.23 477 ***

FINAL TOTAL..... COST: 10,544.73 672 ****

Automatic replenishment report.
(Courtesy of Creative Data Systems, Inc.)

UNIT SALES CLASS SUMMARY

DEPT 20 LADIES SPORTSWEAR

WEEK ENDING 2/20/83 03 3

SELECTIONS: SEASON ALL STORE ALL DEPTNO 20 CLASS ALL GRPS 1=ALL 2=ALL 3=ALL 4=ALL 5=ALL VENDOR ALL

CLASS: 130 JEANS – DENIM

AVG RETAIL SALES: 12.83 ON HAND: 14.82 REC: 13.61 ON ORDER: 13.59 SE: SP SPRING

	TOTAL	01	02	03	04	05	06	07	08	09	10
THIS WEEK	13	1	1	3	2	4		1		1	
LAST WEEK	14		2	4	3		3	1			
2 WEEKS AGO	24		6	3	4	6	2	3			
3 WEEKS AGO	18	2	2	4	4		4	3			
4 WEEKS TOTAL	11			2	3		2	2			
SEASON TO DATE	80	12	12	16	16	13	12	11			
TOT RECEIPTS	305	91	91	33	38	38	38	44			
ON HAND	225	79	79	17	22	25	26	33			
ON ORDER	1,075										
$ SALES	159	2	2	152	153	153	303	153			
$ SALES	1,026	154	154	205	205	167	154	141			
$ INVENTORY		15.00	15.00	20.00	20.00	16.25	15.00	13.75			
$ INVENTORY	3,334	10.22	35.11	7.56	9.78	11.11	11.56	14.66			
		341	1,171	252	326	370	385	489			

CLASS: 131 ACTIVEWEAR

AVG RETAIL SALES: 8.81 ON HAND: 6.72 REC: 6.73 SE: SP SPRING

	TOTAL	01	02	03	04	05	06	07	08	09	10
THIS WEEK	31	5	5	4	8	7	3	4			
LAST WEEK	9				2	2	2	1			
2 WEEKS AGO	13	2	2	3	1	3	3				
3 WEEKS AGO	11	2	2	2	3		2	2			
4 WEEKS TOTAL	8					2					
SEASON TO DATE	72	11	11	11	15	15	11	9			
TOT RECEIPTS	120	12	12	28	17	17	17	17			
ON HAND	48	12		17		2	6	8			
ON ORDER											
$ SALES	634	97	97	97	132	132	97	79			
$ SALES	523	80	7	114	13	13	41	55			
$ INVENTORY		25.00	15.27	15.27	20.83	20.83	15.27	12.50			
$ INVENTORY			2.08	35.42	4.16	4.16	12.50	16.66			

CLASS: 634 NOVELTY TOPS

AVG RETAIL SALES: 9.29 ON HAND: 7.10 REC: 5.86 ON ORDER: 6.11 SE: SP SPRING

	TOTAL	01	02	03	04	05	06	07	08	09	10
THIS WEEK	12			2	2	3	3	3			
LAST WEEK	12	1	1	2	2		1	3			
2 WEEKS AGO								2			
3 WEEKS AGO	12	2	2	2	2	2	2	2			
4 WEEKS TOTAL	54	7	7	9	9	9	10	10			
SEASON TO DATE	971	259	129	133	133	133	114	70			
TOT RECEIPTS	917	259	122	124	124	124	104	60			
ON ORDER	19						19				
$ SALES	503	65	65	84	84	84	93	93			
$ SALES		28.24	12.96	16.66	16.66	16.66	18.52	18.52			
$ INVENTORY	6,510	1,840	13.30	13.52	13.52	13.52	11.34	6.54			
$ INVENTORY			866	880	880	880	738	426			

Unit sales class summary.
(Courtesy of Creative Data Systems, Inc.)

Language of the Trade

automatic stock replenishment
buying plan
classification summary
distribution summary
dollar merchandise plan
model stock
open-to-buy (OTB)
price points
product classification
six-month plan
staple merchandise
subclassification

Summary of Key Points

1. In planning how much to buy, the buyer relies heavily on internal as well as external merchandise information.
2. The most important information available to buyers who are planning for the next period's merchandise is past sales.
3. Six months is the traditional time period for merchandise planning, although other time frames are also used. The choice is that of the particular retailer and his or her type of operation.
4. The Federal Reserve Bank is important in that it predicts the state of the economy. This is an indicator that often helps the buyer with decisions about making merchandise purchases.
5. Stores with more than one unit must assess past sales for each to make certain that the proper inventory levels will be met.
6. A model stock is a plan that carefully outlines the classifications of merchandise to be purchased, the subclassifications, price points, size distributions, and color choices.
7. Model stock development is different for staple goods and fashion merchandise.
8. Quantities of staple merchandise need not be so carefully addressed, since their selling periods are often endless.
9. The merchandising of fashion items into a model stock is difficult because of the perishability factor with these types of merchandise.
10. The term *classification* refers to the particular kinds of items that are found in a department.
11. A subclassification is actually a merchandise style.
12. Price point records are carefully kept to show which selling prices are most important, which are least important, and which are somewhere in the middle. They help the buyer decide whether price point adjustments are necessary.
13. While sizes generally remain constant in a model stock, attention must be paid to certain styles that might be more appropriate for some than for others.
14. Fashion colors change from season to season and generally require careful planning by the buyer.
15. Open-to-buy is the difference between the merchandise that is needed by the buyer and the merchandise that is available.
16. The open-to-buy may be figured at any time of the month.

17. Open-to-buy calculations have become extremely simple to come by with the vast number of computer programs.
18. Staple goods are often automatically reordered by retailers so that appropriate merchandise levels can be simply achieved.

Review Questions

1. Discuss the importance of a six-month merchandising plan. Is this time frame essential for all retailers?
2. What is the most important barometer on which six-month plans are based? Why?
3. In addition to the barometer, what other indicators are used by buyers in the formulation of their six-month planning?
4. How does the Federal Reserve enter into the buyer's merchandise planning?
5. Why are this year's and next year's figures placed in six-month plans?
6. Define the term *model stock.*
7. Why is the formulation of a model stock an important part of merchandise planning?
8. Which general merchandise category requires little work in developing its model stock?
9. Why does fashion merchandise require such careful model stock planning?
10. What is the difference between the terms *classification* and *subclassification?*
11. What other term is used as a synonym for *classification?*
12. How important is it for buyers to regularly check their sales according to price points?
13. Are purchases according to sizes standard for all merchandise within one classification?
14. In what way can a buyer use "sales by color" for fashion merchandise if those colors are unlikely to be in favor for the next selling season?
15. What is a distribution summary?
16. Define the term *open-to-buy.*
17. Why is the open-to-buy so important for buyers to employ regularly?
18. At what times is the open-to-buy calculated?
19. How does an automatic replenishment system work?
20. Why are automatic replenishment systems used by merchants?

CASE PROBLEM I

Having been in business for thirty-five years, Amy's Emporium, a department store with five branches, has come through some difficult periods in the American economy. Some of the leaner years have necessitated that the store's merchandisers pull in the reins, tighten their belts, and proceed cautiously with buying plans.

Historically, no period has been as dangerous as the one the company now faces. The economy has been lagging, economic forecasts have been grave, and management is troubled by the fear that buyers are overly optimistic in planning their purchases. Of particular concern are the luxury departments, featuring furs, precious jewelry, handcrafted glassware, and other merchandise of considerable cost.

A meeting of all the store's buyers has been called to project an atmosphere of caution. Because this is the period in which buyers must begin their purchasing estimates with six-month

merchandise plans, an understanding of the situation is vital. Special attention was focused on luxury merchandise. Although the preceding five-year period has shown approximate storewide sales increases of 5 percent in most departments, furs has exceeded all others, with a growth rate of 10 percent for each of the five years. Management still has asked the fur buyer to proceed cautiously with the dollar plan.

Questions

1. If you were the fur buyer, which in-store indicators would you investigate in the formulation of your buying plans?
2. Which external sources would you survey in the planning?

CASE PROBLEM 2

Caryn's Boutique opened five years ago and has grown by leaps and bounds. The operation began as a "corner" of an established men's shop; it has mushroomed into a separate retail operation apart from the premises it originally shared. The first year of operation (in the men's shop) saw Caryn's Boutique gross $47,000. Today, annual sales are in the vicinity of $475,000.

Much of the store's success was based on the ingenuity of its owner, Caryn. Merchandise purchased was not carefully planned quantitatively but was based on a general "feeling" for additional goods. With the opening of the present operation, all the operational expenses have grown significantly. Caryn has found sales increasing beautifully, but the unsold merchandise has mounted considerably. In her previous operation Caryn bought sparingly because of space limitations. Now, overbuying has become a serious problem. Not in the habit of carefully planning model stocks, Caryn has found her inventory to be short in some items and overstocked in others. Obviously, the key to success of the business is the development of a model stock prior to actual purchasing.

For the coming summer season, Caryn has shopped the market and decided to restrict her purchases to swimsuits, dresses, shirts, skirts, shorts, pants, accessories, and novelty items of the season.

Let alone applying the actual dollars to the merchandise needed, Caryn is confronted with the problem of the development of a model stock for the coming season. Understanding that action based on whim is no longer practical and could be devastating, she is open to suggestions.

Questions

1. Briefly describe the first consideration of Caryn's buying plan.
2. How could she determine, in order of importance, the need for each type of merchandise indicated in the case?
3. List the various steps Caryn should plan before finalizing her purchases.
4. Should she plan to spend every dollar allocated for her initial investment? Defend your answer.

CASE PROBLEM 3

R & L Stores, one of the South's largest supermarket chains, has been having difficulties in recent years. The company, which has been a household word for fifty years in its trading areas, has been showing small but troublesome losses. Its traditional operation has simply been unable to meet the price competition of discount competitors. The problem seems to be that during many uninterrupted years of growth and success, the company has allowed its costs of operation to reach too high a level.

The board of directors of R & L has appointed a team whose responsibility it is to study every level of the company's operation in search of areas in which costs can be cut.

In the area of merchandising, the team has decided that many of the buying departments can be joined together under a single head buyer. This would permit considerable savings, since many purchasing jobs could be phased out. They suggest that through an expansion of the automatic reordering program, such departments as cookies, cakes, breads, and cereals can be placed on completely automatic reordering under the control of one buyer. Naturally, this would permit considerable savings in buyers' salaries.

Questions

1. Will automatic reordering work?
2. Explain the system and its application.

CHAPTER 11

Merchandise Sourcing and Timing the Purchase

On completion of this chapter, the student should be able to:

- Discuss the importance of good vendor relationships to both large and small buyers.
- Describe six important vendor characteristics that must be satisfied in the selection of a merchandise resource.
- Explain the importance of periodic vendor evaluation and the necessity of good record keeping in order to perform this task.
- List and define four classifications of merchandise resources.
- Give the advantages and disadvantages of using the following resources: manufacturers, store-owned resources, service wholesalers, and rack jobbers.

Buyers are charged with the responsibility of purchasing from vendors who provide merchandise that most closely satisfies the needs of the store's customers and provides the retailer with the greatest profit.

The buyer must not only choose from among the practically limitless number of resources, both domestically and abroad, but also must decide whether to purchase directly from the producer or from an intermediary institution such as a wholesaler; he or she also must decide when the purchases should be made. These choices are not always made at the buyer's discretion but are often dictated by a number of factors. For example, in some industries, such as appliances, purchasing from the manufacturer isn't readily available even to the giant retailer—everyone must go to a wholesaler. On the other hand, the very nature of fashion merchandise necessitates, if possible, the direct method of purchase even by the smallest merchant. Of course, if that small retailer doesn't have the need for the minimum amounts set by the manufacturer, or credit restrictions hamper such purchases, buying must be accomplished through wholesalers who have less-stringent buying conditions.

Buyers must consider the factors that make some resources better than others, the classifications of resources and the reasons for purchasing them, and the timing of the purchase.

SELECTING THE BEST MERCHANDISE RESOURCES

A buyer's success depends in large part on his or her choice of resources. He or she must always be aware of the fact that success is based on the profitability of the actual sales of the merchandise rather than the personal attractiveness of the selections. In other words, there is no point in ordering a style that seems to have the characteristics necessary to become a hot item if the vendor cannot meet the delivery dates and requirements of the buyer. Determining which vendors are to be used requires careful weighing of many factors. Ideally, the major portion of the purchases should be limited to a few key resources, with some ordering reserved for trials with new suppliers. When just a few resources are used, the retailer becomes an important user and can generally expect great attention to his or her orders. Of course, this is not always the case, since many merchants require a vast number of suppliers to fill their merchandise requirements. The number of resources and amount of experimentation with new ones vary from company to company, generally based on size and the classifications of merchandise handled.

High-Tech Innovation

Today's merchants have come to rely on a variety of technical innovations that make their businesses more profitable through faster delivery reaction time from their suppliers, which ultimately improves the service to their customers.

A vast number of innovative practices have helped the buyers satisfy their merchandising needs. New innovations are being introduced all the time, and the retailer must carefully assess each to make certain that their presence will be more beneficial than the practices they have in place. Change just for the sake of change may be unnecessarily costly and could bring little newness to the company's operation.

The **electronic data interchange (EDI)** technology is an excellent tool to improve the retailer's purchasing. EDI is the electronic exchange of machine-readable data in standardized formats between one organization's computer and another's. It eliminates the need for a lot of paper pushing by buyers and merchandisers in getting their goods shipped to the retailers by the vendors. Whenever ordering, invoicing, and shipping are to take place, the task can be accomplished more quickly, saving time and energy, and ultimately cost. With the use of laser scanners, satellite linkups, and wireless systems, retailers and suppliers can communicate as never before.

Another technology, **vendor-managed inventory (VMI),** is also making significant inroads in bringing merchants and vendors closer together. Through the use of scanners at the retail level, manufacturers are able to gather information about the sales of their products in the stores, catalogs, and on Web sites, and to replenish inventories on a continuous basis. Thus the vendor is actively involved in making replenishment decisions for the retailers. Among the major companies who are significantly involved in VMI are JCPenney, and Wal-Mart.

With these and other new techniques that are regularly being introduced to the marketplace, buyers will have more time to scan the globe for new resources, plan better merchandise assortments, and help develop products that will be specifically targeted for their companies.

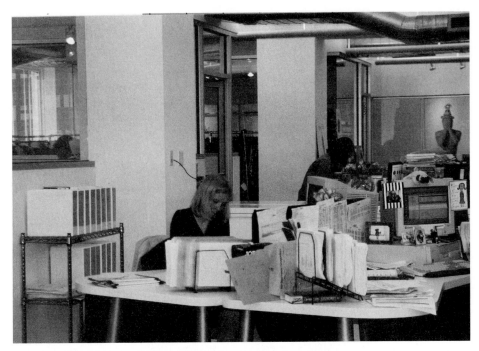

Retailers' and vendors' use of high-tech innovations speed up deliveries.
(Courtesy of Ellen Diamond.)

Vendor Relationships

Mutual respect, trust, and cooperation between the buyer and seller are necessary to ensure long-term profitability for both parties. Regrettably, this does not always occur. When a vendor has a hot line, the demand for the goods is such that it is often unable to fill all of the orders. The decision on which accounts are to be shipped quickly and which customers are to be disappointed is generally based on the relative importance of each customer in terms of loyalty and profits. If someone is to be hurt by a vendor, it is more than likely to be a small independent rather than a giant like Sears. The same holds true for returned merchandise. The better the customer, the more liberal the return policy. Although small stores cannot hope to overcome the edge massive purchasing power gives to the retail giants, they can, by limiting their resources to a few key vendors, improve their relative position. The same holds true of competing large retailers. When there are insufficient goods, the largest user will generally get preference.

Another way for a smaller retailer to ensure fair treatment is by building a good personal relationship with vendors. It is not unusual for a vendor to "steal" a few pieces from the order of a major customer to please small retailers. It is especially true for those the vendor knows to be loyal customers, who give him or her a large portion of their business, and with whom he or she has built a friendly relationship over a long period.

To a large extent, a buyer's relationship with vendors is built on the dependability of the resources in such areas as similarity between the delivered goods and the original samples; no substitution of colors, sizes, or styles without permission; acceptance of legitimate returns; and similar evidences of good faith.

JCPenney's use of VMI helps vendors with replenishment decisions.
(Courtesy of Ellen Diamond.)

Both large and small retailers, by limiting the majority of their purchasers to a few resources, can improve their relationships with the suppliers. However, this should not be overdone. Some purchasing power must be saved for new vendors who have come into the marketplace and offer products that will benefit the retailer's profitability.

Vendor Characteristics

Many other factors must be considered in the selection of resources, including the merchandise offered, vendor distribution policies, promotional merchandise policies, advertising allowances, shipping and inventory maintenance, vendor cooperation, competitive pricing, and adherence to purchase-order specificity.

THE MERCHANDISE OFFERED

Naturally, no supplier should be considered whose offerings are not appropriate for the retailer's inventory in terms of price point, style, and consumer preference. However, there are degrees of suitability, and the first judgment in vendor selection must be whether or not the items are salable. For most merchandise, buyers require more than suitability. Fashion merchandise, for example, requires uniqueness and originality. This may be accomplished through design, durability, and even the packaging.

The availability of goods when needed is also crucial. What good is an outstanding product if it is unavailable at the time it is needed on the selling floor? The vendor's season does not coincide exactly with the retailer's. Some vendors, to reduce their

markdowns, start curtailing production long before the retailers' needs have been completed. If goods are still selling well in the retail environment, continuity of merchandise is a must. When consumers are still in a buying frame of mind, empty shelves will not satisfy their needs.

A good resource should be maneuverable and adaptable to market demands. When the original line of merchandise that was initially introduced at the beginning of the season lacks some items that are hot in the marketplace, the vendor should be willing to add adaptations of these styles in midseason while consumer demand is strong. If the vendor is opposed to such merchandising, the buyer should consider making purchases from other resources. It must be understood that suppliers who merely stay with their initial collection's offerings may not provide the goods that will eventually become the season's winners.

If specific national brands and labels are key to the success of the retailer, vendor selection is automatic. In fashion-oriented operations, names like Ralph Lauren, Tommy Hilfiger, Liz Claiborne, Calvin Klein, and DKNY are essential. It is not up to the buyer to decide if they are needed or not, but to select from those collections the items that seem to have the most consumer appeal. A designer label or brand alone does not guarantee success and ultimate profit. These lines must be as carefully examined as any others to make certain that the right choices are being made.

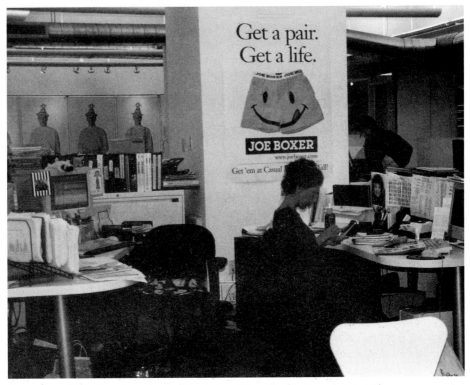

For major retailers of men's underwear, the choice of lines like Joe Boxer is automatic.
(Courtesy of Ellen Diamond.)

More and more retailers are inclined to have goods manufactured for them that meet specific requirements. They often bear the store's own label instead of that of the vendor. These goods must be ordered from a vendor who is capable of following the specifications outlined by the buyer. This type of purchasing, generally reserved for the major retailers because of the large quantity requirements, is steadily growing. Because of the degree of exclusivity it provides the retailer, it offers price protection from competitors. In Chapter 18, considerable attention will focus on merchandise that is being produced by manufacturers for exclusive retail use.

VENDOR DISTRIBUTION POLICIES

With the exception of highly advertised, branded **convenience goods** (items that are purchased with a minimum of effort) and designer collections that are a must for fashion operations, no buyer wants to carry the same merchandise as the competition. In selecting vendors, the buyer should attempt to find sellers who agree to limit sales of the particular styles purchased to a well-defined geographic area. Legislation, however, makes this a difficult task. Manufacturers are not able to exclusively distribute merchandise at their discretion. Any merchant with the proper credit credentials, for example, cannot be denied the right to purchase from a company.

Vendors approach this problem in any one of a number of ways, because exclusivity often results in the placement of larger orders from retailers. They might require a large minimum order to be eligible for delivery, eliminating retailers who are not capable of making such purchases. Merchandise production might also be limited so that orders will be filled on a preferential or seniority basis. By doing this, "latecomers" to the vendor, unable to receive their orders in a timely manner, might be discouraged from purchasing. If shipments cannot be guaranteed, then buyers cannot take the chance of having inventory gaps. Finally, many of the vendors have instituted policies that restrict specific "groups" within the collection to certain retailers. By doing this, merchants have some degree of exclusivity. Vendors are not breaking the law since other merchants may still carry the "name" brand, but not the exact merchandise as the competition.

PROMOTIONAL MERCHANDISE POLICIES

More and more retailers are running periodic sales to offer bargains to their clientele. At these times, markdowns of slow sellers are offered as well as merchandise that has been specifically brought to the store that has been purchased off-price—merchandise that buyers have been able to purchase at less than the usual wholesale price. By mixing the markdowns with these special purchases, buyers are able to achieve better overall markups and higher profits.

Just about every manufacturer has goods left that have not sold as well as anticipated. Just like their retailer counterparts, vendors must also dispose of this merchandise at reduced prices. Some suppliers dispose of the goods in their own factory outlets or through sales to merchants who deal exclusively in off-price retailing. Others have promotional policies that first allow their regular customers the opportunity to buy this "distress" merchandise. In the women's swimsuit industry, for example, it is typical of high-profile manufacturers to offer their regular customers the opportunity to buy **closeouts** before the goods are disposed of elsewhere. Often, this markdown is in the

midst of the retail selling season, and gives the merchant the opportunity to bolster his or her inventory at lower costs. When the merchant runs a sale, it is more profitable because of this price advantage.

Retailers who offer these special sales events must make sure that a certain number of the vendors they deal with will provide them with merchandise closeouts. In this way, the "**bottom line**" will be better.

ADVERTISING ALLOWANCES

In today's retail environment, the promotion of one's business is becoming extremely costly. With the costs of print and broadcast advertising continuously spiraling upward, some retailers are finding it difficult to come by the dollars necessary for all of their advertising needs. To stretch the advertising budget, buyers regularly try to negotiate with vendors for advertising allowances. The concept is known as **cooperative advertising.** In this plan, the vendor shares in the cost of advertising with the retailer. Each pays 50 percent of the cost of the advertisement. In this way, for example, a merchant who has budgeted $1 million for advertising actually has $2 million to spend.

Not all vendors, especially those who are small, can participate in such programs. In such situations, the buyer must carefully assess the need for this supplier's goods and should purchase only if suitable substitutes cannot be found at vendors who do provide advertising dollars. Of course, if this vendor's goods provide excellent profits to the retailer, purchases should continue.

A more complete discussion of cooperative advertising will be presented in Chapter 20.

SHIPPING AND INVENTORY MAINTENANCE

Like retailers, suppliers vary greatly in size. Some will ship only large-quantity orders. Others, with limited resources, are unable to handle large orders. It is important that the buyer select resources that are not only able but eager to handle the order.

The shipping practices of the vendor are important in many ways. Primarily, the buyer must be sure the goods will be at the company on the specified delivery date. If the merchant's customers are to be satisfied at the time they want the merchandise, it must be in stock. If this isn't the case, the customers may go elsewhere.

Speed of delivery for orders and reorders is an important factor, especially for fashion merchandise and other perishables. The longer it takes for such items to reach the merchant's premises, the less time they will be available during the expected selling cycle.

Another important consideration pertaining to speed of delivery has to do with space limitations and financing. More and more retailers are finding that space is at a premium for stocking merchandise and that they are unable to carry the quantities they normally would like to. For this reason, quick delivery is essential to fill the shelves and satisfy customer needs. As for financing, large orders require large monetary outlays, something that many retailers cannot afford. By ordering smaller shipments, and reordering more merchandise as needed, the financing can be spread out over a longer period.

Retailers who cannot buy in large quantities often turn to wholesalers for their needs. Although wholesalers' prices tend to be higher than the manufacturers', they keep large inventories on hand so that they can respond immediately to their customer's

needs. Delivery from wholesalers may take only one day, a very important advantage to retailers who carry minimum inventories.

In practice, buyers quickly learn which vendors they can depend on for prompt delivery and which they cannot. Those who routinely live up to delivery conditions as outlined in the purchase orders should always be given first consideration when new orders are to be placed.

COOPERATION WITH CLIENTS

Vendor cooperation covers a number of areas that could help make the buyer's performance reach its greatest potential. They include the truthfulness of the sales rep's presentations, a willingness to provide promotional assistance, the presentation of special events such as trunk shows, the provision of visual merchandising props, training in the use of certain products, and merchandise ticketing services.

When a buyer sets out to purchase the products that have been outlined in his or her merchandising plans, he or she is often confronted with a great number of different styles. From the wealth of available merchandise, the lines or collections must be carefully scrutinized to select the items that seem to have the greatest sales potential. While buyers have the final say in terms of selection, they often seek the advice and counsel of sales representatives in terms of what they should choose. These vendor representatives can be most helpful to the buyer. Because they are fully aware of what the other retailers are buying, and what items are selling better than others, they can pass on information as to what's hot and what's not. Of course, some sales representatives might be less than candid with the buyers. They might want to dispose of some slow sellers and make recommendations for the buyers to purchase these items. It is up to the buyer to assess the seller's truthfulness before acting on any recommendations. This assessment comes from past experience. If the representative's recommendations have proven to be "on target," then future suggestions can be taken. If, on the other hand, past recommendations turned out to be disastrous, caution should be exercised for future considerations.

Complete reliance on salespersons' information could be dangerous, however. It is the buyer who must make the final judgments.

In addition to the cooperative advertising allowances already discussed, vendor cooperation may come by way of providing promotional assistance to the buyer. Some vendors, for example, arrange for in-store fashion shows at their own expense. Such presentations, when undertaken by the retailer, are generally costly and sometimes out of the company's reach. With the enormous competition in retailing today, merchants are always looking for ways in which to bring attention to themselves. Similarly, with the significant amount of vendor competition, more and more designers and manufacturers are offering these promotional activities to their customers in order to gain their business. Buyers should always look to their suppliers for such cooperation, and when there is little difference from one vendor's line to another, the one that provides such promotional assistance should be chosen.

One company that offers such assistance to its clients is Liz Claiborne, which is covered in the Retail Buying Focus.

One way in which buyers can get a better feel for their customers' responses to specific merchandise collections is through the presentation of **trunk shows**—events that feature either a designer or company representative who brings his or her collection to the retailer's premises for the customers to see it and learn about it firsthand. The goods are

A Retail Buying Focus

LIZ CLAIBORNE

The name Liz Claiborne is recognized by most fashion consumers throughout the United States. In the late 1970s, Claiborne and two partners began what has become one of the most successful operations ever to reach the fashion consumer market. At first there was only one collection, but with its unique success, the company expanded and began to produce variations on the initial collection. Liz & Company, Lizwear, Dana Buchman, and Claiborne, its men's division, are just some of the collections that make up the Liz Claiborne empire. Other products such as shoes and eyewear are licensed, which gives the company name even greater exposure.

Early in its history, Liz Claiborne recognized that it would be beneficial to co-operate with its retail clients by helping them sell the merchandise. It participated in cooperative advertising, as many companies do, but it didn't stop there. Taking a cue from the higher-priced fashion houses, it began to participate in fashion show presentations in the stores. In the early days, Claiborne would make in-store appearances in conjunction with a fashion show production. The promotions were immediately successful. Shoppers would see the line presented in runway format and hear the company designer discuss the various styles.

Today, the company is totally involved in cooperating with its customers to keep its name in the forefront of fashion. Although Claiborne herself has retired from active involvement in the business, the fashion show approach she began is still an important part of the organization's pubic relations program. Professionally trained representatives regularly take to the road and present in-store fashion shows. They provide commentary and are available at the show's conclusion to meet and greet customers and answer questions about the Liz Claiborne collections.

Not only does this improve relations between the retailer and the company, but it usually helps boost sales for both the store and itself.

sometimes brought in large trunks, thus the name of the concept. While buyers can usually select only a portion of the line to be carried by the store, the entire collection is made available through the trunk show. Customers are often invited to try on the different styles and to order them. In certain situations, merchandise may be adjusted to the customer's needs and color preferences, but this is generally reserved for higher-priced lines. St. John's Knits and Bob Mackie are just two who regularly use the trunk show format.

Some vendors, particularly in the cosmetics industry, create point-of-purchase display materials for placement in stores. They are in the form of counter cards, signs, and merchandise containers, and each helps draw attention to the products. Since cosmetics are often purchased impulsively, display pieces of this nature often motivate customers to buy. With the considerable expense of visual merchandising props, buyers who get them without cost from the vendor are helping their company to stretch their display budgets.

In some merchandise classifications such as small appliances, computers, fax machines, and copy machines, demonstration is necessary to make the sale. With all of the technological advances seen today, the operation of these products is sometimes

complicated. So that merchants may do the best job in showing how these products are used, many vendors offer demonstrations. By taking the guesswork out of proper equipment usage, the retailer is more than likely to provide a positive impression to its customers.

It is frequently desirable to deal with resources that are able to ticket goods in advance of shipment—referred to as **preticketing.** This service is an important one in terms of time, space, and labor savings. Preticketed goods may be moved directly to the selling floor, saving the usual time necessary to get them there. This gives the merchant some extra selling time. It is especially important for reordered merchandise that must reach the shoppers as quickly as possible. Reducing the amount of space required for merchandise handling allows for more space to be devoted to selling. With retail rentals continuously increasing, this is an important consideration. Retail selling space is vastly more valuable than warehouse or workroom space.

Although buyer–vendor cooperation is essential for any successful retailer, it is the merchandise that is most important. Once it has been determined that the vendor's product is suitable for the buyer's merchandise mix, the areas of cooperation can be addressed.

COMPETITIVE PRICING

Naturally, the only resources to be considered are those within the price points offered by the retailer. Of course, within each price range there is generally a wealth of suppliers who offer much the same merchandise. In these cases, the buyer must ascertain which comparable products offer the best value. For example, in a buyer's predetermined model stock there might be a call for modestly priced sweaters to retail somewhere in the $35 to $40 range. Depending on the store's markup, these items could wholesale anywhere from $15 to $17. All things considered—such as style, quality, color assortment, and fibers—the best-priced merchandise should be chosen. If one item wholesales for $15 and another $16, the former should be purchased. While the $1 differential seems inconsequential to consumers, to merchants it is very meaningful. When significant quantities are in question, this amount could bring extra profits to the company. Just consider if the merchant is a giant in the industry like Wal-Mart or Sears, where a particular style might warrant tens of thousands of pieces, retail sales would also reflect tens of thousands of additional dollars.

Don't forget that this competitive pricing should come into play only when there is no significant difference among the products under consideration. Price is not the only factor to be considered.

ADHERENCE TO PURCHASE-ORDER SPECIFICITY

Buyers carefully place purchase orders that indicate styles, colors, sizes, delivery dates, discount terms, and so forth. These factors are extremely important to the six-month plan and model stock that has been developed. Adherence to the orders is necessary for the buyer to have a merchandise mix on the selling floor that will satisfy the customer's needs.

All of this planning is only part of the equation for success. The vendors chosen to fill the purchase orders must faithfully stay within the parameters set by the buyers. While this seems like a simple task to complete, it isn't always the case. Some suppliers often stray from the purchase orders for a number of reasons. They might not have the specific color that was requested and might substitute another in its place. All of the

sizes that were indicated might not be available, so others are sent instead. The original fabrics might not have been used in the actual production, and substitutions are made. Merchandise might take longer than expected to produce, necessitating later deliveries.

These deviations from the original purchase order should be unacceptable. Each could seriously affect retail sales. Buyers know what best suits their customer's needs, and when the products are needed to best serve those needs. Any variation from what was ordered should not be accepted.

Adherence to the specifics of the agreement is a must. Vendors who violate this contractual obligation should not be considered for future buying plans.

The Bottom Line

In the final analysis, the essential feature of a key resource is profitability. Will the vendor faithfully produce merchandise that features the qualities needed by the buyer's company, will it be delivered on time, and will it serve the needs of the customer? If the answers to these questions are yes, then it is more than likely that the merchant will achieve the profits needed to run a successful operation.

PERIODICALLY EVALUATING RESOURCES

Periodically, the buyer must weigh and measure the contribution of each resource in every price point for which he or she is responsible. Vendors whose lines have not measured up to expectations must be eliminated from future purchasing plans. A number of different records are kept that give the buyer a quick look at the relative worth of each supplier in terms of profitability for the company.

Evaluation Aids

The types of records that are kept by retailers for the buyer to use in the evaluation of resources are numerous. Today, each of these is conveniently stored in pocket-size, hand-held devices, the majority of which are Palm Pilots. Before these inventions, resource diaries, resource lists, and vendor analysis forms were carried by the buyers to the marketplace. In some instances, some are still preferred by buyers.

RESOURCE DIARIES

The **resource diary** is a compact book that lists the essential features of each vendor. It is generally made up of computerized printouts on loose-leaf pages, one for each vendor from whom the buyer purchases. The loose-leaf arrangement allows for the buyer to insert new vendors and eliminate those who are no longer being used by the company. It is generally carried by the buyer on trips to the market. In this way, each vendor's record can be quickly examined for any number of purposes.

Today, many buyers forgo this traditional method of vendor records and use the aforementioned electronic devices such as Palm Pilots for their information. By merely

keying in the vendor's name, the information may be recalled from the stored memory. Whichever method is used, the information available is the same.

A typical resource diary is shown on page 245, listing important information about each resource such as type of merchandise offered, its location, contact people, importance to the store, terms of purchases made in the past, and any other items that might be necessary to consider for future purchasing.

Most important about this information is that it be kept up-to-date. Since changes in personnel, relocation of sales office, importance to the retailer, advertising allowances, and credit ratings are possible, updating is essential for meaningful decision making.

Although most seasoned buyers have much of the vendor information stored in their memories, newcomers to the industry do not have this advantage. For them, such record keeping is invaluable when purchasing plans are being made.

PRINCIPAL RESOURCE LISTS

Another invaluable tool is the buyer's **resource list.** The document lists the company's principal resources ranked by the total dollar purchasing done with each supplier. In the list shown on page 246, the amounts in the upper-left-hand corner indicate the total purchases of the department for each of several years. The central listing by supplier indicates the amount of business done with that resource by season of the year. The use of the columns for each year provides comparisons; that is, it gives a trend of growth or decline with each vendor on a seasonal and annual basis. Of further interest would be a comparison of the percentage of growth of each supplier with the department as a whole. Any decline in the relative growth of a supplier calls for further investigation to determine whether the problem can be rectified or the resource replaced.

VENDOR ANALYSIS FORMS

The **vendor analysis form** features a presentation of the gross margin for each style of each vendor. It is essentially an income statement. The information generated comes from data stored in the computer. The one featured on page 247 is typical of those used in the industry but is by no means the only one.

OTHER EVALUATION AIDS

The producers of computerized programs continue to develop more and more software that helps to make the buyer's decision making better than ever before. Programs by giants like IBM and smaller companies like Creative Data Systems, Inc. produce a host of different products that are in use throughout the retail industry. The major retail giants sometimes have in-house programmers who create software specifically for their company's needs. Whatever the case, buyers are able to quickly recall just about every bit of information needed to make decisions.

Typically, the information used for evaluation, in addition to that which was already offered includes:

1. Accuracy of quantities shipped and billed.
2. Ability of vendor to meet delivery dates.
3. Pricing accuracy.
4. Substitution history.

```
RESOURCE DIARY

                              Dept. No.

                              Date

Resource

Merchandise     Top Grade____Medium____Low-end____

Activity (Mfr., Jobber, Importer, etc.)

Sales Office Address                    Telephone _____

Factory or Warehouse Address

Company Officers and Titles

Buyer Contacts-State peculiarities or special handling re-
   quired by

      a. Sales Office

      b. Factory

Rating-Dun & Bradstreet

Ethics of Firm

Ranking in Industry

Vendor Importance to Store

Store Importance to Vendor

Record of All Arrangements (Terms, Trade Discounts, Cash
   Discounts, Cooperative Advertising, etc.)

Remarks (State clearly any additional information not
   covered above that will guide any member of our
   organization who may have to deal with this vendor.)

Semi-Annual

Date                              By Whom
```

Note: It is recommended that this Resource Diary be kept in loose-leaf form.

Resource diary.

$ COST PURCHASES

Year	Dept.	Approved	Date
2 –	343,017		2/17/–
2 –	604,359		2/24/–
2 –			
2 –			

Resource – Key Contact	General Comment	Season	2 –	2 –
Design For Living M. E. Andrews, Pres.	Top quality maker — exclusive with us — nationally adv. — most cooperative — better than average markup — low markdowns Class A Terms 2/10/60X	Spring	37,007	81,116
		Fall	24,119	59,412
Hobbies — Antiques and Stamps		Total	61,126	140,528
Modern Age John Jackson, Sales Mgr.	Excellent novelty house — alert to new ideas — also sells Store A — very reliable and profitable —	Spring	16,981	44,051
		Fall	19,128	38,946
Hobby — Fishing	repairs at minimum	Total	36,109	82,997

$ COST PURCHASES Dept. _____

Year	Dept.	Approved	Date
2 –	2 –	2 –	2 –
2 –	2 –	2 –	2 –
2 –			
2 –			

Principal resource list.

Vendor analysis form.

MERCHANDISE	STYLE NO.	SEA-SON	BEGINNING OF SEASON				NO. REC'D	O.H. END OF SEASON	NO. SOLD	COST PER UNIT	ORIGINAL MARKDOWN				TOTAL SALES	TOTAL COST OF MDSE. HANDLED	UNIT RETAIL END OF SEASON	CLOSING INV. RETAIL	CLOSING INV. COST	COST OF MDSE. SOLD	G.M.	G.M. %
			O.H.	UNIT RETAIL	TOTAL RETAIL	TOTAL COST					UNIT RETAIL	NO. SALES	UNIT RETAIL	NO. SALES								
			1	2	3	4	5	6	7	8	9	10	11	12	13	14	15	16	17	18	19	
					1×2	3×8	7+6−1								9×10+ 11×12	4+5×8		6×15	6×8	14−17	13−18	
SLACKS	112	575	40	10	400	200	100	20	120	5	10	120	—	—	1200	700	10	200	100	600	600	50

SEASON	FALL OR SPRING YR.	FROM	TO	DEPT. NAME		BEGIN	END	VENDOR'S NAME
				DEPT. NO.		A	B	VENDOR'S NO.
				CUM. M.U. %				
				COMPLEMENT				GROSS MARGIN PERCENT

TOTAL

```
VENDOR INQUIRY                                    PROGRAM-NAME: 201US031
                                                  PFKEY  1 - RESTART
   DEPT    20      LADIES SPORTSWEAR              PFKEY 16 - EXIT
   VENDOR  437801  LONGSTREET INDUSTRIES, LTD.
   DATE    06/8-

   RECEIPTS:              MARKDOWNS:

     UNITS      420         UNITS       56      ADV CONTRIBUTIONS:      .00
     @ RTL     6715.80      @ RTL      280.23
     @ COST    3156.43                           # P.O.'S PLACED:        6
                           PURCHASES:
   SALES:                                         # SHIPMENTS:           5
                           @ RTL      7438.20
     UNITS      324         @ COST     4462.92    OVER SHIPMENTS:        0
     @ RTL     5389.77
     @ COST    3108.45     INVOICED AMTS:         UNDER SHIPMENTS:       1

   RETURNS:                 INVOICE    3782.40
                            DISC        231.18
     UNITS       23         FREIGHT      45.20
     @ RTL      367.77      RETAIL     6715.80

                                              Press "ENTER" to continue *
```

Computer display illustration.
(Courtesy of Creative Data Systems, Inc.)

5. Return history.

6. Handling of adjustments.

7. Terms of purchases.

8. Advertising and promotional allowances.

9. Compliance with shipping instructions.

10. Adherence to special requests.

11. Time frame for reorders.

12. Reliability in terms of exclusive distribution.

These are just a few of the specifics of the records that are kept.

ESTABLISHING VENDOR RELATIONSHIPS

It is very much to the buyer's advantage to have a good relationship with each of the resources. Since most vendors, especially those with "marquee" status, have a wealth of accounts and must service each of them, the buyer wants to make certain that he or she receives favorable treatment in such areas as delivery, prices, and so forth. To achieve such a cooperative goal, the following are important:

1. Orders should be placed as early as possible to give the vendor ample time to deliver the merchandise.

2. Cancellations of orders, except in extreme situations, should be avoided.

3. The amounts agreed on for cooperative advertising allowances should not be exceeded.

4. Payments should be made promptly.

5. Merchandise returns should be avoided unless there is justification for such returns.

6. Lines currently used should be given priority consideration when purchase plans are being formulated.

7. Unfair price cutting that could lead to problems for the vendor should be avoided.

8. Confidential information about a vendor should not be shared with his or her competitors.

CLASSIFICATION OF RESOURCES

There are several categories of resources available to buyers. Each serves a different need and should be considered when purchase plans are being formulated. Those that are most important are manufacturers, manufacturers' representatives, service wholesalers, limited-function wholesalers, and rack jobbers. In addition, many retailers are using store-owned resources for a portion of their merchandise needs.

Manufacturers

Buying directly from the producer certainly affords a number of advantages, but the choice is not always left to the buyer. Many manufacturers decline to sell directly to retailers no matter how much they might purchase. They distribute their merchandise through wholesalers. This is generally true for foods, some appliances, and convenience goods such as cigarettes.

Buying from manufacturers, when permissible, offers many advantages. Among the reasons for direct purchase are the following:

- Manufacturers' sales personnel are generally more knowledgeable than those of the wholesalers and provide better advice on merchandise, advertising, point-of-purchase display props, and so forth.
- In fashion merchandise, for which speed of delivery is extremely important, the use of a middleman would slow the distribution process. With the direct purchasing channel of distribution, the buyer is able to get the goods to the selling floor very quickly.
- Often, producers enable the retailer to have goods tailored to his or her specifications. It might be a sleeve that would be more salable if it were shorter than the sample, or a hemline that is longer than the one being featured.
- By eliminating the middleman, the price is generally better. This results in a chance for better profit margins.

While these are benefits to the retail buyer, sometimes the company's size prevents direct access to the manufacturers. Minimum orders, for example, are typical of leading producers. Only retailers who are large enough may be able to take advantage of direct purchasing. With the advent of buying groups, through which smaller retailers may pool their orders, purchasing directly from producers has become available. Because of this approach, many manufacturers are able to directly satisfy the merchandise requirements of small, independent retail operations.

Manufacturers' Representatives

Although many manufacturers typically sell directly to retailers through their own sales offices and showrooms, others rely on sales representatives, or **manufacturers'**

Manufacturers' sales personnel are completely knowledgeable about their products.
(Courtesy of Ellen Diamond.)

representatives (reps), as they are generally referred to in the trade. Because of such factors as limited capital and limited selling space, they often opt for these intermediaries to represent them. By doing so, the producer is able to concentrate on production and leave selling to professional sellers. Although the buyer is not able to interact with the manufacturer, he or she is afforded several advantages, including:

- The ability to purchase more than one line at one selling point. Since most reps feature several compatible lines of merchandise, the buyer may examine all of them under one roof without having to go from showroom to showroom. This saves the buyer a great deal of time and energy.

- With the compatibility of these lines, the buyer is often able to see which items in one are compatible with those in the other lines. In the case of a jeans collection, for example, a sweater from another of the reps' groups might be the perfect fit to motivate the ultimate consumer to buy both. Without this convenient arrangement, the buyer might have to visit many showrooms to locate the perfect sweater match.

- By using reps, the manufacturer often has representatives in various parts of the country showing the line. This arrangement sometimes results in the buyer being able to view the merchandise closer to home than in the traditional wholesale market, which is often farther away from the retail operation.

- Since the rep's only business is selling, he or she is often more likely to better service the buyer's account than the manufacturer is willing to do. Commission is the likely method of remuneration for these reps, so service is the ingredient they have to offer to make their living.

Service Wholesalers

A wholesale operation may be either of the service or limited-function categories. The **service wholesaler,** as the name implies, offers a variety of services to its customers, while the **limited-function wholesaler** is merely acting as a selling agent, much like that of the manufacturers' reps.

The service wholesaler is the more dominant entry in the marketplace. The role is to act as an intermediary between the producer and the retailer, making all of the necessary arrangements to satisfy both parties' needs, and providing benefits to each. For the manufacturer, the wholesaler takes him or her out of the distribution game. Accounts are sought and serviced, and the manufacturer needs only to produce merchandise. Since wholesalers purchase in very large quantities, they reduce the manufacturer's inventory-carrying needs. They also provide market information to the producer, reduce the risks involved in selling directly to the retailer, and simplify bookkeeping. These advantages are extremely important to these middlemen.

The benefits to the retailer are also numerous and include:

- Purchasing small quantities. Since service wholesalers stock large inventories, the buyer is able to make purchases as needed. This allows for a smaller inventory at the store level.

- Retailers are able to buy a vast assortment of different manufacturers' products under one roof. This enables the buyer to easily compare products and select the ones that seem best.

- With service the key to the wholesaler's success, the retail buyer is assured of prompt delivery, attention to special requests and, often, personal delivery.

- There is often liberal credit. Most wholesalers offer credit advantages such as larger credit limits, and longer periods in which to pay the bills, than retailers would get from the manufacturers.

- With smaller order requirements, many retailers are able to improve their stock-turnover ratios, a topic that will be fully explored in Chapter 17.

- Since the wholesaler's success is predicated on satisfying retail clients, he or she is often willing to supply up-to-date market information, merchandise planning assistance, and promotional aids.

Whereas these benefits to the retail buyer are important, there are also some disadvantages associated with purchasing from wholesalers, including:

- Prices are generally higher because the wholesaler must also make a profit on the goods bought from the manufacturer.
- Because of the higher prices, the retailer must take smaller markups and be satisfied with lower profits.

The rule of thumb is, when purchasing from the manufacturer is available, it is the better choice than that of buying from wholesalers.

Limited-Function Wholesalers

As this name implies, the services offered by this wholesale classification are few. They are in business primarily as sales agents for a number of manufacturers and are sometimes called *brokers*. Unlike their service-oriented counterparts, these companies do not stock merchandise. Since retailers who buy from them forfeit the services, the prices they pay are generally lower than if purchased through a service wholesaler.

In some industries, the choice is not up to the retailer but is the established practice for specific product lines. If retailers do have a choice, then a decision must be made as to which type of wholesaler is better for their operation. For example, if immediate delivery is very important, then the choice is to use a service wholesaler who stocks the goods.

Rack Jobbers

The **rack jobber** is actually a wholesaler. Unlike the other wholesalers, however, rack jobbers provide the unique service of maintaining a store's inventory for the products they sell. In the paperback book industry, for example, rack jobbers supply the racks or cases in which the paperbacks are displayed. They stock these racks with an assortment of books that they believe will be most profitable for the retail account. At this point, no charges for the merchandise are made to the retailer. Periodically, the rack jobber comes to the merchant's premises, checks the inventory, and receives payment only for the merchandise that has sold. Additional copies of the titles that sold well are then added to the inventory, and those that didn't sell are deleted and replaced with others. The retailer does little in the maintenance of the products supplied by the rack jobber. Big users of the rack jobber's services are supermarkets, for items other than the typical grocery, meat, poultry, and produce merchandise. Products such as paperbacks, greeting cards, hosiery, and impulse items are often merchandised this way.

The major advantages of this type of purchasing for the retailer are:

- There is no outlay of money until the products are sold. This frees up capital for merchandise that is purchased in the traditional manner.
- The store's employees are not concerned with fixing the displays of these products.
- There are no risks of markdowns since slow sellers are replaced with faster sellers.
- No time is needed to make purchases. All of the work is done by the rack jobber.

TIMING THE PURCHASE

Once the buying plan has been finalized, taking into account both the qualitative and quantitative considerations, and the decision as to which resources should be contacted for purchasing, the timing of the purchase is the next issue to be addressed. All retailers do not have the same purchasing time frames. The policies of each company dictate when it is best to purchase to be most profitable. The traditionalists who buy at full price and the opportunistic merchants who buy when the merchandise is bargain-priced have two different approaches in terms of the timing of their purchases.

Traditional Retailers

Those who are considered traditionalists in retailing are department stores, specialty chains, and others whose philosophy it is to get the merchandise onto the selling floor as early in the season as possible. Stores with fashion orientations, such as Neiman Marcus, Bloomingdale's, Macy's, Saks, Lord & Taylor, and Bergdorf Goodman, are just a few in this group. They each subscribe to the *fashion-first concept,* meaning that they must be the first in their respective trading areas to show the merchandise as soon as it comes out of production. Their fashion-conscious clientele, who usually do not care about price, purchase early in the season. As soon as the market weeks open, these buyers quickly head for such designers and manufacturers as Calvin Klein, DKNY, Ralph Lauren, Tommy Hilfiger, Liz Claiborne, and Jones New York. Such early purchasing generally guarantees the earliest possible delivery.

These lines, and others from the domestic markets, require purchasing as early as six months before delivery can be expected. With manufacturing now a global affair, offshore purchasing may require ordering as much as one year prior to shipping. Purchasing so far ahead of the selling season, as is the case with foreign buying, must be carefully planned. Particularly in fashion merchandise, where color and hemlines are sometimes unpredictable, such early decision making might be extremely difficult. With the whims of the fashion-consuming public, early selections might be faulty. Even the most seasoned buyer can make mistakes.

Retailers other than those with fashion orientations do not need such early deliveries. These merchants often buy a little later in the season, after the lines have been "edited." When a vendor first introduces a line it might have, for example, a hundred samples. Soon after the collection's introduction, it might be reduced to half of the original offering based on the buyers' early impressions. Buying later takes out some of the guesswork needed in early selection.

Merchants who purchase from wholesalers have the benefit of buying merchandise only a few days before it is needed. **"Hand-to-mouth" buying** is typical for these retailers. Of course, each retail segment has its own timing requirements due to the nature of the merchandise, and must play the game appropriately.

Off-Price Retailers

Those in the business of offering merchandise at the lowest possible prices to the consuming public are the off-pricers. Their philosophy is to buy **opportunistically**—that

T.J. Maxx is an off-price retailer that purchases designer labels opportunistically.
(Courtesy of Ellen Diamond.)

is, when the wholesale market is ready to close out merchandise at greatly reduced prices, these merchants are ready to buy.

They do not plan exact purchases as carefully as do their traditional counterparts in terms of specific styles, colors, and fabrics, but usually only in the general types of merchandise they will need for the dollars that have been budgeted. This group of buyers scouts the market just about every day looking for the bargains. Unlike the traditionalists, who do the bulk of their purchasing during market weeks, these buyers go from vendor to vendor every day of a season hoping to find closeouts. They are also constantly in communication with resources by way of telephone, faxing, and e-mail. Timing is extremely important in the sense that they must find the bargains before the competition does.

The off-price merchants very often carry the same labels and brands as the traditional retailers, only later in the season. Designer labels like Ralph Lauren, DKNY, and Calvin Klein are commonplace in outlets like T.J. Maxx, Stein Mart, Loehmann's, Marshalls, Burlington Coat Factory, and other off-price companies. It is just that they are available only after the vendor has reduced the wholesale prices, leaving the assortments somewhat limited in terms of size and color availability. Of course, when the bargain shopper finds a well-known label at a great price, these factors are often unimportant.

Experience teaches each buyer when it is most appropriate to place orders, and when to bring goods to the customer.

Language of the Trade

bottom line
closeouts
convenience goods
cooperative advertising
electronic data interchange (EDI)

factory outlets
"hand-to-mouth" buying
limited-function wholesalers
manufacturers' representatives
marquee labels
opportunistically
order specificity
preticketing
purchase-order specificity
purchase timing
rack jobbers
resource diary
resource list
service wholesalers
trunk shows
vendor analysis form
vendor-managed inventory (VMI)

Summary of Key Points

1. Buyers must not only choose from the practically limitless number of resources, but also must decide whether to purchase directly or indirectly and when the purchase should be made.
2. One very important consideration in terms of decision making about resources is the types of high-tech innovations the potential company has available to its accounts.
3. Positive vendor relationships must be built in order for the buyer to have his or her account properly serviced.
4. Dependability of the vendor must be considered in terms of such factors as producing products that are identical to the original samples, adherence to purchase-order requests, and a policy that fairly considers returns.
5. The most important consideration in selecting a resource is its ability to produce merchandise that is exactly what the merchant needs.
6. Merchants must make certain that the resource does not sell merchandise identical to the competition.
7. Advertising allowances should be available from the vendors to extend the retailers' advertising budget.
8. The truthfulness of a vendor is important to the buyer so that buying suggestions can be taken into account at the time orders are being placed.
9. Promotional activities such as trunk shows help retailers bring attention to their companies.
10. Adherence to order specificity is extremely important to the buyer so that his or her model stock will be on target.
11. Buyers must keep such records as resource diaries and resource lists to help them evaluate the vendors from whom they purchase.
12. There are many different resource classifications ranging from manufacturers to rack jobbers.
13. Buying from a service wholesaler affords the merchant the benefit of purchasing hand-to-mouth.

14. Limited-function wholesalers are actually sales reps in that they do not stock merchandise but merely act as the liaison between the producer and the retailer.
15. A rack jobber provides the unique service of inventory maintenance to the retailer.

Review Questions

1. What is the name of an important high-tech innovation that exchanges machine-readable data in standardized formats between two computers?
2. How does VMI help major companies with their inventories?
3. Why is it important for a retailer to expect delivered goods to be identical to the original samples?
4. Is it important for a buyer to limit his or her purchases to a few vendors?
5. What is the most important consideration in the selection of a resource?
6. When is vendor selection automatic?
7. Why are vendors often unable to restrict their offerings to just those companies with whom they would like to do business?
8. How can a vendor who ships his or her line to competing merchants make each one's inventory somewhat unique?
9. What is meant by the term *closeout*?
10. Discuss what is meant by cooperative advertising.
11. What is a trunk show?
12. Why is it important for buyers to note on their orders the words *no substitutions?*
13. Name and describe two major resource evaluation aids used by buyers.
14. What is a resource diary?
15. Essentially, what is a vendor analysis form?
16. In what ways do manufacturers' and wholesalers' operations differ?
17. What is a service wholesaler?
18. How does a limited-function wholesaler differ from a service wholesaler?
19. Why do some manufacturers use outside reps to sell their lines?
20. What is a rack jobber?

CASE PROBLEM I

Brown's Department Store is a high-volume, single-unit organization that for years has been a leading retailer in a downtown central district. Although the store's profits have held up well during the past five years, the earnings seem to be somewhat below that of a nearby competitor, a department store corporation whose figures are made available through end-of-year reports. Somewhat disturbed by this, Brown's executive operating committee has hired a new general merchandise manager and has instructed her to make a department-by-department analysis to determine the weak spots.

After studying the necessary reports, the new manager has pinpointed ladies' sportswear as the worst offender. These are her criticisms:

1. While the original markup is high, excessive markdowns have resulted in an overall low figure.
2. The department's gross sales have remained constant, whereas the total for the store has shown a steady increase.
3. The average inventory has been high in relation to sales, resulting in poor turnover rates.

When confronted with this information, the buyer resigned in anger. The store's policy has been to promote from within, and an assistant buyer has been named the new buyer. It has been decided that her first chore will be an evaluation of the resources that have been used in the past.

Questions

1. What resource characteristics should she evaluate?
2. What information will she need for the evaluation?
3. Where will she be able to find this data?

CASE PROBLEM 2

Quality Foods, Inc. operates a chain of twenty large supermarkets in the suburbs of a large midwestern city. The owners are young, talented, and aggressive. Thanks to their operating ability, they have been successful, and the rate of expansion has been better than originally anticipated. If anything, they have grown too quickly. While more conservative management would have waited until enough profits had accumulated to finance expansion, Quality Foods has opened new units on credit available because of its success. The cost of building and stocking new units has led to a weak working capital position.

All the departments in the store are owner operated. At a recent director's meeting, two suggestions were made to ease the shortage of working capital. Both concern nonfood merchandise, a source of considerable profit to the company.

The suggestions are as follows:

1. Use traditional wholesalers for nonfood merchandise.
2. Use rack jobbers for these merchandise classifications.

Questions

1. List the advantages and disadvantages of using wholesalers.
2. List the advantages and disadvantages of using rack jobbers.
3. What information do you need to make the final decision?

SECTION THREE
Making the Purchase

Buyers today have more resources available to them than ever in the history of retailing. Not only are they able to purchase in the numerous domestic regional markets, but nearly every corner of the world features merchandise in seemingly infinite varieties. Because of this wealth of products, buyers of fashion apparel, shoes, jewelry, dinnerware, tableware, rugs, foods, and any other items are constantly scanning the globe to find the best products to satisfy their customers' needs.

In cities like New York (America's premier fashion market), Chicago, Los Angeles, San Francisco, Dallas, and Atlanta, buyers are able to find almost any type of merchandise—in terms of quality and price points—that they need for their inventories. Whether couture level, bridge collections, or more modestly priced lines, the merchandise is there to be selected.

For larger companies, overseas purchasing has become commonplace. Not only can buyers select from the well-known brands that are produced in European, Asian, and other global markets, but they can also seek vendors who will produce merchandise that they have developed for their exclusive use. The globe is dotted with producers who are able to fill the specific needs of these buyers and are able to turn out quality products at significant savings. With so much competition facing today's retailers, the only solution for many of them is to develop their own brands for import to the United States.

Once they find vendors who offer the most suitable merchandise, buyers must negotiate the most favorable prices to bring higher profits to their companies and then write the orders. As you will learn in this section, price negotiation requires skill and must take place in the framework of legislation that has been established by the federal government.

As for the writing of the order, much care must be exercised to make certain that the negotiated terms are understood by the vendor. It is only with this care that the correct merchandise will arrive on the retailer's premises at the prices agreed to and at the times necessary for inclusion in the inventory.

CHAPTER 12

Purchasing in the Domestic Marketplace

On completion of this chapter, the student should be able to:

- Discuss the advantages and disadvantages of the different buying options available to buyers.
- Explain some of the plans that must be made for market visits during market week.
- Describe the different types of market settings in which buyers make their initial selections.
- Explain why many buyers often wait until they return to their home offices to place their purchase orders.
- Discuss why some purchases are made at the retailer's premises.
- Discuss why some buyers make their purchases from catalogs.

In the purchase of merchandise from domestic suppliers, buyers have several alternatives in terms of how they may make their purchases. These include visits to the wholesale markets, in-store buying from **road sales representatives,** purchasing from catalogs that have been supplied by manufacturers and wholesalers and from resources on the Internet, as further examined in Chapter 15.

Some buyers resort to just one means of making their purchases, while others use all of them. The decision is based on the size of the retail operation, the merchandise classifications that make up the model stock, the distance between the company and the regional wholesale markets, and the tasks, other than purchasing, required of the buyer.

There is no single approach that is better than another. When new seasonal purchases are made, as in the case of fashion merchandise, a trip to the market is generally considered the best approach. It gives the buyer the opportunity to see a host of vendors' offerings with a minimum of effort and the time to compare the various product lines. Supermarkets, on the other hand, generally rely on suppliers to visit their headquarters so that deals can be struck. Because the merchandise found at these retail outlets is usually constant, the only concern for the buyer is making the best deal. Professional expertise tells each buyer which approach is best to use.

TABLE 12.1 Selected Domestic Market Weeks	
Market	*Location*
Consumer Electronic Show	Las Vegas, Nevada
SE Men's Market	Atlanta, Georgia
Housewares & Variety	Rosemont, Illinois
Men's and Boy's Apparel Market	Dallas, Texas
Home Furnishings Market	Atlanta, Georgia
Kid Power	New Orleans, Louisiana
Variety Merchandise Show	New York, New York
Tupelo Furniture Show	Tupelo, Mississippi
International Toy Fair	New York, New York
JA International Jewelry Show	New York, New York
Imprinted Sportswear Show	Tampa, Florida
Travel Goods, Leather Accessories Show	Washington, D.C.
NAMSB	New York, New York
Women's and Children's Apparel Market	Atlanta, Georgia
MAGIC	Las Vegas, Nevada

PURCHASING IN THE WHOLESALE MARKET

The market visit is essential for clothing, wearable accessories, home furnishings, furniture, and other merchandise that is either of a seasonal or fashion orientation. It enables the buyer to see firsthand, at the times the collections are being introduced, what is new in the marketplace. It also assures them of the earliest possible delivery time, which is very important to many retail operations.

In each industry there are specific market weeks, a period that was briefly described earlier in this book, for buyers to see the lines of vendors they already purchase from, and new ones that they might consider. Some of the domestic market weeks are shown in Table 12.1.

Typically, the market visit is the best choice. It ensures the buyer time to visit each of the vendors from whom he or she already purchases, and others that are new to the marketplace. It also allows for comparisons between one vendor's line and another's, to see which one has the most sales potential for the company. Finally, there is no better place to feel the "**pulse of the market**" than in these wholesale merchandise centers.

Planning for the Visit

Trips to the market are undertaken at different times and at different intervals, depending on the nature of the goods, the store's proximity to the market, the season of the year, and business conditions. Women's wear buyers generally make the most trips since that industry offers the most market weeks. By comparison, menswear and home furnishing's markets are less frequently in session. Buyers do not limit their market trips only to market weeks but also make trips at other times as needed. Buyers at some stores, with the good fortune to be located close to a wholesale market, may make the trip a couple of times a week, not necessarily to buy, but to see what's new. Some vendors add items to their

The fabric carts rolling amid the delivery trucks are typical of the major wholesale markets.
(Courtesy of Ellen Diamond.)

collections between season openings, and buyers who have the benefit of these frequent trips may avail themselves of a hot item that wasn't featured early in the season.

For most merchants, however, the trips are often restricted to major buying trips. When these trips are to be taken, a great deal of planning is essential so that the best results may be achieved.

MAJOR INVOLVEMENT IN THE TRIP

The six-month plans and model stocks discussed in other chapters must be completed before any trip may take place. Included are price point adjustments, changes in pricing policies, vendor analysis, dollar allocations for merchandise, and any qualitative and quantitative decision making.

Once these factors have been addressed by the buyer, a round of meetings with key management executives and pertinent staff personnel is necessary to get their professional input. The general merchandise manager and divisional merchandise manager have an overall view of the retail operation, and they could provide additional insights that the buyer might not have considered. The fashion director, an important executive in most department stores, could supply an overall view of the various arms

Buyers in New York City's Garment Center are greeted by a sculpture of a sewer completing a garment. *(Courtesy of Ellen Diamond.)*

of the fashion industry and what the buyers might expect for the next season. Since these directors have scouted the market to discover new trends in silhouette, colors, and fabrics before the buyer makes the trip, such advice is invaluable.

In smaller stores, the buyer does not have the advantage of such management input. Because the owner is often the buyer, and limited funds do not allow for specialists, the in-store information comes from past sales and the buyer's own professional experience. In cases where the buyer of a small store is an employee, he or she takes his or her cues from the owner, especially for budget allocations. Product selection is left to the buyer's discretion.

Whether the company is large or small, it is the buyer who makes the merchandise selection decisions. If the anticipated purchase is a major one, especially from a new vendor, and it requires a trip to the market, the merchandise manager may accompany him or her, along with an assistant buyer, and in some situations, a fashion director.

In addition to the regular market visits, interim trips might be taken. Often, the inventory needs a "shot in the arm" to bolster sales or if the store wants to investigate a new resource that has been heralded by the trade papers. If the buyer's schedule permits, then the visit is made. For those located close to the wholesale market, the visit could take only a few hours; for others, an overnight venture might be necessary. Whichever is the case, these trips do not require the planning associated with those for the new season's offerings.

MARKET SPECIALIST ASSISTANCE

As previously discussed, there are different market specialists who assist the buyer with planning and actual purchasing. The **resident buying office (RBO),** the best known of these external advisory sources, provides a great deal of assistance to buyers who are coming to the market, especially during market week. With thousands of buyers converging on a wholesale market during this period, and available time there relatively brief for each buyer, a great deal must be accomplished in this time frame. The resident buying office helps make personal arrangements for the buyer and his or her associates if they are also coming to market, makes known the buyer's arrival in important trade papers, and prescreens the collections in advance of the buyer's arrival. It is this assistance that can make the buyer's trip more meaningful and profitable for the retail organization.

Personal Arrangements. Whether it is New York City, Dallas, Chicago, Las Vegas, or any other major market, the opening of an industry's lines often results in a shortage of hotel space. Market week puts severe demands on hotel managers. To ensure that the buyers have their accommodations reserved, sufficient advance planning is a must. The resident buying office sometimes reserves blocks of rooms for its clients and makes the

The buyer makes final plans before the market visit.
(Courtesy of Ellen Diamond.)

reservations if requested by the store buyers. The RBO makes certain that the hotel is conveniently located to the vendor's showrooms or trade expositions, and that sufficient services such as faxes and computers for e-mail correspondence are available. Since the RBO is primarily a service organization, this is just an example of how it aids its clients.

Notification of Buyer's Arrival. Whenever a buyer visits the market, it is important that his or her date of arrival and length of stay is made available to the merchandise resources. Although appointments have generally been set with vendors who are currently being used by the retailer, other resources might warrant purchasing consideration. Sometimes the buyer is unaware of a new supplier who might carry merchandise suited to the store's needs. In this case, it is beneficial if the buyer's arrival is noted in a trade paper. Using this information, interested vendors and sales reps may contact the buyer and explain the characteristics of the new line.

Prescreening of Lines. With time being of the essence for a buyer's market visit, any prior information about the next season's collections can help the buyer in his or her decision making. So that this productivity can be maximized, the resident buyer often prescreens the key lines and makes the information available to the store buyer. This can be done either through verbal or written communication prior to the market visit, or during the traditional stop at the resident buying office facility.

A resident buyer scans a trade paper to see if a buyer's arrival is noted.
(Courtesy of Ellen Diamond.)

Store buyers can then learn beforehand which colors are expected to be hot, which styles will be likely to set the trends, which new fabrics will be introduced, pricing trends for the new season, and anything else imperative to the store buyer's future plans. Often an RBO sends fliers to the retailer in order to prepare their representatives for what will be shown in the market.

The Domestic Marketplaces

Throughout the United States there are many regional markets that offer a variety of products to retailers. Some of these markets represent manufacturers and wholesalers of specific merchandise classifications, whereas others feature a wealth of different products. Whether it is fashion apparel, electronics, home furnishings, gourmet food items, or anything else, just about everything is available in America for most buyers to satisfy their model-stock requirements. Of course, as you will see in Chapter 13, merchandise acquisition is a global experience, with buyers regularly scanning the world for much of their merchandise.

While this globalization continues to grow, most buyers realize that domestic procurement affords a great number of advantages. These include relative ease in market coverage, less-costly expense in getting to the marketplaces, generally faster delivery, the potential for opportunistic purchasing, and lower cost for shipments.

The merchandise available, as already indicated, is in many product classifications. One of the greatest American offerings is in fashion-oriented products, including apparel for men, women, and children; accessories such as footwear, jewelry, handbags, and belts; "innerwear"; home furnishings such as dinnerware and glass; and other items. Other product classifications ranging from appliances and electronics to foods are also available from numerous domestic resources. Because of their enormous importance, the fashion centers will be explored.

FASHION CENTERS OF THE UNITED STATES

America's fashion capital is in New York City, with regional markets scattered from coast to coast. Each features an abundance of products to satisfy the needs of the retail buyers. The choice of which one to visit is usually based on the breadth and depth of the merchandise assortment needed, and the proximity of a market to the retailer's headquarters.

New York City. Throughout a number of bustling areas, men's, women's, and children's apparel and accessories, as well as products for the home, are available to buyers. Whether it is the **Garment Center** or **Seventh Avenue,** or some other area such as Soho, buyers come to New York City to transform their buying plans into actual purchases. America's major designers and manufacturers are headquartered there. In addition to maintaining showrooms for the buyers to examine the lines and write their orders, many resources design the collections in these facilities and sometimes use space for production. With the ever-growing costs associated with manufacturing, most companies have opted for less-costly production facilities in other parts of the country or abroad.

Companies of every type and magnitude are found in New York City. They range from the couture labels of Ralph Lauren, Bill Blass, Donna Karan, and Calvin Klein to the bridge collections of Jones New York and Dana Buchman to more modestly priced lines. At the busiest times of the year—market weeks—the showrooms are crowded with

Another resident buyer's duty is to prescreen lines before the retail buyer comes to market. *(Courtesy of Ellen Diamond.)*

buyers and merchandisers who are viewing the collections and writing their orders for future deliveries.

California. The West Coast's leading fashion centers are in Los Angeles and San Francisco. In these markets, as in New York City, a wide variety of fashion merchandise is available at numerous price points. In addition to the lines that originate in these two cities, many New York vendors maintain showrooms there to accommodate buyers from that region.

Los Angeles, the next largest center to New York City in terms of volume, is a leader in casual clothing. With the lifestyle of that region, casual apparel and accessories are a

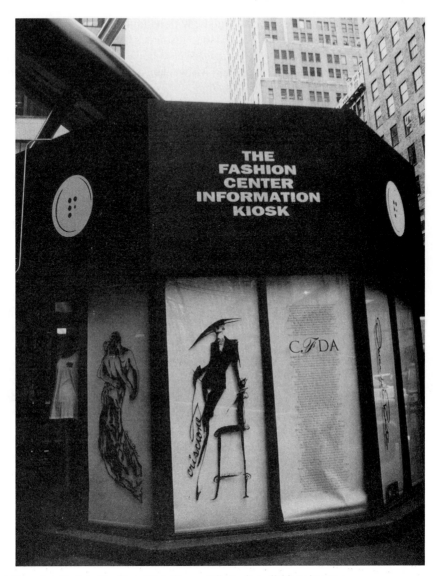

An information kiosk in New York City's Garment Center is available to buyers.
(Courtesy of Ellen Diamond.)

natural. Of course, couture-level clothing is also popular, with the likes of Bob Mackie holding forth in that region.

San Francisco, the third largest of the American fashion centers, is home to many manufacturers such as Esprit, Jessica McClintock, and Levi Strauss. One of the reasons for the considerable importance of San Francisco is that it is home to The Gap, one of America's largest chains that produces its own goods.

Other Fashion Centers. Dotted throughout the United States are other regions that produce and market apparel and accessories. Miami, for example, has grown significantly as a manufacturing city and regional market for buyers from the South to

come to for their stores' needs. Dallas, with its famous "mart," is home to many local designers and manufacturers and also to resources from other parts of the country who maintain sales offices there. Atlanta is also home to fashion merchandise, with an emphasis on home furnishings, and Milwaukee is a city where leather shoes, wallets, and handbags are produced and sold.

The Market Visit

The length of the market visit is determined by the task at hand. If it is to see the next season's collections during market week, the time may be for a week or more. If the purpose is to look for new products between market week visits, a day or two may be spent. Time must be allocated to see the various vendors, and, if the retailer has market representation with a market specialist such as a resident buying office, then some time should be spent there to gain some preliminary market insights.

CALLING ON THE MARKET SPECIALISTS

If it is the beginning of a new season, the buyer generally arrives at his or her hotel a day before market week. This is usually on a Sunday. The first call of the morning of Day 1 is at the resident buying office, or *market specialists*—a term that many offices are now using in place of *RBO*. Although each office follows a plan specifically geared to the needs of its clients, the approach is usually similar to the one about to be described.

Each retail buyer is given a schedule that indicates general meetings and events appropriate to all buyers, as well as appointment schedules that have been tailored to the buyer's specific needs. The schedule often specifies such agenda items as general merchandising meetings, individualized conferences, fashion show presentations, and market appointments. The chart on page 271 presents an agenda for a menswear buyer. This buyer's plan has been organized to permit maximum market coverage in the time allocated. By examining this schedule, we see that the first day, or at least a good part of it, is spent at the RBO for the purpose of familiarization. A general meeting is held for all the member stores' merchandising teams to recognize what is in store for them during their time in the market, as well as in the season before them. The agenda for such meetings is presented by the various merchandising vice presidents or merchandise managers, who discuss such topics as price changes; market conditions; changes, if any, in import regulations; the general direction of specifics, such as private-label offerings by the RBO; and fashion directions such as style, color, and fabrics. If there is an in-house fashion forecaster or director, he or she also provides an overview of the fashion changes in the industry. Because this is a general meeting for all merchandise classifications, the presentations are general in nature and appropriate to all buyers and merchandisers.

At this point, the group disbands into groups according to specific merchandise classifications. The major classifications, such as menswear and women's wear, are sometimes presented in an informal fashion show. That is, menswear buyers view a presentation of men's clothing and accessories, while women's wear buyers are shown fashions appropriate to their departments.

In these presentations, the merchandise featured represents the RBO's samplings of what the market will be offering to the merchants. The office attempts to show a wide range of the styles offered in the "bread and butter" lines, styles available from lesser-known

STORE NAME	The Constable
MERCHANDISE MANAGER	Philip Stern
BUYER	John Richards
ASSISTANT BUYER	Michael Fredrick
MERCHANDISE CLASSIFICATION	Men's Clothing

AGENDA

Monday (At Office)

9:00–10:00	General Meeting
	Topic: Trends for the coming season
	(All classifications)
10:15–11:00	Fashion Show
	Topic: Men's wear, Fall and Winter
11:15–Noon	Merchandise Presentation
	Feature: Prices, fabrics, directions
Noon–1:30	Lunch
1:45–2:45	Individual conference
	Office representative: Carl Mann
3:00–5:00	Use of assigned workspace to review appointments, adjust plans, etc.

Tuesday/Wednesday

9:00–5:00	Attendance at NAMSB
	Appointment schedule with specific companies will be distributed at individual conference.

Thursday

	Appointments at manufacturer's and designer's showrooms.

Friday

9:00–Noon	Use of workspace to organize notes on possible merchandise acquisitions.
1:00–2:00	Meeting with office representative, Carl Mann

A buyer's schedule for market week.

resources, merchandise produced under the RBO's private label, or anything else that might be considered appropriate for the coming season. Attention is paid to making certain that the featured merchandise represents all price points as well as a cross section of fashion-forward and traditional silhouettes, colors, and fabrics.

This event enables the buyer to prepare for upcoming appointments in the market. He or she takes notes on the presentation that can be used when viewing the various lines. Table 12.2 shows an excerpt from a typical device some full-service offices provide for members to use while seeing the show. The selections noted at this time may not necessarily be bought once the final purchasing is completed.

At the conclusion of the special fashion presentation, the buyers generally have some time to inspect the featured garments. Frequently there are color swatches available to examine. This is also an important time when buyers from noncompeting retail operations can exchange ideas and discuss anything of mutual interest. This exchange of ideas is done in an atmosphere free from worry about competition because, as noted earlier in this book, the RBO is a vehicle for noncompeting merchants to be represented in the wholesale market. Experienced buyers learn that this is a valuable time to discover how stores are dealing with concerns and problems similar to their own.

Lunch is sometimes served after the meeting period and often features speakers from the industry. It is also a time for buyers to spend additional time with their counterparts from other companies to gather other invaluable merchandising information.

TABLE 12.2 Notetaking Form

Owens and Lasher Associates Fashion Production: Fall and Winter

Resource	Price	Description
Cambria Ltd.	$125.75	D/B Glen Plaid Suit
O and L—Private Label	92.50	D/B Pinstripe
Pierre Cardin	135.00	3 pc. Flannel (Wool/Poly)
Palm Beach	89.50	Sportcoat—Stripe
Jhane Barnes	110.00	Blouson Jackets (Tweed)
Calvin Clothes	115.00	Tweed Blazer
O and L (P/L)	69.50	Sport Coat (Oatmeal Tweed)
O and L (P/L)	95.00	Leather Battle Jacket
	95.00	Leather Pants
TFW	$139.50	3 Button Sack Suit

After lunch, it is traditional for each store buyer to have a little private time with an RBO representative. The time might be used to further explore the styles that were presented, new resources that were featured, decisions concerning proportions of private-label merchandise to branded goods, and any other topics of concern. If more time is needed with the resident office rep, it usually takes place later in the week.

For the remainder of the first day, time and space is available at the RBO to review appointments and to adjust plans according to what was learned at the meetings.

VISITING THE RESOURCES

Following the schedule that is shown on page 271, this particular buyer spends the next two days of market week calling on specific vendors who are presenting their lines at **NAMSB,** one of the more important trade expositions for the menswear industry. Under one roof, usually at the Javits Center in New York City, more than 1,200 manufacturers are presented. Approximately 25,000 retailers from all over the country converge on NAMSB to see the next season's offerings. Menswear buyers also head for **MAGIC,** the largest of these trade shows, that is held in Las Vegas, Nevada, and other expos such as the Midwest Men's Wear Collection in the Chicago Apparel Center, which might suit their needs.

It should be noted that buyers of other merchandise classifications also have trade shows available to them. The women's wear, children's wear, gifts, and home furnishings industries feature major expositions. One of the more important organizers of these events is WWDMAGIC featured in the following Retail Buying Focus.

At the NAMSB trade show, the buyer calls on those resources for which appointments have been set. Each line requires a particular amount of time for viewing. The time varies depending on how extensive each line is and whether the garments are featured on live models or hangers.

With each line, the buyer "takes numbers," a term commonly used in the industry to signify an interest in a particular style. He or she records them for possible incorporation into the eventual purchase requisitions. Rarely do buyers write merchandise orders when first inspecting a line unless it is for inventory replenishment. This delay enables the buyer to compare all of the merchandise in the market and decide which

A Retail Buying Focus

WWDMAGIC

The most important women's trade show in the United States is WWDMAGIC. It is part of Advanstar Communications, Inc., a worldwide business organization that produces many different trade shows that include MAGIC, the largest of the menswear expositions, publishes more than hundred business magazines, and provides direct marketing, database, and reference products and services to targeted industry sectors that include retail and fashion.

When Advanstar acquired The Larkin Group, a company that sponsored many different fashion-oriented trade shows, together with its MAGIC events it was able to service more than 14,000 exhibitors and attract about 300,000 retail attendees.

WWDMAGIC is produced in Las Vegas in February and August at the Las Vegas Convention Center and the Hilton hotel. It's a joint effort of *Women's Wear Daily* and the MAGIC Marketplace. Its attendees are department stores, specialty chains, mass merchandisers, and independents from around the world who converge on the event to purchase women's fashion merchandise at most price points.

The advantages offered to its participating retailers are many and include saving time by seeing a wealth of collections under one roof, interfacing with noncompeting counterparts to exchange ideas, learning about trends from numerous seminars, and making comparisons among similar product lines.

It is the one show that provides all of the advantages needed to make meaningful buying decisions.

items are best suited for the model stock. By digesting the information taken from the numbers he or she is interested in, a more intelligent and potentially profitable merchandise assortment will be forthcoming. The notes taken serve as the basis for the orders that will ultimately be processed. When time permits, most buyers move from booth to booth at the trade shows to consider new lines that are suitable for their needs. It is when scores of resources are gathered into one centralized facility that the buyer can easily and quickly view lines he or she has never before purchased.

Day 4 might be used to visit those vendors who are not represented at the trade show, since not everyone chooses to participate. Their lines may be at higher or lower price points than those typically found at the particular exposition, or of a designer-oriented nature that might be inappropriate for a trade show environment.

Whether the sales team is located in the temporary quarters of a trade facility or a permanent showroom, most vendors try to accommodate the buyers in every way to motivate them to buy. Some make souvenirs available that display the company logo to serve as a reminder, while others provide them with forms for taking numbers. At some vendor booths, silhouette brochures are available so that the buyer may take them back to their headquarters to use when placing orders. Each device that is offered is just one more promotional tool to keep the vendor in the buyer's plans.

On the last day of the week, the buyer often returns to the resident buying office to organize the notes taken about the offerings of the market. It is a time to review some

Buyers at the NAMSB trade show.
(Courtesy of Ellen Diamond.)

of the office's private-label merchandise and to assess whether it is needed for the buyer's model stock. Since not every style that was noted can become part of the ultimate purchasing plan, it is time for reflection. The RBO's staff is ready to answer any questions and make further recommendations.

At this point, the buyer assembles all of his or her notes that were gathered during market week and heads for home. It is back to the company's headquarters where the final purchasing considerations are made. With the help of such key individuals as merchandise managers and assistant buyers, the orders are written and sent to the various vendors.

PURCHASING AT THE RETAILER'S PREMISES

Although most purchasing professionals agree that there is no better place to view the new season's offerings than in the wholesale marketplace, buying at the retailer's premises is also sometimes considered.

In the middle of any season or major purchasing period, vendors send their sales reps from city to city to either visit merchants who haven't been to market, or to sell new items that have been recently added to the line. Most buyers welcome these visits since they may provide an item or two that might have been overlooked even if there was a market visit.

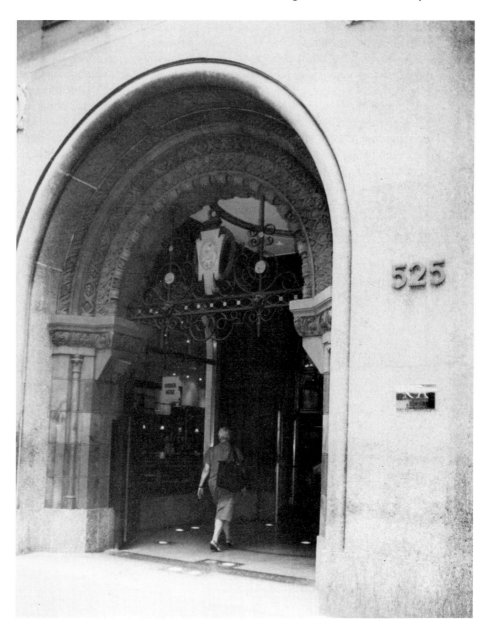

Visits to vendor showrooms are part of the buyer's trip to the market.
(Courtesy of Ellen Diamond.)

The buyer might also have more time to concentrate on this merchandise than he or she did during the hectic times in the market.

One of the pitfalls of buying from the "road salespeople" is that they spend time in the territories that have been assigned to them to sell to as many retailers as possible. They go from store to store hoping to make sales. Often, the merchants they visit are in direct competition with each other, sometimes resulting in the purchase of identical

merchandise by each. This purchase can prove to be a disastrous decision if different retail prices are ultimately charged by each merchant.

When purchasing is done at the retailer's premises, care must be exercised that some degree of exclusivity is guaranteed. The first merchant to purchase should note the order with conditions that make the styles he or she selected confined only to him or her for his or her own trading area. Of course, the sales rep may sell other items in the line to the competitors. Without this precautionary measure, unnecessary problems could arise.

In some retail classifications, such as supermarkets, visits from suppliers are routine events. They might be to introduce a new food or food-related item, or to offer the merchant a special promotional deal. In supermarkets, these special promotions are commonplace and often motivate considerable purchasing power.

WORKING THE LINE WITH THE VENDOR

Whether the purchasing takes place in the trade show arena, manufacturer's showroom, or on the retailer's premises, it is essential that the buyer and the vendor's representative work closely together to make certain that the right buying decisions will be made. Although the retail buyer is prepared in terms of general needs, assortment requirements, quantity estimates, and so forth, it is the rep who can help refine the order to a point where it will more than likely satisfy the needs of the retailer's customers.

The professional seller has all of the information at his or her fingertips regarding the new collection. The vendor will most often be prepared to discuss color and fashion trends, new silhouettes, fabrics, and so forth. Preplanning on his or her part will center

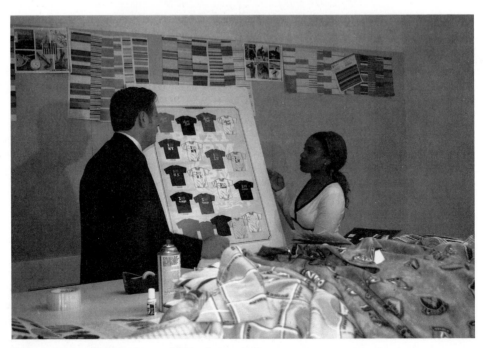

Buyer and vendor discuss color possibilities for new style.

on the past season's business with the company such as reorders, total expenditures, promotional endeavors with the line, and any problems that might have occurred. By being knowledgeable about the retailer's past experience with the company, the vendor is able to provide guidance for the purchase at hand.

This familiarization imparts confidence building and trust. Not only will the buyer be able to assess the new line using his or her own instincts, but he or she will also have a "partner" to help make the final decisions. For example, questions regarding which color to choose from the assortment that is available, which styles should be selected from the collection, on which sizes to concentrate for a particular style, how to merchandise the line on the selling floor, and so forth, can be addressed.

It is this relationship between the buyer and the vendor, when working the line, that will more than likely produce a purchase order that will satisfy both parties' needs.

CATALOG PURCHASING

Many vendors, particularly those with product lines that do not rapidly change, offer catalogs to prospective accounts that feature all of their merchandise. Resources that produce or wholesale products such as hardware, picture frames, lighting fixtures, cabinetry, towels, carpets, eating utensils, and dinnerware often use catalogs to sell their products. This method of doing business might be in addition to the use of showrooms and route salespeople, or it may be the only method employed by the seller. For the retailer, catalog purchasing has a number of advantages, including:

- The ability to examine the vendor's offering at one's leisure. Visits to the markets may be hurried, and poor decisions may be made. Similarly, office calls by traveling sales reps may come at inopportune times that could interfere with the buyer's other duties and responsibilities.

- The seller's input could be biased and result in unwarranted purchases. By using the catalog, vendor "pressure" is eliminated.

- Various catalogs can be compared at one time, giving the buyer the opportunity to carefully assess what's available from competing suppliers.

Of course, catalog purchasing does not allow the buyer to inspect the actual items. A picture may not truly represent the merchandise. Colors may be different from those actually produced, fabrics might not feel as expected, and the quality might not be as good as the illustration conveyed.

Whatever method of purchase is decided on, the buyer must be certain that the merchandise is the best to be found to satisfy his or her customer's needs.

PURCHASING ON THE INTERNET

The procurement of merchandise on the Internet has become an ever-increasing channel for buyers to use. Not only does it provide them with a wealth of different available products, both at regular wholesale prices and at closeout prices, but it constantly changes as new products become available. The popularity of this as a viable additional purchasing venue is fully explored in Chapter 15.

Language of the Trade

buyer's arrival notice
domestic market weeks
Garment Center
MAGIC
NAMSB
notetaking form
prescreening
pulse of the market
resident buying office (RBO)
road sales representatives
Seventh Avenue

Summary of Key Points

1. Buyers have several alternatives for purchasing merchandise from vendors—visits to wholesale markets, in-store buying, and purchasing through catalogs and the Internet.
2. For fashion buying, the visit to the marketplace is the best means of assessing new lines.
3. All across the United States, hundreds of market weeks are scheduled to introduce the coming season's merchandise offerings.
4. A visit to the wholesale market involves a great deal of planning, such as vendor analysis, dollar allocations to be spent, changes in pricing policies, and quantitative and qualitative considerations.
5. Market representatives assist the store buyers with hotel reservations and vendor appointments needed for market visits.
6. The resident buying office sometimes places the buyer's arrival time in trade papers so that vendors may easily contact them.
7. Market specialists often prescreen the lines before the buyers' arrival so that they can advise them of what is currently being featured by the various resources.
8. The major domestic fashion center is in New York City's Garment Center, also known as Seventh Avenue.
9. California is second to New York in terms of fashion suppliers, with Los Angeles and San Francisco being the major cities for such merchandise.
10. Important American fashion centers include Miami, Atlanta, and Dallas.
11. The market visit is a hectic event that requires careful planning so that the buyer may call on a number of vendors in a short time.
12. Resources may be visited at either trade expositions or permanent vendor showrooms.
13. Some retailers make their purchases from traveling road representatives who call on them.
14. For some merchandise classifications, vendors offer catalogs to prospective retail accounts that feature the company's entire product line.
15. The Internet has become a valuable option for buyers to use for their purchases.

Review Questions

1. What are the three techniques used by buyers for merchandise acquisition?
2. Why does the visit to the wholesale market better prepare the buyer than the other two methods?

3. Which types of merchandise are represented in the various market weeks in the United States?

4. How does planning help the buyer when he or she visits the market?

5. What types of planning does the buyer make before the actual trip to the market?

6. In what ways do the resident buyers assist the store buyers before they come to market?

7. What purpose does the notification of buyer's arrival serve?

8. Is it necessary for market specialists to prescreen the lines before meeting with the retail buyers?

9. Where is America's most important fashion center located? Where are the next two important centers?

10. Why is the resident buying office visited prior to calling on the vendors?

11. Is it necessary for the buyer to have a set schedule once he or she arrives in the wholesale market during market week?

12. Why do buyers defer order placement until they examine the entire market's offerings?

13. Briefly list the typical visitations for a buyer during the market week period.

14. Why do some merchants purchase from road sales reps in their stores rather than going to the wholesale markets?

15. Explain why some industries use catalogs to sell to retail buyers.

16. In what way is wholesale product acquisition better on the Internet than through vendors' catalogs?

CASE PROBLEM 1

Collins and Frost is a medium-sized department store located in northeastern Texas. It has a flagship store and three branches, all of which are within a seventy-mile radius. C and F, as it is known in the trade and to its customers, is merchandised through its flagship store. At the head of the merchandising division is a general merchandise manager, Amy Brodsky, who supervises three divisional merchandise managers, one of whom is Beverly Nadler, the DMM for menswear. As is the case with these organizations, each DMM is responsible for a number of buyers. At C and F there are twenty buyers, five of whom are menswear division purchasers.

For the past three years, Jeff Stevenson, the men's clothing buyer, has noticed a greater demand for designer suits and sportcoats. With each year's purchases, he has increased his initial orders for designer goods. At the last divisional meeting, Mr. Stevenson expressed his thoughts on the expansion of his department to feature a designer boutique. He feels that the steady increase in demand for such merchandise certainly warrants the new direction. Ms. Nadler is in agreement and has taken the concept to Ms. Brodsky, who has the ultimate responsibility for such decisions.

At this point, the merchandising division is in total agreement on the establishment of a men's boutique. The GMM and DMM want a little more input from other sources before making a final decision. They have directed the buyer, Mr. Stevenson, to plan a trip to the major wholesale market to gather more information pertinent to the department's new emphasis.

Questions

1. Who should accompany Mr. Stevenson to the market?

2. With whom should they meet for general input? Why?

3. Should they visit designer resources? Why?

4. Would you suggest they actually open the new boutique? Why?

CASE PROBLEM 2

Amanda Lauren is a small specialty chain that sells apparel and accessories aimed at the twenty-two- to thirty-five-year-old market. Its price points are midrange and include many of the popular manufacturers' labels in the inventories of its six units.

Business has been steadily increasing ever since the company was founded ten years ago. Year after year new vendors were added to the resource list, and most have proved to be excellent suppliers. Of late, however, some of these lines have started to appear in off-price stores that are located close enough to some of its units to present problems. At these off-price operations, the prices for some of the identical goods are considerably lower. While they might not be available at the same time of the year, there are nonetheless complaints from some customers. Elimination of some of these vendor's lines would leave gaps in the inventory.

One suggestion was to begin to mix private-label merchandise into the model stock. While this might be a solution, the small size of the operation prevents the company from producing its own merchandise or having a manufacturer do it for the company. The idea of the private label is still intriguing the Amanda Lauren management team.

Question

1. How can Amanda Lauren offer private-label items without having to produce its own?

CHAPTER 13

Foreign Market Purchasing

On completion of this chapter, the student should be able to:

- ■ Evaluate overseas markets and assess their importance to American retailers.

- ■ Discuss the role of the federal government in terms of importing merchandise for sale by retailers in the United States.

- ■ Describe some of the deterrents of import purchasing for professional purchasers.

- ■ Explain some of the many reasons why American buyers go abroad to purchase merchandise.

- ■ Identify some of the problems associated with purchasing merchandise from foreign countries.

- ■ Discuss some of the methods for procuring foreign-made merchandise.

- ■ Explain some of the qualifications needed by American buyers who purchase abroad.

- ■ Describe the planning that goes into buying trips to other countries.

When retail buyers plan their purchases, they have numerous resources available to them, as we discussed in Chapter 11. To complicate matters even further, not only do they have large numbers of vendors to choose from here in the United States, but there is a wealth of others all over the globe. Today, more than at any other time, every conceivable type of product is being produced in vast numbers of markets. The product classifications include apparel for the entire family; wearable accessories such as shoes, jewelry, gloves, scarves, belts, and hats; furniture; home furnishings that include dinnerware, glassware, dining utensils, rugs, and lamps; computers and electronics; and food items of every possible type.

You might wonder why the search for these overseas items continues to escalate. With the scores of merchants regularly joining the crowds to such faraway places as India, the Caribbean nations, China, Italy, France, the United Kingdom, Japan, Korea, Hong Kong, and Germany, to name just a few, it seems that such purchasing practices are extremely profitable.

If you look back about fifty years, the purchase of foreign-made merchandise was generally restricted to a limited number of retailers. Those who sold high-fashion, or **haute couture,** merchandise found Paris and Italy the places to be, and those seeking

Retailers like The Gap, that practice the store is the brand merchandising, use foreign producers for their goods. *(Courtesy of Ellen Diamond.)*

lower-priced goods of all types headed for some of the Asian countries. Today's merchants are not only from these ultra-chic stores, but also include Wal-Mart, Target, department stores that merchandise inventories at every price point, chain organizations, off-pricers, and those that restrict their inventories to private brands and labels. It is this latter group, collectively known as the store is the brand retailers, who seek not only items for which they can have exclusive rights, but also can produce, in conjunction with overseas manufacturers, goods that they can call their own.

When shoppers enter their favorite stores, look through the numerous catalogs that make their way into their homes, or browse the Internet for merchandise, it is obvious that foreign-produced items are available in large numbers and that consumers are purchasing them.

As we look to the future, overseas resources will continue to play a part in American retailing, and for many retailers they will dominate their businesses' merchandise mixes.

THE FEDERAL GOVERNMENT'S ROLE IN IMPORTING MERCHANDISE

When American buyers plan their domestic purchases, they make decisions such as what they are going to purchase, in what quantities the items will be bought, from which resources they will buy the goods, and when the actual deliveries will be expected. While this is not a simple task to perform, as we have learned in the previous four chapters, it doesn't come with any strings attached. When imports are being considered, it's another story. Along with all of the other factors to consider, there are the problems of quotas, tariffs, and government trade agreements that become part of the buying plan. In America, the price quoted by the vendor is the price paid, of course, less the discounts that are negotiated. Throughout the remainder of the global market, a buyer must contend with other conditions. The factory or wholesale price is merely a starting point, as we will see later in the chapter. A product offered for sale at $400 might end up on the retailer's shelf selling for $1,500! Although this seems like an enormous price differential, it is based on such "extras" as high shipping costs, duties or tariffs, costs for customs clearance and, of course, the markup.

You might ask why a duty or tariff is imposed by our government on imported merchandise. The answer is that if left uncontrolled, American manufacturers might be unable to compete with those from other countries. With many overseas workers earning very little in the production of goods, the final wholesale prices are comparatively low. Without the additional expense of tariffs, domestic manufacturers simply could not compete. By adding these costs, the playing field is somewhat leveled.

There are two aspects of importing that require further explanation. One involves the retail buyer who goes abroad to seek merchandise to his or her liking and purchases it for resale in the United States. The other involves two types of American businesses that enter the overseas market to have merchandise produced exclusively for their needs. One is a giant retailer like The Gap or The Limited, which helps overseas producers develop specific items exclusively for these stores' import programs. The other is an American designer, such as Liz Claiborne or Calvin Klein, for example, who contracts with offshore producers to manufacture merchandise according to these designers' creations or specifications.

Trade agreements and duty regulations have far-reaching implications for purchases made abroad and will be further explored for better comprehension.

Trade Agreements that Affect Merchandise Sourcing

Major agreements that have far-reaching effects on importing and retailing are the North American Free Trade Agreement (NAFTA), the one that was enacted by the World Trade Organization (WTO), and the Central America–Dominican Republic–United States Free Trade Agreement (CAFTA-DR). Each has its own set of rules and affects different countries. Another, the General Agreement on Tariffs and Trade (GATT), is no longer in existence, having been replaced by the WTO agreement. The discussion of GATT is presented to provide an overview of how the federal government was involved in trade agreements before it reached today's involvement.

GENERAL AGREEMENT ON TARIFFS AND TRADE (GATT)

Enacted in 1994, after a great deal of negotiating by President Clinton and the U.S. Congress, the **General Agreement on Tariffs and Trade (GATT)** was the law of the land. The pact generally reduced tariffs on a great number of products by about 40 percent. It included a host of new trading rules between the United States and 123 other countries. Its ultimate goal was to eliminate trade barriers among the participating countries. Overseeing the agreement was the World Trade Organization, which had the jurisdiction to enforce the provisions of the pact and lodge penalties against abusers.

Although tariff reduction was a key point, GATT also dealt with quotas. Specifically, GATT was to eventually eliminate all quotas. The elimination was to be done at a gradual pace; it began with a quota reduction of 16 percent on January 1, 1995, on textile and apparel products imported into the United States and would culminate in 2005 with a quota-free economy. To make certain it would have an excellent chance for success, the plan phased out quotas in four stages.

With the costs associated with tariffs and taxes virtually eliminated by this pact, buyers will have benefited with the opportunity to assess markets all over the globe for merchandise that would suit their needs without increasing prices to customers.

NORTH AMERICAN FREE TRADE AGREEMENT (NAFTA)

Considered to be one of the most complete trade agreements ever entered into by the United States, the **North American Free Trade Agreement,** or **NAFTA,** came into being in 1994. The plan eliminated the trade barriers that once existed between the United States, Mexico, and Canada.

When the agreement was first enacted, it was expected that Mexico would be a major beneficiary as a result of its becoming a chief supplier to the United States. Not only has this happened in the short time that NAFTA has been in effect, but recent figures released by the Commerce Department reveal that Mexico has arrived as a powerhouse in the textile and apparel business. In a relatively short time, it replaced China as the leading exporter to America for these combined industries. With the more restrictive policy on quotas and import duties for Asia, it is likely that sourcing from Mexico will become even more dominant. In addition to the price advantages of NAFTA, another benefit to the United States is the close proximity of Mexico, which allows for faster shipments. Of course, the Asian and other foreign markets are likely to have their positions improved once GATT ends all trade restrictions.

At this time, labor organizations continue to worry about the ultimate effects of NAFTA on individual earnings for many Americans. With potentially lower prices from Mexico, unions fear that employment in the United States will falter for those affected by the agreement. It is still too early to know what the long-term effects will be.

WORLD TRADE ORGANIZATION AGREEMENT (WTO)

Born out of GATT, the **World Trade Organization (WTO)** became the world's leading global trading body. The regulations of GATT remain the primary principles for multilateral trade in merchandise.

Mexico has become a chief beneficiary of NAFTA.
(Courtesy of Ellen Diamond.)

The major purpose of the WTO is to guarantee that global trade "commences smoothly and predictably." To ensure that its principles are successfully carried out, the body has formulated legal parameters for global trading among member nations. This has enabled a system for international trade among the more than 140 member nations to function in a stable manner. The WTO rules become a part of a country's legal requirement and, therefore apply to local companies and nationals in terms of how they conduct business in the international arena. If, for example, a company decides to invest in a foreign country, the rules of the WTO will determine how that can be accomplished.

The decisions of the organization are determined by consensus, although a majority rule might be utilized in special cases. The *Ministerial Committee,* which is based in Geneva, Switzerland, holds meetings every two years to make decisions. Trade disputes are settled by the WTO which might issue trade sanctions against the country in violation, until the dispute is settled.

The overall aim of the WTO is to encourage investments by nations in other countries that will hopefully improve their economies and standards of living.

CENTRAL AMERICA–DOMINICAN REPUBLIC–UNITED STATES FREE TRADE AGREEMENT (CAFTA-DR)

The most recent trade agreement, the **Central America–Dominican Republic–United States Free Trade Agreement (CAFTA-DR),** is one that specifically involves six countries. They are the United States, Costa Rica, Dominican Republic, El Salvador, Guatemala, and Honduras. Enacted in July 2005, the export zone created will be the United States' second largest free trade zone in Latin America after Mexico. In addition to tariff reduction, it provides new market access for U.S. consumer products and agricultural products.

The United States Customs Service. As referred to earlier in the chapter, the U.S. Customs Service imposes tariffs and quotas on merchandise imported into the United States, except for certain classes of goods and merchandise that come from specific regions.

TARIFF ASSESSMENT

Much of the merchandise that is imported into the United States is subject to a *tariff* or **duty.** Some, such as antiques, are duty-free. The duty rate imposed on merchandise is a percentage of the appraised value. The rates of duty vary according to the merchandise classification and the country of origin. Some goods are dutiable under the *"normal trade relations" rates,* formerly known as **most-favored-nation (MFN)** rates. Merchandise imported from countries that do not have this status carry significantly higher rates. There are rate concessions given to goods that come from least-developed, developing countries (LDDC). Duty-free status is also available for specific items from developing countries.

The rates charged are determined by the U.S. Customs Service. The stated rates in the tariff schedules change from time to time and should always be checked by buyers before entering into a purchasing agreement. Because the assessed duty can contribute considerably to the cost of the merchandise, it is vital that the buyer have a clear understanding about what tariffs will be applied, and whether similar merchandise may be purchased domestically at comparable costs.

DUTY-FREE STATUS

Under certain conditions, the government authorizes importing merchandise that is not subject to duty, such as those specified in the previously discussed trade agreements.

QUOTAS

A **quota** is the set amount of merchandise that a country's government allows to be imported in a specific category. Quotas are generally established for numbers of units rather than dollar amounts, and are set by legislation and presidential proclamations issued pursuant to specific legislation and provided for in the Harmonized Tariff Schedule of the United States (HTSUS). The quota arrangements are for the protection of producers in the United States.

There are two categories of quotas—absolute and tariff rate. In the case of **absolute quotas,** any merchandise that exceeds the established limit must be disposed of through a variety of means established by the U.S. Customs Service. Merchandise

that is subject to **tariff rate quotas** and is above the established limits may enter at a higher rate of duty or remain in a bonded warehouse awaiting the opening of a new quota. Strict adherence to these quotas is important because exceeding them could result in significant losses to the importer.

Often an importer uses up the assigned quota and wants to import additional merchandise. Quotas may be purchased from holders of quotas who do not expect to use the entire quota allocated for a period. Thus a major designer like Calvin Klein who has merchandise produced overseas may avail himself of additional goods via this route. Sometimes additional quotas aren't available by purchase, and importing must be suspended for the period.

Unlike the domestic purchaser, who can order without restriction, the participants in importing their own goods must be fully aware of quota restrictions and changes so that their merchandise needs can be satisfied.

Importers should carefully consider the exceptions to the general rules of duty and quotas. Sometimes, by entering relationships with countries that enjoy duty-free status or are not part of the established quota system, American merchants can produce or purchase goods that cost less than those imported from the other countries.

The rules and regulations that govern the tariff and quotas are so complicated that it is good business practice to use experts who are more familiar with the situation. Misjudgment of requirements could make an otherwise good deal into one that is riddled with problems. The end result could be a loss rather than a profit.

REASONS FOR PURCHASING FOREIGN MERCHANDISE

With all of the complications involved in purchasing foreign-made merchandise, you might wonder why American merchants choose to do so. In the United States, there is just about every conceivable type of imaginative as well as functional product. From automobiles to fashion merchandise and foods to household items, just about everybody's desires can be satisfied. Why, then, are more and more merchants scanning the globe to discover foreign-produced items? It certainly is easier to purchase at home and not have to deal with the rigors of these offshore purchases.

In spite of the restrictions placed on these international merchandise acquisitions, there are some reasons why these quests continue.

Lower Cost

Merchandise from abroad that is comparable in quality, variety, and innovation to American-made goods often is less expensive. Contributing to the lower costs is the fact that often the raw materials used in the production of these items come from abroad, and the factory workers are often paid far less than their American counterparts. For example, manufacturers produce their own brands offshore to compete with domestically made men's clothing. By using materials produced overseas and paying wages much below those paid in the United States, overseas manufacturers are able to offer American buyers merchandise comparable to American-made goods at significantly lower prices. In stores where

fashion as well as lower price is of paramount importance to the consumer, carrying this imported merchandise could mean greater sales. For stores that produce their own designs overseas, as does Macy's with its Alfani label, the costs are considerably lower. In Korea, where some of this collection is manufactured, the costs of production are so much lower than in the United States that Macy's is able to bring high fashion to its customers at considerably lower price points than if it used domestic production facilities.

Lower prices for offshore products are not limited to menswear. Women's and children's apparel, accessories of all types and qualities, home furnishings, food, television receivers, and the like are plentiful abroad at equal savings.

Of course, importing does not always mean lower costs. When you consider the prices for couture designs from fashion centers such as Paris, Milan, and London, it is obvious that the attraction is not price.

Quality

While the United States is a leader in quality merchandise, there are certain countries that continue to produce goods that are superior to ours. The reasons for the exceptional quality are many. First, the natural resources of a country might contribute to the quality. For example, Belgian linen is the finest in the world. The reason is that the pure water necessary for extremely fine linen is found only in the Coutral area of Belgium. Similarly, the quality of the mulberry leaves fed to silkworms for the production of silk is best in Japan.

Second, craftsmanship accounts for the quality of merchandise produced in some countries. Few can compete with the Irish in the creation of fine linen garments or the ability of Germans to produce lenses. The expertise of the Mercedes-Benz is found in Germany, where quality is the automobile's signature. Finally, the time necessary for the production of some goods is simply impossible in the United States at our hourly rate. A fine handmade Persian rug, for example, might require a year to create. Such quality would make its cost prohibitive if it were made in America.

Greater Profit

The more efficient the organization, the greater the profit it will achieve. Efficiency can be increased in a number of ways. More efficient purchasing can contribute to greater profits. Goods produced in foreign countries often afford the retailers higher markups. This does not mean that the buyer can recklessly mark merchandise at whim; there is a great deal of competition in foreign merchandise. But there are occasions when buyers can purchase special goods that they intend to mark up more than usual. This is especially true if "exclusivity" arrangements can be accomplished by the buyer. With this advantage, no one else can purchase the merchandise and price it for less. For this reason, merchants with the necessary financial resources scout markets less frequented by other companies. In fact, a large department store or chain organization can bring an article that it has developed to a foreign producer to have it made for its own use. Promising to buy all of the overseas manufacturer's production of the item guarantees the purchaser freedom from competition. Retailers like The Gap, The Limited, Crate & Barrel, and Macy's regularly involve themselves in such arrangements. By working with lower costs and higher markups because of the exclusivity factor, a greater profit will be realized.

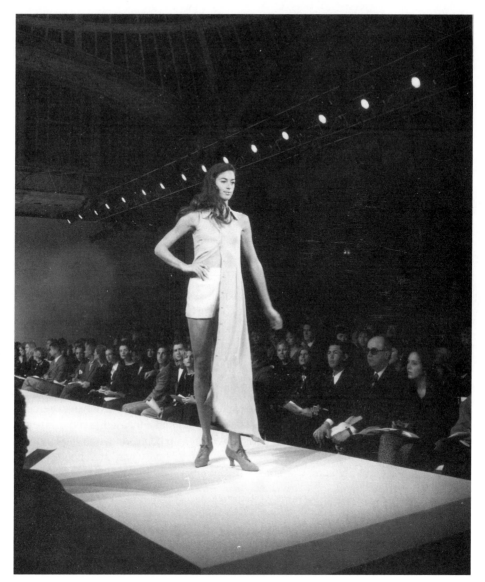

The prestige of couture designs, as seen on the runway, influences some consumers to buy.
(Courtesy of Ellen Diamond.)

The emergence of the private label has made this type of importing more important than ever before. If most major retailer's private labels are carefully examined, they will reveal that the vast majority of the merchandise comes from outside the United States.

Prestige

There is a segment of the consuming public that is enthralled with the notion of owning prestigious merchandise. This might be inconsistent with the advantage of a lower price, but there are those willing to pay more if the label makes an impression. Whether

it is the couture designs of Armani, Lacroix, or Lagerfeld; from Europe's fashion capitals; or such automobiles as Mercedes-Benz, BMW, or Lexus; the "label" is often the most important factor to the purchaser. Affluent people discuss their luxury labels with the same excitement as those who hold tickets to the Super Bowl. Wearing labels from Paris, owning bone china from Great Britain, or having suits from Savile Row all provide interest to those so inclined.

Wishing to cater to these affluent shoppers, some retailers carry such products. In women's fashions, for example, the introduction of a famous European designer's latest collection is met with enormous excitement. The holder of a ticket to this type of fashion show is as excited as the sports enthusiast holding a ticket to the last game of the World Series. Making these fashion items available in limited quantities makes them even more appealing. It is the exclusivity factor, and the need to show their peers that they are among the select few who have such costumes, that makes the merchandise even more appealing.

Unavailability of Merchandise in the United States

Although most product classifications are produced in America, there are certain items that are unique to other parts of the world. For example, a growing number of specialty food stores feature imported merchandise. Only these foods will satisfy the tastes and needs of some customers. While it is certainly recognized that domestic caviar will suffice for the typical American, gourmet lovers will not consider anything but Russian caviar. Likewise, handmade jewelry from Asia cannot be imitated in the United States without changing the methods of production and raising the cost. Hand-carved picture frames and pottery are extremely desirable and found in abundance in Mexico at extremely favorable prices. Duplication of such products here would make their costs more expensive.

Although copies of just about anything can be produced in the United States, the imitation usually comes as a poor substitute. Thus when merchandise at a desirable price and quality is unavailable in this country, buyers are apt to scout distant markets in search of them.

PROBLEMS RELATED TO THE ACQUISITION OF FOREIGN MERCHANDISE

As we have just discussed, buyers for every type of retail operation are covering global markets in record numbers. However, this trend is subject to many difficult obstacles. Each of these deterrents must be evaluated before any buying trip takes place. Once they have been considered, it is then that the buyer must make the ultimate decision on foreign buying. Some of the more problematical concerns follow.

Delivery

One of the keys to the success of any retail operation is to have the merchandise on hand as it is needed by the customer. Buyers anticipate these needs and must make certain that delivery will come as expected. Before any order is placed, an assurance must be

forthcoming from the vendor with regard to the date of receipt for the ordered goods. With open-to-buys such a vital ingredient in the buyer's planning strategies, the targeted delivery is even more of a concern. In practice, even in the case of domestic merchandise, an absolute delivery guarantee cannot be made. Such factors as unforeseen strikes by production people or truckers can seriously hamper the receipt of ordered items. Delivery often proves to be even more problematic when it comes to shipments from abroad. A handler's strike at the seaports or a wildcat walkout at a factory may be extensive, causing severe inventory problems. Sometimes the buyer's inability to check these situations because of the distance from the suppliers compounds the problem.

No matter how carefully the buyer plans, problems could arise with getting the merchandise on the shelves. There might have been a company promotion that involves advertising. With many ads set far in advance of their runs, the late arrival of goods could seriously affect profits. Even more frightening is when merchandise is earmarked for a catalog. With a great deal of "lead time" necessary for catalog production, buyers must send their selections to the publishers many months before the merchandise is due for arrival. With the item now in place in the sales catalog, and unavailable for any of the already stated reasons, disaster could be at hand. Not only won't the merchandise be there to produce sales for the company, but consumers could be agitated by not being able to receive the items that were being promoted. This could motivate the customer to shop elsewhere, and if satisfied by another retailer, could become a "regular" for the competition.

Quality Variations

The very nature of buying from foreign resources could be troublesome in terms of the quality of the goods. Often the goods are ordered by a description, sample, or illustration, and when the delivery is made the actual merchandise differs from what was anticipated. Returns of such inferior products might be difficult because of the time, expense, and distance involved, but more important, considerable damage can result because of the shortages on the selling floor. As in the case of late delivery, as noted, the buyer's inventory has a void that could lead to customers shopping elsewhere. While quality variation is not a problem exclusively of foreign-made merchandise, it is generally more prevalent than in domestically produced goods.

To minimize the problems, many major retail organizations send quality controllers to offshore manufacturers in the hope that their presence will ensure adherence to the expected quality of the merchandise ordered. These quality control experts are almost always used by companies that are having vast collections of private-label merchandise produced offshore.

Reorders

The key to a buyer's success usually lies in the ability to select merchandise that will be ordered again and again. It is this merchandise that helps the buyer maintain the necessary markup to show a profit. Lead time to guarantee delivery of reorders is virtually impossible. If the item is a staple, such as a food product that is used all the time,

the problem might be overcome through sizable reorders that allow for long delivery periods. This is fine as long as the item will continue to be in demand. In the case of seasonal or fashionable goods, however, the reorder from overseas resources is virtually impossible. For example, the Italian-made bulky sweater might initially sell extremely well but will require a delivery promise of three months for the reorder. In that case, the season would more than likely be over before the reorder arrives.

Buyers of such merchandise must fully comprehend the selling period for their merchandise and realize that promptly filled reorders are the exception rather than the rule for foreign-produced items.

Early Selection of Colors

Fashion buyers are confronted with making color selections as part of their job. This is a necessary function in the industry. They can perform the job more efficiently by familiarizing themselves with color information. This information is available from trade papers such as *Women's Wear Daily,* consumer publications like *Elle* and *Glamour,* fashion-reporting services, market specialists, and fashion forecasters. Except for the color predictions that come from the fashion forecasters, color news is not often available at the time it is necessary to place orders for imported merchandise. Sometimes, the purchase orders are placed as much as a year before delivery is scheduled. There is usually sufficient time to make color choices based on industry barometers for domestic purchases but not on foreign goods.

While color choices are often risky, overseas ordering can prove to be even more problematic.

Size Discrepancy

Measurements vary from country to country. American measurements are the largest in the world. Thus shoes imported from France might not be salable to Americans who require larger sizes. Goods purchased from the Far East might be in proportions not commensurate with the American figure. The actual sizes may also vary. A man wishing to buy a pair of shoes or a suit manufactured in Great Britain will find that they have no resemblance to our size structure.

In recent years, buyers have approached the size problem. Retailers who purchase in significant quantities can supply the foreign producers with exact measurements or patterns. In this way, they can capture the flavor of the foreign design while making certain that their American customers will be accommodated. When specification of size structure is impossible, buyers must exercise extreme care in their purchases. Failure to do so could result in an assortment of merchandise headed for markdowns.

Money Allocation

When buying from American manufacturers, retailers do not pay for goods in advance of shipment. They negotiate payment terms on the purchase order and have some time before the merchandise must be paid for. Frequently, manufacturers abroad insist on partial payment for the goods at the time of the order. In this case, with orders taking

as much as a year to deliver, the capital could be tied up for a long period. Retailers with limited capital might find such arrangements unprofitable. They might have to borrow money in order to continue their operations, with such loans cutting into their profits.

Time Involved

Visits abroad often require more time than it would take to cover the domestic markets. Buyers in the United States might cover their resources in a matter of a few days, but might find equal coverage offshore taking as much as double the time. Even in the Paris market, the couturiers are so spread out that it is difficult to move easily from one to the other. In classifications other than fashion merchandise, investigation of a few lines of merchandise might require movement through a few cities before the right goods are located. Buyers with limited time to spend away from their other duties and responsibilities could find coverage of the foreign markets a difficult task.

Capital Risk

Because the goods available for purchase from other countries are sold in the currencies of those countries, a great deal of risk is involved in such purchases. The American dollar is worth different amounts at different times, with considerable fluctuation a possibility. Such changes could cause significant problems for the buyer. For example, an item that could be considered a bargain at the time it is ordered could be more expensive at the time when delivery is made and payment is due. If the rate of exchange at the time of purchase for Euros is 1.01 to the dollar and the cost of an item is 100 Euros, the dollar amount would be $101 for the item. If, however, when the invoice is to be settled the Euro is worth 1.08 to the dollar, the cost would be $108. This change could mean the difference between a profit and a loss. These risks should be carefully considered at the time of purchase.

Actual Cost Determination

The price quoted for foreign-bought merchandise reflects only the price that is being charged by the vendor. This is by no means the final cost of the goods. A number of factors must be considered to determine how much the buyer will actually pay for the purchase. One consideration is the delivery charge. Because the shipping distance may be considerable, transportation costs will undoubtedly be higher than for the domestic acquisition. Buyers in need of immediate delivery must be fully aware of the expense of airfreight. Another consideration is the amount of duty that could be added to the purchase price. Complete understanding of customs tariffs is of paramount importance because, as we discussed earlier in this chapter, there is a great deal of variation according to the merchandise in question and the country from which it has been purchased. Items such as insurance, packing charges, and storage expense will also increase the actual cost of the merchandise.

Before the buyer finalizes a foreign purchase plan, a detailed computation to determine the *landed cost* should be undertaken. The **landed cost** is the actual or

final cost of the goods to the retailer. Determination of the landed cost is important so that the buyer can figure out at what price he or she must finally retail the goods to realize a profit. Sometimes the buyer might decide in the final analysis that while the initial cost was appropriate for the purchase, the landed cost was too much to be profitable.

It might be assumed that seasoned buyers can automatically calculate the landed cost by adding a "typical percentage" to the initial cost. But what appears to be a simple expense for storage can turn out to be much greater because of unexpectedly long storage.

Following is an example of the landed cost for the purchase of Italian men's accessories.

Initial cost: 100 ties @ 1.01 euros each	101
100 ties @ 1.12 euros each	112
Total initial cost	213
Less 2% discount	4.26
	208.74
Packing charge	22.00
7% commission (on initial cost) to agent	14.91
Shipping charge	82.00
Storage	21.00
	348.65
Duty: 30% (estimated) on initial cost, plus packing	104.59
Total landed cost (in euros)	453.24

The buyer then must translate the foreign currency into dollars at the current exchange rate. If the entire price for the goods is not paid for at the time of purchase—which it generally is not—then this is only an estimate, since rates fluctuate on a daily basis. Sometimes the costs could be more than originally thought.

Cost of Promotion

Nationally advertised brands are immediately known and accepted by a nucleus of the consuming public. The buyer's promotional budget, which will be discussed in Chapter 20, is often enriched by cooperative advertising allowances available from well-known manufacturers. Even without this allowance, such goods generally require less promotion because of the consumer's awareness of the brand. Some foreign merchandise, except for internationally renowned products, is unfamiliar to customers. To guarantee its acceptance, it is often necessary to appropriate large amounts for promotional purposes because most foreign suppliers do not give advertising allowances. Not only will larger-than-usual dollar amounts be expended, but the buyer must have specialists at home who can prepare a promotional campaign. Of course, not all imports require this careful attention. Every fashion devotee immediately recognizes the Lagerfeld label, but a new brand might require above-average promotional exposure.

Political Unrest

Occasionally foreign countries become engaged in political problems that could severely hamper the production and sales of merchandise. The Iraqi war disturbed the manufacture of goods in the Middle East. Retailers in other nations who used these countries to make some of their goods found that delivery was seriously affected, and in many cases was not made at all.

With the political climate unsettled in many other parts of the globe, merchants must reconsider these locales in the acquisition of merchandise. Since orders are often placed as early as six months in advance of their need, a political struggle might adversely affect the retailer's merchandising plans.

Caution must be exercised by the buyers and merchandisers in the purchase of goods from foreign venues, and contingency plans must be made to avert merchandise shortages.

Global Disfavor

Some countries that sell their goods offshore sometimes fall out of favor with the consumers in the nations to which the goods are headed. Many years ago, after the Second World War, Japanese products were often shunned by American citizens because of the atrocities committed in Japan. It took many years for the problem to be resolved.

In 2003, when the United States was looking for nations in every part of the world to become "coalition partners" for the Iraqi invasion, France decided not to participate. Instead it chided the United States for its participation. As the war escalated and the French rhetoric increased, many Americans decided to boycott products that were made in France. Everything from apparel to wine was affected, and purchases of these products plummeted. Those merchants whose inventories featured these items found that they were often unsalable. Many retailers had to take a severe loss with this assortment of goods. French merchandise became problematical to sell, requiring the merchants to look elsewhere to replace the otherwise desirable products.

Although it is sometimes impossible to predict such problems, retailers must be ready to assume the burden of markdowns if such happenings occur.

While these are some of the problems related to importing merchandise, they are by no means the only ones. Others, such as expenses to return damages and losses of goods in transit are possibilities. Both apparent and unforeseen problems must be considered to ensure the success of the buyer's import purchases.

METHODS USED IN THE PURCHASE OF FOREIGN GOODS

The purchase of imports may be achieved in a number of ways, not only by direct visits. The choice is determined by the size of the retailer, the proportion of imported goods in relation to the store's total merchandise inventory, the time the buyer has available for the pursuit of such goods, the size of the foreign markets and their distance from the United States, and the cost involved in such merchandise procurement.

Buyers flock to overseas trade shows to buy imports.
(Courtesy of Ellen Diamond.)

The retail organization must address these factors and decide which approach is best for the buyer to use.

Visit to the Foreign Market

Only the very large retailers make direct visits to foreign markets for their purchases. Buyers who represent department stores, chain organizations, catalog companies, and Internet Web sites in the United States frequent the foreign markets at regular intervals. It is not uncommon for large companies to send teams of merchandisers that include the general merchandise manager, divisional merchandise managers, buyers, and assistant buyers on foreign buying expeditions. Very often these purchases require significant expenditures and necessitate a team effort.

Buyers can familiarize themselves with foreign markets through the U.S. Department of Commerce as well as by communicating with the commerce departments of the countries in question. Many large retail organizations maintain relationships and representation with foreign agents who plan for the buyers' visits in much the same manner as the resident buying offices do in the United States.

Purchasing may take place at the vendor's headquarters, as with a great deal of domestic purchasing, or at trade expositions that are organized at regular times. These international fairs or expositions are found all over the world and feature a wealth of different merchandise classifications. By attending these expos rather than the individual resource showrooms, the buyer is able to cover the market more quickly. Events such as PLMA World of Private Labels, for example, in Hong Kong enable the major

TABLE 13.1 International Trade Events

Event	Location
Asian International Gift Fair	Singapore
PAACE—Pan American Auto Accessories	Mexico City
FMI Asia Mart	Hong Kong
Mostra de Trejados (textiles)	Barcelona
Tech Textile Asia	Osaka
SISEL (sportswear)	Paris
Mode Accessories International	Toronto
Collections Premiers	Dusseldorf
Modit	Milan
The London Show	London
Quebec Market Week	Toronto
IGEDO	Dusseldorf
Interstoff	Frankfurt

retailer to establish a relationship with a supplier to produce a private-label collection. Instead of having to explore numerous regions for this plan, everything could be accomplished under one roof. Comparisons from vendor to vendor can be made at the expo, with an ultimate decision made in less time.

Some of the leading international trade events are shown in Table 13.1. The availability of merchandise cuts across just about every classification of goods. However, it is the fashion buyer who puts the most time and effort into international visits. So demanding is the merchandising of fashion items, that the direct visit, if possible, is the best way to study a market. In this way, the buyer can assess what is available.

Those who buy at the uppermost levels of couture fashion regularly attend the openings of the collections in such European cities as Paris, Milan, and London. In Paris, the business of fashion is so important that the **Chambre Syndicale de la Couture Parisienne** regulates the industry. This body offers membership only to designers who meet specific requirements. Its jurisdiction includes rules concerning sale of merchandise, copying, and times that members can show their collections to prospective buyers. The "time" role makes certain that there is no overlapping of the major shows. The advance notification of the times of the various presentations enables buyers to schedule themselves so that each event can be covered. There is no need to choose one show over another. Most buyers enjoy their experiences in Paris because the market comes under such strict regulation.

Commissionaires—Foreign Resident Buyers

Unable to travel abroad to purchase merchandise, some retailers accomplish the tasks with representation by **commissionaires.** The counterparts of the American resident buyers or market specialists, they provide a great number of services for their retail clients. They scout the market in anticipation of the buyer's arrival and provide him or her with pertinent fashion news. In cases where direct purchasing is not possible, the commissionaire will represent the retailer and make the necessary purchases. By being

in the marketplace year round, this expert is aware of everything that is newsworthy in fashion.

For a commission, generally 7 percent of the total purchases, the commissionaires provide a variety of services in addition to placing initial orders. They reorder goods that have sold and are still available, arrange for merchandise storage and transportation, and do anything else to make the retailer comfortable with purchasing. Some of these agents work for fixed fees instead of the usual commission arrangement.

Although this is an invaluable service, extreme care should be exercised in its usage when direct purchasing cannot be used. It should be remembered that this is foreign-made merchandise that has not been specifically earmarked for the American consumer. The buyer must make certain that all of the specifications of the purchase be understood so that no mistakes will be made. In this way, satisfaction will be ensured.

The very large American resident buying offices are represented throughout the world by exclusive arrangements with commissionaires. Sometimes these offices are known as **foreign purchasing agents.**

Importers

Many merchants, especially the smaller ones, who cannot visit the foreign markets themselves, or are unable to afford the costs of commissionaire representation, use import wholesalers to purchase goods from abroad. Throughout the United States, there is a significant number of importers who offer a variety of merchandise that comes from all over the globe.

Merchandise from these sources costs the retailer a little more than if the goods were acquired through a direct purchase. It is, however, generally worth it to the small user to take this route rather than incur the expenses from trips to other countries. Like the traditional wholesalers of consumer goods in America, import wholesalers make available many lines of merchandise. This enables the merchant to compare foreign offerings without having to leave the wholesaler's warehouse or showroom.

Some buyers argue that this type of purchase does not involve higher cost. They believe the prices paid are not really higher because of the quantity discounts available to the wholesaler. Because the wholesaler pays a lower price than that usually paid by the smaller retailer, the final price might not be as high as it appears to be.

Import wholesalers offer a wide variety of general merchandise ranging from *hard goods* to *soft goods* as well as foods. Generally, however, these suppliers limit their offerings to specialties such as apparel, food, or appliances.

While the typical customer who uses this type of resource is the smaller merchant without direct access to the goods, the larger organization in need of a particular item for immediate delivery sometimes uses this type of resource.

Import Fairs

To service customers who cannot go abroad in search of merchandise, companies have organized trade fairs at various locations in the United States to show foreign wares to store buyers. New York City, for example, has been the scene of import fairs that offer a wide variety of photographic and recording equipment to retailers. This type of

Atelier features international collections in New York City.
(Courtesy of Ellen Diamond.)

selling continues to grow in importance each year because it affords the retailer the opportunity to examine a multitude of lines under one roof. This saves a great deal of time in the hectic life of a buyer.

Private Foreign Buying Offices

Some retail organizations have the capacity to deal in imported merchandise at such high levels that they find it beneficial to operate their own overseas buying offices. These offices are constantly searching for merchandise that will appeal to their home stores as well as seeking manufacturers to produce merchandise according to specification. Very often the American buyer finds an item that is available in the United States but that he or she would like to have produced abroad at a lower cost. The giant retailers, whose import volumes permit such an agreement, maintain foreign offices.

THE OVERSEAS MARKETS

Just as there are domestic markets throughout the United States, the rest of the world provides numerous centers for retailers to pursue merchandise. Some countries are noted for specific classifications of merchandise, whereas others produce and sell an abundance of different products.

Fashion apparel for the entire family; wearable accessories such as shoes, gloves, belts, and jewelry; home furnishings that include dinnerware, glassware, rugs, and furniture; electronics; and foods are just some that are available.

Although the far corners of the globe are constantly being covered by a wealth of buyers of all these types of merchandise, it is the merchandiser of fashion who regularly visits these markets for their goods. The nature of fashion merchandise, with its ever-changing styles, makes frequent trips abroad necessary.

The Foreign Fashion Capitals

By and large, the major fashion centers outside the United States are in some European countries, as well as many in Asia. Some serve the American retailer with a variety of product types and price points, while others concentrate on one major classification and one level of pricing.

THE EUROPEAN CENTERS

Throughout Europe there is an abundance of couture fashion merchandise as well as collections that are more modestly priced. Buyers from all over the world, notably the United States, converge on these markets to scoop up the latest that the fashion world has to offer. Stores like New York City's Bergdorf Goodman and Saks Fifth Avenue, Beverly Hills' Giorgio, and Dallas's Neiman Marcus are just a few who regularly attend the collection openings to buy couture designs. Although more and more European cities are becoming important to fashion, Paris, Milan, and London still reign as home to fashion "royalty."

Paris. Still the fashion capital of the world, Paris boasts such legends as Karl Lagerfeld, Christian Lacroix, Yves Saint Laurent, and couture houses that bear the names of design greats who have long passed away, such as Chanel and Dior. In addition to these household names, hundreds of others, with varying degrees of recognition, are busy creating original designs. Only a few are members of the coveted Chambre Syndicale de la Couture Parisienne. Membership involves compliance with stringent rules and regulations, and only a few have been rewarded with acceptance.

While the French runways feature the often-outrageous haute-couture, or high-fashion, designs, the bulk of the business from that fashion center is from many secondary lines that bear the names of the same designers. These collections are known as prêt-à-porter, or ready-to-wear. Because only a minuscule portion of the world can afford the high-priced haute-couture merchandise, it is the secondary collections that bring profits to the design houses.

In addition to purchasing couture and prêt-à-porter lines, the American buyers attend the shows in Paris, as well as those in the other fashion capitals, to learn about new fashion trends and to use some of these ideas in their own private-label collections. Although sketching at these shows is forbidden, many buyers make mental notes of a particular hemline or sleeve for incorporation into other designs they might develop for their stores in the United States.

Milan. Today, Milan is almost on equal footing with Paris for original couture creations. It too has its fashion royalty, headed by Giorgio Armani, Gianfranco Ferre, and Gianni Versace. Like their French counterparts, the Italian haute-couture collections are purchased by the most prestigious stores, with the secondary lines getting the majority of the business.

Milan is a major center for fine woolens, and many American designers and retailers who produce their own private-label collections go there to purchase the materials. Sweaters, a mainstay in fashion merchandise, are produced at high-quality levels in Milan, and are regularly purchased by American buyers for their stores.

Of course, much of the finest men's tailored clothing comes from the very same designers in Milan that have popularized women's couture fashion. In fact, for some designers, this is an even more profitable part of their business.

London. For many years, London was a major center for finely tailored men's clothing. In the 1960s, the traditional producers of apparel were joined by names and designs that took the global fashion industry by storm. The move was spearheaded by Mary Quant, a young designer who introduced minis and "hot pants" and quickly set the pace for "mod" dress.

Before long, many newcomers to fashion helped to establish London as a vital fashion center. Today, retailers are busy purchasing the collections of Vivienne Westwood, Zandra Rhodes, Betty Jackson, and a host of other important creative talents.

Of course, the finely tailored gentlemen's attire is still a major emphasis of British fashion, with designers like Turnbull & Asser, Burberry, and Gieves & Hawkes still leading players.

Europe's Other Leading Fashion Capitals. Throughout Europe, more and more countries are making themselves known in the world as fashion innovators in both wearable fashions and furnishings for the home.

The Scandinavian countries of Denmark, Sweden, Finland, and Norway collectively make up a significant fashion region. In addition to apparel, home fashions are also important news for that part of the world. Finland's Marimekko produces home fashion collections that receive global recognition, and Sweden's Orrefors and Kosta Boda glass are world famous. In terms of apparel, Denmark is the leader at the upper price levels, with the others more dominant in popular price ranges.

Once primarily the market for fine cameras and optics, Germany is fast becoming a powerful force in the fashion arena. Today, it boasts in excess of two thousand apparel manufacturers, many of whom have become international names. Buyers from all over the globe, particularly from America, purchase the collections of Hugo Boss, Escada, and Jil Sanders in significant amounts.

Spain has long been a country where leather shoes, accessories, and apparel have been manufacturing mainstays. Today, Madrid and Barcelona are important producers of women's and children's apparel, the bulk of which is exported to overseas retailers.

Poland and Hungary, although not known for their original fashion designs, have become important producers for many American companies. Liz Claiborne, for example, uses those nations to manufacture some Claiborne products, and Macy's uses Poland to produce some of their private-label menswear. With the lower costs attributed to production in these centers, Poland and Hungary are emerging as important resources for buyers to have specific merchandise produced as private-label items.

While Czechoslovakia, as we once knew it, no longer exists, the country now known as the Czech Republic is fast becoming a leader in glass exports. Every conceivable type of glassware, from the traditionally ornate patterns to those featuring a more contemporary look, are being marketed to the United States and other countries. With the significant price advantage and high quality of the glass, American retailers are beginning to incorporate the products into their inventories.

ASIA AND THE PACIFIC RIM

Since the 1950s, many Asian countries have gained importance as suppliers of a host of products. In particular, cameras, television receivers, VCRs, and opticals have been purchased in record numbers by American retailers. Since the 1960s, the area has become one of the more important suppliers of fashion merchandise to the world. The "Big Four"—China, Taiwan, Korea, and Hong Kong—as well as Japan account for the greatest volume produced by the Asian countries. India, while not yet as important as these countries, is emerging as a strong nation for buyers to visit for merchandise procurement. The products American buyers purchase from these countries are original designs, products that have been made according to American manufacturer's specifications, retailer's private-label collections, and textiles.

Japan. Whereas most Americans are familiar with the high-quality automobiles that have come to our shore, many do not know the significance of Japan's fashion merchandise in our retail organizations. Buyers from all over the world, with the United States a dominant user, converge on Tokyo to purchase original designs for their stores. Collections from designers like the internationally renowned Hanae Mori and Issey Miyake, as well as many new headliners, attract a global market. In addition to the original designs, Japan is a major player in the manufacturing process for American companies. The designs are created in the United States and then transformed into the finished products by the Japanese.

Of course, Japan's silk exports are globally famous. As the world's number one silk-producing nation, Japan has become a leader in textile production. The vast majority of the silk apparel and accessories found in American stores are produced in that Asian fashion capital.

China. Headlines in the trade papers, consumer newspapers, and on television continue to extol the importance of China as an economic and sourcing powerhouse. With its lower costs of production and expansion of industrial offerings, a wide variety of products such as original fashion items, workshops for private label brands, electronics, and so forth, buyers are flocking to China's shores for an ever-increasing percentage of their purchases. Shanghai, in particular, is becoming a major competitor to Hong Kong as an industrial leader. The skyline of Shanghai is replete with enormous cranes that indicate the expansion of their industries. Of course, Hong Kong is still a powerhouse, and is now as active as ever even though it officially became a part of the People's Republic of China.

Hong Kong. Although Hong Kong's future was uncertain when it became a part of the People's Republic of China in 1997, the fears of many for this fashion-producing nation have been allayed. It is still a center where American buyers flock to purchase the wares of that region. With its comparatively low costs of production, it emerged and remains as one of the world's most prolific manufacturing countries.

Products from Hong Kong include home fashions, a multitude of accessories, and every price point in apparel. Most retailers will admit that this Asian resource is one that ensures profitability for their companies.

India. More and more American countries are outsourcing many of their services to India. When you dial companies such as Dell for technological assistance, for example, you are immediately connected to someone in India. Retail buyers are also

making more and more visits to India for merchandise acquisition as well as for making arrangements to have private labels produced there. With their increasing advances in technology and the ability to produce goods at a fraction of the price of the same products made in the United States, the attraction is a significant one. Rug buyers and other home products, as well as fashion apparel and accessories, are making India a regular stop on their overseas ventures.

THE CARIBBEAN COUNTRIES

Buying from Caribbean countries is extremely profitable for American retailers because of the extremely low costs of the goods produced there. Not affected by the problems associated with quotas and tariffs because of the special status they enjoy, they are able to export goods at very low costs. The purpose of the American government in establishing such an agreement was to help these nations improve their lots as merchandise producers.

Without the quota restrictions and tariffs applied to other nations, buyers find that countries like Jamaica, the Dominican Republic, and Haiti are excellent resources for their companies.

Hong Kong—a major offshore market for fashion merchandise.
(Courtesy of Ellen Diamond.)

CANADA AND MEXICO

Although Canada and Mexico are entirely different in terms of merchandise offered, collectively they have become important providers of goods for American merchants because of NAFTA. Canada, already an important supplier of apparel and textiles to the United States, is becoming even more important because of this act that eliminates trade barriers. With more than two thousand manufacturers of garments and textiles, American buyers are flocking to Canada in record numbers to purchase their products.

Mexico has become an extreme beneficiary of NAFTA. With the ability to produce merchandise at a fraction of what it would cost in most other countries, it is becoming one of American buyers' most important resources. Apparel, accessories, and home furnishings are just a few of the classifications Mexico produces and exports. It also serves as the producer for many American fashion manufacturers.

In addition to these major foreign markets, buyers from the United States visit Ireland for linen and woolen products, Iran and Turkey for handmade rugs, Belgium for the world's finest linens, Australia for woolens, France's Provence region for dinnerware and cotton prints, and Switzerland for timepieces.

IMPORT BUYER QUALIFICATIONS

As you learned in Chapter 1, those who are assigned the responsibility for purchasing must possess a great number of qualifications in order to satisfactorily perform this duty. In addition to the regular qualities and qualifications, those who venture overseas to buy for their companies must be even better prepared than their counterparts who just cover the domestic markets. In this chapter, and in Chapter 14, buyer preparation for those who venture offshore is explored.

It is these "extra" abilities, such as foreign language usage and computational skills, that are discussed in this chapter, and social and cultural awareness and political neutrality, discussed in the next chapter, that help make such buying endeavors profitable for companies.

Language

While English is becoming more and more a universal language in the world of business, it is not spoken or understood by every potential merchandise supplier. Those who have knowledge of other languages are at a distinct advantage. Being able to directly communicate without having to depend on an interpreter has tremendous value. Although interpreters play important roles in the consummation of a deal, something can be lost in the translation. Those with considerable import buying experience will generally agree that being able to communicate directly could make dealing easier and reduce the problems that result from misunderstandings. While markets in Hong Kong have large businesses with English-speaking representatives to deal with directly, some of the smaller companies in other Asian markets do not enjoy this luxury. Similarly, while Mexico has many English-speaking people, those in remote areas that offer desirable merchandise are unable to speak English. Although it might not be feasible to engage buyers who are fluent in many languages, it is important that those who purchase abroad

have a basic ability to greet the seller and communicate key points of the purchase. Of course, those strong in language skills might not have the other essentials necessary for excellence in negotiation. In the next chapter, attention is focused on how one can learn the proper art of language usage from a company called Languarama.

Computational Skills

As we discussed earlier in this book, a basic understanding of the mathematical concepts that are pertinent to buying plans is essential. The computational skills must be even sharper for buyers who must consider the variable costs of purchases made abroad. While these skills are simple to perform, it is their applications that are important. Any error could affect the ultimate profit a company could expect.

In importing, it is often necessary for the buyer to complete a detailed **importing flow chart** that begins with the factory price for an item and concludes with the retail price. It addresses a wealth of different costs, each having an impact on the eventual retail price.

The following typifies such an importing flow chart:

Factory price of product	+	Inland freight	+	Export packing	=	FOB vessel (port of exit)
400	+	20	+	20 + 60	=	500
FOB vessel	+	Ocean freight	+	Marine insurance	=	CIF (port of exit)
500	+	0	+	100	=	600
CIF	+	Customs clearance	+	Customs duty	=	Landed price
600	+	20	+	50	=	670
Landed price	+	Inland transportation			=	Importer's buying price
670	+	20			=	690
Importer's buying price	+	Markup			=	Importer's selling price
690	+	5% (34.50)			=	724.50
Importer's selling price	+	Inland transportation			=	Retailer's buying price
724.50	+	20			=	744.50
Retailer's buying price	+	Markup			=	Retailer's selling price
744.50	+	744.50 (50% on retail)			=	$1,489

Comprehension of Trade Terms

In making deals, import buyers must be able to speak the language of international trading. Technical terminology is part of the everyday dialogue between buyers and sellers.

The following list features some of the trade terms that require comprehension before a trip abroad can be made.

Bill of lading: Carrier's receipt for the goods, which represents title to the merchandise. It also indicates the specifics of the shipping terms.

Bonded warehouse: Government-approved storage facility in which merchandise may be held without payment of duty. Ultimate release of goods requires duty payment or export.

Chief value: Determination of that part of the goods that is its greatest cost factor and on which applicable duty is based.

CIF: Regularly used term that stands for initial cost of the goods, shipping insurance, and freight costs. Stands for cost, insurance, and freight.

Commissionaire: Foreign resident buyer or agent who charges importers a fee for services rendered in participation of the purchase.

Counter sample: Corrected sample that incorporates changes made by the import buyer.

ELC: Estimated landed cost of the merchandise.

Exchange rate: The value of one company's currency as compared to another. Because the rates fluctuate on a daily basis, it is imperative for buyers to regularly check to determine feasibility of the cost.

Exfactory: A term used to quote prices at the factory.

Landed cost: Importer's final cost, which includes such factors as merchandise, shipping, packing, insurance, commissions, and tariffs.

Letter of credit: Used in financing most import purchases, it is a promise from the purchaser's bank to the seller that goods will be paid for.

POE: The port of entry through which goods pass into a country.

Prêt-à-porter: French ready-to-wear, or mass-produced, merchandise.

Specification buying: Purchases that are made with input from the buyers. Such details as sizing, fabric selection, and trimmings are specified by the buyer.

Tariff: Synonymous for *duty,* it is an extra cost that is added onto certain imports to make them more price-competitive with domestically produced goods.

Visa: Permission granted to individuals wishing to enter certain countries. It is used in addition to a passport.

Way bill: A carrier-produced document that contains the details of the shipment.

PLANNING THE TRIP ABROAD

Because buying trips abroad generally require a great deal of effort packed into a brief time, it is imperative that details be carefully addressed before the buyer departs. Attention to particular specifics prior to departure will help ensure a trip that is profitable as well as free from mishaps. Problems that arise on domestic buying ventures are more easily handled than those that may occur out of the country. Such elements as letters of credit, itinerary planning, hotel arrangements, and foreign agent contacts

must be carefully planned. Slipups on any one of these could easily complicate the buyer's ability to negotiate the best deal.

Letters of Credit

Most import purchases are made on the basis of letters of credit that guarantee the purchaser's bank will pay the seller or the seller's bank for the goods that have been bought. Prior to leaving for the trip abroad, the buyer's company arranges for the bank to supply the necessary letter of credit to be used for each importing transaction.

The various stages in the use of the letters of credit are as follows:

Step 1. The retailer completes the bank's letter of credit application and returns it to the bank.

Step 2. The retailer's bank then sends the letter of credit to the foreign seller's bank.

Step 3. The receiving bank forwards the letter of credit to the seller.

Step 4. Once the deal has been completed, the seller makes the shipping arrangements.

Step 5. Documents are then prepared, as outlined in the letter of credit, and delivered to the seller's bank.

Step 6. When the documents are in order, they are sent to the buyer's bank, which pays the seller's bank according to the terms of the letter of credit.

When all the stages are complete, the retail buyer makes arrangements to have the goods delivered to his or her premises. If the details are not carefully planned before the buyer's departure for the trip abroad, extra time could be required to consummate the deal. In such dealings, where time is of the essence, improper handling of such details could kill the transaction.

In the development of import programs where the buyer is actually involved in the materials and trimmings used in production, letters of credit must be initiated for use with many suppliers. It is not uncommon for the various components of the merchandise to be bought from many different sources in different countries.

Itinerary Planning

Import buyers live on schedules that leave little time for anything but travel from destination to destination. Itineraries or schedules are arranged for them, detailing arrivals, departures, and so forth, so that they can fit everything into their allotted time.

The sample itinerary on page 308 details departures and arrivals in the cities to be visited. Some itineraries spell out hotels, appointments, and other details as well.

Hotel Arrangements

Prior to the departure, hotel accommodations should be made so that the buyer can be reached by the home office as well as by those with whom appointments have been set. It is imperative that those who will be working with the buyer be notified of the buyer's hotel. In selecting a hotel, attention should be paid to the conveniences that will make the stay more productive. For example, English-speaking personnel might be needed to relay messages from the buyer's home office as well as to translate messages from

			March 4, 2006
	ITINERARY		
Ms. Sheri Litt			

March 9	BWI	U.S. Airways Flight 7872	Depart 3:05 PM
	JFK		Arrive 4:10 PM
	JFK	AA Flight 705	Depart 6:20 PM
March 10	Heathrow		Arrive 5:55 AM
March 11–13 London		
March 14	Heathrow	British Air Flight 304	Depart 8:30 AM
	Paris-Chas. Degau.		Arrive 10:50 AM
	Paris	Air France Flight 840	Depart 6:00 PM
	Heathrow		Arrive 8:20 PM
March 15 London		
March 16	Heathrow	Italiana Flight 459	Depart 10:50 AM
	Milan-Linate		Arrive 1:45 PM
March 17–19 Milan		
March 20	Milan	AA Flight 843	Depart 12:30 PM
	JFK		Arrive 3:20 PM
	JFK	U.S. Airways Flight 7987	Depart 5:05 PM
	BWI		Arrive 6:00 PM

A sample itinerary.

foreign representatives. Fax facilities and computers are a must so that documents and e-mails can be sent and received by the buyer, to or from his or her headquarters. Faxes are essential in cases where designs must be sent back to the United States for approval or adjustments. If some business is to be transacted at the hotel, it is necessary to have suitable business space in addition to the buyer's sleeping quarters. Hotels that are centrally located and convenient for market visits should be considered. Advantageous locations are time savers.

The more preliminary details are worked out in hotel planning, the easier it will be for the buyer to function.

Agent Contacts

Most companies make use of foreign agents to assist them with their vendor dealings. Some of the larger retailers have agents who work exclusively for them, while others, whose requirements are less stringent, employ agents on a freelance basis. The agents are involved in every aspect of the buying trip, from making specific appointments to helping consummate the deal. Because they are capable of speaking the language of the country in which the import purchase is accomplished, they can make communication between the buyer and seller simple.

On trips that take buyers to several countries, often one agent accompanies them for the entire trip. For example, on a trip to the Far East, buyers sometimes travel to places like Hong Kong, Korea, and Japan within a week. Using one agent who speaks all of the languages and is willing to travel makes the trip easier.

Agents must be contacted far in advance of the foreign travel to make certain that they will be available as needed, that they can confirm appointments for the buyer, and that

they can do any preliminary investigating necessary to make the buyer's visit a productive one. With time such a vital factor in foreign purchasing, an experienced agent is a must.

When the market has been carefully covered, and the lines have been evaluated, it is time to negotiate the terms of the order and write it.

Language of the Trade

absolute quotas
bill of lading
bonded warehouse
Central America–Dominican Republic–United States Free Trade Agreement
 (CAFTA-DR)
Chambre Syndicale de la Couture Parisienne
chief value
CIF
commissionaires
counter sample
duty
ELC
exchange rate
exfactory
foreign purchasing agents
General Agreement on Tariffs and Trade (GATT)
haute couture
importing flow chart
landed cost
letter of credit
most-favored-nation (MFN) status
North American Free Trade Agreement (NAFTA)
offshore production
POE
prêt-à-porter
quotas
specification buying
tariff
tariff rate quotas
visa
way bill
World Trade Organization (WTO)

Summary of Key Points

1. Merchants who practice the store is the brand retailing are involved only with products that they have produced for them with their own labels.
2. Tariffs are imposed by the federal government to level the playing field for American manufacturers.
3. GATT is a trade agreement that was the basis for the provisions set forth in the World Trade Agreement (WTO) that will ultimately remove trade restrictions around the world.

4. NAFTA was enacted so that there will not be any tariffs among trading that involves the United States, Canada, and Mexico.
5. Some countries enjoy status that allows for a lesser rate of duty or tariff.
6. A quota is a set amount of merchandise that can be imported into the United States in a specific category.
7. Retailers purchase abroad for a number of reasons, including lower cost, quality, greater profit potential, prestige, and the unavailability of merchandise in America.
8. Buying offshore can cause some problems for the merchant, such as slow delivery, quality variations from the original samples, tardiness of reorders, and the need to make early color selections.
9. The landed cost is the actual cost of the merchandise to the retailer.
10. Buyers can purchase foreign goods through such means as personal visits, the use of commissionaires, purchasing from import wholesalers, and attending import fairs.
11. A commissionaire is a foreign agent much like the resident buyer in the United States.
12. International trade events are held all over the globe that feature a wealth of different consumer products.
13. The major foreign fashion capitals are Paris, Milan, and London.
14. Asia and the Pacific Rim have become one of the more important suppliers of many merchandise classifications.
15. In addition to the typical buyer qualifications, those who purchase abroad should also have the ability to speak foreign languages, be aware of social and cultural differences, be politically neutral, and have the necessary computational skills for figuring such matters as landed costs and importing flow charts.
16. There are numerous trade terms that each foreign buyer should know firsthand in order to negotiate effectively.
17. A letter of credit guarantees the buyer's payment for the merchandise purchased.
18. It is essential to prepare a detailed travel itinerary so that the time spent abroad will be productive.

Review Questions

1. Why does the search for merchandise from overseas markets continue to escalate?
2. For what reason does the government play a role in the importing of goods from abroad?
3. How will the GATT agreement ultimately affect buyers from around the globe?
4. Which countries come under NAFTA?
5. What is meant by the term *tariff assessment,* and how does it affect the prices paid for foreign-bought goods?
6. Are all goods dutiable at the same rate when brought into the United States by store buyers?
7. Why does the U.S. government authorize duty-free status for some countries?
8. What is the difference between the absolute and tariff rate quotas?
9. For what reasons do many American buyers go abroad to seek some items?
10. Does prestige ever motivate consumers to buy? Explain why or why not?
11. What are some of the problems related to foreign-merchandise acquisition?
12. Why are reorders of foreign-produced goods sometimes avoided by retail buyers?
13. Explain how currency fluctuation may prove to be a difficult situation for retailers who purchase overseas.
14. What is meant by the term *landed cost,* and how does it differ from the *quoted cost?*

15. In addition to using the direct method for purchase abroad, what other means are employed by buyers who wish to purchase imported goods?
16. Who are the foreign counterparts of American resident buyers, and on what basis do they receive their remuneration?
17. What purpose does an import fair serve the buyer?
18. What is the Chambre Syndicale de la Couture Parisienne?
19. Which types of apparel collections are usually the main profit-makers for couture designers?
20. Why is buying from countries like Jamaica and Haiti extremely profitable for America's retailers?
21. How important is it for American buyers to be aware of the cultural and social customs of other countries when negotiating a purchase?
22. What is an importing flow chart?
23. Why is a letter of credit an important document to prepare before a buyer arrives in a foreign country?
24. Is it necessary for a retailer to carefully plan its buyer's travel itinerary before the trip abroad is taken? Why?
25. Why do foreign agents often accompany American buyers on their trips to vendors?

CASE PROBLEM 1

Ever since it has been in business, California Cobblers, a moderately priced shoe chain, has made it a policy to purchase all of its merchandise from domestic resources. It has promoted itself to its clientele as a store that carries only American-made merchandise. Not only does the company believe it is the right thing to do to help the nation's economy, but it has also made purchasing much easier than buying from overseas resources.

The last few years have seen wholesale prices rise steadily, and in turn California Cobblers has had to mark up its merchandise to higher price points. There was some negative reaction from customers in terms of escalating prices, but not enough to warrant any merchandising changes.

Chandra Kelly, the product developer for the company in charge of creating its private-label collection, has used American suppliers exclusively for the production of the line. She has always been satisfied with the vendors, getting the service she needed to get the shoes onto the selling floor in a timely fashion.

With the enactment of NAFTA, John Leighton, the merchandise manager, has approached the store's management team and asked them to reconsider their American-only policy. He believes that purchasing from Mexican resources under this new pact would reduce the cost of the shoes. With the lower wholesale prices, the chain would be more profitable. Ms. Kelly, on the other hand, isn't in favor of the change, citing the American-only policy as responsible for the store's success.

At this time, the company is considering the change.

Questions

1. With whom do you side in this situation, Ms. Kelly or Mr. Leighton?
2. What are some of the reasons for your opinion?

CASE PROBLEM 2

The Clothes Barn is a specialty retailer that operates three small units in Vermont. It has been in business for eight years and caters to an affluent market. Its merchandise offerings include dresses, coats, suits, sportswear, and accessories for the discriminating woman. Its reputation as a fashion leader has been established. Merchandise is purchased from prestigious manufacturers in the United States. In her continuous search for fashionable merchandise, Lisa Stone, the head buyer, has visited all the important markets in America. In the past few months, exciting foreign goods, at her usual price points and fashion level, have come to her attention through trade papers and customer requests. Much as she would like to satisfy her own curiosity and her customer's inquiries, there isn't sufficient money or time available for her to make trips abroad.

Management has suggested purchasing through importers. While this might be appropriate for some companies, Ms. Stone believes the store's reputation was achieved through careful merchandise selection and that such a plan would permit outsiders to make the merchandising decisions. Now there is a critical need for imports, but the problem still needs a solution.

Questions

1. Evaluate the possibility of the store's hiring a buyer solely for the purpose of foreign buying.
2. How could Ms. Stone remain in the United States yet still make her own purchases of foreign merchandise?

CASE PROBLEM 3

First and Best, a supermarket chain, is located in the metropolitan New York City area. It has twelve units and is considered to be one of the finest supermarket chains in the region. Because it is small as compared with its competitors, First and Best has been able to cater more carefully to the needs of customers. Its clientele, more affluent than typical supermarket customers, is offered such services as free delivery, telephone and fax orders, and charge privileges other than the usual third-party credit cards.

To cater more fully to the needs of customers, the general merchandise manager has suggested that the company organize gourmet departments featuring foods of all nations. The company's owner is against the new program, protesting that purchasing foreign foods would present such problems as undependable delivery, large outlays of capital, enormous time spent purchasing the merchandise, and so forth. Furthermore, he believes that America produces a sufficient variety of foods to satisfy even the most discriminating person's needs.

Questions

1. What arguments could be made to support the merchandiser's position?
2. If the company agreed to the new plan, how would you suggest that it initially merchandise gourmet foods from all nations?

The Importance of Business Etiquette When Purchasing in Global Markets

On completion of this chapter, the student should be able to:

- Understand the importance of being aware of social and cultural differences in foreign countries by comparison to those in the United States.

- Comprehend the importance of political neutrality when doing business abroad.

- Learn the different ways to master cross-cultural skills.

- Understand the importance of avoiding linguistic faux pas.

- Recognize the major aspects of business etiquette that is appropriate when conducting business abroad.

As we discussed in Chapter 13, the playing field in the overseas markets is somewhat different than that of the domestic arena. Buyers and merchandisers must be aware of trade agreements with other nations. Chapter 13 focused on some of the problems that might occur from these offshore purchases, language differences, and other factors that could affect product acquisition.

Although these are the typical areas of concern, retail purchasing representatives must totally understand there are others that will help make the buying experience a profitable one. It is not merely a matter of having good negotiating skills, as is the case in any professional purchasing endeavors, or recognizing which countries are best suited for particular product needs, but of having an understanding of the nuances that might affect the purchase.

All countries have their own social and cultural standards, just as we do in the United States. They, however, are most likely different from ours. The discussion of politics is often considered taboo in many countries, and if improperly addressed, could lead to the termination of an impending sale. Finally, proper etiquette is essential when meeting with foreign business representatives. While we generally understand the guidelines of proper etiquette in dealing with American business representatives, oftentimes they are quite different from what is expected offshore.

Although buyers must be technically knowledgeable about the products they are purchasing and the terms and conditions of the sale that best suit their company's needs to turn a profit, a complete understanding of these "subtleties" are essential.

This chapter will focus on the subtleties of purchasing abroad, where you can best learn about them, and what is considered appropriate to discuss, other than specific business details, in meeting with foreign purchasing counterparts.

SOCIAL AND CULTURAL AWARENESS

Anyone who travels abroad will generally return home with a host of stories that center on the strangeness of the country just visited. Tourists need not be as educated in terms of cultural differences as the professional businessperson should be. While a tourist might offend only those in the host country, a business executive's offensive behavior could destroy a deal.

A buyer returned from an Arab nation where he related that the deal wasn't consummated because of two offensive acts. One involved sitting on the floor. The American pointed the soles of his shoes directly at the Arab seller, which he later found out was rude and unacceptable. The other was the typical question often asked in American business conversations: "How's your wife?" This error was a spoken one. In Arab countries, you must never inquire about a wife or ask anything of a personal nature. When traveling to a foreign land, it is imperative that the customs of the culture be carefully learned. It might not be the terms of the deal that turn the vendor sour, but the words and actions might be unintentionally offensive. While the removal of your shoes might sound strange to Americans visiting Japanese homes, it is necessary for making a good impression.

POLITICAL NEUTRALITY

In America, we are often thrown into a battle when we enter into the world of politics. Most professional businesspeople are aware that political differences are taboo in business discussions. Although a good session with friends could become heated, generally all parties kiss and make up and resume their friendships. Many an offshore deal has been damaged, however, when politics is explored.

The buyer who purchases abroad should never engage in a political discussion with the foreign seller. It is prudent to understand the basic political philosophies of each country to which the buying visits are made, but it is important to play a neutral role. In the United States, we openly and freely criticize our president and other leaders, but in some countries this is unacceptable. You might find communism deplorable, but when dealing with China it is not a topic to be considered. Too often, Americans, accustomed to speaking their political minds, kill a deal by engaging in political conversation.

MASTERING OF CROSS-CULTURAL SKILLS

Once the decision has been made to enter overseas markets for purchasing products, it is essential that the parties involved acknowledge and understand the cultural differences of those who inhabit many of these nations. Buyers and merchandisers directly interface with sellers, and during those meetings, success will more likely be achieved if the cultural barriers are addressed.

The business executives who manage these global duties cannot solely rely upon learning on-the-job. Merely spending time in a country does not fully prepare them for the challenges that lie ahead. Extensive training that involves detailed information about the countries in which they will conduct business in terms of cultural values is imperative.

To evaluate cultural diversity, there are two databases that management at all levels, not only buyers and merchandisers, is able to utilize. One is the World Values Survey that is available online at http://www.worldvaluessurvey.org. The organization surveys more than eighty cultures around the world to understand how the basic values affect people's attitudes toward economics, gender roles, family values, communal identities, and ethical concerns. In an ongoing project, it shows how the communities around the world are different from each other, and how businesses can use the data to effectively and respectively adjust their operations and methodology of doing business

Discussing communist roots is a no-no.

to successfully interface with each one, and bring favorable results to them and their companies.

The other important database is being gathered by the Global Leadership and Organizational Behavior Effectiveness Research project. The focus is on the relationship between leadership and values. Specifically, it surveys people in sixty countries to catalog their values and to learn how to lead in these value contexts. Buyers and merchandisers, through careful study, may learn how to best interact with these countries.

A personalized way in which to learn about cultural differences is through the enrollment in special courses. An organization such as Linguarama, featured in the Retail Buying Focus, is one such company.

Specifically, some of the general **cross-cultural skills** that need understanding and refinement include proper dress, avoidance of linguistic faux pas, and the offering of appropriate gifts during meetings. These should not be considered as generalities, since different countries have their own standards. Many will be further explored later in the chapter when the individual countries are discussed.

Proper Dress

Generally, though not always, buyers who engage in purchasing situations in their own countries understand how to dress properly for the occasion. The first impression is a

A Retail Buying Focus

LINGUARAMA

For more than thirty years Linguarama has been training professionals and business-people in the art of proper language usage. Initially, the British-based company offered onsite courses for those interested in improving their linguistic skills. A variety of courses were offered that focused on individual needs.

Today, as more companies enter the global marketplace and send teams to a variety of countries to expand their businesses and make offshore purchases, the need for cultural awareness is vital for success. The differences between one country's way to conduct business and another's may be significant. It is imperative that before making the trip abroad, there is a complete understanding as to how and why people think, act, and conduct business the way they do.

Recognizing that most business executives, including buyers and merchandisers, lack the cross-cultural skills to enter the global arena, Linguarama has developed a series of courses to raise cultural awareness. These courses are offered not only in its facilities, but also on the Internet for those in different countries.

The training has been successfully offered to people from more than sixty countries in over twenty-five languages. To date, more than one thousand companies have been provided total training solutions.

By logging on to the Web site at http://www.linguarama.com, a complete overview of Linguarama's cultural awareness training programs can be examined.

visual one, and it can make or break what is to follow. Taking a chance on appearing in an offensive outfit is potentially dangerous. It might be offensive to the foreign party, and could be the reason for a failed meeting.

Some of the considerations for particular dress include avoiding outdated clothing. This is especially important for buyers who should be aware of the latest fashion trends and innovations. Anything less than fashion perfection may give the wrong impression and adversely affect the business negotiation. Of course, this doesn't mean that the buyer should wear anything but business-oriented clothing. While "tattered" jeans, for example, may be the fashion rage, this is generally inappropriate for face-to-face buyer–seller meetings.

Another is to avoid the pitfall of dressing improperly according to the culture of another country. While it is sometimes difficult to gather information about appropriate dress in every overseas destination, a good starting point is to learn about its culture. For women going to the Middle East on buying expeditions, short skirts, for example, will be frowned upon. The safest approach for any dress "regulation" is conservatism. By using the services of the Linguarama, discussed in the Retail Buying Focus, a great deal may be learned about dress.

Avoidance of Linguistic Faux Pas

Even though Brits and Americans speak English, oftentimes the words have different meanings. Again, companies such as Linguarama can help guide you in using appropriate language.

Appropriate dress is an essential part of conducting business.

Gift Giving

In the United States there are standard gifts that are acceptable as part of any business meeting. Vendors sometimes offer theater tickets to buyers as a means of showing gratitude for their purchases. While this is standard practice, anything more might be misconstrued as a bribe. In foreign venues, improper gift giving could lead to the wrong conclusions and should be carefully approached to make certain that there is no room for misunderstanding.

APPROPRIATE BUSINESS ETIQUETTE IN OFFSHORE MARKETS

An area that is sometimes misunderstood by executives who visit foreign shores to transact business involves the use of appropriate **etiquette.** What might be acceptable in the United States might be improper in another country. What is considered proper etiquette in everyday business transactions at home is not necessarily looked upon with favor elsewhere. In Bulgaria, for example, nodding your head indicates disagreement, whereas in the United States it indicates agreement. Such a simple misunderstanding could kill a deal.

The guidelines for proper etiquette include dressing appropriately, making certain that appointments are kept within the expected time, carefully choosing topics for discussion and avoiding those that could prove offensive, using appropriate names and titles of individuals at the meeting, knowing when to give a gift and which types are appropriate, and using proper language.

One of the best ways to level the playing field is to use an interpreter. He or she will be capable of not only understanding the language, but also the nuances that make up the discussion and negotiation. Companies such as Executive Planet Inc. have interpreters available for the vast majority of languages that the American buyer, or any businessperson, might warrant. They also produce **palm-powered guides** for those who regularly go offshore to transact business. A wealth of topics are covered in these devices that buyers can use to learn the proper guidelines for such meetings.

The number of countries that buyers from the United States visit periodically to satisfy their professional purchasing requirements are numerous. The following exploration will be restricted to some of the major venues that American buyers visit.

China

Headlines in trade papers and consumer periodicals, as well as television news broadcasts, immediately reveal the ever-increasing importance of China as a supply nation. Whether it is electronics or fashion, and a wealth of other products, buyers are flocking to China's major production centers to purchase products that they will export to their retail operations. Whether it is Hong Kong, a longtime favorite under British rule, and now officially part of the People's Republic of China; Singapore, fast becoming a threat to Hong Kong's dominance; or any other Chinese province, the rules of etiquette are specific and must be understood by foreign purchasing agents to ensure that they will be treated properly.

BUSINESS DRESS

Conservative dress is the key. For men, suits and ties are essential, with subtle coloring the norm. Bright colors are considered inappropriate and should be avoided. Women

should also be conservatively dressed in either business suits with high-neck blouses or dresses. Short skirts are out of the question. For meetings, care must be exercised that women never appear taller than their male counterparts. Thus, flat shoes or low heels are best. If there is an after-dinner reception, higher heels are acceptable. For business meetings, jeans and other casual attire are unacceptable.

PUNCTUALITY

Appointments should be set far in advance of the proposed meeting. Not only does this ensure better use of the time allocated for these foreign visits, but it is also expected. Once an appointment has been confirmed, arriving on time is essential. Latecomers will be looked on as insulting the host company. Punctuality is considered a matter of respect. If lateness occurs because of an unforeseen problem, profuse apologies are a necessity. It should be understood that while the workday is typically from 8 AM to 5 PM, a two-hour break is typical from noon to 2 PM. Executives sometimes take an even longer lunch period.

INTRODUCTION GUIDELINES

The meeting generally begins with a nod or slight bow. In some cases, a handshake is in order. The cue should be taken from the company representative, with the gesture first initiated by the buyer's counterpart.

Once these preliminaries have been completed, it is appropriate to address the company's representative with the use of *Mr.*, *Mrs.* or *Miss*, plus the surname.

After the greeting has been completed, a business card should be offered to the seller. It should be written in English and Chinese. Gold ink is a plus since it is considered a sign of prosperity and prestige. The card that is offered to the buyer should be carefully read, and not quickly stuffed into your pocket as this is a sign of disrespect.

SALES CONVERSATION AND DEMONSTRATION

If possible, a few phrases in Chinese will be helpful in beginning the conversation. Other preparation might include learning about Chinese culture and history, each of which will probably be appreciated by the seller.

There are several responses during the conversation that should be carefully addressed. For example, instead of saying *no* to a question, the approach should be with the word *maybe*. A definite *no* might be considered impolite. Sometimes the company representative might ask personal questions concerning age, marital status, and so on. If you are inclined not to answer, you might reply with "unspecifics." For your part, however, the asking of personal questions about family and other topics should be avoided unless you have established a relationship during another meeting.

Avoid talking about politics. In particular, avoid any references to "Red China" or "Communist China."

Once the niceties have been dispensed with, the heart of the sales presentation should commence.

You should understand that long negotiations are traditional in China. Patience is a virtue during these presentations, with the buyer never showing signs of annoyance. The sale might take several visits before and if it is to be consummated. Even after the deal has been settled, the Chinese are known to push for a better deal.

In addition to the talking points, proposals should be prepared in writing. If the potential is for a large purchase, numerous copies should be prepared since these deals often involve several people.

If in doubt about the ability to properly negotiate, an agent should be employed for sales preparation and the handling of specifics during the visit.

GIFT GIVING

Oftentimes, gifts are in order. It is especially appropriate when the seller presents the buyer with a gift. To be prepared for such an occurrence, the buyer should bring gifts to reciprocate.

Care should be exercised in gift giving. They might include crafts from the visitor's country, books that contain pictures of the United States, a formal dinner, and so forth. Items such as scissors and knives should be avoided because they are signs of severing a relationship. Also to be avoided are handkerchiefs, clocks, and gifts wrapped in blue or white since they are associated with funerals.

BUSINESS ENTERTAINING

Standard practice includes entertaining. Business lunches are the norm, with breakfast meetings unlikely events. Banquets are standard and are becoming more and more part

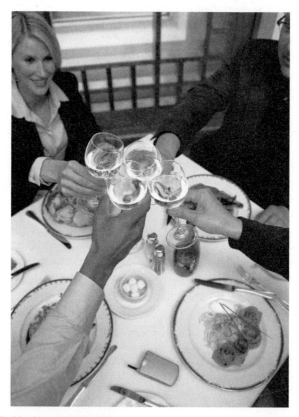

Executives at a typical business lunch in China.

of the business venture. Seating is very important, making the buyer more secure when he or she is asked to be seated in a specific place. Places are selected on a hierarchical basis. Business is not discussed at these banquets; it is a time to bring the two parties together in preparation for continuous formal meetings.

There are many do's and don'ts during these meals. How to eat, the use of chopsticks, leaving food on the plate, and other issues are extremely important to understand and should be learned either from an agent or a Web site such as http://www.executiveplanet.com.

France

Whenever a discussion on fashion creativity takes place in professional circles, it is France that is generally addressed as a starting point. Buyers and merchandisers from all over the world converge on Paris, the perennial fashion capitol, at least twice a year to discover the latest trends and to purchase haute couture for their upscale fashion operations. They attend the shows organized by **Chambre Syndicale de la Couture Parisienne** where they either meet with the designer representatives or make appointments to purchase the collections.

BUSINESS DRESS

Being the fashion capitol of the world requires that dress be up-to-the-minute and either fashion forward or classical. Men wear suits with shirts and ties, and women are clothed in either dresses or suits.

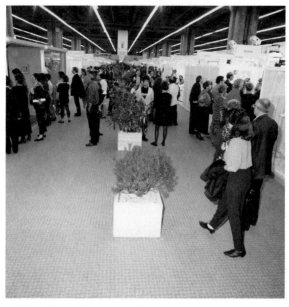

Buyers registering for a Prêt-a-Pòrter fashion show in Paris.

PUNCTUALITY

Although the French are very relaxed about on-time arrivals, it is good business practice to arrive at predetermined meetings at the specified time. This sets a professional mood, and gives the buyer the necessary time to conduct business. Meetings, especially during the market weeks when the new collections are introduced, are numerous, and being punctual allows for many to be attended during a single period.

INTRODUCTION GUIDELINES

The use of *Monsieur* or *Madame,* followed by the surname, is always appropriate. Being rather formal in their business dealings, this introduction should be used even when meetings at other times have taken place.

SALES CONVERSATION AND DEMONSTRATION

Before concentrating on the specifics of the sale, some of the topics that are considered appropriate include more information about the place where the seller lives and its customs, sports of interest, and perhaps some of the places that have been visited by him or her. There should rarely, if ever, be discussion about the expense involved in visiting France, the poor monetary rate of exchange, and questions regarding the seller's personal life such as family.

GIFT GIVING

Perhaps, a small gift would be in order such as something that represents the United States. Since the French are ardent wine lovers, a bottle of fine wine would be appropriate. It should be produced in France and from such regions as Orange or Châteauneuf-du-Pape, both excellent wine regions.

BUSINESS ENTERTAINING

Lunch is always in order as a departure from the regular sales venue. It should be paid for by the buyer, and should be leisurely and take as much time as necessary. Wine is a must at this and dinner meals, with the buyer asking for the French sales representative's advice on the selection. If dinner is offered by the seller, it should be used as a social event, and not as a forum where business is discussed during the meal. It is appropriate for brandy to be ordered after the meal. The French, unlike many of their American counterparts, consider dining an event rather than a rushed venture.

In the following focus, CYBORLINK.COM, proper etiquette is offered.

Japan

Running the gamut from fashion to electronics, Japan is a leading country for American buyers to purchase products for their retail operations. Although it is an Asian nation, it is unlike any other country in the region in terms of business dealings. Men are completely dominant in this culture, and individualism is a factor that is generally not considered.

Dining is generally part of the French business engagement.

A Retail Buying Focus

CYBORLINK.COM

One of the quickest ways for retail organization buyers to learn about international etiquette and manners is by logging on to http://www.cyborlink.com. It is currently the Internet's leading resource for such information. It helps bring the buyer onto a level playing field when they go abroad to make their purchases.

A wealth of different countries are represented on the Web site including Canada, Australia, Spain, China, Japan, Germany, Italy, Indonesia, and many others. When a particular country is accessed online, the user is first greeted with an introduction that offers such information as the form of government, a breakdown of the population, and anything in general that might provide an overall impression of the country. More specifically, it makes suggestions regarding the buyer's appearance, appropriate behavior, proper communication usage, and other considerations.

Each country is also addressed by Geert Hofstede of the Netherlands, a professor who has a global reputation for assessing specifics and offering an overview of the country's history, philosophy, and so on, each of which may be invaluable during business meetings.

The Web site also offers other resources that can be easily accessed such as tips on handling language difficulties, names of local newspapers, information about the culture, briefing papers, and others.

You can access a specific country by using an appropriate URL. For example, if you are looking for information about Mexico, go to http://www.cyborlink.com/mexico.

BUSINESS DRESS

Dressing as well as you can impresses the Japanese. Of course, that means proper attire such as business suits for men and a dress or suit for women. Pants are never to be worn by women for business meetings. It is imperative for women never to appear taller than men, so high heels should be avoided. Little jewelry is in order. For both sexes, casual attire is not appropriate during these meetings.

PUNCTUALITY

It is important to be on time for any business meeting. For social occasions, such as dinner appointments, late arrivals will not be offensive.

INTRODUCTION GUIDELINES

Business cards should be offered and received with both hands. It is best to have them printed in English on one side and in Japanese on the other. The card should be offered

Bowing is customary in Japanese business meetings.

with the English side up. The seller's card should be read as soon as it is received, which shows a sign of respect. Bowing is a customary occurrence in Japan. If greeted with a bow, the same should be exercised with the level of the bow the same as the one received. In some situations, a handshake may be substituted.

The verbal introduction should be with the buyer's last name plus the word *san* which translates as *Mr.* or *Ms.* First names should not be used during business meetings.

SALES CONVERSATION AND DEMONSTRATION

Subtlety is an ever-present element in any situation that involves negotiation. The Japanese do not like the word *no*. They may answer with *yes*, but might really mean no. Past experience will be the way to interpret the word *no*. The use of a local agent will help with these nuances.

In terms of conversation before the actual sales presentation, topics such as baseball are excellent since the Japanese are ardent fans, places in the country that you might have visited, and familiarity with local foods. Talking about World War II is unacceptable. If there is nothing to speak of before the actual sale, silence is the best approach. If possible, use the words *sumimasen* (excuse me) and *kekko desu* (I've had enough) at the appropriate times. Never rush the presentation since the Japanese are very patient individuals when involved in business deals, and waiting for the right moments to make points will often have positive results.

GIFT GIVING

This is a very important aspect of the business transaction whether it is offered at the time of the meeting or during a social invitation. Gifts should be properly wrapped, avoiding white (which means death) and bright colors. It is best to have the item professionally wrapped so as not to make any mistakes. The gifts should be given at the end of the visit. As strange as it might sound, top choice beef, special brandy, and whiskey are appreciated. A fine wine is also a good choice.

BUSINESS ENTERTAINING

Entertaining a business executive is rarely done at home. If, however, it is offered, it must begin with the removal of shoes at the front door. Slippers are usually offered and should be worn. While many Americans are not adept at using chopsticks, it is customary in Japan. It is best to master the use and understand the rights and wrongs of chopstick usage such as using the provided "rest" as a place to set them down, and never leaving them in unfinished food. When in doubt, follow the lead of the host. Drinking requires specific rules of etiquette such as waiting for your drink to be poured. These rules should be learned before attending any social event. At the end of the meal, the words *gochisousama-deshita* should be offered to indicate that the experience was enjoyable.

India

In today's business arena a great deal of business is being transacted in India. Not only are all kinds of services being outsourced, as we read in the newspapers and see on television, but an abundance of fashion and home products are being bought by merchants

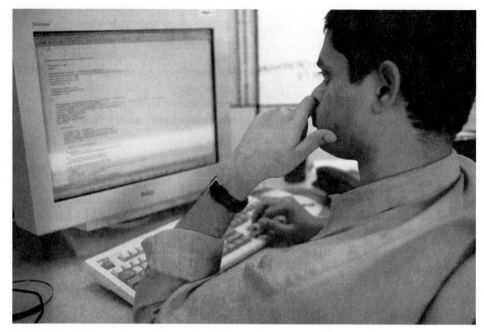

India has become a very important player in global business.

for resale in their stores, catalogs, and on the Internet. Trips to India by professional buyers are becoming commonplace and should be accomplished when the "rules of the game" have been mastered.

BUSINESS DRESS

Suits and ties are the expected norm for men, with women given the choice among traditional business suits, pantsuits, or dresses. Because cows are revered in India, it is a good idea to refrain from using any leather products such as belts and handbags. When the climate is exceedingly hot, jackets may be removed. Following the lead of the host is the best approach.

PUNCTUALITY

Setting appointments and promptly arriving on time is essential. They are very formal in such matters, and common courtesy is a measure of politeness.

INTRODUCTION GUIDELINES

Although there are fourteen major and more than three hundred minor languages spoken in India, English and Hindi are the official ones. For meetings between buyers and sellers, however, English is most often the language that is spoken. If the individual has a title such as company president, then this title should be used in addressing him or her. Anything less would be considered rude and might hamper the terms of the impending deal.

SALES CONVERSATION AND DEMONSTRATION

As noted, the proper use of titles is imperative, especially at the beginning of the sales presentation. First names should not be used. Care should be exercised in small talk before the key points of the deal are discussed. If personal questions are asked of you, then it is appropriate to ask them in return. Never use one finger to point as it may be considered an insult. Although many changes are taking place in India in business situations, it is best to stay within traditional guidelines unless other practices are obvious.

GIFT GIVING

If given a gift, it should not be opened until the giver leaves the meeting. Never give gifts of leather since these are considered offensive.

BUSINESS ENTERTAINING

While dining is often part of the day if the business negotiation is a lengthy one, lunch is preferred to dinner. Of course, with the previously mentioned changes, dinners are becoming more prevalent. Remember that Hindus do not eat beef and Muslims do not eat pork. This rule should be followed by the American buyers although these practices are not followed in typical dining. It might sound strange, but saying *thank you* at the end of the meal to which you have been invited might be considered a form of payment and therefore insulting.

Australia

Trade with Australia is relatively modest when compared with other regions of the world. For American retail buyers, however, opals are a major product classification. Some fashion items are also bought, but the amount pales in comparison to purchases from other countries.

BUSINESS DRESS

Conservative dress is the key to proper appearance. Men should wear traditional business suits, shirts, and ties. Women have the choice between suits with skirts or pants. During after-hour meetings, a more casual, informal appearance is an option.

PUNCTUALITY

It is bad practice to arrive late for a meeting that has been scheduled. It is indicative of poor manners in Australia. The result might be a negative one that could adversely affect the ultimate terms of the deal.

INTRODUCTION GUIDELINES

Although English is the language spoken, word usage differs somewhat than what Americans are accustomed to. For example, instead of the usual "Good morning," "G'day" is the norm. Informality is generally the rule for introductions, with formal titles generally skipped. Business cards should be offered soon after the greeting has been made.

Australia is one of the best sources for opals, shown here in the mines.

SALES CONVERSATION AND DEMONSTRATION

As is the case in many countries, small talk is an accepted way to start the sales conversation. Topics such as sports and travel are often used at this time. A friendly rapport should be established at this point, with brevity a must. Since the Australians are not generally religious, religion should not enter into the conversation. Once the niceties have been addressed, the time is ripe to begin the sales presentation. Listening is as important as making your own points. Information about the company or product should never be exaggerated, but should be accurate.

GIFT GIVING

Gifts are not typical of the Australian business venture. A gift is rarely, if ever, offered at the time of the sale. If, however, the buyer is invited to the home of the seller, small gifts such as chocolates or wine are appropriate.

BUSINESS ENTERTAINING

Afternoon tea at around 4:00 PM is a must during any negotiation period. Going to a pub after a day's negotiation is traditional. The buyer should pay for a round of drinks, only when it is his or her "turn." Dinner at the end of the day is also often part of the business deal, with supper later in the evening an alternative choice.

Germany

In recent years, Germany has become increasingly more important as a fashion center. In addition, electronics have remained an important product classification, with wines another product that continuously attracts American buyers. More and more retailers are purchasing German products than ever before.

BUSINESS DRESS

Conservatism is the key to German dress. Darks suits and white shirts are typical for men and women. Occasionally, if the buyer is in Germany to purchase fashion products, a more fashion-forward appearance is acceptable. With Jil Sanders and Hugo Boss collections, designed in Germany, those in the fashion industry are ready to accept fashionably dressed buyers.

PUNCTUALITY

It is imperative that appointments are kept. Even a few minutes late is often considered an affront to the waiting executive. Buyers will find that their ability to negotiate will be hampered by tardiness.

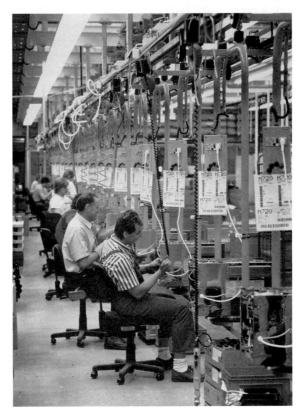

Appliances made in Germany attract buyers from around the world.

INTRODUCTION GUIDELINES

Business formality is expected. German men usually greet each other with the word *herr* preceding the last name, and *frau* if the individual is a woman. Even if past meetings have been experienced, the formality still is important. Handshaking is expected at introduction times, and again at the conclusion of the presentation. If possible, a few words spoken in German will be appreciated. A business card should be attached to any written proposal rather than handing it directly to the individual. In the absence of such materials, it is best to hand the card directly to the recipient just before the meeting has concluded.

SALES CONVERSATION AND DEMONSTRATION

Small talk is appropriate before the business information is presented. World War II discussion is absolutely off limits! Germans love soccer, and talking about it is a plus especially since the World Cup was hosted in Germany in 2006. Words such as *danke* (thank you) and *bitte* (please) are appreciated during the presentation. The actual negotiation process is a very serious one, and should not include any humor in the discussion. Business is business and nothing else! Looking directly into the seller's eyes is important.

GIFT GIVING

Gifts are not expected.

BUSINESS ENTERTAINING

Lunch is the preferred meal for business events. If dinner is offered by the seller, drinking will be an important part of the meal. At either time, business should not enter into the conversation until the meal has been finished, if at all. Invitations to Germans' homes are rare since Germans are very private and generally guard their private lives.

Mexico

Ever since the signing of NAFTA, Mexico and the United Sates have become important trading partners. In particular, fashion apparel, accessories, and home furnishings have attracted the attention of American retail buyers. With lower prices than elsewhere, and the close proximity that makes speedy delivery and inexpensive shipping a plus, purchases continue to increase.

BUSINESS DRESS

Conservative dress is proper for doing business in Mexico. Dark suits, white shirts, and ties are best for men, with women choosing between dresses and classic business suits. If the association has been a long-standing one, a little less formality might be acceptable. The cue should be taken from the seller.

PUNCTUALITY

Unlike other countries, Mexico is not rigid about time. Arriving a little late for a meeting is acceptable. Scheduling an appointment is better after 10 AM and before 1 PM. If later, it conflicts with a traditionally long lunch and little business may be transacted.

Pottery production for export has increased under NAFTA.

Buyers arriving in ever-increasing numbers in Mexico City.

INTRODUCTION GUIDELINES

First names are used only if the individual is invited to do so. In other situations, either *Mr.*, *Ms.*, or *Mrs.* is used, and even more preferred are the words *Senor*, *Senora*, or *Senorita*. Careful attention should be paid to the proper surnames which are generally comprised of two names. If the occasion is one that involves previous meetings, it sometimes includes embraces. Small talk such as a reference to Mexican art and artists is a good diversion before the actual sales talk progresses.

SALES CONVERSATION AND DEMONSTRATION

You should be careful not to discuss such hot topics as illegal aliens coming to the United States. Business is transacted not only during the regular meeting, but also at lunch where the negotiations may continue. In either case, the structure is not as formal as in other countries. Once the small talk has been finished, the actual selling points are made. Be aware that even when such factors as shipping dates have been finalized, the actual dates are not always kept. Buyers must be ready to be very lenient in terms of these discrepancies.

GIFT GIVING

Gifts are not expected at business meetings. If one is offered it should be a simple item such as a pen with a company logo on it. Secretaries, however, do like to receive gifts. They might be perfume or scarves.

BUSINESS ENTERTAINING

Business lunches are preferred to dinners. Working breakfasts are sometimes popular, and usually take place at the buyer's hotel. In any of these situations, brevity is preferred by the seller. He or she is ready to quickly deal and get on with other matters.

United Kingdom

The world of fashion is alive and well, especially in London. Designers from the sophisticated to the avant-garde are in great abundance and rival the efforts of those creative forces in Paris and Milan. Both men's and women's apparel and accessories are high quality and continue to attract buyers from the most prestigious American retail establishments.

BUSINESS DRESS

Although business dress regulations are somewhat relaxed today in the United Kingdom, conservative dress is the safe way for buyers to visit vendors. Dark suits, white shirts, solid or small-patterned ties, and laced shoes are best. Women should also dress conservatively, but if the purchases are fashion oriented, they might dress a little more contemporary.

Proper conservative dress is an essential part of business in the United Kingdom.

The British pub is a typical place for a business luncheon.

PUNCTUALITY

It is considered impolite to arrive at any time other than the time that has been pre-arranged. In fact, it is safe to arrive a few minutes early.

INTRODUCTION GUIDELINES

A handshake is generally preferred before any words are spoken. Do not crowd the seller since the British generally prefer space between themselves and the buyers. Soft-spoken introductions are generally the way to proceed. Small talk about your visit to the country, sports, and so on is generally appropriate before the actual sale begins. Formality is the key, with the use of *Mr.*, *Mrs.*, or *Ms.*—unless the meeting is one that regularly takes place and a more casual approach has been practiced in the past.

SALES COMMUNICATION AND DEMONSTRATION

Although Americans speak English, oftentimes our word usage may differ from the British usage. Certain words that are commonly used should be mastered to see if the British meanings are different. Once the small talk has been dispensed with, the heart of the buyer's wants should be addressed. The British are a little slower in their decision making, thus extra time should be allocated if terms of the sale must be determined.

GIFT GIVING

Unlike other countries, businesspeople in the United Kingdom do not expect gifts.

BUSINESS ENTERTAINING

The pub is a typical place where lunch may be served during the day of the sales meeting. Discussion of the impending deal is appropriate at this time. If dinner is offered by the seller, any discussion of business should be avoided.

Indonesia

Retailers of artificial flowers and furniture are finding Indonesia an excellent resource. Prices are considerably less than if similar goods were purchased in many other countries. In doing business in Indonesia, you will typically find rules of behavior different than those experienced in European markets, and somewhat similar to Arab nations.

BUSINESS DRESS

Business suits are generally the order of the day, but contrasting coats and pants are acceptable. You should inquire about the proper dress for a particular meeting before making an appearance. Women's skirts must cover the knees and blouses should have long sleeves. A suit is a proper ensemble.

PUNCTUALITY

Being on time for meetings is proper, but late starts are typical and acceptable. Even though the seller might arrive late, the buyer should be ready at the appointed hour. Comments about tardiness are unacceptable, and not even joked about as might be the case in the United States.

INTRODUCTION GUIDELINES

A handshake is generally weak and lasts several seconds. Men and women, however, do not generally shake hands or touch in public because of religious reasons. If, however, a woman initiates it, it is considered acceptable in some business situations. A bow is also sometimes used and might be combined with the handshake. A business card that is written in English on one side and Indonesian on the reverse is preferred. The card should be carefully read as a sign of courtesy and not quickly stored in a pocket. The formal use of names is important and should include *Mr.*, *Ms.*, or *Mrs.* and the last name, unless the seller initiates the use of first names. The use of the word *selamat*, meaning "peace," is traditionally used.

SALES COMMUNICATION AND DEMONSTRATION

Mundane topics such as the weather are safe as conversation openers. After the initial niceties, the terms of the deal are then discussed. Negotiation is done in a soft-spoken voice; loudness is inappropriate.

GIFT GIVING

Small gifts are sometimes offered. The opening of them, however, is not appropriate. There are specific rules about gift giving, whether it is at a business meeting or later at a dinner. Muslims and Hindus have specific rules regarding food and alcohol. Muslims will also be offended with gifts made of pigskin, and Hindus with items made of cowhide. Gifts that show pictures of dogs are unacceptable since dogs are considered unclean. With many Chinese in Indonesia, make sure not to give such offensive items as knives, scissors, handkerchiefs, or umbrellas.

BUSINESS ENTERTAINING

Conversation about business should be refrained from during a dinner meal. Such conversation is reserved for before or after the meal. Eating with your right hand is considered proper. Leaving a little food on your plate is considered proper, but asking for a second helping is all right.

Language of the Trade

Chambre Syndicale de la Couture Parisienne
cross-cultural skills
cultural awareness
etiquette
linguistic faux pas

palm-powered guides
political neutrality
social awareness

Summary of Key Points

1. The awareness of trade agreements is essential when doing business abroad.
2. Cultural standards are different from country to country and should be understood before attending business sessions.
3. Social and cultural awareness is a must so that discussion and behavior during business meetings are carried off without any potential for error.
4. It is relatively easy to learn about cross-cultural skills by accessing such Web sites as http://www.worldvaluessurvey.org.
5. Linguarama is an excellent resource for learning about proper language usage in foreign countries. The company's offerings may be examined on its Web site at http://www.linguarama.com.
6. Proper dress is imperative in business situations. Improper attire could hamper the negotiation.
7. The uttering of a linguistic faux pas could undermine the efforts of the buyer during the sales presentation.
8. Gift giving is very often part of the business meeting. However, care should be exercised in choosing the right gift.
9. In China, a bow is often part of the introduction process. You should observe by taking the cue from the seller if a bow and/or a handshake is in order.
10. Certain references should be avoided during a business session. In China, for example, the mention of the country as a communist nation is off limits.
11. In France, dining as part of the business negotiation should be leisurely, rather than a rushed venture.
12. You should be aware that Japan is a male-dominated culture and that women might not be treated as equals in business situations.
13. Although there are fourteen major languages in India, and more than three hundred minor languages, English is the one that is most often used in business dealings.
14. Although Australians speak English, it is somewhat different from that which Americans use. For example, *G'day* is the normal greeting and should be used.
15. Keeping Germans waiting even a few minutes for a business appointment is considered rude and might adversely affect the deal.
16. Mexicans are not rigid about time, making a late arrival acceptable.
17. Formality is the key to doing business in the United Kingdom.
18. Indonesians have very specific rules about food that should be understood by the American buyer.

Review Questions

1. Do the differences in social and cultural standards of other countries sometimes affect negotiations between the buyer and seller? Explain.
2. Why is it important for buyers who are purchasing offshore to be careful to remain politically neutral?

3. Is it acceptable for buyers who deal offshore to learn the proper etiquette on the job?
4. How can Linguarma help prepare the buyer for his or her visit to offshore markets?
5. Is dress ever a consideration for buyers when calling on foreign countries to make purchases for their retail ventures?
6. Might a faux pas affect the outcome of a buying proposition? Explain.
7. Is it appropriate to offer gifts to sellers as part of the purchasing process?
8. How important is it for the buyer to be punctual when calling on companies for purchasing purposes?
9. Is it always necessary for a "bow" to be part of the introduction process in China?
10. Which French organization is responsible for the scheduling of fashion shows in France?
11. Which beverage is the buyer expected to participate in during the lunch meal in France?
12. How might a buyer quickly learn about international etiquette without taking special courses?
13. What language is used in most business meetings in India?
14. Why should buyers be wary of ordering beef or pork at business lunches in India?
15. What is the expected introductory word used in Australia when meeting a business associate?
16. What is the key to proper dress for business meetings in Germany?
17. Why has Mexico become an ever-important trade partner with the United States?
18. How does punctuality for appointments differ in Mexico by comparison with most other countries?
19. In which English-speaking country does language usage differ from that which is spoken in the United States?
20. Are the rules of behavior different in Indonesia than they are in most European countries?

CASE PROBLEM I

With the advent of more and more merchandise being produced in foreign countries, and fewer American vendors trying to satisfy all the needs of retailers in the United States, it has become necessary for many buyers to venture abroad to make purchases. While the buyer's preparation for offshore purchasing is often similar to that which is experienced in the United States, there are some differences that are important to understand. Without the knowledge of what is acceptable in a negotiating situation, and what is not, the buyer may put himself or herself at a disadvantage.

In addition to focusing on the terms of the deal such as shipping dates, discounts, product exclusivity, and so forth, which Jennifer Rogers is accustomed to as a seasoned buyer, she is preparing herself for a visit to China for the first time to buy for the retail chain she represents. Ms. Rogers has been working for Carlyle Stores, an upscale fashion organization, for five years and mostly buys in domestic wholesale markets. The stores number fifteen, and are located in and around the Chicago area. In addition, the company operates a catalog division and a Web site. The merchandise mix includes a wealth of high-fashion, upscale apparel and accessories for women. Her responsibility is career clothing.

Although Ms. Rogers concentrates on lines that are seen in many traditional department and specialty stores, she also looks for exclusive designs that her company can sell under its private-label program. Some of the collections are produced by American

designers and others by offshore designers who have gained international distinction. In both cases, she purchases in the United States in which the American organization is based, and the global producers have representation. Today, however, with a desire to locate unique fashions that have not gained popularity in the United States, she has decided to make some trips abroad to satisfy her merchandising curiosity and buy lines that would be exclusive to Carlyle's trading area.

Although Ms. Rogers is a seasoned buyer, she doesn't feel sufficiently prepared for the challenge. Her knowledge of foreign languages, cultural differences, appropriate business etiquette, and so forth is extremely limited. With a trip scheduled for five weeks from today, she would like to make certain that she is prepared to avoid the potential for linguistic faux pas, understand the expected greetings for the business meetings she is arranging, be prepared with acceptable business dress, and anything else that would make the venture a fruitful one. With so little time for formal preparation in language courses, and the right way to make a positive impression on the selling agents in global markets, she is trying to short-circuit any longtime preparation for the trip.

Questions

1. If Ms. Rogers had a great deal of preparation time before the trip, how could she best prepare herself with learning the foreign language?
2. With a minimum amount of time, and little available for on-site learning, how might she learn about the customs language, and so forth of the country to be visited?

CASE PROBLEM 2

Carl Tompkins is a buyer for Exotic Furniture Imports, a retail operation that specializes in home furnishings from around the world. The company has grown from an individual unit to a chain that now boasts more than 120 stores throughout the United States, and a Web site. Interest in this type of merchandise continues to grow, making the company target additional trading areas with the goal of 225 stores or perhaps more, to be reached in ten years.

Mr. Tompkins's buying responsibility is exclusively for furniture that includes tables, chairs, accent pieces, and bedroom ensembles that are primarily constructed of reed, exotic woods, and other natural materials. His purchases have been made exclusively through wholesale catalogs and at trade shows that he visits whenever they take place in the United States. Today, his interest is in Indonesia, a country that produces a wealth of this type of merchandise at very attractive prices. With this being a "hot" market, he is now planning a trip to that country to see firsthand what is available, and if he could arrange for a factory to manufacture specific items for his company's exclusive use.

Since this is a first-time venture for him, he wants to be fully prepared for the journey. He has little, if any, meaningful knowledge of Indonesia and would like to learn whatever he can before he leaves for the buying trip.

Questions

1. What areas of preparation should he learn about before he embarks on this trip?
2. How might he best prepare himself for such a journey?

CHAPTER 15

Wholesale Purchasing on the Internet

On completion of this chapter, the student should be able to:

- Learn how to research manufacturers of any product classifications on the Internet.

- Contact a wealth of fashion producers across the globe for the purchase of their product lines.

- Locate a significant number of contractors who might be able to satisfy their needs for private-label manufacturing.

- Research a wealth of wholesale companies so that their products might be explored for future buying needs.

- Make full use of the Web sites so that product lines may be examined and orders may be placed.

- Utilize resident buying offices' Web pages to gather such information as market trends, new resources, and product acquisition.

- Learn about merchandise brokers who could provide closeout goods for those who specialize in value retailing.

- Discuss the advantages and disadvantages of professional purchasing on the Internet.

As pointed out in the two preceding chapters, buyers have numerous venues from which they can make their purchases. The primary ones are those in which they directly interact with the vendors in premises that they visit. In that way, the purchasing team is able to examine the merchandise firsthand, and determine if it meets their company's needs.

While this is generally the best way to assess the market's offerings, there are times and circumstances that prevent these meetings from taking place. In the past, those unable to make the visits to wholesale markets were sometimes given the opportunity to purchase from catalogs or from market representatives who would go from retailer to retailer, a few times a year, to display the goods that they had available for sale. The catalog, as a purchasing tool, is advantageous for merchandise classifications that are considered to be staples. That is, their designs change infrequently and are of the type that do not warrant handling by the purchaser. Men's hosiery, small appliances, children's underwear, and computer accessories fall into the staples category. Fashion products, by the nature of their designs, fabrics, and the **perishability factor,** make selections from booklets and

pamphlets less than desirable. Even when store visits are the ways in which merchandise lines may be evaluated, they generally come only a few times a year and not frequently enough to show items that might have been added between collection previews.

Given the shortcomings of anything less than the visits to the wholesale markets, the buyer is often at a purchasing disadvantage. The buying decision making is hampered by his or her inability to go to market as often as merchandise replenishment is needed.

With the advent of the Internet, not only have consumers benefited from the vast amount of merchandise that has been made available to them, but so have the professional retail purchasers. Without having to leave their buying headquarters, they can avail themselves of a wealth of product classifications by merely logging on to any number of **Web sites** for wholesale merchandise. Again, just as the consumer can **surf the Net** to determine what is available, so can the buyer. It is this combination of favorite Web sites that can be quickly accessed and a wealth of wholesale outlets that are listed according to product classification that makes an enormous array of merchandise accessible to the buyer.

As you will learn in this chapter, a buyer now has the ability to view the items directly from a vendor's Web site, examine the products that have been offered by wholesale distributors at *closeout prices,* and access the Web sites of market specialists such as *resident buying offices,* where third-party recommendations are always available.

WHOLESALE PRODUCT ACQUISITION ON THE INTERNET

Traditional retailers as well as value-oriented organizations each have the opportunity to enhance and refresh the merchandise assortments that they generally purchase directly in the wholesale markets on the Internet. Some regularly use the Internet to go to their best suppliers, whereas others merely log on to discover new vendors. It might be a high-fashion designer, manufacturer, contractor, wholesaler, or **middleman** (who stocks vendor offerings and resells them to the retailing community), a **manufacturer's representative** (who acts as the sales agent for several manufacturers), **advisory groups** (which introduce the newest products to member retailers), and merchandise brokers (who act as product suppliers for retailers).

The professional purchasing staffs of retailers, both large and small, may use one or all of these resources.

Manufacturers

This group of vendors either produces the entire product package that includes design and manufacturing or involves itself in only one aspect of the creative package. Some merely develop product prototypes and leave the manufacturing to outside contractors, a classification that will be addressed later in the chapter.

Nearly every manufacturer classification has a wealth of Web sites that provide photographs and descriptions of products that are available for sale. Some enable the buyer to purchase directly from the Web site, while others are informational in nature and feature e-mail addresses that are available for further contact with the vendors.

The routes to learning about manufacturers' offerings are twofold. A buyer might log on to a specific vendor's Web site to learn about the current merchandise offerings. It might be a Web site that has been regularly used by the retailer for past purchases, or a Web site that the buyer has become aware of and wants to view in order to evaluate the product line. The other approach involves surfing the Web to locate new vendors to assess their merchandise collections. In looking for new fashion manufacturers, for example, Internet research may turn up thousands of potential resources.

Without any prior knowledge of producer names or product lines, thousands of company names will quickly appear for the buyer to peruse. America Online (AOL) users in search of fashion manufacturers, for example, need only to enter the words *fashion manufacturers* in the "search" area on the screen. By doing so, more than four hundred thousand vendor names will appear representing companies from all over the world. Table 15.1 shows a representation of overseas Web sites, product specialties, and the countries from which the goods are available.

When a particular manufacturer seems to be of interest to the buyer, logging on to its Web site brings a wealth of information about the company and its product line. By examining it, a buyer is able to make a determination about the potential of such a line for its retail operation. Products from all over the world are available without the costs connected with global travel.

Using Table 15.1, a buyer might find http://www.999-fashion.com/home.html worthy of further investigation. By logging on to it, information featuring the company's history, its product specialties, factory capabilities, production output, dollar turnover, and its latest collections may be quickly assessed. If the manufacturer's company seems to fit with the buyer's organization, then further exploration may be in order. Some of the features of the Web sites such as http://www.999-fashion.com include a photo gallery of the latest product lines, fabrics, prices, and the trends in the field. As the product offerings continue to change, as they often do on a daily basis in some segments of the fashion industry, continuous updating of the Web site gives the buyer a meaningful look at product offerings and availability.

TABLE 15.1 Fashion Manufacturer Web sites

Web Site	Product Specialties	Country of Origin
http://www.999-fashion.com/ home.html	Young fashions, sportswear, beachwear, denim wear, outerwear, children's wear	India
http://www.uk20.co.uk/ fashmanafact.html	Fashion merchandise, sports wear	United Kingdom
http://www.trade-india.com/dyn/ gdh/eyp/Apparel	Home apparel fashions, athletic wear, beachwear, jackets, knitwear	India
http://www.posizionamento-motori-di-ricerca.c	Clothing, knitwear, private labels, sportswear	Italy
http://www.minimidimaxi.com/ Canadian_ fashion/	Men's and women's fine-quality leather	Canada

When an area of interest, rather than a specific vendor, is sought a buyer could log on to a host of Web sites that feature a cross section of manufacturers in a particular product area. If outerwear is the case, for example, browsing will turn up a number of Web sites that specialize in this product. More specifically, a particular wholesale market that features the product line can be easily located. One example is http://www.minimidimaxi.com/Canadian_fashion/Manufacturers/Apparel_Category/Outer_Wear, which features a host of different Canadian manufacturers of outerwear. Numerous vendors from Montreal, Winnipeg, Toronto, and MontRoyal, replete with product offerings, appear for the buyer's perusal. What better way is there to learn about potential resources without leaving the comforts of your buying facilities?

Designers

Whether it is furniture design, apparel, footwear, jewelry, or a host of wearable accessories, there are numerous designers in their respective fields who create unique products that are worthy of the attention of the buying professional. As in the case of manufacturers who are globally positioned, designers are also found in the four corners of the world. Some are the marquee names that are the field's leaders, while others might be emerging forces that could provide buyers with collections that could spell success for their companies.

The impracticality of in-person collection evaluation of the vast number of designers in the marketplace requires that other means become necessary. The use of the Internet enables a significant number of offerings to be viewed with a minimum of effort. For the discovery of designers who might fit the needs of the buyer's merchandise plans, it could involve surfing the Net until sites of interest are located. The use of such search engines as http://www.askjeeves.com, or merely going to AOL and entering areas of interest and searching in that manner could turn up design Web sites of interest.

From the couture-level designers to the ones that are more **bridge-oriented,** there is an abundance of "names" waiting to be explored. At the upper end of the fashion spectrum, creative geniuses such as Issey Miyake offer Web sites that are replete with archived collections of the past that could give the buyer an understanding of the designer's conceptual approach to a look at the most recent collections. By logging on to http://isseymiyake.com/archives/fal, past collections may be viewed. For the latest product line, full-color presentations are offered in both the HTML version or the Flash 6 version that gives an animated approach to the viewer. If there is sufficient interest in the collection, the buyer may make a direct contact with the vendor and leave an order.

At the bridge level of the fashion apparel industry, Ellen Tracy is a mainstay. Her Web site presents the latest collections as well as a contact page in which buyers are able to get more information about the line. By merely filling out the form online, communication with the company is initiated.

Contractors

Oftentimes, buyers are charged with the responsibility of developing private-label collections for their companies. These endeavors, which are broadly examined in Chapter 18, generally do not require the buyer to be the creative force in product

New design with accompanying swatches for potential sale on Internet to buyers.

design, but merely to locate the appropriate **contractors** who will most successfully manufacture special products for a retailer's exclusive use.

One such site that has a wealth of contracting information is Evelyn Forsythe Creations, Inc., http://www.fashiondex.com/index.vs. The listing features up-to-date apparel contracting source sites. Both domestic and international apparel contractors and services are broken down by clothing classification and by region. On the home page of the Web site, another Web site, http://www.apparelproduction.com, lists names of overseas factories for the buyer's perusal.

Wholesalers

Sometimes referred to as *middlemen* because they are the organizations that act as intermediaries between the manufacturers and the retailers, **wholesalers** play a significant role in supplying merchandise to professional purchasers. Their importance varies from one product classification to another. In some industries, they are the only means of merchandise acquisition for retailers, while in others, such as the fashion industry, the choice lies with the purchaser.

Unlike manufacturers that produce one line of merchandise and sell only their own collections, wholesalers represent many producers. By utilizing a wholesale company as a means of purchase acquisition, the buyer is able to compare a host of product offerings without having the need to deal with many different vendors.

Purchasing from wholesalers has become easier than ever before with the continuous growth in online purchasing. Retail buyers can quickly access the Web sites of specific suppliers with whom they have had satisfactory relationships and learn about their most recent offerings, or surf the Web and locate a host of new resources. Whichever the choice, Internet purchasing from wholesalers has provided a fast route toward merchandise acquisition.

In the search for new wholesale resources a retail buyer might begin by merely typing in the word *wholesaler* on a favorite search engine. By using AOL for the search, thousands of Web sites quickly appear for further examination. When one seems to be appropriate for the buyer's needs, clicking on it immediately brings up the home page of the Web site.

An example of the simplicity of such research might be underscored by accessing http://www.wholesaleindex.com, one of the many resources that are available online. If the buyer is interested in closeout merchandise, for example, the user merely clicks on "Closeouts." A wealth of different product offerings, by company, appear on the screen for further examination by the buyer. Perusal of the various companies provides a synopsis of their specialties so that the buyer can hone in on the one that has the most potential. Table 15.2 shows what the buyer has available to him or her for further consideration. By clicking on the one that provides the most interest, the buyer is immediately led to that vendor's Web site.

For example, assume the buyer's responsibility is for footwear. From the featured list, *Closeout Warehouse* seems to feature an assortment of merchandise that could have potential for the buyer's merchandise mix. By moving the mouse to the "open" symbol next to the company's name, the Web site quickly appears for further exploration. The buyer can learn about the company, the products it has available for sale, and the specials it is offering at the time. Further investigation reveals a host of different product names such as Adidas, Caterpillar, Hang Ten, and Salomon, all well-known brands. Ordering can be accomplished online or, if more information is required, direct contact may be made at the company's e-mail address, jimmy@thecloseoutwarehouse.com.

TABLE 15.2 Miscellaneous Closeout Wholesalers

Company	Product Offerings
AAA Closeouts Network	Apparel, baby items, computers, electronics, sporting goods
Buyxout	Household goods, toys, games
Closeout Warehouse	Apparel and footwear
Clozeout.com	Dresses, skirts, suits, hats
L.A. Surplus, Inc.	General merchandise
Merchandise U.S.A., Inc.	Housewares, giftwares, toys, hardware
Palletsmart	General merchandise
Great Discounters, Inc.	Health and beauty supplies, party goods, office supplies
R.G. Riley	Sweats, tee-shirts, tank tops, shorts
WHAM! Food & Beverage	Foods and beverages

The number of wholesale establishments found on the computer seems to be without end, and through careful examination can lead the purchaser quickly to the right merchandise offerings.

Manufacturer's Representatives

With some similarity to traditional wholesalers, as described previously, the manufacturer's representative also acts as the middleman between the producer and the retailer. The only difference is that in the former category the intermediary takes title to the goods, or buys them for resale, while in the latter category he or she is merely a producer's representative, acting only as an agent who negotiates the sale and receives a commission for services rendered.

Just as vendor groups may be accessed on the Internet, so may manufacturer's representatives. Again, using a search engine will bring up a host of manufacturer's **reps**—a term used in the trade.

The reps represent numerous different product classifications ranging from wearing apparel to toys and many classifications in between. By carefully scrolling through the wide number of manufacturer's representatives that are featured on the Internet, a buyer may select those that seem to fit his or her company's needs. For example, a buyer may choose one that is located in the same city, to allow FG in-person meetings.

Some reps' Web sites merely feature a home page that describes the company and provides an e-mail address for further contact. This, of course, requires further investigation, either in person or by some other means, for an order to be placed. At the other end of the spectrum are the Web sites that provide a wealth of information that includes the history of the company, the lines offered, specials that may be available, biographies of the company's representatives, and **trade shows** in which it participates.

For the buyer who wishes to purchase online, it is the full-scale Web site that fits the bill. One example of such a group is R-Biz Associates. By logging on to http://www.rbizassociates.com, a buyer is offered information about the company and the product lines it represents. The following paragraphs feature some of the highlights of the company's Web site and show how the buyer is able to make merchandise selections from his or her office.

HOME PAGE

A brief description of the company discusses its origins and that it specializes in unique toys and gifts. It also offers the means to receive catalogs from the company, to make arrangements for in-person appointments, or to direct order. The buyer then is invited to access any pages of interest on the site.

R-BIZ REPS

For those interested in learning more about the individuals who represent the company, biographies along with pictures are presented for inspection. Of course, if ordering online is the buyer's goal, then these bios might not be important. However, after placing an order, if there isn't total satisfaction, the purchaser is able to refer to the Web site and locate the individual responsible for the particular geographical area of the delivery. The web site provides each rep's biography with his or her address, phone number, cell

phone, e-mail address, and area of responsibility. In this way, the sale becomes more personalized and can bring the buyer greater comfort when ordering merchandise.

MANUFACTURERS

A list of manufacturers represented by R-Biz is featured along with its product lines, thus the buyer is able to assess the nature of the products "repped" by the company. Oftentimes, as in the case of R-Biz, many of the lines are household names and immediately recognizable by the buyer, making his or her purchase more likely.

SPECIALS

Just as manufacturers offer special deals to their accounts, so do manufacturer's representatives. Most buyers are always on the lookout for special purchases that can bring additional revenue to their companies and help improve their maintained markup. Since these deals come up sporadically, and often without the buyer's knowledge, placement of them on the Web site can quickly and easily be brought to the merchant's attention. All too often, those purchasers who wait for reps to make in-person calls to their offices, or make periodic market visits, miss out on the specials that are theirs for the taking.

These buying opportunities change from day to day, resulting from manufacturer overruns, overstocked positions, closeout situations, special offers, and discontinued merchandise. After browsing the availability of the special items, the buyer is offered the choice of immediate order placement by e-mail, telephone, or online.

Table 15.3 shows a sample offering that appeared on the R-Biz Web site, along with the terms of the deal.

TRADE SHOWS

For those purchasing agents who wish to examine the R-Biz lines in person, they are able to do so at several different trade shows. At these events the various manufacturers' full lines are featured for closer inspection and placement of orders. The Web site is periodically updated to alert the buyers to the shows, places, and times for their attendance. Table 15.4 lists some of the shows that buyers were alerted to. By knowing these dates well in advance, the buyers are able to set their schedules so that they can attend.

TABLE 15.3	**Quarterly Specials**					
Company	*Date*	*Amount*	*Discount*	*Freight*	*Billing*	*Specials*
Balitano	7/1–8/31	$350		1/2 free freight		
Carlisle Company	Until 9/30	$500				Free 6 pc. #9804 Mini Disco Ball
Marion Creations		$1,000		Free	Net 60	
Mega Marbles		$1,500				Various items. Ask your rep.
Smethport Specialties	Until 8/31	$350			Net 60	

TABLE 15.4 Upcoming Trade Shows

Show	Location	Booths
New York Toy Fair, February 16–19, 2006	Javitz Center	N/A
Pomona Toy Fair, March 8–11, 2006	Pomona Fairgrounds	#2034–2522
Los Angeles Gift Show, July 16–23, 2006	LA Mart	#810
San Francisco Gift Show, August 3–7, 2006	Moscone Center South	#1152–1160
San Francisco Gift Show, August 23–27, 2006	Moscone Center South	#1152–1160

Resident Buying Offices

As you learned in Chapter 6, there are many who describe themselves as resident buying offices (RBOs). In addition to all of the ways in which they serve their clients, RBOs have now made significant use of the Internet to reach them and provide product information along with specific fashion items that are available for purchase. The Retail Buying Focus features The Doneger Group, the nation's largest RBO—or market specialist firm, as it prefers to be called.

With membership in the Doneger organization comes the privilege of logging on to its Web site at http://www.doneger.com to bring product knowledge and awareness anytime of the day or night. Formerly, professional purchasers either waited to receive a host of flyers that centered on the products' worthiness, or they made trips to the Doneger headquarters to see the latest fashions in the field. Although both approaches were generally considered acceptable, neither offered the immediate notification of style changes, trends, fabrics news, and anything else that a Web site could offer.

As discussed in Chapter 6, resident buying offices not only provide product information but also offer the service that actually buys items for the client base. The merchandise is either specific items from various vendors that the company features or private-label products for the retailer's exclusive use. Keep in mind, that often time is of the essence when it comes to purchasing fashion merchandise. Thus, the Doneger Web site alerts the buyer to changes in the marketplace and introduces items that might spark the retailers' existing merchandise mix. Doneger online is a place where average buyers are able to become more adept at their purchasing skills without the need to leave the confines of their offices.

For an annual fee, the buyer may utilize all of the services of The Doneger Group. Daily examination of the Web site reveals an abundance of information waiting to be digested and assessed for individual retailer needs. Following are some of the different areas of information that http://www.doneger.com features.

THE HOME PAGE

When accessing the Web site, the buyer is greeted with a directory that features many different aspects of the Doneger subsidiaries and services. He or she might choose to learn about the corporation itself, its divisions, client services, and other areas of interest, especially if the buyer is new to the company. For those determining if Doneger serves their needs, there is a special arrangement that is complimentary to would-be

A Retail Buying Focus

THE DONEGER GROUP

When Henry Doneger, the founder of a company now called The Doneger Group, first opened his company's doors to retail buyers, no one could have imagined that it would become the world's largest market specialist catering to fashion merchants. Not only does it serve the needs of department stores, specialty chains, mass merchandisers, off-price merchants, and independent retailers all across the United States, but it also serves many overseas operations.

At one time it was just one of several offices of this type, but little by little it absorbed the operations of many of its competitors to achieve the enviable position it holds today in the wholesale marketplace. Its roles are diverse and include providing advisory information to retailers in terms of product information, new vendor resources, trends in the marketplace, analysis of the global fashion industry, promotional approaches, and anything that is current in retailing.

In addition to being information providers to clients, the company also engages in a number of different retailer services such as purchasing products according to the instructions of the retailer's buying staffs, and developing private-label products for the exclusive use of their membership. While it initially began as a specialist in women's apparel and accessories, today it covers the menswear market, children's clothing, and home furnishings.

Preparing the retail buyers for the upcoming season is of paramount importance to Doneger. With a wealth of buyers and merchandisers on its staff, it scours the wholesale markets to assess the season's newest collections in preparation for market week, a period in which the retail buyers come to town to preview merchandise lines and place their orders. It is through intensive planning that the Doneger team is ready to provide the retailers with the necessary information to make the buying trips productive. Meeting with buyers on an individual basis is typical of the services the company offers, so that individual purchasing needs may be addressed.

Today, The Doneger Group has expanded its expertise in yet another direction—that of providing information to clients online. By accessing the Web site, retail members may feel the pulse of the marketplace without leaving the confines of their offices. It has proven to be an invaluable tool for members to get up-to-the-minute information about the wholesale market, trends, and resource information.

future members. Those who already enjoy membership would immediately go to the specific area of interest.

REGISTRATION AND INFORMATION APPLICATION

If interest in the company is sparked by what is seen, a registration and information application is provided for those wishing to become members. Once completed, the buyer submits the application and quickly learns about fees and other requirements for membership.

AREAS OF INTEREST

There are numerous areas of interest, other than direct buying, that assist the buyer in learning all about market conditions and anything else that could make purchasing better. By clicking onto the appropriate place on the index page, the buyer is immediately led to the appropriate area. These areas of interest include:

- *Doneger marketplace,* a series of pages that offer research information about market trends and conditions, business planning tools for members, and so forth. Particularly beneficial are segments called *The Week in Fashion* that feature the latest weekly fashion highlights.
- *Doneger creative services,* a division that emphasizes trends and color forecasting, product analysis, and customized research to serve individual needs.
- *Price point buying,* a company division that specializes in opportunistic purchasing for retailers who wish to buy up-to-the-minute high-quality closeouts to better their overall profit margins.
- *Doneger consulting,* is a customized planning and development segment of the company. Buyers are able to get perspectives on consumer trends, design direction, and product development that can serve their private-label programs.
- *Pressroom,* which provides insight into the fashion industry, covering such topics as forecasting and merchandising.

At the Doneger Web site, and numerous others in the resident buying industry, the retailers' purchasing agents can find the latest industry information and make purchases as well.

Merchandise Brokers

As more and more **value retailers** are coming into prominence in the United States, such as flea market vendors and closeout stores, there is a need for a constant flow of goods that can be purchased at prices considerably below the traditional wholesale. Many manufacturers are left with unsold goods at a season's end that must be disposed of to make room for their newest arrivals. Similarly, numerous department stores are left with merchandise at the conclusion of their regular selling seasons that must be cleared for more timely products. Both of these business classifications must find ways to quickly clear their shelves and ready themselves for the incoming lines.

One way to achieve this is through the use of the **merchandise broker,** an entity that makes the arrangements for merchandise disposal between buyers and sellers. With such products regularly coming to market on a daily basis, the need for quick disposal rests in the hands of these brokers. With the advent of the Internet, such timely product disposal can be promptly undertaken. Buyers who have relationships with particular brokers merely log on to their Web sites and learn about product availability. Others who are new to the game can access merchandise brokers by searching the Web. If you use the search function on AOL, for example, and types in the words "merchandise brokers," approximately sixty thousand listings appear. Careful perusal may turn up those that seem to be appropriate to the searcher's needs. By just accessing those that seem favorable for the buyer's particular needs, a significant amount of product information appears that can be further examined in detail. Purchases can be made directly on these Web sites, or may be finalized by contacting the company via e-mail, fax, or telephone.

Registration and information application.
(Courtesy of The Doneger Group.)

ADVANTAGES AND DISADVANTAGES OF ONLINE PURCHASING FOR RETAIL BUYERS

The decision to purchase at a vendor's showroom, at trade shows, through in-house supplier visit, or through catalogs is the prerogative of the buyer. For some, there is no equal to viewing the actual merchandise, while to others this approach is less important. Buying on the Internet offers some distinct advantages as well as disadvantages to professional purchasers. They include:

A **Marketing Site** is a presentation option that allows a manufacturer to have a significant presence within the Doneger Marketplace conveying important information about the company, the product and the brand.

The "marketing site" feature enables buyers to learn about a company's product and brand. *(Courtesy of The Doneger Group.)*

Advantages

1. Merchandise that is added to a vendor's inventory may come at any time. Waiting for the next visit to the market or a call from a traveling rep may delay the time in which the new items may be assessed and considered for inclusion in the current season's merchandise assortment. With the new product shown on a supplier's Web site, an immediate decision may be made as to its potential as a moneymaker for the retailer.

2. Buyers can be alerted to price breaks and product closeouts in a matter of a few moments. They can quickly buy products at reduced prices that can help improve the department's maintained markup, providing the potential for greater profitability. This is **opportunistic buying** at the highest level.

3. Merchandise sourcing has become a global phenomenon. Products are available from every corner of the world, many of which are not within the professional purchaser's normal marketplaces. The Internet makes the research of product lines, in most places on the globe, generally routine. By using any search engine such as http://www.askjeeves.com, and asking where a host of product lines may be available, the buyer has at his or her fingertips products that might round out the missing links to a perfect merchandise assortment.

Virtual Showrooms are online showcases with all the advantages of the latest technology. Retailers can build and edit a line sheet as they shop the various lines, creating a merchandising assortment tailored to their specific stores' needs.

Full color digital images, along with specific style information, give retailers a clear view of a vendor's product line right from their desks. Additionally, retailers can contact manufacturers directly by clicking on email links provided.

◄ back next ► register now

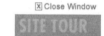

The "virtual showroom" allows the buyer to build and edit the manufacturer's line and create his or her own merchandise assortment online.
(Courtesy of The Doneger Group.)

4. Browsing on the Internet can be accomplished at any time of the day or night. It might be during the buyer's normal workday, or at times when he or she is away from the office when the rigors of the workweek don't interfere with merchandise searches.

5. Many Web sites offer *live action* for a better look at the merchandise than the appearances afforded through catalogs. Fashion merchandise, for example, is often shown on models so that the buyer can see how the garment looks on a human form. The Issey Miyake Web site, http://www.isseymiyake.com, offers the viewer different program versions in which models are seen parading the designer's creations. This is second best to seeing the collection offered on the runway.

6. When a buyer must find a *hot item* to add to his or her inventory at a moment's notice, prompt delivery is often needed. By using the Internet, a particular item might be found that could spell the difference between profit and loss for a particular time period. Even the best prepurchase planning doesn't always result in the best merchandise mix. Scouting a market in person or waiting for a catalog to be sent will never be as quick as Internet research and order placement.

A is a series **Product Development Presentation** of pages that allow a manufacturer to convey their overall capabilities as a private label resource.

☒ Close Window

◄ back next ► register now

SITE TOUR

Buyers interested in product development for their own private labels learn about manufacturer capability online. *(Courtesy of The Doneger Group.)*

Disadvantages

1. In many product classifications, such as fashion apparel, the **hand** of the garment, or how it feels, is essential to the buyer's final decision in terms of its merit as part of the department's offerings. A woolen sweater might have all of the eye appeal necessary for inclusion in the inventory, but the variety of woolens will not be evidenced in a picture. Some will be softer than others, providing them with greater customer appeal. Only through touching the sweater will the buyer be able to assess its real merit. This is available only through market visits, in-house visits by road representatives, or by the receipt of samples that have been sent to the buyer for inspection.

2. Negotiating the sale might not be satisfied on the vendor's Web site. While terms and delivery dates are often carefully spelled out, areas of negotiation such as advertising and promotional allowances need in-person discussion. Of course, these details can sometimes be discussed on the telephone before the final sale has been consummated. This, however, takes the purchase out of the realm of complete Internet buying which merely provides a starting point for negotiation.

3. Oftentimes a buyer wants to assess a vendor before a professional relationship may be considered. It is the rapport between the buyer and seller that, once established,

may prove to be the vital ingredient for future success. Character assessment cannot be accomplished without a person-to-person meeting, something that is lost through Internet use. After a time when the "partnership" has been positively established, the vendor's Web site may be used to place orders.

4. In some product classifications, such as designer apparel, it becomes necessary for the buyer to determine the level of exclusivity of the merchandise in his or her particular trading area. Merchandise of this nature cannot be traded in every retail outlet in a community or it will find less favor with shoppers. To this end, the degree of "confinement" of the line to the buyer within a reasonable geographic location can be established only through personal contact. Again, once this has been delineated, future purchases may be accomplished through the vendor's Web site.

ADVERTISING AND THE WEB

More and more vendors are designing Web pages to alert consumers to merchandise collections. Just as retail buyers scan the pages of consumer periodicals to see what is being shown to their potential customers, they also do so on the Internet. In this way they can learn about manufacturers' offerings of which they were unaware, and investigate further to see if the lines are appropriate for their clienteles.

Buying is not merely purchasing the same lines over and over again to develop a model stock. To be successful the professional purchaser must always be in the market for the hottest offerings and add and delete vendors from his or her resource list. In this way the purchaser will always be ready with the newest merchandise available in the field.

By regularly looking at the newest advertisements from new resources, the buyer will achieve the following:

- Learn about merchandise sources that are new to the marketplace.
- Learn the latest in a company's handling of designs of recent trends.
- Become familiar with the names of the major retailers that carry the lines so that in-person inspection may be warranted.
- Establish the price points of the company's merchandise line.
- Distinguish the selling features of the products offered for sale.

To alert the buyer to any aspect of his or her market, vendor advertising on the Internet provides just one additional source of information.

Language of the Trade

advisory groups
bridge-oriented
closeout prices
contractor
hand (of the garment)
home pages
logging on
manufacturer's representative

merchandise brokers
merchandise collections
middleman
opportunistic buying
perishability factor
reps
trade shows
value retailers
Web sites
wholesaler

Summary of Key Points

1. Many different types of vendors now have Web sites that make purchasing possible for professional purchasers.
2. Other than direct market visits or visits by manufacturer's reps, particularly for fashion merchandise, the use of the Internet is best for merchandise acquisition.
3. There are many factors regarding the purchase of fashion items that make Internet use better than catalogs.
4. By merely using the search function, an Internet user can access more than four hundred thousand vendors and their Web sites.
5. Buyers may get a quick overview of vendor offerings from all over the globe through the use of the Internet.
6. Many fashion designers have made their Web sites even more exciting by offering live presentations of models wearing their creations.
7. By logging on to to a Web site such as http://www.wholesaleindex.com, a buyer is quickly able to access a large number of wholesale organizations in a multitude of product classifications.
8. A manufacturer's rep is an individual or company that features a variety of products rather than just one manufacturer's offerings.
9. Resident buying offices provide a host of services, in addition to enabling the direct purchase of goods, on their Web sites.
10. Merchandise brokers are individuals or companies that arrange sales between suppliers and buyers.
11. By using a vendor's Web site, a buyer can get the pulse of the market without making in-person trips.
12. While the Internet provides many advantages for buyer use, it cannot make the fashion merchandise's hand available to the buyer.

Review Questions

1. What classifications of suppliers might retail buyers find on the Internet?
2. How might you find a listing of fashion manufacturer Web sites on the Internet with no knowledge of their names?
3. Typically, what is the scope of the countries in which manufacturers may be listed on Internet Web sites?
4. How completely might a fashion designer's offerings be featured on his or her Web site?
5. Why might a retail buyer wish to e-mail a contractor on the Internet?

6. How do wholesalers differ from manufacturers?
7. What is the difference between a wholesaler and a manufacturer's representative?
8. Are the terms of the deal often available on the Web sites of closeout specialists? If more information is needed, how might you proceed to get it?
9. For what reasons do retail buyers use The Doneger Group Web site?
10. What retailer classifications are more likely to use the services of merchandise brokers?
11. Define the term *value retailer.*
12. Why is it advantageous for the professional buyer to use the Internet for purchases?

CASE PROBLEM I

One of the more successful retail brick-and-mortar operations in the Chicago, Illinois, trading area is Joy Green. Founded by Ms. Joy Green in 1988, it has grown from a single store to a small chain that now numbers eight units. Its forte has always been upscale women's apparel, featuring the marquee labels that are known throughout the country. The shops specialize in price ranges that concentrate at the bridge level with smaller offerings immediately above and below that price point. Typical of the brands carried are Anne Klein, Calvin Klein, DKNY, Ralph Lauren, and others that gather the bulk of the American fashion headlines in the editorial presses' columns.

Business continues to be brisk with those vendors, but more and more competitors regularly emulate the company's mix by carrying the same lines. Although it has tried to gain a degree of exclusivity from vendors, its requests have fallen on deaf ears. The suppliers have had so much success with their collections that they are reluctant to change their marketing strategies to allow for the confinement of their lines to certain retailers.

Reading all of the trade papers such as WWD has brought to the company's attention the wealth of fashion products from worldwide resources. Around the globe manufacturers of fashion items have grown significantly. In the four corners of the world producers are creating designs of distinction that compare to the fashion-forward looks of the American designers who seem to have a hold on the present market's offerings. The buying team, along with Ms. Green who now serves in the capacity of general merchandise manager, had several product planning meetings to consider the addition of some of these unheralded lines to their assortments. The consensus has been positive; they would like to further pursue the inclusion of foreign merchandise that would unlikely be found in their competition's stores.

While the reaction has been favorable, only one obstacle seems to be in the way of further investigation of these global resources. The expenses attributed to making personal overseas visits are prohibitive to a company of Joy Green's size. Travel abroad is not only costly, but significantly time-consuming—a luxury that the buying team simply cannot afford. One suggestion has been to cover the trade shows that come to the United States that feature a small number of these fashion collections. Another is to use the services of a resident buying office to discover the names of these vendors and to view some of the samples that the RBO might have on hand. The company's buyers and merchandisers are very interested in pursuing this new merchandising approach, but do not seem settled on the approaches that have come forth from the meeting.

Questions

1. What are the advantages and disadvantages of the methods of foreign merchandise procurement as suggested by the buying team?
2. What route might the Joy Green associates take to get a better look at the global vendors who supply fashion merchandise, and to make their acquisitions without the usual route of trade show attendance?

CASE PROBLEM 2

A new retail operation is in the planning stages that would concentrate on a segment of value retailing. Specifically, it would deal only with closeout merchandise that could be bought at a fraction of the original wholesale prices and be offered to its potential customer base at bargain prices. The principals in this new venture are Jack Slaughter and Sam Jacobson, each with years of experience in retailing. They worked as buyers for major department stores and have bought apparel for the whole family as well as home furnishings. While their past employment has been in traditional retailing, they believe the need for closeout outlets is the wave of the future.

At this point they have contracted for a large warehouse structure on the outskirts of Jacksonville, Florida, to begin their venture. It is easily accessible from major interstates and has ample parking to accommodate a large number of would-be shoppers. In addition to their own monies, they have tentatively made loan arrangements with a bank to finance the operation. All seems to be going well, with discussions now concentrating on merchandise acquisition.

The backgrounds of both partners include procuring merchandise for their past employers by regularly going to the country's major wholesale markets and visiting the trade shows and vendor's showrooms. Since their buying centered on traditional merchandising, this was the best way to satisfy their merchandise needs. In the case of this new type of merchandising, where opportunistic buying is key to its success, the old purchasing methodology won't satisfactorily fill their store with the "bargains" that they hope to offer to their clientele. Also, traveling from vendor to vendor would be very time-consuming and take them away from their store's headquarters that, in the beginning, would require their attendance every day.

Ready to go full speed ahead, and with the planned opening only five months away, they have made some contacts with potential vendors to purchase closeout merchandise when it becomes available, but it's not enough to fill the warehouse in which they will operate.

Questions

1. What tool would you suggest they use for merchandise acquisition of this nature, and why?
2. Specifically, produce a plan that would bring to their attention the vendors and products in a timely fashion.

CHAPTER 16

Negotiating the Purchase and Writing the Order

On completion of this chapter, the student should be able to:

■ Explain cash discounts and their importance to the success of a retail organization.

■ Define the following terms and discuss how they affect purchase orders: *anticipation*, *trade discounts*, *seasonal discounts*, *advertising allowances*, and *postdating*.

■ List and describe the factors that should be taken into account to reduce transportation costs.

■ Discuss some of the additional considerations that must be addressed by those who purchase overseas.

■ Explain consignment buying.

■ Define each of the shipping terms that a buyer must note on a purchase order.

Once the buyer has planned his or her purchases based on qualitative and quantitative considerations, and has selected the resources from which they will be made, the next stages involve negotiating the points of the purchase and the actual writing of the order. As covered earlier in this book, the actual order writing often takes place once the buyer returns home from the market visit so that all of the gathered information can be further assessed.

NEGOTIATING THE PURCHASE

While "**haggling**" over prices is not a normal practice for consumers to attempt, except in unusual cases, price negotiation is commonplace in the wholesale arena. Of course, most vendors maintain one-price policies just as their retail counterparts do. In such situations, however, when merchandise is left over at a season's end, the supplier is eager to move it and generally makes price concessions to the retailers to do so. At this point, negotiation is a must. The experienced buyer knows how to motivate the resource to sell to him or her at the lowest possible prices. Those who buy for off-price ventures are extremely good at this type of negotiation since this is the manner in which they

make all of their purchases. By getting the lowest possible prices they are able to offer bargains to their customers.

Buyers for traditional stores are also involved in purchasing closeouts of merchandise at a fraction of their regular wholesale prices. They do this to mix into their inventories products that cost less and hopefully will make up for the markdowns taken on regularly purchased merchandise.

Whatever price concessions a buyer receives from the vendors will help improve profit margins.

In an earlier chapter we discussed legislation that was enacted in 1936 that somewhat hampers the buyer's ability to always get a more favorable price than the one quoted by the seller—the **Robinson Patman Act.** This legislation was designed to limit price discrimination and attempts to protect small businesses by forbidding their giant competitors from getting an edge by using their size to obtain lower prices. The law, however, permits price reductions in the following instances:

1. When the price reduction is made to meet the low price of a competitor
2. When the lower price is based on cost savings in selling to the favored customer
3. When the price is reduced on goods that were obsolete or on the verge of becoming obsolete, as in the case of fashion merchandise that is about to go out of style, or **job lots**

A vendor who singles out a particular account for a price reduction must base the action on the fact that one of the above criteria has been satisfied. Failure to do so will bring penalties from the government if the prices have been reduced.

A buyer discusses some of the terms of the purchase with the sales representative.
(Courtesy of Ellen Diamond.)

Understanding the Robinson Patman Act is essential for all buyers. Although trying to negotiate price is an acceptable practice, it must be done within the limits of the legislation. However, there are several approaches that the buyer may use in getting favorable prices. The initial price may not be negotiated for most purchases, but there are several discounts, allowances, and conditions that are appropriate to any transactions. These include cash discounts, anticipation, trade discounts, quantity discounts, seasonal discounts, advertising allowances, and the concept of postdating the order.

In addition to these negotiating considerations there are others that include transportation costs and consignment buying.

Cash Discounts

Cash discounts are reductions in the selling price awarded to retailers for prompt payment of their invoices. This is a discount that favors both the vendor and the retailer. The former gains quicker payment for the merchandise that can be used to pay the costs of production. The latter benefits the merchant by being able to buy the goods for less.

Typically, the cash discount is available in one of two ways, and the method used is often determined by the specific industry in which the sale is made. Except for the fashion industry, the following method is common:

ILLUSTRATION 1

A buyer is awarded a 2 percent discount if payment is made within ten days and no discount if payment is made after ten days. If the invoice was for $100 and had terms of 2/10 n/30, the retailer would pay $98 for early payment, and the entire bill, $100, for payment in thirty days.

With this type of cash discount the amount of the discount might vary, as might the days needed to receive the discount, as well as the days it must be paid without the discount. Such variations might read 3/10 n/60, 6/10 n/30, and so forth.

ILLUSTRATION 2

A buyer who has purchased six sweaters at $50, for a total of $300, is offered a cash discount of 8/10 **EOM** (end of month) on an invoice that was received by the store on January 15. To qualify for the 8 percent discount, the retailer must pay the invoice "ten days after the end of the month of delivery." That is, the amount of $276 (300−24) must be paid by February 10.

In the fashion industry, EOM discounts are the norm. The amount of the discount, however, may be different for different items.

Whatever the cash discount basis, the buyer must carefully note it on the purchase order so that it can be taken by the company when the invoice is paid.

Anticipation

Although not nearly as common as cash discounts, **anticipation,** if allowed by the vendor, offers another opportunity for savings. It is considered to be a special form of the cash discount that is especially important to the financially secure retailer who can afford to pay bills earlier than typically necessary. By getting this extra advantage, the retailer is able to increase his or her profit margins. Since many retailers' actual net profit

386 SECTION III Making the Purchase

may be in the 1 to 3 percent range, this extra savings can mean the difference between profit and loss.

Many resources do not readily allow for the anticipation discount, however. They clearly state on their invoices "No anticipation allowed." This may be one area that could be negotiated at the time the order is placed.

Anticipation works in this manner. The amount, usually 12 percent per annum, may be deducted for payment before the end of the cash discount period. For example, a bill on which a cash discount of 2 percent plus anticipation is allowed if paid within thirty days may be settled with a 3 percent discount if paid at once; 2 percent for the cash discount and 1 percent for anticipation (12 percent per year divided by twelve months equals 1 percent per month).

It also benefits the retailer if the buyer is able to negotiate long-term credit, or **postdating,** a concept that will be further explored later in this chapter. With this allowance, a bill that is due in sixty days, double the typical thirty days, for example, allows for twice as much anticipation to be deducted if paid at once.

The formula for anticipation is as follows:

$$\text{Amount of bill} \times \text{Rate of anticipation} \times \text{Days prepaid}$$

Illustrative Problem

A bill for $100 subject to terms of 2/10 n/60 dated March 1 is to be paid on March 7. If anticipation is allowed at 12 percent, what is the amount of the check required to pay the invoice?

Solution

$$\$100 \times 2\% = \$2$$
$$\$100 - \$2 = \$98 \text{ amount of bill due}$$
$$60 - 6 = 54 \text{ days}$$
$$\$98 \times 0.12 \times 5 \ 54/60 = \$1.76$$

then:

$$\$98 - \$1.76 = \$96.24 \text{ amount due}$$

Trade Discounts

In some industries, the price paid by the vendor's accounts is based on a list price. The **list price** is the published price set by the producer from which a percentage or **trade discount** is taken. The discount percentage awarded is based on the business classification of that account. In industry, there are different types of customers to whom the producer may sell. It might be another manufacturer, a wholesaler, a retailer, and sometimes an ultimate consumer. Each purchaser is entitled to a specific discount based on the type of company he or she represents.

The purpose of this type of discount arrangement is to enable the manufacturer to publish one set of prices for his or her merchandise, and to merely assign the appropriate discount percentage to be taken. In this way, if the manufacturer uses a catalog to sell the products, there is no need to publish separate catalogs, with different prices, for each group of customers. The mere taking of the right discount is sufficient to do business.

Frequently, when a buyer receives an invoice that has a trade discount, there may be other discounts also noted. These might be for cash or, perhaps, seasonal discounts. Whatever the case, the first discount is taken, then from the remainder the next, and so forth.

ILLUSTRATIVE PROBLEM

The R. C. Peters Company just purchased $1,000 worth of dinner plates. Being a retailer, it is given a discount of 40 percent. According to the terms of the sale, the company is also entitled to a 20 percent discount as an inducement to buy early, and an additional 10 percent for payment within the allocated time frame. How much must Peters pay if the bill is settled on time?

SOLUTION

	$1,000
Less 40%	400
	600
Less 20%	120
	480
Less 10%	48
Net cost	$432

While the decision about the amount of the trade discount to be taken is generally clear-cut, some retailers have also established wholesale divisions for their companies. By doing so, they are technically entitled to the wholesaler's discount, which is generally larger than that of the retailer. If this is the case, then the buyer must be able to negotiate with the producer to get the larger discount. Often, when there is a legal decision to be made concerning such a situation, the retailer is not the winner. Another attempt to get the wholesale price for retailers involves independent merchants who have banded together to form a wholesale organization for purposes of group purchasing. In these types of situations, the courts have ruled in favor of the retailers since they actually operate a wholesale enterprise.

Whatever the case, buyers must understand what type of trade discount they are entitled to, and must be able to quickly do the arithmetic to see if the net price is what they want to pay.

Quantity Discounts

Some **quantity discounts** are permitted under the Robinson Patman Act because they can be shown to result in cost savings in such areas as bookkeeping and transportation. An example of a quantity discount follows:

Dozens Ordered	Price Per Dozen
1–10	$20.00
11–30	9.50
31 and over	9.00

Sellers offer quantity discounts because of the savings that result and as an incentive for the purchaser to buy more. Naturally, a buyer must be aware of the quantity

discounts available. Whether or not he or she takes advantage of them is another matter. While a discount might be tempting, it is a good business practice only if there is a need for the larger quantity. Overbuying of an item could result in a markdown, a dollar amount that is certainly greater than the quantity discount. In most cases, fashion merchandise is not a product classification that warrants a quantity discount. This is generally reserved for staple goods, which have longer selling periods.

Another type of quantity discount is the cumulative variety. These are based on volume for a specific period of time. Where regular quantity discounts are on a per-order basis, the cumulative types are for total orders for a specified amount of time. In such cases, the percentage allowed escalates as the total orders reach a certain level. The following shows how the concept works:

Total Season Purchases	Cumulative Discount
$ 0–10,000	2%
$10,001–20,000	3%
$20,001 and over	4%

Cumulative discounts encourage buyers to place the bulk of their orders with one resource. Of course, quantities aren't the only factor to consider. First and foremost is the merchandise. If one vendor's products necessitate only minimal ordering, then an extra percentage point or two should not matter. When all of the considerations of the purchases have been addressed and the merchandise from a few resources is basically identical, placing a single large order with one vendor might be feasible.

Caution is always in order when any type of ordering is done.

Seasonal Discounts

Certain seasonal products such as toys (they sell in the greatest quantities during the Christmas selling season), swimsuits, and outdoor furniture are sometimes offered to the buyer with discounts for buying prior to the selling season. To produce the amounts that will be needed by the merchants who sell them, manufacturers must continue to produce and warehouse them until they are purchased. It would be impossible for any business dealing in seasonal goods to produce sufficient quantities exactly when they are needed. However, ongoing production requires money for labor, materials, and storage without the benefit of being able to sell these goods and receive payment.

To motivate retailers of these items to purchase early in the season so that they can at least minimize the enormous costs of warehousing, many manufacturers offer **seasonal discounts** as incentives. These discounts are permitted by the Robinson Patman Act if they are offered to all potential buyers. Under such circumstances, a swimsuit company that normally ships the bulk of its products in April for peak selling in May and June will ship in February and March, provided it offers the extra discount.

Given this opportunity, the retail buyer must assess his or her storage facility as well as the capital requirements needed to pay for the goods earlier than necessary. He or she must also address any problems that might be related to open-to-buys because of the early purchase, the early selection of colors, and the potential for price changes after the order has been placed. A bargain is a bargain only if the timing and conditions are right.

Advertising Allowances

One of the problems that many retailers face each year is the limitation placed on monies allocated for advertising. With the competitive nature of retailing, it is essential for merchants to publicize their companies on a regular basis, and with inadequate budgets this can be problematic.

One way in which retailers may overcome this problem is through the use of **cooperative advertising.** This is a plan in which vendors pay up to one-half of the costs for retailers' advertisements of the vendor's products. Many resources are willing to help in these advertising ventures because it is a way to promote their own products and potentially account for additional purchases.

Most cooperative advertising arrangements are based on retailer purchases. A percentage of the invoice is earmarked for advertising, of which the vendor and the retailer share the expense, as illustrated in the following problem.

ILLUSTRATIVE PROBLEM

The Mayfair Company purchased an order for goods from Arkwright Ltd. that amounted to $10,000. Under the terms of the agreement, both the seller and the buyer agree to a 5 percent allowance for advertising, with the ultimate cost of the ad to be split equally.

SOLUTION

$$\$10,000 \times 0.05 = \$500$$

Cost of the advertisement $1,000

Share of each participant $1,000 \div 2 \times \$500

Thus an ad that would cost the retailer $1,000 requires only 50 percent or $500. In reality, this is the way in which a retailer's advertising budget can be doubled. A further discussion on cooperative advertising will be offered in Chapter 20.

Postdating

Another area of negotiation is for an additional period of time before the bill becomes due, called postdating, as explained earlier. Sometimes, the trade refers to it as "dating the order." This practice enables the retailer to sell some of the merchandise before payment must be made.

As an example, an order that is placed calls for delivery on March 1, has been postdated June 1, and carries a discount of 8/10 EOM. Under the regular terms, for the customer to receive the 8 percent discount, the invoice must be paid by April 10. With the postdating arrangement, the payment may be made July 10.

Transportation Costs

One of the areas of purchasing expense that has increased considerably is in the transporting of goods from the supplier to the retailer. While domestic transportation costs continue to increase, costs are even higher when the purchase is coming from overseas.

It is in this area that the buyer must try to get the best possible terms. If left to the discretion of the seller, the retailer could be faced with some expenses that might have been avoided.

As a general rule, the cost of transporting the goods is the responsibility of the purchaser. The merchandise is sold **FOB factory,** which means that the title passes from the seller to the buyer as soon as the goods leave the factory. In many cases, however, in order to motivate the buyer to purchase the goods, vendors will pay the shipping costs, or at least a percentage of them.

When the buyer is making his or her initial purchasing plans, he or she should consider the distance from which the goods will be shipped. As a rule, the greater the distance from the shipping point to the buyer's premises, the greater the cost. For this reason, the buyer should make certain that the goods be bought as close to home as possible. Of course, if one particular resource provides the most desirable merchandise, then that should be where they must be bought regardless of shipping costs.

If there is no way in which to have the cost of shipment paid for or shared by the vendor, then the buyer must make every effort to choose the most cost-effective method for shipment. Different transporters have different price structures, and each should be investigated for the best deal. Of course, when time is of the essence, as in the case of a special order, shipping costs may not be considered. The fastest way to receive the goods is the only factor to consider.

When shipping decisions are left to the supplier, he or she might choose the method that is most convenient to use. By the buyer familiarizing himself or herself with all of the alternative shipping methods and costs, the result might be a savings on costs. With each penny saved, the retailer is able to turn a better profit.

These are some of the areas where costs could be reduced that a buyer should consider before any transportation decisions are made.

SIZE OF SHIPMENT

It is less expensive to ship a full carload than a partial one. In such cases, the buyer should consider the timing of the purchase so that one large order can be placed instead of many smaller ones. Also, many shipping companies have minimum costs per shipment, making shipping of a single item as costly as shipping several. If possible, these single-unit orders, unless absolutely necessary, as in the case of special orders, should be avoided.

TIMING OF DELIVERY

Typically, slower carriers such as waterways are less expensive than rapid ones such as airways. Similarly, train and truck delivery is less costly than **airfreight.** When possible, ordering should be done far enough in advance to take advantage of the time factor. Of course, when time is of the essence to satisfy a customer's immediate needs, then transporters like Federal Express, although costly, should be considered.

SELECTION OF CARRIERS

Different carriers have different rate schedules. It is imperative that the buyer knows which ones offer the better deals. As a rule, regular parcel post is less costly than UPS, and UPS is less costly than Federal Express. In some parts of the country, there are private carriers who might have better rates than any of these shipping companies. They

should be familiar to the buyer so that shipping costs can be compared and the best choice can be made.

INSURANCE PROTECTION

Insuring deliveries is important in case they are lost. In some cases, such as with UPS, there is a minimum amount of insurance that is free. If additional insurance is necessary, it is the responsibility of the buyer to arrange for it. Sometimes companies carry policies that cover all shipments in case they aren't received. The buyer must know if his or her company carries such a policy, how much insurance is included with the cost of delivery, and how much extra insurance costs would be.

PACKING CONSIDERATIONS

Sometimes the merchandise may be packaged in more than one way. Dresses, for example, might be obtained on hangers covered with plastic or flat in boxes. The first arrangement allows for quick transfer to the selling floor, but the weight of the hangers can significantly increase shipping costs. The buyer is responsible for determining which benefits his or her company more—the simpler handling with hangers or the reduced costs without them.

When each of these considerations is carefully addressed, the retailer will be the beneficiary.

Consignment Buying

A consignment sale is one in which the vendor retains ownership of the goods even though physical possession has been transferred to the retailer. It is not until the merchant has sold the merchandise to the consumer that a sale from the producer to the retailer has been consummated. **Consignment buying,** or memorandum buying as it is sometimes called, is widely practiced in the precious jewelry and fur businesses. With the cost of such goods so high, many retailers do not have the necessary capital to purchase the goods outright. To transact business in these fields, vendors often have to make consignment concessions to their accounts. Very often in cases where this type of purchasing is done, the retailer's markups are lower than if the traditional purchasing method was used. Since the resource is offering this opportunity, he or she often charges a premium for such merchandise. Of course, the retailer benefits by not having to risk large sums of money, as with an outright purchase.

In most cases, consignment buying is not available. Vendors want to sell their merchandise and want their clients to take the risks. Buying on consignment, however, is sometimes the way to go for both the sellers and the buyers. The following conditions lend themselves to this type of arrangement:

1. On new types of goods, when consumer acceptance cannot be adequately estimated, sellers will offer buyers the opportunity to buy on consignment.
2. When a low-volume item is carried more for prestige than for salability, the seller might motivate the buyer to try the item by not requiring payment until the sale is made.
3. Sometimes when a manufacturer that is overstocked wants to move out inventory, consignment buying might be offered. At the end of a season in the fur industry, resources with extra stock often ship their garments to vendors for three- or four-day

sales, at which time much of their merchandise can be disposed. The retailer benefits in that he or she mixes in the new acquisitions with his or her own inventory that has been depleted, giving the customer the opportunity to select from a fuller assortment.

4. When new, inexperienced buyers enter the market, they are often unsure of their purchasing capabilities. By buying on consignment, they can learn if they have made the right merchandise selections without the risk of outright purchases. Many take advantage of these situations when offered by the vendors.

5. When quantities are uncertain and the demand is sharp but short-lived, this type of merchandising is often used. For example, when the buyer of textbooks for a college bookstore is uncertain of course enrollment, he or she may order large quantities on the condition that unsold books may be returned to the vendor.

One of the dangers of consignment buying is that a buyer might be tempted to stock the shelves with what might be less than desirable merchandise. This practice must be used only when the conditions call for it and the goods seem to be exactly what the merchant needs.

How to Negotiate

Although the vast majority of resources have strict one-price policies, there is sometimes room for price negotiation. It is up to the buyer to assess when and under what conditions this is possible. This comes from experience and the buyer's knowledge of each vendor's practices. Of course, price reductions are commonly obtained at season's end or when a vendor's inventory is stocked higher than needed. In these situations, the buyer should be able to negotiate the best possible prices, often lower than those usually offered by the vendor.

Price bargaining is something that is learned from experience. In practice, some of the following should be addressed.

SETTING LIMITS

When the buyer determines his or her six-month plans and model stocks, he or she has carefully considered the amount of merchandise needed for a profitable season. With this in mind, certain limits have been set before the doors of the vendor's showroom are entered. Every resource knows of the planning that takes place and is aware that the buyer works within certain limits. Although this is standard practice in the industry, predetermined limits are not set in stone.

If the merchandise is something better than anticipated, the buyer might be inclined to buy more, especially if a price advantage can be obtained for the larger purchase. In cases in which the buyer might be in the market for a large quantity so that he or she can run a promotional sale, a price consideration might convince the buyer to purchase. These are just some of the conditions that set the stage for bargaining.

JUSTIFYING THE OFFER

Whenever an offer below the stated price is made, the buyer should be prepared to justify it. It might be that a special sale is being held by the store, that the newness of the merchandise may present some risk, or the lateness in the selling season. When such justifications are presented, the vendor might be convinced to consider the offer.

SPLITTING THE DIFFERENCE

In any negotiation, there is generally a difference of opinion as to what the price should be. In such cases, one way to settle the price is to split the difference. That is, if the seller is asking $4 and the buyer is offering $2, $3 might be the price that will satisfy both parties.

WRITING THE ORDER

After the selections have been made and the prices and terms have been negotiated, it is time for the order to be written. This is the stage at which an agreement is entered into, and is tantamount to the writing of a contract. Both parties are contractually bound to its terms and conditions. Bearing this in mind, the order must be written with extreme care.

The order forms that are used are either those that have been prepared by the retailer or ones that the manufacturers supply. The large retail organization uses its own, and the smaller merchant generally relies on the vendor for the order form.

The forms produced by the merchant offer a number of benefits, including:

1. All merchandise departments use the same form, making it easier and faster for the clerical staff and receiving personnel to handle.
2. The form can be tailored to the requirements of the company, with the right number of copies necessary for implementation of the order.
3. Legal conditions may be set forth for the protection of the retailer.

Typical terms that may be used when orders are placed include the following:

1. *Air express:* Express service on regularly operated lines that are quick and reliable, but very expensive.
2. *Airfreight:* Freight is quickly shipped and is less expensive than air express.
3. *EOM discount terms:* Under this condition, the bill is due ten days after the end of the month stated on the invoice.
4. *Fishyback:* A transportation system in which a truck trailer is loaded directly onto a ship, avoiding costly unloading and reloading.
5. *FOB destination:* Title to goods passes when they arrive at their destination. Because the vendor owns the goods until then, he or she pays the freight.
6. *FOB factory:* Title passes at the point of shipment. Buyer owns the goods in transit and pays the freight.
7. *LCL:* Less than a full-freight carload.
8. *Parcel post:* A federally operated system for shipping small parcels. Also available is *priority mail* that delivers packages in two or three days, and *express mail* that guarantees overnight delivery.
9. *Piggyback:* A transportation system in which a trailer is loaded directly onto a freight train car.
10. *Postdating:* The extra time allotted to retailers to pay their bills and still take advantage of the cash discount.
11. *ROG:* Under *receipt of goods terms,* the amount of time before payment is due doesn't begin until the goods are in the hands of the buyer.
12. *UPS:* United Parcel Service.

Once all of the details have been worked out, the order is written.

PURCHASE ORDER WORKSHEET

VENDOR: DUCK HEAD DEPT #: 355 START SHIP: 7/25 TERMS: NET 30

VENDOR #: 9992145 PO #: 111225667 CANCEL: 8/15 OTB MONTH: AUGUST

STYLE #	DESCRIPTION	COLOR	UNIT COST	UNIT RETAIL	ASST 1 UNITS	ASST 1 COST	ASST 1 RETAIL	ASST 2 UNITS	ASST 2 COST	ASST 2 RETAIL	ASST 3 UNITS	ASST 3 COST	ASST 3 RETAIL	ASST 4 UNITS	ASST 4 COST	ASST 4 RETAIL
12345	S/S PLAID KNIT	RED	14.00	38.00	18	$252	$684	12	$168	$456	12	$168	$456	12	$168	$456
12344	S/S HERRINGBONE KNITS	WHITE	14.00	38.00	18	$252	$684	12	$168	$456	12	$168	$456	6	$84	$228
12342	S/S WINDOWPANE PLAID WOVEN	BLUE	12.00	34.00	12	$144	$408	12	$144	$408	12	$144	$408	6	$72	$204
12346	S/S MINI CHECK WOVEN	RED	12.00	34.00	12	$144	$408	12	$144	$408	6	$72	$204	6	$72	$204
12347	S/S SOLID PIQUE	WHITE	10.00	28.00	12	$120	$336	12	$120	$336	6	$60	$168	6	$60	$168
12343	S/S SOLID PIQUE	NAVY	10.00	28.00	12	$120	$336	6	$60	$168	6	$60	$168	6	$60	$168
123400	S/S STRIPE WOVEN	MULTI	12.00	34.00	12	$144	$408	6	$72	$204	6	$72	$204	6	$72	$204
					96	$1,176	$3,264	72	$876	$2,436	60	$744	$2,064	48	$588	$1,632

STORE #	ASST #	UNITS	RETAIL
100	1	96	$3,264
101	1	96	$3,264
102	2	72	$2,436
103	2	72	$2,436
104	2	72	$2,436
105	2	72	$2,436
106	3	60	$2,064
108	3	60	$2,064
110	3	60	$2,064
114	3	60	$2,064
116	4	48	$1,632
118	4	48	$1,632
120	4	48	$1,632
TOTAL UNITS			864
TOTAL COST			$3,384
TOTAL RETAIL			$29,424

A purchase-order worksheet prepared by the buyer before the order is written.

The buyer writing a purchase order.
(Courtesy of Ellen Diamond.)

FOLLOWING UP THE ORDER

Whether the purchase was made abroad or domestically placed, it is necessary to periodically check on its status. While specific delivery instructions have been noted on the order form, including dates for shipments to begin and conclude, this is not always guaranteed. From time to time vendors have problems, such as late delivery of materials, that might delay the shipments. While this is a real problem, on other occasions the lateness may be due to the vendor's delivering the merchandise to a more favored account. This should be unacceptable to the buyer. Although it is difficult to assess the reason for the delivery's tardiness, this is not the buyer's problem. He or she must look out for the best interest of the retailer and must make it plain that if the goods are received late they might not be accepted. Remember that the planning that has taken place was done to make certain that goods arrive on the selling floor at the time best to maximize profits. It is for this reason that both parties abide by the terms on the order form, which is a contract. Only when the lateness of the receipt of merchandise will not affect the retailer's **bottom line** will it be accepted later than promised.

Orders may be followed up in a number of ways. If the buyer is located close to the wholesale market, he or she could pay a call to the resource to determine the cause of the

39045

CUSTOMER NUMBER

LOG NUMBER

BASCO ALL-AMERICAN SPORTSWEAR CORP.

Showroom: 58 West 40th Street, 10th Floor, New York, NY 10018, (212) 764-1730

Accounting: 118 West 22nd Street, 7th Floor, New York, NY 10011, (212) 255-4595

SPECIAL INSTRUCTIONS

DATE: ☐ WOMEN'S ☐ MEN'S ☐ NEW ACCOUNT

BILL TO:	SHIP TO:	SALESPERSON:	BEGIN SHIPPING:
		CUSTOMER'S P.O. NO.:	COMPLETION DATE F.O.B. NEW YORK
		STORE NO.:	SHIP VIA:
ZIP	ZIP	DEPT. NO.:	TERMS:
TELEPHONE ()	BUYER'S NAME:		INPUT:

STYLE	COLOR		DESCRIPTION	28	29	30	31	32	33	34	36	TOTAL UNITS	UNIT PRICE	EXTENSION
	NO.	NAME		4	6	8	10	12	14					
				S	M	L	XL							
				36	38	40	42	44						
												TOTAL		

Claims: All claims must be made within ten days of receipt of goods.
Returns: No returns accepted without our return authorization label. Address all requests for return authorization to Showroom.
Ship: Goods delivered to common carrier or sent via parcel post are at the risk of the purchaser.

BUYER'S SIGNATURE

BUYER'S COPY

Vendor order form.

(Courtesy of Basco.)

372

delay and when it will be shipped. If the merchant is affiliated with a resident buying office, this might be another route to take—one of the chores given to assistant resident buyers is the follow-up. Contacts by telephone, faxes, and e-mail are other alternatives.

Whatever method is employed, it is up to the buyer to follow through. Late delivery is a violation of the contract, and the goods in question need not be accepted at that time. One important consideration for future buying from vendors who deliver late is never to buy from them again. Late deliveries can cause a great number of problems for the merchant, such as a gap in a particular merchandise classification and an inappropriate amount of merchandise in the model stock to reach the anticipated sales quotas.

Earlier in this book, reference was made to the resource diaries maintained about each vendor. It should be noted on any resource's page when deliveries are habitually late. This can serve as a reminder to the buyer that purchasing from this vendor could cause unnecessary trouble with future purchases.

ESTABLISHING FUTURE VENDOR RELATIONSHIPS

It is unquestionably to the buyer's advantage to maintain a sound, ongoing relationship with his or her resources. Most professional purchasers will agree that this will help make future negotiations more favorable. When there is a possibility for a better price, there is the likelihood that the favored customer will get the advantage. In terms of closeouts, the buyer who has established himself or herself as a good account will probably get the first call when this merchandise is available at rock-bottom prices. On-time delivery of merchandise is often given to the better accounts. Preferential treatment for reorders is another benefit.

By remaining loyal to a vendor, and not taking advantage through unnecessary returns of merchandise, the buyer can become an important client and reap the benefits of such relationships.

Buying is an art, and only the most astute purchasers will be able to bring the right merchandise at the right time to the companies they work for.

Language of the Trade

air express
airfreight
anticipation
bottom line
cash discount
consignment buying
cooperative advertising allowance
EOM terms
fishyback
FOB destination
FOB factory
following up order
haggling

job lots
LCL
list price
piggyback
postdating
quantity discount
Robinson Patman Act
ROG
seasonal discount
trade discounts

Summary of Key Points

1. Although most vendors have one-price policies, under certain conditions there is room for negotiation.
2. The Robinson Patman Act is a piece of legislation that forbids price discrimination toward small retailers.
3. Cash discounts are awarded to merchants who pay their bills within a specified time.
4. Some vendors allow retailers to anticipate their bills by offering them an additional discount.
5. A trade discount is a reduction in the wholesale price that is based on the classification of the purchaser.
6. Although quantity discounts are generally unallowable according to the Robinson Patman Act, a vendor might offer them when savings are the result of the large purchase.
7. To motivate retailers to buy merchandise earlier in the season than necessary, some resources offer them seasonal discounts. This is typical in the toy and precious jewelry industries.
8. Some vendors offer retailers cooperative advertising allowances as inducements to purchase from them. This arrangement gives the merchant the opportunity to stretch his or her advertising budget.
9. To get extra time to pay their bills, and still obtain any available cash discounts, vendors and merchants enter into postdating agreements. It is the seasoned buyer who is able to get the most time to pay the bills.
10. Transportation arrangements should never be left to the discretion of the vendor, because he or she might use the most expensive method of shipping.
11. Consignment buying is when a resource agrees to ship merchandise to a retailer and doesn't require payment unless the goods are sold. If unsold, the merchant has the right to return them.
12. When an order is being written, attention should be paid by the buyer to make certain that all of the terms agreed to have been noted. Since the order form is a contract, it will be used in any disputes.
13. It is imperative to establish and maintain good relationships with vendors so that the merchant will become an important account and receive favorable treatment.

Review Questions

1. Is it ever appropriate for buyers to haggle over price with a supplier?
2. Which classification of retail buyer is most knowledgeable in terms of price negotiation?

3. Why is job-lot merchandise offered at lower prices to the retailer?
4. What was the purpose of the passage of the Robinson Patman Act?
5. Under the Robinson Patman Act, is it ever appropriate for a resource to charge less than the originally stated wholesale price?
6. What is meant by the term *anticipation?*
7. In what way does the postdating of an order help the retailer?
8. What is the purpose of trade discounts?
9. Why is it appropriate for some purchases to be made prior to the actual time the goods are needed for sale?
10. Under the usual cooperative advertising allowance, how does the vendor determine how much he or she should contribute to the ad?
11. Besides being able to pay a bill later, what other purpose does postdating serve for the retailer?
12. Should shipping arrangements ever be left to the discretion of the vendor, since he or she is most familiar with shipping methods?
13. Is consignment buying ever a potential danger for the merchant?
14. In negotiating a purchase, what are some of the key points that should be addressed?
15. Why is it important for retailers to establish sound relationships with their resources?

CASE PROBLEM I

The Acme Store is a large, successful one-unit store in a downtown urban area in the Midwest. The store was founded in 1935, and it grew steadily from its inception through the early 1990s. Since then, though still profitable, its growth has been declining. This is due in large part to the relocation of many of its customers to the suburbs.

The store's merchandising division has been and continues to be excellent. Thanks to assertive buying and careful merchandise selection, the store attracts more than its fair share of the market. Moreover, the goods are sold at a markup in excess of that achieved by the competition. The extra markup has been due to the extraordinary services provided. The suggestion that some of these services be curtailed was ignored because this would probably affect sales.

It has become apparent to top management that the store's operation is not likely to be improved. Under the current conditions, shrinkage of the volume and profits will be offset only if corrective measures are applied in some areas.

One of the areas that seems to offer possibilities for savings is shipping costs. A preliminary spot check of completed orders has revealed that most of the company's buyers indicate shipping instructions to the vendor by noting "best way" or "cheapest way."

You have been hired by the store as an expert in transportation. All of the store's records are available to you for your perusal.

Questions

1. What will you look for?
2. What suggestions will you make?

CASE PROBLEM 2

The swimsuit buyer for a large department store has been placing the greatest portion of her orders with a major, nationally branded manufacturer throughout the season. She has been successful with the merchandise and maintains an excellent relationship with the vendor.

She has been informed that on July 1 the vendor plans a drastic price reduction on goods that have proven salable in the past. From her past experience, the buyer knows that many of her store's customers have put off buying their swimwear in anticipation of an annual July 15 sale.

The buyer has a list of fourteen styles she is interested in. These originally sold at $50 each. They will be offered for sale at $25 each during the sale. For the sale to be a success, a markup of at least 40 percent is required.

Questions

1. What is the highest price the buyer can afford to pay for each swimsuit?
2. What concessions can the buyer try for in addition to a price reduction?
3. What effect will the Robinson Patman Act have on the negotiations?

SECTION FOUR

Additional Buyer Responsibilities

A buyer's involvement doesn't end once he or she has made the purchases that he or she believes will satisfy the needs of the customer. A great number of other responsibilities and tasks are part of the buyer's regimen, including pricing the merchandise, assisting in the development of private-label goods, disseminating product information to the store's personnel, and helping plan promotional endeavors.

Most retailers provide guidelines for their buyers in terms of pricing the merchandise, but it is generally the buyer who determines the actual selling prices of the particular items. Some might get additional markups because of the nature and exclusivity of the goods, or lower prices to meet the competition. By pricing "right," profits will be maximized.

More and more merchants are offering private-label products in their stores. In many cases the buyer assists in the development of these items. While the buyer is not called on to actually design the goods, he or she does offer suggestions about silhouettes, sleeve lengths, and so forth. From their coverage of the various marketplaces, buyers are in a position to study the offerings and suggest how their own products could incorporate the best features.

By providing store personnel with product information, those who interact with the customers will be better prepared to answer questions. The buyer is most knowledgeable in terms of product information, and passing this knowledge on to those in the store will make selling easier.

Salespeople are assisted in achieving their goals through effective advertising, special events, and visual merchandising. While the buyer is neither responsible for these components of selling nor expected to be an expert in such matters, it is through his or her assistance that these endeavors will be improved. By suggesting the most appropriate merchandise to be promoted, as well as the selling points that should be stressed, the promotions are likely to bring more positive results.

When these areas of additional responsibilities are handled properly, the buyer's purchases are more likely to translate into higher profits.

CHAPTER 17

Merchandise Pricing

On completion of this chapter, the student should be able to:

- Differentiate between the manner in which a large store buyer and a small retailer set prices.

- Understand the mathematics involved in markup at retail, cost, related problems, cumulative markup, average markup, markdown percentage, and turnover.

- Write an essay on markdowns, including timing, amount, and markdowns as a means of evaluating buyers.

- Discuss the advantages and shortcomings of turnover information.

- List and briefly discuss the factors that affect pricing policies.

- Define price points and discuss five advantages of their use.

Profits are the ultimate test of the effectiveness of the buying function. Profitability is measured by comparing the cost of an item with its selling price. The buyer must be just as concerned with the selling price of goods as with their cost, because each of these functions affects profits equally.

PRICING POLICIES

The success of a retail operation depends in large part on its pricing policies. Decisions on overall pricing are made on an executive level considerably higher than the buyer. In most instances, the buyer is given a target markup percentage and volume for a particular period. This usually takes the form of a budgeted sales figure and a markup percentage (the difference between the cost and the selling price stated as a percent). The success of a small retailer or of a buyer in a large store is measured by whether he or she falls short of, meets, or exceeds this budget.

Markup percentages are generally not set uniformly throughout a store. Different departments, for a variety of reasons that will be discussed later in the chapter, are expected to yield varying profits. Although the markup percentages are increased slightly year after year as operating costs increase, each department's increase generally remains in the same proportion to those for other departments in the store.

Departmental Pricing

The buyer, then, is given a fairly rigid markup percentage to work with and can expect to be called in to discuss any substantial variation from this amount. However, there is considerable flexibility from there on. For example, a buyer who is told that the department is expected to produce a markup of 50 percent is not generally forced to fit every item into that slot. The 50 percent figure is an average markup, and the buyer may, at his or her discretion, go above or below it on each item. In other words, management is not concerned with the profitability of individual items. It expects a 50 percent average markup; how this is arrived at is the responsibility of the buyer. This allows for considerable skill and ingenuity. One mark of a good buyer is the way in which he or she handles this averaging.

Overall Store Pricing

In some organizations, particularly those that deal in off-price merchandise, the markup that is taken is generally uniform throughout the store. These merchants usually do not consider the various merchandise classifications they have in their inventory to determine selling prices. The companies also do not pay attention to the competition. The goal is to achieve a specific markup on everything that they sell and "move" the merchandise as quickly from the shelves and racks as possible.

Pricing for the Small Retailer

The purpose of a pricing policy is to make certain that the excess of the selling price over the cost of the goods sold is sufficient to cover expenses and yield a reasonable profit. Naturally, this is as important to a small retailer as to a large one. All retailers, regardless of size, operate under a pricing policy set by top management. The difference is that the large store executive has to set up formal pricing guidelines to be carried out by subordinates, whereas the small operator need not be so formal because he or she will do (or at least closely supervise) the buying. This lack of rigidity in following policy is one of the few advantages the small operator has over the giants.

MERCHANDISING MATHEMATICS

Buyers are responsible for achieving a certain **average markup.** They arrive at this figure by averaging a variety of different markups on a wide assortment of merchandise. Obviously, they must become very proficient with the mathematics of markup calculation if they are to be successful at the job.

Markup

Markup is the difference between the cost and the desired selling price of goods. As mentioned earlier, it must be sufficient to cover the expense of operating the business plus a desired profit. Thus if the cost of merchandise is $75,000, the operating

expenses $15,000, and the desired profit $10,000, the goods must be sold for $100,000. Then:

− Sales	$100,000
Cost of goods	75,000
= Markup	25,000
− Expenses	15,000
= Profit	10,000

The markup of $25,000 is the excess of sales over the cost of goods. It is sufficient to cover the expense and leave a profit of $10,000.

$$\text{Retail (selling) price} - \text{Cost} = \text{Markup}$$

INDIVIDUAL INITIAL MARKUP

Individual initial markup is the markup on an individual item that the buyer hopes to achieve.

PROBLEM

A pair of slacks that cost $50 is offered for sale at $100. What is the markup?

SOLUTION

$$\text{Retail price (\$100)} - \text{Cost (\$50)} = \text{Markup (\$50)}$$

Markup, when referred to by buyers, is always calculated as a percentage. This is done by dividing the amount of markup by the cost or the retail price.

Markup on Retail. In almost all instances, markup is based on retail. Because sales figures are always available, the use of retail makes calculation much easier. For example, knowing a store grossed $2,000 in weekly sales and that the average markup is 40 percent, it is easy to calculate the gross profit of $800 ($2,000 × 40%). If the markup percentage were based on cost, it would be necessary to calculate the cost of the $2,000 in sales before applying the markup percentage.

The formula for calculating the markup percentage on retail is:

$$\frac{\text{Markup}}{\text{Retail}} = \text{Markup percentage based on retail}$$

PROBLEM

A scarf that cost $10 is priced to sell at $15. Determine the markup percentage based on retail.

SOLUTION

$$\text{Retail} - \text{Cost} = \text{Markup}$$
$$\$15 - \$10 = \$5$$
$$\frac{\text{Markup}}{\text{Retail}} = \frac{\$5}{\$15} = 33\frac{1}{3}\%$$

Markup on Cost. Although not widely used, some retailers use a markup percentage based on cost. A retail produce store whose selling prices vary greatly from day to day finds cost a more stable base for markup calculations.

The formula for calculating markup on cost is:

$$\frac{\text{Markup}}{\text{Cost}} = \text{Markup percentage based on cost}$$

The markup percentage based on cost in the preceding problem would be calculated in this manner:

$$\frac{\text{Markup}}{\text{Cost}} \quad \frac{\$5}{\$10} = 50\%$$

RELATED MARKUP PROBLEMS

There are related markup calculations with which merchandise buyers must be familiar. These require a slight rearrangement of the basic formula.

Finding the Retail When the Cost and Markup on Retail Are Known.

PROBLEM

Find the retail price of a table that cost $84 and is to be marked up 60 percent on retail.

SOLUTION

$$\text{Retail} = \text{Cost} + \text{Markup}$$
$$100\% = 40\% + 60\%$$
$$(\text{Cost})\ 40\% = \$84$$
$$1\% = \frac{84}{40}$$
$$1\% = \$2.10$$
$$(\text{Retail})\ 100\% = \$210.00$$

Finding the Cost When the Retail Price and Markup on Retail Are Known.

PROBLEM

Find the cost of a radio selling at $60 that is marked up 35 percent on retail.

SOLUTION

$$\text{Cost} = \text{Retail} - \text{Markup}$$
$$\text{Cost} = 100\% - 35\%$$
$$\text{Cost} = 65\%$$
$$\text{Cost} = 65\% \times \$60\ (\text{retail price})$$
$$\text{Cost} = \$39.00$$

CUMULATIVE MARKUP

As we will see later in the chapter, the buyer, although budgeted to a specific departmental markup, cannot achieve this desired profit on every item. Competition, for example, might force some of the goods to be marked up less than he or she would like. To offset this problem, the buyer can reach the goal only by marking up other items above the target figure. Under these conditions the desired markup becomes an average of many varying individual markups.

Buying is an ongoing function. The buyer is constantly visiting manufacturers and wholesalers to purchase additional goods. Because it is necessary for the buyer to meet a targeted markup figure, he or she must know the markup percentage on the goods handled to date. From this information, the buyer will know whether he or she needs high-markup, normal-markup, or low-markup goods. To determine the **cumulative markup,** the following formula is used:

$$\text{Retail price of all goods on hand} - \text{Cost of all goods on hand}$$
$$= \text{Markup on all goods on hand then}$$

$$\frac{\text{Markup on all goods on hand}}{\text{Retail price of all goods on hand}} = \text{Cumulative markup percentage}$$

PROBLEM

At the beginning of the month, a clothing buyer had goods on hand that cost $10,000 and were marked up to sell for $15,000. During the first two weeks, she bought additional goods for $5,000 that were to be sold for $10,000. What was the cumulative markup at that time?

SOLUTION

	Cost	*Retail*
Opening inventory	$10,000	$15,000
Purchases	5,000	10,000
Total goods on hand	$15,000	$25,000

$$\text{Retail} - \text{Cost} = \text{Markup}$$
$$\$25,000 - \$15,000 = \$10,000$$

then

$$\frac{\$10,000}{\$25,000} = 40\% \text{ cumulative markup}$$

Average Markup. Cumulative markup informs the buyer of the relationship between the markup on the goods already bought and the markup that has been budgeted in advance. From this information, the buyer is able to determine whether he or she is above or below goal and by what amount. The way in which the buyer uses the cumulative percentage in arriving at the target percentage is a problem of averaging.

PROBLEM

A retail dress shop plans to spend $12,000 during the month for merchandise. The purchases are to be marked up 40 percent on retail. During the first three weeks of the month, $6,000 worth of goods are bought and offered for sale at $9,000. At what price must the remaining budgeted purchases be marked to achieve an average 40 percent markup at retail?

SOLUTION

1. Find the total planned purchases at retail.

$$\text{Retail} = \text{Cost} + \text{Markup}$$
$$100\% = 60\% + 40\%$$
$$60\% = \text{cost}$$
$$60\% = \$12,000$$
$$1\% = \frac{\$12,000}{60}$$
$$1\% = \$200$$
$$100\% = \$20,000$$

2. From the total planned purchases at cost and retail, subtract the purchases already made.

	Cost	Retail	Markup
Total planned purchases	$12,000	$20,000	40%
Purchases already made	6,000	9,000	
Balance needed	$6,000	$11,000	

To average a markup of 40 percent, the remaining $6,000 of purchases must be marked up to sell for $11,000. This yields a dollar markup of $5,000 ($11,000 – $6,000) and a markup percentage of 45.45:

$$\frac{\text{Markup}}{\text{Retail}} = \frac{\$5,000}{\$11,000} = 45.45\%$$

If there were goods on hand at the beginning of the month (opening inventory), they would be taken into account by being added to the total planned purchase. In the preceding problem, assume there was $1,000 worth of goods on hand at the beginning of the month that carried a retail price of $2,000.

	Cost	Retail	Markup
Total planned purchases	$12,000	$20,000	40%
Less opening inventory	$1,000	$2,000	
Purchases already made	6,000	9,000	
Balance needed	$7,000	11,000	
	$5,000	$9,000	

Under this condition, the $5,000 balance of purchases needed would have to be ticketed at $9,000 to bring the average markup to 40%. The markup percentage on the goods to be bought would be determined as follows:

$$\frac{\text{Markup } (\$9,000 - \$5,000)}{\text{Retail}} = \frac{\$4,000}{\$9,000} = 44.44\%$$

Maintained Markup. If all merchandise were sold at the price initially marked, profits would soar dramatically. However, for a variety of reasons this is not possible. Prices are reduced because the item didn't sell as well as anticipated, because of soilage, because new merchandise is ready to be received and space is needed, because the season is nearing an end, because the item was a fad and therefore short lived, and for other similar reasons.

When these price reductions have been taken, the markup that is actually achieved is called the **maintained markup.**

PROBLEM

A sweater buyer purchased hundred pieces at $30 and marked them to sell for $60. Toward the end of the season, he was left with twenty pieces, which he reduced to $40 each. What was his maintained markup for the sweater purchase if he sold the balance for $40?

SOLUTION

1. Find the initial markup.

$$\begin{aligned}
\text{Initial markup} &= \text{Original retail} - \text{Cost} \\
&= \$6,000 - \$3,000 \\
&= \$3,000
\end{aligned}$$

2. Find the initial markup percentage.

$$\begin{aligned}
\text{Initial markup\%} &= \frac{\text{Initial markup}}{\text{Original retail}} \\
&= \frac{\$3,000}{\$6,000} \\
&= 50\%
\end{aligned}$$

3. Find the maintained markup percentage.

$$\begin{aligned}
\text{Maintained markup} &= \text{Net sales} - \text{Cost} \\
&= \$5,600* - \$3,000 \\
&= \$2,600
\end{aligned}$$

4. Maintained markup percentage = Maintained markup.

$$\begin{aligned}
\text{Net sales} &= \frac{\$2,600}{\$5,600} \\
&= 0.464 \\
&= 46\%
\end{aligned}$$

The buyer actually achieved 4 percent less than he originally hoped to obtain (50% – 46% = 4%).

*80 sweaters sold @ $60 each = $4,800

20 sweaters sold @ $40 each = $5,600

$$\overline{\hphantom{20 sweaters sold @ } \$800}$$

Markdowns

Markdowns are reductions in selling price. To understand fully the nature of markdowns, you must start with the concept that the original price is purely an estimate.

REASONS FOR MARKDOWNS

1. *Excessively high-selling prices.* When selling prices are set at a level that discourages sales, markdowns become necessary. This may be a serious error because the proper selling price may not be placed on the goods until too late in the season. This often results in lower selling prices than would have occurred had the merchandise been properly marked. This is not to be confused with intentionally high prices being set early in the season to attract customers who are willing to pay a premium to be fashion leaders. This practice frequently increases the cumulative markup.

2. *Errors in buying.* Buying errors are probably the most common reasons for markdowns. The most salable goods are valuable only if the quantities purchased are matched with an adequate estimate of consumer demand. When the amount of purchases exceeds the quantity sold, costly markdowns will result. Similarly, miscalculations in colors or sizes will force prices to be reduced. Markdowns of seasonal goods often occur when goods are ordered too close to the end of the season. Customers are simply not interested in buying winter coats in March at the regular price.

3. *Errors in selling.* Slow-moving stock must be marked down. Frequently, sales are lost owing to poor display and weak sales personnel. It is often difficult to determine whether the loss of profits due to markdowns is a result of poor buying or of inefficient sales management. The best that can be done is to constantly evaluate the sales force and weed out the weak performers.

4. *Nonerror markdowns.* Not all markdowns result from buying or selling errors. Many seasonal goods depend on the weather. Snow tires are not sold in dry winters. A warm fall can be ruinous to outerwear. Occasionally, new products appear on the market suddenly and make older goods obsolete. Stores that stocked expensive conventional tires had problems when steel-belted radials came out. Other goods may be marked down despite the best efforts of the most capable, hardworking people. There will always be shopworn merchandise and odd sizes that can be sold only at reduced prices.

Sometimes, management encourages markdowns to earn the store a reputation for always having a full assortment of merchandise in stock. Management encourages late buying, which may result in markdowns. In other words, management is willing to pay the cost of markdowns for the image of carrying a full assortment.

MARKDOWNS AS A MEANS OF EVALUATING BUYERS

Markdowns are frequently a serious problem for buyers. Too often, top management, in judging the efficiency of its buyers, gives too much weight to markdowns. A buyer should be judged by his or her overall record, of which markdowns are only a small part. Anyone can cut down on markdowns by playing safe and buying small quantities of staple goods, a policy that will lose many sales. The best way to kill incentive, ingenuity, aggressiveness, and enthusiasm in buyers is to be overly critical of markdowns.

```
DEPT: 355                                                                    PMF650000
                        PRICE MANAGEMENT FACILITY                            RUN DATE: 06-15-2003
                        PRICE CHANGE ID: 9230015000003915  PERM  MKD  IN PROCESS   TIME: 09:59:39
EFFECTIVE: 06-22-2003 00:00:00   DESCRIPTION: PC ID# 9230015000003915  MONTAGE S/S KNITS   PAGE: 1
EXPIRATION:12-31-2004 00:00:00

PARTICIPANTS: 0210

                                                          CURRENT   NEW                TOTAL   TOTAL
CLASS  NUMBER   DESCRIPTION      NUMBER     DESCRIPTION  COLOR  SIZE  PRICE   PRICE  ADJUSTMENT  UNITS  IMPACTS

3540  3201492  MONTAGE INT'L I  1939P154  BLUE PLAID POLO          24.00   11.99    0.00      27   324.27
                                1939P158  PLAID POLO              24.00   11.99    0.00      29   348.29
                                1939P166  S/S TAN GROUND          24.00   11.99    0.00      14   168.14
                                1939P168  WHT/BLUE STRIP          24.00   11.99    0.00       4    48.04
                                1939P169  OLIVE PLAID POL         24.00   11.99    0.00      21   252.21
                                1939P246  WHT WITH BLK SQ         24.00   11.99    0.00      79   948.79
                                1939P268  NAVY TRIBAL STR         24.00   11.99    0.00      59   708.59
                                1939P353  OLV SQS/DIAMOND         24.00   11.99    0.00      79   948.79
                                1939P357  NAVY BASKET WEA         24.00   11.99    0.00      80   960.80
                                1939P364  3-D FR.BLUE/MUS         24.00   11.99    0.00      88  1056.88

                                               SUBTOTAL PRICE CHANGE IMPACT:             480  5764.80

                                            GRANT TOTAL PRICE CHANGE IMPACT:             480  5764.80
```

Permanent markdown printout.

387

TIMING MARKDOWNS

Markdowns are losses in selling price. The smaller the markdown, the less the loss. Timing is a crucial factor in determining the size of the markdown. The purpose of the markdown is to attract customer attention, but this can be done only when the shopper is in a buying mood. The less interested the buyer is in the goods, the more drastic the markdown needed to attract attention. Markdowns can be minimized by being taken as early as possible in the season, when the maximum number of shoppers are interested. A small markdown taken as soon as demand for an item diminishes is more likely to move goods than a drastic slash late in the season. This will not only improve profitability but will also provide the buyer with the money to buy new styles in the middle of the season. Constantly bringing in new merchandise during the season is necessary to encourage shoppers to call again and again. Perhaps the most important factor in successfully marking down goods is the sales information available to the buyer. Sales reports must be accurate, prompt, and diligently studied to ensure proper timing.

At one time it was the traditional practice for stores, particularly exclusive specialty shops, to postpone their markdowns to the end of the season and run a semiannual, storewide markdown event at that time. This practice, accompanied by heavy advertising, attracted many customers to the store and reduced the number of bargain hunters during the height of the selling season. Such sales were usually held in January and July. Most stores today compromise their timing. Large stocks of slow-moving goods are marked down immediately. Monthly sales are used to move any goods that sell slowly plus odd sizes and shopworn stock. Macy's, for example, generally holds one-day Wednesday sales each month that move great quantities of slow sellers.

Slow-moving merchandise of a staple nature is often warehoused and carried over to the following season rather than sold at a marked-down price. The advantages are obvious, because the goods can be sold at a higher price at the beginning of the next season. The disadvantages of this practice are the cost of storage, loss of freshness, possible damage, and tying up capital. Moreover, most staple goods have a way of becoming obsolete owing to changes in style or the emergence of new fabrics or other materials.

Some stores mark down certain goods automatically. That is, after a specific period the goods may be marked down 25 percent. Several weeks later the prices are slashed again, and so forth. It is doubtful that such an inflexible policy can be widespread. It does not take into account such factors as a season that is delayed by unusual weather. The best-known automatic markdown system is in Filene's Basement flagship in Boston. Merchandise is marked down 25 percent after fourteen days, 50 percent after twenty-one days, 75 percent after twenty-eight days, and given to charity if unsold after thirty-five days. Naturally, the system is unique. It is based on expert buying of closeout merchandise, coupled with rapid merchandise turnover, to bring the store a profit.

AMOUNT OF MARKDOWN

The purpose of a markdown is to attract customers to goods that have previously been ignored. Too large a markdown reduces profits unnecessarily; too small a markdown will not produce the desired interest. The exact amount is a test of the buyer's ingenuity and must be based on the extent of customer disinterest, the amount of goods on hand, and the time left in the season. Often there is time for a second slash later in the season. Under such conditions, the initial markdown would be smaller than the later one.

Filene's Basement attracts scores of shoppers for bargain prices that are periodically reduced.

MARKDOWN CALCULATIONS

Buyers are vitally interested in their overall markup percentage. Because this amount is affected by markdowns, the buyer must be able to calculate the markdown percentage on the sales of reduced merchandise.

PROBLEM

A furniture buyer ran a sale on kitchen furniture. The goods had an original retail price of $10,000 and were reduced for the event by 15 percent. All the goods were sold. Calculate the markdown percentage based on sales.

SOLUTION

1. Calculate the dollar markdown.

Original retail × Reduction percentage = Dollar markdown
$10,000 × 15% = $1,500

2. Calculate the amount of the sales.

$$\text{Original retail} - \text{Dollar markdown} = \text{Sales (new retail)}$$
$$\$10,000 - \$1,500 = \$8,500$$

3. Calculate the markdown percentage based on sales.

$$\text{Markdown\%} = \frac{\text{Dollar markdown}}{\text{Amount sold}}$$

$$= \frac{\$1,500}{\$8,500}$$

$$= 17.6\%$$

Stock Turnover

Stock turnover, or **merchandise inventory turnover,** is a ratio that indicates the number of times per period that the stock of goods has been sold and replaced by fresh merchandise. This information is widely used by management to check the efficiency of a department and by a buyer to find weak spots within a department. Good turnover generally indicates good management because it measures the speed with which goods pass from the store to customers.

CALCULATING TURNOVER

The formula for calculating turnover for a period is:

$$\frac{\text{Sales}}{\text{Average inventory at selling price}} = \text{Turnover}$$

Turnover can be calculated for a week, a month, a season, or a year. Sales, of course, means the sales for the period, and the inventory used is the average inventory at retail for the period. The average inventory for a month can be calculated by adding the beginning- and end-of-month inventories and dividing by two. If the turnover for longer periods is to be calculated, inventories at the end of each month are added, and the average is determined by dividing the total by the number of inventories totaled. When weekly inventory figures are available, weekly turnover may be computed.

PROBLEM

From the following information, find the turnover for the six-month period.

		Sales	Inventory at Retail
July	1		$15,000
July	31	$10,000	22,000
August	31	8,000	18,000
September	30	12,000	25,000
October	31	20,000	40,000
November	30	15,000	30,000
December	31	35,000	60,000
		$100,000	$210,000

SOLUTION

1. Find the average inventory.

$$\$210,000 \div 7 = \$30,000$$

2. Find the turnover.

$$\frac{\text{Sales}}{\text{Average inventory}} = \text{Turnover}$$

$$\frac{\$100,000}{30,000} = 3.33 \text{ stock turnover}$$

ADVANTAGES OF GOOD TURNOVER

Generally, the higher the turnover the better and more quickly goods are sold. A good turnover ensures the constant arrival of new goods in the department. This improves traffic, store reputation, and the morale of the sales personnel. Goods that move quickly are rarely marked down. They remain fresh, and the amount of handling is reduced. Moreover, inventory that moves out quickly is easily financed. In short, all other things being equal, profits follow turnover.

Buyers should compare their turnover with both the published records of similar operations (see Table 17.1) and their own records from prior periods. In addition, by breaking down their operation by price line or groups of similar items, the weaknesses of certain areas can be identified and dealt with.

A major problem with the calculation of turnover is that the necessary inventory figures are not always available. The increasing use of computers for inventory control has overcome this problem for the larger stores.

SHORTCOMINGS OF TURNOVER INFORMATION

While turnover offers an excellent yardstick for efficiency, it is of little use alone. One problem is that it does not indicate profits. A high turnover can be achieved by a poorly

TABLE 17.1 Turnover by Merchandise Classification

Type of Retail Firm	Approximate Number of Stock Turnovers Yearly
Gasoline service stations	21
Grocery and meat stores	18
Confectionery stores	12
Budget millinery	11
Liquor stores	6
Paint and wallpaper stores	5
Drugstores	4
Infants' and children's wear	4
Furniture stores	3
Family clothing stores	2
Retail shoe stores	2

run operation. For example, by keeping the inventory low, a high turnover can be achieved despite the fact that customers cannot find the goods they are after. Turnover can also be increased by insufficient markup. Bargain prices will increase sales, but only at the expense of profits.

FACTORS THAT AFFECT PRICING POLICIES

Buyers for both large and small stores are forced to adhere to overall markup percentage policies. The buyer for a large store gets the information from management. The small store operator, though less rigid, needs a certain minimum markup percentage to survive. The exact percentage of markup is influenced by many factors.

Store Image

Some high-prestige stores, such as Bergdorf Goodman, Neiman Marcus, Fendi, and Saks Fifth Avenue, have been able to implant in their customers' minds an image that makes their clientele willing to pay a premium for goods bearing a highly prized label. Generally, such an image carries with it a higher than ordinary cost of doing business. Such prestige is the result of expensive fixtures, highly paid personnel, and extensive service. Extra markup is necessary to cover the extra cost of the image.

Services

Stores that offer such services as free garment alterations, individualized sales help, decorator advice, and the like must increase their markup to cover these additional costs. It is incorrect to regard price as the only factor influencing customers. Such stores as Saks Fifth Avenue, Neiman Marcus, and Nordstrom run highly successful operations based on a clientele that knowingly pays a premium in return for the additional services these stores offer.

Convenience

Small local retailers are able to get higher prices than their giant competitors by cutting down on customer travel time or by remaining open for longer hours.

Competition

Perhaps the most important of the factors affecting price is the pressure of competition. There is a limit to the amount of premium customers are willing to pay for extra service, image, or convenience. Each retailer must find its own price niche,

Stores such as Fendi have images that often warrant premium prices.
(Courtesy of Ellen Diamond.)

which carefully balances the operation against those of competitors by taking all influences on price into account.

Private Labels

One way of getting around the problem of competitor pricing is by carrying merchandise that is unique and cannot be compared. Private labeling allows a store to stock goods that none of its competitors can carry. For example, the Charter Club label is carried exclusively by Macy's and cannot be comparison-shopped. Private labels are available to smaller retailers through resident buying offices. Many small retail liquor stores carry goods bearing their own label. Because private brands require very little selling and no promotional expenses for the manufacturer, the retailer can often buy them cheaply and attach a higher-than-normal markup to them.

Merchandise Characteristics

Certain goods have characteristics that dictate a markup policy. High-risk goods, for example, must be marked up sufficiently to cover markdowns and other losses. Fashion goods, perishables, and seasonal goods fall into this category.

Other goods have high overhead costs associated with them. Precious jewelry needs an expensive vault, bulky merchandise like furniture needs expensive floor space, and expensive menswear requires highly paid salespeople. Additional markup is necessary to cover the additional overhead required by such merchandise.

Promotional Costs

Advertising and sales promotion are extremely expensive, and the markup must be sufficient to cover such costs. This does not mean that heavily advertised merchandise is more expensive. Frequently, big advertisers depend on quick turnover to keep prices low. However, in setting markups, promotional costs must be kept in mind.

Leaders and Loss Leaders

One way to entice traffic into a store is to offer a specific item of merchandise or a whole department at a selling price that is at, below, or near cost. Supermarkets regularly feature different items, each week, at or below cost.

Discount Operations

A discount operation is one that competes exclusively on a price basis. It offers minimal services, bare fixtures, and no prestigious label. It seeks a rapid turnover at lower than usual markup. The buyer for such a store searches for quantity discounts on name brands as well as lesser-known merchandise with which to sweeten the overall markup by getting normal or better-than-normal markups on these not easily compared items.

PRICE POINTS

No store can be large enough to carry an adequate stock of merchandise in every **price range.** To attempt such a "general store" approach would force so limited an assortment in each range that a customer would be offered very little to choose from. A woman shopping for a dress has a good idea of the amount she wishes to spend. Unquestionably, she will select a store with a wide assortment of dresses in that range. By definition, a **price point** is a situation in which a narrow range is used in place of a variety of prices.

Price Point Selection

In general, the image of the store sets the overall tone of price lining. That is, a high-image, prestigious store will not carry low-priced apparel. Naturally, it will offer high-priced merchandise. However, within the term *high-priced* there are many price points available.

For example, a "high-priced" man's suit can run anywhere from $1,250 to $2,500. Establishing the proper price line for a particular store and the number of price lines to be carried requires particular care and constant control. These decisions depend on customer demand, and experience has shown that relatively few price lines are needed. Because customer demand varies, experimentation for price line changes must be continual.

An important consideration in the selection of price lines is that they should be far enough apart to make the difference in the quality of the goods easily apparent to the customer and the salesperson.

Advantages of Price Points

Price points, or price lines as they are sometimes referred to, are widely used because of the advantages they provide.

INCREASED SALES

Concentrating the merchandise at a price that has been determined as most appropriate to customer demand requires elimination of the slower-moving goods. This concentration provides the shopper with a wide variety of goods at prices he or she is willing to pay. The elimination of slow-moving goods increases sales and turnover while decreasing markdowns.

EASIER SELECTION

It is easier for a customer to choose between two items when their prices are similar. The shopper does not have to decide between a $50 pair of shoes and a $175 pair. If they are both marked in the range of $50 to $75, the decision may be based only on style and quality.

BETTER CONTROL

The effect of price pointing is to decrease the number of items carried while increasing the depth of backup stock for each item. This results in fewer out-of-stock situations. In addition, fewer items require less time for a salesperson to find a particular piece and make it easier to determine the depth and condition of the stock. The decrease in assortment that results from price lining increases the salesperson's familiarity with the stock and reduces storage space.

REDUCED MARKING COSTS

When there are a few prices that can be quickly learned by the personnel, savings may be affected in such overhead areas as marking, paperwork on returns, and remarking of returned goods.

BETTER PURCHASING

As the number of items becomes more concentrated, the number of possible resources supplying the store dwindles as well. The buyer, then, can be more specialized and become familiar with more vendors for the specific goods. Buying a wide assortment of goods limits buying visits to a relatively few vendors in each category. Price pointing

enables the buyer to concentrate on a few vendors. This increases the retailer's importance to them and enables the buyer to get preferential treatment in such areas as delivery date, price, and acceptance of merchandise returned to the vendor.

IMPROVED PROMOTION

Price pointers are able to focus their advertising and visual merchandising. Rather than being forced to spread out their promotional budget so that every area is touched, they concentrate on the merchandise their experience has shown to be in greatest demand. This leads to improved promotional efficiency.

Language of the Trade

> average markup
> cumulative markup
> departmental pricing
> individual initial markup
> leader merchandise
> loss leaders
> maintained markup
> markdown
> markup
> merchandise inventory (stock) turnover
> price points
> price range

Summary of Key Points

1. Profitability depends on markup and pricing. Markup is budgeted in advance by the merchandising manager and serves as a means of judging a buyer's efforts.
2. The more important formulas involving markup are:

$$\text{Markup} = \text{Retail} - \text{Cost}$$
$$\text{Markup}\% = \frac{\text{Markup}}{\text{Retail price}}$$
$$\text{Markup on cost} = \frac{\text{Markup}}{\text{Cost}}$$

3. Cumulative markup is the markup on all the goods handled to date plus merchandise that is about to be purchased.
4. Average markup is the markup on all the goods handled during a period.
5. Markdowns are reductions in selling price. Markdowns may be due to an excessively high selling price, errors in buying, errors in selling, weather, obsolescence, and the like.
6. Buyers are frequently judged by the size of the markdowns; this can be a serious error on the part of top management.
7. The timing of markdown is crucial. The earlier the markdown, the smaller the price reduction.

8. The size of the markdown requires good judgment. It must be large enough to attract customers but not so large that profits are reduced unnecessarily.
9. The formula for markdown percentage is:

$$\frac{\text{Dollar markdown}}{\text{Amount sold}} = \text{Markdown percentage}$$

10. Stock turnover is a ratio that indicates the number of times per period that the stock of goods has been sold and replaced by fresh merchandise. It is a means of checking the efficiency of the buyer. The formula is:

$$\frac{\text{Sales}}{\text{Average inventory (at retail)}} = \text{Stock turnover}$$

11. A good turnover rate ensures the constant arrival of new goods and improves traffic, store reputation, and morale. However, there are shortcomings to turnover information. For example, it does not indicate profitability, and it can be achieved by carrying an inadequate inventory.
12. Some factors that affect pricing policies are store image, services, conveniences, competition, private labels, characteristics of the merchandise, promotional costs, leaders and loss leaders, and discount operations.
13. A price point, or price line, is a situation in which a single price or range is used in place of a variety of prices. In general, the price line selected depends on the image of the store. Price lining has the following advantages: increased sales by concentrating on the goods customers desire, easier selection by customers, better control, better buying, reduced marking costs, and improved promotion.

Review Questions

1. Why don't department stores allow each buyer to decide on the overall markup for a department?
2. A buyer is given an overall markup that he or she has to achieve. How does this affect the pricing of individual items?
3. Compare the pricing policy set by the owner of a small retail store with that set by the executive management of a department store.
4. Calculate the markup on retail and the markup percentage on an item costing $7 and selling for $10.
5. Do any retailers base their markup calculations on cost? Why? Give examples.
6. Find the retail price of a sweater that cost $42 and is to be marked up 60 percent on retail.
7. Find the cost of a lamp selling at $120 that is marked up 35 percent on retail.
8. Define *cumulative markup*. Give the formula for its calculation.
9. Define *average markup*. How is it used?
10. Define *markdowns*. Give the formula for the calculation of the markdown percentage based on sales.
11. Discuss and give examples of markdowns that result from buying errors.
12. Give examples of markdowns that are caused by selling errors.
13. Do all markdowns result from errors? Explain.
14. Discuss the importance of the proper timing of markdowns.
15. What factors must be taken into account in determining the amount of the markdown?

16. Goods with an original retail price of $5,000 were marked down 30 percent; all the goods were sold. Calculate the markdown percentage based on sales.
17. Define *stock turnover.* Give the formula for its calculation.
18. What are the advantages of a good rate of turnover?
19. Can turnover alone be used to judge the efficiency of an operation? Explain.
20. Discuss briefly six factors that affect pricing policies.
21. What are price points? What advantages do they offer?
22. How should price points be selected?

CASE PROBLEM 1

John Douglas operates a small, moderately priced women's wear shop. The store has been open for two years and has barely managed to break even, after paying Mr. Douglas a small salary.

The proprietor spent ten years as a salesperson in a large, very successful store carrying the same type of merchandise he carries in his own business. From his experience he understands the store operation very well. In addition, he has excellent taste, which he is able to match to the requirements of his customers. As a result, he rarely buys the wrong goods. However, his experience is limited to selling and customer relations. He knows very little about buying procedures or proper planning.

His accountant has informed him that he needs a 40 percent markup on sales to cover his expenses and leave him a reasonable profit. For the season beginning September 25 and ending December 25, he planned to carry goods costing $60,000. On September 25, he had $10,000 worth of goods with a retail value of $15,000. By December 1, the goods he had purchased cost $45,000, to retail at $65,000.

Questions

1. At what percentage must the balance of his purchases be marked up to achieve his desired markup?
2. Comment on Mr. Douglas's planning.

CASE PROBLEM 2

You are the merchandising manager of the home furnishings division of a large urban department store. A year ago, the floor coverings buyer resigned. After many interviews with applicants from both within and outside the store, you decide to hire Frank Thomas, one of the assistant buyers for the floor coverings department. Mr. Thomas is a young man who graduated from the store's executive training program five years ago. He has much less experience than some of the other applicants. However, you were so impressed with his aggressiveness, intelligence, and regard in the eyes of his coworkers that you decided to go with him. Naturally, since you are responsible for this choice you are concerned about the results of his first full year's operation.

The year has just ended and the only information available is the data necessary to compute the stock turnover.

		Sales	Inventory at Retail
January	1	—	$ 100,000
January	31	$35,000	100,000
February	28	45,000	220,000
March	31	55,000	200,000
April	30	60,000	180,000
May	31	50,000	140,000
June	30	45,000	130,000
July	31	40,000	100,000
August	31	40,000	100,000
September	30	45,000	200,000
October	31	60,000	230,000
November	30	85,000	150,000
December	31	40,000	100,000

During the last year the previous buyer was on the job, the stock turnover was 3.2, and annual sales were $510,000.

Questions

1. Calculate the stock turnover.
2. What conclusions can you draw from the turnover?
3. What other information will you need to make a definite decision on the new buyer's ability?

CHAPTER 18

The Development of Private-Label Programs

On completion of this chapter, the student should be able to:

- ■ Enumerate the many reasons for the widespread use of manufacturers' and designers' labels by retailers.

- ■ Explain why more and more retailers are increasing their private-label assortments.

- ■ Discuss the ever-growing concept often referred to as the store is the brand.

- ■ Describe the buyer's role in many retail organizations in the development of private-label merchandise.

- ■ Cite the different approaches retailers use to acquire private-label merchandise for their inventories.

- ■ Explain how retailers introduce their private-label programs to their customers.

- ■ Discuss some of the labeling considerations merchants use when determining the names to use on their own brands.

The development and introduction of private labels and brands is constantly on the increase. What was once a small part of a retailer's merchandise assortment is fast becoming a significant factor for most retail operations. Not too long ago, only a few major retailers such as Sears embraced the private-branding method of retailing. During the past thirty years, others have joined the bandwagon, with many today engaging exclusively in private labels and brands for their companies. Several chains, including The Gap, Banana Republic, Benetton, and Eddie Bauer, have taken this type of merchandising to the limit by focusing on the store is the brand concept, in which all of their offerings are private-label merchandise.

While this concept is gaining popularity with both merchants and consumers, it is not the only way in which retailers are modeling their inventories. Many still rely on the marquee labels and brands of well-known manufacturers and designers. Some stay exclusively with these offerings, whereas others provide a mix of these labels with those that are privately merchandised by retailers. It is up to each merchant to determine which approach is best for the company. For those who opt for a mix of manufacturer and

private labels, it is necessary to determine the proportion of each that best suits the needs of the targeted shoppers.

Today's retailing arena is more complicated than ever before. Not only are catalogs and Internet Web sites competing with the brick-and-mortar operations, but the traditionalists are always competing for the consumer's dollar with the off-price merchants. Most of these operations are in the business of producing private-label goods for their customers and are constantly trying to develop products of their own to outdistance the competition.

Many questions must be resolved in playing the private-label game. How should the merchandise be acquired? Should production be at the hands of the retailer? Should the label bear the store's name, a catchy-sounding brand, or the signature of a recognizable celebrity? In what way can the new product line be promoted? Should the inventory be 100 percent private label, or should it be just one part of the company's overall merchandise mix?

Most of the decision making surrounding private-label merchandise comes from top management. They are the ones who determine the company's goals and decide which approach is best to reach that goal. However, in many retail operations, buyers are called on to play some roles in private-label merchandising. In some operations, they are the ones who help develop the specific private-label products and determine how they best fit in the company's overall assortment.

Attention in this chapter will focus on the comparisons between manufacturers' and private labels, as well as all of the problems addressed in the merchandising of a company's own line.

Banana Republic is a store that merchandises itself as the store is the brand.
(Courtesy of Ellen Diamond.)

MANUFACTURERS' BRANDS AND LABELS

Throughout retailing history, merchants and consumers alike have chosen manufacturers and designers with recognizable names. The stocking of such items generally guaranteed a steady stream of business for the merchant. Shoppers knew exactly what to expect from such purchases and generally made their selections without the fear of making a mistake. The well-known brand or label doesn't come immediately with a company's entry into the marketplace but only after significant promotional campaigns and satisfaction from shoppers who have been happy with their selections.

There are numerous reasons for retailers to heavily stock these brands and labels, including:

1. *Customer demand.* Successful producers' brands and labels have an established consumer following and will attract shoppers to the stores that carry them. These products not only account for significant business but also help increase the store's traffic. Having more people in the store makes it likely that other merchandise will be seen and presumably purchased.

2. *Promotional costs.* To make a brand or label better known, manufacturers spend significant sums in their promotion. The promotion helps presell the merchandise to the public even before they enter the store or look through the many catalogs that come into their homes. With this attention to promotion, merchants are able to spend less on the advertising of these brands and labels, saving them substantial sums for the promotion of other items in their inventories such as private-label goods. In addition to the vendor-sponsored promotions, many producers provide advertising allowances to the retailers by way of **cooperative advertising.** In this arrangement, the manufacturer often pays as much as 50 percent of the advertising costs incurred by the retailer for the specific brand or label. Retailers benefit by literally cutting in half their promotional expenditures for such merchandise.

3. *Quicker sales.* Since the manufacturers' brands and labels are usually well known, the shopper often purchases them more quickly than merchandise that is unfamiliar. This becomes cost-effective since less time is needed by sales associates to motivate shoppers to purchase. The benefits of these products need little or no explanation because there is generally previous customer experience with such goods.

4. *Inventory replenishment.* The manufacturers' brands and label merchandise generally sell in large quantities, so the producers are likely to stock these products in their own inventories. This enables the retailer to reorder best sellers without having to wait for long periods for additional merchandise to be produced. In the case of unbranded goods, manufacturers are often reluctant to produce more than what was initially ordered by the merchants. These lapses in inventories could lead to long replenishment delays, possibly causing the retailer to lose sales.

5. *Quality control.* To safeguard and protect the brand that has been established, the producer takes no chances on the quality of the goods that are being produced. By maintaining the highest production standards, there is generally a decrease in the number of complaints and returns of such items. Lesser-known products and private-label merchandise, on the other hand, are often less carefully produced, sometimes resulting in numerous customer complaints and returns.

6. *Prestige.* By carrying well-known brands and labels, a retailer's prestige is likely to improve. Merchants often feature these collections in special sections or departments. Typically brands like Liz Claiborne, Ralph Lauren, DKNY, and Calvin Klein are spelled out in bold letters to announce their presence to the shoppers. Not only does this signage tell shoppers where the merchandise can be found, but it also signals that the store carries prestigious merchandise. While many of today's consumers are very interested in value, many are also motivated to buy merchandise that has a prestigious appeal. These **marquee** brands and **labels** often help bolster the retailer's prestige and image.

7. *Price maintenance.* If retailers have little fear about the competition's *price cutting,* they can generally reap greater profits. Although price maintenance is no longer a guarantee in retailing because of the need for merchants to compete with the off-price operations and to quickly sell merchandise during slow times, there are some brands that control the prices in the stores in which they sell. Ralph Lauren, for example, with its Lauren collection, carefully controls the pricing of its merchandise. Not only must the merchants adhere to the preestablished selling prices, but they also must "take markdowns" only at the times determined by the vendor and in the amounts that it approves. Such agreements enable the merchants to operate in an environment that prevents unfair price cutting by the competition. However, in the case of many branded lines such price maintenance is not typical—it is the exception rather than the rule.

It is safe to say that the vast majority of retailers continue to carry "famous" brands or labels in their inventories. They are often the core or nucleus of their operations and generally provide positive profit margins. Of course, with the increased boom in private labeling, merchants must carefully decide what proportions of each product classification to carry.

PRIVATE BRANDS AND LABELS

As was suggested earlier in the chapter, the private-brand concept is not new to retailing. Sears's brands such as Coldspot, Kenmore, and Craftsman have been successfully sold exclusively by that company for many decades. The products are produced by reputable manufacturers who also make similar merchandise with other nationally known names. By using these manufacturers for their own brands, Sears guarantees a well-made product for its customers.

However, even with the vast attention to **private brands** and **labels,** stores such as Sears are incorporating more and more manufacturer brands into their product mixes. From their research, they have determined that their customers want an assortment of each classification from which to choose. It proves that each retail operation hasn't a standard formula for success to follow but must decide which approach is best for the company.

In any case, before a retail organization makes a decision to alter its merchandising philosophy and embark on a private-label concept, it is important to use a variety of research tools to evaluate its potential. Customer reactions to private brands and labels must be initially assessed before any other research is used. Unlike retailing's past merchandising practices, in which the buyers made the decisions without consumer consideration, today's shopper is all important in terms of merchandise selection. The "consumer is king" philosophy is alive and well and should be carefully adhered to. When the consumer has shown a liking for a certain merchandising philosophy, sales will be more easily accomplished.

Determining Customer Attitudes

Many of the larger retail empires regularly take consumer surveys to assess their attitudes toward **manufacturers' brands** and **labels.** The results of these surveys have shown, by and large, that customers are showing less reliance on manufacturers' brands and labels and relying more on the store's reputation for their merchandise selection. That is, instead of seeking a particular brand to purchase, customers often opt for a visit to a particular store, catalog, or Web site from which they have received satisfaction, to meet their shopping needs.

Often, retailers are remiss in conducting research studies and tend to evaluate surveys that have been taken by outside sources. One of the better-known groups that regularly engages in important research is the Newspaper Advertising Bureau (NAB). In a study concerning consumer purchasing, it uncovered a significant finding for merchants who are uncertain about private-label merchandise. Using the telephone for its research, and with 2,705 men and women responding from a total of 4,000 calls, the findings were more significant in terms of "store reliability" than most retailers would have guessed. Table 18.1 clearly shows that 58 percent of the market makes purchasing decisions on retailer reputation and reliability rather than a specific manufacturer's brand. This barometer gives buyers a positive signal to develop a private-label or brand program or, if they are already involved in one, to consider an adjustment in the merchandising mix to coincide with the figures revealed in the survey. Naturally, caution should be exercised to determine if the individual store's customers are those reflected in the NAB survey. Only a thoroughly researched investigation of its own customers, taken either by an in-house staff or outside research organization, would give the retailer the proper information.

Meeting the Competitive Challenge

Today's retail environment is filled with a great deal of competition that makes the merchant's role for success more difficult to achieve than ever before. Traditional retailers such as department and specialty stores often have the same manufacturers' brands in their inventories and sometimes engage in price battles to achieve an edge with the consumer. Some of the traditionalists reduce the retail prices of their merchandise a few weeks after its arrival to make room for new goods, causing anguish for merchants who do not choose to use early markdowns.

TABLE 18.1 Newspaper Advertising Bureau Survey—Customers' Attitudes about Brands and Retailer Image

	Men	Women	Composite
Branded-label merchandise gives me better quality and value	45%	35%	39%
If the retailer is reliable, it makes no difference whose brand is on the merchandise	53	62	58
No answer	2	3	3
	100%	100%	100%

Many discounters such as Target and Wal-Mart generally sell their merchandise at lower prices than other retailers. Those who do not play the discounting game often find price resistance from their customers.

The off-price merchant's presence is deeply affecting the traditional retailers by featuring the same **marquee labels** at lower prices. Although the acquisitions of these well-known lines are purchased later in the season, they nonetheless are on the store's shelves at the same time as the traditional retailer but at lower prices.

With the competition from the traditionalists who take early markdowns, the discounters who take smaller markups, and the off-pricers who purchase for less and sell for less, the only way many traditional retailers are dealing with the problem is with private-label goods. The exclusivity of this merchandise eliminates the worries that are brought about by merchants who compete via lower pricing. When the merchandise is exclusive to a company, there is no way in which prices may be compared by shoppers.

To achieve this merchandising edge, more and more merchants are developing their own private-label programs.

Determining the Breadth and Depth of Private-Label Involvement

Once the decision has been made to enter the arena of private labeling, the retailer must determine how broad the offerings should be and the extent to which they will become part of the merchandising mix. Most retailers designate a proportion of their inventories for private-label goods, while others have taken the route of a relatively new form of retailing known as the store is the brand.

PROPORTIONAL PRIVATE-LABEL INVENTORIES

Most department stores and some chain organizations include private-label merchandise as part of their offerings. The extent of this exclusive merchandise differs from company to company. Macy's, for example, is heavily involved in private-label products. It features a range of merchandise classifications in men's, women's, and children's apparel, home fashions, and wearable accessories. Labels like Charter Club and Alfani, each exclusive to the organization, are merchandised in extremely large numbers. So successful have some labels been that the company has established separate stores for Charter Club lines.

Other department stores that trade heavily in private-label goods are Bloomingdale's, Belk, and Dillard's.

Private-label merchandise is not used exclusively by department stores and traditional chain organizations. Many off-price ventures are involved in incorporating their own brands with those of well-known manufacturers and designers. Merchants such as Stein Mart, a coast-to-coast chain operation that specializes in off-price apparel, accessories, and home fashions, feature a host of their own labels. By using this format, they are able to attract shoppers to their stores by offering marquee labels while also motivating shoppers to buy some of their own products.

THE STORE IS THE BRAND

The store is the brand concept eliminates the need to determine proportionality between nationally branded merchandise and private label because the entire inventory

Macy's is heavily involved in private-label merchandise.
(Courtesy of Ellen Diamond.)

is private label. This philosophy centers on the importance of making the company's name and the label it carries one and the same. Shoppers immediately know that only one brand is available. The Gap is the world's leader in the store is the brand concept. In its regular stores, Gap Kids and Baby Gap stores, the Banana Republic division, and Old Navy, only labels that are identified with those stores' names are carried.

With the success of The Gap, other chains are following in their tracks. Eddie Bauer, for example, merchandises a host of wearable products as well as fashions for the home exclusively under its own label.

These operations require a great deal of time spent in product development. Specialists, as well as buyers, scan the globe looking for items that will fit their programs and contract with manufacturers for their production. Often the specialists make adjustments to the products they find to make them more suitable for their clienteles. Sometimes they design items and have them made for their inventories.

Whatever the case, the store is the brand concept requires more attention to product development than any other form of retailing.

Enjoying the Advantages of the Private Brand and Label

Careful analysis of the information presented thus far in this chapter indicates that the merchant who either incorporates private labels and brands into the company's merchandising mix, or uses this type of product exclusively in the operation, enjoys

Today's Man is an off-price retailer that mixes private labels with famous brands.
(Courtesy of Ellen Diamond.)

The Gap is the world's leading the store is the brand merchant.
(Courtesy of Ellen Diamond.)

specific advantages. Some of these have already been briefly addressed, but their importance necessitates further underscoring, while others will be offered for the first time. The advantages include:

1. The customer base that is built up by the private label or brand belongs to the store rather than to the manufacturer or designer. When satisfied with the merchandise, customers return again and again, since this is the only place the goods are available. Manufacturers' brands are available in numerous places and do not necessarily bring a customer back to a particular store for their purchase.

2. Purchasing requirements often established by vendors may be problematical for the retailer. These might include specific ways the seller might want the goods to be shown on the selling floor or conditions that concern advertising. Those in the private-label business need not be concerned with such matters.

3. Since the merchandise is exclusively that of one retailer, price cutting by the competition or the taking of early markdowns is not possible.

4. The exclusivity factor makes it impossible for shoppers to comparison shop to check out other stores' prices for identical merchandise.

5. Although manufacturers' brands are often tailored to a broad audience, those that are made for the retailer's exclusive use can be designed specifically to meet that company's needs. All too often the national brand doesn't meet the needs of every merchant.

6. Profits are generally higher with this type of merchandise since the middleman's profits are avoided. By eliminating the vendor's markup, the retailer is able to turn a better profit and offer merchandise that is more competitively priced in comparison with similar goods.

7. Private-label merchandise that is acquired from outside manufacturers may cost less than these companies' regular merchandise because there is no promotional expenditure built into the price. Nationally branded merchandise prices are based on a number of factors, one of which is the cost to advertise it. Because the brand is not being advertised, this dollar amount is taken out of the product's cost.

8. Vendor policies that involve merchandise returns, the setting of retail prices, and the timing of markdowns are avoided with private-label goods. There is no control by an outside organization.

PROGRAM DEVELOPMENT

Depending on whether a store decides to embark on a private-label or private-brand concept to use as a part of its present merchandising mix or to expand on its current program, it has different routes to take to achieve its goal. Sometimes situations occur that prompt a retailer to alter its merchandising philosophy by taking a radical step. A case in point is The Gap. Not long ago, The Gap was deeply involved in selling Levi Strauss jeans. While it was a successful venture for many years, Levi Strauss began selling to other outlets that began cutting prices. This price competition seriously affected The Gap's **bottom line.** Instead of staying with the Levi products, The Gap changed its operation to one that exclusively featured its own label merchandise. The decision was a profitable one: The Gap has become one of the more successful private-label merchants in retailing.

The decision concerning the best route to take in private labeling is not that of the buyers', but they certainly have considerable input into this managerial determination because of their expertise with specific lines of merchandise.

The three major methods of private-label merchandise acquisition are direct outside sources, resident buying office acquisitions, or company-owned production.

Direct Purchasing

When retailers opt for the direct purchasing route, they can buy from two distinct types of vendor groups. One group consists of nationally known vendors who produce goods under their own labels as well as manufacture specific items for retailers' exclusive use. The other group of vendors are private-label manufacturers who deal exclusively in items produced only for merchants with their own labels. Each group has certain advantages that need to be considered before decisions are made.

PURCHASING FROM NATIONAL MANUFACTURERS

Buying directly from recognized manufacturers ensures that the goods will have fine quality. Since these producers must maintain specific standards for the goods they produce, the private-label assortments will feature the same quality. One of the earliest leaders in arranging for its private brands to be produced by national manufacturers is Sears. The Coldspot and Kenmore brands, as well as others, are virtually the same as the nationally branded entries except for minor design changes. The success of these two private Sears brands indicates that this is a profitable approach for some retailers.

In menswear, tailored clothing is a very important product classification that national manufacturers produce for private-label retail collections. The same company that produces such well-known labels as Burberry and Halston in the United States also manufactures a host of private-label suits, sportscoats, and pants for merchants all across America. Many of these stores feature the well-known brands alongside their own private-label goods.

Acquisitions from national manufacturers are available in women's clothing and accessories, menswear, children's wear, home furnishings, and countless food items that have been selling on grocers' shelves for decades.

PURCHASING FROM PRIVATE-LABEL MANUFACTURERS

In every type of product classification, there are manufacturers who are in the business of providing merchandise exclusively for retailers selling private labels and brands. In this country and abroad, there are manufacturing consultants who bring producers and sellers together for the express purpose of private-label merchandising. These are not representatives of nationally branded good, but are agents who deal exclusively with private-label vendors.

The goods are developed by the retailer's merchandising team, which includes general merchandise managers, divisional merchandise managers, buyers, and product developers. Their ideas are brought directly to the private-label manufacturers with whom they work or to other contractors who have facilities to make the goods.

One of the major manufacturing consultants is Mitchell Paige, which provides private-label products for large department stores and chains throughout the United

States. The company's service begins with the design of the goods according to the retailer's specifications, coupled with its own expertise, and ends with delivery of the finished products to the merchant. Mitchell Paige provides designs for men's, women's, and children's apparel, as well as a host of fashion accessories.

Resident Buying Office Acquisitions

An alternative to dealing directly with manufacturers is to use the products that have been developed by resident buying offices (RBOs) for the exclusive use of their clients. RBOs such as The Doneger Group feature collections that are made exclusively for their customers. The company's clients are able to purchase products that bear labels designed by Doneger and are unavailable anywhere else but at stores affiliated with Doneger. Since the RBO makes certain that its member stores are not competitive with one another in terms of location, this type of private-label acquisition guarantees exclusivity within a certain radius without the efforts associated with product development. Although there isn't *total* exclusivity, it promises that merchandise will be distributed only to noncompeting clients of the RBO.

Many smaller retailers, who are unable to establish their own programs, opt for this alternative. Without such offerings, these smaller merchants are unable to enter the very profitable arena of private labeling.

Company-Owned Production

Many of the major retailers choose to develop their own styles and produce them in their own factories. Companies like The Gap and The Limited are examples of organizations that use company-owned production.

The advantages of such private-label endeavors are many. First and foremost is the cost of the merchandise. By eliminating middlemen such as outside manufacturers and contractors, the costs are considerably lower. These savings enable the retailers to bring competitively priced merchandise to their customers and turn greater profits.

Another advantage is that the factories work strictly for the retailer and are able to tailor the products to their specific needs. This exclusive arrangement also enables the products to reach the selling floors more quickly, since orders from other companies do not take any production time.

Quality control is yet another advantage because the retailer is able to carefully watch the production and make certain that all needs are met.

Of course, there are some disadvantages to this type of private-label acquisition. The money needed for a production facility is considerable. Companies that do not have sufficient capital will sometimes drain funds from their retail divisions to fund these ventures. This could easily affect the running of the operation and cause considerable financial harm. Only companies with significant capital should consider their own production endeavors.

Another disadvantage is that retailing and manufacturing are two different industries. Each requires specific expertise in order to carry out a successful operation.

Doneger private labels.
(Courtesy of The Doneger Group.)

Sometimes a highly successful merchant doesn't foresee the pitfalls associated with manufacturing and has less than desirable results when trying to run these two different types of operations. When the manufacturing route is taken, the merchant must rely on production experts to carry out the manufacturing programs.

THE BUYER'S ROLE IN PRODUCT DEVELOPMENT

Traditionally, retail buyers make their purchases from vendors all around the world who produce merchandise that best suits the needs of their customers. As you learned earlier in this book, they are the decision makers in terms of product acquisition and must cut the best deal for their company.

In today's retailing arena, the buyer's duties and responsibilities have changed in some organizations. Specifically, those who incorporate private labels and brands into their model stocks generally call on their buyers to participate in the development and acquisition of such goods. Product development implies that designing is part of the task. Although buyers are not designers and are not expected to create original styles and models, because of their merchandise expertise, they are extremely valuable in the product-development process.

With buyers acting as the intermediaries between the vendors and the clienteles they serve, they come to know exactly what the market has to offer and what customer needs require satisfaction. Through regular scanning of manufacturers' and designers' lines, they come to understand what is being offered in terms of prices, styles, fabrications, colors, and so forth. Through this continuous inspection, they are able to ascertain which items should meet with their customers' approval and which details might be incorporated into their company's own private-label collections.

design partnership™

You speak, we listen. And the result is Design Partnership—work clothes that reflect your

point of view. Because they're shaped by your opinions, executed to your standards. How?

Each garment comes with a response tag so you can tell us what you think. And you have.

In fact, we've learned quite a bit over the past two seasons. Your preferences in styles and

fabrics. Your insistence on quality. And as you'll see in our third collection, we hear you.

Just who is the "we" you ask? Three working women bringing know-how in fashion design,

retailing and real-life closets to the drawing board. Putting their experience—and your

ideas—right on the hanger.

Design Partnership, a Spiegel private label.
(Courtesy of Spiegel Catalog.)

In an upcoming women's wear collection that is being readied for the next season and bears the retailer's signature, for example, the buyer might suggest a particular sleeve length or neckline that seems to be a highlight of many manufacturers' collections. A particular button or trim might be seen that would benefit a particular silhouette.

In addition to examining existing collections, buyers also take their cues from events that are popular somewhere in the world. It might be a popular film or play that features a particular style of dress or a room setting in a magazine that provides a fresh idea for a new bedding collection.

The buyers involved in product development must always be on the lookout for something exciting that can become a merchandising success. Their eyes and ears must be regularly tuned in to what's happening in the marketplace and anywhere else from which ideas may be taken.

While it should be emphasized that buyers are not designers, some have moved from the merchandising ranks to the design arena. Perry Ellis, for example, was a store buyer who went on to become one of America's most successful designers. Ralph Lauren—while not a buyer but a salesperson—used his exceptional style acumen to become a design legend all over the world.

INTRODUCTION OF A PRIVATE-LABEL PROGRAM

Once a retailer has made the decision to embark on a private-label collection, it must initiate a program to introduce it to the consuming public. In the case of manufacturer and designer labels and brands, there is little need for retailers to promote the products extensively. The producers themselves, in an effort to make their lines more visible to the public, undertake large promotional campaigns that include advertising and special events. A designer such as Donna Karan, for example, might participate in the promotion of her collections by making personal appearances in key retail operations. This type of publicity brings shoppers to the stores and minimizes the merchant's need to spend excessive promotional dollars on vendors' offerings.

On the other hand, once the store has made the decision to offer its own labels and brands, it must initiate a plan to introduce them to the consuming public. Having taken the steps necessary to develop the new product lines hardly guarantees customer acceptance. Retailers must be willing to make substantial dollar investments in these programs to motivate the customers who come into their stores, use their catalogs, or make purchases on their Web sites.

Significant among the various approaches that have been taken by retailers to introduce their private labels are:

- *Creation of separate departments in the stores to feature the line.* These specialized areas give the new products a place away from all other merchandise to show its importance to the company's overall product mix.

- *Interior and window visual presentations to dramatize the private labels.* The displays and merchandise placement must motivate the shopper to look more closely at the new goods.

- *Extensive advertising campaigns in a multimedia approach.* The use of newspaper, magazine, radio, and television advertising covers all bases and gives steady exposure to the retailer's clientele as well as to new customers.

- *Customer giveaways featuring the new private label.* By offering small items such as pens and totes, each emblazoned with the private-label signature, the customer has a constant reminder of the retailer's new exclusive merchandise.
- *Sales training classes for employees to enhance knowledge of the merchandise.* By doing this, the retailer makes certain that customers' questions can be answered quickly, making a purchase simpler.
- *Fashion shows and informal modeling of the items.* The fanfare connected with such presentations often motivates customer attendance and makes the merchandise "come to life."
- *Shopping bag giveaways that display the new label.* Many consumers tend to keep shopping bags for long periods and use them often to carry their personal belongings. This serves as a constant reminder of the new label.

Retailers have hired outside consultants to work with their own staffs for ideas to incorporate in the introduction of their private labels. Only total involvement will ensure customer awareness of the private-label collections that buyers and merchandisers, as well as product developers, have provided for their retail operations. In the Retail Buying Focus, Macy's involvement with private labels is examined.

The Labeling Factor

As addressed in the Macy's Retail Buying focus, the label itself is an important factor in the success of private branding. There are several roads that retailers take to ensure success from these merchandise lines. They include the use of the company's name for the label, names that conjure up a particular image for the shopper, and signatures of famous people from different arenas that bring instant recognition to the merchandise.

THE COMPANY NAME

Some retailers believe in the principle that the use of their company's name on the label brings favorable results. In businesses such as The Gap and The Limited, who want to emphasize the store is the brand concept, this is the route they take. Customers who are satisfied with the overall merchandise of the store in terms of price points and quality come to look at the merchandise and the store as one and the same.

With the enormous success of these companies, others such as Eddie Bauer, Crate & Barrel, and Pottery Barn have followed their lead.

IMAGE BUILDERS

More and more retailers are developing labels for their private collections that use a variety of names reminiscent of designer signatures, foreign countries, regions that impart a particular image, or sports-sounding arenas.

Jennifer Moore and Christopher Hayes, as discussed in the Retail Buying Focus, sound very much like designer labels. With the popularity of the designer collections, stores sometimes choose to use similar approaches for their own brands.

In addition to using the "name" on a label, other retailers have taken to using "exotic" labels that impart the belief that the merchandise comes from an overseas venue. In the case of Macy's Alfani label, the sound is Italian, but the actual production occurs in less-prestigious countries.

A Retail Buying Focus

MACY'S PRIVATE LABELS

One of the most successful department store organizations in the world is Macy's, a member of the Federated family of stores, with stores spread throughout the leading retail centers of the United States and specialized catalogs that reach a wealth of households.

Macy's has kept pace, and often outdistanced competitors, by paying attention to customer needs and providing them with what they have demanded. Its merchandise mix has long included the top names in wearable fashions and furnishings for the home. Apparel, accessories, home products, furniture, and other merchandise classifications regularly feature the names of the industry leaders. In fashion merchandise, it offers the established designer collections such as Liz Claiborne, Ralph Lauren, Donna Karan, Calvin Klein, and Dana Buchman, as well as those that show promise in the field. For home products such as dinnerware and glassware, signatures such as Versace, Waterford, and Lenox grace the shelves.

The store's product mix, however, is not limited to the lines that are available at other companies throughout the country. It has invested heavily in collections that are Macy's alone and markets them under a variety of private labels. It is generally conceded that in the retail industry, Macy's is the leading department store merchant of private-label goods. The names that have become as popular as many national brands include Jennifer Moore, Christopher Hayes, Charter Club, Alfani, and INC, the most important of all the private labels.

To the typical customer, these, and other private labels, are goods that carry a well-known, branded label. This is certainly not the case, since Macy's designs and produces the merchandise for exclusive use in its stores. What accounts for the success of these labels is their names and the way Macy's visually merchandises many of them. Charter Club, for example, is reminiscent of many Ralph Lauren products. Its position on the selling floor is often in close proximity to Ralph Lauren merchandise and is displayed in a similar manner. This brings the shopper who wants a price point lower than the Polo label of Ralph Lauren to consider the comparable Charter Club items. For those who still want the marquee Lauren label, it is there for the purchasing.

Christopher Hayes and Jennifer Moore, on the other hand, bring customer attention because of their names. With so many consumers enthralled by the designer labels that abound in retailing, Macy's has created labels that often make the shopper believe that these are designer signatures. With the Alfani private collection, the name given to the clothing seems to deliver the message of "Italian made." With Italy being such an excellent resource for fine men's clothing, the customer feels that this is an Italian line of merchandise. Close inspection of the Alfani label often shows that the item was manufactured in Korea and Poland.

None of these are deceptive techniques but are the creations of astute marketers. As long as the products are at the quality and price points desired by the company's clientele, they are sure to be profitable entries in the store's overall merchandising mix.

Marshall Field's, now a division of Macy's North, used sports-sounding labels for an extensive entry into private labeling. In its menswear department alone, it features several categories, with each using a sports-oriented label:

- Field Sport for active and active-styles sportswear.
- Field Gear for rugged wear.
- Club Fellow for heavy-volume goods.

FAMOUS-SIGNATURE LABELS

In this era, sports celebrities, performers, media personalities, and other people who are making entertainment headlines can be a big consumer draw when their signatures are used on a retailer's labels. Many individuals are fascinated with famous people and are ready to purchase merchandise with which they are associated.

One of today's "headliners" who continues to make a mark in print and on television with products and fashions for the home is Martha Stewart. Her followers are numerous, and as soon as she mentions a restaurant, chef, place to visit, or a book, its popularity soars.

Trading on her recognition, Kmart, now a part of Sears Holdings, has an agreement with her for a private-label collection of bedding. In the stores, the Martha Stewart pictures are all over the "domestics" departments, as well as on each of the products that bears her signature. From all accounts, the success has been substantial.

When extreme care and attention is given to private-label retailer collections, it is evident that this type of merchandising has become an industry mainstay. From the many indicators apparent in today's retailing empires, it is likely that this merchandising technique will continue to flourish.

Language of the Trade

bottom line
cooperative advertising
manufacturer brands
manufacturer labels
marquee labels
private brands
private labels
the store is the brand

Summary of Key Points

1. The use of private labels and brands is reaching new heights in the retail community.
2. Some of the reasons why retailers make significant use of nationally known brands and labels include customer demand, quality control of the products, prestige, and quick inventory replenishment.

3. One of the earliest entries into private branding was the Sears organization. Its success with names such as Coldspot and Kenmore led other retailers to follow suit with their own brands.

4. One of the major reasons for the explosion in private labeling is that it assists the merchant in meeting competitive challenges.

5. The store is the brand concept is one in which a retailer's entire inventory is made up of a private brand.

6. Private labels and brands afford the merchant such advantages as the avoidance of price competition, an increase in profits, and the ability to tailor goods specifically to the customer's needs.

7. In developing a private-label or private-brand program, the retailer must decide whether to purchase the goods from outside vendors or produce its own merchandise.

8. Many of the major resident buying offices produce private labels that are distributed solely to their clients.

9. Buyers are not designers but are store representatives who often provide their companies with suggestions about new product designs.

10. Private-label programs necessitate a great deal of promotion when they are first introduced. This assists them in attracting customers to the new line.

11. Macy's is one of the leading department stores in private-label merchandising.

12. The names on the labels are extremely important to the success of the private brand. Some give the impression that a designer has styled them, while others bear the signatures of famous personalities.

Review Questions

1. Why is the private-label and private-brand concept gaining in importance with retailers?

2. If the popularity of private labels is so significant, why do most merchants still rely on manufacturers' and designers' labels for their model stocks?

3. How does the retailer benefit from buying manufacturers' label merchandise in terms of promotion?

4. Why does a well-known manufacturer's brand often lead to quicker sales on the selling floors and in catalogs?

5. Who was the first major retailer in the United States to develop its own brands?

6. According to the NAB, what was consumers' reaction to specific brands of merchandise?

7. Which type of retailers, in addition to the traditionalists, are including private-label collections in their inventories?

8. How does the store is the brand private-labeling approach differ from the ones used in major department stores?

9. What are some of the advantages of private-label programs?

10. Why are profits often higher with private brands than with manufacturers' brands?

11. Is it better to have private-label merchandise produced by outside resources or by the retailer itself?

12. What role does the resident buying office play in private-label merchandise?

13. Are there any disadvantages for companies in producing their own private-label merchandise?

14. In what way does a retailer's buying staff assist the company in the development of private labels and brands?

15. What types of approaches have retailers taken in the introduction of their private-label programs?
16. What are some of the typical approaches that retailers use in determining the names to be used for their private-label collections?

CASE PROBLEM 1

Cameron-Shaw is a leading retail operation consisting of a flagship in Dallas and fifteen branches throughout Texas and California. The flagship and its branches are all extremely successful in terms of volume and profits. Its volume ranks among the top in department store organizations in the West.

The stores are operated as high-priced, prestigious retailers. The labels and brands that they carry are among the best known and come from all of the major fashion centers in the world.

The company does not offer private labels or brands to its customers. Instead, along with its marquee labels, it mixes in an assortment of little-known brands. Its records show that these lower-image labels achieve greater markups and profits than the better-known products. This, of course, is based on an absence of competition that is the case with its high-profile lines.

With the evidence that higher markups can be achieved with lesser-known goods, the buyer for bridge collections, Emina Chang, has suggested that the company consider entering into private labeling. This would enable the organization to carry merchandise that it develops and mark it up higher. She reasons that with the company's excellent reputation, and the assistance of an outstanding buying team, private labeling should be a relatively easy task.

Ms. Chang suggests that they first begin with some bridge merchandise and slowly add other lines to the model stock.

Questions

1. What other information would you like to have, in addition to Ms. Chang's opinion, before embarking on a private label?
2. Do you think a store of this nature is appropriate for this type of merchandising?

CASE PROBLEM 2

Alex Michaels is a chain of eighteen units that specialize in off-price men's clothing and furnishings. Its buyers regularly comb the globe looking for merchandise closeouts that they can bring to their customers for less money. They have been successfully accomplishing their goals in this manner since the company began doing business twenty years ago.

Vendors from all over the world contact them via telephone, fax, and e-mail to alert them to products that are being sold at below the regular wholesale prices. They are such volume purchasers that they are considered prime users for merchandise the vendors wish to dispose of quickly.

While the markups they achieve on their purchases are very good, some members of the management team believe that some could be even greater. Their suggestion is to develop some private-label collections that could bring higher markups and ultimate profits since the middlemen would be eliminated in such merchandise acquisition. Although this is a departure from the approach that has brought them considerable success, it could make them even more successful.

There has been a great deal of discussion among the buyers and merchandisers at Alex Michaels. Some agree with the proposal, but others think it would be better to remain with the status quo, arguing, why flirt with failure?

Questions

1. If the new plan is approved, how much private-label merchandise should be incorporated into the inventory?
2. Should the company make its own products or use outside sources for this new merchandise?

CHAPTER 19

Disseminating Product Information to Retail Personnel

On completion of this chapter, the student should be able to:

- Explain why it is necessary for retail buyers to communicate with employees at the store level.
- Describe the various techniques that buyers use for their communication activities.
- List the recipients of product information with whom the buyer communicates.
- Discuss each of the classifications of product information that the buyer passes on to the store's employees and their importance in helping sell the merchandise.

As we have seen in the preceding chapters, the buyer spends countless hours planning purchases. Having addressed areas of concern such as qualitative and quantitative considerations, resource selection, and pricing merchandise that has been purchased, the job is not yet complete. This planning has only made the merchandise available to the company's potential customers. While this is the major role played by the buyer, it doesn't guarantee that customers will, in fact, purchase these items.

Although there is no guarantee of customers' satisfaction with the goods, or that they will be willing to buy, there are some ways in which sales may be made more likely to occur. The interaction of the buyer with the employees in the retail outlets to disseminate product information ensures the likelihood of easier selling. In brick-and-mortar operations whose store managers, department managers, visual merchandisers, and sales associates are armed with all of the information needed to answer shoppers' questions, sales are more likely to happen. Knowing what the appropriate responses to questions should be, and how to handle them quickly, the buyer's selections will more than likely turn into sales. Even in off-site organizations—those that interact with catalog customers, Web site browsers, and home shopping consumers—the need to have product information has become paramount.

Each season, particularly in the fashion industry, new styles, colors, and fabrics abound. Especially when there are significant changes, such as drastic changes to hemlines, those on the selling floor must be able to handle any of the customers' concerns. Will these lengths last? Is this a new trend or just a fad? Will the new skirt length be accepted in the workplace? These and other questions can be quickly handled if the buyer has prepared the sellers in advance.

Buyers who understand that preparing those on the selling floor and associates who assist the off-site shoppers with pertinent product information will bring better profits to their companies.

THE NEED FOR THE DISSEMINATION OF PRODUCT INFORMATION

Although buyers and merchandisers, and the fashion directors in stores that deal primarily with fashion merchandise, are totally knowledgeable in terms of the products they buy, those who interface with consumers do not necessarily have the same understanding. In the various retail outlets all over the world, while those at the store level, in particular, are concerned with managing their outlets or departments, or selling to consumers, their product knowledge is often at a minimum.

For example, if you have ever gone shopping and asked a sales associate for information about a product, it is possible that the experience has been less than enlightening. Sales associates are sometimes few in number, and when they are there to serve the shoppers, they often are less knowledgeable than those making the inquiries. Not only do the salespeople lack this information, but often so do the store manager and department managers. These managers are more concerned with setting employee schedules, handling customer complaints, helping reassign floor space, and generally managing their particular units. It is the buyer's job to help the sales personnel understand the products on the selling floor.

COMMUNICATION TECHNIQUES USED BY BUYERS TO REACH RETAILERS

In the retailing of yesteryear, brick-and-mortar organizations—the mainstay of selling to shoppers—were considerably smaller than they are today. Except in the larger companies, buyers were able to regularly visit the stores to which they supplied the merchandise. It was a typical obligation for buyers to make the rounds of department store branches and units in the chain operations. If the company was very large, and the various outlets were not within close proximity to the company's flagship or center of operations, then **"key" stores** were earmarked for the visits. By concentrating on these particular units, the buyer was able to assess the business at the others.

This communication was considered vital to the movement of the merchandise from the store's shelves and racks to the consumers' homes. Of course, with the enormity of many retail empires, today this in-person visit is more likely to be the exception rather than the rule.

Company visits, even when possible, need to be augmented by other means of communications, such as the telephone, fax, e-mail, and the latest technique used by large retailers—in-house, closed-circuit TV. While communication with the people who sell merchandise through any channel is imperative, it is the contact with store personnel that is most important.

Store Visits

Regular visits by buyers to the stores they serve are typical of many organizations. Buyers set aside time in their schedules to make store appearances. Store managers, department managers, and sales associates are able to ask the questions that have been raised by customers. These could concern particular merchandise that they would like to see on the selling floor, when new arrivals could be expected for specific needs, the availability of certain styles in other colors and fabrics, the adjustment of particular models to suit customer needs, or anything else that might need further clarification.

In addition to just talking, those in the store can literally point to items that need further explanation for their inclusion in the model stock and show the types of goods that customers would like to see in greater supply. These might be addressed on the telephone, with faxes, and with e-mails, but not as meaningfully.

The appearance by the buyer in the various stores in the organization also shows employees their importance to the organization. Those at the store level might have little input into merchandise selection, but with such sessions, their voices can be heard and their morale boosted.

Telephone

When the buyer is simply inundated with such tasks as planning future purchases and making market visits, there is often little time to visit the individual stores in the chain. This is particularly true in companies with several hundred units or more, in which the distance from the home office, where the buyers work, to the stores is just too far and too time-consuming to get to them.

More and more buyers regularly cover markets all over the globe in their quest for goods. Such endeavors take a great deal of time and little, if any, is left for in-person communication. Most major retailers have regional managers who make visits to the stores and bring the information they have discovered back to the buyers whom they represent. While this is better than nothing at all, it is less satisfactory than making a personal visit.

In cases in which the buyer or his or her representative is unable to go to the individual units, the telephone is an option for communication. It is quick and sometimes serves the buyer's, store manager's, department manager's, and sales associates' needs. Questions about reorders, availability of goods, concerns with care of merchandise, handling of complaints about product performance, and the like may be handled in a telephone call.

However, telephone calls sometimes can't answer questions about specific items that must be seen in order for a problem to be solved. Newer techniques such as faxing and e-mails are more likely to satisfy the questions of the buyers and their store representatives.

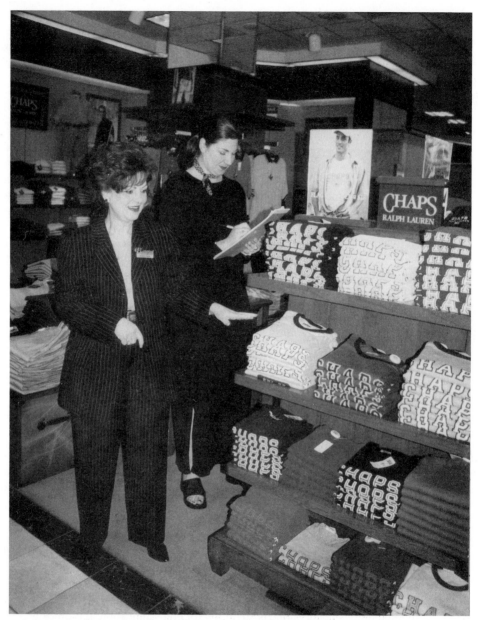

Buyers make store visits to communicate with sales associates.
(Courtesy of Ellen Diamond.)

Fax

When **faxing** came into prominence, it opened yet another channel of communication between the buyer and those in the retailer's stores. It took several leaps from the conventional telephone and enabled the buyer to transmit messages as well as photographs and drawings of merchandise to the recipients in the stores.

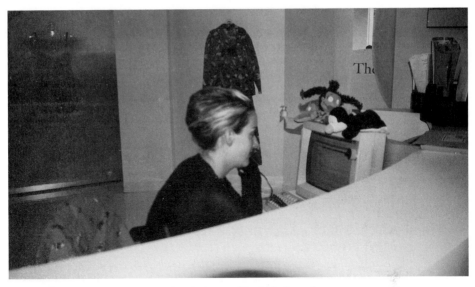

The telephone is used by the buyer when the home office is far from the stores.
(Courtesy of Ellen Diamond.)

Buyers are always receiving illustrations of new items from vendors and resident buying offices in the hope that their interest will be piqued. Sometimes, the buyers would like input from their store and department managers concerning specific items before they purchase them. With the use of the fax, back-and-forth communications can reveal any changes that the store's managers might suggest that could play a greater role in satisfying their shopper's needs.

Faxing is extremely easy, and quick responses, so important to fashion merchandising in particular, are always possible. One advantage to faxing over using the telephone is that the fax can be used around the clock. The individual earmarked for the fax need not be at the store to receive the information. The faxes merely stay in the machine's receiving "bin" until the intended recipient comes to work. The costs associated with a fax are as little as with the telephone, since the transmittal is accomplished over telephone lines. Of course, the machine itself initially costs from $75–$200, and paper must be supplied at minimum expense.

Faxes may be sent and received all over the world, wherever telephone lines are available and both parties have fax machines. See figure on page 426.

E-mail

The use of the computer for communication purposes has greatly enhanced the buyer's ability to quickly transmit and receive information and photographs. This is particularly important for urgent business. Available at any time of the day or night, it has been a favorite method for buyers to reach the stores for which they purchase.

As most individuals know, both the sender and recipient of **e-mail** messages must subscribe to an online service. The most widely used is America Online, or AOL. However, many large retailers have their own in-house servers. Each participant to whom a buyer wants to send an e-mail establishes an e-mail address. Once an address is placed

The Contemporary Male

FAX TRANSMISSION

TO: ALL SALES ASSOCIATES, MENSWEAR DEPT. 55A

FROM: CARYN STEELE, BUYER

SUBJECT: STYLE # 618, VENDOR 128

Regarding the above noted style, a sample of which I sent to your department manager, I would like some input from you about its sales potential. Specifically, are you getting calls for this type of merchandise?

Please send your responses to me via fax, as quickly as possible, because I am ready to place an order.

The fax is used by buyers for quick responses.

into the sender's address book, the sender merely accesses the specific address, composes the correspondence, and tells the system to forward the mail.

So quick and efficient is this system that more and more buyers are making use of it in place of the telephone and fax. Of course, there must be easy access for those who are the retrievers of this type of mail. In most major organizations, computers are available in a variety of locations for use by managers.

Bulletin Boards

A great number of retailers require their employees to use time clocks or other means of verifying the arrival and departure of many employees. This is particularly true in the case of sales associates. In many places where **time clocks** are located, the store has placed bulletin boards to announce important information to the employees. Thus the checking in of sales associates not only records the associate's attendance but also serves as a location where important fliers are featured.

When a buyer wants to disseminate information about advertisements, for example, he or she sends "**tear sheets**" to the stores and has them placed on the bulletin boards. This guarantees that anyone **punching the time clock** will see the advertisement and be alerted to the potential traffic that might result from its publication.

Other communications that have been sent by buyers and find their way to the bulletin boards might include special markdowns for one or two days, incentives that

could increase sales, and notices that might alert those in the departments that positions for assistant buyers might be available.

It cannot be assumed that once an ad has been placed that its success is guaranteed. Only when managers and sales associates—often far away from the company's headquarters and unaware of the ad—are alerted to it will sales be more likely.

Each buyer has to determine which method of communication best serves his or her individual needs. Of course, as has been emphasized before, in-store visits are without equal. In their absence, these other devices are essential.

Closed-Circuit TV

Some retailers have invested in **closed-circuit TV** systems so that those at the home offices, flagship stores, or corporate offices can visually communicate with the stores.

At the beginning of each season, the buyers and merchandisers prepare merchandise presentations about products that will be in the store's inventories. The buyer shows each item and discusses its merits. The viewers, made up of store managers and sales associates, learn about the details of the goods, the fabrics, unusual construction, methods for laundering or cleaning, style importance to the season, and any other selling points that will help answer potential questions from shoppers.

RECIPIENTS OF PRODUCT INFORMATION

It can never be assumed that those who are in the stores are experts in terms of product knowledge. With more and more retailers relying on a wealth of part-timers to sell their merchandise, it is probable that much can be done to make them more knowledgeable.

When a shopper asks a question and the seller seems ill-prepared to answer it, a sale might be lost. With the significant amount of competition faced by today's merchants, and the numerous methods by which the customer may be served, product knowledge is essential. It is therefore necessary for everyone involved with selling the goods to be cognizant of the key features of the goods. Whether it is the store manager who oversees the branch, the department manager who has specific responsibility for one merchandise classification, the sales associate who regularly interacts with the shoppers, the visual merchandisers who display the goods in windows and on selling floors, or the advertising manager who prepares the artwork and copy for the ads, everyone must be knowledgeable so that sales will be maximized.

Store Managers

Whether they are at the helm of a department store's flagship, one of its branches, or a unit in a chain organization, the store manager is a valuable source of information for the buyer. In department store operations, the buyer is often based in the company's main store, a place where the store manager presides. In these cases, daily interaction between buyer and manager is simple and requires no other means of communication.

The buyer merely seeks out the store manager to learn about particular wants, needs, and merchandise recommendations. This information is often vital to the buyer's future purchases. In addition, the store manager learns firsthand about anything new that will be coming into the store's inventory, what types of merchandise promotions the buyer is planning, the general direction of the marketplace, and so forth. With this type of information in hand, the store manager is better able to prepare his or her subordinates in terms of the merchandise.

At the branch or unit levels, with less opportunity for direct, in-person contact, the other means of communication are used. It is imperative that these managers learn about what's happening in terms of merchandise and that they be prepared to handle the questions of their subordinates in their stores. All too often these store managers are "shortchanged" when it comes to buyer interaction. They generally must rely on computer printouts, fliers, and other printed matter for their information. If a company is to maximize the potential for profit, these managers must learn all there is to know about the products they will be receiving. If they are knowledgeable, they can pass the selling points on to their staffs.

Department Managers

In large retail organizations, buyers purchase for specific merchandise classifications, many of which are housed in separate departments. These departments are headed by managers who have responsibilities similar to those who operate small stores. In order for them to make certain that the products they receive are totally understood in terms of fabrics, colors, style direction, and so forth, they must get direction from the buyer.

Often, a new item comes to the selling floor with which there is little familiarity. It might be a new fabric that requires a different type of care than other fabrics, or it might be a style that has never been in the department's model stock. If this is the case, the manager must know about the benefits of such goods for the consumer and must be able to translate them into favorable selling points. By knowing this product information in advance, the pitfalls of not answering a customer's questions can be avoided.

Too often, a department manager's familiarity with a product is taken for granted. If this is the case, he or she could be at a disadvantage when the sales associates are looking for assistance.

Sales Associates

Those responsible for selling the merchandise are on the "firing line" each and every day. They must be able to show the customer the merchandise that best satisfies their needs and quickly handle any questions about the products that could arise. "Can I launder this easily while on vacation?" "Does this item quickly shed wrinkles?" "Is this swimsuit fade proof?" These are just some questions that could arise during an attempted sale.

While ticket information sometimes gives the necessary clues, there are times when the information needed is not available. Ideally, product information should come from the buyer. He or she is most knowledgeable in terms of product comprehension and can dispense such information with the greatest authority.

Regular communication with department managers provides buyers with a wealth of information. *(Courtesy of Ellen Diamond.)*

Of course, many buyers are just too busy to supply this information directly to the sales associates in person. Other techniques can be used to disseminate such product knowledge, as has been explored earlier in the chapter. Such information will help the sales associates understand all of the product's details so that he or she will be able to handle any customer questions.

Visual Merchandisers

With not enough sales associates available on the selling floors the need for better visual presentation is necessary. The **visual merchandisers** who "display" the department's goods must be fully aware of what it is that the buyer wants to emphasize, and what features of the products should be highlighted through explanatory signage that tells the customer about the product's benefits or through strategic placement of key items.

Without the assistance of the buyer, the visual team members are at a disadvantage. They must merely use their judgment to determine what should be stressed. Although these display people do not interact with the customers in the sale of the goods, it is their role to present the items in the best possible light. Without product knowledge, this is often an impossible chore to perform perfectly.

Advertising Managers

When buyers are looking to promote a particular item in their inventory, they must send it to the advertising department so that an ad can be developed for placement with the media. The individuals who create these ads are completely knowledgeable about artwork, copy, and layout design but are often ill prepared when it comes to specific merchandise.

To create the most compelling advertisement, these experts must fully understand the qualities of the items, the key selling points, and the benefits to the potential purchasers. Only with buyer input can this information be forthcoming. Who has more product knowledge than the buyer?

If the buyer's promotional budget is to be spent wisely, and sales are to be maximized from the advertisement, the buyer must be prepared to offer anything there is to know about the product.

Off-Site Representatives

Although ordering through catalogs is routinely accomplished without the need to interact with customers, occasionally there is a need to answer questions. It might center on other colors that are not indicated in a catalog's pages, or a question regarding the care of the garment. In such cases, the company service representatives need to be fully informed about the merchandise that is being offered for sale in these booklets. They must be fully aware about everything featured and be ready to answer questions that might arise.

Today, the Internet has become more than a channel where automatic ordering takes place. Browsers are often faced with purchasing decisions that might warrant communicating with a company rep. Some companies now feature interactive Web sites in which shoppers are able to communicate with people who could satisfactorily handle their questions. In this way, a sale is more likely to be consummated.

On the home shopping channels, direct communication between the seller and the consumer has become commonplace. Questions are quickly answered, making the sale easier to finalize.

When product information has been supplied to these company representatives, sales are more likely to be made.

TYPES OF PRODUCT INFORMATION NEEDED FOR DISSEMINATION

There is a great deal of product information that surrounds each item in a retail organization. Whether it is a fashion product, an appliance, or a computer, it is essential that

the sellers understand the different features of the merchandise and are able to explain the benefits to potential customers. If this information is at the sales associate's fingertips, the sale is more likely to come to a satisfactory conclusion.

For fashion merchandise, specifics about styles, color, fabrics, care, and quality features are some of the areas that might raise customer concerns. For nonfashion products, the necessary information includes operating techniques, servicing, **warranties** and **guarantees,** special power requirements, adaptability, and so forth.

Fashion Merchandise

It seems like every day a new fashion item comes to the marketplace. While it may not really be that frequent, there always seems to be something new in the retailer's inventory that needs an explanation. The buyer must be prepared to discuss and disseminate anything of a new nature that will help the sales associate make the sale, and report this information to the company's catalog developers for inclusion in their layouts and to the advertisers who are preparing the copy for upcoming ads. The following are but some of the types of fashion information that should be disseminated to those individuals.

STYLES

To motivate shoppers to make new purchases, designers and manufacturers regularly add new styles to their collections. Of course, there is rarely a totally new style, but one that has either resurfaced from an era gone by, or one that has been updated from an earlier successful seller.

Customers are sometimes leery of purchasing new styles for fear that they might just be **fads** and will be fashionable for only a short period. In such cases, the seller should know all about the advantages of these styles; how, when, and where they are appropriate for use; and their potential for a long life. When a new hemline that is radically different from one of the past season comes to the forefront, this is a time when buyer must prepare the sales staff for potential customer questioning. By explaining to the customer the rationale behind such styling, and how it will better serve their fashion needs, a sale might be easier to make.

COLOR

As is the case with styles, new colors regularly are touted for the new season. Some might be basics or neutrals that will be long-lasting in any wardrobe, and others will be the latest designer offering found somewhere on the color wheel.

The buyer should pass on his or her knowledge about how new color offerings might be incorporated into existing wardrobes, how the new could be coordinated with the old, and how these newer colors might enhance the individual's appearance. Very often something radically new causes concern for the shopper, and a little reassurance could help clinch the sale.

Some fashion enthusiasts always seem ready to embrace the new color palette, while others offer resistance. It is the latter group that needs the reassurance that can come only from the buyer's dissemination of information on new color offerings.

FABRICS AND FIBERS

Basically, there is always an offering of fabrics that are composed of natural fibers along with those that are constructed with the synthetic varieties. The former group, the naturals, rarely need explanation since they have been mainstays in most consumers' wardrobes. Sometimes, of course, new finishes to natural fibers add extra benefits that make their selling easier. In this case, the buyer should explain these new features so that they can be used as selling points. Synthetic fibers are another case. Although the basic fibers such as nylon, polyester, and so forth are usually in every store's inventory, there generally seems to be a new "name" representing that class of fibers and fabrics. For example, microfibers, produced by specially processing polyester, played an extremely important part in the fashion world when they were first introduced. People unhappy with the "old" polyesters needed to be assured of this new, luxury fabric. Armed with important product information, the salespeople were able to motivate the customers to buy and make them regular seekers of these fabrics.

When shoppers are aware of the benefits that lie ahead with new fibers and fabrics, selling will be easier.

CARE

Before they are ready to buy, many shoppers are concerned with the care that will be necessary to maintain the items they are about to purchase. Will it be necessary to dry clean the item? Can it be machine-washed? Must it be hand-washed? These questions can best be answered when the buyer passes along such information.

While labels generally give care directions, they often do not give the consumers the best way to ensure the product a long life. Manufacturers who prepare these labels sometimes do not spell out the instructions. By knowing exactly how to care for the product, the consumer will more than likely be satisfied with the results.

QUALITY

The quality level of a product is generally concomitant with the price. Higher-priced items typically are of better quality than lower-priced merchandise. If some lower-priced items are of unusually high quality, this information should be made available to the seller. It might be the construction technique used, the fabrics employed, the trimmings, or perhaps a feature that makes the item wrinkle-resistant.

Shoppers generally seek the most for their money and must know if their needs are being served.

Nonfashion Merchandise

The sellers of nonfashion products such as electronics and appliances must be equally as knowledgeable as their fashion-merchandise counterparts about the features of the items they sell. In these merchandise classifications, the information is often technical and requires complete understanding in order to make the sale. Concerns such as operating techniques, servicing, warranties and guarantees, special power requirements, and adaptability are just some of the areas that might bring questioning from the potential purchaser.

OPERATING TECHNIQUES

Even in today's world of more sophisticated consumers, there are always concerns that require clarification. One is how to operate a product such as a computer or a stereo system to maximize results. While computers and stereos are not new products, there are always new models with new features that require consumer familiarization. This technical information necessitates the salesperson's understanding in order to pass it along to the potential purchaser. Often, although there may be operating instructions that come with the items, they are sometimes difficult to understand and need further clarification.

When the consumer feels comfortable with the instructions and uses, he or she is more likely to buy.

SERVICING

Unlike fashion merchandise, products such as computers, television sets, and DVD players need occasional servicing. Many consumers are reluctant to buy unless they fully understand where the products may be serviced, what the costs will be, and how long the repair will take. Even when the need for the product has been satisfied, this information must be delivered by the seller before the sale may be completed.

Sales associates should know about the costs and details of service contracts, and how the consumer could obtain product repair.

WARRANTIES AND GUARANTEES

Most of the nonfashion items already presented come with warranties and guarantees. These documents spell out specific details for the customer to take advantage of. The seller should be aware of time limitations, exclusions and inclusions, and anything else that will help the shopper make a decision.

SPECIAL POWER REQUIREMENTS

In some cases, as with room air conditioners, there might be a need for special electrical lines before the product could be used. The seller must be able to provide such information to the consumer and prepare him or her for such needs. In this way, when the product is taken home there will be no surprise about the installation and the item will not be returned.

ADAPTABILITY

Some products such as electric shavers feature different currents. Although the American requirement for these items is a 110-volt current, the overseas requirement is 220 volts. Many of these products automatically adapt to the different current requirements. With this knowledge, consumers who travel are more likely to purchase, since the item will satisfy their every need.

Similarly, vacuum cleaners, made primarily for carpet cleaning, may also serve the consumer in other ways. Many can be used for hard surfaces or to clean furniture. Whatever the additional features are, they should be understood by the seller so that these benefits can be passed on to the potential customer.

It cannot be too strongly stressed that complete product knowledge is a plus when trying to make a sale. The practice of passing along such information to the sales associates should be a routine matter for the buyer if the information isn't forthcoming from any other source. With the information in hand, sellers will find it easier to make the sale, and the profits of the company will improve.

Language of the Trade

bulletin board notification
closed-circuit TV
e-mail
fad
faxing
guarantees
key stores
punching a time clock
tear sheets
time clocks
visual merchandisers
warranties

Summary of Key Points

1. The buyer is a key provider of product information that must be passed on to the store's managers, department managers, and sales associates so that customers' questions may be answered.
2. Although the best method to communicate product information to store personnel is through direct visitation, this is generally impossible for the buyer to accomplish because of the distance from the home office to the stores.
3. Alternative methods for the dissemination of product information to the stores are telephone, faxes, and e-mails.
4. A new method that some merchants are using to familiarize their employees with merchandise offerings is closed-circuit TV. The buyer makes a presentation that is aired throughout the company's retail outlets.
5. E-mails are excellent for relaying product information in that the sender of the message and the recipient can interact instantaneously.
6. A bulletin board that is strategically placed where the employees must sign their time cards ensures that the items that have been advertised will be seen.
7. Those who must understand product information are store managers, department managers, sales associates, and developers of catalogs and advertisements.
8. By knowing all of the product's details, those who create the ads will be able to offer the best selling points of the product to the periodical's readers.
9. Visual merchandisers, who are responsible for interior and exterior merchandise displays, will be better able to perform their duties if they understand all of the product's details.
10. Product information is necessary for fashion-oriented merchandise and nonfashion products. For fashion items, the information should center on style, color, quality, fabric, and so forth. For nonfashion items, it should be on technical information, product usage, and so forth.

Review Questions

1. Why is it essential for the store's buyers to familiarize those in the stores about product knowledge?
2. What is the best means of bringing any product information to the people in the flagships, branch stores, and units of a chain?
3. Is there any advantage to a buyer's use of a fax instead of the telephone to bring product information to a department manager?
4. Why might the use of e-mail rather than of a fax better serve the buyer in disseminating information?
5. Which is more cost-efficient—faxing or e-mailing?
6. In what way may a bulletin board help a buyer communicate with store employees?
7. Describe the latest innovation that some buyers are using to describe the new products that are coming into the store.
8. To whom in the store must the buyer disseminate product information?
9. Why should a buyer familiarize the visual merchandisers about product information?
10. How does product information serve those who develop catalogs and prepare advertisements?
11. How important is it for buyers of fashion merchandise to explain the new styles that are coming into the department?
12. Is it necessary for buyers to familiarize the sales staff with information about new fabrics and fibers?
13. Whereas care tags are commonplace on merchandise, is it necessary for the buyer to pass along such information to the store personnel?
14. Why is it so important for information about the use of nonfashion merchandise to be passed along to sales associates?
15. Is it necessary to offer information on product servicing to potential customers?

CASE PROBLEM 1

Bev Nadler is the buyer for active sportswear for Mangle's, a department store organization in the Midwest. The company is based in Omaha, Nebraska, where it has its flagship store. It also operates fourteen branches within a radius of three hundred miles. In business for fifty-five years, Mangle's continues to show increased volume and steady profits each year.

Ms. Nadler's department is exceptionally profitable. It regularly ranks high among those that provide the greatest sales figures. She firmly believes that her success is due, in part, to her regular visits to the stores to interact with managers and sales associates about the merchandise. In this way, she can learn about customer requests as well as offer product information that could be used in answering customer questions.

In the past year, Mangle's has made more and more use of imports. To get the best possible deals in foreign countries, offshore visits have become necessary. The buyers must make several trips abroad each year to get the best possible merchandise for their departments. To accomplish this task, store visits have become less and less frequent. While understanding the need to go abroad, Ms. Nadler is concerned that the neglect of her personal communication with managers and sales associates will affect business.

She has brought her concern to management, which has made a few suggestions to her to use in place of the in-person visits. One was to rely on the telephone for her

information dissemination. Another was to use faxing. A third was to make use of e-mails. While these seemed somewhat satisfactory, Ms. Nadler didn't think they were enough to serve her purposes.

At this time, she is trying to come up with another technique that would better suit her needs.

Questions

1. Do you agree with management's suggestions that the use of the telephone, faxes, and e-mails will serve Ms. Nadler?
2. What other type of system could she employ to make a greater visual impact on managers and sales associates?

CASE PROBLEM 2

One of the more successful off-price operations in family apparel and accessories in the Northeast is Fashion World, a company with more than three hundred units in New York, New Jersey, and Connecticut. Its bargains are legendary, and its merchandise offerings are substantial.

The company regularly offers, at bargain prices, assortments that feature such labels as Ralph Lauren, Calvin Klein, DKNY, and Tommy Hilfiger. By constantly visiting these and other vendors to seek closeouts, it has been able to acquire goods at much below initial wholesale prices. Its name continues to attract more and more shoppers to the store and vendors who are ready to dispose of end-of-season goods.

Although it has a steady stream of shoppers who frequent its many outlets, it believes that it's important to advertise special purchases. Ads that typically feature such headlines as "Famous Maker Goods at Closeout Prices" and "Designer Labels at a Fraction of the Original Selling Price" are regularly placed by the company. These ads bring scores of shoppers to the store who are ready to buy.

One problem has been that once inside these stores, which have very large selling areas, the customers can't always seem to locate the advertised items or learn from salespeople just what they are. The store has spent money on advertising but hasn't been able to reap the profits associated with it. One of the problems stems from the fact that the majority of the sales associates work part time and cannot be personally informed by management about these special purchases. Sales meetings have been suggested, but with the various time schedules for these salespeople, it is impossible to schedule meetings.

Management currently is trying to solve the problem.

Question

1. What system would you employ that is inexpensive yet seems to be appropriate for solving the problem?

The Buyer's Role in Planning Advertising, Special Events, and Visual Merchandising

On completion of this chapter, the student should be able to:

- ■ Explain how the buyer arranges for his or her company to obtain advertising participation from the vendors.

- ■ Discuss the concept of indirect advertising.

- ■ Explain why the buyer is the person designated to select the merchandise that will be advertised.

- ■ Describe an advertising request form, and explain what purpose it serves.

- ■ Differentiate among the various pricing terms such as *regularly, originally, comparable value,* and *value* and why it is important to use them properly.

- ■ Discuss the buyer's overall importance to the success of the various promotional tools used by retailers.

- ■ Distinguish between institutional and promotional special events and the buyer's involvement in each.

- ■ Define the term *visual merchandising.*

- ■ Explain how the buyer is often involved in some aspects of visual presentation.

As we have discussed in all of the previous chapters, the buyer is given a number of tasks to perform, most of which concentrate on the actual purchase of merchandise. In addition to the buying responsibility, the buyer is also involved with many aspects of promotion so that the goods he or she has selected will have a better chance to sell. Significant among these promotional endeavors is the role that the buyer plays in planning advertising, special events, and visual merchandising.

Although the buyer does play a role in all of the aspects of promotion, he or she is not expected to create the ads or promotional devices used. The buyer plays a supportive role and generally gets the ball rolling. He or she chooses the merchandise that

will be featured in advertisements, special events, and interior and window installations. Another part of the buyer's involvement is to supply information that will be used to augment the merchandise and make the promotion a better one.

In terms of overall duties and responsibilities in promotion, the buyer apportions the allocated budget for use in several areas, negotiates with vendors for cooperative advertising allowances, selects the merchandise that will be featured in the chosen formats, prepares the necessary request forms that precede any formal promotional action, and suggests and arranges for special events and visual presentations.

These tasks are formidable ones and, when performed properly, will help boost the sale of the merchandise that the buyer has purchased for his or her department. The buyer who merely chooses to do a "routine" job in this area will not reap the benefits that come from significant involvement.

THE PROMOTIONAL BUDGET

The buyer would love to have unlimited dollars to fund all of the promotions that will help sell the merchandise. As is the case in any business, unlimited funding for any project is

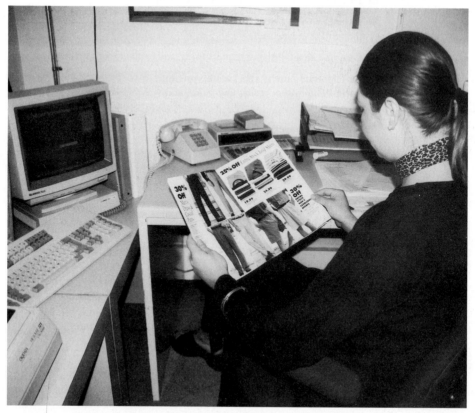

A buyer examines a direct-mail catalog for which she supplied the merchandise.
(Courtesy of Ellen Diamond.)

virtually nonexistent. To turn a profit, management must apportion the budget in a way that covers every department and every program in which a company is involved.

One such part of the retailer's many divisions is promotion. This is the segment of the company that deals with the planning and execution of print and broadcast advertising, the development and presentation of promotional and institutional special events, and the development of visual presentations that address both interior and exterior needs.

With many of today's merchants expanding their businesses through the use of catalogs and Internet selling, the budget has to be earmarked for those ventures in addition to the ones that take place in their brick-and-mortar environments.

The amounts designated for any promotional endeavors are based on a number of factors. Included are past sales volume, projected figures, the size of the company, potential for expansion, long-range objectives, competition, and economic conditions. Once the final budget determination has been established by top management, each buyer is given an amount that must last for a predetermined period. The length is usually either six months or a year.

With the dollar amount established, the buyer must decide how best to apportion the allocated funds. While few buyers are ever satisfied with the budget that has been established for them, they nonetheless must stay within the confines of the commitment. This is no simple task. Dollars must be set aside for advertising and other promotional endeavors that will last for the designated period as well as the coverage needed in all of the promotional outlets. A buyer who spends too much early in the season runs the risk of having insufficient funds for later use.

To stretch the promotional dollars, experienced buyers make significant attempts at gaining outside monies from vendors. It is the mutual cooperation between retailer and vendor that helps sell merchandise and benefit both parties. Known as **cooperative advertising,** the plan is one in which the cost of advertising is shared equally by the merchant and the supplier. The details of this concept will be explored further in the next section.

ADVERTISING

Without question, the most significant portion of the promotional budget is spent on **advertising.** Whether it is for newspapers (generally the most widely used of the advertising outlets), magazines, television, radio, billboards, or direct mail, advertising is considered to benefit retailers more than any other promotional activity.

The buyer generally has the ultimate power to decide where and when the advertising expenditures will be used. Once the decision has been made, it is next a question of how much should be spent on advertising merchandise, and how much, if any, should be set aside for institutional purposes. The institutional concept is one that is used to promote an image or idea rather than specific merchandise. In many retail operations, this expenditure is comparatively minimal and sometimes comes out of a general budget rather than the buyer's.

Advertising Classifications

There are three types of ads that may be used by the retailer—those that have promotional orientations, the kind that are institutionally based, or ads that combine both

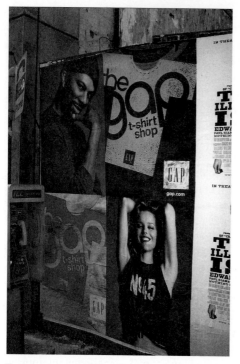

Temporary paper billboards can be changed often.

Brands are being featured on billboards where masses regularly pass by.

features. Each serves a different purpose for the retailer. The buyer, if the expenditure comes out of his or her budget, must determine which approach is most appropriate to maximize sales.

PROMOTIONAL ADVERTISEMENTS

Promotional advertisements, sometimes called product or merchandise ads, are the most widely used. Their presence, in either the print or broadcast media, calls attention to specific merchandise or promotions that the buyer is pursuing. If, for example, a particular style is being strongly featured in a department, the buyer might wish to expend some dollars to bring the customer's attention to it. A special sale might be another time when this type of ad is utilized. It calls attention to the fact that goods will be marked down either for a short time, as in the case of an anniversary sale, or that the reductions will be permanent. Yet another ad of this nature might feature photographs of a particular designer's offerings. Whatever the case, the intention of promotional advertising is to bring immediate attention to the products in the hope that they will increase business. If the buyer has chosen carefully regarding what should be advertised, and the ad is one that satisfactorily features the items, then the consumer should be motivated to buy, and the cost of the ad will be worth the investment.

This ad spells out the type of merchandise offered by
B. Oyama.
(Courtesy of Uptown *magazine.)*

We warmly salute the
Apollo Theater
for years of dedication to
bringing out the best
for audiences in Harlem
and beyond.

ESTEE
LAUDER
C O M P A N I E S

AMERICAN BEAUTY • ARAMIS • AVEDA • BOBBI BROWN COSMETICS
BUMBLE AND BUMBLE • CLINIQUE • DARPHIN PARIS
DONALD TRUMP THE FRAGRANCE • DONNA KARAN COSMETICS • ESTÉE LAUDER
FLIRT! • GOOD SKIN™ • GRASSROOTS™ • JO MALONE • LA MER
MAC • MICHAEL KORS BEAUTY • MISSONI • ORIGINS • PRESCRIPTIVES
RODAN + FIELDS • SEAN JOHN • TOM FORD • TOMMY HILFIGER

Institutional ads such as this one are used to
foster a company's image.
(Courtesy of Uptown *magazine.)*

INSTITUTIONAL ADVERTISEMENTS

Of a completely different nature is the **institutional advertisement,** the ad that concentrates on improving the retailer's image by focusing on such areas as company services, association with charitable organizations, the raising of consumer awareness on social issues, and the like. The money for this type of advertising is not generally taken from a particular buyer's budget unless the ad is aimed to specifically benefit one merchandise department. Such an ad could feature a buyer's specific merchandise that will be presented in a fashion show, with proceeds going to a charity. Because the buyer's department will be the beneficiary of the event, he or she might be charged with the advertising expense.

One of the problems usually associated with institutional ads is the difficulty in measuring their success. They don't bring immediate results, as in the case of promotional advertising, but they are longer-term investments.

COMBINATION ADVERTISEMENTS

Occasionally, buyers are able to use advertisements that combine both the promotional and institutional concepts—called **combination advertisements.** These might be ads, such as those often used by Lord & Taylor, that feature American-made merchandise. The message is that the clothing that is designed and produced in America satisfies the consumer's fashion needs while at the same time contributes to the country's economy. Hopefully, the outcome that will be realized is greater sales for the specific merchandise.

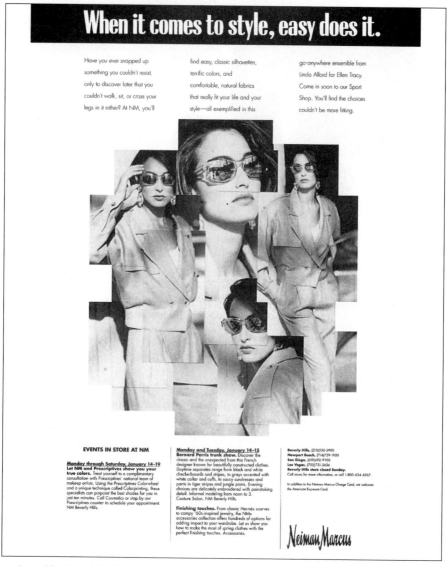

A combination ad that features specific merchandise and announces special events.
(Courtesy of Neiman Marcus Direct.)

In all three types of advertising, the buyer often tries to involve vendors so that the expenses can be shared.

Cooperative Advertising

Often, as a condition of purchasing, the buyer attempts to get the vendor to agree to share in the merchant's advertising expenses. This is particularly the case when potential purchases will be significant. The manufacturer or designer is inclined to agree to share the expense for a number of reasons. First, without this agreement the buyer might opt

to take his or her business elsewhere. With the wealth of merchandise and suppliers available, this is a possibility. Second, it provides the seller with exposure to the consumer market that is generally unavailable. Third, it is a route that manufacturers can take to motivate buyers to purchase in larger quantities.

The amount that the vendor pays in cooperative advertising is based on the size of the purchase. Generally, the seller agrees to pay for 50 percent of the proposed advertisement for a sum that is based on a percentage, often 5 to 10 percent, of the buyer's purchase. For example, if a buyer purchases $50,000 worth of merchandise and is allowed 5 percent for advertising, then the amount can be used to pay for 50 percent of the ad. In other words, the following formula is used:

$$\text{Total purchase price} \times \text{Advertising allowance} = \text{Cooperative allowance}$$
$$\$50,000 \times 0.05 = \$2,500$$

If the ad costs $5,000, then the vendor is obligated to pay 50 percent, or $2,500.

With a great deal of attention paid to negotiating cooperative advertising arrangements, the buyer is able to double his or her own advertising budget. It should be noted that the money can be used for any form of advertising, unless the vendor requires the right of final approval. Such terms may be worked out at the time of the purchase.

While cooperative advertising has obvious advantages for the buyer and the retail organization, buyers must be aware that this sharing of the advertising expense might present some problems. Most significant is the one that deals with the actual merchandise that is to be bought. First and foremost in any consideration is that the merchandise be the best available to satisfy the needs of the customers. Motivation for purchasing should never come from the size of the allowance, but from the merchandise. Overzealous buyers might concentrate on the allowances and consider the goods as less important. This is a situation that is destined for failure. How much profit will be gained from advertising merchandise that is less than desirable? The answer is obvious. Poor selections, no matter how often they are advertised, will end up on the markdown rack. Another pitfall might be to purchase more than has been planned to gain the extra advertising allowances. The orders should always be within the guidelines established in the merchandising plan and should meet the requirements of the model stock that has been developed. Orders that are too large might also be destined for markdowns. Finally, most seasoned retailers agree that no amount of money used in advertising will sell unwanted merchandise. The purpose of advertising is to sell desirable merchandise faster and in larger quantities.

These warnings should be heeded at all times so that only the best goods will come to the selling floor.

Indirect Advertising

As an inducement for buyers to spend large amounts of money on their lines of merchandise, some vendors offer to list the names of the buyer's company in their own advertisements. The focus of such ads is in magazines in which many manufacturers and designers spend large sums to promote their products. The purpose of these vendor ads is to get their names across to the consumer. While retailers concentrate on getting people

into their stores to shop, or to look at catalogs and Internet Web sites, there is often insufficient attention paid to the merchandise source. These vendor-sponsored ads concentrate on the products themselves and generally not on where they can be obtained. Some manufacturers and designers, however, recognize the need for retailers to be noted so that customers know where their lines can be bought. This, of course, is sometimes accomplished through cooperative advertising, where the name of the vendor, along with retailer, is given. By offering **indirect advertising** to prominent retailers, the manufacturer exposes the customers to the places where the goods might be bought. This technique places emphasis on the producer's line, and somewhere in the ad mentions key retail outlets. There is no charge to the retailer for this exposure, but it serves as an inducement to purchase.

As in the case with cooperative advertising, this should not be the only motivation for a buyer to purchase a particular line of merchandise. Only in cases where the goods will appropriately fit into the planned model stock should the buyer proceed with the purchase.

Selection of Merchandise for Advertisements

Whether the advertisement is one that is being considered for the broadcast or the print media, or if it is to be featured in a special promotion or visual presentation, the merchandise selected for it must be carefully considered. Although buyers choose goods with the hope that they will sell well, not everything can be considered worthy of advertising. Some items are included merely as staple goods that are always needed to satisfy customer needs but need not be promoted. Other goods prove to be slow sellers, and no amount of advertising will make them sell faster. Advertising should be reserved for merchandise that has a great deal of sales potential. It might be an item that is selling well and will do better through advertising. It might also be a new item, such as a fashion innovation, that is being touted by the press in consumer periodicals. Still another situation that sometimes warrants an investment in an ad is one that announces a clearance sale.

In the selection of the best items to promote through advertisements, the buyer is the most qualified to make the judgment. By paying attention to sales activity in his or her department, the buyer is aware of what is becoming a best seller. These hot items are destined to become even "hotter" once the ad runs.

Although the ultimate decision about selecting products for advertising is left to the buyer, many stores dictate an approach that should be used before any merchandise is chosen. Fashion retailers, such as Neiman Marcus and Saks Fifth Avenue for example, pride themselves on being the first in their trading areas to present the latest styles. Their images demand that they show their customers that they are first with the latest trends. In this case, sales activity is not a factor since there hasn't yet been any. Although such policy may be risky, it is expected that the buyer will be very knowledgeable about the new trends and will select the best possible merchandise for the ads.

Other merchants, such as those in the grocery business, will generally wait until special deals have been negotiated by the buyer so that an ad announces the bargains to the consumer. No specific goods must be selected—the only concern is the price of the items and the traffic it will generate. In off-price retailing, price is also the name of the game. With value as a major factor, the ad runs when the customer will benefit from the low prices. Of course, if a special deal has been consummated between the buyer and a famous designer, then an ad might be inserted to announce the promotion.

Once the decision has been made in terms of merchandise selection, the next step for the buyer is to make certain that all of the bases have been covered in order for the ad to be placed in a timely fashion and that various details have been addressed to make the ad profitable.

Buyer Participation in the Advertising Process

Although the buyer isn't required to possess any creative advertising ability, he or she plays an important role in bringing the ad to fruition. There are various stages that must be attended to before and during the advertisement's development. These often include the completion of an advertising request form, approval of the artistic team's **layout,** examination of the proof of the ad, and dissemination of tear sheets to those on the selling floor if the ad is of the print variety, notification of the ad's placement, and, finally, an evaluation of the ad to measure its success.

COMPLETION OF THE ADVERTISING REQUEST FORM

If you have ever closely examined a print ad, occasionally it has some errors. The ad might omit an important factor such as the price, some information may be misspelled or reversed in the layout, and some copy might not describe the adjoining illustration. These problems interfere with the consumer's ability to judge the merchandise and can lead to lower-than-expected sales.

These situations can be easily corrected if caution is exercised during the preliminary process. It all begins with the completion of an **advertising request form.** The buyer is the one who begins the procedure by carefully completing the form. When not satisfactorily and accurately completed, the result could be less than desirable, with the expense of running the ad costly and unrewarding.

On the form shown on page 446, newspapers are given the bulk of space. This indicates the importance of this medium to retailers. It does not, however, mean that the other media are unimportant. Each advertisement must be carefully assessed to determine which of the media should be selected for specific purposes.

If the decision has been made by the buyer to place an ad in the newspaper, he or she must also determine if there is more than one that serves the trading area and decide which should be used. Also, the size of the ad must be decided on to bring the most favorable results. If the merchandise warrants a television advertisement, a decision must be made about not only where it should be placed, but how long it should run. Buyers do not generally have advertising expertise and must meet with those who do in order to make the right decisions. The company's advertising manager, an advertising agency representative, or an in-house research department, if there is one, are excellent sources for this type of information. They are the ones most familiar with the media and are able to research the best routes for profitable advertising.

Today, more and more buyers are selling their merchandise through catalogs and Internet Web sites. These outlets require yet another type of expertise. They bring direct sales to the retailer without store visits, thus requiring creative advertising knowledge that will make such purchasing simple. In catalog ads, for example, the insertion of an order form that is easy to complete, a telephone number that can be used at any time, or a fax number that can be accessed are in order. Any way in which ordering can be accomplished with ease is likely to generate more business.

ADVERTISING REQUEST

CIRCLE ONE	Z	DI	X

THIS FORM WILL NOT BE ACCEPTED UNLESS INFORMATION IS COMPLETE

DEPT. NO.

	DATE	SIZE			DATE	SIZE
☐ TIMES			☐ COLONIE			
☐ NEWS			☐ AMSTERDAM NEWS			
☐ POST			☐ SUFFOLK SUN			
☐ L.I.P.			☐ OTHER (LIST)			
☐ NEWSDAY			☐			
☐ WEST. GRP			☐			
☐ N. H. REG.			☐			

MERCHANDISE FOR NEW ART WORK IS DUE IN 15th FL. LOAN ROOM WHEN PINK SHEET IS DUE

EXCEPTION: Ready-to-wear merchandise is due directly after weekly Merchandise Review Meeting. Bulk merchandise should be available on the floor for movement to studio, or for sketching, when called for. Merchandise in LOAN ROOM? ☐Yes ☐No

Do not request New Art Work BEFORE checking file FOR OLD ART.

No. of Illus.	Illustrations to be featured. Points to be emphasized
No. of New	
No. of Old	Date and medium in which old art ran last (attach proof)

OTHER MEDIA. ☐ MAGAZINE NAME_____ ISSUE_____ ☐ SALE BOOKLET ☐ OTHER DIRECT MAIL ☐ RADIO ☐ TV

MAIL ORDERS Yes ☐ ☐ No PHONE ORDERS Yes ☐ ☐ No COUPON Yes ☐ ☐ No

TOTAL AMT. OF MDSE. AT RETAIL $_____ NO. OF UNITS_____ DAY SELLING IS TO BEGIN_____ NUMBER OF DAYS ON SALE_____

ON SALE AT: (CIRCLE) ALL STORES - H. S. - R. F. - HUNT. - B. S. - JAM. - W. P. - PARK. - FLAT. - NEW HAV. - QUEENS - COLONIE - NEW ROCHELLE - SM. HAV.

ABOUT THE MERCHANDISE: (NOTE: Please complete the following IN DETAIL.)

ITEM	STYLE NO.	CURR. RETAIL	ADV. PRICE	QUOTE PHRASE & PRICE*	SIZES	COLORS
1.						
2.						
3.						
4.						
5.						
6.						

MOST IMPORTANT SELLING POINTS (from customer's view) AND SUPERIORITY TO COMPETITIVE ITEMS. (Use other side if necessary.)

IMPORTANT: PINK SHEETS WILL NOT BE ACCEPTED UNLESS THE FOLLOWING INFORMATION IS PROVIDED.

1. TEXTILE FIBER PRODUCTS	2. NON TEXTILE PRODUCTS	3. ELECTRICAL ITEMS
List all information on the product label. If available, a fiber identification tag may be stapled in place.	Copy from label or tag all information relative to composition of parts of product including finishes.	Copy all name plate ratings including volts, amps, watts, horsepower, BTU, CFM, etc. Indicate if UL approved.

THIS IS A ☐ SALE LAST PREVIOUS DATE_____ LAST PREVIOUS PRICE_____

☐ CLEARANCE ☐ SPECIAL PURCHASE ☐ MFG'S CLOSE-OUT ☐ OTHER

INFORMATION ON COMPARATIVE PHRASES: (Note: Complete in detail as applicable.)

1. ☐ "REGULARLY" - means temporary reduction. Refers to price immediately before sale and price to which merchandise will return following sale.
 (a) period during which merchandise was selling on floor at regular price_____
 (b) approximate number of units_____ Is this the normal selling rate?_____
 (c) Is stock to be augmented with merchandise which is not identical?_____

2. ☐ "ORIGINALLY" - means first price during the recent course of business. (Recent course of business is current selling season for seasonal merchandise such as apparel and sporting goods, etc. and not more than 12 months for non-seasonal merchandise such as furniture, appliances, etc.).
 (a) period during which merchandise was selling on floor at original price_____
 (b) approximate number of units_____ Is this the normal selling rate?_____
 (c) Is stock to be augmented with merchandise which is not identical?_____

3. ☐ "COMPARABLE VALUE" - merchandise of equal grade and quality in all material respects,
 OR
 ☐ "VALUE" - identical merchandise selling in other stores.
 Indicate stores at which merchandise is likely to be found._____
 _____ If in Macy's stock, indicate style # and price_____

BUYER OR ASST. BUYER_____ MDSE. ADM. OR V.P._____ COMP. OFFICE REPRESENTATIVE_____

PART 1 ADVERTISING DEPT. COPY

Advertising request form.

446

On most advertising request forms, the buyer is instructed to note the amount of merchandise that is available for sale in terms of dollars and units. This is extremely important to guarantee that when a customer comes to the store to buy, or uses alternative means of purchasing, the merchandise will be on hand. How many times have shoppers wanted to purchase items that appear in ads only to find that they aren't available? This not only leads to the loss of a sale but could cause consumer unhappiness. A trip to a store is time-consuming, and the unavailability of the goods could send the shopper elsewhere. For such reasons, buyers are required to carefully choose merchandise that is in stock or can be quickly ordered if the supply decreases. In cases in which the supply is limited, merchandise managers, who must countersign the request form, return it to the buyer. It is a waste of time for the customer, and money for the retailer, when merchandise that is advertised is in short supply.

In addition to selecting the appropriate advertising medium, and making certain of the goods' availability, the buyer must provide all of the information necessary to create the ad. Information such as style number, current retail price, advertised price if it is sale merchandise, sizes, colors, fabrics, and so forth are indicated in the spaces provided on the form. The buyer should also indicate any important selling points that can be included in the ad. It might be such merchandise features as "wrinkle resistant," "laundering ease," or "special construction" that could motivate purchasing. If the item is an electric shaver, for example, a feature of "adaptable electric currents" could turn the prospective customer who wants the item for traveling purposes into a purchaser.

One of the more important portions of many request forms is the one that deals with **comparative phrases.** Many consumer complaints are registered with better business bureaus and consumer affairs agencies because of misleading pricing terminology. This can come about as a result of the buyer's ignorance about pricing terms, or intentional misrepresentation. Retailers who intentionally misrepresent prices not only face criminal charges, but can also cause the downfall of their companies.

To clarify pricing information, many states have enacted legislation that clearly defines the often confusing price-related words such as *regularly, originally,* **comparable value,** and *value.* These terms are not interchangeable. Briefly defined, they indicate the following:

- *Regularly.* The merchandise in question normally sells at a particular price and is reduced only for a specific time. At the end of the specified period, the goods will return to the **regular** (or normal) selling **price.**
- *Originally.* An item that sold at the beginning of a selling season or period at a higher price but has been reduced to a new price. This is usually associated with fashion or seasonal goods or any merchandise the buyer is trying to dispose of.
- *Comparable value.* This term is the most confusing to the consumer and is sometimes abused by the buyer. Merchandise advertisements that include the term *comparable value* do not indicate that the merchandise ever sold at a higher price, but that "in the buyer's opinion" it is equal in quality to merchandise currently available at other retailers.
- *Value.* Used to indicate a lower price for identical merchandise at other outlets.

The misuse of these terms may not only bring charges against the retailer but also can seriously damage the company's reputation. When customers feel they have been misled, they are likely to shop elsewhere. Through word of mouth, customers can

generate a negative image for any store that violates advertising principles. In today's retail environment, where competition is at a very high level, those who do not fairly play the game will be the eventual losers.

Once the buyer completes the form and signs it, it goes to the merchandise manager or merchandise administrator for his or her signature, and then on to the advertising manager who, once having signed it, passes it along to the creative staff who develop the ad.

LAYOUT APPROVAL

The request form is accompanied by the actual merchandise that is to be advertised so that it might be photographed or sketched. A **loan tag** or sheet is attached to each garment once it leaves the merchandise department. This is used to keep track of the item and make certain that it is returned to the proper location.

Once the illustrations have been completed and the **copy** written, a layout is prepared. This final rendering shows exactly how the ad will look, whether it is of the print or broadcast variety. At this point, it is sent to the buyer, who carefully examines it to make certain that every detail is absolutely correct. Imagine the trouble if the wrong price has been inserted.

Having verified all of the information, the buyer returns the layout to the advertising department for transmittal to the appropriate medium.

EXAMINATION OF A PROOF

Although the advertising staff is responsible for the ad in its production stage, the buyer must check to make certain that no errors have been made. It is unwise for the buyer to assume that the ad is error-free. When the ad has been translated from the "drawing board" to actual print, any number of mistakes can occur. The price can be misstated, a word misspelled, or the wrong copy inserted next to the photograph. It is at this **proof** stage that any errors can be rectified. Once the ad goes into production, it is too late to make changes.

After the ad has been carefully checked it is ready to proceed. When it is finally printed or "aired," the buyer awaits the outcome. In the case of a print ad, the buyer receives a **tear sheet,** an actual copy of the ad that has been pulled from the newspaper or magazine to show that it has run.

TEAR-SHEET USAGE

Aside from the fact that a tear sheet presents proof that the ad was published, it also serves as a tool that the buyer can use to help sell the advertised products. Only the inexperienced buyer believes that his or her role in advertising stops at this point. While the intention is to motivate shoppers to purchase, there is no assurance that this will happen. Even when they do come to the store, there is no guarantee that those on the selling floor have been made aware of the ad's presence.

Tear sheets may be used to notify store and department managers, and of course sales associates, of the ads' presence. By posting them in appropriate places, such as on bulletin boards in employee locker rooms or rest areas or at time clocks, another step has been taken to ensure that they have been seen.

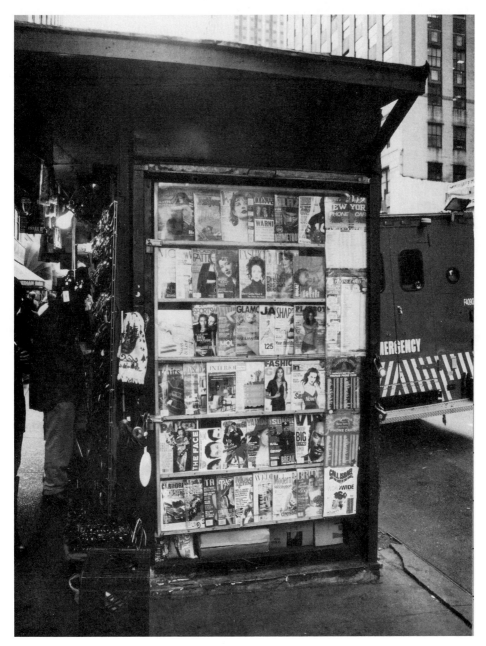

Many fashion merchants use magazine advertising.
(Courtesy of Ellen Diamond.)

STAFF NOTIFICATION

In addition to the use of the posted tear sheets, the buyer should communicate the running of the ad to everyone who might help sell the advertised merchandise. The methods used to get the message across can be either an in-person meeting with managers and salespeople or some other means. When the branches are to be notified, in-person contact is generally impractical. For those at a distance from where the buyer operates, the use of the telephone, faxes, or e-mails serve the purpose. It might also be wise to fax copies of the tear sheets to those units in the organization and tell where they should be posted.

It is often the branch store that is totally unaware of an ad's placement. If this is the case, the dollars expended for the advertisement could be wasted.

EVALUATION OF THE ADVERTISEMENT

A seasoned buyer not only wants to see that the advertised items sell as expected but also understands that evaluation of the ad's effect is important. One comparison that should be made is the sales volumes before the ad was placed and after it ran. This is a simple task for the buyer to perform by just looking at the two sets of sales figures. Of course, if the company has its own research department, other more sophisticated research can be used.

If the advertising was carefully planned and all of the details were addressed to guarantee its success, the advertising expenditure will have been worthwhile.

VISUAL MERCHANDISING

One of the tools that the early retailers used to show the merchandise to its best advantage was a **display.** Whether the company was a small individual proprietorship or a major organization, time and effort went into the planning and execution of both window and interior displays. Today, the display concept has been expanded to **visual merchandising.** The concept includes not only formal displays but also the placement of the merchandise on the selling floor, design of the sales arena that best augments the goods offered for sale, the lighting that focuses on the goods, the signage that is strategically placed, and so forth.

With the vast windows that once graced every brick-and-mortar location no longer as prominent as they once were, retailers have turned over the sales floors to the visual teams to do their "magic." Of course windows, the **silent sellers** of retailing, still bring in the crowds if they are part of a store's environment. With today's significant costs for retail space, large windows are often out of the question. Except for the downtown flagships, where the major Christmas themes are still in abundance, displays of the past are gone.

Whether it is the windows that remain, or the interior spaces, the buyer still relies on visual merchandising to help sell the goods—maybe in the store's **shadow boxes** or **vitrines** that formally feature the merchandise, or in the aisles that house the racks and shelves. In the more formal fixtures, the visual merchandiser installs the presentations. On the selling floor, however, the buyer might move racks around to get a better vantage point, or the department managers might change a mannequin.

Fashion alone is not the only product classification in which visual merchandising is making the buyer's purchases more appealing. In the grocery industry, interiors

A shopper examines a window in a downtown flagship.
(Courtesy of Ellen Diamond.)

have taken on a new excitement with the presentation of the items. Produce, in particular, is featured in inviting environments that quickly motivate the shoppers to buy. Fresh flower arrangements have become the norm at many supermarkets, making the interiors more visually appealing. Companies like Harris Teeter, a supermarket chain based in the South, and Fresh Market, another entry from the South, have taken visual merchandising to new heights. One step into these stores, and a new food shopping excitement awaits the consumer. It's not that the merchandise is necessarily unique as compared with the past, but the presentation gives it added appeal. Buyers of these types of goods have had much success because of these new approaches.

The major role of the buyer, in terms of visual merchandising, is not to make the physical changes but to select the merchandise that needs to be featured. It is the emphasis on the most eye-appealing items that will generally translate into sales.

Buyers, and for that matter department managers and sales associates, should be properly schooled in the basics of visual presentation. In a fashion operation, if a

mannequin needs to be changed or a jewelry case needs to be rearranged, it shouldn't be necessary to wait for the visual team to make the changes. With simple rules that can be learned from basic visual merchandising manuals, or from courses that are taught in colleges, the fundamentals can be learned. Waiting for a visual merchandiser to perform these tasks may take too long to serve the department's immediate needs.

SPECIAL EVENTS

One aspect of promotion that underscores the retailer's creative ability is the presentation of a **special event.** These events are termed "special" because they are not part of the everyday merchandising undertaken by the store. They run the gamut from such spectaculars as Thanksgiving Day parades and fireworks presentations to informal fashion shows and celebrity personal appearances.

Major events such as the holiday parades like Twin City Federal's "Holidazzle" are the work of an enormous number of regular employees as well as outside specialists who are hired especially for the event. By contrast, the store buyer often plays a major role in a special event that centers on the offerings of his or her department. It might be a cooking demonstration by a famous chef, the appearance of a designer, or the presentation of a **trunk show.** These often come about as a result of the buyer's initiative and creative thinking. When a buyer is successful in getting Oscar de la Renta to appear in the store to introduce his new fragrance, or Tommy Hilfiger to talk about his latest collection, the crowds are certain to come.

You might question the value of special events in terms of their costs and resulting customer purchases. While the success of some events is difficult to measure, others can be easily evaluated. For example, if a buyer is fortunate enough to have well-known interior designers come to his or her department to create model rooms, sales could be quickly measured for the items used in the designs. Comparisons can be made between the periods preceding the special event and the time after it. While the results might take awhile to assess, because such purchases are not generally made on impulse, they can nonetheless be measured. Simpler is the case of a fashion show presentation that uses the designer or a celebrity as the motivational "bait." At the conclusion of such events, the merchandise is often made available for immediate purchasing. A mere glance at the interest shown in the merchandise on the racks, and subsequent visits to the cash registers, indicates the success of the show. A buyer soon knows if he or she made the right decision to spend the dollars necessary for the special event.

Immediate impact on sales is not always possible for specific merchandise. The Macy's Thanksgiving Day Parade surely generates a great deal of store traffic, but it is difficult to tell if the parade motivated people to buy the latest handbag. No one can provide an accurate answer. However, if Macy's continues to offer its parade year after year, the ends must justify the means.

It is not these storewide extravaganzas that are within the buyers' realm of responsibility. It is the events that are arranged for presentation within their departments over which they have a great deal of jurisdiction. Buyers receive a budget allocation much as they do for advertising. Also, as in the case of advertising, seasoned buyers negotiate with the vendors to share in the costs of such presentations. A designer might be convinced not only to make a personal appearance at a fashion show, but also

Men's Moderate Area Dept 355
Flow Chart (Large Size)

GUY HARVEY OR DUCK'S UNLTD	M.E. SPORT TROPICAL KNITS		M.E. SPORT TROPICAL WOVENS	NAK CAMP SHIRTS
Andhurst s/s blended knits	Arrow s/s blended knits	M.E. Sport /NAK Traditional print knits	25% OFF PERMS	50% OFF Clearance
Saddlebred solid and stripe pocket tees	Arrow Sport knits or Van Heusen	Andhurst cvc wovens	Saddlebred s/s solid twill wovens	BUGLE BOY S/S SOLID sheeting
Saddlebred s/s solid pique	Alexander Julian fancy knits	Duck Head Knits and wovens	Saddlebred s/s printed twill wovens	Arrow s/s Chavella wovens
Saddlebred printed fancy knits	GRAND SLAM fancy knits	Duck Head Knits and wovens	Alexander Julian wovens	Arrow America sport s/s wovens
trunk goes here				

The buyer's selections and where they will be placed on the selling floor.

Macy's Thanksgiving Day Parade.
(Courtesy of Macy's.)

to pay a portion of the costs associated with the project. Once the designer is sold on the idea that the show will benefit the retailer and also result in reorders, the vendor is likely to provide monetary assistance.

These joint ventures are often made possible because of the buyer's ability to convince vendors to participate. They are not automatic occurrences, but come as a result of the buyer's negotiating ability.

As in the case of advertising, the two classifications of special events are promotional and institutional.

Promotional Events

Special events used to sell specific merchandise are known as **promotional** (or merchandise) **events.** They might include the January white sales that most major department stores use to dispose of their inventories, customer appreciation days, and special sales that might run for brief periods, usually from one to three days. One that is tied directly into the buying staff is a favorite among many major merchants, commonly called "Assistant Buyer Days." It is an event that requires assistant buyers to cover the market and obtain merchandise that offers excellent value. Markdowns from the retailer's current inventory are also included in this promotion. The other sales events also involve the buyer's procurement of value-oriented merchandise. They necessitate trips to the market to get off-price items that will be mixed with the current items that the store wishes to dispose of. These special, short-period sales are extremely prevalent in retailing and generally attract a great deal of attention.

The special sales are not exclusively restricted to the retailer's brick-and-mortar units but also to the catalogs they publish. Buyers are called on to participate in special purchasing for these direct-mail pieces and also to prepare inventory markdowns from existing stocks.

In addition to the sale-oriented promotions, buyers are also involved in suggesting other special promotions that motivate increased store traffic. These include events such as fashion shows, personal appearances by celebrities, trunk shows, seminars delivered by industry personalities, and demonstrations by vendor representatives.

Each of these has the potential to sell merchandise in greater quantities than without the promotions. When a famous designer appears at a store, the crowds are often there to greet him or her and purchase the products being presented. Whenever cookware buyers have made arrangements for famous chefs to make store appearances and use specific cookware to prepare recipes, sales for the pots and pans they use generally soar. If a trunk show is the special event in which a company representative brings a designer collection to a store, buying is an end result.

In all of these presentations, it is generally the buyer who makes the contact and brings whomever is necessary to the store to make the event memorable as well as profitable. The buyer uses creativity to develop these promotional concepts, and if done satisfactorily, business generally benefits.

Institutional Events

One of the ways in which retailers increase general store traffic and promote the store's image is through the use of **institutional events.** These are not necessarily designed to sell specific merchandise but rather to generate consumer interest in the retailer. These

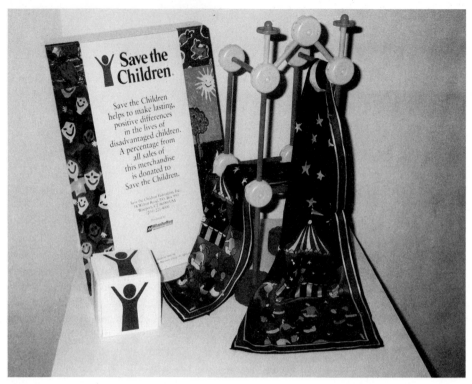

An institutional event promotes goodwill.
(Courtesy of Ellen Diamond.)

are akin to the fabulous Christmas window displays that are traditional at retailers such as Macy's, Saks Fifth Avenue, and Lord & Taylor. These displays feature attractions such as animated presentations that draw large crowds.

Although the buyers do not play specific roles in theses events, they are required to make certain that their inventories are at levels that will meet the needs of the vast crowds. It might be special holiday merchandise, goods that have been acquired off-price and can motivate shoppers to buy because of their value, or just markdowns from inventory that will appeal to price-conscious consumers.

In some cases, the institutional event might also have a specific product tie-in. At Macys on state Street in Chicago for example, at a recent annual Christmas "tree-lighting" ceremony in the store, appearances were made by Disney characters who were led by Mickey and Minnie Mouse. The buyers of Disney-oriented products had to make certain that there was a sufficient supply of goods to satisfy the needs of the shoppers who came to the event.

When the buyer has actively participated in the preparation of advertisements, visual presentations, and special events that feature his or her merchandise, it is likely that sales will increase and that profits will be maximized.

Language of the Trade

advertising
advertising request form
combination advertisements

comparable value
comparative pricing phrases
cooperative advertising
copy
display
indirect advertising
institutional advertisements
institutional events
layout
loan tag
original price
promotional advertisements
promotional events
proof
regular price
shadow box
silent sellers
special event
tear sheet
trunk show
value price
visual merchandising
vitrine

Summary of Key Points

1. The buyer is rarely expected to create advertisements but is generally required to be an active participant in some of the aspects of their preparation.
2. Promotional budgets are provided for individual buyers to use for advertising and other promotional endeavors.
3. The dollar amounts designated for each buyer are generally based on past sales and *the company's eye on the expansion of his or her department*.
4. Astute buyers are able to make their advertising dollars go even further through vendor participation in cooperative advertising.
5. When making advertising determinations, buyers must first decide how much should be apportioned between promotional and institutional endeavors.
6. The vast majority of the buyer's advertising monies are spent on promotions that attempt to sell specific merchandise.
7. Sometimes buyers are able to get their company's names featured in vendor's ads without any cost to themselves. These ads are called indirect advertisements.
8. The buyer selects the merchandise that will be advertised and then completes an advertising request form that addresses all of the forthcoming ad's particulars and details.
9. Buyers must carefully use the right comparative phrases in the ads to avoid any misunderstandings by consumers.
10. Once an ad has run, it is imperative for the buyer to make the necessary preparations to notify the staff of the ad's placement. This will guarantee that store employees will be ready to handle customer questions.
11. Visual merchandising is extremely important to buyers. It is this concept that places the merchandise in its most favorable light.

12. Special events are promotions that buyers engage in to help sell their products.
13. The special events are divided into two categories, promotional and institutional, much the same as advertising.
14. Buyers do not develop special events but participate in them to make certain that they have the merchandise needed after the event takes place.

Review Questions

1. What is the buyer's role in a company's advertising program?
2. How is the buyer's promotional budget determined by top management?
3. Which of the advertising media is most widely used by retailers?
4. In what way are advertisements classified? What are the main classifications?
5. Why does a retailer participate in institutional advertising if it doesn't necessarily bring immediate sales to the company?
6. If a buyer wants to stress a particular item in an ad as well as deliver a message about the company's image, what type of advertisement should be placed?
7. How is the amount available from vendors to buyers for cooperative advertisements determined?
8. What is meant by the concept of indirect advertising?
9. Why does the buyer make the decision about which products should be advertised by his or her department?
10. What is an advertising request form, and who initiates its use?
11. Why is the appropriate use of comparative terms so important for the buyer to understand?
12. Why should a proof of the ad be scrutinized before it goes into print?
13. How does the tear sheet, if properly used by the buyer, help increase sales?
14. By what means does a buyer notify those on the selling floor that something has been advertised?
15. Why do most merchants no longer have the benefit of large exterior display windows?
16. What is the buyer's major role in visual merchandising?
17. What is meant by the term *special event?*
18. Are special events promotional or institutional?
19. Since special events are generally major retail endeavors, is it ever necessary for the buyer to participate in their planning?
20. Why do retailers present special events that are institutionally oriented?

CASE PROBLEM I

Taft's Department Store, an eight-unit organization located in New England, has been in business for fifty years. It is considered one of the most successful operations of its kind in that region. Through its many years of operation, it has continuously provided its clientele with the finest, most unusual merchandise available. To bring these items to the company, the buyers travel the globe and return with products that will be of interest to the clientele. Some of its merchandise, in fact, is available to no other organization within a three-hundred-mile radius. Customers seeking the unusual in both soft and hard goods come from great distances to avail themselves of Taft's offerings. With so much competition for the company, it is a credit to them to have met with so much success.

For the past year, the company has witnessed a considerable increase in its cost of operation. Management has held several high-level meetings to develop strategies to combat the higher cost of doing business so that they could remain as profitable as they have been in past years. Many suggestions were made, including consolidation of the business day, which would decrease the payroll; fewer customer services; and a substantial decrease in the promotional budget.

Each senior manager was asked to digest the recommendations that had come forth at the meetings and suggest more appropriate measures. At the final decision-making meeting, it was management's consensus that a reduction in the promotional budget was the only solution. The other recommendations were eliminated from consideration. Against heavy opposition from the buyers, management argued that promotional dollars were available from many vendors and would make up for the deficiency in the budget. Their suggestion was to concentrate more on the companies that offer promotional cooperation.

The buyers were asked to organize their thoughts concerning their opposition to management's decision and be prepared to present their reasons at a future meeting.

Questions

1. Are cooperatively sponsored promotions advisable for a company like Taft's?
2. Describe the disadvantages to the company that might result from too much emphasis on cooperative promotion.

CASE PROBLEM 2

Sandra Rhodes has been appointed as the new furniture buyer for Bliss, Ltd., one of the few remaining major retailers to specialize in furnishings for the home. In addition to furniture, it carries a large selection of carpets and rugs from all over the world, lighting fixtures, tableware, and accessories. Its inventory features a wide assortment of contemporary as well as period designs.

Although sales have kept pace with projections, the new management team that has been in place for six months believes the company has never reached its full potential in furniture sales. The bulk of its business has come from the other merchandise classifications. Hence the decision to hire Ms. Rhodes, who has a reputation for excellent purchasing ability and a keen knowledge of merchandise production.

For her first special furniture event, Ms. Rhodes has decided on a warehouse sale so that she can quickly reduce the inventory developed by her predecessor. Understanding some of the drawbacks of warehouse sales, she nonetheless feels that this is the best technique to employ without radically altering the company's regular selling floors in the various stores.

Being a meticulous planner, Ms. Rhodes always carefully prepares each aspect of the promotion.

Questions

1. Which of the media should she use to advertise the event?
2. For what duration should the event be presented?
3. Will such an event harm the credibility of the company?

Glossary

ADVERTISING Any paid for form of nonpersonal presentation and promotion of ideas, or services by an identified sponsor.

ADVERTISING AGENCY A company that completely specializes in all aspects of advertising, beginning with the creation of the ad and ending with its placement.

ADVERTISING MANAGER The person responsible for all types of advertising that the buyer needs to prospect for customers.

ADVERTISING REQUEST FORM A document that a buyer must complete before an ad can be planned by the advertising department.

AGENT A business unit that negotiates purchases or sales or both but does not take title to the goods.

AIR EXPRESS Express service on regularly scheduled flights.

AIR FREIGHT Shipment by air freight planes. Quick and less expensive than air express.

ANTICIPATION A special form of cash discount.

ASSISTANT BUYER An individual who assists the buyer by taking over his or her less responsible tasks.

AUTOMATIC REORDERING A system in which merchandise, generally staple items, are reordered without the need for frequent buyer input.

BRANCH STORE A unit of a retailer that is smaller than its flagship store.

BRAND A name, term, symbol, design, or a combination, intended to identify the goods or services of one seller or group of sellers and to differentiate them from those of competitors.

BRICK AND MORTAR RETAILER A term that identifies merchants who operate their businesses from stores.

BRIDGE A category of fashions between haute couture and mass.

BROKER An agent who does not have direct physical control of goods but represents the buyer or seller.

BUYER The individual responsible for purchasing merchandise for the retailer.

BUYING MIX The elements of buying: what to by, how much to buy, from whom to buy, and when to buy.

CASH DISCOUNT A reduction in the price for prompt payment.

CENTRALIZATION An arrangement under which a group of managers working in the home office controls all of the units in the organization.

CHAIN STORE SYSTEM A group of stores that are centrally owned and operated with some degree of centralized control.

CHAMBRE SYNDICALE DE LA COUTURE PARISIENNE The organization that regulates fashion in Paris.

CHANNEL OF DISTRIBUTION The route through which a product or service is marketed and moves from the producer to the user.

CHARGEBACK A monetary concession given by the vendor to the retailer for goods that did not sell as well as expected.

CLOSEOUT Merchandise that is left at the vendor at season's end that is disposed of at a lower price.

COLLECTION The line of merchandise that a designer creates.

COLLEGE BOARD A consumer panel or focus group composed of college students.

COMMISSIONAIRE A foreign resident buyer.

COMPARISON SHOPPER An individual who provides comparative information on other retailers in such areas as price, visual presentations, promotions, advertising, and merchandise assortments.

COMPUTER HARDWARE The machinery in a computer installation.

CONSIGNMENT BUYING An arrangement under which title to goods does not pass until the buyer sells the merchandise.

CONSUMER PANEL A focus group of consumers used by retailers for information on merchandise and pricing.

CONSUMER'S REPORT The periodical produced by Consumer's Union that evaluates and rates a variety of products.

CONTRACT An agreement between two or more parties that is legally enforceable.

CONVENIENCE GOODS Products that consumers purchase with a minimum of effort. They include tobacco products, soap, newspapers, chewing gum, and many small items.

COOPERATIVE ADVERTISING Advertising that is jointly paid for by the retailer and the vendor.

COOPERATIVE BUYING An arrangement by which individual orders are pooled to qualify for discounts.

COOPERATIVE RESIDENT BUYING OFFICE A buying office that is owned and operated by a group of stores.

CORPORATE BUYING OFFICE A resident office that is a division of a retail corporation.

CREDIT AGENCY An institution that provides credit information.

CREDIT LINE The amount of credit an organization is willing to extend to its customers.

CREDIT MANAGER The person who is responsible for the extension of customer credit and the supervision of collections of customer accounts.

CROSS-CULTURAL SKILLS The skills that are necessary to favorably interact with people of different cultures.

CUMULATIVE MARKUP Markup on goods on hand divided by retail price of goods on hand.

DAILY NEWS RECORD A trade paper, generally referred to as DNR, that specializes in menswear.

DECENTRALIZATION An arrangement in some chain organizations that allows individual store managers to make decisions in such areas as merchandise selection, promotion, and markdowns.

DEMOGRAPHICS The statistical characteristics of a category of purchasers.

DEPARTMENT STORE A major retail organization that sells a wide variety of hard goods and soft goods. It separates its main functions into divisions.

DIRECT MAIL A method that uses fliers and brochures to reach the consumer with product offerings through the mail.

DIRECT RETAILING Selling to consumers in their homes or places of business through such means as catalogs, e-mail, and cable television.

DISCOUNT OPERATION A retail organization that features a wide assortment of goods that is sold below the traditional prices.

DIVISIONAL MERCHANDISE MANAGER The individual who is second in command to the retailer's top merchandising executive. His or her responsibilities are within a specific merchandise division in the company.

DOLLAR MERCHANDISE PLAN A budgetary system of merchandising based upon dollar amounts.

DUN & BRADSTREET A credit-checking agency.

DUTY An amount that is added to the selling price for merchandise that is purchased from most foreign countries.

E-MAIL An electronic system that is used to send messages.

EOM End of Month.

FAD A term used to describe a short-lived fashion.

FAIRCHILD PUBLICATIONS The largest publisher of fashion periodicals.

FAMILY LIFE CYCLE The stages of development of a family from marriage through maturity.

FASHION A style that is popular at any given time.

FASHION COORDINATOR A specialist in fashion show production, style, and color forecasting who works closely with the buyers.

FASHION COUNT A research tool that involves observation of consumers.

FASHION DIRECTOR An executive who provides fashion information to the merchandising team.

FASHION FORECASTER An individual who helps designers and retailers learn about the upcoming trends in fashion.

FASHION REPORTING SERVICE A company that provides pertinent fashion information to the manufacturing and retailing industries.

FAX A machine that enables communication of messages over telephone lines.

FLAGSHIP STORE The main store of a department store organization.

FOLLOWING UP ORDERS A task that involves communication with vendors to determine the status of orders that have been placed.

F.O.B. Free on board.

F.O.B. DESTINATION Title to goods passes when it arrives at its destination. Since the vendor owns the goods until then, he or she pays the freight.

F.O.B. FACTORY Title to the goods passes at the point of shipment.

FOCUS GROUP A small group of individuals who are questioned in terms of preferences. Their responses are analyzed to help make changes in product marketing and selling.

FRANCHISEE An individual who becomes part of a franchised operation.

FRANCHISER A person or company that owns a specific company and has the right to expand its operation by allowing others to own and operate individual outlets.

FRANCHISING An exclusive arrangement whereby an individual and an operating company do business together in a specified way.

FULL-LINE DEPARTMENT STORE A retail organization that merchandises a complete assortment of hard and soft goods.

GARMENT CENTER The name used to describe New York City's most important area for manufacturers and designers to sell their goods.

GATT General Agreement on Tariffs and Taxes is a governmental act that reduces tariffs and taxes on imports.

GENERAL MERCHANDISE MANAGER The head of a retailer's merchandising division.

GROUP BUYING An arrangement in which buyers pool their orders to get better terms.

HAND-TO-MOUTH PURCHASING Buying when the need arises.

HARD GOODS Merchandise such as furniture and appliances.

HAUTE-COUTURE High fashion.

HOME SHOPPING NETWORKS Cable television stations that expressly sell merchandise to consumers.

HOT ITEMS Goods that are fast sellers.

HUMAN RESOURCES MANAGER The individual responsible for staffing the company and overseeing the various employee programs.

IMPULSE GOODS Goods purchased without prior planning.

INCOME STATEMENT A summary of revenues and expenses for a period of time.

INDEPENDENT RESIDENT BUYING OFFICE An office that offers services to independent retailers.

INDIRECT ADVERTISEMENT A manufacturer's ad that mentions retailers' names.

IN-HOUSE VIDEO COMMUNICATION A system that uses closed-circuit communication between the buyers and the store's managers and sales associates.

INITIAL ORDER The first order placed by a buyer.

INTERNATIONAL BOUTIQUE SHOW A major trade exposition for women's fashion merchandise.

INTERNET RETAIL WEB SITE A location on the Internet that consumers can access and make purchases.

INTERNET SHOPPING An off-site method used by consumers to purchase merchandise.

JOB LOT An assortment of merchandise that the vendor closes out to the retailer at highly discounted prices.

KEYSTONE MARKUP A term that indicates the retail price is double that of the wholesale price.

KEYSTONE PLUS MARKUP The retail price is double the wholesale plus a little extra.

LANDED COST The total cost of the goods to the retailer.

L.C.L. Less than a full freight carload.

LEASED DEPARTMENT An independently operated department within a department store.

LINE AND STAFF An organizational structure that uses decision makers, company producers, and advisory personnel.

LINE ORGANIZATION A form of organization in which authority flows in a straight line from top management to lower levels.

LINGUISTIC FAUX PAS The spoken mistakes that are made because they often have different meanings in different languages.

LIST PRICE The manufacturer's published price from which discounts are taken.

LOSS LEADER A product of known or accepted quality priced at a loss or no profit for the purpose of attracting patronage to the retailer.

MAGIC The name of the largest men's trade exposition in the United States.

MAIL ORDER HOUSE A company that receives its orders by mail or telephone and generally offers its goods in catalogs and print ads.

MANUFACTURER'S AGENT An agent who represents several noncompeting lines of merchandise.

MANUFACTURER'S BRAND Merchandise that features the seller's brand or label.

MANUFACTURER'S OUTLET A store that is owned by the manufacturer that usually sells closeout items at discounted prices.

MARKDOWN A reduction in the selling price.

MARKET It might be either the group of people that is being targeted for business, a place where business is transacted, or the conditions within which buyers and sellers make decisions on the transfer of goods and services.

MARKET ANALYSIS An aspect of marketing research that involves the measurement of the extent of a market and the determination of its characteristics.

MARKET CONSULTING ORGANIZATION A company that helps businesses with their tasks such as buying, product development, and so on.

MARKETING The performance of business activities that direct the flow of goods and services from the producer to the user.

MARKETING RESEARCH The systematic gathering, recording, and analyzing

of data about problems relating to the marketing of goods and services.

MARKET WEEK A period in which buyers from all over the country attend showrooms and trade expos to preview the manufacturer's new lines.

MARKUP Difference between the cost and selling price.

MERCHANDISE INVENTORY The value of goods being offered for sale.

MERCHANDISE INVENTORY TURN-OVER The average amount of time it takes for the average inventory to sell in a year.

MERCHANDISE MANAGER One who oversees the merchandising division.

MERCHANDISE PLANNING Determining the merchandise assortment in terms of styles, price points, and so forth.

MIDDLEMAN An individual who is involved in selling the manufacturer's goods to the retailer.

MODEL STOCK The necessary assortment featured by retailers to satisfy the customers' needs.

MOST FAVORED NATION STATUS This is the designation given to certain countries that enables their goods to be sold with lower tariff rates and restrictions.

NAFTA A trade agreement that eliminates the tariffs between the United States, Canada, and Mexico.

NAMSB A major trade exposition for menswear.

NATIONAL BRAND A manufacturer's brand that enjoys wide territorial distribution and recognition.

NET PROFIT The profit after deducting the cost of goods sold and operating expenses.

NRF The National Retail Federation, the largest retail association.

OBSERVATION RESEARCH A marketing research tool that relies exclusively on observing consumers.

OFF-SITE RETAILING Businesses that operate through catalogs and Web sites.

OPEN-TO-BUY The difference between the merchandise available and the merchandise needed for a particular period.

OPERATING EXPENSES All expenses of doing business other than the cost of the merchandise sold.

OPPORTUNISTIC PURCHASING Buying when the prices have fallen to the desired level.

OPTICAL SCANNER A device used for inputting data into the computer system.

PALM-POWERED GUIDES Assistance that is available for use in negotiations on instruments such as palm pilots.

POSTDATING A means of extending the credit payment.

POWER CENTER A retail shopping center that houses major value-oriented retailers.

PRE-TICKETING A service provided by the vendor that tickets the merchandise for the retailer.

PRICE CUTTING Offering merchandise or services for sale at below the usual selling price.

PRICE LEADER A company whose pricing policy is followed by others in the same industry.

PRICE POINTS The major focus of prices that are merchandised by a company.

PRIVATE LABELS Lines of merchandise that are sold exclusively by one retailer.

PRIVATE RESIDENT BUYING OFFICE A resident office that is owned and operated by one retail organization.

PRODUCT CLASSIFICATION A term used to indicate merchandise types such as apparel, furniture, and so on.

PRODUCT DEVELOPMENT The design and development of a new item.

PRODUCT LINE A group of items that are closely related.

PROOF A copy of an advertisement that goes to buyers and other interested parties to make certain that it is correct.

PUBLICITY The nonpersonal stimulation of demand for a product or service by planting news about it in a published medium to obtain favorable results.

QUOTA For imported merchandise, the amount that can be brought into the country.

RACK JOBBER A wholesale business that services the retailer by stocking inventory, replacing slow sellers with new merchandise, and charging only for the items that have been sold.

REORDER Merchandise that is replenished because of its customer appeal.

RESIDENT BUYER An agent who helps the retail buyer make a number of decisions including vendor and merchandise selection.

RESOURCE DIARY A detailed listing of resources.

RETAILER A merchant whose main business is selling directly to the consumer in stores, through catalogs, or on Web sites.

RETAIL NEWS BUREAU A fashion-retail information service.

ROAD SALES REPRESENTATIVE A manufacturer's sales rep who visits the merchants in their stores or home offices.

ROBINSON PATMAN ACT A piece of legislation that forbids price discrimination.

R.O.G. Receipt of goods.

SALES ANALYSIS The study and comparison of sales data.

SALES FORECAST An estimate of sales in dollars and units for a specific future period.

SALES PER SQUARE FOOT A measurement used by retailers to assess the success of their operations.

SALES PROMOTION Any activity such as advertising, visual merchandising, and special events that helps sell merchandise.

SEARCH ENGINE A tool used on the Internet to find areas of interest.

SEVENTH AVENUE A term used by those in the fashion industry to describe New York City's garment center.

SILENT SELLER A term used to describe a store's window displays.

SHOPPING GOODS Consumer merchandise that requires careful selection before a decision is made to buy.

SIX-MONTH PLAN A plan that the buyer uses for future purchases.

SOFT GOODS Any type of wearing apparel.

SOFTWARE Computer programs or instructions.

SPECIAL EVENTS Happenings in stores that are offered to stimulate business on a one-time basis.

SPECIALIZED DEPARTMENT STORE Companies such as Saks Fifth Avenue and Neiman Marcus that restrict the vast assortment of their offerings to one classification.

SPECIAL ORDER Merchandise that is ordered specifically for one customer.

SPECIALTY GOODS Merchandise that has unique characteristics and whose availability is severely limited.

SPECIALTY STORE A retail operation that restricts its merchandise to a limited line.

STAFF RELATIONSHIP An organizational relationship that provides for advisory services.

STAPLE GOODS Merchandise that is always in fashion.

STORE IS THE BRAND A retail concept where only the store's own brand is available for sale.

STYLE The shape or silhouette of a design.

SUBCLASSIFICATION Another word used synonymously with style.

SUBSTITUTE SHIPPING The sending of items by vendors to retailers that weren't ordered, in place of those that were.

SURF THE NET To explore various Web sites on the Internet.

TABLE OF ORGANIZATION The organization of the functions and divisions of a company.

TARGET MARKET The audience a business is trying to reach.

TARIFF The amount of duty that is levied on merchandise.

TEAR SHEET A copy of an advertisement.

TESTING BUREAU A lab facility that tests merchandise.

TRADE ASSOCIATION An organization of businesses with like interests.

TRADE DISCOUNT A reduction from the list price to differentiate between buyers.

TRADE PAPER A periodical that is earmarked for industrial purchasers.

TRADING AREA The major district that a retailer wishes to reach.

TRUNK SHOW A promotional event in which manufacturers and designers visit stores to show their collections to the store's customers.

VALUE ORIENTED MERCHANT A retailer such as an off-pricer or discounter who deals in merchandise that has price appeal.

VISUAL MERCHANDISING The practice of presenting merchandise in windows and interiors that enhance sales.

WANT SLIP A system to record customer requests for merchandise.

WEB SITE An Internet location where products and services are featured.

WHOLESALER A business that acts as the intermediary between the manufacturer and retailer.

WOMEN'S WEAR DAILY The leading industry fashion publication in the world.

Photo Credits

Page 36: Rafael Macia, Photo Researchers, Inc.; Page 93: Louis Sullivan, Carson, Pirie, Scott & Co.; Page 94: Nelson Hancock © Rough Guides; Page 102: Jacques M. Chenet/Newsweek, Getty Images, Inc.–Liason; Page 170: Amy Etra, PhotoEdit, Inc.; Page 171: Getty Images–Stockbyte; Page 173: Gary Buss, Getty Images, Inc.–Taxi; Page 175: Michael Newman, PhotoEdit, Inc.; Page 176: Michelle Bridwell, PhotoEdit, Inc.; Page 177: Michael Newman, PhotoEdit, Inc.; Page 178: Robert Daly, Getty Images, Inc.–Stone Allstock; Page 179: Getty Image, Inc.; Page 180: PhotoEdit, Inc.; Page 181: Tony Freeman, PhotoEdit, Inc.; Page 182: Getty Images, Inc.–Stone Allstock; Page 183: Sears, Roebuck & Co.; Page 186: Courtesy of Ellen Diamond; Page 188: Courtesy of Uptown Magazine; Page 276: Courtesy of Ellen Diamond; Page 315: David King Collection; Page 317: Folio, Onmi-Photo Communications, Inc.; Page 320: Ryan McVay, Getty Images, Inc.–Photodisc; Page 321: Federation Francaise du Pret a Porter Feminin; Page 323: Peter Wilson © Dorling Kindersley; Page 324: Susanna Price © Dorling Kindersley; Page 326: Joerg Boethling, Peter Arnold, Inc.; Page 328: Stefan Mokrzecki, Photolibrary.com; Page 329: Michael Rosenfeld/Stone/ Getty Images; Page 331 (top): Courtesy of Ellen Diamond; Page 331 (bottom): Robert Fried/robertfriedphotography.com; Page 333 (top): Getty Images/Digital Vision; Page 333 (bottom): The Stock Connection; Page 343: Courtesy of Ellen Diamond; Page 389: Lee Snider, The Image Works; Page 440 (top left): Courtesy of Ellen Diamond; Page 440 (top right): Courtesy of Ellen Diamond; Page 441 (top left): Courtesy of NuAmerica Agency; Page 441 (top right): Courtesy of NuAmerica Agency; Color insert, Page 2 (top): Getty Images, Inc.; Color insert, Page 2 (bottom): Photo: FashionSyndicatePress.com; Color insert, Page 3 (top): Michael Keller, Corbis/Stock Market; Color insert, Page 3 (bottom): Bob Schatz, Getty Images, Inc.–Stone Allstock; Color insert, Page 4 (top): Michael Goldman, Getty Images, Inc.–Taxi; Color insert, Page 4 (bottom): Rhoda Sidney, PhotoEdit, Inc.; Color insert, Page 5: Ogust, The Image Works; Color insert, Page 6: Mark Richards, PhotoEdit, Inc.; Color insert, Page 7: Courtesy of Uptown Magazine; Color insert, Page 8: Rosanne Olson, Getty Images, Inc.–Stone Allstock

Index